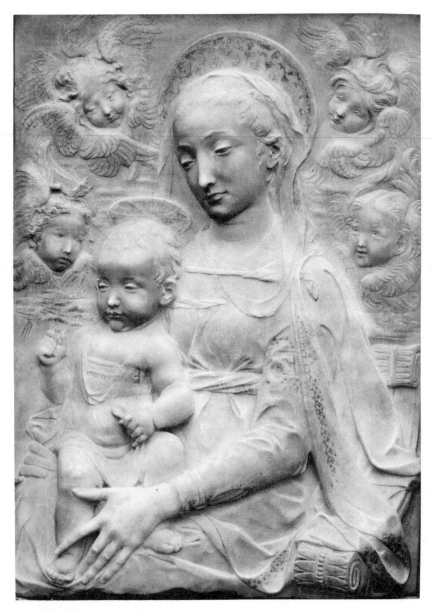

Antonio Rosellino (1427–1478)
Madonna and Child with Angels
Bas-relief, marble.
The Metropolitan Museum of Art,
Bequest of Benjamin Altman, 1913.

Fifteenth-Century
Central Italian Sculpture

an annotated bibliography

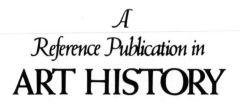

A
Reference Publication in
ART HISTORY

Marilyn Aronberg Lavin, Editor
Italian Renaissance

Fifteenth-Century
Central Italian Sculpture

an annotated bibliography

SARAH BLAKE WILK

REFERENCE PUBLICATIONS
IN
ART HISTORY

G. K. Hall & Co, 70 Lincoln Street, Boston, Massachusetts

For Emily and Julie

Library of Congress Cataloging in Publication Data

Wilk, Sarah Blake.
 Fifteenth-Century central Italian sculpture.

 (A Reference publication in art history)
 Includes indexes
 1. Sculpture, Renaissance—Italy—Italy, Central—
Bibliography. 2. Sculpture, Italian—Italy—Italy,
Central—Bibliography. I. Title. II. Series.
Z5954.I8W54 1986 016.73'0945'6 85-27168
[NB619.C44]
ISBN 0-8161-8550-6

This publication is printed on permanent/durable acid-free paper
MANUFACTURED IN THE UNITED STATES OF AMERICA

Contents

Contents

Contents

Contents

The Author

Sarah Wilk is an associate professor of Art History at Rutgers University, New Brunswick, New Jersey. She has published on Tullio Lombardo, Donatello, and Titian. She is currently completing a monograph on the Chapel of the Arco of St. Anthony in the Santo, Padua.

Editor's Preface

No period in the history of postclassical art has been studied as much as has the Italian Renaissance. Yet, in recent years, no other period has undergone so much reevaluation. In the early nineteenth century when Passavant was eulogizing Raphael, and Crowe and Cavalcaselle wrote the first edition of their History of Painting in Italy (1864), the favored technique was stylistic analysis, and the goal was attribution. By tacit agreement, experts followed the predilections of Giorgio Vasari (Lives of the Most Eminent Painters, Sculptors, and Architects [2 ed. 1568]) and deemed the High Renaissance in Florence and Rome as the pinnacle of art.

By the mid-twentieth century, efforts to struggle free of these historical preconceptions were succeeding. The later sixteenth century (the period of "Mannerism") was saved from oblivion. Studies of iconography stood on the podium next to those of style. Ferrara and Brescia, Naples and Bologna were recognized as centers of culture along with Florence and Rome. Miniature painting, printmaking, garden architecture, liturgy, patronage, and other historical phenomena were considered within the art scholars' purview. In short, no longer confined to connoisseurship, Italian art history has been placed in its sociocultural context and extended to the realm of the historian of art.

This broadened outlook is the basis for the organization of the Italian Renaissance series of bibliographies. About twenty in all, the individual titles have been determined by a kind of grid based on medium, topography, and chronology. There are volumes devoted to painting (and drawing), to sculpture, to architecture, to printmaking, to the decorative arts, and to ephemera, theater, and urbanism. Topographical regions form the subdivisions: central Italy (Tuscany, Lazio, Umbria, and the Marches), north Italy (Lombardy, Piedmont, Liguria, Emilia-Romagna, and the Veneto); south Italy; and Sicily. These subdivisions are further grouped chronologically according to parts of centuries (1400-1465, for example), whole centuries, or periods greater than a century, as in the case of the decorative arts volume. A few of the major artists have volumes of their own; Leonardo, Raphael, Michelangelo, Titian,

and Palladio are therefore excluded from the usual categorization by medium, region, and period.

The authors have reviewed all of the works cited; their annotations are descriptive and are meant to point out the lasting values or specific limitations of each item. The intent of each volume is to provide about 1,500 to 2,000 concise but well-rounded references to books, articles, and reviews from the early days of the history of art through current scholarship that takes its place with the classics of Renaissance art historiography.

Marilyn Aronberg Lavin
Princeton University

"We who have survived the [Pre-Raphaelite] craze for
Quattrocento sculpture know that its importance is not
mere love of Florence, fascination for refined expres-
sive lines, delicacy of charming Madonnas, or the some-
what literary appeal of enchanting women and bold,
youthful men."

[Georg Swarzenski, "Some Aspects of Italian Renaissance
Sculpture in the National Gallery, I." Gazette des
beaux-arts , 6th ser. 24 (September 1943):154].

Foreword

SCOPE OF THE BIBLIOGRAPHY

The aim of this volume is to provide a compact and selective annotated bibliography of fifteenth-century Central Italian sculpture. The designation "Central Italian" here refers to sculpture executed by artists born in the provinces of Tuscany, Lazio, Umbria, and the Marches.

This bibliography is not exhaustive. Only materials available before 1985 could be included. In the process of selection the following criteria were used. Publications concerning major works of sculpture in the round and relief were given first place. Those concerning minor works such as medals, metalwork, and small-scale ceramics were included only when the sculptors were major artists (e.g., Pollaiuolo, the Della Robbia). Likewise, publications about nonsculptural works by major sculptors (e.g., stained glass designed by Ghiberti or Donatello) were included here as an appropriate extension of this volume's subject matter. Yet writings about paintings by major fifteenth-century sculptors who were also major painters were excluded because they will appear in the volume devoted to Central Italian painting of the period.

While I have generally omitted encyclopedia articles, those in the Algemeines Lexikon der bildenden Künstler by U. Thieme and F. Becker 1 (referred to in the text as Thieme-Becker Künstler-Lexikon) have been included for several reasons. Although the entries concerning major figures are admittedly out of date, they are historically interesting as a reflection of the critical evaluation of those artists at the time of writing. In the case of minor sculptors, the entries frequently constitute the only summaries of the sculptors' careers. Moreover, the summary bibliographies in the Lexikon remain useful. Certain entries from the Encyclopedia of World Art are also included, mainly because they are succinct accounts of the sculptors' careers written by leading authorities of the 1960s and 1970s, with bibliographies postdating those in the Lexikon.

Foreword

The present volume has a straightforward general structure divided into two major parts: works arranged under various subject categories (Sections I-X) and works on individual artists (Section XI). The first section is a general one that lists documents and surveys. It is followed by six sections where the arrangement is topographical. The remaining three sections in the first part cover various specialized topics, including sculpture in materials other than stone, sculptural commissions for other than individual statues, cultural and social background, the influence of antiquity, iconography, and so forth. The reader should consult the Contents for individual headings. The first part ends with listings of public and private collections, exhibitions, and reviews of exhibitions. The second and largest part of the bibliography is devoted to works about "Individual Sculptors."

Citations are organized alphabetically by author under each of these headings. Anonymous articles are listed under "Anon.," anonymously authored books under their titles. In cases where there are many references under an individual heading or within an author's section the entries have been subdivided according to the following organization. Books are listed first, with reviews numbered as subentries under the main entry. These monographs and studies are followed by unpublished theses, then by books on specific commissions. Reviews for these entries are also included as subentries when appropriate. Articles are found at the end of each subject or artist section. In the section on "Theoretical Writing" editions of the individual theoretician's writings are followed by secondary sources. Entries not examined by the author are marked with an asterisk. An extensive subject index is included at the end of this volume. The reader is advised to consult that index to locate citations for specific objects and commissions; additional information on objects and commissions is to be found in monographs on the artists.

Research for this volume was done at the Frick Art Reference Library, the Avery Library of Columbia University, the Metropolitan Museum of Art Library, and the New York Public Library in New York City; at the Marquand Library, Princeton University; and at Voorhees Library, Rutgers University. I wish to acknowledge several grants from Rutgers University that helped pay the expenses of preparing this volume. I am grateful to Susan Cooperman Vick, Sylvia Bakos, and Patricia McDermott, graduate students at Rutgers, who helped by combing periodical indexes and cross-checking bibliographies. I am also grateful to Walther Bohne for his assistance on questions of translation. My biggest debt is to Brian Wallis, who assisted me greatly in compiling the bibliography and made many valuable suggestions that improved it. I am also indebted to Phil Mariani, who painstakingly typed and retyped the manuscript.

Introduction

Although fifteenth-century Central Italian sculpture is one of the best studied fields in art history, there is very little primary literature about sculpture from the period. The only contemporary sources that deal with it in broad terms are the theoretical treatises of Alberti and Pomponius Gauricus. Alberti's De Re Aedificatoria (entry 15) indicates his conception of the civic role of sculpture, while his De Statua (entry 14) pertains exclusively to the technical problems of statuary. His most useful treatise is De Pictura (entries 13 and 14), which deals with compositional and aesthetic considerations relevant to relief sculpture as well as painting. While the latter treatise reveals the theoretical issues regarded as important by fifteenth-century artists, it tells us nothing specific about them. It briefly praises Brunelleschi, Ghiberti, Donatello, Luca della Robbia, and Masaccio, and only that acknowledgment indicates the artists whom Alberti held in highest regard.

Gauricus's De Sculptura of 1504 (entry 26) is a history of sculpture from ancient times to his day. It stresses the superiority of Greco-Roman sculpture and praises sculptors like the Lombardi and Riccio, fifteenth-century classicizing artists of the region where he lived. He praises the Florentines, Donatello and Luca della Robbia, without discussing their sculpture in any detail.

Another treatise of some interest is Filarete's Trattato dell'architettura (entry 24) which, like Alberti's treatise on the same subject, discusses the role of sculpture in the ideally planned city and indicates in passing remarks contemporary opinions about various sculptors.

Probably the most significant primary source on fifteenth-century Central Italian sculpture is Ghiberti's Commentarii (entry 27), the only text by a major sculptor of the period. It contains an autobiography, as well as Ghiberti's evaluation of earlier art. Written in the 1450s, it concerns Ghiberti primarily and,

unfortunately, does not provide us with much information about other fifteenth-century sculptors.

For information about the lives and careers of other fifteenth-century sculptors, we must turn to a sixteenth-century writer, Vasari (entries 10 and 11). Although his first edition of the Vite dates from 1550, Vasari was able to trace recent traditions. His career in Rome and his own Tuscan pride caused him to give greatest attention to the biographies of the artists native to and active in those areas. Vasari not only provides specific data about dozens of fifteenth-century sculptors but, in arranging the anthology, reveals his conception of the evolution of fifteenth-century art. Underlying his historical presentation is the assumption that sixteenth-century art surpassed that of the previous century and represented the zenith of Italian achievement.

Seventeenth- and eighteenth-century collections of artists' lives tend to repeat Vasari's work and provide little new information about the increasingly far-removed fifteenth-century sculptors. Of much greater significance in these later centuries is the Italian tradition of local patriotism that resulted in the writing of many historical chronicles and guidebooks for towns and specific monuments in Central Italy. Because their subject matter is generally narrow, they will not be discussed here. The most important are included in the bibliography; for the rest, the reader is referred to Schlosser's monumental study of these sources, La letteratura artistica (entry 3).

It was not until the nineteenth century that the next phase in the study of fifteenth-century Italian sculpture began. The intense interest in Greco-Roman civilization that had resulted in the eighteenth-century excavations of Pompeii and Winckelmann's influential essays on ancient art gradually stirred interest in the Italian Renaissance as the first modern revival of the classical past. Cicognara's history of Italian sculpture (entry 44) is the first such major study; it reveals a neoclassical bias in the way it exalts Renaissance sculpture at the expense of the medieval and Baroque.

In France the developing interest in archaeology is reflected in the early date of foundation of the Société nationale des antiquaires de France (1817) and the publication by mid-century of the Gazette des beaux-arts. The Gazette was the first periodical to publish articles on archaeology and art, including many on fifteenth-century Italian sculpture.

This archaeological interest was even stronger in Germany and resulted in numerous excavation projects, scholarly studies of ancient art and civilization, and the foundation of institutions like the Bibliothek des deutschen archäologischen Institut in Rome (1829). Study of later historical periods followed shortly thereafter. University chairs in the newly defined discipline of art history were

established. Rumohr's Italienische Forschungen (1824-31; entry 63) marks the beginning of systematic connoisseurship based on the examination of original documents. The pioneering study of fifteenth-century Italy, the Civilization of the Renaissance in Italy (entry 42), was written by the great German-trained Swiss, Burckhardt. This book, the Cicerone, a guide to Italian art (entry 41) and Burckhardt's university lectures (entry 1210) further stimulated German scholarship in the Italian Renaissance period. The foundation of major collections of Italian sculpture, particularly at the Kaiser Friedrich Museum, Berlin, and the establishment of significant research libraries like the Kunsthistorisches Institut in Florence (1888) also contributed to the burgeoning of scholarship.

In England the establishment of the South Kensington Museum (which later was renamed the Victoria and Albert) in the 1850s made fifteenth-century Italian sculpture available for study and further spurred interest in the period. Private collectors, particularly in that country, acquired significant pieces of fifteenth-century sculpture, especially Madonna and Child reliefs and portrait busts, partly because these objects were portable and readily available. (Occasionally larger complexes housed in Italian churches also came on the market as a result of the secularization of churches by Napoleon.)

By the mid-nineteenth century, the Romantic movement and Pre-Raphaelitism focused attention on other nonclassical aspects of Italian Renaissance art. Especially in England, but also in Germany and France, they incited interest in the fifteenth century as the epoch where artists' individual artistic personalities seemed more distinct, not subsumed by one dominant period style as in the High Renaissance.

The reaction to fifteenth-century art caused by these artistic and literary movements coincided with the differently motivated response of the flourishing European middle class: it became intrigued by fifteenth-century Florence as the site of the first great age of the bourgeoisie. Finally, the religious revival of the Victorian Age, and specifically the emergence of the Tractarian movement, stirred appreciation of fifteenth-century Italian art. Artistic production of the Quattrocento was felt to epitomize their goals of pious, direct, and emotionally moving Christian content and form.

The extraordinary result of these conjoined enthusiasms for the fifteenth century is well expressed by Wölfflin who, in the first edition of his Die klassische Kunst (1899), wrote that his study of the High Renaissance was written to correct exaggerated admiration for the fifteenth century. He somewhat ironically described that enthusiasm in the following terms:

"The early Renaissance calls up a vision of
slender-limbed, virginal figures in variegated robes,

blooming meadows, floating veils, spacious halls with
wide arches resting on graceful pillars. It means all
the fresh vigour of youth, shining eyes, all that is
bright, transparent, lively, cheerful, natural, and
varied. Pure nature, yet nature with a touch of fairy
splendour."[2]

The favorite of mid-nineteenth-century collectors was Luca della
Robbia, whose classicism and sincere religious content epitomized
current taste and initiated a fashion for majolica in nineteenth-
century England. Also very popular were the minor sculptors of the
aptly named "sweet style": Desiderio, Mino, the Rossellinos, and
Agostino, whose Madonna and Child reliefs captivated mid- and late
nineteenth-century audiences. A more scholarly outgrowth of this
interest was the various surveys of fifteenth-century sculpture by
Charles Perkins, an American expatriate in Victorian England, whose
volumes provided the basic reading material on the subject (entries
56-58).

Although Donatello had always been recognized as the major
sculptor of the century and Perkins had stressed how Christian he
was, he did not become very popular until the late nineteenth
century. Intensified interest in Donatello probably developed around
the fifth centenary of his birth, which spurred a series of
monographs on him. (Semper's two volumes [entries 796-97] have
proved to be of lasting value.) Recognition of Rodin's naturalistic,
expressive style may have also coincided with the centenary to
influence late nineteenth-century appreciation of Donatello,[3] earning
him a place of honor alongside the more charming devotional sculptors
of the Quattrocento.

The age of intensive archival research and source analysis began
in the late nineteenth century and involved scholars all over Europe.
Especially important for Italian Renaissance studies is Milanesi's
edition of Vasari's Vite (entry 11), which is still considered the
classic edition. Of particular interest for the study of Florentine
sculpture is Poggi's monumental study of the archives of the Duomo in
Florence (entry 107). The French scholar, Eugène Müntz, did valuable
research on the collections and patronage of the Medicis and the
fifteenth-century popes (entries 91 and 162-65). The Quellen-
schriften für Kunstgeschichte und Kunsttechnik, supervised by von
Eitelberger, was founded in Vienna and published a series of new
editions of primary sources edited by leading scholars (entries 14
and 797).

A second major development in late nineteenth-century scholarship
was the emergence of more rigorous methods of connoisseurship, the
impact of which was first felt in the study of painting. The leading
exponent of this methodology was Morelli. His attempts to identify
objective criteria and scientific method for distinguishing artists'
styles published in his "Princip und Methode,"[4] made a major impact
on scholars such as Adolfo Venturi, whose Storia dell'arte italiana

(entry 69) treats both painting and sculpture and ranks as the first
thorough survey of fifteenth-century Italian sculpture. Morelli was
also a pioneer in the use of photographs to study works of art, and
their introduction was of capital importance. (The Madonna and Child
reliefs, so popular earlier, reproduced better than any other
sculptures in line engravings, which may well have influenced their
popularity.)

More rigorous methods of connoisseurship were also reflected in
the articles and catalogues of Bode and Schottmüller, scholars
associated with the Kaiser Friedrich Museum, Berlin (entries 395-97
and 399-400). Systematic application of "scientific" connoisseurship
to fifteenth-century sculpture only began, however, with publication
of Lányi's research in a series of articles in the 1930s (entries
104, 937-40, 1500, and 1666-67). His scholarship redefined the
careers of Donatello and Nanni di Banco and other sculptors active in
the Forentine Duomo workshops. Unfortunately, Lányi died before he
could publish most of his work. His principal project, a monograph
on Donatello, was continued by H.W. Janson and finally appeared in
1957. Lányi's system of archival research, careful physical
examination of the sculpture, and detailed three-dimensional
photography, had enormous influence on later scholarship,
particularly that of Pope-Hennessy.

In the late nineteenth century Americans emerged as scholars in
the field of art history. Allan Marquand of Princeton University
first began publishing articles, then authoritative books, on the
sculpture of the Della Robbia (e.g., entries 1739-40). The art
department at Princeton, the first department devoted to archaeology
and art history in this country, was established in this period. The
founding of the College Art Association and its major scholarly
journal, the Art Bulletin (1913), followed soon after.

MODERN SCHOLARSHIP

This section is intended to guide the reader to the most basic
recent sources. What are now considered the two authoritative
surveys of this period were written by an American and English
scholar, respectively: Seymour's 1966 Pelican volume, Sculpture in
Italy, 1400-1500 (entry 67), and volumes 1 and 2 of Sir John
Pope-Hennessy's Introduction to Italian Sculpture, written in 1955
and 1963 and revised in 1971-72 (entries 60-61; a newly revised
edition is scheduled to appear in paperback in late 1985). They
differ fundamentally in approach and organization. Seymour
formulates a conceptual and historical basis for the study of
fifteenth-century sculpture. In attempting to give equal weight to
regions other than Tuscany, he interrelates sculptures produced all
over Italy decade by decade. He also includes dozens of minor
sculptors. Pope-Hennessy, by contrast, offers most of his analysis
of fifteenth-century sculptors in a monographically organized
catalogue, although in volume 2 there are essays surveying the

evolution of various types of commissions. As the world's foremost connoisseur of Italian Renaissance sculpture, Pope-Hennessy uses that method primarily and focuses on the major figures, who are mainly Tuscans.

DONATELLO

Janson's magisterial two-volume study (entry 786) remains the fundamental book on Donatello. Janson carefully analyzed the arguments from all earlier literature on Donatello and compiled a catalogue that covers all his certain and probable sculptures. There is, however, no essay providing a synthesis of Donatello's career. The more than 500 photographs are the single best corpus ever assembled on any sculptor and are indispensable.

The focus of Janson's book was to summarize and make sense of each commission. It laid the foundation for dozens of articles and books that have since appeared on specialized aspects of Donatello's sculptures. These have come primarily from German scholars such as Herzner, Lisner, Poeschke, Rosenauer, and Wundram, but also from the Italians, Fiocco and Sartori, and the English, John White and Ronald Lightbown. They have challenged many of Janson's conclusions, especially concerning Donatello's relationship with Nanni di Banco and his Paduan commissions.

The new book by Bennett and Wilkins (entry 776 bis) provides a useful assessment of the recent literature about Donatello and some questions concerning his sculpture. In addition, the authors analyze in detail selected issues, including some individual commissions, technical and stylistic considerations, and Donatello's relationships with patrons. This book complements Janson's monograph.

GHIBERTI

Krautheimer's extraordinary two-volume study on Ghiberti (entry 1179) is till unsurpassed in its analysis of all aspects of Ghiberti's life, thought, and sculpture, and it probably always will be. No aspect of his assessment of Ghiberti has been redefined in any major way. One should consult the recent volumes of essays on Ghiberti (entries 1181-82), however, for their contributions and the most up-to-date bibliography. Krautheimer's assessment of the recent literature is found in the introduction to the third edition of his Lorenzo Ghiberti (entry 1179), and in his introduction to the volume of conference papers on Ghiberti (entry 1237).

BRUNELLESCHI

Brunelleschi's sculpture has not been well studied. There are early, out-of-print and hard-to-find descriptions of the Pistoia Silver Altar from the tradition of Italian regional pride in monographs like Beani's (entry 631). The best modern work on his sculpture is by Sanpaolesi (entries 643 and 676). One should also

consult the papers from recent conferences on Brunelleschi (entries 635 and 637) and his adopted son, Buggiano (entry 681).

JACOPO DELLA QUERCIA

Despite his stature, there is no thorough monograph on Quercia. Seymour's volume (entry 1607) is the most readable account, but Seymour himself described it as a preliminary study. Part of the problem seems to be that no one, including Seymour, can decide how to integrate Quercia into the history of fifteenth-century sculpture.

There are, however, excellent monographs on his most important commissions: the Fonte Gaia in Siena (Hanson, entry 1613), the Baptismal Font, Siena (Paoletti, entry 149), and the Portal of San Petronio, Bologna (Beck, entry 1614). In addition, many valuable essays on all aspects of Quercia's career are found in the recent conference (entry 1608).

LUCA DELLA ROBBIA

There are two major monographs of scholarly importance on Luca della Robbia, the recent, thorough catalogue raisonné by Sir John Pope-Hennessy (entry 1743) and the series of exhaustive catalogues of sculptures by the Della Robbia and Buglioni by Allan Marquand (e.g., entries 688 and 1740). Pope-Hennessy's monograph not only updates but considerably enriches Marquand's assessment of Luca because he considers Luca's sculpture in light of the work of other contemporaries. Although Marquand's catalogues no longer provide the best interpretation of the material, they are still basic sources on della Robbia sculptures.

MID-CENTURY SCULPTORS

Despite their phenomenal nineteenth-century popularity, scholarship on the mid-century sculptors, Desiderio, Mino, and the Rossellino brothers, is less developed. The only extensive monograph on Desiderio is seriously flawed (Cardellini, entry 732); it should be used in conjunction with the older monograph by Planiscig (entry 733) which, although aimed at a general audience, is sound.

There is a solid, modern monograph on Mino da Fiesole which is controversial, however, because it identifies him with Mino del Reame (Sciolla, entry 1440).

Schulz's monograph on Bernardo Rossellino and his workshop (entry 1859) is the basic authority on this artist; Planiscig's earlier account of Bernardo's career (entry 1830), which includes his architecture and Antonio's sculpture as well, is not superseded by it.

Introduction

POLLAIUOLO

There are a number of modern monographs on the Pollaiuolo that cover all aspects of their artistic production (entries 1542 and 1546-48). Ettlinger's (entry 1546) is the most recent.

VERROCCHIO

There are two basic, modern accounts of Verrocchio's sculptures. The exhaustive catalogue of his workshop's production in painting and sculpture by Passavant (entry 1921) supplies a valuable corpus of photographs of Verrocchio's certain and attributed sculptures. Seymour's preliminary monograph (entry 1924) takes a contractionist stand on Verrocchio's oeuvre vis-à-vis Passavant.

NOTES

1. Ulrich Thieme and Felix Becker, Allgemeines Lexikon der bildenden Künstler, 37 vols. (Leipzig: Wilhelm Engelmann [vols. 1-2]; E.A. Seemann [vols. 3-37], 1907-50).

2. Heinrich Wölfflin, Die Klassische Kunst (Munich: F. Brockmann A.-G. 1899). Quoted from the English translation, The Art of the Italian Renaissance (New York: Schocken Books, 1964), p. 2.

3. Jenö Lányi, "Problemi della critica donatelliana." Critica d'arte 19, no. 2 (1939):9.

4. Ivan Lermolieff [Giovanni Morelli], "Princip und Methode," in Kunstkritische Studien über italienische Malerei: Die Galerien Borghese und Doria Panfili in Rom (Leipzig: F.A. Brockhaus, 1890), pp. 1-78.

footerxxvi

General

COLLECTIONS OF DOCUMENTS

1 GAYE, GIOVANNI. Carteggio inedito d'artisti dei secoli XIV,
 XV, XVI, pubblicato ed illustrato con documenti pure inediti
 dal dott. Giovanni Gaye. . . . 3 vols. Florence: G. Molini,
 1839-40, no illus.
 Notable documents and letters relevant to art from ar-
 chives of Florence and other cities. Vol 1: 1326-1500. Most of the
 hundreds of documents concern fifteenth-century art. Facsimiles
 included. Indexed by date with full description of each document.

2 MILANESI, GAETANO. Nuovi documenti per la storia dell'arte
 toscana dal XII al XV secoli raccolti e annotati da G.
 Milanesi. Florence: Dotti, 1901, 176 pp., no illus.
 Documents, primarily from the Archivio de' contratti,
 Florence, that concern Tuscan art from the twelfth to fifteenth
 century. Not indexed.

LITERARY SOURCES UP TO 1700

Basic Authority on Local Histories and Art Theory

3 SCHLOSSER MAGNINO, JULIUS. La letteratura artistica: Manuale
 delle fonti della storia dell'arte moderna. Translated by
 Filippo Rossi. 3d ed. by Otto Kurz. Florence: La Nuova
 Italia Editrice; Vienna: Anton Schroll & Co., 1967, 792
 pp., no illus. [First published as Die Kunstliteratur (Vienna:
 Anton Schroll & Co., 1924).]
 Invaluable history and analysis of art theory, chronicles,
 and guidebook literature from the Middle Ages through the eighteenth
 century. Includes lengthy section on local histories and guidebooks,
 arranged by region. Extensive bibliography.

Other Sources

4 BALDINUCCI, FILIPPO. Notizie de' professori del disegno da
 Cimabue in qua. . . . 6 vols. in 3. Florence: Per Santi
 Franchi, 1681-1728. 2d ed. with notes by D.M. Manni, 21 pts.
 in 10 vols., Florence, 1767-74; 3d ed. prepared by Giovanni
 Piacenza, 5 vols., Turin, 1768-1817; edition in Classici
 italiani, Milan, 1811-12; edition with notes by F. Ranalli, 5
 Vols., Florence: Batelli, 1845-47; facsimile of latter ed., 2
 vols., Florence: SPES, 1974.
 Vol. 3: 1400-1550. Individual biographies of artists from
Northern Europe and Italy. Includes all major fifteenth-century
sculptors.

5 _____. Vocabolario toscano dell'arte del disegno nel quale si
 esplicano i propri termini e voci, non solo della pittura,
 scultura, & architettura. . . . Florence: Per Santi Franchi
 al Segno della Passione, 1681, 188 pp., no illus.
 Early dictionary of specialized vocabulary for painting,
sculpture, and architecture.

6 FACIUS, BARTOLOMAEUS. "Bartholomaeus Facius on Painting: A
 Fifteenth-Century Manuscript of the De Viris Illustribus," by
 Michael Baxandall. Journal of the Warburg and Courtauld
 Institutes 27 (1964):90-107, 8 figs.
 De Viris Illustribus by Facius or Fazio, first printed in
1745 but written in 1456. Of the few European artists included,
three are sculptors: Lorenzo and Vittorio Ghiberti and Donatello,
whose sculptures are listed. Parts of manuscript dealing with paint-
ers and sculptors are translated here and commented on.

7 MORISANI, OTTAVIO. "Gli artisti nel 'De Viris' di B. Facio."
 Archivio storico per le provincie napoletane 72-73, n.s.
 33-34 (1953-54):107-17, no illus.
 Discusses Fazio's remarks about Ghiberti and Donatello.

8 ORLANDI, PELLEGRINO ANTONIO. Abcedario pittorico nel quale
 compendiosamente sono descritte le patrie, i maestri, ed i
 tempi, ne' quali fiorirono circa quattro mila professori di
 pittura, di scultura, e d'architettura divisa in tre
 parti . . . Il tutto disposto in alfabetto per maggior facilità
 de' dilettanti. . . . Bologna: Constantino Pissari, 1704, 436
 pp., no illus. 2d ed., enlarged, 1719.
 Early anthology of artists' lives that has one of first
bibliographies about art. Includes only most important fifteenth-
century sculptors. Very brief entries. Interesting as reflection of
eighteenth-century estimation of artists.

9 RICHARDSON, JONATHAN. An Account of Some of the Statues,
 Bas-Reliefs, Drawings, and Pictures in Italy, France, etc.
 London: Printed for J. Knapton, 1722, 357 pp., no illus.
 Early guidebook, valuable for verifying locations and
existence of works.

10 VASARI, GIORGIO. Le vite de' più eccellenti architetti, pittori, et scultori italiani, da Cimabue insino a' tempi nostri, descritte in lingua toscana da G.-V.-, pittore aretino, con una sua utile e necessaria introduzzione a le arti loro. 3 vols. in 2. Florence: Torrentino, 1550.
 First publication of Vasari's collection of lives of Renaissance artists (mid-thirteenth through mid-sixteenth centuries). A primary source. See following entry. Reprinted first by Corrado Ricci: Giorgio Vasari, Le vite del Vasari nell'edizione del MDL, 4 vols. (Milan: Bestetti, 1927).

11 _____ . Le vite dei più eccellenti pittori, scultori, ed architettori . . . co' ritratti loro et con le nuove vite del 1550 insino al 1567. 3 vols. Florence: Giunti, 1568, illus.
 Classic edition by Gaetano Milanesi: 8 vols. (Florence: Sansoni, 1787-1818); index volume dated 1885.
 English edition by Gaston du C. De Vere: 10 vols. (London: The Medici Society, 1912-15). No notes or scholarly apparatus.
 Most recent scholarly edition: _____ , Le vite de' più eccellenti pittori, scultori, e architettori nella redazione del 1550 e 1568, ed. Rosanna Bettarini and Paola Barocchi, 3 vols. (Florence: Sansoni, 1966-71). 1550 and 1568 edition are printed side-by-side to allow comparison. Very precise text and detailed textual annotations. Elaborate index.
 New scholarly edition in progress: André Chastel et al., eds., Les vies des meilleurs peintres, sculpteurs, et architectes (Paris: Berger-Levrault, 1980-).
 The standard anthology of lives of Renaissance artists and the fundamental source for Italian Renaissance art. Second edition is a revision and amplification of 1550 edition.

12 VESPASIANO DA BISTICCI. Vite di uomini illustri del secolo XV. Edited by Paolo d'Ancona and Erhard Aeschlimann. Milan: Ulrico Hoepli, 1951, 613 pp., 86 figs. English ed. The Vespasiano Memoirs: Lives of Illustrious Men of the XVth Century. . . . Translated by William George and Emily Waters. London: G. Routledge & Sons, Ltd., 1926, 484 pp.
 Biographies of notable fifteenth-century personages, with many allusions to artists. Indexed.

THEORETICAL WRITINGS

Alberti

13 ALBERTI, LEON BATTISTA. Alberti: De Pictura. Edited by Cecil Grayson. Biblioteca degli scrittori d'Italia degli Editori Laterza. Reprint. Rome and Bari: Gius. Laterza & Sons, 1975, 119 pp., no illus.
 Annotated edition of Alberti's important treatise of 1435-36, which described the one-point perspective system and analyzed new means for relief sculpture and painting. Compiled by leading scholar of his writings. Indexed. Supersedes paperback translation with

3

introduction and notes by John R. Spencer, On Painting (London: Routledge & Kegan, Paul, 1956), 141 pp., no illus.

14 _____. On Painting and On Sculpture: The Latin Texts of De Pictura and De Statua. Edited and translated by Cecil Grayson. London: Phaidon, 1972, viii, 167 pp., 8 figs., diags.
 Annotated translation of Alberti's two treatises that pertain directly to sculpture, compiled by leading authority on his writings. With introduction, notes, and index.
 Earlier edition: Leone Battista Alberti: Kleinere kunst-theoretische Schriften. Edited by Hubert Janitschek. Quellenschrif-ten für Kunstgeschichte und Kunsttechnik des Mittelalters und der Renaissance, edited by R. Eitelberger v. Edelberg, 11. Vienna: C. Graeser, 1877, 323 pp., no illus.
 Annotated German translation of De Statua and Della pit-tura. German text on opposite page from Italian or Latin text. With introduction and index. Largely superseded by Grayson.

14a Onians, John. Review of On Painting and On Sculpture, by Leon Battista Alberti, translated by Cecil Grayson. Art Quarterly, n.s. 1, no. 3 (Summer 1978):267-68, no illus.
 Review amplifies Alberti's meaning by providing more accur-ate and nuanced translations of key phrases. Most notably: De Statua is not "On Sculpture" but simply "How to Make a Statue," for above all Alberti's text is a technical manual for creating large-scale sculptures.

15 _____. Ten Books on Architecture. Edited by Joseph Rykwert, including the "Life of Alberti," by Raphael du Fresne, 1739. London: Alec Tiranti, 1955. [Reprint of 1755 English ed. The Architecture of Leon Battista Alberti in Ten Books, Of Painting in Three Books, and Of Statuary in One Book. Translated by James Leoni. London: Edlin, 1726. 2d ed. 1736., 3d ed. 1755.]
 Standard English translation of first and most important Renaissance treatise on architecture, the De Re Aedificatoria (Flor-ence, 1485). Includes Alberti's ideas about the civic role of sculp-ture.

Secondary Sources

16 AIKEN, JANE A. "Leon Battista Alberti's System of Human Pro-portions." Journal of the Warburg and Courtauld Institutes 43 (1980):68-96, 1 fig.
 Demonstrates that Alberti's system of human proportions contained in De Statua is not derived empirically but evolves from mathematical relationships in ancient and medieval accounts of human proportions.

17 BARELLI, EMMA. "The 'Sister Arts' in Alberti's 'Della Pit-tura.'" British Journal of Aesthetics 19, no. 3 (Summer 1979):251-62, no illus.

Studies theoretical bases of Alberti's <u>On Painting</u>, in particular, interrelationship of aesthetics of painting and literature. Defines Renaissance terms like <u>istoria</u> and <u>inventione</u> as employed by Alberti.

18 BATTISTI, EUGENIO and GARIN, EUGENIO. "Alberti's Thought and Treatises on Art." In <u>Encyclopedia of World Art</u>. London: McGraw-Hill, 1959, 1: cols. 208-16, no illus.
 Incisive analysis of Albert's theories about art by two authorities. With extensive bibliography.

19 CLARK, KENNETH. "Leon Battista Alberti on Painting." <u>Proceedings of the British Academy</u> 30 (1944):283-302, 8 figs.
 Analyzes Alberti's <u>Della pittura</u> published ca. 1435, which proposed stylistic and scientific rules for relief sculpture and painting based on classical sources, both literary and sculptural. Argues that the treatise's influence in Early Renaissance was limited but proved most valuable to late fifteenth-century artists.

20 FLACCARENTO, GIORGIO. "Sulla data del 'De Statua' de Leon Battista Alberti." <u>Commentari</u> 16 (1965):216-21, no illus.
 Argues that <u>De Statua</u> was written in Rome ca. 1466, that is, more than thirty years after <u>De Pictura</u>.

21 JANSON, HORST W. "The 'Image made by Chance' in Renaissance Thought." In <u>De Artibus Opuscula, XL: Essays in Honor of Erwin Panofsky</u>. Edited by Millard Meiss. 2 vols. New York: New York University Press, 1961, 1:254-66; 2: pl. nos. 87-88.
 Discusses brief passage from <u>De Statua</u> that considers primacy of "fantasia" over mimesis and traces its sources in Pliny, Lucretius, and Philostratus. Notes its influence on late fifteenth-century art.

22 PARRONCHI, ALESSANDRO. "Sul <u>Della statua</u> albertiano." <u>Paragone</u> 10, no. 117 (September 1959):3-29, no illus.
 Argues that Alberti's treatise <u>Della statua</u> probably predates <u>Della pittura</u>, in part because of the former's medieval character, notably its associations with Aristotle and the notion of a fixed distance between the sculpture and the beholder. Demonstrates its relationship with Donatello's early sculpture.

23 RIESS, JONATHAN B. "The Civic View of Sculpture in Alberti's 'De Re Aedificatoria.'" <u>Renaissance Quarterly</u> 32, no. 1 (1979):1-17, no illus.
 Concludes that Alberti valued highly the form and iconography of sculpture for its role in upholding ideal order, peace, and unity of city.

<u>Filarete</u>

24 FILARETE (Antonio di Pietro Averlino). <u>Antonio Averlino Filarete's Tractat über die Baukunst (Trattato dell'</u>

architettura). Edited by Wolfgang von Oettingen. Quellen-
schriften für Kunstgeschichte und Kunsttechnik des Mittelalters
und der Renaissance, n.s. 3. Vienna: C. Graeser, 1896, 760
pp., 15 figs. Facsimile edition and translation into English
by John R. Spencer. 2 vols. New Haven and London: Yale
University Press, 1965, 1:339 pp. (translation and notes); 2:
unpaginated facsimile.
 Valuable for comments about contemporary sculptors. Dis-
cusses also role of sculpture in architectural programs and in adorn-
ing city.

Secondary Sources

25 SPENCER, JOHN R. "'Rinascere a vedere.'" In Stil und Über-
 lieferung in der Kunst des Abendlandes (Akten des 21. inter-
 nationalen Kongresses für Kunstgeschichte, Bonn, 1964). 3
 vols. Berlin: Gebr. Mann, 1967, 3:234-36, no illus.
 An untitled treatise on art, ca. 1461-63, by Filarete,
 locates beginning of new style (or Renaissance style) in Florence
 around 1400.

Gauricus

26 GAURICOS, POMPONIO [Pomponius Gauricus]. De Sculptura (1504).
 Edited by André Chastel and Robert Klein. Geneva: Librairie
 Droz, 1969, 288 pp., 52 figs.
 First published in Florence, 1504. Important treatise on
 sculpture by Neapolitan humanist associated with Paduan intellectual
 circles. Presented as parallel texts in Latin and French with crit-
 ical notes. An important source for contemporary information and
 theory. With comprehensive bibliography and index. Supersedes
 earlier edition by Heinrich Brockhaus (introduction and notes) (Leip-
 zig: F.A. Brockhaus, 1886), 265 pp., no illus.

Ghiberti

27 GHIBERTI, LORENZO. Lorenzo Ghibertis Denkwürdigkeiten (I
 commentarii). Edited by Julius von Schlosser. 2 vols. Ber-
 lin: Im Verlag von Julius Bard, 1912. [First published as
 "Lorenzo Ghiberti's Denkwürdigkeiten: Prolegomena zu einer
 künftigen Ausgabe," Kunstgeschichtliches Jahrbuch der k. k.
 Zentralkommission 4 (1910):105-211, 10 figs.]
 Scholarly edition of Ghiberti's Commentaries with original
 text and German translation, plus introduction and appendices. More
 useful than edition by Ottavio Morisani, I commentarii (Naples: R.
 Ricciardi, 1947), 224 pp., no illus., brief preface and index, which
 is not a thorough critical edition.

Secondary Sources

28 FENGLER, CHRISTIE K. "Lorenzo Ghiberti's Second Commentary:
 The Translation and Interpretation of a Fundamental Renaissance

6

Treatise on Art." Ph.D. dissertation, University of Wisconsin, 1974, 330 pp. [Dissertation Abstracts, 35/09-A (1975):6022.]

Ghiberti's brief history of art from Giotto to his day, incorporating his own autobiography. Translation into English with annotations, based on existing manuscript (not autograph) in Biblioteca nazionale, Florence, and interpretation of the work within historical context.

29 GAGE, JOHN. "Ghiberti's Third Commentary and Its Background." Apollo 95, no. 123 (May 1972): 364-69, 5 figs., 2 color pls.

Cites Ghiberti's experience as goldsmith and creator of stained glass in regard to Third Commentary's spiritual symbolism of light and its humanist implications.

30 HURD, JANICE L. "The Character and Purpose of Ghiberti's Treatise on Sculpture." In Lorenzo Ghiberti nel suo tempo (Atti del Convegno internazionale di studi, Florence, 18-21 October 1978). 2 vols. Florence: Leo S. Olschki, 1980, 2: 293-315, no illus.

Argues that, contrary to widely held opinion originating with Vasari, Ghiberti's treatise on sculpture was carefully organized and its three commentaries closely interrelated. Source of its structure was Vitruvius's Ten Books on Architecture, from which he also took sections of text. Appendix charts borrowings.

31 _____. "Lorenzo Ghiberti's Treatise on Sculpture: The Second Commentary." Ph.D. dissertation, Bryn Mawr College, 1970, 248 pp. [Dissertation Abstracts 32 (1971):332A.]

Demonstrates that in selection of ancient and contemporary models for sculptor, Ghiberti chose those which conformed to his own ideal of visual reality, specifically those utilizing illusionistic narrative relief. Includes facsimile and annotated translation of sole (nonautograph) manuscript of treatise (Biblioteca nazionale, Florence).

32 MURRAY, PETER. "Ghiberti e il suo Secondo commentario." In Lorenzo Ghiberti nel suo tempo (Atti del Convegno internazionale di studi, Florence, 18-21 October 1978). 2 vols. Florence: Leo S. Olschki, 1980, 2:283-92, no illus.

Analyzes novel features of Ghiberti's Second Commentary.

Miscellaneous

33 BARASCH, MOSHE. "Der Ausdruck in der italienischen Kunsttheorie der Renaissance." Zeitschrift für Ästhetik und allegemeine Kunst Wissenschaft (Mélanges Joseph Gantner) 12 (1967):33-69, no illus.

Concludes that Quattrocento and High Renaissance artists regarded facial expression as the principal vehicle for conveying emotion, but late sixteenth-century artists regarded other elements, color in particular, as more important.

34 BLUNT, ANTHONY. Artistic Theory in Italy, 1450-1600. 2d ed.
 Oxford Paperbacks, vol. 50. Oxford: Clarendon Press, 1962,
 168 pp., 11 figs. [First published 1940.]
 Deals primarily with the sixteenth century but first
chapters analyze Alberti's theory.

35 KEMP, M. "From 'Mimesis' to 'Fantasia': The Quattrocento
 Vocabulary of Creation, Inspiration, and Genius in the Visual
 Arts." Viator: Medieval and Renaissance Studies 8 (1977):
 347-98, 7 figs.
 Analyzes importance of invention and "fantasia" as opposed
to imitation of nature or "mimesis," for the Renaissance artist.
Examines treatises of Alberti, Ghiberti, Filarete, Francesco di
Giorgio, and Leonardo.

 SURVEYS

36 BALCARRES, LORD [David A.E.L. Crawford]. Evolution of Italian
 Sculpture. London: John Murray, 1909, 348 pp., 53 figs.
 Reprint. New York: Burt Franklin, 1973.
 Still useful chronological survey from Antelami to the
Baroque; arranged by subject or theme rather than by artist. Impor-
tant historically as early survey that promoted interest in Italian
sculpture in England.

37 BALDINI, UMBERTO, et al. Toscana. Milan: Electa Editrice,
 1974, 511 pp., 438 figs., 84 color pls.
 Ostentatiously printed historical introduction to art and
architecture of Tuscany from Roman times through twentieth century.
Valuable for its illustrations, many in color.

38 BAUM, JULIUS, ed. Baukunst und dekorative Plastik der Früh-
 renaissance in Italien. Stuttgart: I. Hoffman, 1926, 334
 pp., 517 figs.
 Very useful photographic survey of types of architecture
and architectural decoration of the Quattrocento, including tombs.
Grouped by category, with brief introductory essay and detailed notes
on monuments.

39 BIAŁOSTOCKI, JAN, ed. Spätmittelalter and beginnende Neuzeit.
 Propyläen Kunstgeschichte, vol. 8. Berlin: Propyläen Verlag,
 1972, 474 pp., 468 figs., 76 color pls.
 History of European fifteenth-century art and architecture,
including full treatment of minor arts, which sets Italy within
context of rest of continent. Comprised of essays by authorities.
Large corpus of good photographs, each with detailed comments and
bibliography. Extensive, general bibliography, chronological chart,
index.

40 BODE, W[ILHELM] von. Die Kunst der Frührenaissance in Italien.
 Propyläen-Kunstgeschichte. Berlin: Propyläen Verlag, 1926,
 624 pp., 589 figs., 41 color pls.

Profuse, large-scale illustrations constitute valuable corpus of visual material covering both painting and sculpture of the Early Renaissance. Brief introduction.

41 BURCKHARDT, JACOB. Der Cicerone: Eine Anleitung zum Genuss der Kunstwerke Italiens. Basel: Schweighauser'sche Verlagsbuchhandlung, 1856, 1112 pp., no illus.
 Classic guidebook to Italy and important nineteenth-century source; remains useful reference for its completeness, insightful observations, and logical organization. Among various subsequent editions and translations, see especially the tenth edition, edited and annotated by Wilhelm von Bode and Cornelius von Fabriczy, 4 vols. (Leipzig: E.A. Seemann, 1898).

42 BURCKHARDT, JACOB CHRISTOPH. Civilization of the Renaissance in Italy: An Essay. Translated by S.G.C. Middlemore. 3d rev. ed. London: Oxford University Press; New York: Phaidon, [1950], 462 pp.
 Many editions, of which first was published in German in 1860. The classic study of Italian Renaissance history and culture, intended as prolegomena to his never-written history of Italian Renaissance art. The seminal and unsurpassed study of the Renaissance social milieu and its relationship to art. Few direct references to sculpture.

43 CARLI, ENZO. Scultura italiana: Il Gotico. Milan: Electa, 1967, 73 pp., 96 figs., 38 color pls.
 Magnificently illustrated survey of thirteenth- to early fifteenth-century Italian sculpture. Includes Quercia and Ghiberti. Introductory essay. Notes on each plate. Bibliography. Indexes.

44 CICOGNARA, CONTE LEOPOLDO. Storia della scultura dal suo risorgimento in Italia fino al secolo di Canova. Continued by Johann Joachim Winckelmann, Jean Baptiste d'Agincourt et al. 2d ed. Vol. 4. Prato: Giachetti, 1823-25, 452 pp.
 Classic older study of Italian sculpture from the Early Christian period through the nineteenth century. Illustrated with line drawings. Of historical interest. Vol. 4: fifteenth century, including sculpture of Venice, Lombardy, Naples, and Tuscany. Major figures only. No notes, bibliography.

45 COURTAULD INSTITUTE ILLUSTRATION ARCHIVES. [General editor, Peter Lasko.] Archive 2: 15th and 16th Century Sculpture in Italy. Edited by Constance Hill. London: Harvey Miller, 1976-.
 Corpus of excellent photographs of fifteenth-century sculpture in Italy, arranged by region. Part of ongoing series of publications of photograph collection of Courtauld Institute.

46 DELOGU, GIUSEPPE. Italienische Bildhauerei: Eine Anthologie vom 12. bis 19. Jahrhundert. Zurich: Fretz & Wasmuth, [1942], 327 pp., 180 figs. Italian ed., amplified. Antologia della scultura italiana dall'XI al XIX secolo. Milan: "Silvana,"

[1956], clvii, 354 pp., 214 figs., 19 color pls.
 Brief essay on twelfth- to nineteenth-century Italian
sculpture, followed by discusson of specific monuments, each with a
photograph and bibliography.

47 DVOŘÁK, MAX. Geschichte der italienischen Kunst im Zeitalter
 der Renaissance: Akademische Vorlesungen. Vol. 1, Das 14. und
 15. Jahrhundert. Edited by Johannes Wilde and Karl M. Swoboda.
 Munich: R. Piper & Co., 1927, 194 pp., 97 figs.
 Publishes texts of Dvořák's university lectures, which
focus on Donatello as one of founding fathers of Renaissance and
discuss cultural and social impact of his work.

48 FRANCASTEL, PIERRE; ALAZARD, JEAN, et al., eds. Les sculpteurs
 célèbres. Paris: Lucien Mazenod, [1954], 421 pp., 15 figs., 1
 col. pl. relevant to fifteenth-century Central Italian sculp-
 ture.
 Large volume covering broad historical range; contains
important essays on a number of sculptors, including Jacopo della
Quercia (by Giulio Carlo Argan, pp. 210-11), Ghiberti (by Richard
Krautheimer, pp. 212-15), Donatello (by Pierre Francastel, pp. 216-
19), Luca della Robbia (by Giulia Brunetti, pp. 222-23), and
Verrocchio (by André Chastel, pp. 224-25).

49 GODFREY, FREDERICK M. Italian Sculpture, 1250-1700. London:
 Alec Tiranti; New York: Taplinger, 1967, 332 pp., 208 figs.
 General survey/handbook, profusely illustrated, with good
stylistic appreciations but no original research. Bibliography,
biographies, index.

50 JOHANSEN, PETER. Renaissance: Entwicklung der kunstlerischen
 Probleme in Florence--Rom von Donatello bis Michelangelo.
 Leipzig: O. Harrassowitz; Copenhagen: H. Hagerup, 1936, 396
 pp., 284 figs.
 Selective survey of Quattrocento, focusing on the develop-
ment of style as seen through the works of representative masters, in
particular, Donatello. Deals primarily with painters.

51 KEUTNER, HERBERT. Sculpture: Renaissance to Rococo. History
 of Western Sculpture, edited by John Pope-Hennessy, vol. 3.
 London: Michael Joseph, 1969, 352 pp., 330 figs., 8 color pls.
 Brief text provides general survey of a broad period
(approximately 1400-1780). Some provocative points regarding the
sociological function and place of sculpture. Full-page plates with
notes.

52 KNAPP, FRIEDRICH. Italienische Plastik vom funfzehnten bis
 achtzehnten Jarhundert. Munich: Hyperionverlag, 1923, 130
 pp., 160 figs.
 Rather dated and predictable survey covering a broad period
and treating art history as a progression of individual masterworks.
Some good insights into specific monuments, plus fine large photos.

53 MACLAGAN, ERIC R.D. Italian Sculpture of the Renaissance. The
 Charles Eliot Norton Lectures for the Years 1927–28. Cam-
 bridge: Harvard University Press, 1935, 277 pp., 140 figs.
 General survey adapted from lectures covering Italian
sculpture from the Romanesque through Bernini. Many insights and
conclusions based on the author's familiarity with the holdings of
the Victoria and Albert Museum.

54 MIDDELDORF, ULRICH. Raccolta di scritti: That Is, Collected
 Writings. 3 vols. Florence: SPES, 1979–80.
 Publication of all of Middeldorf's articles. Vol. 1:
1924–38; vol. 2: 1939–73; vol. 3: 1974–79. See author index under
Middeldorf for individual articles.

55 MUNTZ, EUGENIO. Precursori e propugnatori del Rinascimento.
 Translated by Guido Mazzoni. Biblioteca storica del Rina-
 scimento, vol. 1. Florence: G.C. Sansoni, 1902, 198 pp., no
 illus.
 History of fifteenth-century Tuscany and its sculpture and
painting by leading early authority. An introductory chapter surveys
thirteenth- and fourteenth-century Italian history and art.

56 PERKINS, CHARLES C. Historical Handbook of Italian Sculpture.
 New York: Charles Scribner's Sons, 1883, 432 pp.
 First comprehensive treatment of the subject in English.
Combines the content of his earlier works (entries 57–58);
fifteenth-century Tuscan sculpture is discussed on pp. 73–162.
Includes notes, appendix, and an index by artist and site. No photo-
graphs but small line engravings on the text pages. Of historical
interest as the basic English-language handbook that spurred revival
of interest in Italian Renaissance sculpture in Victorian England.

57 _____. Italian Sculptors: Being a History of Sculpture in
 Northern, Southern, and Eastern Italy. London: Longmans,
 Green, & Co., 1868, 337 pp., 35 line engrs.
 Major nineteenth-century English-language history of med-
ieval and Renaissance Italian sculpture in these areas. Chapters
covering Rome (no. 3) and Naples (no. 4) are relevant to this study.
Integrates history with discussion of monuments. Indexed.

58 _____. Tuscan Sculptors: Their Lives, Works, and Times. 2
 vols. London: Longman, Roberts, & Green, 1864, 43 figs.
 French ed. Paris, 1869.
 One of the earliest modern histories, covering the period
1240–1606. Among Quattrocento sculptors, focuses on Ghiberti, Dona-
tello, and Brunelleschi. Ambitious for its time but now antiquated.

59 POPE-HENNESSY, JOHN. Essays on Italian Sculpture. New York
 and London: Phaidon, 1969, ix, 243 pp., 248 figs.
 Collection of seven studies, of which six had been pub-
lished previously. Four deal with aspects of Donatello's work, one
is on Agostino di Duccio, one is on Antonio Rossellino, and another

is on Italian bronze statuettes. Not updated. See author index
under Pope-Hennessy for individual articles.

59a Covi, Dario A. Review of Essays on Italian Sculpture, by John
 Pope-Hennessy. Art Bulletin 52, no. 3 (September 1970):316-18,
 no illus.
 Disputes Pope-Hennessy's attribution of Arezzo Font relief
to Donatello, ca. 1410-12. Covi considers it later (ca. 1420s) and
by a lesser artist.

60 _____. Italian Gothic Sculpture (An Introduction to Italian
 Sculpture, Part 1). London and New York: Phaidon, 1955, 228
 pp., 144 figs.
 Authoritative history of mid-twelfth- to early fifteenth-
century Italian sculpture that includes Ghiberti, Quercia, and Nanni
di Banco in the stylistic category of "Gothic." Brief monographic
chapters on each artist. Section of notes on sculptors and on speci-
fic sculptures illustrated is most useful, concise account of sculp-
tors and literature about them available. Profusely illustrated.
 Revised edition: Italian Gothic Sculpture (An Introduction
to Italian Sculpture, Part 1). London and New York: Phaidon, 1972,
284 pp., 205 figs.
 Expanded text that takes into account recent research by
author and other authorities. Some new illustrations. Replaces
first edition. A newly revised edition is scheduled to appear in
paperback in late 1985.

61 _____. Italian Renaissance Sculpture (An Introduction to
 Italian Sculpture, part 2). London and New York: Phaidon,
 1963, 365 pp., 309 figs. 2d ed. 1971.
 The authoritative study of fifteenth-century Italian sculp-
ture, with chapters surveying development of sculpture typologically.
Section of notes on sculptors and specific sculptures is best concise
account of their careers and bibliography available anywhere. In
section of notes on sculptors, second edition takes into account
findings published since 1963, but is otherwise unchanged. A newly
revised edition is scheduled to appear in paperback in late 1985.

61a Janson, H.W. Review of Italian Renaissance Sculpture (An
 Introduction to Italian Sculpture, part 2), by John Pope-
 Hennessy. College Art Journal 19, no. 1 (Fall 1959):
 97-99, no illus.
 Criticizes Pope-Hennessy for overemphasizing influence of
Roman sculpture, eliminating Ghiberti, Nanni di Banco, and Jacopo
della Quercia (whom he considers to be Gothic sculptors); and cover-
ing little after 1460. See entry 67b.

62 _____. The Study and Criticism of Italian Sculpture. New
 York: Metropolitan Museum of Art, 1980, 270 pp., 244 figs.
 Ten essays on fifteenth-century Italian sculpture that
reflect the author's connoisseurship method. The previously unpub-
lished introduction traces history of this method in painting and

sculpture research. Other essays have all been updated since their
original publication.

63 RUMOHR, KARL FRIEDRICH von. Italienische Forschungen. Edited
 by Julius Schlosser. Frankfurt am Main: Frankfurter Verlags,
 1920, 655 pp., no illus. [Originally published in 3 vols.,
 Berlin: Nicolai'schen, 1827–31.]
 Important early art historical criticism consisting of
individual essays on problems of critical interest in Italian art
from the Carolingian period to Raphael, including some treatment of
fifteenth–century sculpture.

64 RUSSOLI, FRANCO. Scultura italiana: Il Rinascimento. Vol. 3.
 Milan: Electa, 1967, 50 pp., 100 figs., 40 color pls.
 Covers fifteenth– and sixteenth–century sculpture up
through Michelangelo in a brief essay with no footnotes. Short
bibliography. Profusely illustrated; all photos have short descrip-
tions.

65 SCHUBRING, PAUL. Die italienische Plastik des Quattrocento.
 Handbuch der Kunstwissenschaft. Berlin: Akademische Verlags-
 gesellschaft Athenaion, [1915], 282 pp., 370 figs. 2d ed.
 Wildpark and Potsdam: Athenaion, [1924], 282 pp., 370 figs.
 Important early survey dealing primarily with Florentine
sculpture; also covers important works in Siena, Bologna, Padua,
Rome, Naples, Venice, Lombardy, Verona, and Ferrara as well.

66 SEROUX d'AGINCOURT, JEAN–BAPTISTE; SEROUX d'AGINCOURT, LOUIS;
 and SEROUX d'AGINCOURT, GEORGES. L'histoire de l'art par les
 monuments, depuis sa décadence au IVe siècle jusqu'à son
 renouvellement au XVIe. 6 vols. Paris: Treuttel & Würtz,
 1823, 325 figs.
 Early general history of art, profusely illustrated with
line engravings. Vol. 2 covers sculpture; vol. 4 focuses on archi-
tecture but includes Ghiberti's doors for the Florence Baptistry,
Renaissance tombs, etc.

67 SEYMOUR, CHARLES, Jr. Sculpture in Italy: 1400 to 1500.
 Pelican History of Art. Harmondsworth, Eng.: Penguin Books,
 1966, 321 pp., 160 figs., 26 reconstructions and line drawings.
 Major history of fifteenth–century Italian sculpture that
is organized chronologically, integrating sculpture from all regions
into a decade–by–decade analysis of stylistic development. Treats
issues such as art theory, workshop organization, and patronage.
Includes many minor sculptors. Extensive bibliography subdivided
into categories contains a section for each sculptor.

67a Eisler, J. Review of Sculpture in Italy, 1400–1500, by Charles
 Seymour, Jr. Acta Historiae Artium 16 (1970):145–48, no
 illus.
 Mainly a corrective on some points of detail. Provides new
information on Giovanni Dalmata's activity in Hungary, 1487–89.

67b Janson, H.W. Review of Sculpture in Italy, 1400-1500, by
 Charles Seymour, Jr. Yale Review, n.s. 56, no. 4 (Summer
 1967):586-93, no illus.
 Reviews development of study of Renaissance sculpture, con-
trasting Pope-Hennesy's emphasis on individuals and lack of histor-
ical context with Seymour's focus on sculptural ensembles and collab-
orative works and his use of decade-by-decade chronological organiz-
ation for comparison of sculptures from all regions of Italy.

68 VALENTINER, W.R. Studies of Italian Renaissance Sculpture.
 New York and London: Phaidon, 1950, 239 pp., 247 figs.
 Ten previously published essays on Renaissance sculpture
(many substantially revised here). Large corpus of photographs, many
not included in the earlier versions of the articles and previously
unpublished. See author index under Valentiner for individual
articles.

69 VENTURI, ADOLFO. Storia dell'arte italiana. . . . Vol. 6, La
 scultura del Quattrocento. Milan: Ulrico Hoepli, 1908, 1140
 pp., 781 figs.
 Standard, comprehensive history of fifteenth-century Ital-
ian sculpture arranged by region and then monographically by artist.
Indispensable corpus of photographs. Evaluations of artists are
largely out-of-date and many attributions have been changed, but it
is still useful, especially for minor artists.

69a Pillion, Louise. Review of Storia dell'arte italiana . . ., by
 Adolfo Venturi. Revue de l'art ancien et moderne 25 (May
 1909): 321-31, 4 figs.; (June 1909):418-30, 7 figs.
 Discusses state of art historical studies, influence of
sculpture on painters ca. 1420, possible influence of Northern sculp-
ture, and the Christian characteristics of Italian sculpture.

70 WATERS, W[ILLIAM] G[EORGE]. Italian Sculptors. 2d ed. Lon-
 don: Methuen; New York: George H. Doran, [1926], 285 pp., 78
 figs. [First ed. 1911.]
 Handy, alphabetical dictionary of sculptors working in
Italy, 1150-1690, with brief biographies. Includes catalogue of
anonymous sculptures and index of sculptures by city and church.

Florence

COLLECTIONS OF DOCUMENTS

71 Del PIAZZO, MARCELLO AND GUIDORIZZI, LAURA. "Gli artisti
 fiorentini del Quattrocento nei castasti contemporanei."
 Commentari 1 (1950):189-92, 250-58, no illus.; 2 (1951):236-41,
 no illus.
 Publishes numerous catasto records of Agostino di Duccio
and Verrocchio.

72 HARTT, FREDERICK and CORTI, GINO. "New Documents concerning
 Donatello, Luca and Andrea della Robbia, Desiderio, Mino,
 Uccello, Pollaiuolo, Filippo Lippi, Baldovinetti, and Others."
 Art Bulletin 44 (1962):155-68, no illus.
 Publishes records of Cambini bank that cite Bartolommeo
Serragli's transactions, probably as agent for Medici family, with
various artists.

73 LERNER-LEHMKUHL, HANNA. Zur Struktur and Geschichte des flor-
 entinischen Kunstmarktes im 15. Jahrhundert. Lebensräume der
 Kunst, Eine Studienfolge, edited by Martin Wackernagel, vol. 3.
 Wattenscheid: Karl Busch, 1936, 59 pp., 4 tables. [Disserta-
 tion, Münster, 1934.]
 Collects documents of commissions for Quattrocento works of
art and analyzes them in terms of relative price, materials, amount
of work, and importance of artist. Useful comparative tables.

74 MANCINI, GIROLAMO. "Il bel San Giovanni e le feste patronali
 di Firenze descritte nel 1475 da Piero Cennini." Rivista
 d'arte 6 (1909):195-227, 5 figs.
 Publishes for first time letter written in 1475 by Piero
Cennini describing Baptistry, Florence, and celebrations of Baptist's
feast day. He claims that Luca della Robbia, Donatello, and
Michelozzo worked on Ghiberti's East Doors.

75 MATHER, RUFUS G. "Documents Mostly New Relating to Florentine
 Painters and Sculptors of the Fifteenth Century." Art Bulletin
 30 (1948):20-65, no illus.
 Transcription of all catasti, guild records, and death
 records of twenty Quattrocento painters and sculptors, including
 Agostino di Duccio, Verrocchio, Antonio Pollaiuolo, Bernardo Rossel-
 lino, Brunelleschi, Benedetto da Maiano, Ghiberti, and Mino da
 Fiesole.

76 PROCACCI, UGO. "L'uso dei documenti negli studi di storia
 dell'arte e le vicende politiche ed economiche in Firenze
 durante il primo Quattrocento nel loro rapporto con gli
 artisti." In Donatello e il suo tempo (Atti dell'VIII convegno
 internazionale di studi sul Rinascimento, Florence-Padua,
 1966). Florence: Istituto Nazionale di Studi sul Rinasci-
 mento, 1968, pp. 11-39, no illus.
 Evaluates information from the catasti, or tax declarations
 in Florence, using those of Donatello, Michelozzo, and Pagno di Lapo.
 Problems discussed include the frequent misrepresentation of age and
 income and the different organization and functioning of workshops
 and partnerships. Focuses on the Donatello-Michelozzo partnership
 and how catasti aid in establishing dates of their sculptures.

 LITERARY SOURCES UP TO 1700

77 ALBERTINI, FRANCESCO. Memoriale di molte statue et picturae
 che sono nella inclyta ciptà di Florentina. Florence, 1510.
 Facsimile ed. London: H. Horne, 1909; also in Five Early
 Guides to Rome and Florence. Edited by Peter Murray. Farn-
 borough: Gregg International Publishers, 1972, unpaginated, no
 illus.
 Very early guide to Florence written by a Florentine priest
 and student of Ghirlandaio.

78 BILLI, ANTONIO. Il libro di Antonio Billi esistente in due
 copie nella Biblioteca nazionale di Firenze. Edited by Carl
 Frey. Berlin: G. Grote, 1892, 104 pp., no illus.
 Valuable early source with brief biographies of all major
 Florentine sculptors. Written ca. 1516-30, it probably reflects a
 lost, earlier manuscript. Important source for Vasari.

79 BOCCHI, FRANCESCO. Le bellezze della città di Fiorenza.
 Edited and enlarged by Giovanni Cinelli. Florence: Gio.
 Gugliantini, 1677, 584 pp., no illus.
 Important early guide to Florence. First published in
1591.

80 BORGHINI, RAFFAELLO. Il riposo. 2 vols. Florence: Giorgio
 Marescotti, 1584, 684 pp., 2d ed. Edited by Girogio Bottari.
 Florence, 1730, no illus. Facsimile edited by Mario Rosci. Il
 riposo: Saggio biobibliografico e indice analitico. 2 vols.
 Milan: Edizioni Labor, 1967, 1:684 pp., no illus., 2:190 pp.,
 no illus.

Extensive information on fifteenth-century sculpture. Vol.
1: facsimile edition with annotations and indices by Mario Rosci.
Vol. 2: introductory essay with bibliography, index with detailed
breakdown for each name and relevant page citations in Borghini and
Vasari.

81 GELLI, GIOVANNI BATTISTA. "Vite d'artisti di Giovanni Battista
 Gelli. " Edited by Girolamo Mancini. Archivio storico
 italiano, 5th ser. 17 (1896):32-62, no illus.
 Annotated publication of this important sixteenth-century
(ca. 1550-63) anthology of lives of artists. Includes a detailed
biography of Donatello and shorter biographies of Ghiberti, Brunel-
leschi, Buggiano, Nanni di Banco, Michelozzo, Dello Delli, and
Verrocchio.

81a Fabriczy, Cornelius von. Review of Venti vite d'artisti di
 Giovanni Battista Gelli, published by Girolamo Mancini.
 Repertorium für Kunstwissenschaft 19 (1896):353-58, no illus.
 Summary of importance and contents of Gelli's Lives, writ-
ten in the sixteenth century but only published in 1896. Notes that
while first half of Gelli's manuscript is carefully written, second
half was not corrected by Gelli and is less reliable.

82 LANDUCCI, LUCA. Diario fiorentino dal 1450 al 1516 da un
 anonimo fino al 1542. Edited by Iodoco del Badia. Florence:
 G.C. Sansoni, 1883, 392 pp., no illus. English translation by
 Alice de Rosen Jervis. London: J.M. Dent & Sons, New York:
 E.P. Dutton, 1927.
 Introduction and notes by Del Badia enrich this diary of
Florence between 1450 and 1516. Reliable firsthand account that
makes many mentions of sculpture.

83 MAGLIABECHIANO CODEX. Il codice magliabechiano cl. XVII. 17.
 contenente notizie sopra l'arte degli antichi e quella de'
 fiorentini da Cimabue a Michelangelo Buonarroti scritta da
 anonimo fiorentino. Edited by Carl Frey. Berlin: G. Grote,
 1892, 404 pp., no illus.
 Basic source written ca. 1537-42; includes brief biog-
raphies of Florentine artists. Important for Vasari. Notes by Frey
summarize Florentine art historiography up to Vasari. Indexed.

84 [MANETTI, ANTONIO]. "Art Historians and Art Critics--IV, XIV
 Uomini Singhularii in Firenze," by Peter Murray. Burlington
 Magazine 99, no. 655 (October 1957):330-36, 2 figs.
 Publishes Manuscript of XIV Uomini, attributed to Antonio
Manetti. It includes near-contemporary biographies of Donatello,
Ghiberti, Luca della Robbia, and Brunelleschi. Evidence for dating
XIV Uomini later than generally believed, i.e., ca. 1494-97. Doubts
that Manetti also wrote anonymous Vita of Brunelleschi.

85 MIGLIORE, FERDINANDO LEOPOLDO del. Firenze: Città
 nobilissima illustrata. Florence: Stella, 1684, 571 pp.,
 no illus.
 Important early guide to Florence.

86 NERI di BICCI. Le ricordanze (10 marzo 1453-24 aprile 1475).
 Edited by Bruno Santi. Pisa: Edizioni Marlin, 1976, 526 pp.,
 no illus.
 Introductory essay with bibliography and facsimile of Neri
 di Bicci's account books, followed by extensive index. Valuable for
 indications of his collaboration with sculptors.

86a Middeldorf, Ulrich. Review of Le ricordanze (10 marzo 1453-24
 aprile 1475), by Neri di Bicci. Edited by Bruno Santi.
 Renaissance Quarterly 31, no. 2 (Summer 1978):218-21, no illus.

HISTORIES, GUIDEBOOKS, AND ARTICLES

HISTORIES OF FLORENCE AND THE MEDICI

87 CHASTEL, ANDRÉ. "Vasari et la légende médicéenne: 'L'école du
 jardin de Saint Marc.'" In Studi vasariani (Convegno inter-
 nazionale per il IV centenario della prima edizione delle Vite
 del Vasari, Florence, 16-19 Sept. 1950). Florence: G.C.
 Sansoni, 1952, pp. 159-67, no illus.
 Studies development of "school" in the garden of San Marco,
 where Bertoldo supervised antique collections of Lorenzo de' Medici
 and where Vasari claims young Michelangelo was educated. Debunks
 notion it was an academy of art of the sort that developed later.

88 De la COSTE-MESSELIÈRE, MARIE-GENEVIÈVE. "Les collections des
 Médicis." Oeil, no. 71 (November 1960):28-39, 74, 19 figs., 2
 color pls.
 General history of early Medici collections of books,
 paintings, and sculpture, some of which are now dispersed, based on
 inventories, etc.

89 GOMBRICH, E[RNST] H. "The Early Medici as Patrons of Art." In
 Italian Renaissance Studies: A Tribute to the Late Cecilia M.
 Ady. Edited by Ernest F. Jacob. London: Faber & Faber, 1960.
 Reprinted in Norm and Form: Studies in the Art of the
 Renaissance, 2d ed. (London and New York: Phaidon, 1971), pp.
 35-57, figs. 53-90.
 Studies patronage of Cosimo, Piero, and Lorenzo de' Medici,
 basing assessment on contemporary sources and distinguishing differ-
 ent collecting tastes, motives, and goals of generosity of successive
 generations of this family. Passing reference to sculpture commis-
 sions.

90 GOTTI, AURELIO. Le gallerie di Firenze. Florence: Cellini,
 1872, 478 pp., no illus.

History of the Medici, their patronage, and collections of art.

91 MUNTZ, EUGÈNE. Les collections des Médicis au XV siècle.
 Paris: Jules Rouam; London: Gilbert Wood & Co., 1888, 112
 pp., no illus.
 Transcribes all known documents (descriptions and inven-
 tories) pertaining to the collections of the early Medici (manu-
 scripts, sculpture, painting, furniture, gems, etc.). Standard
 reference for Medici collections.

GUIDES TO FLORENCE

92 BRUNO, RAFFAELLO del. Ristretto delle cose più notabili della
 città di Firenze. Amplified by C.M.C. 3d ed. Florence:
 Giusseppe Manni, 1719, 168 pp., no illus., 1 map.
 Guidebook to most notable Florentine landmarks.

93 BUSIGNANI, ALBERTO, and BENCINI, RAFFAELLO. Le chiese di
 Firenze. Vol. 1, Quartiere di Santo Spirito. Vol. 2,
 Quartiere di Santa Maria Novella. Florence: G.C. Sansoni,
 1974-79, 1:271 pp., 179 figs.: 2:271 pp., 177 figs.
 Well-illustrated guide to churches in Florence, arranged
 like Richa's according to sections of city. Part of ongoing series
 of volumes projected to cover all of Florence. Publishes documents
 and sources about each church. Large, clear photographs give sense
 of context of church's decoration.

94 COCCHI, ARNALDO. Le chiese di Firenze dal secolo IV al secolo
 XX. Vol. 1, Quartiere di San Giovanni. Florence: Pellas,
 1903, 290 pp., 20 figs.
 History of construction and decoration of Florentine churches
 in this quarter, conceived as part of unfinished comprehensive his-
 tory of churches in Florence. With citations of important documents.

95 GUIDA d'ITALIA del TOURING CLUB ITALIANO. Firenze e dintorni.
 Milan: Aldo Garzanti, 6th ed., 1974, 496 pp., no illus., 3
 maps, 3 plans.
 Very useful, exhaustive guide to works of art in city and
 suburbs of Florence. Bibliography.

96 MORENI, DOMENICO. Notizie istoriche dei contorni di Firenze.
 6 vols. Florence, 1791-95, no illus.
 Valuable early guide to the environs of Florence. Index to
 each volume.

97 PAATZ, WALTER, and PAATZ, ELIZABETH. Die Kirchen von Florenz:
 ein kunstgeschichtliches Handbuch. 6 vols. Frankfurt am Main:
 Vittorio Klostermann, 1940-54, indexes, plans.
 Complete catalogue of the churches of Florence. For each
 church includes a history of its organization and construction and
 full inventory of sculpture and furnishings. Extensive notes provide

documents and citations of previous research. Unillustrated. The standard reference.

98 RICHA, GIUSEPPE. <u>Notizie istoriche delle chiese fiorentine divise ne' suoi quartieri. . . .</u> 10 vols. in 5. Florence: P.G. Viviani, 1754-62.

Important early history of Florentine churches, treating construction and tombs and other important monuments associated with them, as well as role of building in Florentine history. Arranged according to section of city. Occasional line engravings. Each volume indexed.

INDIVIDUAL MONUMENTS

Duomo

99 CAVALLUCCI, C[AMILLO] J[ACOPO]. <u>S. Maria del Fiore e la sua facciata: Narrazione storica.</u> Florence: Giovanni Cirri, 1887, 173 pp., no illus.

History of construction and decoration of Duomo, Florence, with particular attention to its façade. Appendices concerning plans and competitions for façade. Lengthy section of transcribed documents.

100 COCCHI, ARNALDO. <u>Les anciens reliquaires de Santa Maria del Fiore et de San Giovanni de Florence.</u> Florence: Pellas, 1903, 69 pp., 12 figs.

Catalogues series of thirteenth- to seventeenth-century reliquaries in Florentine Duomo and Baptistry, giving description, documentation, and history of each.

101 CRISPOLTI, VIRGILIO. <u>Santa Maria del Fiore alla luce dei documenti.</u> Florence: Vallecchi, 1937, 558 pp., 45 figs.

History of construction and decoration of Duomo, Florence, up to early twentieth century, with citations of relevant documents. Bibliography, index.

102 GUASTI, CESARE. <u>Santa Maria del Fiore: La costruzione della chiesa e del campanile, secondo i documenti tratti dall' archivio dell'opera secolare, e da quello di stato.</u> Florence: M. Ricci, 1887, 321 pp., no illus.

Major publication of transcribed documents and analysis of their content. Concerns construction of Duomo and Campanile from 1293 to 1421.

103 KAUFFMANN, HANS. "Florentiner Domplastik." <u>Jahrbuch der preussischen Kunstsammlungen</u> 47 (1926):141-67, 216-37, 35 figs.

Thorough study of Duomo sculpture workshops, ca. 1370-1409, based on documents and surviving sculpture. Especially valuable for establishing stylistic identities of early masters: Piero di Giovanni Tedesco, Jacopo di Piero Guidi, and Luca di Giovanni. Analyzes second and third campaigns on Porta della Mandorla (1404-9; 1414-22),

which include sculptures attributed to Giovanni d'Ambrogio and Lorenzo di Giovanni d'Ambrogio, Niccolò di Piero Lamberti, and Nanni di Banco. Attributes to latter Porta della Mandorla <u>Annunciation</u> and <u>St. Pancratius</u> (Bargello, Florence).

104 LÁNYI, JENO. "Le statue quattrocentesche dei Profeti nel Campanile e nell'antica facciata di Santa Maria del Fiore." <u>Rivista d'arte</u> 17, 2d ser. 7 (1935):121-59, 245-80, 13 figs.
Major article based on extensive archival research and careful stylistic analysis. Establishes authorship, identification, and dating of statues carved for Campanile and Duomo façade and tribune buttresses by Donatello, Nanni di Bartolo, Nanni di Banco, Ciuffagni, and Giuliano da Poggibonsi.

105 LISNER, MARGRIT. "Die Skulpturen am Laufgang des Florentiner Domes." <u>Mitteilungen des Kunsthistorischen Institutes in Florenz</u> 21 (1977):111-82, 83 figs.
First comprehensive study of relief sculpture decorating <u>ballatoio</u> of Duomo, Florence, carved between 1364 and 1421. Analyzes types of decoration and concludes that there was no fixed program. First publication of detailed photographs permits attribution of sculptures under the cupola to young Jacopo della Quercia (pre-Baptistry competition) and young Donatello, as well as Giovanni d'Ambrogio and Jacopo di Piero Guidi. Reliefs assigned to Donatello reflect influence of Roman sculpture and are used to support theory of Donatello's trip to Rome, 1402-3.

106 MUNMAN, ROBERT. "The Evangelists from the Cathedral of Florence: A Renaissance arrangement recovered." <u>Art Bulletin</u> 62, no. 2 (June 1980):207-17, 12 figs.
Reestablishes original arrangement on Duomo façade of seated <u>Evangelists</u> by Donatello, Nanni di Banco, Niccolò Lamberti, and Ciuffagni; carved between 1408 and 1415, they were removed in 1587 (now in Museo dell'Opera del Duomo, Florence).

107 POGGI, GIOVANNI. <u>Il Duomo di Firenze: Documenti sulla decorazione della chiesa e del campanile tratti dall'Archivio dell'opera</u>. Italienische Forschungen, Kunsthistorisches Institut in Florenz, vol. 2. Berlin: B. Cassirer, 1909, 428 pp., 89 figs.
Basic source on the Duomo and Campanile decoration. Essay traces history of exterior sculpture programs of Duomo and Campanile, and interior decoration of Duomo. Appendix of 291 pages of transcribed documents, arranged chronologically, lays out factual evidence.

108 ROSENAUER, ARTUR. "Die Nischen für die Evangelisten-Figuren an der Florentiner Domfassade." In <u>Essays Presented to Myron P. Gilmore</u>. Villa I Tatti, The Harvard University Center for Italian Renaissance Studies. Edited by Sergio Bertelli and Gloria Ramakus. Florence: La Nuova Italia Editrice, 1978, 2:345-52, 4 figs.

Late sixteenth-century drawing of Florence Duomo façade before alteration (Museo dell'Opera del Duomo, Florence) shows niches containing four Evangelist sculptures by Donatello, Nanni di Banco, Niccolò di Piero Lamberti, and Ciuffagni. Style of niches (ca. 1400) may reflect Ghiberti's participation.

See also entries under individual sculptors.

Porta della Mandorla

109 PARIBENI, ENRICO. "Riflessi di sculture antiche." Archeo-
 logica classica 13 (1961):103-5, 5 figs.
 Annunciate Angel from Porta della Mandorla, Duomo, Flor-
 ence, is related to Praxitelean-type head.

110 SEYMOUR, CHARLES Jr. "The Younger Masters of the First Cam-
 paign of the Porta Della Mandorla." Art Bulletin 41, no. 1
 (March 1959):1-17, 18 figs., 2 diags.
 Studies first sculptural campaign of Porta della Mandorla,
 Duomo, Florence (ca. 1390-1400), which marks emergence of stylistic
 trends basic to Early Renaissance: traditional Florentine style of
 Giovanni d'Ambrogio; two "younger" styles characterized by gothiciz-
 ing Lorenzo di Giovanni d'Ambrogio and more classical Niccolò di
 Piero Lamberti. Development of these opposing styles provides back-
 ground for Ghiberti's Baptistry Doors. Important refutation of
 Vasari's claim that young Quercia worked on Porta della Mandorla.
 Attributes Hercules figure to Niccolò di Piero Lamberti, establishing
 his significant place in Florentine sculpture ca. 1400. Using Lam-
 berti's St. James Major, Orsanmichele, evaluates Lamberti's stylistic
 development as moving from Brunelleschi's influence (Porta della
 Mandorla) to Ghiberti's.

See also entries under individual sculptors.

Campanile

111 TRACHTENBERG, MARVIN. The Campanile of Florence Cathedral:
 "Giotto's Tower." New York: New York University Press, 1971,
 230 pp., 338 figs., 1 color pl., appendix of documents.
 The basic analysis of building history and decoration of
 Campanile, dealing only peripherally with fifteenth-century addi-
 tions. Nevertheless provides indispensable background for Prophet
 statues and Luca della Robbia's reliefs.

See also entries under Donatello, Niccolò Lamberti, Nanni di Banco,
and Nanni di Bartolo.

Orsanmichele

112 BARGELLINI, PIERO. Orsanmichele a Firenze. Milan: Arti Graf-
 iche Ricordi, 1969, 183 pp., 41 figs., 27 color pls.

History of Orsanmichele and its decoration intended for general audience. Valuable corpus of color plates of all sculptures commissioned for its exterior.

113 BRUNETTI, GIULIA. "Una piccola questione di Orsanmichele." In Festschrift Herbert Siebenhüner zum 70. Geburtstag. Edited by Erich Hubala and Günter Schweikhart. Würzburg: F. Schöningh, 1978, pp. 83-92, 7 figs.
 Argues that two brackets with acanthus leaves and cherub heads on side of tabernacle commissioned by Arte dei medici e speziali [Guild of doctors and pharmacists] at Orsanmichele are mid-fifteenth-century and thus fifty years later than rest of tabernacle, which is usually attributed to Simone Talenti.

114 FRANCESCHINI, PIETRO. L'oratorio di San Michele in Orto in Firenze: Illustrazione storica ed artistica dedotta dai documenti. Florence: S. Landi, 1892, 108 pp., no illus.
 Basic account of building, transformation, and decoration of Orsanmichele.

115 HARTT, FREDERICK. "Thoughts on the Statue and the Niche." In Art Studies for an Editor: Twenty-Five Essays in Memory of Milton S. Fox. Edited by Frederick Hartt. New York: Harry N. Abrams, Inc., 1975, pp. 99-116, 29 figs.
 Considers importance of enclosure to revival of monumental sculpture in Early Renaissance Florence. Compares effect of sculptures with and without niche, especially Orsanmichele sculptures by Donatello, Ghiberti, Verrocchio, and Nanni di Banco.

116 MARRAI, B[ERNARDO]. "Oratorio di Or San Michele." Rivista d'arte 6 (1909):250-55, no illus.
 Report on the restoration of Orsanmichele. Traces history of the building, its various functions, structural transformations, and decoration.

117 PASSERINI, LUIGI. "La loggia di Or-Sanmichele [sic]." In Curiosità storico-artistiche fiorentine. 2 vols. Florence: S. Jouhaud, 1866-75, 1:115-62, no illus.
 History of Orsanmichele and its decoration with appendix of four transcribed documents.

118 REYMOND, MARCEL. "Les débuts de l'architecture de la Renaissance (1418-1440)." Gazette des beaux-arts, 3d per. 22 (1900):89-100, 425-34, 13 figs.
 Stylistic demonstration of how Renaissance architectural styles supplanted medieval forms in Florence, 1418-40. Treats Orsanmichele tabernacles and tomb architecture. Disputes restoration of Luca della Robbia's Cantoria (Museo dell'Opera del Duomo, Florence).

119 SCHMARSOW, AUGUST. "Die Statuen an Orsanmichele." In Florentiner Studien: Festschrift zu Ehren des Kunsthistorischen Institutes in Florenz (Leipzig Universität). Leipzig: A.G.

23

Liebeskind, 1897, pp. 36-53, 12 figs. [Reprinted from series in Nationalzeitung (1889); in Italian in La vita nuova 1, nos. 11-13 (1889).]
Attributions of statues at Orsanmichele based on stylistic analysis; now of historical interest.

See also entries under individual sculptors.

Badia

120 UCCELLI, GIO[VANNI] BATTISTA. Della Badia fiorentina: Ragionamento storico. Florence: Tip. Calasanziana, 1858, 125 pp., no illus.
History of Florentine Badia, with appendix of unpublished documents (transcribed here) and citations of published documents. Important for Mino da Fiesole.

Baptistry

121 LUMACHI, ANTONIO. Memorie storiche dell'antichissima basilica di S. Gio. Batista [sic] di Firenze. . . . Florence: Lorenzo Vanni, 1782, 175 pp., 1 fig.
Early history and description of Florentine Baptistry and its decoration. Important for Silver Altar, Ghiberti's doors, and Donatello's Mary Magdalen and Tomb of Pope John XXIII (Coscia).

Loggia dei Lanzi

122 FREY, CARL. Die Loggia dei Lanzi zu Florenz. Berlin: Hertz, 1885, 394 pp., 2 street plans.
Early scholarly study of construction history and decoration of Loggia dei Lanzi, with comprehensive transcription of documents. Deals peripherally with fifteenth-century sculpture. Essential to understanding of decoration of whole Piazza Signoria. Also notes on Orsanmichele, Duomo, and Baptistry. Indexed.

Palazzo Vecchio

123 MOISE, FILIPPO. Illustrazione storico-artistica del Palazzo de' Priori oggi Palazzo Vecchio e dei monumenti della piazza. Florence: Ricordi & Jouhaud, 1843, 195 pp., 3 line engrs.
Description of building history of Palazzo Vecchio and decoration of interior rooms, as well as Loggia dei Lanzi and major monuments of piazza. Discusses role of this complex in Florentine history.

Piazza della Signoria

124 FADER, MARTHA A.A. "Sculpture in the Piazza della Signoria as Emblem of the Florentine Republic." Ph.D. dissertation, University of Michigan, 1977, 366 pp. [Dissertation Abstracts International 38, no. 11 (1977-78):6367A-68A.]

Analyzes Piazza della Signoria and sculpture placed there from thirteenth to sixteenth century. Donatello's Marzocco of 1420 and his Judith, ca. 1459, are major pieces in what Fader establishes as first phase, that of Florentine Republic (1324-1504).

125 WEIL-GARRIS, KATHLEEN. "On Pedestals: Michelangelo's David, Bandinelli's Hercules and Cacus, and the Sculpture of the Piazza della Signoria." Römisches Jahrbuch für Kunstgeschichte 20 (1983):377-415, 30 figs.
Analyzes relationship between pedestal and statue of group of sculptures in Piazza della Signoria. Includes Donatello's Marzocco and Judith, with references to other Donatello sculptures as well.

Santa Croce

126 MOISE, F[ILIPPO]. Santa Croce di Firenze: Illustrazione storico-artistica, con note e copiosi documenti inediti. Florence: The Author, 1845, 508 pp., 1 line engr.
History of establishment of major Franciscan church in Florence and its construction and decoration, especially the many tombs located there. Discusses convent buildings, cloisters, and Pazzi Chapel as well. Details major donations to church and its role in Florentine history.

127 ROSSI, FERDINANDO. Arte italiana in Santa Croce. Florence: Barbèra, 1962, 159 pp., 116 figs., 30 color pls.
Survey of architecture, sculpture, paintings, and stained glass of Santa Croce. Large-scale, clear illustrations provide good sense of overall appearance and relationship of aspects of decoration. Bibliography.

San Lorenzo

128 CIANFOGNI, NOLASCO. Memorie istoriche dell'Ambrosiana R. Basilica di S. Lorenzo di Firenze. Edited by Domenico Moreni. 2 vols. Florence: Domenico Ciardetti, 1804-17, 292 pp., no illus.
History of San Lorenzo in Florence up to ca. 1425, followed by appendix of transcribed documents. Completed after Cianfogni's death by Moreni.

SURVEYS

129 AVERY, CHARLES. Florentine Renaissance Sculpture. London: John Murray, 1970, 274 pp., 186 figs. New York: Harper & Row, Icon Editions, 1978, paperback.
Compact, introductory survey by leading scholar. Designed in part as guide with list of locations of principal sculptures.

130 BERTINI, ALDO. Scultura fiorentina del '400 e del '500.
 Edited by A. Quazza. Turin: G. Giappichelli, 1965, 141 pp.,
 no illus.
 Edited class lectures with limited footnotes and no biblio-
 graphy, illustrations or index. Focus on Verrocchio.

131 BODE, WILHELM von. Denkmaler der Renaissance--Skulptur
 Toscanas. 11 vols. plus index by Frida Schottmüller. Munich:
 F. Bruckmann A.-G., 1892-1905.
 Invaluable corpus of 567 large-format plates of Central
 Italian sculpture, primarily from Quattrocento, with accompanying
 text (vol. 1). Especially useful for minor masters. Indexed by
 sculptor and location.

132 BODE, WILHELM von. Florentiner Bildhauer der Renaissance.
 Berlin: Bruno
 Cassirer, 1910, 334 pp., 176 figs. English ed. Florentine
 Sculptors of the Renaissance. Translated by Jessie Haynes. 2d
 ed., revised and corrected by F.L. Rudston Brown. New York:
 Scribner's, 1928, 258 pp., 105 figs. Reprint. New York:
 Hacker Art Books, 1969.
 Classic early collection of essays on wide range of topics
 by director of the Kaiser Friedrich Museum, Berlin. Especially
 useful for the minor products of sculptural workshops, terracotta
 squeezes, Madonna reliefs, and portrait busts, and for its photo-
 graphs, mostly unpublished. Now largely superseded in its attribu-
 tions and conclusions; however, of historical interest.

132a L[oeser], C[harles]. Review of Florentiner Bildhauer der
 Renaissance, by Wilhelm von Bode. Burlington Magazine 5, no.
 16 (July 1904):418-19, no illus.

133 CHASTEL, ANDRE. Art et humanisme à Florence au temps de
 Laurent le Magnifique: Études sur la Renaissance et
 l'humanisme platonicien. Paris: Presses Universitaires de
 France, 1959, 578 pp., 96 figs.
 Scholarly study of art in Florence, 1470-1500, placing
 works of art in context of history of ideas, particularly humanism.
 Matches images with intellectual events, providing surprising and
 insightful juxtapositions. Valuable illustrations and notes.

134 GALASSI, GIUSEPPE. La scultura fiorentina del Quattrocento.
 Milan: Ulrico Hoepli, [n.d.], 281 pp., 300 figs.
 General discussion of fifteenth-century Florentine sculp-
 ture, arranged by major artists. Brief footnotes, no bibliography.

134a Pope-Hennessy, John. Review of La scultura fiorentina del
 Quattrocento, by Giuseppe Galassi. Art Bulletin 32, no. 2
 (June 1950):157-58, no illus.
 Highly critical review that outlines the unresolved prob-
 lems of Quattrocento sculpture not addressed by the book.

135 HARLECH, WM. ORMSBY-GORE, IV. <u>Florentine Sculptors of the</u>
 <u>Fifteenth Century.</u> London: Macmillan & Co., 1930, 153 pp., 32
 figs.
 Brief chronological survey focusing on the eighteen most
 notable sculptors. Uncritical observations from an aesthetic view-
 point. Includes list of principal works by each artist.

136 REYMOND, MARCEL. <u>La sculpture florentine.</u> 4 vols. Flor-
 ence: Fratelli Alinari, 1897-1900, 79 figs.
 Profusely illustrated, folio-size history of Italian sculp-
 ture, clearly and systematically arranged by artist with each essay
 constituting a brief catalogue of the artist's oeuvre. Vol. 1:
 pre-1400; vols. 2: 1400-1450; vol. 3: 1450-1500.

137 SIREN, OSVALD. <u>Studier i florentinsk renässansskulptur och</u>
 <u>andra konsthistoriska amnen.</u> Stockholm: Wahlström &
 Widstrand, 1909, 260 pp., 89 figs.
 In Swedish. Collected essays on various aspects of
 Renaissance art, including Ghiberti's first bronze door, Baptistry,
 Florence; Donatello's and Ghiberti's Madonnas; the David motif in
 Renaissance sculpture; and antique influence on Ghiberti and Dona-
 tello. Few notes, no bibliography.

138 STOKES, ADRIAN. <u>The Quattro Cento: A Different Conception of</u>
 <u>the Italian Renaissance. Part One. Florence and Verona: An</u>
 <u>Essay in Italian Fifteenth-Century Architecture and Sculpture.</u>
 London: Faber & Faber, 1932, 240 pp., 64 figs.
 Essay on major fifteenth-century Florentine sculptors,
 integrating stylistic analysis with what author terms a "psycho-
 logical" approach. Of historical interest.

Siena

SOURCE MATERIAL

COLLECTIONS OF DOCUMENTS

139 BACCI, PELEO. <u>Documenti e commenti per la storia dell'arte.</u>
 Florence: Felice le Monnier, 1944, 157 pp., no illus.
 Documents pertaining to artists, mainly painters, in Tus-
 cany. Includes Quercia, Vecchietta, and Cozzarelli.

140 BACCI, PÈLEO. "Elenco delle pitture, sculture e architetture
di
 Siena compilato nel 1625-26 da Mons. Fabio Chigi, poi Alessan-
 dro VII." <u>Bullettino senese di storia patria</u> 46, n.s. 10
 (1939):197-213, 297-337, no illus.
 Important inventory of art and architecture arranged by
 site and compiled by Fabio Chigi in the 17th century.

141 BORGHESI, SCIPIONE, and BANCHI, L. <u>Nuovi documenti per la</u>
 <u>storia dell'arte senese raccolti da S. Borghese e L. Banchi,</u>
 <u>appendice alla raccolta dei documenti pubblicata dal Comm.</u>
 <u>Gaetano Milanesi.</u> Siena: Torrini, 1898, 702 pp., no illus.
 Continuation of Milanesi's archival research (entry 143)
 that includes 350 newly published documents on Sienese art, indexed
 chronologically and by place, subject, and artist. Important for
 fifteenth-century Sienese sculpture.

142 Della VALLE, GUGLIELMO. <u>Lettere senesi . . . sopra le belle</u>
 <u>arti.</u> 3 vols. Vol. 1, Venice: Giovambatista Pasquali, 297
 pp.; vol. 2, Rome: Generoso Salomoni, 283 pp.; vol. 3, Rome:
 Giovanni Zempel, 480 pp., 1785-86, no illus.
 Important anthology of biographies of fifteenth-century
 Sienese artists that includes documents and citations from earlier
 sources. Vol. 2, pp. 146-68, for Quercia; vol. 3 for other
 fifteenth-century sculptors.

143 MILANESI, GAETANO. <u>Documenti per la storia dell'arte senese</u>
 <u>raccolti ed illustrati dal dott. Gaetano Milanesi.</u> 3 vols.
 Siena: Porri, 1854-56, no illus.

Vol. 2: Fifteenth century, arranged by date. Vol.3 includes index by artist. Useful compilation of material, including many references to fifteenth-century sculpture, not available elsewhere. Document reference numbers no longer correspond to current Sienese archival ordering.

LITERARY SOURCES UP TO 1700

144 ROMAGNOLI, ETTORE. Biografia cronologica de' bellartisti senesi dal secolo XII a tutto il XVIII. Siena: Biblioteca Comunale, pre-1835 manuscript. Facsimile edition in 13 vols. Florence: SPES, 1976. Vol. 4: 1400-1450; vol. 5: 1450-1500. Index at end of each volume. Vol 13: comprehensive index.
 Important anthology of lives of Sienese artists. Major source for fifteenth-century sculptors.

GUIDEBOOKS AND ARTICLES

ALL OF SIENA

145 BROGI, F[RANCESCO]. Inventario generale degli oggetti d'arte della provincia di Siena, 1862-1865. Siena: Carlo Nava, 1897, 658 pp., no illus.
 Census of works of art in Sienese province arranged alphabetically by town and then site. Each work is described, measured, and attributed.

146 DAMI, LUIGI. Siena e le sue opere d'arte. Toscana illustrata, vol. 6. Florence: Lumachi, 1915, 279 pp., 34 figs.
 Handy history of Siena's notable monuments and works of art. Small, unclear photos. Extensive bibliography, subdivided by topic.

147 HEYWOOD, WILLIAM, AND OLCOTT, LUCY M. Guide to Siena. 2 vols. Siena: Enrico Torrini, 1908, 384 pp., 17 figs., folding map.
 General guide covering history and art of Siena. Art section by Lucy Olcott contains detailed notices of location of art works, but with little critical or scholarly information.

INDIVIDUAL MONUMENTS

Baptistry

148 LUSINI, V. Il S. Giovanni di Siena e i suoi restauri. Florence: Fratelli Alinari, 1901, 118 pp., 20 figs.
 History of decoration of Baptistry, Siena, and its restorations. Appendix of documents and inscriptions. Important for Baptismal Font, although largely superseded by Paoletti (entry 149).

149 PAOLETTI, JOHN T. The Siena Baptistery Font: A Study of an
 Early Renaissance Collaborative Programme, 1416-34. Out-
 standing Dissertations in the Fine Arts. New York: Garland,
 1979, 315 pp., 87 figs. [Ph.D. dissertation, Yale University,
 1967, 2 vols., 401 pp. Dissertation Abstracts 30 (1969-70):
 1477A.]
 Analyzes collaboration of Ghiberti, Donatello, and Jacopo
 della Quercia on Baptismal Font, Baptistry, [San Giovanni], Siena,
 1416-34, with new documents that clarify chronology. Considers
 sculptures within historical and iconographic context.

 Duomo

150 CUST, ROBERT H.H. The Pavement Masters of Siena (1369-1562).
 London: George Bell & Sons, 1901, 160 pp., 26 figs., plans.
 Small guide to marble flooring (Duomo, Siena) containing
 wealth of material on sculptors involved. Biographical summaries of
 sculptors and chronology of project.

 SURVEYS

151 CARLI, ENZO, ed. Capolavori dell'arte senese. Florence:
 Electa, 1946, 110 pp., 234 figs.
 History of Sienese painting and sculpture from the thir-
 teenth to fifteenth century that focuses on painting. Includes some
 major fifteenth-century sculptors.

152 CARLI, ENZO. Gli scultori senesi. Milan: Electa, 1980, 251
 pp., 187 figs., 57 color pls.
 Recent, lavishly illustrated history of Sienese sculpture
 from the fourteenth to beginning of sixteenth century by the leading
 specialist. Brief essays on each artist include thorough bibliog-
 raphies. Many photographs of details. Indexed by artist and author,
 as well as location.

153 Del BRAVO, CARLO. Scultura senese del Quattrocento. Florence:
 EDAM, 1970, 136 pp., 400 figs.
 Survey of fifteenth-century Sienese sculpture, focusing on
 Francesco di Valdambrino, Vecchietta, and Antonio Federighi. Full
 scholarly apparatus. Valuable corpus of illustrations.

153a Freytag, Claudia. Review of Scultura senese del Quattrocento,
 by Carlo Del Bravo. Pantheon 30 (1972):249-50, no illus.

153b Paoletti, John T. Review of Scultura senese del Quattrocento,
 by Carlo Del Bravo. Art Quarterly 36, nos. 1-2 (Spring-Summer
 1973):102-6, no illus.
 Important notes on and attributions to Jacopo della Quercia
 and his followers: Francesco di Valdambrino, Domenico di Niccolò de'
 Cori, and Vecchietta. With new research on Federighi.

154 SCHUBRING, PAUL. Die Plastik Sienas im Quattrocento. Berlin:
 G. Grote'sche Verlagsbuchhandlung, 1907, 256 pp., 143 figs.
 Authoritative survey of Sienese Renaissance sculpture,
organized as separate studies of individual artists. Generously
illustrated with many less known works.

154a Fabriczy, C[ornelius] v[on]. Review of Die Plastik Sienas im
 Quattrocento, by Paul Schubring. Repertorium für Kunstwissen-
 schaft 31 (1908):384-91, no illus.

Rest of Tuscany

SOURCE MATERIAL

COLLECTIONS OF DOCUMENTS

155 BACCI, PELEO, ed. <u>Documenti toscani per la storia dell'</u>
 <u>arte.</u> . . . 2 vols. Florence: Gonnelli, 1910-12, 35 pp., 27
 figs. Reprint. Florence, 1944.
 Documents about history of art in Pistoia with biblographic
 notes and tables of contents. Covers Baptismal Font, Duomo, by
 Benedetto da Maiano and Andrea Ferrucci (vol. 2, pp. 138-65); Andrea
 della Robbia's work for Duomo (vol. 2, pp. 167-85).

156 TANFANI CENTOFANTI, LEOPOLDO. <u>Notizie di artisti tratte dai</u>
 <u>documenti pisani.</u> Pisa: Enrico Spoerri, 1897, 590 pp., no
 figs.
 Biographies, including transcribed documents, about artists
 born or active in Pisa from the twelfth to seventeenth century.
 Important for Donatello and Andrea Ferrucci, among others. Fully
 indexed.

GUIDEBOOKS AND HISTORIES

157 GUIDA d'ITALIA del TOURING CLUB ITALIANO. <u>Toscana.</u> Milan:
 Alfieri & La Croix, 1974, 4th ed., 815 pp., no illus., 14 maps,
 19 plans.
 Thorough guide to works of art located in Tuscany; espe-
 cially useful for minor sculptures not studied elsewhere. Includes
 Siena. Bibliography. (City of Florence treated in separate volume).

TOWNS

Carrara

158 CAMPORI, GUISEPPE. <u>Memorie biographiche degli scultori,</u>
 <u>architetti, pittori, ecc. nativi di Carrara e di altri luoghi</u>
 <u>della provincia di Massa, con cenni relativi agli artisti</u>

italiani ed esteri che in essa dimorarano ed operarono e un saggio bibliografico. Modena: Vicenzi, 1873, 466 pp., no illus. Reprint. Bologna: Forni Editore, 1969.

Includes artists who either worked in Carrara or who came to Carrara to choose marble, with well-documented annotations. Indexed by century and alphabetically by artist. Includes many references to fifteenth-century sculptors.

Fiesole

159 GIGLIOLI, ODOARDO H. Catalogo delle cose d'arte e d'antichità d'Italia: Fiesole. Catalogo delle cose d'arte e di antichità d'Italia, vol. 6. Rome: Libreria dello Stato, 1933, 350 pp., 264 figs.

Well-illustrated catalogue of major monuments and works of art in Fiesole. Each piece described, its inscriptions and condition noted, and bibliography listed. Valuable for treatment of fifteenth-century sculptures in Duomo and Museo Bardini, as well as Della Robbia glazed terracotta sculptures in various churches.

Lucca

160 BELLI, ISA. Guida di Lucca. Lucca: Il Messaggero, 1953, 382 pp., 40 figs.

Handy guide to Lucca that contains history of city and extensive bibliography, including list of manuscripts referring to Lucchese art in Biblioteca governativa, Lucca. Indexed.

Pistoia

161 Il Gotico a Pistoia nei suoi rapporti con l'arte gotica italiana (Atti del 2° convegno internazionale di studi, Pistoia, April 1966). Rome: Tipografia Centenari, 1966, 417 pp., 150 figs.

Publishes papers presented at conference supplemented with footnotes and illustrations. Individual papers indexed by author.

Rome

COLLECTIONS OF DOCUMENTS

162 MÜNTZ, EUGÈNE. Les arts à la cour des papes: Innocent VIII,
Alexandre VI, Pie III (1484-1502), recueil de documents inédits
ou peu connus, publié sous les auspices de l'Académie des
Inscriptions et Belles Lettres. . . . Paris: Ernest Leroux,
1898, 303 pp., 14 figs., 94 engrs.
 Collection of documents regarding art commissioned by papal
court, arranged by patron and medium. Indexed by artist and monu-
ment.

163 MÜNTZ, EUGÈNE. Les arts à la cour des papes: Nouvelles
recherches sur les pontificats de Martin V, d'Eugène IV, de
Nicolas V, de Calixte II, de Pie II, et de Paul II. Rome:
Imprimerie de la Paix de Phillippe Cuggiani, 1884, 88 pp., no
illus. [From Mélanges d'archéolgie et d'histoire, 1881-82 and
1884-85.]
 Additional documents on fifteenth-century papal patronage,
arranged chronologically. Unindexed.

164 MUNTZ, EUGENE. Les arts à la cour des papes pendant le XVe et
le XVIe siècles: Recueil de documents inédits tirés des
archives et des bibliothèques romains. . . . 3 vols.
Bibliothèque des Écoles françaises d'Athènes et de Rome, nos.
4, 9 and 28. Paris: E. Thorin, 1878-82, no illus. New ed.
Hildesheim, Zurich, and New York: Olms, 1986, 997 pp., no
illus.
 Documents on papal commissions, arranged chronologically by
pope and then by monument or medium. Vol. 1: Martin V-Pius II
(1417-64); vol. 2: Paul II (1464-71); vol. 3: Sixtus IV-Leo X
(1471-1521).

165 MÜNTZ, EUGÈNE. "La Renaissance à la cour des papes, III: La
sculpture pendant le règne de Pie II." Gazette des beaux-arts,
2d per. 18 (1878):91-101, no illus.

Although most fifteenth-century popes favored painting, there was a strong revival of interest in sculpture under Pope Pius II; the sculptors patronized were generally lesser known. Publishes many documentary references to these minor masters, as well as new information on Mino da Fiesole, Isaia da Pisa, Paolo Romano, and other Romans. Discusses various projects for chapels, restoration, and the Benediction Loggia of 1463-64.

LITERARY SOURCES UP TO 1700

166 MURRAY, PETER, ed. Five Early Guides to Rome and Florence. Farnborough: Gregg International Publishers, 1972, unpaginated, no illus.
 Facsimile republication of anonymous La edifichation de molti pallazi e tempii de Roma (Venice, 1480), Francesco Albertini's Opusculum de Mirabilibus Novae e Veteris Urbis Romae (Rome, 1510), and Palladio's Descritione de le chiese de Roma and L'antichità di Roma (Rome, 1554). Brief introduction, no notes. Albertini, a Florentine priest and student of Ghirlandaio, gives first quite accurate account of ancient Rome and offers contemporary description of its rebuilding under Julius II. Other accounts are important early descriptions of Rome. Earlier annotated edition of Albertini by August Schmarsow (Heilbronn: Henninger, 1886), 77 pp., no illus.

GUIDEBOOKS AND ARTICLES

ALL OF ROME

167 FORCELLA, VINCENZO. Iscrizioni delle chiese e d'altri edifici di Roma dal secolo XI fino ai giorni nostri. 13 vols. Rome: Tip. della Scienze Matematiche e Fisiche, 1869-79, no illus.
 Comprehensive transciption of inscriptions found in Roman sites, arranged by location, and then chronologically.

168 GUIDA d'ITALIA del TOURING CLUB ITALIANO. Roma e dintorni. Milan: Alfieri & La Croix, 1962, 764 pp., no illus., 6 maps, 11 plans.
 Comprehensive, handy guide to works of art in Rome and surrounding area, arranged by neighborhood. Bibliography.

INDIVIDUAL MONUMENTS

Palazzo Venezia

169 ZIPPEL, GIUSEPPE. "Paolo II e l'arte." Arte 13 (1910):241-58, 6 figs.
 Discusses the Palazzo Venezia, which was built for Paul II, and his art collections housed there (documents included).

St. Peter's

170 DIONYSIUS, FILIPPO L. [Dionisi]. Sacrarum Vaticanae Basilicae
 Cryptarum Monumenta Aereis Tabulis Incisa. Rome: Archangeli
 Casaletti, 1773, 252 pp., 83 figs.
 Guide to tombs and other monuments in the Vatican grottoes.

171 DUFRESNE, DÉSIRÉ. Les cryptes vaticanes. Paris: Desclée,
 Lefebvre & Co., 1902, 128 pp., 15 figs., plans.
 Handbook/guide to monuments in Vatican grottoes. Each
 monument described in detail with full record of inscription. Mostly
 Early Christian, but also tombs of Renaissance popes, Paul II and
 Nicholas V. Discusses sculptural fragments with some speculation on
 attributions.

172 GUARDUCCI, MARGHERITA. "La Tomba di San Pietro in un rilievo
 del Quattrocento." Atti della Pontificia accademia romana di
 archeologia: Rendiconti 49 (1976-77):177-90, 7 figs.
 Publishes little-known fifteenth-century relief from Con-
 fessio of St. Peter, St. Peter's, Rome (now in Pico Cellini collec-
 tion, Rome). Relief represents what fifteenth-century thought ori-
 ginal tomb of St. Peter looked like, and hence its importance.
 Deciphers its iconography as two miracles of St. Peter.

Santa Maria Maggiore

173 ANGELI, PAOLO DEGLI. Basilicae S. Mariae Maioris de Urbe a
 Liberio Papa I Usque ad Paulum V Pont. Max Descriptio et
 Delineatio, Auctore Abbate Paulo de Angelis. Lib. XII. . . .
 Rome: B. Zannetti, 1621, 252 pp., 14 detailed line engrs.
 Important early guide to Santa Maria Maggiore in Rome.
 Source for original appearance of Ciborium of Cardinal d'Estouteville
 by Mino da Fiesole.

Santa Maria del Popolo

174 CANNATA, ROBERTO, et al. Umanesimo e primo Rinascimento in S.
 Maria del Popolo. Il Quattrocento a Roma e nel Lazio. Rome:
 De Luca, 1981, 112 pp., 182 figs.
 Catalogue of exhibition held 12 June-30 September 1981.
 Analyzes painting and sculpture executed to decorate Santa Maria del
 Popolo, Rome (1472-1509). Important for Isaia da Pisa, Mino da
 Fiesole, and Gian Cristoforo Romano. Extensive bibliography.

LAZIO

175 GUIDA d'ITALIA del TOURING CLUB ITALIANO. Lazio. Milan:
 Alfieri & La Croix, 1964, 630 pp., no illus., 13 maps, 16
 plans.
 Most useful guide to Lazio that exhaustively catalogues
 works of art in region. Brief introductory history of area. Bibli-
 ography.

SURVEYS OF ROMAN SCULPTURE

Books

176 GOLZIO, VINCENZO, and ZANDER, GIUSEPPE. L'arte in Roma nel
secolo XV. Bologna: Licinio Cappelli, 1968, 546 pp., 240 pls.
(with several figures per plate).
 Comprehensive history of fifteenth-century painting, sculp-
ture, and architecture in Rome. Annotated bibliography. Brief bio-
graphies of artists with bibliographies. Indexed.

177 GREGOROVIUS, F[ERDINAND]. Le Tombe dei papi. 2d ed., enlarged
and revised by C[hristian] Huelsen. 2 vols. Rome: Edizioni
del Centauro, 1931, 115 pp., 112 figs.
 Amplified republication of Gregorovius's essay on history
of papal tombs, first written in 1857. Updated in terms of scholarly
discoveries; includes photographs of the monuments. Supersedes Eng-
lish translation of second edition by R.W. Seton-Watson (Westminster:
Archibald Constable, 1903, 174 pp., 15 figs.)

178 MONTINI, RENZO U. Le tombe dei papi. Rome: Angelo Belardetti
Editore, 1957, 475 pp., 199 figs.
 Comprehensive catalogue of papal tombs, arranged chrono-
logically according to reign of pope. With photographs, inscrip-
tions, reconstructions, and bibliography relevant to each monument.

179 RICCOBONI, ALBERTO. Roma nell'arte: La scultura nell'evo
moderno dal Quattrocento ad oggi. Rome: Mediterranea, 1942,
651 pp., 513 figs.
 History of Roman sculpture from fifteenth to twentieth
century. Biography of each sculptor followed by description of his
major works in Rome. Index by name and location. Clear black-and-
white illustrations.

180 STEINMANN, ERNST. Rome in der Renaissance, von Nicolaus V. bis
auf Julius II. Leipzig: E.A. Seemann, 1899, 172 pp., 141
figs.
 History of Roman art, primarily those objects commissioned
by the popes from Nicholas V to Julius II. No footnotes or bibliog-
raphy. Small illustrations.

181 TOSI, FRANCESCO M. Raccolta di monumenti sacri e sepolcrali
scolpiti in Roma nei secoli XV e XVI. 5 vols. in 3. Rome:
Editore Proprietario, 1853-56, unpaginated, 301 line engrs.
 Catalogue of large line engravings of major altars, taber-
nacles, and tombs of fifteenth- and sixteenth-century Rome, with
inscriptions and basic history for each.

Unpublished Theses

182 CALLISEN, STERLING A. "Renaissance Sculpture of Rome with
Special Reference to Andrea Bregno." Ph.D. dissertation,

Harvard University, 1936. [Summary in Harvard University
(G.S.A.S.) Summaries of Theses, 1936 (Cambridge, Mass.:
Harvard University, 1938), pp. 124-28.]

Thorough study of Roman sculpture 1450-1500, focusing on
Andrea Bregno (1418-1503). Discusses Paolo Romano and Isaia da Pisa
(argues against his authorship of the Eugenius IV Monument, San Sal-
vatore in Lauro); Mino da Fiesole and the problem of Mino del Reame;
and Giovanni Dalmata as assistant to Bregno. Publishes all documents
relating to Bregno.

Articles

183 CIACCIO, LISETTA. "Scoltura romana del Rinascimento: Primo
 periodo (sino al pontificato di Pio II)." Arte 9 (1906):165-84,
 433-41, 21 figs.
 Analyzes major Roman sculptural commissions of the 1450s
and early 1460s and groups them stylistically.

184 De NICOLA, GIACOMO. "Il sepolcro di Paolo II." Bollettino
 d'arte, 1st ser. 2 (1908):338-51, 11 figs.
 Publishes drawing from sixteenth-century Codex Berolin-
ensis, c. 82 (Kupferstichkabinett, Berlin), that records dismantled
tomb of Paul II, clarifying later modifications to it. Inscription
visible in drawing indicates tomb was finished in 1477. Hypothesizes
tomb was begun in 1475.

185 FRASCHETTI, STANISLAO. "Una disfida artistica a Roma nel
Quattrocento." Emporium 14 (1901):101-16, 26 figs.
 Brief, superficial essay on fifteenth-century Roman sculp-
ture covering Paolo Romano, Isaia da Pisa, "Mino del Regno," and Mino
da Fiesole.

186 GIORDANI, PAOLO. "Studii sulla scultura romana del Quattro-
 cento: I bassorilievi del Tabernacolo di Sisto IV, relazioni
 iconografiche." Arte 10 (1907):263-75, 13 figs.
 Relates cycle of reliefs of St. Peter from Tabernacle of
Sixtus IV, Vatican grottoes, to late medieval fresco cycles of saints
and to Imperial cycles of reliefs. Traces motival and compositional
borrowings from ancient Roman sculptures. Attributes reliefs to
Nardo da Guidozzo.

Marches and Umbria

SOURCE MATERIAL

PERUGIA

187 MARIOTTI, ANNIBALE. Lettere pittoriche perugine, o sia
 ragguaglio di alcune memorie istoriche risguardanti le arti del
 disegno in Perugia. Perugia: Badueliane, 1788, 290 pp., no
 illus.
 Important early source for artists working in Perugia, like
 Agostino di Duccio and Mino da Fiesole. Indexed by artist and site.

GUIDEBOOKS AND HISTORIES

REGION

188 GUIDA d'ITALIA del TOURING CLUB ITALIANO. Marche. 3d ed.
 Milan: Alfieri & La Croix, 1962, 507 pp., no illus., 20 maps,
 16 ground plans.
 Most useful guide to Marches arranged by city, with
 thorough account of works of art located in region. Brief intro-
 ductory history of area. Bibliography.

189 GUIDA d'ITALIA del TOURING CLUB ITALIANO. Umbria. Milan:
 Alfieri & La Croix, 1962, 456 pp., no illus., 9 maps, 13 plans.
 Thorough guide to works of art in region, especially useful
 for sculptures not studied elsewhere. Brief introductory history of
 area. Bibilography.

INDIVIDUAL CITIES

Rimini

190 YRIARTE, CHARLES. "Les arts à la cour des Malatesta." Gazette
 des beaux-arts, 2d per. 19 (1879):19-47, 122-46, 444-75, no
 illus., small line engrs.
 Thorough survey of Malatesta family in Rimini and their

patronage of the arts, focusing on the Tempio Malatestiano. Important for Agostino di Duccio's sculpture.

Urbino

191 ROTONDI, PASQUALE. Il Palazzo Ducale di Urbino. 2 vols. Urbino: Ist. Statale d'Arte per il Libro, 1951, 511 ppp., 501 figs. English trans., abr. London: Alec Turanti, 1969, 111 pp., 410 figs., 7 line drawings.
 Authoritative study of architecture and decoration of Palazzo Ducale, Urbino.

191a Bazin, Germain. Review of Il Palazzo Ducale di Rubino, by Pasquale Rotondi. Gazette des beaux-arts, 6th per. 48 (1956):190-92, no illus.

192 VENTURI, ADOLFO. "L' ambiente artistico urbinate nella seconda metà del Quattrocento." Arte 20 (1917):259-93, 33 figs.
 Survey of late fifteenth-century painting, sculpture, and architecture from Urbino, focusing on the Palazzo Ducale and portrait sculpture by Laurana.

193 VENTURI, LIONELLO. "Studii sul Palazzo Ducale di Urbino." Arte 17 (1914):415-73, 47 figs.
 Discusses role of Gian Cristoforo Romano in architecture and sculptural decoration of Palazzo Ducale, Urbino, specifically decoration of door of "Sala del magnifico" and door of "Sala della Iole." Includes brief discussion of Francesco di Simone Ferrucci's sculpted door frame. Appendix (pp. 472-73) with cited documents attributing Tempio Malatestiano reliefs, Rimini, to Agostino.

SURVEYS OF MARCHIGIAN AND UMBRIAN SCULPTURE

194 SERRA, LUIGI. L'arte nelle Marche. Vol. 2, Il periodo del Rinascimento. Rome: Arti Grafiche Evaristo Armani, 1934. 547 pp., 698 figs.
 Fundamental history of fifteenth- and sixteenth-century Marchigian art and architecture, divided into sections on architecture, sculpture, and painting. With bibliography and index by artist and location. Small illustrations. Section on fifteenth-century sculpture, pp. 142-95.

ARTICLES ON ANONYMOUS UMBRO-MARCHIGIAN SCULPTURES

195 BONGIORNO, LAURINE. "An Umbrian Statue of St. Sebastian." Allen Memorial Art Museum Bulletin (Oberlin) 28, no. 3 (1971):141-52, 9 figs.
 Identifies wooden figure of St. Sebastian in this collection as fifteenth-century Umbrian sculpture.

196 BUCK, RICHARD D. "The Making of a Saint." <u>Allen Memorial Art</u>
 <u>Museum Bulletin</u> (Oberlin, Ohio) 28, no. 3 (1971):153-62, 7
 figs.
 Radiographic analysis of the fifteenth-century Umbrian
figure of <u>St. Sebastian</u> in Oberlin reveals specific wood of which it
was made and how pieces were fitted together.

197 FRANCOVICH, GEZA de. "Un gruppo di sculture in legno
 umbro-marchigiane." <u>Bollettino d'arte</u>, 2d ser. 8
 (1929):481-510, 33 figs.
 Group of wood sculptures from the Marches and Umbria is
analyzed in terms of the influence of Rizzo, Francesco Laurana, and
Piero della Francesca.

198 VENTURI, LIONELLO. "Opere di scultura nelle Marche." <u>Arte</u> 19
 (1916):25-50, 21 figs.
 Publication of many little known, anonymous thirteenth- to
fifteenth-century sculptures preserved in the Marches. Among the
fifteenth-century monuments are the Tomb of Antonio da Montefeltro
(Palazzo Ducale, Urbino, post-1404); the Tomb of Paola Bianca Mala-
testa (San Francesco, Fano); the bronze statue of <u>St. Nicholas</u> and
his marble Shrine (San Nicola, Tolentino); and a <u>Madonna and Child</u>
relief by Domenico Rosselli (San Giuseppe, Urbino).

Major Sites outside Central Italy where Central Italian Sculptors Worked

BOLOGNA

199 MALAGUZZI VALERI, FRANCESCO. "Sculture nel Rinascimento a
 Bologna." Dedalo 3 (1922):341-72, 29 figs.
 Publishes many anonymous fifteenth-century Bolognese sculp-
tures by artists influenced by Quercia, as well as other sculptures
showing more general Tuscan influence.

200 SUPINO, I.B. La scultura in Bologna nel secolo XV: Ricerche
 e studi. Bologna: Nicola Zanichelli, 1910, 222 pp., 31 figs.
 (1) Discusses Tombs of the Saliceto by Andrea da Fiesole,
with documents (pp. 19-31, 3 figs.). (2) Analyzes Quercia's sculp-
tures in Bologna; includes some documents and discussion of assist-
ants' role (pp. 41-82, 15 figs.). (3) Discusses Niccolò Lamberti's
work in Bologna (pp. 86-87, doc. 88). (4) Discusses Pagno di Lapo's
sculpture in Bologna (1453-67), including decoration of chapels in
San Domenico and San Petronio; with documents (pp. 90-93, no illus.).
(5) Analyzes Prophet reliefs by Francesco di Simone Ferrucci on
window enframements (San Petronio, Bologna); with documents (pp.
96-103, 2 figs.). (6) Documents transcribed here record Agostino's
presence in Bologna in 1463 (pp. 106-7).

FERRARA

201 GRUYER, GUSTAVE. "La sculpture à Ferrare, I." Gazette des
 beaux-arts 3d per. 6 (1891):177-203, 7 line engrs.
 General history of Ferrarese sculpture beginning in the
tenth century. Concentrates on fifteenth-century sculpture when
important sculptors active there are Tuscans: Jacopo della Quercia,
Michele da Firenze, Cristoforo da Firenze, and Niccolò Baroncelli.

COURT OF MATTHIAS CORVINUS, HUNGARY

202 SCHAFFRAN, EMERICH. "Mattia Corvino re dell' Ungheria ed i
 suoi rapporti col Rinascimento italiano." Rivista d'arte 14,
 2d ser. 4 (1932):445-62, 5 figs.; 15, 2d ser. 5 (1933):191-201,
 no illus.
 In pt. 1 analyzes Matthias Corvinus's patronage of Italian
 artists during his reign (1458-90). Includes fountain and bronze
 reliefs of Alexander the Great and Darius (now lost) made for him by
 Verrocchio.

203 VAYER, LAJOS. "Alexandros és Corvinus" [Alexandre et Matthias
 Corvin: contribution à l'oeuvre de Verrocchio et à l'icono-
 logie de l'humanisme italiano-hongrois]. Müvészettörténeti
 értesitö 24, no. 1 (1975):24-36, 14 figs.
 In Hungarian. Relates series of relief profiles of ancient
 heroes, attributed to Verrocchio, to Matthias Corvinus's desired
 association with Alexander the Great. Patronage of Corvinus compared
 to that of Lorenzo de' Medici.

See also entries under Gian Cristoforo Romano; Robbia, Andrea della;
and Verrocchio.

MANTUA

204 BERTOLOTTI, A. Figuli, fonditori, e scultori in relazione con
 la corte di Mantova nel secoli XV, XVI, XVII: Notizie e
 documenti raccolti negli archivi mantovani. Milan: Bortolotti
 di Giuseppe Prato, 1890, 115 pp., no illus.
 Transcription of documents concerning sculptors who worked
 for Mantuan court, including Agostino di Duccio, Donatello, Gian
 Cristoforo Romano, Andrea della Robbia, and Luca della Robbia.

205 CAMPORI, GIUSEPPE. Gli artisti italiani e stranieri negli
 stati estensi: Catalogo storico, corredato di documenti
 inediti. Modena: R.D. Camera, 1855, 537 pp., no illus.
 Entries about commissions executed within Este domains
 summarizing available information and citing documents and early
 sources. Arranged alphabetically by artist. Relevant for Donatello,
 Agostino di Duccio, and Civitali. Indexed by city and by artist.

NAPLES

206 FILANGIERI, GAETANO, ed. Indice degli artefici delle
 arti maggiori e minori, la più parte ignoti o poco noti,
 sî Napoletani e Siciliani, sî delle altre regioni d'Italia o
 stranieri che operarono tra noi. 2 vols. Documenti per la
 storia, le arti, e le industrie delle provincie napoletane,
 vols. 5-6. Naples: Tip. dell'Accademia Reale delle Scienze,

1891, vol. 1: A-G, 627 pp., no illus., indexed; vol. 2: H-Z, 678 pp., no illus., indexed.

Publishes documents pertaining to work in all media by artists active in Naples. Arranged alphabetically by artist.

TRIUMPHAL ARCH OF ALPHONSO I OF ARAGON (ARAGONESE ARCH)

Books

207 FILANGIERI [di CANDIDA], RICCARDO. Castelnuovo, reggia Angioina, ed Aragonese di Napoli. Naples: Editrice Politecnica, 1934, xvi, 321 pp., 69 figs.

Analyzes history of Castello and its decoration through nineteenth century. Discusses Triumphal Arch (chap. 4). No notes or bibliography.

208 HERSEY, GEORGE. The Aragonese Arch at Naples, 1443-1475. New Haven and London: Yale University Press, 1973, 133 pp., 123 figs.

Monograph on Triumphal Arch, Castel Nuovo, Naples, tracing history of its construction and decoration, analyzing its iconographic program and sources, and identifying contributions of various artists involved, including Isaia da Pisa, Andrea dell'Aquila, Antonio di Chellino, and Paolo Romano. Review of earlier literature. With appendices and excerpts from documents and biographies of collaborating artists. Full scholarly apparatus.

208a Lightbown, R.W. Review of The Aragonese Arch at Naples, 1443-1475, by George Hersey. Art Quarterly, n.s. 1, no. 3 (Summer 1978):268-71, no illus.

Thorough review of major aspects of arch including patronage, significance, source of design, sculptors, and inscriptions, generally at variance with Hersey.

209 KRUFT, HANNO-WALTER, and MALMANGER, MAGNE. Der Triumphbogen Alfonsos in Neapel: Das Monument und seine politische Bedeutung. Tübingen: Verlag Ernst Wasmuth, 1977, 192 pp., 137 figs., 1 line drawing. [Excerpted from Acta ad Archaeologiam et Artium Historiam Pertinentia (Institutum Romanum Norvegiae) 6 (1975):213-305.]

Monograph on Triumphal Arch, Naples, based on new analysis of documents and major photographic campaign. Argues that arch and its decoration should be understood partly as political statement concerning the disputed succession of Ferrante to the throne of Naples.

Articles

210 BERTAUX, E[MILE]. "L'arco e la porta trionfale d'Alfonso e Ferdinando d'Aragona a Castel Nuovo." Archivio storico per le provincie napoletane 25 (1900):27-63, 6 figs.

Summary of Fabriczy's archival findings (entry 211) which Bertaux has checked and agrees with, supplemented by his comments.

211 FABRICZY, CORNELIUS von. "Der Triumphbogen Alphonsos I am Castel Nuovo zu Neapel." Jahrbuch der königlich preussischen Kunstsammlungen 20 (1899):1-30, 125-58, 6 figs.
 First major study of arch based on available documents. Establishes chronology: first campaign before 1455-58; second campaign: 1465-67/68. Proposes Pietro da Milano as designer. Discusses contributions of Isaia da Pisa, Paolo Romano, and Andrea dell'Aquila and bronze doors of Guglielmo Monaco. Publishes many important documents in appendices.

212 FILANGIERI di CANDIDA, RICCARDO. "L'arco di trionfo di alfonso d'aragona." Dedalo 12 (June 1932):439-66, 19 figs.; (August 1932):594-626, 34 figs.
 Analyzes sculptural decoration of Triumphal ARch in terms of documents and style. Important for discussion of Paolo Romano, Isaia da Pisa, Andrea dell'Aquila, and Antonio di Chellino.

213 FILANGIERI di CANDIDA, RICCARDO. "Rassegna critica delle fonti per la storia di Castel Nuovo." Archivio storico per le provincie napoletane 62, n.s. 23 (1937):267-333, no illus.
 Military and artistic history of Castel Nuovo during the Aragonese period, based on extensive archival work. Includes transcription of most important documents. Discussion of major projects in Castel Nuovo commissioned by house of Aragon, especially Triumphal Arch.

214 SCIOLLA, GIANNI CARLO. "Fucina aragonese a Castelnuovo, 1." Critica d'arte, n.s. 27, no. 123 (1971):15-36, 24 figs.
 Defines roles of Isaia da Pisa, Andrea dell'Aquila, and Antonio di Chellino in Triumphal Arch at Castel Nuovo.

215 SCIOLLA, GIANNI C. "Fucina aragonese a Castelnuovo, 2." Critica d'arte, n.s. 19, no. 126 (1972):19-38, 24 figs.
 Attribution of sculptural decoration of Triumphal Arch, including assignment to Paolo Romano of Calvary figures on front right side and heads from top of arch.

See also entries under Andrea dell'Aquila and Paolo Romano.

PADUA

216 RIGONI, ERICE. "Notizie di scultori toscani a Padova nella prima metà del Quattrocento." Archivio veneto, 5th ser. 6, pt. 2 (1929):118-36, 1 fig. Reprinted in Erice Rigoni, L'arte rinascimentale in Padova: Studi e documenti (Padua: Editrice Antenore, 1970), pp. 103-21, 1 fig.

Publication of documents about Tuscan sculptors active in Padua from ca. 1420–50: Marco and Andrea da Firenze; Giovanni, called Nani di Bartolomeo, who worked with Piero Lamberti on the Tomb of Raffaele Fulgosio (Santo, Padua); Nicolò Baroncelli; and Giovanni di Stefano, who worked with Donatello.

VENICE

217 FIOCCO, GIUSEPPE. "Leo Planiscig, 'Die Bildhauer Venedigs. . .'." Rivista d'arte 13, 2d ser. 3 (January–June 1931):266–82, 13 figs.

Disputes Planiscig's attributions in following entry; Fiocco generally gives Tuscan sculptors more important role in development of Venetian Renaissance sculpture and attributes to them many important commissions.

218 PLANISCIG, LEO. "Die Bildhauer Venedigs in der ersten Hälfte des Quattrocento." Jahrbuch der Kunsthistorischen Sammlungen in Wien, n.s. 4 (1930):47–120, 91 figs.

Thorough study of the International style in Venice as developed by Florentine artists, Niccolò di Piero Lamberti, who worked there from 1416; his son, Piero di Niccolò Lamberti; Giovanni di Martino da Fiesole; Nanni di Bartolo, active after 1424 on the Tomb of the Brenzoni, San Fermo Maggiore, Verona, the Tomb of Beato Pacifico, Santa Maria Gloriosa dei Frari, Venice, and the Portal of San Nicola in Tolentino. Also examines Buon workshop and Master of the Mascoli Altar.

219 WOLTERS, WOLFGANG. La Scultura veneziana gotica (1300–1460). 2 vols. Venice: Alfieri, 1976, 351 pp., 917 figs.

The authoritative survey of sculpture carved in Venice and the Veneto, including that of foreigners working there, like Piero di Niccolò Lamberti, Nanni di Bartolo, and Niccolò Baroncelli. Introductory chapters synthesize careers of sculptors and catalogue raisonné describes each piece, its condition, inscriptions, and commission history, and provides bibliography. Extraordinary corpus of photographs, many of them taken for this book. Extensive bibliography and index.

Specific Materials

Books

220 ARTS COUNCIL OF GREAT BRITAIN, THE VICTORIA AND ALBERT MUSEUM,
LONDON. Italian Bronze Statuettes. Introduction by John
Pope-Hennessy. Exhibition organized by the Arts Council of
Great Britain with the Italian Ministry of Education and
Rijksmuseum, Amsterdam. 47 pp., 32 figs. [Dutch catalogue:
Meesters van het brons der Italiaanse Renaissance, unpaginated,
94 figs.
 Important exhibition (27 July-1 October 1961) of 203
bronzes, primarily sixteenth century, but including important early
works by Ghiberti, Bertoldo, Pollaiuolo, Francesco di Giorgio, and
Vecchietta. Scholarly entries with provenance and references. See
also entry 233.

221 BODE, WILHELM von. The Italian Bronze Statuettes of the
Renaissance. 2d ed., edited and revised by James David Draper.
New York: M.A.S. DeReinis, 1980, xviii, 111 pp., 266 figs.
[First published in German, 2 vols. (1907). English ed.
Wilhelm von Bode, with Murray Marks. The Italian Bronze
Statuettes of the Renaissance. Translated by William Grétor.
3 vols. London: Grevel, 1908-12, 101 pp., 266 figs.]
 Important pioneering study of Renaissance bronzes. Cata-
logue arranged by school of origin or type. Most attributions still
reliable; inaccuracies on owners, titles, and attributions corrected
in Draper's new edition, which also incorporates recent findings.

222 CIARDI DUPRÉ, MARIA GRAZIA. I bronzetti del Rinascimento.
Elite, le arti, e gli stili in ogni tempo e paese, vol. 23.
Milan: Fratelli Fabbri, 1966, 157 pp., 67 color pls. English
ed. Feltham: Hamlyn, 1970.
 Survey of fifteenth- and sixteenth-century European bronze
statuettes for general audience. Good color plates and small format
of book make it useful. Limited discussion of fifteenth-century
Florentine examples.

223 LANDAIS, HUBERT. <u>Les bronzes italiens de la Renaissance.</u>
 L'Oeil du connoisseur. Paris: Presses Universitaires de
 France, 1958, 119 pp., 24 figs., 8 color pls.
 "A collector's handbook" that nevertheless provides an
 intelligent introduction to the subject. Brief examination of the
 influence of antique types and techniques. Some discussion of Dona-
 tello. Bibliography.

223a G[loton], J.-J. Review of <u>Les bronzes italiens de la Ren-</u>
 <u>aissance</u>, by Hubert Landais. <u>Information d'histoire de l'art</u>
 4, no. 4 (September–October 1959):118-19, no illus.

223bis MIDDELDORF, ULRICH, AND STIEBRAL, DAGMAR. <u>Renaissance Medals</u>
 <u>and Plaquettes</u>. Florence: SPES, [1983], unpaginated, 1 color
 pl., 97 figs.
 Detailed analysis and photography of limited number of
 medals, including examples by Adriano Fiorentino, Bertoldo, and
 Niccolò Fiorentino. Excellent photographs taken from originals, not
 casts, as is often the case.

224 NICODEMI, GIORGIO. <u>Bronzi minori del Rinascimento italiano.</u>
 Milan: L.F. Bolaffio, 1933, 235 pp., 138 figs.
 Basic history of fifteenth- and sixteenth-century Italian
 small bronzes, with sections on Lorenzo and Vittorio Ghiberti,
 Brunelleschi, Donatello and his followers, Filarete, Bellano, Ber-
 toldo, Verrocchio, and Pollaiuolo. Small illustrations.

225 PLANISCIG, LEO. <u>Piccoli bronzi italiani del Rinascimento.</u>
 Milan: Fratelli Treves, 1930, 66 pp., 383 figs.
 Survey of fifteenth- and sixteenth-century Italian bronze
 statuettes that includes sculptures of Donatello, Filarete, Bertoldo,
 and Pollaiuolo. Brief introductory essay, well illustrated. No
 notes or bibliography.

225a Weinberger, Martin. Review of <u>Piccoli bronzi italiani del</u>
 <u>Rinascimento</u>, by Leo Planiscig. <u>Zeitschrift für bildenden</u>
 <u>Kunst</u> 65 (1931-32): supp. 53-54, no illus.
 Argues that statuette of <u>David</u> (formerly Kaiser Friedrich
 Museum, Berlin) derives from marble <u>Martelli David</u> (National Gallery,
 Washington, D.C.), and dates from late Quattrocento.

226 SCHOTTMULLER, FRIDA. <u>Bronze Statuetten und Geräte</u>. 2d ed.
 Berlin: Richard Carl Schmitt & Co., 1921, 204 pp., 142 figs.
 [First published in 1918, 166 pp., 123 figs.]
 Discusses style and technique of bronze statuettes and
 vessels from ancient Egyptian epoch to eighteenth century. Focuses
 on works in Berlin museums.

227 WEIHRAUCH, HANS R. <u>Europäische Bronzestatuetten, 15.-18.</u>
 <u>Jahrhundert</u>. Braunschweig: Klinkhardt & Biermann, 1967, 539
 pp., 576 figs.
 The authoritative study of fifteenth- to eighteenth-century

European small bronzes, with section of fifteenth-century Florentine
and Sienese bronze statuettes, as well as brief discussion of large-
scale Renaissance bronze sculpture. Full scholarly apparatus.
Lavish, high-quality illustrations.

Articles

228 CIARDI DUPRE dal POGGETTO, MARIA GRAZIA. "I bronzetti toscani
 del Quattrocento." Antichità viva 18, no. 2 (1979):28-35, 10
 figs.
 Inventory of Palazzo Medici[-Riccardi], compiled when
Lorenzo the Magnificent died in 1492, indicates small bronzes there
were used in two different ways: ancient bronzes were displayed
together but contemporary bronzes were used decoratively in the
palace. Published inventories of other Florentine households almost
never list small bronzes.

229 DEONNA, W. "Le tireur d'épine: Statuette en bronze de la
 Renaissance (histoire d'un thème plastique)." Bulletin du
 Musée d'art et d'historie de Genève 8 (1930):90-97, 2 figs.
 Renaissance bronze statuette of Spinario (Musée d'art,
Geneva) derives from the antique and is similar to Brunelleschi's
seated figure in Sacrifice of Isaac relief (Bargello, Florence).
Discusses motif in the Renaissance and lists many similar
adaptations.

230 FOVILLE, JEAN de. "Les bronzes de la renaissance de la
 Bibliothèque nationale: Bronzes italiens du XVe siècle."
 Revue de l'art ancien et moderne 35, no. 204 (March 1914):
 223-36, 12 figs.
 Discusses bronzes in Cabinet des médailles, Bibliothèque
nationale, many previously unpublished. Bust attributed to Dona-
tello; several figures attributed to schools of Donatello and
Pollaiuolo.

231 LONGHURST, M[ARGARET] H. "The Italian Exhibition, I:
 Bronzes." Burlington Magazine 56, no. 323 (January
 1930):9-15, 2 figs.
 Discusses bronzes associated with Bertoldo, including Youth
Playing a Fiddle (Bargello, Florence) and Hercules on Horseback
(Galleria Estense, Modena); also Hercules and Cacus (Bargello, Flor-
ence) by Pollaiuolo. Review of catalogue, Italian Art at Burlington
House Exhibition, and attributions.

232 POPE-HENNESSY, JOHN. "Cataloguing the Frick Bronzes." Apollo
 93, no. 111 (May 1971):366-73, 16 figs.
 New attributions for bronzes: Hercules given to Pollaiu-
olo, finish identical to Berlin and Florence bronzes; Marsyas, by
school of Pollaiuolo, ca. 1470s, after an earlier Donatellesque model
(ca. 1450s).

233 POPE-HENNESSY, JOHN. "Italian Bronze Statuettes--I."
 Burlington Magazine 105, no. 718 (January 1963):14-23, 32 figs.
 Observations on exhibition of Italian bronze statuettes
held at Victoria and Albert Museum, London, 1961 (entry 220).
Reattributes bronze David (Museo e gallerie di Capodimonte, Naples)
to Francesco di Giorgio, rather than Pollaiuolo, on basis of its
markedly different modelling from Pollaiuolo's Hercules and Antaeus
(Bargello, Florence). Valuable discussion of styles of both these
artists, as well as Bertoldo. Reprinted in entry 59.

MAJOLICA

234 DOUGLAS, R. LANGTON. Cantor Lectures on the Majolica and
 Glazed Earthenware of Tuscany. London: William Trounce, 1904,
 24 pp., no illus.
 Detailed survey of the history and technical development of
majolica and glazed terracotta, focusing on the major centers: Siena
(earliest and most important), Florence (especially the Della Robbia
workshops), and Caffagiolo (Medici pottery).

235 HONEY, WILLIAM BOWYER. European Ceramic Art from the End of
the
 Middle Ages to about 1815: A Dictionary of Factories, Artists,
 Technical Terms, Etc. 2 vols. London: Faber & Faber, 1952,
 1:47 pp., 192 figs. (many illus. in each), 2:788 pp.
 Encyclopedia of ceramic history, including index to art-
ists, articles on manufacturies, and guide to literature. Also con-
tains many maps and reproductions of potters' marks. See especially
articles on "Robbia" and "Tuscany."

METALWORK

 Books

236 CHURCHILL, SIDNEY J.A., AND BUNT, CYRIL G.E. The Goldsmiths of
 Italy: Some Account of Their Guilds, Statutes, and Work.
 London: Martin Hopkinson & Co., 1926, 182 pp., 20 figs., 1
 color pl.
 Factual information on organization of goldsmith guilds in
Rome, Florence, Siena, Pistoia, and other cities, based on archival
sources. Discusses various art works, including the Silver Altars of
Pistoia and the Florence Baptistry. Material assembled posthumously
from Churchill's previously published articles. With bibliography.

237 STEINGRÄBER, ERICH. Der Goldschmied: Vom alten Handwert der
 Gold- under Silber-Arbeiter. Munich: Prestel, 1966, 80 pp.,
 74 figs., 1 color pl.
 Brief, but informative and well-illustrated handbook on
history and technique of gold and silver work.

Articles

238 HAFTMANN, WERNER. "Italienische Goldschmied-Arbeiten."
 Pantheon 23 (1939):29-34, 54-56, 10 figs.
 Exhibition review. Studies various goldsmith works, mostly
Early Christian and medieval. Disputes Middeldorf's dating of the
reliquary Bust of San Rossore ca. 1600, maintaining attribution to
Donatello and citing documented transfer of "mezza figura" by Dona-
tello from the Ognissanti, Florence, to Pisa in 1592.

239 LANDOLFI GIOVANNINI, ANNA. "Il Busto reliquario di Sant'Anna
 nel Museo dell'Opera del Duomo a Prato." Antichità viva 22,
 no. 1 (1983):29-38, 19 figs.
 Identifies Reliquary Bust of St. Anne, thought to be late
eighteenth century, as one documented as commissioned from Antonio di
Salvi (1489-90).

240 MACHETTI, IPPOLITO. "Orafi senesi." Diana 4 (1929):5-110, 73
 figs.
 Major comprehensive study of thirteenth- to fifteenth-
century Sienese goldsmith work and its relationship with bronze work,
such as Baptismal Font, Baptistry, Siena, or Vecchietta's bronzes.
Extensive documentation provided.

241 MIDDELDORF, ULRICH. "Zur Goldschmiedekunst der toskanischen
 Frührenaissance." Pantheon 16 (1935):279-82, 4 figs.
 Discusses problems inhibiting study of goldsmith work in
Quattrocento Florence: difficulty of matching documents to existing
works and extensive restoration and adaptation of goldsmith works.
Examines a pair of Ghibertesque Apostles, ca. 1414-20 (Pinacoteca,
Città di Castello); a reliquary casket by Maso di Bartolommeo, 1446
(Duomo, Prato); and an altar cross, probably Sienese, ca. 1460
(Museo, Pienza). Reprinted in entry 54.

242 STEINGRÄBER, ERICH. "Studien zur Florentiner Goldschmiede-
 kunst." Mitteilungen des Kunsthistorischen Institutes in
 Florenz 7 (1955):87-110, 31 figs. Republished in shortened
 translation in Renaissance News 8 (1955):136-40, 3 figs.
 Three problems in late fifteenth-century Florentine gold-
smith work: (1) a reliquary cross, ca. 1500 (Monastery of San
Gaggio, near Florence [now Bargello, Florence]) can be identified
with unfinished cross commissioned from Antonio Pollaiuolo in
documents of 1476-83; (2) a reliquary case (Museo dell'Opera del
Duomo, Florence) is identified with 1476 commission from Vittorio
Ghiberti (son of Lorenzo); (3) discussion of the work of Antonio di
Salvi (1450-1527), a pupil of Antonio Pollaiuolo, including the
documented commission (1490) of a reliquary (Badia, Florence) and
other works.

TERRACOTTA AND STUCCO

Books

243 CAMBRIDGE, MASSACHUSETTS, FOGG ART MUSEUM; WASHINGTON, D.C.,
 NATIONAL GALLERY OF ART; NEW YORK, METROPOLITAN MUSEUM OF ART.
 Fingerprints of the Artist: European Terra-cotta Sculpture
 from the Arthur M. Sackler Collections. Catalogue by Charles
 Avery. Cambridge, Mass.: Harvard University and Arthur M.
 Sackler Foundation, 1981, 298 pp., illus.
 Catalogue of exhibition, 1979-82. Very important catalogue
 of only major collection of European terracottas from Renaissance
 through nineteenth century, exhibited for the first time (cat. nos. 2
 and 7-8, with 25 figs, 1 color pl., are fifteenth-century Floren-
 tine). Introductory essay traces history of terracotta. Scholarly
 catalogue gives brief biographical sketch of each artist and des-
 cription, condition, provenance, and literature about each sculpture.
 The major study of this medium. Bibliography. Extremely valuable
 corpus of photographs.

 Articles

244 BELLOSI, LUCIANO. "Ipotesi sull'origine delle terracotte
 quattrocentesche." In Jacopo della Quercia fra Gotico e
 Rinascimento (Atti del convegno di studi, Siena, 1975). Edited
 by Giulietta C. Dini. Florence: Centro Di, 1977, pp. 163-68,
 27 figs.
 Connects beginnings of fifteenth-century terracotta produc-
 tion to young Donatello and identifies it as a revival of popular
 Greco-Roman technique. Three works using terracotta, a cassone with
 three terracotta panels (Victoria and Albert Museum, London), ca.
 1410; seated Madonna and Child also in that museum; and half-length
 Madonna and Child relief (formerly private collection, Berlin) are
 attributed to Donatello.

245 LENSI, ALFREDO. "Il Museo Bardini: Stucchi e terracotte."
 Dedalo 4, no. 8 (January 1924):486-511, 23 figs., 1 color pl.
 Photographs of fifteenth-century terracottas and stuccos,
 mainly Madonna and Child reliefs, in this museum. Also stucco rep-
 lica of Donatello's Lamentation that clarifies original appearance of
 this composition.

246 MIDDELDORF, ULRICH. "Some Florentine Painted Madonna Reliefs."
 In Collaboration in Italian Renaissance Art (Charles Seymour,
 Jr. Festschrift). Edited by Wendy Stedman Sheard and John T.
 Paoletti. New Haven and London: Yale University Press, 1978,
 pp. 77-90, 6 figs.
 On basis of documents and preserved examples, argues that
 Renaissance terracottas were often polychromed, either naturalistic-
 ally or to simulate bronze or marble. Close relationship between
 fifteenth-century Florentine painting and sculpture is argued through

examples of fifteenth-century paintings based on <u>Madonna</u> reliefs by Donatello, Desiderio, and Antonio Rossellino and painted stuccos done after them. Reprinted in entry 54.

247 REES-JONES, STEPHEN G. "A Fifteenth Century Florentine Terracotta Relief: Technology--Conservation--Interpretation." <u>Studies in Conservation</u> 23, no 3 (August 1978):95-113, 15 figs. [Summaries in English, French, and German.]

Technical examination and restoration of terracotta <u>Madonna</u> relief, attributed to Desiderio or Verrocchio (Museum and Art Gallery, Birmingham) provides detailed information on fifteenth-century technique of clay modelling. This relief (an original, not a cast) was used as model by Della Robbia workshop.

WAX

248 MASI, GINO. "La ceroplastica in Firenze nei secoli XV-XVI e la famiglia Benintendi." <u>Rivista d'arte</u> 9 (1916):124-42, no illus.

Publishes series of documents concerning Benintendi family of Florence, leading makers of wax ex-votos in fifteenth and sixteenth centuries. Documents reveal many details about manufacture and appearance of these sculptures, almost all of which are lost.

249 SCHLOSSER, JULIUS von. "Geschichte der Porträtbildnerei in Wachs: Ein Versuch." <u>Jahrbuch der Kunsthistorischen Sammlungen des allerhöchsten Kaiserhauses</u> 29, no. 3 (1911):171-238, 66 figs.

Comprehensive history of wax portraiture from antiquity through nineteenth century, investigating techniques and function of these sculptures. Includes section on wax ex-votos in fifteenth-century Florence, pp. 207-21.

WOOD

Books

250 BIAVATI, PAOLO and MARCHETTI, GAETANO. <u>Antiche sculture lignee in Bologna dal sec. XII al sec. XIX</u>. Translated by Jeanne O. Van den Bossche. Bologna: Grafica Bolognese, 1974, 518 pp., 336 figs.

Catalogue of wooden sculptures in Bologna arranged by period. Each piece illustrated. Indexed by artist, name of figure represented, and location of sculpture.

251 CARLI, ENZO. <u>La scultura lignea italiana dal XII al XVI secolo</u>. Milan: Electa, 1960, 289 pp., 131 figs., 90 color pls.

Major history of twelfth- to fifteenth-century Italian wood sculpture. Magnificently illustrated. Bibliography. Indexed by artist and location.

252 LISNER, MARGRIT. Holzkruzifixe in Florenz und in der Toskana, von der Zeit um 1300 bis zum frühen Cinquecento. Italienische Forschungen hrsg. Kunsthistorisches Institut, Florenz, ser. 3, vol. 4. Munich: Bruckmann, [1970], 128 pp., 166 figs.
Detailed survey of neglected field by recognized expert. Covers the period from Giovanni Pisano to Michelangelo, with many new attributions to Pollaiuolo, Desiderio, Luca della Robbia, Benedetto da Maiano, Giuliano da San Gallo, and others.

252a Pope-Hennessy, John. Review of Holzkruzifixe in Florenz und in der Toskana, von der Zeit um 1300 bis zum frühen Cinquecento, by Margrit Lisner. Pantheon 34, no. 1 (January-February 1976): 78-80, no illus.
Review calls volume "invaluable both for its ample and excellent illustrations and for its judicious text." Critically evaluates each major attribution and provides much new information and insight.

Unpublished Theses

253 STROM, DEBORAH. "Studies in Quattrocento Tuscan Wooden Sculpture." Ph.D. dissertation, Princeton University, 1979, 234 pp. [Dissertation Abstracts International, order no. 7919319.]
Chap. 1 analyzes traditional technique and revolutionary adaptation by Donatello. Chap. 2: Jacopo della Quercia's wooden sculptures, including the St. Martin Dividing His Cloak, San Cassiano, which the author attributes to Quercia (as did Middeldorf). Chap. 3 reassesses the chronology of Donatello's wooden sculpture in light of the date 1438 recently discovered on the St. John the Baptist (Santa Maria Gloriosa dei Frari, Venice). Selective catalogue raisonné.

Articles

254 BACCI, PELEO. "Per la scultura senese di statue in legno." Balzana: Rassegna d'arte senese e del costume, n.s. 1 (1927):5-17, 8 figs.
Publishes a number of little-known Sienese wood sculptures and long series of documentary references to others, now lost, but once in the Duomo, Siena.

255 CARLI, ENZO. "Restauri alla mostra dell'antica scultura lignea senese." Bollettino d'arte, 4th ser. 35 (1950):77-84, 12 figs.

Restoration reports on a group of Sienese wooden sculptures, including Francesco di Giorgio's St. John the Baptist (San Giovanni Battista, Fogliano [now Pinacoteca, Siena]) and various pieces by Francesco di Valdambrino and Domenico di Niccolò de' Cori.

256 D'ACHIARDI, PIETRO. "Alcune opere di scultura in legno dei secoli XIV e XV." Arte 7 (1904):356-76, 20 figs.
 Discusses three anonymous fifteenth-century Sienese wooden sculptures: seated Virgin and Child (Sant'Agostino, Siena); and two Annunciation groups, one from San Francesco, Asciano, the other from the Collegiata, San Gimignano.

257 DAMI, LUIGI. "Legni policromi di Siena." Dedalo 3 (May 1923):760-76, 10 figs., 1 color pl.
 Analyzes fifteenth-century Sienese polychromed wood sculpture in terms of influence of Jacopo della Quercia and contemporary Sienese painting.

258 Del BRAVO, CARLO. "Schede sulla scultura senese del Quattrocento." Antichità viva 8, no. 1 (1969):15-21, 9 figs.
 Publishes four anonymous fifteenth-century Sienese wooden sculptures: Crucifix (Church of Sant'Egidio, Montalcino); St. Leonard (San Leonardo, Monticchiello); St. Sebastian (Chapel of San Sebastiano, Monticello Amiata); and terracotta standing Madonna and Child (Church of San Agostino, Santa Fiora).

259 FABRICZY, CORNELIUS von. "Kritisches Verzeichnis toskanisches Holz- und Tonstatuen bis zum Beginn des Quinquecento." Jahrbuch der königlich preussischen Kunstsammlungen 30 (1909):1-86, 17 figs.
 Comprehensive and still standard (though now dated) catalogue of wood and terracotta sculptures. Over 350 lesser works, mostly by minor artists, described; arranged by school (Pisan, Florentine, Sienese) and location; with complete index.

STUDIES OF TECHNIQUES AND MATERIALS

Books

260 MALTESE, CORRADO, ed. Le techniche artistiche. Milan: V. Mursia, 1973, 549 pp., 205 figs.
 Handbook of artistic techniques with detailed sections on technical problems of working in the various metals, stones, ivory, terracotta, ceramic, and stucco.

261 WITTKOWER, RUDOLF. Sculpture: Processes and Principles. New York: Harper & Row, 1977, 288 pp., 184 figs.
 Derived from Slade Lectures at Cambridge, England; published posthumously. Analysis of the working methods and techniques of sculptors from ancient Greece to modern times. Includes discus-

sion of theoretical treatises on sculpture. No footnotes. General
bibliography aimed at nonspecialist.

261b Schulz, Anne Markham. Review of Sculpture: Processes and
 Principles, by Rudolf Wittkower. Art Bulletin 60 (1978):
 359-60, no illus.

 Articles

262 AVERY, CHARLES. "'La cera sempre aspetta': Wax Sketch-Models
 for Sculpture." Apollo 119, no. 265 (March 1984):166-76, 20
 figs.
 Examines literary evidence for, and surviving examples of,
wax bozzetti in fifteenth and sixteenth centuries. Includes material
on Donatello, Luca della Robbia, Agostino di Duccio, Francesco di
Giorgio, and Antonio Pollaiuolo.

263 LAVIN, IRVING. "Bozzetti and Modelli: Notes on Sculptural
 Procedure from the Early Renaissance through Bernini." In
 Stil und Überlieferung in der Kunst des Abendlandes (Akten des
 21. internationalen Kongresses für Kunstgeschichte, Bonn,
 1964). Berlin: Gebr. Mann, 1967, 3:93-103, 23 figs.
 Evaluates various roles of sculptural models: Donatello
and Brunelleschi's lead-draped Hercules model for the Duomo, 1415;
Verrocchio's use of terracotta "sketches"; Agostino di Duccio's
pointing system for David, 1464.

264 MACLAGAN, ERIC. "The Use of Death-Masks by Florentine
 Sculptors." Burlington Magazine 43 (December 1923):303-4,
 2 figs.
 Describes characteristic features of sculptures modelled on
death masks: half-opened mouth, unrealistic eyes, and flattened
beard and moustache.

265 STONE, RICHARD. "Antico and the Development of Bronze Casting
 in Italy at the End of the Quattrocento." Metropolitan
 Museum Journal 16 (1981):87-116, 36 figs.
 First detailed analysis of fifteenth-century casting tech-
niques; includes radiographs showing interior construction of
bronzes. Focuses on Antico but discusses Pollaiuolo, Bertoldo, and
Adriano Fiorentino.

Specialized Commissions

ECCLESIASTICAL FURNISHINGS

*266 BARBIER de MONTAULT, XAVIER. Les tabernacles de la Renaissance
 à Rome. Arras, 1879.

267 CASPARY, HANS. Das Sakramentstabernakel in Italien bis zum
 Konzil von Trient: Gestalt, Ikonographie, und Symbolik,
 kultische Funktion. Munich: Verlag UNI-Druck, 1964, 207 pp.,
 14 figs. [Ph.D. dissertation, Ludwig-Maximilians-Universität,
 Munich.]
 Fundamental history of the three types of tabernacles used
 in Renaissance Italy: wall tabernacle, ciborium, and tabernacle
 altarpiece. Most prominent examples derive from fifteeth-century
 Florence, Siena, and Rome and were carved by major artists. Traces
 evolution of these types, their function, and iconography.

268 FREIBERG, JACK. The 'Tabernaculum Dei': Masaccio and the
 'Perspective' Tabernacle Altarpiece." Master's thesis, New
 York University, 1974, 128 pp., 148 figs.
 Analysis of the perspectivized tabernacle, its iconography,
 and its relationship to Masaccio's Trinity fresco, Santa Maria
 Novella, Florence. Includes valuable catalogue of all Italian
 Renassance sculpted tabernacles of "perspective" type.

269 HAFTMANN, WERNER. Das italienische Saülenmonument. Beiträge
 zur Kulturgeschichte des Mittelalters und der Renaissance hrsg.
 von W. Goetz, vol. 55. Leipzig and Berlin: B.G. Teubner,
 1939, 166 pp., no illus.
 History of commemorative monuments supported by columns
 from their origins as antique cult objects to Renaissance church
 furnishings. Examines specifically the religious and social sig-
 nificance of the Renaissance revival of this particular pagan archi-
 tectural form.

270 KURZ, OTTO. "A Group of Florentine Drawings for an Altar."
 Journal of the Warburg and Courtauld Institutes 18 (1955):
 35-53, 21 figs.

Analysis of evolution of fifteenth-century wall tabernacle. Discussion of fifteenth-century drawings that illustrate various solutions combining tabernacle and altarpiece forms.

271 MORSELLI, PIERO. "Corpus of Tuscan Pulpits, 1400-1550." Ph.D. dissertation, University of Pittsburgh, 1979, 519 pp., 143 figs. [Dissertation Abstracts 40/05-A (1979):2317.]
 Collects for the first time group of thirty-six pulpits (extant and lost), ten of which were previously unpublished. Arranged as a catalogue providing dating, attribution, reconstructions, location, patronage, and iconography, much of this information based on newly discovered documentary evidence.

FOUNTAINS

272 COLASANTI, ARDUINO. Le fontane d'Italia. Milan and Rome: Bestetti & Tumminelli, 1926, 56 pp., 306 figs.
 Brief essay precedes survey of fountains from all over Italy, including fountains illustrated in paintings and sculptures (Roman period to nineteenth century). Large, sharp black-and-white plates.

273 WILES, BERTHA HARRIS. The Fountains of Florentine Sculptors and Their Followers from Donatello to Bernini. Cambridge: Harvard University Press, 1933, 163 pp., 220 figs. Reprint. New York: Hacker Art Books, 1971.
 Scholarly study of late Renaissance and early Baroque fountains, generally used as garden sculptures for villas. Discusses types and gradual domination of figure over structure. First chapter provides valuable discussion of fountain sculptures in the Quattrocento.

FURNITURE AND DECORATIVE ARTS (SECULAR)

274 GRIGAUT, PAUL L., comp. Decorative Arts of the Italian Renaissance, 1400-1600. Detroit: Detroit Institute of Arts, 1958, 180 pp., 454 figs., 3 color pls.
 Minor works from American collections, arranged by medium. Includes some bronze statuettes, reliefs, and plaquettes. Description and bibliography for each object; most items illustrated.

275 LABARTE, JULES. Histoire des arts industriels au Moyen Âge et à l'époque de la Renaissance. 6 vols. Paris: A. Morel & Cie, 1864-66, illus.
 Encyclopedic history of the decorative arts in Europe: textiles, manuscript illumination, ceramics, metalwork, ivories, goldsmithery (good discussion of Baptistry Altar, Florence), enamels, mosaics, and sculpture (decorative use, wax, stucco, portraits). See especially, vol. 2, pp. 454-506, on goldsmithery; and vol. 4, pp. 431-41, on Luca della Robbia's technique. Two albums of plates.

276 SCHOTTMÜLLER, FRIDA. Wohnungskulptur und Möbel der italien-
 ischen Renaissance. Stuttgart: Julius Hoffman, 1921, 246 pp.,
 590 figs. English ed. Furniture and Interior Decoration of
 the Italian Renaissance. New York: Bretano's, 1921.
 Extensive photographic survey of Renaissance interior
 decoration, with introductory text that traces the uses of furnish-
 ings and their stylistic development. Also considers architectural
 decorations and sculpture. Illustrations accompanied by scholarly
 notes.

277 SCHUBRING, PAUL. Cassoni: Truhen und Truhenbilder der
 italienischen Frührenaissance. 2 vols. Leipzig: Karl W.
 Hiersemann, 1915, illus.
 Comprehensive study of the social history, style, and
 particular iconography of Renaissance marriage chests. Useful as
 well for its consideration of individual painters and sculptors whose
 shops specialized in these works (Pollaiuolo, Francesco di Giorgio,
 and others). Scholarly and well documented; includes valuable photo-
 graphs and catalogue raisonné.

MEDALS AND PLAQUETTES

Books

278 ARMAND, ALFRED. Les médailleurs italiens des quinzième et
 seizième siècles. Paris: E. Plon, 1879, 200 pp. 2d ed., rev.
 and enl. 2 vols. and supp. Paris: E. Plon, 1883-87. HILL,
 G.F. Not in Armand: A Supplement to "Les médailleurs italiens
 des quinzième et seizième siècles." 2 vols. Halle: A. Riech-
 mann & Co., 1920-21. Reprint of both publications together. 4
 vols. Bologna: Forni Editore, 1966.
 Amplified second edition describes and catalogues 2600
 Italian medals of the fifteenth and sixteenth centuries; unillus-
 trated. Pt. 1 lists known artists; pt. 2, anonymous medals. Valu-
 able index of artists and subjects (portraits and iconography).

279 FABRICZY, CORNELIUS von. Italian Medals. Translated by Mrs.
 Gustave Hamilton. New York: Dutton, 1904, 223 pp., 41 figs.
 (with many medals on each). [Originally published in German as
 Medaillen der italienischen Renaissance (Leipzig: H. Seemann,
 [1903]), 108 pp., 181 figs.]
 English translation of original German edition in a
 higher-quality printing. Excellent discussion of medals, including
 important essay on Florentine medals. Summarizes historical and
 social context, offers new attributions and new biographical infor-
 mation, and considers medals as works of art, not numismatic objects.

280 FRIEDLÄNDER, JULIUS. Die italienischen Schaumünzen des
 funfzehnten Jahrhunderts (1430-1530): Ein Beitrag zur
 Kunstgeschichte. . . . Berlin: Weidmann, 1882, 223 pp., 42
 figs. [Based on articles in Jahrbuch der königlich
 preussischen Kunstsammlungen 1-3 (1880-82).]

Describes and reproduces all known medals up to 1530 and discusses in detail artists, subjects, designs on reverse, and inscriptions. By a well-known curator and connoisseur.

281　HABICH, GEORG, ed. Die Medaillen der italienischen Renaissance. . . . Stuttgart and Berlin: Deutsche Verlags-Anstalt, [1923], 168 pp., 145 figs.
　　　Useful survey through sixteenth century and covering all regions, but especially useful for Florentine medallists. Thorough biographical information; indexes of subjects and artists.

282　HEISS, ALOISS. Les médailleurs de la Renaissance. 9 vols. Paris: J. Rothschild, 1881-92, 139 figs., 10 engrs.
　　　Important source for medallists. Contains short monographic treatments of artists that include biography and catalogue of works. Excellent plates. Vol. 1: Pisanello; vol. 2: Francesco Laurana, Pietro da Milano; vol. 3: Nicolò, Amadeo da Milano; vol. 4: Leon Battista Alberti, Matteo de' Pasti; vol. 5: Niccolò Spinelli, Antonio del Pollaiuolo; vol. 6: Sperandio of Mantua; vol. 7: Venetians; vol. 8: Florence (fifteenth through seventeenth centuries) pt. 1; vol. 9: Florence, pt. 2 (1532-1737).

282a　Ephrussi, Charles. Review of Les médailleurs de la Renaissance, by Aloïss Heiss. Gazette des beaux-arts, 2d per. 32 (1885):229-36, 3 figs.
　　　Good critique of Heiss's discussion of Niccolò Fiorentino, Antonio Pollaiuolo, and Bertoldo.

283　HILL, GEORGE FRANCIS. Corpus of Italian Medals of the Renaissance before Cellini. 2 vols. London: British Museum, 1930, 370 pp., 1024 figs. (vol. 2).
　　　The most significant publication on early Italian medals, arranged by region and by those medallists active in each area. Includes Gian Cristoforo Romano, Francesco di Giorgio, Filarete, and Bertoldo, as well as artists who functioned solely in this medium. Each entry with description and commentary. Full scholarly apparatus.

284　HILL, Sir GEORGE FRANCIS. Medals of the Renaissance. Oxford: Clarendon Press, 1920, 204 pp., 30 figs.
　　　First important and still valuable survey of subject. Publishes Hill's Rhind Lectues (Edinburgh, 1915), with separate essays on technique, on fifteenth-century medals in Northern Italy, Florence, and Rome.

285　KRIS, ERNST. Meister und Meisterwerke des Steinschneidekunst in der italienischen Renaissance. 2 vols. Vienna: Anton Schroll & Co., 1929, 202 pp. 658 figs.
　　　Includes excellent section (chap. 3, pp. 17-32) on collecting of ancient gems in the early Quattrocento and the artistic influence of gems on plaquettes, copies, and reliefs, especially in relation to Ghiberti and relief medallions in the Palazzo

Medici [-Riccardi] courtyard, Florence. Considers Donatello's bronze David (Bargello, Florence) free variant of courtyard medallion. Includes bibliography.

286 MOLINIER, EMILE. Les plaquettes. Catalogue raisonné. 2 vols. Paris: J. Rouam; London: Gilbert Wood & Co., 1886, 1:xl, 215 pp., 1 fig., 82 line engrs.
 Vol. 1 on fifteenth-century Central Italian plaquettes. Presents catalogue of most characteristic versions of all known plaquettes. Each work described, many illustrated; explanations of iconography and subjects; bibliographic information. Introduction contains brief history of plaquettes.

 Articles

287 FRIEDLÄNDER, J[ULIUS]. "Die Italienischen Schaumünzen des funfzehnten Jahrhunderts, 1430-1530, VI: Florenz." Jahrbuch der königlich preussischen Kunstsammlungen 2 (1881):225-54, 1 fig.
 Scholarly discussion and catalogue of seventy-seven Florentine medals, including works by Niccolò Fiorentino, Andreas Guazzolotti, and Benedetto da Maiano.

288 HILL, G.F. "The Roman Medallists of the Renaissance to the Time of Leo X." Papers of the British School at Rome 9 (1920):16-66, 15 figs.
 Thorough study of Roman medals, especially of the popes, from mid-fifteenth to sixteenth century.

289 POPE-HENNESSY, JOHN W. "The Italian Plaquette." Proceedings of the British Academy 50 (1964):63-85, 35 figs.
 History of the plaquette from its sources in Donatello. Focuses primarily on the works of Moderno, Riccio, and other sixteenth-century sculptors. Reprinted in entry 62.

PORTRAITS

 Books

290 KENNEDY, CLARENCE. Certain Portrait Sculptures of the Quattrocento. Studies in the History and Criticism of Sculpture, vol. 3. Northampton, Mass.: Smith College, 1928, no text, 66 figs. (Only 16 copies printed).
 Actual photographs of many views of each sculpture, including portrait busts and busts of young St. John the Baptist attributed to Desiderio, Donatello, and Benedetto da Maiano from the Bargello, Florence; Louvre, Paris; and Kaiser Friedrich Museum, Berlin. Invaluable for stylistic comparison of fifteenth-century Florentine busts.

291 LICHTENBERG, REINHOLD FREIHERR von. Das Porträt an Grabdenkmalen: Seine Entstehung und Entwickelung von Alterthum bis zur italienischen Renaissance. Zur Kunstgeschichte des Auslandes, vol. 11. Strasbourg: J.H. Ed. Heitz, 1902, 151 pp., 44 figs.

Traces use of full-length and bust portraiture in funerary monuments from Etruscan period through Renaissance. Includes many fifteenth-century examples.

292 POHL, JOSEPH. Die Verwendung des Naturabgusses in der italienischen Porträplastik der Renaissance. Würzburg: Konrad Triltsch, 1938, 68 pp., no illus. [Inaugural-Dissertation, Rheinischen Friedrich-Wilhelms-Universität, Bonn.]
 On use of death masks as models for portraiture in Quattrocento Italy. Discusses techniques and cites numerous examples, including the so-called Niccolò da Uzzano bust (Bargello, Florence), which is regarded as a work by Donatello after a death mask.

293 POPE-HENNESSY, JOHN. The Portrait in the Renaissance. The A.W. Mellon Lectures in the Fine Arts, National Gallery of Art, Washington, D.C. Bollingen Series, XXXV, 12. New York: Bollingen Foundation, 1966, 370 pp., 330 figs.
 Analyzes fifteenth- and sixteenth-century Italian portraiture, primarily painted examples. Traces philosophical thinking that influenced revival of portraiture and types of portraits, e.g., court portraits, emblematic portraits, donor portraits, and likenesses of contemporary individuals in secular and religious scenes. Includes many portrait busts.

294 SCHUYLER, JANE. Florentine Busts: Sculpted Portraiture in the Fifteenth Century. Outstanding Dissertations in the Fine Arts. New York and London: Garland, 1976, 315 pp., 117 figs. [Ph.D. dissertation, Columbia University, 1972.]
 "[First] systematic investigation devoted primarily to the origin and purpose of the sculptured portrait bust in fifteenth-century Florence" (author). Provides limited overview of issues such as use of classical sources and life/death masks, but its actual focus is more narrow. Argues that Donatello invented portrait bust with bronze Bust of Byzantine Emperor John Paleologus VIII, dated 1439 (Vatican Museums, Rome), which author attributes for the first time to Donatello, and bust of Niccolò da Uzzano (Bargello, Florence). [See Pope-Hennessy's negative comments in his preface to entry 62].

 Articles

295 BODE, WILHELM von. "Die Ausbildung des Sockels bei den Büsten der italienischen Renaissance." Amtliche Berichte aus den preuzischen Staatssammlungen 40, no. 5 (February 1919):99-120, 18 figs.
 Outlines with numerous examples the origin and development of the use of socles as bases for Renaissance busts, 1430-1530.

296 BODE, WILHELM von. "Italian Portrait Paintings and Busts of the Quattrocento." Art in America 12, no. 1 (December 1923): 2-13, 6 figs.
 General survey of social conditions contributing to development of portraiture in painting and sculpture in Florence and Venice.

297 FEHL, PHILIPP P. "On the Representation of Character in
 Renaissance Sculpture." Journal of Aesthetics and Art
 Criticism 31, no. 3 (Spring 1973):291-307, 17 figs.
 Character in Renaissance sculpture is revealed more through
action than through physiognomy (an idea traceable to Aristotle's
Politics). Discusses Brunelleschi's and Ghiberti's Sacrifice of
Isaac reliefs (Bargello, Florence) and various Donatello sculptures.

298 JANTZEN, JOHANNES. "Kleinplastische Bronzeporträts des 15. bis
 16. Jahrhunderts und ihre Formen." Zeitschrift des deutschen
 Vereins für Kunstwissenschaft 17 (1963):105-16, 23 figs.
 General discussion of style and nature of bronze portrai-
ture in fifteenth and sixteenth centuries (primarily the latter).
Establishes typological categories: statuettes, small busts,
reliefs, bas-reliefs, plaques, and medals, with brief examples of
each.

299 LAVIN, IRVING. "On the Sources and Meaning of the Renaissance
 Portrait Bust." Art Quarterly 33 (1970):207-26, 16 figs.
 Analyzes form of fifteenth-century Renaissance portrait
bust, which is horizontally truncated at chest and lacks base,
correlating it to contemporary theories about the "whole man."
Traces elements of format that are revived from Roman busts and those
that are continuations of medieval reliquary types. Demonstrates how
fifteenth-century type is transformed in sixteenth century into
direct imitation of Roman Imperial bust format.

 TOMBS

 Books

300 BETTONI, NICOLO. Le tombe ed i monumenti illustri d'Italia.
 2 vols. Milan: Serafino Majocchi, 1822-23, 472 pp.
 Anthology of major monuments, including line engraving of
each, transcription of its inscription, and brief description. Of
historical interest.

301 BURGER, FRITZ. Geschichte des Florentinischen Grabmals von den
 ältesten Zeiten bis Michelangelo. Strasbourg: Heitz, 1904,
 423 pp., 278 figs.
 Thorough history of tomb monuments in Florence and by
Florentines in Rome, with special consideration given to the various
forms and their derivation, architectural typologies, incorporation
of portraits, and preparatory drawings. Includes useful appendices.
Fifteenth-century tombs, pp. 80-269.

302 DAVIES, GERALD S. Renascence: The Sculptured Tombs of the
 Fifteenth Century in Rome, with Chapters on the Previous
 Centuries from 1100. London: John Murray, 1910, 381 pp., 88
 figs.
 Valuable compilation of material, including chronological

list of most important tombs, list of tombs arranged by church, and brief biographies of the entombed celebrities.

303 GONNELLI, GIUSEPPE, ed. Monumenti sepolcrali della Toscana disegnati da Vincenzo Gozzini, incisi da Giovan Paolo Lasinio. Florence: Presso l'Editore [Giuseppe Gonnelli], 1819, 106 pp., 48 figs. Expanded French ed. Florence: J. Marenigh, 1821, 151 pp., 73 figs.
 Catalogue of thirteenth- to seventeenth-century Tuscan tombs, arranged by location. Line engravings and descriptions of each are included.

304 LONGHURST, MARGARET H. "Notes on Italian Monuments of the 12th to 16th Century." 2 vols. Photostat. London: Privately Printed, 1962.
 Extensive preliminary notes for a corpus of Italian monuments, left unfinished at Longhurst's death. Focuses primarily on Quattrocento sculptural monuments. For each monument provides attribution, dating, and full bibliography. Reproductions of each monument in vol. 2.

305 MAGGINI, ENRICHETTA. Le tombe umanistiche fiorentine. Florence: Editrice Fiorentina, 1972, 63 pp., 15 figs.
 Handy, brief anthology of nine fifteenth-century Florentine humanist tombs. Includes description and photographs of each monument, as well as inscription. Aimed at general audience. No bibliography. Small-scale photographs.

306 PANOFSKY, ERWIN. Tomb Sculpture: Its Changing Aspects from Ancient Egypt to Bernini. Edited by H.W. Janson. New York: Harry N. Abrams, 1964, 319 pp., 446 figs.
 Survey of typology and iconography of tomb sculpture from ancient Egypt through Baroque period, derived from lectures. Analyzes Renaissance revival of Greco-Roman symbolism, including reintroduction of biographical allusions and other features such as Virtues, activation of effigy, and "arts bereft." The most incisive analysis of fifteenth-century tomb sculpture, set within provocative context of its antecedents and adaptations.

307 RICCI, CORRADO. Monumenti sepolcrali di lettori dello studio bolognese nei secoli XIII, XIV, e XV. Bologna: Poppi, 1888, 26 pp., 31 mounted photographs.
 Survey of Bolognese professors' and men of letters' tombs with their distinctive iconography of professors teaching. Some attributed to Tuscans working in fifteenth-century Bologna like Andrea da Fiesole or students of Quercia. Brief text with description and inscriptions of each tomb. Corpus of thirty-one loose, mounted photographs.

308 SCHUBRING, PAUL. Das italienischen Grabmal der Frührenaissance. Berlin: Otto Baumgärtel, 1904, 35 pp., 90 figs.
 Brief but comprehensive study of Italian Renaissance tomb

monuments, focusing on the Quattrocento. Analyzes the various types, the use of portrait busts and reliefs, and their architecture.

309 SCHUTZ-RAUTENBERG, GESA. Künstlergrabmäler des 15. und 16. Jahrhunderts in Italien: Ein Beitrag zur Sozialgeschichte der Künstler. Dissertation zur Kunstgeschichte, vol. 6. Cologne and Vienna: Böhlau Verlag, 1978, 395 pp., 67 figs.
 Corpus of sepulchral monuments commemorating fifteenth- and sixteenth-century artists, beginning with that of Brunelleschi (Duomo, Florence). Analyzes their typology and iconography. With documents and extensive bibliography.

310 S'JACOB, HENRIETTE. Idealism and Realism: A Study of Sepulchral Symbolism. Leiden: E.J. Brill, 1954, 305 pp., 79 figs.
 Iconographic study of Christian sepulchral monuments in terms of their relationship to pagan past, funeral customs and beliefs about death and afterlife, and pagan motifs. Includes some fifteenth-century tombs, but more valuable for intellectual and religious context of monuments. Extensive bibliography.

311 STEGMANN, CARL von; and GEYMULLER, HEINRICH von. Die Architektur der Renaissance in Toscana. 11 vols. Munich: F. Bruckmann A.-G., 1885-1908, 370 figs., illus. and plans. HALLMAN, RICHARD. Registerband. Munich: F. Bruckmann, 1909.
 Standard reference. Large folio volumes with scholarly text and extensive corpus of photographs, plans, measured drawings of architecture, building types, decoration, and details. Includes tombs. Organized as series of monographs. Vol. 1: Brunelleschi; vol. 2: Michelozzo, Donatello, Verrocchio, Quercia, Della Robbia, Buggiano; vol. 3: Alberti, Bernardo and Antonio Rossellino; vol. 4: Desiderio da Settignano, Giuliano da Maiano, Benedetto da Maiano, Mino da Fiesole; vol. 5: Giuliano da San Gallo; vol. 6: Francesco di Giorgio, Matteo Civitali, Pagno di Lapo Portigiani and others. Subsequent volumes primarily for Cinquecento artists.

 Articles

312 GRANDI, RENZO. "Le tombe dei dottori bolognesi: Ideologia e cultura." Deputazione di storia patria per le provincie di Romagna: Atti e memorie, n.s. 29-30 (1978-79):163-81, no illus.
 Survey of tombs of Bolognese professors and men of letters from 1265 through fifteenth century, including examples by Andrea da Fiesole and Quercia. Tombs show consistent iconographical program of teaching professors. Focuses on historical background of earliest examples rather than monuments themselves.

313 KUHLENTHAL, MICHAEL. "Le origini dell'arte sepocrale del Rinascimento a Roma." Sodalizio tra studiosi dell'arte: Colloqui 5 (1975-76):107-23, 3 figs., diags.
 Reconstructs Filarete's Tomb of Cardinal Martinez de Chiavez (San Giovanni in Laterano, Rome) on the basis of documents.

Considers sources for this and other fifteenth-century funerary monuments in Rome. Proposes this tomb as prototype for fifteenth-century Roman tombs.

Special Topics

314 BURKE, PETER. Culture and Society in Renaissance Italy, 1420-1540. London: B.T. Batsford, 1972, 342 pp., 19 figs.
Valuable discussion of social context of art. Includes chapters on status of arts and artists, artists' relationship with patrons, functions of works of art, and taste and major viewpoints widely held in Italian Renaissance.

315 CHASTEL, ANDRÉ. Marsile Ficin et l'art. Travaux d'humanisme et de Renaissance 14. Geneva: E. Droz; Lille: R. Giard, 1954, 204 pp., 3 figs.
Discusses Neoplatonic philosophy, especially theories of Ficino, in relation to late fifteenth-century Florentine art. Important for understanding intellectual milieu. Appendices with translations into French of two important early sources: Cristoforo Landino's Commentario alla Comedia di Dante Alighieri (1481), which mentions Brunelleschi, Donatello, Ghiberti, Desiderio, and the Rossellino brothers briefly; and Ugolino Verino's De Illustratione Urbis Florentiae (ca. 1500), which mentions Antonio Pollaiuolo, Donatello, and Desiderio as sculptors.

316 DOREN, ALFRED J. Studien aus der Florentiner Wirtschaft-geschichte. Vol 1, Die Florentiner Wollentuchindustries. Vol. 2, Das Florentiner Zunftwesen. Stuttgart and Berlin: J.G. Costa, 1901-8, 1385 pp., no illus. Italian ed. Le arti fiorentine. Translated by G.B. Klein. 2 vols. Florence: Felice Le Monnier, 1940.
Analyzes role of guilds in communal patronage within large study of their function in Florentine economy. Especially valuable for sculptures commissioned for Orsanmichele.

317 GOMBRICH, E[RNST] H. "The Renaissance Concept of Artistic Progress and Its Consequences." In Actes du XVIIe congrès international d'histoire de l'art (Amsterdam, 1952). The Hague: Imprimerie Nationale, 1955, pp. 291-307, 3 figs.
Discusses Quattrocento definition of role of artist: to

71

glorify patron and times and to advance study of art. Thus Ghiberti
saw himself as a second Lysippus, based on his paraphrase of Pliny.
New document records Ghiberti collecting ancient codices, ca. 1430.

318 HARTT, FREDERICK. "Art and Freedom in Quattrocento Florence."
 In Essays in Memory of Karl Lehmann. Marsyas: Studies in the
 History of Art, supplement 1. Edited by Lucy F. Sandler. New
 York: Institute of Fine Arts, New York University, 1964, pp.
 114-31, 12 figs.
 Important essay that suggests that sociological and his-
 torical factors, specifically deliverance from foreign military
 threats, motivated creation of Early Renaissance style in Florentine
 sculptures commissioned for civic monuments like the Duomo, Orsan-
 michele, and the Baptistry (1399-1427).

319 LARNER, JOHN. Culture and Society in Italy, 1290-1420. New
 York: Charles Scribner's Sons, 1972, 399 pp., 24 figs.
 History of "interaction of literature, art, and their
 social environment within Italy," 1290-1420 (author's introduction).
 Interesting analyses of artists' education, their position in
 society, and their relationship with patrons. Appendix of notes on
 contracts includes sculpture for Florence Duomo; Silver Altar of San
 Jacopo, Duomo, Pistoia, and Ghiberti's work for Calimala guild.

320 LEVEY, MICHAEL. Early Renaissance. Harmondsworth, Eng.:
 Penguin Books, 1967, 224 pp., 111 figs.
 Insightful and provocative analysis of fifteenth-century
 intellectual concerns such as humanism and the ancient past as they
 appear in art and literature. Many references to sculpture.

321 WACKERNAGEL, MARTIN. The World of the Florentine Renaissance
 Artist: Projects and Patrons, Workshop and Art Market.
 Translated by Alison Luchs. Princeton: Princeton University
 Press, 1981, 447 pp., no illus., paperback. [Original ed. Der
 Lebensraum des Künstlers in der Florentinischen Renaissance:
 Aufgaben und Auftraggeber, Werkstatt und Kunstmarkt. Leipzig:
 Verlag E.A. Seemann, 1938.]
 Pioneering study of Florentine art from the viewpoint of
 economic, social, and cultural conditions influencing artists.
 Focuses on types of commissions, categories of patronage, artists'
 status, and their shops and working procedures, as well as business
 practices. Translator has added introduction on Wackernagel's meth-
 odology, updated all factual information, and included a lengthy,
 annotated bibliography on themes discussed by Wackernagel that have
 appeared in publications since 1938.

321a Starn, Randolph. Review of The World of the Florentine
 Renaissance Artist: Projects and Patrons, Workshop and Art
 Market, by Martin Wackernagel. Art Bulletin 65, no. 2 (June
 1983):329-35, no illus.

PATRONAGE

322 CHAMBERS, D..S., ed. <u>Patrons and Artists in the Italian</u>
<u>Renaissance</u>. London: Macmillan & Co., 1970, 220 pp., 5 figs.
 Translation and annotation of contracts and letters between
artists and patrons, arranged according to the type of patronage.
Many examples involve fifteenth-century sculpture, e.g., Jacopo della
Quercia at San Petronio, Bologna; Ghiberti at Orsanmichele and the
Baptistry, Florence; and Donatello and Michelozzo sculpting the
pulpit for the Duomo, Prato.

323 PASTOR, LUDWIG von. <u>The History of the Popes from the Close of</u>
<u>the Middle Ages: Drawn from the Secret Archives of the Vatican</u>
<u>and Other Original Sources</u>. Edited by Frederick I. Antrobus.
6th ed. Reprint. Nendeln, Lichtenstein: Kraus, 1969.
 First published in German between 1886-1933 in 16 vols. by
Herder, Freiburg im Breisgau. Vols. 1-6 cover fifteenth-century
papal history. Authoritative year-by-year account of history of each
pope's reign, including thorough account of his patronage. Full
scholarly apparatus.

INFLUENCE OF ANTIQUITY

Books

324 KURTH, WILLY. <u>Die Darstellung des nackten Menschen in dem</u>
<u>Quattrocento von Florenz</u>. Berlin: H. Blanke, 1912, 120 pp.,
no illus. [Dissertation, Friedrich-Wilhelms-Universität,
Berlin, 1912]
 Considers representation of nude in Quattrocento sculpture
and, to a lesser extent, painting. Discusses theory, influence of
the antique, proportions, variation between relief and freestanding
figures, and verisimilitude versus stylization. Good analysis of
Donatello's bronze <u>David</u> (Bargello, Florence).

325 LADENDORF, HEINZ. <u>Antikenstudium und Antikenkopie: Vorar-</u>
<u>beiten zu einer Darstellung ihrer Bedeutung in der mittelalter-</u>
<u>lichen und neueren Zeit</u>. Abhandlung der Sächsischen Akademie
der Wissenschaften zu Leipzig, Philologisch-historische Klasse,
vol. 46, pt. 2. Berlin: Akademie-Verlag, 1953, 190 pp. 50
figs.
 History of copies after Greek and Roman works of art made
from medieval period to this century. Includes much material valu-
able for understanding revival of ancient art in fifteenth century.
Extensive bibliography.

326 LANCIANI, RODOLFO. <u>Storia degli scavi di Roma e notizie</u>
<u>intorno le collezioni romane di antichità</u>. Vol. 1, (A.
<u>1000-1530)</u> Rome: Ermanno Loescher & Co., 1902, 264 pp., no
illus.

Thorough catalogue of notations from contemporary sources concerning excavations and study of ancient art from the eleventh century to 1530, arranged chronologically. With full scholarly apparatus, including bibliography for each notation.

327 MÜNTZ, EUGENE. Les antiquités de la ville de Rome aux XIVe, XVe, et XVIe siècles: Topographie--monuments--collections d'après des documents nouveaux. Paris: Ernest Leroux, 1886, 176 pp., 4 line engrs.
Analysis of ancient monuments and sculptures available in Rome during the Renaissance.

328 PANOFSKY, ERWIN. Renaissance and Renascences. Stockholm: Alquist & Wiksells, 1960. Reprint. New York: Harper & Row, 1969, 242 pp., 157 figs., paperback.
Publication of lectures concerning definition of the Renaissance and characteristics that distinguish it from earlier medieval revivals of Greco-Roman civilization. Lecture four deals with differences between fifteenth-century Italian and Northern Renaissance painting and sculpture, specifically in regard to attitudes toward antiquity and nature. Discusses earlier appearance of classicism in fifteenth-century Florentine sculpture as compared to painting.

329 SEZNEC, JEAN. The Survival of the Pagan Gods: The Mythological Tradition and Its Place in Renaissance Humanism and Art. New York: Harper & Row Torchbook, 1961, 376 pp., 108 figs., paperback. [First published as La survivance des dieux antiques, Studies of the Warburg Institute, vol. 11 (London: Warburg Institute, 1940).]
History of various schools of thought through which knowledge of pagan gods was transmitted into Renaissance, and the ways in which they characterized gods. Important analysis of meaning and sources of imagery of reliefs attributed to Agostino di Duccio in Tempio Malatestiano, Rimini, which are called first frankly profane representations of pagan gods.

330 WEBER, SIEGFRIED. Die Entwickelung des Putto in der Plastik der Frührenaissance. Heidelberg: C. Winter, 1898, 131 pp., 8 figs. [Ph.D. dissertation, Ruprecht-Karls-Universität, Heidelberg, 1898.]
Discussion of classical putto in relationship to Early Renaissance type, especially in Donatello's sculpture.

Unpublished Theses

331 RAGUSA, ISA. "The Re-use and Public Exhibition of Roman Sarcophagi during the Middle Ages and the Early Renaissance." Master's thesis, New York University, 1951, 235 pp., 51 figs.
Studies reuse of Roman sarcophagi for utilitarian functions and, less commonly, as they were recut to be incorporated into

medieval and Renaissance funerary monuments. Catalogue of reused
Roman sarcophagi valuable as indication of what monuments were known
in fifteenth century.

Articles

332 BERTAUX, EMILE. "Le sécret de Scipion: Essai sur les effigies
de profil dans la sculpture italienne de la Renaissance."
Archives de l'art français, n.s. 7 (1913):71-92, 4 figs.
 Regards marble relief of Scipio (Louvre, Paris), generally
attributed to Verrocchio school, as nineteenth-century copy after
ruined original, ca. 1500 (now lost; known through photograph).
Discusses popularity and use of busts of ancient heroes in the
Renaissance; Bust of a Hero (Musée Jacquemart-André, Paris) attrib-
uted to Desiderio.

333 CHASTEL, ANDRE. "'L'Etruscan Revival' du XVe siècle." Revue
archéologique, 3d ser. 1 (January-June 1959):165-80, no illus.
 Outlines interest in Etruscan art as seen in fifteenth-
century Italian literature and art, specifically in the work of
Antonio Pollaiuolo and Bertoldo.

334 De la COSTE-MESSELIERE, M.-G. "Les Médaillons historiques de
Gaillon au Musée du Louvre and à l'Ecole des beaux-arts."
Revue des Arts: Musées de France 7, no. 2 (1957):65-70, 7
figs.
 Marble relief in the style of Verrocchio, now identified as
Scipio (Louvre, Paris), from the French Renaissance Villa Gaillon
(built ca. 1508-10) was used by its original owner to represent
Hannibal in hero cycle. Discusses popularity of relief cycles of
ancient heroes, especially those that were products of Verrocchio's
studio, ca. 1480.

335 DOBRICK, J. ALBERT. "Botticelli's Sources: A Florentine
Quattrocento Tradition and Ancient Sculpture." Apollo, n.s.
110, no. 210 (August 1979):114-27, 20 figs.
 Traces fifteenth-century reuse of motif of antique maenad
with energetic pose and billowing draperies in works of Botticelli,
Donatello, and Ghiberti. Possibly derives from Alberti's suggestions
in De Pictura (ca. 1435). Notes on Ghiberti's antique sources.

336 FITTSCHEN, KLAUS. "Der Herakles-Sarcophag in S. Maria sopra
Minerva in Rom, eine Arbeit der Renaissance?" Bullettino
della Commissione archeologica comunale 82 (1970-71):63-69, 6
figs.
 Wall Tomb of Giovanni Arberini (Santa Maria sopra Minerva,
Rome), dated 1476, is called unique among Renaissance tombs because
of its sarcophagus decorated with Hercules and Nemean Lion, here
identified as a Roman Imperial piece incorporated into this
fifteenth-century tomb.

337 GIGLIOLI, G.Q. "Il rilievo Camuccini del ciclo leggendario di
 Enea nel Lazio." Bullettino della Commissione archeologica del
 governatorato di Roma e Bullettino del Museo dell'impero romano
 67 (1939):109-16, 5 figs.
 Fifteenth-century sculptor, perhaps Paolo or Gian Cristo-
foro Romano, copied a Roman relief of the Sacrifice of Aeneas,
providing early record of its intact appearance. The fifteenth-
century relief copy is in the Uffizi, Florence; the Roman relief, the
co-called "Camuccini fragment," is in the Palazzo Camuccini, Catalupo
in Sabina.

338 GUILLAUME-COIRIER, GERMAINE. "Archéologie et imagination: Les
 représentations du tombeau de Biblulus de Pollaiuolo à
 Piranèse." Gazette des beaux-arts, 6th per., 81 (April 1973):
 215-26, 16 figs. [Summary in English.]
 Various copies (after Pollaiuolo, by Peruzzi, Bramantino,
Sansovino, Santi Bartoli, and Piranesi) of Tomb of Bibulus façade
(Rome) relect changing interpretations of antique from fifteenth to
seventeenth century.

339 JANSON, H.W. "The Revival of Antiquity in Early Renaissance
 Sculpture." Medieval and Renaissance Studies 5 (1969):80-102,
 42 figs.
 Lecture on various fifteenth-century revivals of Greco-
Roman art, focusing on freestanding nude, portrait bust, and eques-
trian monument. Also analyzes the categories of monuments to which
Renaissance artists turned, like sarcophagi and triumphal arches.
Focuses on Donatello but includes Antonio Rossellino.

340 MIDDELDORF, ULRICH. "Su alcuni bronzetti all'antica del
 Quattrocento." In Il mondo antico nel Rinascimento (Atti del V
 convegno internazionale di studi sul Rinascimento, Florence,
 2-6 September 1956). Florence: G.C. Sansoni, 1958, pp.
 167-77, 12 figs.
 Points out use of motifs from Roman art in Renaissance
sculpture and painting, specifically in Ghiberti's East Doors, Bap-
tistry, Florence, and in Pollaiuolo's drawings. Reprinted in entry
54.

341 MINTO, ANTONIO. "Il sarcofago romano del Duomo di Cortona."
 Rivista d'arte 26, 3d ser. 1 (1950):1-22, 7 figs.
 Publishes second-century Roman Dionysiac sarcophagus (Museo
diocesano, Cortona) that Vasari specifically records as having great-
ly inspired Donatello and Brunelleschi.

342 SCHOTTMULLER, FRIDA. "Zwei Grabmäler der Renaissance und ihre
 antiken Vorbilder." Repertorium für Kunstwissenschaft 25
 (1902):401-8, 3 figs.
 Argues that Alcestis scenes on Roman sarcophagi are source
for Verrocchio's Death of Francesca Tornabuoni relief (Bargello,
Florence) and that Meleager sarcophagi lie behind Giuliano da San
Gallo's relief on the Tomb of Francesco Sassetti (Santa Trinità,
Florence).

343 SPENCER, JOHN R. "Volterra, 1466." Art Bulletin 48, no. 1
 (March 1966):95-96, no illus.
 Publishes letter of 1466 describing discovery of Etruscan
 tombs at Volterra. Description makes clear that other Etruscan
 sculptures and vases were already known, indicating that artists were
 familiar with actual Etruscan works by the mid-fifteenth century.

344 Van ESSEN, C.C. "Elementi etruschi nel rinascimento toscano."
 Studi etruschi 13 (1939):497-99, 12 figs.
 Notes correspondence in type and motif between Etruscan art
 and sculptures such as Bertoldo's Bellerophon (Kunsthistorisches
 Museum, Vienna); Ghiberti's Sacrifice of Isaac (Bargello, Florence);
 and the Lavabo (Sacristy, Duomo, Florence).

345 VERMEULE, CORNELIUS C., III. "A Greek Theme and Its Survivals:
 The Ruler's Shield (Tondo Image) in Tomb and Temple."
 Proceedings of the American Philosophical Society 109, no. 6
 (10 December 1965):361-97, 54 figs.
 Development of the tondo portrait from classical motif
 (shield of Achilles) first to Roman rulers' portraits, then to use by
 Ghiberti and private patrons in the Renaissance.

RELATIONSHIP BETWEEN PAINTING AND SCULPTURE

Books

346 COURAJOD, LOUIS. Leçons. Edited by Henry Lemonnier and André
 Michel. 3 vols. Paris: Alphonse Picard & Fils, 1899-1903.
 Publishes Courajod's lectures, which, though dated, contain
 many valuable observations. See especially vol. 2: Origines de la
 Renaissance, pp. 239-87, which discusses influence of painting on
 sculpture ca. 1400, using the Silver Altar of Pistoia, in particular,
 as a point of departure. Later (p. 592) claims early date for Dona-
 tello's and Michelozzo's Tomb of Pope John XXIII (Coscia), Baptistry,
 Florence (before 1423), based on its relationship to the Tomb of
 Tommaso Mocenigo, SS. Giovanni e Paolo, Venice (dated 1423). In-
 cludes bibliography.

Articles

347 FUSCO, LAURIE. "Use of Sculptural Models by Painters in
 Fifteenth-Century Italy." Art Bulletin 64, no. 2 (June 1982):
 175-94, 51 figs.
 Discusses "pivotal presentation," or turning of figure, an
 early way in which painters used sculptural models to plan figures in
 their compositions. Analyzes texts and works of art to trace this
 practice, which seems to have begun with Pollaiuolo.

348 GENGARO, MARIA LUISA. "Rapporti tra scultura e pittura nella
 seconda metà del Quattrocento: Benedetto da Maiano." Bollet-
 tino d'arte, 3d ser. 30 (April 1937):460-66, 6 figs.

Argues influence of Leonardo on Benedetto da Maiano and influence of Benedetto on young Michelangelo.

349 HUYGHE, RENÉ. "La peinture et la sculpture de la Renaissance: Échanges et rapports." Amour de l'art 12, no. 11 (November 1931):446-55, 22 figs. [Summary in English.]
General discussion of interaction of fifteenth-century painting and sculpture, especially low-relief carvings. Suggests many innovations, such as lifesize equestrian figures, occurred first in painting and only later in sculpture.

350 POPE-HENNESSY, JOHN. "The Interaction of Painting and Sculpture in Florence in the Fifteenth Century." Journal of the Royal Society of Arts 117, no. 5154 (May 1969):406-24, 13 figs.
Lecture emphasizes similarities in composition, construction, and perspective in Quattrocento painting and relief sculpture. Focuses primarily on Donatello. Evaluates Donatello's and Ghiberti's work in stained glass, painters' use of sculpted models, and drawings after antique and contemporary sculpture.

DRAWINGS

351 AMES-LEWIS, FRANCIS. Drawing in Early Renaissance Italy. New Haven and London: Yale University Press, 1981, 196 pp. 182 figs.
Pioneer study of types and uses of drawings in the fifteenth century that avoids the usual connoisseurship approach. Valuable for technical information. See especially section on "Sculptural Drawing," pp. 104-9.

352 DEGENHART, BERNHARD, and SCHMITT, ANNEGRIT. Corpus der italienischer Handzeichnungen, 1300-1450. 6 vols. Berlin: Gebr. Mann, 1968-80.
Remarkably thorough and scholarly catalogue of all known drawings. Each work illustrated, often with related drawings, sources and/or copies. Full exhibition history, provenance, references, bibliography, and appendices. Important source for motives and iconography. For Donatello and his circle, see vol. 1, pt. 2, pp. 342-71, 81 figs.; for Ghiberti, vol. 1, pt. 2, pp. 289-96, 14 figs.; for Quercia, vols. 1, pt. 1, pp. 203-12, 16 figs.

THREE-DIMENSIONAL SPACE

Books

353 GIOSEFFI, DECIO. Perspectiva artificialis: Per la storia della prospettiva, spigolature, e appunti. Trieste: Università, Istituto di Storia dell'Arte Antica e Moderna, 1957, 145 pp., 57 figs.

Analyzes history of theoretical development of linear
perspective, using examples of fifteenth-century Italian paintings
and sculpture. Arguments based on empirical observations and optical
treatises.

354 WHITE, JOHN. The Birth and Rebirth of Pictorial Space. 2d ed.
 Boston: Boston Book and Art Shop, 1967, 289 pp., 143 figs., 9
 diags. [First ed. 1957.]
 Pioneering and fundamental study of rediscovery of pic-
torial space in fourteenth- and fifteenth-century Italy. Focuses on
painting but includes analyses of treatment of space in Donatello's
and Ghiberti's reliefs.

355 ZUCKER, PAUL. Raumdarstellung and Bildarchitektur im Floren-
 tinischen Quattrocento. Leipzig: Klinkhardt & Biermann, 1913,
 170 pp., 41 figs.
 Evaluates representation of architecture in Renaissance
painting and sculpture, especially as device for development of
perspective and spatial construction. Considers wide range of
artists, mostly painters, with a good chapter on Donatello. Includes
bibliography.

 Unpublished Theses

356 BURNSIDE-LUKAN, MADELEINE. "Alberti to Galileo--the Renais-
 sance perception of Space." Ph.D. dissertation, University of
 California, Santa Cruz, 1976, 198 pp., no illus. [Dissertation
 Abstracts International 38, no. 3 (1977-78:1566A.]
 Analyzes changes in perception of three-dimensional space
in works of art between 1400 and 1650. Discusses contributions of
Brunelleschi and Alberti.

 Articles

357 ARGAN, GIULIO CARLO. "The Architecture of Brunelleschi and the
 Origins of Perspective Theory in the Fifteenth Century."
 Journal of the Warburg and Courtauld Institutes 9 (1946):
 96-121, 15 figs.
 Discusses fifteenth-century interest in scientific per-
spective and antiquity as result of need to find new, logical form to
contain humanist principle of moral order. Analyzes perspective
space in Donatello's Feast of Herod.

358 CLARK, KENNETH. "Architectural Backgrounds in XVth Century
 Italian Painting, I." Arts, no. 1 [(1947-48)]:12-24, 14 figs.
 Traces early Quattrocento painters' and sculptors' use of
architectural settings to structure their compositions and perspec-
tive. Notes that sculptors preceded painters in developing linear
perspective.

359 DORNER-HANNOVER, ALEXANDER. "Die Entwicklung der Raumvor-
 stellung in den Reliefs des Trecento und Quattrocento." In

Italienische Studien: Paul Schubring zum 60. Geburtstag
gewidmet. Leipzig: Karl W. Hiersemann, 1929, pp. 32-59, 6
figs.
 Analyzes use of perspective and other means to create
illusionistic three-dimensional space in fourteenth- and fifteenth-
century Tuscan reliefs.

360 WHITE, JOHN. "Developments in Renaissance Perspective--II."
 Journal of the Warburg and Courtauld Institutes 14, nos. 1-2
 (1951):42-69, 20 figs.
 General discussion of function of perspective--to achieve
harmony and clarity in re-creation of reality--using Donatello's
relief sculpture to illustrate aspects of development of perspective
system.

WORKSHOP PROCEDURES

361 THOMAS, ANABEL J. "Workshop Procedures of Fifteenth-Century
 Florentine Artists." Ph.D. dissertation, London University,
 1976, 318 pp., no illus.
 Analyzes production methods in fifteenth-century Florentine
painting and sculpture workshops, including those of Donatello,
Ghiberti, and Maso di Bartolommeo. Based on catasto records.

PALEOGRAPHY

362 MARDERSTEIG, GIOVANNI. "Leon Battista Alberti e la rinascità
 del carattere lapidario romano nel Quattrocento." Italia
 medioevale e umanistica 2 (1959):285-307, 15 figs.
 Assesses Alberti's role in revival and evolution of Roman
lapidary script (1450-1500).

363 MEISS, MILLARD. "Toward a More Comprehensive Renaissance
 Palaeography." Art Bulletin 42, no. 2 (June 1960):97-112, 36
 figs., appendix.
 Relates shift from Gothic script to Roman majuscule in
inscriptions on early fifteenth-century Florentine sculptures
(Ghiberti, Donatello, Luca della Robbia, etc.) to equation of
Quattrocento Florence with Republican Rome.

FORGERY

364 BAUMGART, FRITZ. "Zu den Dossena-Fälschungen." Kunstchronik
 und Kunstliteratur, supplement to Zeitschrift für bildende
 Kunst 63 (1929-30):1-3, 3 figs.
 Brief discussion of Alceo Dossena's forgeries, which are
pastiches of wide range of fifteenth-century sculptural styles.

365 POPE-HENNESSY, JOHN. "The Forging of Italian Renaissance
 Sculpture." Apollo 99, no. 146 (April 1974):242-67, 72 figs.
 History of forgery of Renaissance sculpture, outlining
styles of nineteenth-century master forgers and roles of dealer,
Francesco Lombard, and collector, Charles Timbal. Clarifies ques-
tionable attributions to Verrocchio, Mino da Fiesole, Antonio
Rossellino, Desiderio, etc. Reprinted in entry 59.

ICONOGRAPHICAL STUDIES

*366 HATJE, URSULA. "Der Putto in der italienischen Kunst der
 Renaissance." Ph.D. dissertation, Kunsthistorisches Institut
 der Universität, Tübingen, 1954.

367 SIMON, KATHRIN. "The Dais and the Arcade: Architecture and
 Pictorial Narrative in Quattrocento Painting." Apollo 81
 (April 1965):270-78, 9 figs.
 Analyzes how fifteenth-century Italian artists, basing
themselves on Alberti, were first to develop architectural settings
as "an instrument of narrative propriety." Demonstrates argument by
tracing use of arcade with niche or dais in paintings and in reliefs
by Ghiberti and Donatello.

MISCELLANEOUS

Books

368 HAUPTMANN, MORITZ. Der Tondo: Ursprung, Bedeutung, und
 Geschichte des italienischen Rundbildes in Relief und Malerei.
 Frankfurt am Main: Vittorio Klostermann, 1936, 319 pp., 138
 figs.
 Traces pervasive use of tondo form in Renaissance Italy.
Examines sources and meaning in antique medallions and sarcophagi and
application in Renaissance Madonna reliefs. Illustrates and dis-
cusses large number of paintings and sculptures. Extensive notes.
Bibliography.

369 LARSSON, LARS OLOF. Von allen Seiten gleich schön: Studien
 zum Begriff der Vielansichtigkeit in der europäischen Plastik
 von der Renaissance bis zum Klassizismus. Stockhom Studies in
 the History of Art, vol. 26. Stockholm: Almquist & Wiksell
 International, 1974, 176 pp., 146 figs.
 Studies changing attitudes of sculptors regarding number of
viewpoints for their statues. Demonstrates that Renaissance sculp-
tors typically designed statues with four distinct viewpoints.

Articles

370 GODBY, MICHAEL. "A Note on Schiacciato." Art Bulletin 62, no.
 4 (December 1980):635-37, 1 fig.

Analyzes use of various terms like "schiacciato," "mezzo-rilievo," and "bassorilievo" in Ghiberti's Commentaries and Vasari's Lives, suggesting that the term "schiacciato," like the technique, originated in Donatello's workshop.

371 LIEBMANN, M.J. "Giorgio Vasari on Relief." Acta Historiae Artium 27 nos. 3-4 (1981):281-86, 6 figs.
 Analyzes sole discussion of relief sculpture in Renaissance writing, Vasari's chapter in his "Introduzione alle tre arti del disegno." Relates Vasari's terms for different types of reliefs to modern definitions.

372 REYMOND, MARCEL. "L'arc mixtilinque florentin." Rivista d'arte 2 (1904):245-59, 7 figs.
 So-called "mixtilinque arch" is architectural form particular to Early Renaissance Florence and Venice, ca. 1410-35, first appearing on Orsanmichele in 1408. Later used by Ghiberti, Donatello, Michelozzo, and Bernardo Rossellino on buildings and on tombs, but after ca. 1435 it was archaistic.

373 VALENTINER, W.R. "The Simile in Sculptural Composition." Art Quarterly 10, no. 4 (Autumn 1942):262-77, 23 figs.
 On the suggestive power of sculptures. Specifically, the use of the "spiral spring" to suggest dynamic motion in the Renaissance sculptures of Verrocchio, Donatello, and Pollaiuolo. Contrasts use of diagonal to suggest mechanization in modern sculpture.

MUSEUMS, CATALOGUES, AND HISTORIES

AUSTRIA

Vienna, Kunsthistorisches Museum

374 LEITHE-JASPER, MANFRED, and DISTELBERGER, RUDOLF. The Kunsthistorisches Museum, Vienna: The Treasury and the Collection of Sculpture and Decorative Arts. Florence: Scala, 1982, 128 pp., 170 color pls.
 Profusely illustrated survey of sculpture in this collection. Aimed for general audience but with valuable color plates.

375 PLANISCIG, LEO. Die Bronzeplastiken: Statuetten, Reliefs, Geräte, und Plaketten. Kunsthistorisches Museum in Wien, Publikationen aus den Sammlungen für Plastik und Kunstgewerbe, edited by Julius Schlosser, vol. 4. Vienna: Anton Schroll & Co., 1924, 286 pp. 495 figs.
 More comprehensive and updated version of Schlosser's catalogue. Exacting discussion of Filarete's plaquette and tabernacle door (pp. 3-4, 1 fig.)

376 SCHLOSSER, JULIUS von. <u>Werke der Kleinplastik in der</u>
 <u>Skulpturensammlung des allerh. Kaiserhauses</u>. Vol. 1,
 <u>Bildwerke in Bronze, Stein, und Ton</u>. Vienna: Anton Schroll &
 Co., 1910, 22 pp. 77 figs.
 Catalogue of small bronzes and reliefs in the Kunsthistor-
 isches Museum. Focuses especially on the Bolognese school, but also
 contains several important earlier works, including Bertoldo's
 <u>Bellerophon</u>. Brief description, provenance, and bibliography.
 Excellent reproductions.

ENGLAND

London, Victoria and Albert Museum

377 FORTNUM, C[HARLES] DRURY E[DWARD]. <u>Descriptive Catalogue of</u>
 <u>the Maiolica Hispano-Moresco, Persian, Damascus, and Rhodian</u>
 <u>Wares in the South Kensington Museum</u>. London: Chapman & Hall,
 1873, 699 pp., 61 figs., 12 color pls.
 Catalogue with informative essays introducing each geo-
 graphical section. Plentiful illustrations of works and marks.
 Mostly dishes and crockery but with information on <u>botteghe</u>, manu-
 factories, and techniques relevant to terracotta work of Della Robbia
 shops.

378 MACLAGAN, ERIC. <u>Catalogue of Italian Plaquettes</u>. London:
 Board of Education, 1924, 87 pp., 76 figs.
 Short history of plaquettes, plus catalogue consisting of
 brief descriptive entries and references. Works by Donatello,
 Michelozzo, Francesco di Giorgio, Bertoldo, etc., though some attri-
 butions are questionable (Martelli mirror attributed to Donatello).

379 MACLAGAN, ERIC, and LONGHURST, MARGARET H. <u>Catalogue of</u>
 <u>Italian Sculpture in the Victoria and Albert Museum</u>. 2 vols.
 London: Board of Education, 1932, 182 pp., 120 figs.
 Thorough and perspicacious catalogue of extensive holdings
 of Victoria and Albert Museum, offering many judicious attributions
 and much new information. Now largely superseded by Pope-Hennessy's
 1964 catalogue (entry 380), especially in regard to much-disputed
 Chirardini collection.

379a Middeldorf, Ulrich. Review of <u>Catalogue of Italian Sculpture</u>
 <u>in the Victoria and Albert Museum</u>, by Eric Maclagan and
 Margaret H. Longhurst. <u>Burlington Magazine</u> 65, no. 176 (July
 1934):40-44, 4 figs.
 Valuable critique that expands attributions to include
 related works in other collections. Makes interesting connections
 between certain sculptures like Giovanni della Robbia's glazed terra-
 cotta <u>Adoration</u> relief and Perugino's paintings that copy it.
 Reprinted in entry 54.

380 POPE-HENNESSY, JOHN, assisted by R.W. Lightbown. Catalogue of
 Italian Sculpture in the Victoria and Albert Museum. 3 vols.
 London: Her Majesty's Stationery Office, 1964, 767 pp., 426
 figs.
 Thorough scholarly catalogue covers museum's holdings of
Italian sculpture, 8th to 20th century. Each entry includes descrip-
tion, provenance, references, and commentary. Many new attributions
and excellent photographs. Supplants catalogue of 1932 (entry 379).

380a Fleming, John. Review of Catalogue of Italian Sculpture in the
 Victoria and Albert Museum, by John Pope-Hennessy. Connoisseur
 158, no. 636 (February 1965):100-103, 5 figs.

381 ROBINSON, J[OHN] C. Catalogue of the Soulages Collection.
 London: Chapman & Hall, 1856, 200 pp. 8 figs.
 Catalogue of collection of Jules Soulages of Toulouse,
formed in Italy in 1830s. Focuses primarily on Renaissance decora-
tive and minor arts: majolica, medals, bronzes, furniture, and some
sculpture (mostly Cinquecento). Collection now in Victoria and
Albert Museum, London.

382 ROBINSON, JOHN C. Catalogue of the Special Exhibition of
 Works of Art of the Medieval, Renaissance, and More Recent
 Periods, on Loan at the South Kensington Museum, June 1862.
 Rev. ed. London: G.E. Eyre & W. Spottiswoode for Her
 Majesty's Stationery Office, 1863, 766 pp.
 Unillustrated collation of earlier pamphlets documenting
comprehensive loan exhibition from private British collections. Over
8000 objects, including approximately thirty-five Renaissance sculp-
tures, are briefly catalogued.

383 ROBINSON, Sir JOHN CHARLES. Italian Sculpture of the Middle
 Ages and Period of the Revival of Art. London: Chapman &
 Hall, 1862, 223 pp., 20 line engrs.
 Very comprehensive descriptive catalogue of early holdings
of South Kensington Museum, London (later Victoria and Albert Mus-
eum). Each citation contains detailed narratives of provenance and
attribution.

FRANCE

Lyons, Musée de Lyon

384 JULLIAN, RENE. Catalogue du Musée de Lyon. Vol. 3, La
 sculpture du Moyen Âge et de la Renaissance. Lyons: Éditions
 de la Plus Grande France, 1945, 246 pp., 48 pls., esp. pp.
 125-86.
 Comprehensive catalogue, including works attributed to Mino
da Fiesole (marble bust of St. John), Desiderio da Settignano (frag-
mentary relief), Donatello, Andrea della Robbia, School of Antonio
Rossellino, etc. Each work documented with provenance, bibliography,
essay, and photograph.

Paris, Musée du Louvre

385 BEAULIEU, MICHELE. <u>Les sculptures Moyen Âge, Renaissance,</u> <u>temps modernes au Musée du Louvre</u>. Paris: Éditions des Musées Nationaux, 1957, pp. 115-30, 14 figs.
 Summary catalogue of fifteenth-century Italian sculptures in Louvre with brief notes on history of each piece and its provenance. No bibliography. Small, fuzzy black-and-white illustrations.

386 BLANC, CHARLES. <u>Collection d'objets d'art de M. Thiers, leguée</u> <u>au Musée du Louvre</u>. Paris: Jouast & Sigaux, 1884, 286 pp., 23 engr. pls.
 Collection donated to Louvre. Covers broad range of styles and includes pair of terracotta <u>Angel</u> reliefs by Verrocchio and terracotta relief <u>Bust of a Woman</u> by Luca della Robbia.

387 VITRY, PAUL. "Quelques sculptures du Moyen Âge et de la Renaissance de la collection Camondo au Musée du Louvre." <u>Revue de l'art chrétien</u> 57, no. 3 (May-June 1914):158-64, 4 figs.
 Collection of Count Isaac de Camondo presented to Louvre. Includes bronze plaque of <u>Crucifixion</u> attributed to Donatello, considered to be bronze mentioned by Vasari in Medici <u>guadaroba</u>.

Paris, Musée Jacquemart-André

Books

388 De la MOUREYRE-GAVOTY, FRANçOISE. <u>Sculpture italienne</u>. Paris: Éditions des Musées Nationaux, 1975, unpaginated, 207 figs.
 Catalogue of fourteenth- to nineteenth-century Italian sculpture. Significant group of fifteenth-century Central Italian sculptures. Each piece has separate catalogue entry, including bibliography.

388a Del Bravo, Carlo. Review of <u>Sculpture italienne</u>, by Françoise de la Moureyre-Gavoty. <u>Antichità viva</u> 14, no. 3 (1975):65-66, 3 figs.

Articles

389 BERTAUX, ÉMILE; GILLET, LOUIS; and DACIES, ÉMILE. "Le Musée Jacquemart-André: Les donateurs et la donation, l'art italien." <u>Revue de l'art ancien et moderne</u> 34, no. 201 (December 1913):403-38, 5 figs., esp. pp. 413-22.
 Brief discussion of most important Italian sculptures in the collection, including several <u>Madonna</u> reliefs by Luca della Robbia, bronze <u>Martyrdom of St. Sebastian</u> plaque by Donatello, and <u>Madonna</u> relief and marble hero plaque by Desiderio da Settignano.

390 FOVILLE, JEAN de. "L'art chrétien au Musée Jacquemart-André:
 La sculpture." Revue de l'art chrétien 57, no. 1 (January-
 February 1914):1-16, 11 figs.
 Important collection of Renaissance sculpture including
pair of bronze angels, here given to Matteo de' Pasti (not Dona-
tello), Madonna relief by Luca della Robbia, and bronze reliefs by
Verrocchio from Tomb of Francesca Tornabuoni.

391 MICHEL, ANDRE. "La sculpture au Musée Jacquemart-André."
 Gazette des beaux-arts, 4th per. 10, (December 1913):465-78, 7
 figs.
 Surveys important works in collection but accepts many now
disputed attributions (to Donatello, Desiderio, and Antonio Rossel-
lino). Information on provenance and attributions.

392 VENTURI, LIONELLO. "Una risorta casa del Rinascimento italiano
 (Il Museo André a Parigi)." Arte 17 (1914):58-75, 24 figs.
 Discussion of collection that includes marble relief of
Bust of a Hero by Desiderio and bronze relief of the Martyrdom of St.
Sebastian attributed to Donatello.

 GERMANY

 East and West Berlin, Staatliche Museen (Formerly Kaiser
 Friedrich Museum)

 Books

393 BANGE, E.F. Die italienischen Bronzen der Renaissance und des
 Barock. Vol. 2, Reliefs und Plaketten. Staatliche Museen zu
 Berlin, Beschreibung der Bildwerke der christlichen Epochen.
 3d ed. Berlin and Leipzig: Walter de Gruyter & Co., 1922, 140
 pp., 1059 figs.
 The major catalogue of this extensive collection of reliefs
and plaquettes; includes many fifteenth-century Central Italian
pieces.

394 BERLIN, STAATLICHE MUSEEN-BODE MUSEUM (East Berlin). Majolika-
 Plastik der italienischen Renaissance. Introduction by Hanne-
 lore Sachs. Kleine Schriften, vol. 7. Berlin: 1964, 23 pp.,
 25 figs.
 Brief introduction to illustrations of glazed terracotta
sculptures by the Della Robbia.

395 BODE, WILHELM von. Italienische Bildhauer der Renaissance:
 Studien zur Geschichte der italienischen Plastik und Malerei
 auf Grund der Bildwerke und Gemälde in den Königl. Museen zu
 Berlin. Berlin: W. Spemann, 1887, 300 pp., 43 line drawings.
 Collection of twelve essays, previously published in the
Jahrbuch der königlich preussischen Kunstsammlungen and elsewhere,
including: "Donatello und seine Schule"; "Die florentiner Thonbilder

 86

in den ersten Jahrezehnten des Quattrocento"; "Luca della Robbia und
sein Neffe Andrea"; "Andrea del Verrocchio"; "Versuche der Bildung
weiblicher Typen in der Plastik des Quattrocento"; "Die florentiner
Marmorbildner in der zweiten Hälfte des Quattrocento"; and "Ital-
ienische Porträtskulpturen des XV. Jahrhunderts."

396 BODE, WILHELM von. Die italienischen Bildwerke der Renaissance
 und des Barock, Staatliche Museen zu Berlin: Bildwerke des
 Kaiser-Friedrich Museums. Vol. 2, Bronzestatuetten, Büsten,
 und Gebrauchsgegenstande. Berlin and Leipzig: Walter de
 Gruyter & Co., 1930, 63 pp., 303 figs. [Earlier catalogue of
 same collection: Wilhelm von Bode, Königliche Museen zu
 Berlin: Beschreibung der Bildwerke der christlichen Epochen,
 vol. 2, Die italienischen Bronzen (Berlin: Georg Reimer,
 1904), 137 pp., 1422 figs.]
 Major scholarly catalogue of fifteenth- to eighteenth-
 century Italian busts and bronze statuettes, approximately twenty-
 five of which are attributed to fifteenth-century Florentine sculp-
 tors. Each entry has description of object, commentary, provenance,
 bibliography, and illustration.

397 BODE, WILHELM von. Die italienische Plastik. Handbucher der
 Königlichen Museen zu Berlin. 4th ed. Berlin: Georg Reimer,
 1905, 207 pp., 103 figs., plans.
 Small, general survey, designed to provide a context for
 Kaiser Friedrich Museum sculptures. Mentions principal sculptural
 programs from Early Christian through Baroque (but focuses primarily
 on Renaissance).

398 FEIST, PETER H. Florentinische Frührenaissance Plastik in den
 Staatlichen Museen zu Berlin. Leipzig: Seemann, 1959, 51 pp.,
 16 figs.
 Brief history of Early Renaissance sculpture, using as
 representative examples fifteenth-century Italian works in collec-
 tion.

398bis [METZ, PETER (introd.)] Bildwerke der christlichen Epochen von
 der Spätantike bis zum Klassizismus aus den Bestanden der
 Skulpturenabteilung der Staatlichen Museen, Stiftung
 preussischer Kulturbesitz, Berlin-Dahlem. Munich:
 Prestel-Verlag, 1966, 171 pp., 144 figs., esp. pp. 89-95, figs.
 72-83.
 Most recent catalogue of the West Berlin collections which,
 although brief, is very helpful in clarifying which sculptures once
 in the Kaiser Friedrich Museum, Berlin, are now in the Berlin-Dahlem
 Museum.

399 SCHOTTMÜLLER, FRIDA. Bildwerke des Kaiser-Friedrich-Museums:
 Die italienischen und spanischen Bildwerke der Renaissance und
 des Barock. Vol. 1, Die Bildwerke in Stein, Holz, Ton, und
 Wachs. Berlin and Leipzig: Walter de Gruyter & Co., 1933, 257
 pp., each piece illus.

Important catalogue of sculpture, arranged geographically. Brief description and essay for each work, comprehensive bibliography. Includes many important and rarely reproduced items.

400 SCHOTTMULLER, FRIDA. Königliche Museen zu Berlin, Beschreibung der Bildwerke der christlichen Epochen. Vol. 5, Die italienischen und spanischen Bildwerke der Renaissance und des Barocks in Marmor, Ton, Holz und Stuck. Berlin: Georg Reimer, 1913, 207 pp., 466 figs.
 Valuable catalogue of large and important collection of the Kaiser Friedrich Museum, Berlin. Especially useful for great number and variety of minor works, terracottas, etc. Includes 466 entries, each illustrated.

400a Middeldorf, Ulrich. Review of Die italienischen und spanischen Bildwerke der Renaissance und des Barocks in Marmor, Ton, Holz, und Stuck, by Frida Schottmüller. Rivista d'arte 20 (1938).
 Detailed commentary on Schottmüller's attributions. Reprinted in entry 54.

Articles

401 BODE, WILHELM von. "Florentiner Bronzestatuetten in den Berliner Museen." Jahrbuch der königlich preussischen Kunstsammlungen 23 (1902):66-80, 7 figs.
 Discusses collection of bronze statuettes, including caryatid-like female attributed to Ghiberti and bronze sketch related to Martelli David, attributed to Donatello.

402 BODE, W[ILHELM von]. "Die italienischen Skulpturen der Renaissance in den Königlichen Museen zu Berlin, IV: Versuche der Bildung weiblicher Typen in der Plastik des Quattrocento." Jahrbuch der königlich preussischen Kunstsammlungen 6 (1885): 75-81, 1 fig., 1 line drawing.
 Stimulating essay that uses sculptures in Kaiser Friedrich Museum, Berlin, to outline fifteenth-century characterization of women in contrast to antique and medieval characterizations. Traces briefly development of Madonna and Mary Magdalen types.

403 BODE, WILHELM von. "Die italienischen Skulpturen der Renaissance in den Königlichen Museen zu Berlin, VI: Die florentiner Marmorbildner in der 2. Halfte des Quattrocento." Jahrbuch der königlich preussischen Kunstsammlungen 7 (1886): 23-39, 8 figs.
 Discusses small marble architectural element with putti by Benedetto da Maiano, various Madonna reliefs (some after Donatello), and marble Madonna relief by Mino da Fiesole.

404 "Verzeichnis der im Flakturm Friedrickshain verlorengeganen Bildwerke der Skulpturen-Abteilung." Berliner Museen: Berichte aus den ehemaligen preussischen Kunstsammlungen 3, nos. 1-2 (1953):10-24, no illus.

Unillustrated listing of sculptures from Berlin museums
destroyed in World War II. Includes approximately 100 works in wood,
stone, and terracotta from Quattrocento Tuscany. "Subject to some
caution as later information has become available" (Seymour, entry
67).

HUNGARY

Budapest, Museum of Fine Arts

405 AGGHÁZY, MARIA G. Italian and Spanish Sculpture: Collection
 of Old Sculpture in the Budapest Museum of Fine Arts. Buda-
 pest, Corvina/Magyar Helikon, 1977, 150 pp., 17 figs., 48 color
 pls.
 Brief general essay intended for nonscholarly audience,
 followed by valuable corpus of photographs of eleventh- to
 seventeenth-century Spanish and Italian sculpture in the Budapest
 Museum; twenty-four pieces are fifteenth-century Central Italian.

406 BALOGH, JOLÁN. Katalog der ausländischen Bildwerke des Museums
 der bildenden Künste in Budapest, IV-XVIII Jahrhundert. 2
 vols. Budapest: Akadémiai Kiadó, 1975, 307 pp., 499 figs.
 Recent, scholarly catalogue of sculpture in collection that
 includes extensive number of fifteenth-century Tuscan pieces. Each
 work is illustrated and each entry contains a full bibliography.

407 BALOGH, JOLÁN. "Studi sulla collezione di sculture del Museo
 di belle arti, V." Acta Historiae Artium Academiae Scientiarum
 Hungaricae 11 (1965):3-67, 91 figs.
 Studies of fourteenth- to sixteenth-century Italian sculp-
 ture in collection, including works attributed to Giovanni della
 Robbia and Neroccio.

408 BALOGH, JOLÁN. "Studi sulla collezione di sculture del Museo
 di belle arti di Budapest." Acta Historiae Artium Academiae
 Scientiarum Hungaricae 12 (1966):211-346, 169 figs.; 15 (1969):
 77-138, 82 figs.
 Publishes many bronzes illustrating the production of
 several centuries. Part of series of articles forming preliminary
 catalogue of sculpture collections of Museum of Fine Arts, Budapest.

409 BALOGH, JOLÁN. "Studien in der alten Skulpturensammlung des
 Museums der bildenden Künste, II." Az országos magyar
 Szepmüvészeti Múzeum evkönyvei 9 (1937-39):45-75, 147 figs.
 Analyzes fourteenth- to sixteenth-century Italian and
 French sculptures, mainly in terracotta and wood. Includes sculp-
 tures attributed to Neroccio, Benedetto da Maiano, and many anonymous
 sculptors.

410 BALOGH, JOLÁN. "Tanulmányok a szépmüvészeti múzeum szobrászati
 gyüjteményében" [Studies on the sculptural collections of the

Museum of Fine Arts]. <u>Az országos magyar szepmüvészeti múzeum</u>
<u>evkönyvei</u> 6 (1929-30):5-51, 55 figs.
 In Hungarian. Pts. 4-7 of essay deal with fifteenth-
century Tuscan sculpture collection, including works attributed to
Ghiberti, Michelozzo, Benedetto da Maiano, and others.

411 SCHUBRING, PAUL. "Italienische Renaissance in Budapest."
 <u>Zeitschrift für bildende Kunst</u> 25 (January 1914):91-104, 34
 figs.
 Well-illustrated survey of Renaissance sculpture (mostly
terracotta and wood) in the Museum of Fine Arts, Budapest. Includes
terracotta <u>Angel Gabriel</u> by Agostino di Duccio, terracotta relief by
Benedetto da Maiano, Madonna and Child reliefs attributed to Dona-
tello and Desiderio da Settignano and works by the Master of the
Marble Madonnas, Matteo Civitali, and others.

ITALY

Florence, Museo Bardini

412 LENSI, ALFREDO. "Il Museo Bardini: Stucchi e terrecotte."
 <u>Dedalo</u> 4 (1924):486-511, 23 figs., 1 color pl.
 Summary of collection's rich holdings of fifteenth-century
Florentine terracottas, principally Madonna and Child reliefs.

413 LENSI, ALFREDO. "Il Museo Bardini, III: Marmi e pietre."
 <u>Dedalo</u> 6 (1925-26):753-72, 18 figs.
 Summary of extensive holdings in marble and stone sculp-
ture, including many fifteenth-century Florentine examples of tomb
slabs, <u>camini</u>, and Madonna reliefs.

Florence, Museo dell'Opera del Duomo

414 BECHERUCCI, LUISA, and BRUNETTI, GIULIA. <u>Il Museo dell'Opera</u>
 <u>del Duomo a Firenze</u>. 2 vols. Florence: Electa, 1971, 621
 pp., 422 figs., 71 color pls.
 Scholarly catalogue of works of art in all media removed
from Duomo, Campanile, and Baptistry; constitutes history of decora-
tion of these three preeminent monuments. Excellent surveys of
literature on each piece; description and condition of work; exten-
sive photographic corpus, including many details; and comprehensive
bibliography.

415 POGGI, GIOVANNI. <u>Catalogo del Museo dell'Opera del Duomo:</u>
 <u>Nuova ed. ampliata ed arricchito di documenti</u>. Florence:
 Barbera, 1904, 78 pp., 16 figs.
 Summary catalogue of this collection superseded by
entry 414.

Florence, Museo dell'Ospedale degli Innocenti

416 BELLOSI, LUCIANO. Il Museo dello Spedale degli innocenti a
 Firenze. Florence: Electa, 1977, 291 pp., 272 figs., 25 color
 pls.
 Catalogue of glazed terracotta reliefs by Andrea della
 Robbia decorating Ospedale degli innocenti, Florence, as well as
 works of art in its collections: fifteenth-century Madonna reliefs
 and glazed terracotta Bust of the Madonna and Child by Luca della
 Robbia.

Florence, Museo Horne

417 GAMBA, CARLO. "Il Palazzo e la raccolta Horne a Firenze."
 Dedalo 1 (1920):162-85, 24 figs.
 Discussion of architecture and decorative sculpture (cap-
 itals and camini) by Giuliano da San Gallo, as well as collection
 that includes statue of St. Paul, attributed to Vecchietta, and
 relief of Young St. John the Baptist by Desiderio.

Florence, Museo nazionale (Bargello)

418 BERTI, LUCIANO. National Museum "Bargello": New Guide (Testo
 dell'itinerario a cura di Luciano Berti). Florence: Edizioni
 GM, 1972, 73 pp., illus., 2 color pls.
 Well-illustrated guide written as tour of Bargello, useful
 for its photographs.

419 ROSSI, FILIPPO. Il Museo nazionale di Firenze (Palazzo del
 Bargello). 4th ed. Itinerari dei musei e monumenti d'Italia,
 no. 9. Rome: Libreria dello Stato, 1964, 119 pp., 179 figs.
 Pocket-size list of sculptures in collection, arranged room
 by room. Small photographs useful only for identification.

420 ROSSI, UMBERTO. "Il Museo nazionale di Firenze nel triennio
 1889-1891." Archivio storico dell'arte 6 (1893):1-24, 17 figs.
 Publication of new sculpture acquisitions, including pair
 of candelabra with putti attributed to Benedetto da Maiano, glazed
 terracotta reliefs by Luca della Robbia, and various small bronzes.

421 SUPINO, IGNINO BENVENUTO. Catalogo del R. museo nazionale di
 Firenze (Palazzo del Potestà). Rome: Tip. dell'Unione
 Cooperative Editrice, 1898, 482 pp., no illus.
 Brief catalogue prefaced by historical sketch of collec-
 tion's foundation.

Milan, Castello Sforzesco

422 VIGEZZI, SILVIO. La scultura in Milano (Museo archeologico,
 Castello Sforzesco). Milan: G. Delvigi, 1934, 219 pp., 67
 figs.

Thorough catalogue of collection that contains a few fifteenth-century Tuscan and Roman pieces attributed to Agostino di Duccio, Francesco di Giorgio, and others.

Rome, Museo Cristiano (Vatican)

423 COTTON, A.G., and WALKER, R.M. "Minor Arts of the Renaissance in the Museo Cristiano." Art Bulletin 17, no. 2 (June 1935): 118-62, 39 figs.
 Discussion of minor sculptures executed outside Florence and Rome, but made under Donatello's influence. Important discussion of styles of Donatello's various Paduan assistants: Giovanni di Pisa, Urbano da Cortona, Antonio di Chellino, Francesco Valente, and Bartolommeo Bellano.

UNITED STATES

Boston, Isabella Stewart Gardner Museum

424 VERMEULE, CORNELIUS C.; KAHN, WALTER; and HADLEY, ROLLIN van H. Sculpture in the Isabella Stewart Gardner Museum. Boston: Trustees of Museum, 1977, 188 pp., 264 figs., esp. pp. 106-20, figs. 137-48.
 Scholarly catalogue of all sculpture in collection, including a dozen fifteenth-century Central Italian pieces, mainly from workshops of prominent artists. Each entry with full bibliography.

Boston, Museum of Fine Arts

425 G., [?]. "The Quincy Adams Shaw Collection: Sculptures of the Italian Renaissance." Museum of Fine Arts Bulletin (Boston) 16, no. 94 (April 1918):19-27, 9 figs.
 Brief, illustrated survey of important collection that includes Donatello's (Shaw) Madonna of the Clouds, four terracotta reliefs by Luca della Robbia, relief of Madonna with an Angel Supporting the Christ Child by Francesco di Simone da Fiesole [Ferrucci]; marble Bust of a Youth by Mino da Fiesole, and terracotta Bust of Lorenzo de' Medici as a Youth by Verrocchio.

426 MARQUAND, ALLAN. "Italian Sculptures in the Shaw Collection at the Boston Museum, Part II: The Della Robbias." Art in America 6 (October 1918):253-63, 5 figs.
 Attributes to Luca della Robbia Madonna of the Lilies and Shaw Madonna of the Niche; Madonna and Child attributed to Andrea della Robbia's atelier, ca. 1480-1525; St. John the Baptist, formerly attributed to Antonio Rossellino, but here given to the sculptor of Trivulzio and Sant'Ansano busts, a member of the Della Robbia school strongly influenced by Antonio Rossellino.

427 MARQUAND, ALLAN. "Some Sculptures in the Shaw Collection of
 the Boston Museum: Part Three." Art in America 7, no. 1
 (December 1918):2-10, 3 figs.
 Discusses Madonna with an Angel Supporting the Christ
Child, attributed to Francesco di Simone [Ferrucci]; Angel with a
Palm, relief for tabernacle by the school of Bernardo Rossellino or
Bernardo's follower, Matteo Civitali; Bust of a Roman Emperor, com-
panion to Caesar relief (Bargello, Florence) by Mino da Fiesole.

Detroit, Detroit Institute of Arts

428 VALENTINER, W.R. "Late Gothic Sculpture in Detroit." Art
 Quarterly 6, no. 4 (Autumn 1943):276-305, 24 figs.
 Discusses sculptures in Detroit Institute of Arts that
illustrate continuing Gothic influence throughout Quattrocento:
works by School of Jacopo della Quercia, Donatello, Agostino di
Duccio, Mino da Fiesole, and Antonio Pollaiuolo.

Los Angeles, Los Angeles County Museum

429 VALENTINER, W.R. Gothic and Renaissance Sculptures in the
 Collection of the Los Angeles County Museum. Los Angeles: Los
 Angeles County Museum, 1951, 185 pp., 72 figs.
 Collection contains twenty-one works, mainly by lesser
artists; most originally in Hearst collection. In brief essays
Valentiner offers new attributions to Francesco di Simone [Ferrucci],
Andrea della Robbia, Mino del Reame, etc.

New York, Frick Collection

430 The Frick Collection: An Illustrated Catalogue of the Works of
 Art in the Collection of Henry Clay Frick. With an introduc-
 tion by Sir Osbert Sitwell. 12 vols. Vol. 5, Sculpture of the
 Renaissance and Later Periods, by Sir Eric Maclagan with emen-
 dations by Mirella Levi D'Ancona, edited by David Jacques Way,
 foreword by Charles Seymour, Jr. New York: Frick Art Refer-
 ence Library, 1954, 61 pp., 37 figs.
 Scholarly catalogue presented in beautifully illustrated
monumental folio volume. Several new attributions including statu-
ette of Hercules in Repose given to Francesco di Giorgio. Rejects
authenticity of David with the Head of Goliath that Valentiner
attributed to Francesco di Giorgio.

431 POPE-HENNESSY, JOHN, assisted by Anthony F. Radcliffe. The
 Frick Collection: An Illustrated Catalogue. Vol. 3:
 Sculpture, Italian. New York: Frick Collection, 1970, 254
 pp., illus.
 Well-illustrated catalogue of "one of the finest collec-
tions of small bronzes in the world" (Pope-Hennessy), including
Pollaiuolo's Hercules, a Pollaiuolesque Marsyas, and bronzes by
Vecchietta, Bertoldo, and others.

New York, Metropolitan Museum of Art

432 MONOD, FRANÇOIS. "La galerie Altman au Metropolitan Museum de
 New York": "Les sculptures et les objets d'art." Gazette des
 beaux-arts, 5th per. 8 (December 1923):367-77, 6 figs.
 Briefly discusses Madonna reliefs by Della Robbia shop,
 Madonna of the Cherubim by Rossellino school, portrait bust from
 funerary monument by Mino da Fiesole, and St. John the Baptist by
 Mino.

433 NEW YORK, METROPOLITAN MUSEUM OF ART. Handbook of the Benjamin
 Altman Collection. New York: Metropolitan Museum of Art,
 1914, 168 pp., 48 figs. 2d ed. 1928, no illus.
 Gallery handbook; see esp. pp. 119-41 (2d ed.). Brief des-
 criptions of several important works by Donatello, Antonio Rossel-
 lino, Luca della Robbia, Verrocchio, Mino da Fiesole, and Benedetto
 da Maiano.

434 PHILLIPS, JOHN GOLDSMITH. "Medals of the Renaissance."
 Bulletin of the Metropolitan Museum of Art 9 (November 1950):
 77-82, 10 figs.
 Brief discussion of museum's collection of Renaissance
 medals, including three by Niccolò Fiorentino portraying Savonarola,
 Charles VIII of France, and Lorenzo the Magnificent.

Santa Barbara, Santa Barbara Museum of Art

435 MIDDELDORF, ULRICH, and GOETZ, OSWALD. Medals and Plaquettes
 from the Sigmund Morgenroth Collection. Chicago: Art
 Institute of Chicago, 1944, 64 pp., 211 figs.
 Brief but enlightening comments on medals and plaquettes
 from all countries of Europe and all periods. Descriptive catalogue
 citations with references and good reproductions. Collection now at
 Santa Barbara Museum of Art.

Washington, D.C., National Gallery of Art

Books

436 HILL, GEORGE F., and POLLARD, GRAHAM. Renaissance Medals from
 the Samuel H. Kress Collection of the National Gallery of Art:
 Based on the Catalogue of Reanissance Medals in the Gustave
 Dreyfus Collection by G.F. Hill, Revised and Enlarged by Graham
 Pollard. London: Phaidon, 1967, 307 pp., 716 figs.
 Updated scholarly catalogue of the finest private collec-
 tion of medals ever formed, that of Gustave Dreyfus, now part of the
 Kress Collection, National Gallery of Art, Washington, D.C. Each
 entry with description, commentary, and bibliography.

437 MIDDELDORF, ULRICH. Sculptures from the Samuel H. Kress
 Collection: European Schools, XIV-XIX Century. London:
 Phaidon, 1976, 128 pp., 219 figs.

Thorough, scholarly catalogue of collection especially strong in Italian Renaissance works. Brief essays on each work plus description, reproduction, provenance, and bibliography; divided by country, school, and century. Many new attributions. Thorough index and cross-references.

437a Pope-Hennessy, John. Review of Sculptures from the Samuel H. Kress Collection: European Schools, XIV–XIX Century, by Ulrich Middeldorf. Apollo 104, no. 173 (July 1976):70–73, no illus.
Thorough review that challenges attribution of Bust of a Lady to Desiderio, giving it insted to Benedetto da Maiano. Also attributes terracotta Madonna and Child relief to Nanni di Bartolo and other works to Benedetto da Maiano.

438 POPE-HENNESSY, JOHN. Renaissance Bronzes from the Samuel H. Kress Collection: Reliefs, Plaquettes, Statuettes, Utensils, and Mortars. London: Phaidon, 1965, 333 pp., 616 figs.
Scholarly catalogue of Renaissance bronzes from Europe, primarily Italy, including 130 statuettes and utensils and 459 reliefs and plaquettes. Brief essays on each work, plus description, provenance, bibliography, and reproduction; divided by country, school, and century. Reevaluates many attributions. Objects largely from Gustave Dreyfus collection.

439 SEYMOUR, CHARLES, Jr. Masterpieces of Sculpture in the National Gallery of Art. Washington, D.C.: National Gallery of Art, Smithsonian Institution, [1949], 184 pp., 141 figs.
Covers all periods, but with primary focus on Italian Renaissance. Important works by Jacopo della Quercia, Ghiberti, Donatello, Michelozzo, Desiderio, Antonio Rossellino, Laurana, Verrocchio, Mino da Fiesole, Francesco di Giorgio, Alberti, etc. Fine scholarly notes, but especially valuable for detailed, large-format photographs (many by Clarence Kennedy).

440 WASHINGTON, D.C., NATIONAL GALLERY OF ART. Preliminary Catalogue of Paintings and Sculpture: Descriptive List with Notes. Compiled and edited by Charles Seymour, Jr. Washington, D.C.: National Gallery of Art, 1941, 247 pp., 17 figs.
Small catalogue/handbook with useful notes on all works, including objects formerly in Mellon, Kress, and Dreyfus collections.

Articles

441 COMSTOCK, HELEN. "Quattrocento Portrait Sculpture in the National Gallery, Washington." Connoisseur 122, no. 509 (September 1948):45–49, 10 figs.
Brief, insightful discussions of Renaissance portrait busts in National Gallery of Art, including: busts of children and of "Marietta Strozzi" by Desiderio; Pietro Talani and a Genoese Man by Benedetto da Maiano; Astorgio Manfredi (dated 1455) and Rinaldo della Luna by Mino da Fiesole; and a warrior by Antonio Pollaiuolo.

442 SWARZENSKI, GEORG. "Some Aspects of Italian Renaissance
 Sculpture in the National Gallery." Gazette des beaux-arts,
 6th per. 24 (September 1943):149-56, 4 figs.; 25 (November
 1943):283-304, 17 figs.
 Pt. 1: general discussion of role of sculpture collections
 in museums, pointing to limitations even of fine collections like
 that of the National Gallery, Washington. Pt. 2: perceptive study
 of principal works in the National Gallery, focusing primarily on
 portrait busts; analysis of nature and history of portrait busts in
 Renaissance Florence.

443 VALENTINER, W.R. "The Clarence H. Mackay Collection of Italian
 Renaissance Sculptures." Art in America 13, no. 5 (August
 1925):239-65, 10 figs.
 Collection includes stucco bust of young St. John, cast
 from Desiderio's (not Donatello's) marble in Louvre; female bust by
 Desiderio (so-called "Isotta da Rimini"); terracotta Bust of Man by
 Benedetto da Maiano (related to other unpublished busts); Bust of
 Lorenzo de' Medici, here attributed to Verrocchio; bust of St.
 Catherine of Siena by Jacopo della Quercia, here corrected to be a
 Madonna and Child by Neroccio (influenced by Mino da Fiesole). Many
 of these works are now in National Gallery of Art, Washington.

444 WITTKOWER, RUDOLF. "Sculpture in the Mellon Collection."
 Apollo 26, no. 152 (August 1937):79-84, 9 figs.
 Various Renaissance sculptures analyzed: Madonna and Child
 relief by Andrea della Robbia, terracotta St. John the Baptist by
 Donatello, Madonna relief and marble Bust of a Boy by Desiderio and
 Fides Caritas by Mino da Fiesole.

Worcester, Worcester Art Museum

445 JANSON, HORST W. "Italian Renaissance Sculpture: A Catalogue
 of Carvings in Stone, Wood, and Terracotta." Worcester Art
 Museum--Volume II, 1936-37:45-62, 10 figs.
 Complete listing and description of early fourteenth- to
 eighteenth-century Italian sculpture. Omits purely decorative and
 architectural sculpture, as well as small bronzes.

PRIVATE COLLECTIONS

AYNARD COLLECTION

446 BERTAUX, EMILE. "Trois chefs-d'oeuvre italiens de la
 collection Aynard." Revue de l'art ancien et moderne 19, no.
 107 (February 1906):81-96, 7 figs.
 On Edouard Aynard collection, Lyons. In particular:
 terracotta Madonna and Child by Jacopo della Quercia, bronze
 plaquette (probably tabernacle door) of Madonna and Child with
 Dancing Angels by Donatello(?), and small marble relief of Vision of
 St. Catherine(?) by Agostino di Duccio.

BECKERATH COLLECTION

447 BOMBE, WALTER. "Die Sammlung Adolph V. Beckerath." Cicerone
 9-10 (May 1916):167-86, 10 figs.
 Summary discussion of prominent collection containing works
by or attributed to Donatello, Bernardo Rossellino, Antonio Rossel-
lino, and others.

DREYFUS COLLECTION

448 HILL, GEORGE FRANCIS. The Gustave Dreyfus Collection. vol. 3,
 Renaissance Medals. Oxford: Oxford University Press, 1931,
 311 pp., 141 figs.
 Catalogue of important collection of medals (now Kress
Collection, National Gallery, Washington, D.C.). Provides scholarly
catalogue information, bibliography, description, and obverse and
reverse illustrations for each medal. Includes works by Bertoldo,
Niccolò Fiorentino, and Matteo de' Pasti. See especially "Italian
Medals before the Time of Benvenuto Cellini," pp. 1-155.

449 MAYER, AUGUST L. "Die Sammlung Gustave Dreyfus." Pantheon 7
 (1931):10-18, 1 fig. [Photographs by Clarence Kennedy.]
 Records sale of one of last and most important private
collections of Quattrocento sculpture. Discusses history of collec-
tion that includes major works by Verrocchio, Desiderio, Mino da
Fiesole, Luca della Robbia, and Antonio Rossellino.

450 RICCI, SEYMOUR. The Gustave Dreyfus Collection. Vol. 2,
 Reliefs and Plaquettes. Oxford: Oxford University Press,
 1931, 300 pp., 127 figs.
 Introduction provides valuable information on plaquettes,
collections of reliefs, and sales. Scholarly catalogue describes
major corpus of works, each illustrated in actual size. Now part of
the Kress Collection, National Gallery, Washington, D.C.

451 VAUDOYER, JEAN-LOUIS. "La collection Gustave Dreyfus." Amour
 de l'art 6 (July 1925):245-64, 73 figs.
 Well-illustrated survey of important collection of
Renaissance medals, plaquettes, bronzes, sculptures, and paintings.
Includes works by Pollaiuolo, alberti (self-portrait plaque), and
Mino da Fiesole; a Donatello tondo relief; a Desiderio relief; and
several busts by Verrocchio.

452 VITRY, PAUL. "La collection de M. Gustave Dreyfus, 1: La
 sculpture." Arts 6, no. 72 (December 1907):1-32, 36 figs.
 Thorough, insightful article on premier French collection
of Renaissance sculpture. Well illustrated. Includes important
works by Luca della Robbia, Antonio Rossellino, Mino da Fiesole, and
Verrocchio.

DUVEEN COLLECTION

453 Duveen Sculpture in Public Collections of America: A Catalogue
Raisonné with 600 Illustrations of Italian Renaissance
Sculptures by the Great Masters Which Have Passed through the
House of Duveen. New York: William Bradford Press, 1944, 676
pp., 231 figs.
 Catalogue of fifteenth-, sixteenth- and seventeenth-century
Italian sculpture, with at least one full-page black-and-white photo-
graph, description, collection history, and bibliography for each
sculpture.

FIGDOR COLLECTION

454 FALKE, OTTO von; DEMMLER, THEODOR; FRIEDLÄNDER, M.J.;
PLANISCIG,
 LEO; and SCHESTAG, AUGUST. Die Sammlung Dr. Albert Figdor,
Wien. 5 vols. in 2. Vienna: Artaria & Co.; Berlin: Paul
Cassirer, 1930, 1: unpaginated, 507 items, 72 figs.; 2:
unpaginated, 810 items, 156 figs.
 Contains short section (vol. 1, nos. 120-39) authored by
Planiscig, "Italienische Skulpturen und Plastiken in Stein, Holz,
Ton, und Stucco," with a catalogue and excellent photos of minor
works attributed to Matteo Civitali, Desiderio da Settignano, Andrea
del Verrocchio, Antonio Rossellino, and Benedetto da Maiano among
others.

FOULC COLLECTION

455 LEMAN, HENRI. La collection Foulc: Objets d'art du Moyen Âge
et de la Renaissance. 2 vols. Paris: Éditions Les Beaux
Arts, 1927, 111 pp., 205 figs.
 Brief citations for 207 items in this collection. Includes
works by Desiderio da Settignano, Mino da Fiesole (Scipio) and Ber-
toldo and a bronze statuette of David (now in the Metropolitan Museum
of Art, New York) by an unknown Florentine.

456 PLANISCIG, LEO. "Italienische Renaissanceplastiken aus der
Sammlung E. Foulc, Paris." Pantheon 3 (1929):215-20, 10 figs.
 Collection contains marble Madonna and Child relief from
Santa Maria Nuova by Desiderio da Settignano, Adoration tondo by Luca
and Andrea della Robbia, and Aphrodite statuette signed by Adriano
Fiorentino, among other works.

GOLDMAN COLLECTION

457 VALENTINER, WILHELM R. The Henry Goldman Collection. New
York: Privately Printed, 1922, 55 pp., 32 figs. (200 copies).
 Small but important collection of fifteen paintings and
seven sculptures, including small seated terracotta Madonna and Child

attributed to Donatello and terracotta relief by Andrea della Robbia.
Excellent plates and evaluation of each work.

458 VALENTINER, WILHELM R. "Die Sammlung Henry Goldman in New
 York." Kunst und Künstler 21 (February 1923):148-56; (March
 1923):186-92, 14 figs.
 Survey of collection with short discussions of several
Renaissance sculptures, including a Seated Madonna and Child attrib-
uted to Jacopo della Quercia, Standing Madonna and Child from the
school of Donatello, and Madonna and Child relief by Andrea della
Robbia.

LANZ COLLECTION

459 PIT, A. "Quattrocento-Plastik der Sammlung Lanz--Amsterdam."
 Münchner Jahrbuch der bildenden Kunst 7 (1912):39-57, 26 figs.
 Summary discussion of important private collection that
includes: terracotta St. John the Evangelist by Benedetto da Maiano;
St. John the Baptist by Mino da Fiesole; terracotta Ecce Homo relief,
perhaps by Nanni di Banco; terracotta Madonna and Child relief by
Luca della Robbia; marble Reclining Nymph by Adriano Fiorentino; and
Wisdom, a terracotta bust that is related to Fonte Gaia attributed to
Jacopo della Quercia.

SALTING COLLECTION

460 HILL, G[EORGE] F. "The Italian Medals in the Salting Collec-
 tion." Burlington Magazine 20 (October 1911):18-24, 18 figs.
 Summary of important medals in collection, including some
by Gian Cristoforo Romano, Bertoldo, and other late fifteenth-century
Florentines.

461 HILL, G[EORGE] F. "The Salting Collection--I, The Italian
 Bronze Statuettes." Burlington Magazine 16 (1910):311-18, 4
 figs.
 Discussion of major bronzes in collection then recently
bequeathed to Victoria and Albert Museum, London. Includes Resting
Hercules and Hercules and the Nemean Lion, both attributed to Ber-
toldo.

SIMON COLLECTION

462 FRIEDLÄNDER, M.J.; BANGE, E.F.; SCHOTTMULLER, F.; KUHNEL, E.;
 and FOERSTER, C.F. Die Sammlung Dr. Eduard Simon, Berlin. 2
 vols. Berlin: Paul Cassirer; Hugo Helbring, 1929, 320 pp.,
 214 figs.
 Important collection of high-quality Renaissance paintings,
bronzes, medals, sculptures, and decorative arts. Includes works by
Ghiberti, Luca della Robbia, Benedetto da Maiano, and others. Excel-
lent plates and catalogue.

463 SCHOTTMÜLLER, FRIDA. "Bildwerke und Ausstattungsstücke der
 Sammlung Eduard Simon." Cicerone 21, no. 17 (September
 1929):489-96, 8 figs.
 Brief discussion of important Berlin collection, including
Madonna and Child by Luca della Robbia and works by Francesco di
Giorgio and Giuliano da San Gallo (moldings).

EXHIBITIONS

1904

Siena

464 SIENA, PALAZZO PUBBLICO. Mostra dell'antica arte senese.
 Catalogo generale illustrato. Catalogue by Corrado Ricci.
 Siena: Sordomuti di L. Lazzeri, 1904, 365 pp., 13 figs.
 Catalogue of major exhibition (April-August 1904) of hun-
dreds of Sienese paintings, sculptures, and decorative art objects.

465 Perkins, F. Mason. "Sienese Exhibition of Ancient Art."
 Burlington Magazine 5, no. 18 (September 1904):581-87, 5 figs.
 Reviews exhibition, discussing newly discovered marble
figures of St. Anthony and St. Ambrose by Jacopo della Quercia.
Marble bust of St. Catherine (Palmieri collection), generally given
to Mino da Fiesole, is here attributed to Neroccio.

466 Poggi, Giovanni. Review of Mostra dell'antica arte senese.
 Emporium 20 (July 1904):31-48, 18 figs.
 Discussion of exhibition as an overview of Sienese painting
and sculpture.

1912

London

467 LONDON, BURLINGTON FINE ARTS CLUB. Catalogue of a Collection
 of Italian Sculpture and Other Plastic Art of the Renaissance,
 1912. Introduction by Eric Maclagan. London: Privately
 Printed, 1913, 143 pp., 69 figs.
 Important exhibition catalogue of works drawn from British
private collections. Introduction contains interesting notes on
Renaissance sculptural technique, including a translation of Pomponio
Gaurico's dialogue, "De Sculptura."

468 Daniel, A.M. "Italian Sculpture at Burlington Fine Arts Club."
 Burlington Magazine 21, no. 113 (July 1912):278-84, 4 figs.
 Exhibition review that comments on many important, pri-
vately owned works, including terracotta Madonna and Child with Seven
Angels (Morgan collection, New York) attributed to Luca della Robbia;
bronze Cupid attributed to Donatello (W. Newall collection, London);

and bronze Cupid with Bow, school of Donatello (Sir William Bennett collection, London).

469 Richter, Louise M. "Die Austellungen alter sienesischer Kunst in London und Siena." Zeitschrift für bildende Kunst, n.s. 16 (1905):99-108, 12 figs.
 Review of Burlington Fine Arts Club exhibition and simultaneous exhibition in Siena, Palazzo Pubblico.

470 Schubring, Paul. "Italienische Renaissanceplastik aus englischem Privatbesitz: Burlington Fine Arts Club, London, 1912." Zeitschrift für bildende Kunst 23 (1911-12):301-8, 8 figs.
 Exhibition review that discusses sculptures by Agostino di Duccio (Madonna and Child relief, then in Lord Oswald's collection, London); Vecchietta's Resurrection of Christ relief and Pollaiuolo's Hercules, both in Pierpont Morgan collection, New York; and Cupid statuette, attributed to Donatello (W. Newall collection, London).

1934

Amsterdam

471 AMSTERDAM, STEDELIJK MUSEUM. Italianische Kunst in Nederlandisch Bezit [Italian art in Dutch collections]. Amsterdam: Druk de Bussy, 1934, 274 pp., 222 figs., 1 color pl.
 In Dutch. Catalogue of very comprehensive exhibition (1 July-1 October 1934) of Italian works in Dutch private collections, including many examples of the decorative arts. Contains sculptures by Jacopo della Quercia, Donatello, Luca della Robbia, Verrocchio, and Antonio Rossellino and drawing of Triumphal Arch in Naples.

1938

Detroit

472 DETROIT, DETROIT INSTITUTE OF ARTS. Catalogue of an Exhibition of Italian Gothic and Early Renaissance Sculptures. Catalogue by W.R. Valentiner. Detroit: Detroit Institute of Arts, 1938, 19 pp., 100 figs.
 Catalogue of January-February 1938 exhibition containing illustrations and incisive attributions for 100 sculptures from the period 1250 to 1500. Scholarly publication of many important smaller works in American collections.

473 Middeldorf, Ulrich. "Die Austellung italienischer Renaissanceskulptur in Detroit." Pantheon 22 (1938):315-18, 4 figs.
 Comments on attributions, especially on terracotta Birth of Christ relief attributed to Ghiberti (Edsel Ford collection, Detroit), which he relates to Genesis scenes (Victoria and Albert Museum, London; Museo dell'Opera del Duomo, Florence). Disputes

attribution to Bertoldo of equestrian statuette (formerly Foulc collection, now Philadelphia Museum of Art); considers it seventeenth century. Reprinted in entry 54.

474 Ragghianti, Carlo L. "La mostra di scultura italiana antica a Detroit (U.S.A.)." Critica d'arte 3 (1938):170-83, 72 figs.
 Lengthy review of this major exhibition of thirteenth- to fifteenth-century Italian sculpture. Review analyzes attributions and compares pieces to well-known sculptures.

475 SIENA, PALAZZO PUBBLICO. Catalogo della mostra di sculture d'arte senese del XV scolo nel V centenario della morte di Jacopo della Quercia. Catalogue by Anna Maria Francini Ciaranfi. Siena: Tip. S. Bernardino, 1938, 30 pp., 20 figs.
 Exhibition of sixty-one fifteenth-century Sienese sculptures, plus casts of Jacopo della Quercia's Fonte Gaia reliefs. Brief catalogue entries describe and give present location of sculptures. Bibliography.

476 Haftmann, Werner. "Jacopo della Quercia und die Sienesische Skulptur des Quattrocento: Zur Ausstellung im Stadtpalast zu Siena." Pantheon 22 (1938):367-75, 10 figs.
 Overview of artistic milieu of Early Renaissance Siena in context of exhibition review. Clarifies and identifies important role of Francesco di Valdambrino in assisting Jacopo della Quercia. Stresses importance of Francesco di Giorgio's sculpture.

477 Pope-Hennessy, John. "A Jacopo della Quercia Exhibition." Burlington Magazine 74 (1939):36, 1 fig.
 Pope-Hennessy's list of disputed attributions from exhibition of fifteenth-century Sienese sculpture at the Palazzo Pubblico, Siena.

1949

Siena

478 SIENA, PALAZZO PUBBLICO. Le sculture lignee senesi. Catalogue by Enzo Carli. Milan and Florence: Electa, 1951, 187 pp., 176 figs., 8 color pls.
 Catalogue of comprehensive show of Sienese wood sculpture from the Romanesque period through the fifteenth century held at Palazzo Pubblico, Siena, in 1949. Detailed history of Sienese wood sculpture; annotations regarding non-Sienese wood sculpture in Sienese territory; summaries regarding artists, technical information on sculptures, bibliography, and index by location.

479 Carli, Enzo. "Chefs-d'oeuvre de la sculpture du Moyen Age." Amour de l'art 46-48 (1950):34-47, 15 figs.
 Review of postwar exhibitions in Pisa and Siena of medieval and Early Renaissance sculptures removed for protection, including

some rediscovered works. Fine photographs of works by Jacopo della Quercia, Vecchietta, Neroccio, Francesco di Giorgio, etc.

480 Pope-Hennessy, John. "An Exhibition of Sienese Wooden Sculpture." Burlington Magazine 91, no. 560 (November 1949): 323-24, no illus.
 Discusses problems of interpreting wooden sculpture: polychromy obscures stylistic detail, difficulty of relating it to work in other media. Notes on attributions offered in this exhibition.

1961

Arts Council of Great Britain. Exhibition of Italian Bronze Statuettes. See entry 220.

1964

Northampton, Mass.

481 Renaissance Bronzes in American Collections. An Exhibition organized by the Smith College Museum of Art, Northampton, Mass., 9 April-3 May 1964. Meriden, Conn.: Meriden Gravure Co., 1964, unpaginated.
 Essay by Pope-Hennessy introduces small loan exhibition of Renaissance bronzes, four of which are attributed to fifteenth-century Central Italians by their owners. Each entry with description, provenance, photograph, and bibliography.

1972

London

482 LONDON, HEIM GALLERY. Sculptures of the Fifteenth and Sixteenth Centuries. Heim Exhibition Catalogues, no. 15. London: Heim Gallery, 1972, unpaginated, 46 figs.
 Exhibition (30 May-8 September 1972) of forty-six fifteenth- and sixteenth-century European sculptures, including sixteen fifteenth-century Tuscan examples.

483 Negri Arnoldi, Francesco. "An Exhibition of Italian Sculpture in London." Burlington Magazine 114, no. 834 (September 1972): 641-53, 25 figs.
 Detailed review of Heim Gallery, London, exhibition of Renaissance sculpture with particular attention given to attributions to Luca della Robbia, Mino da Fiesole, Benedetto da Maiano, and Master of the Marble Madonnas.

1980

Allentown, Pa.

484 ALLENTOWN, PA. ART MUSEUM. Beyond Nobility: Art for the
 Private Citizen in the Early Renaissance. Catalogue by Ellen
 Callmann. Allentown, Pa.: Art Museum, 1980, 126 pp., 135
 figs., 4 color pls.
 Small but comprehensive exhibition (28 September 1980-4
 January 1981) of paintings, sculpture, and minor arts resulting from
 secular commissions (merchants, bankers, etc.) to show breadth of
 Renaissance patronage. Includes Alberti self-portrait plaquette,
 several bronze plaquettes from school of Donatello, stuccos by or
 after Antonio Rossellino and Andrea della Robbia, and medals of the
 Strozzi Family by Niccolò Fiorentino.

 Impruneta

485 La civiltà del cotto: Arte della terracotta nell'area
 fiorentina dal XV al XX secolo. Exhibition at Impruneta,
 May-October 1980. Florence: Coop-Officine Grafiche Firenze,
 1980, 253 pp., illus. (not numbered).
 Catalogue tracing history of terracotta production around
 Impruneta, with a section on terracotta sculpture. Deals with
 artisan work and architectural terracotta as well. Discusses work-
 shops, materials, and artisans specializing in terracotta. Profusely
 illustrated.

1979-80

 Fingerprints of the Artist: European Terracotta Sculpture from
 the Arthur M. Sackler Collections. See entry 243.

Individual Sculptors

ADRIANO FIORENTINO

486 FABRICZY, CORNELIUS von. "Adriano Fiorentino." Jahrbuch der königlich preussischen Kunstsammlungen 24 (1903):71–98, 9 figs.
Monographic study based on examination of signed medals and new documents pertaining to Adriano Fiorentino's work in Naples and Saxony. New attributions include early bronze statuette of Aphrodite (Foulc collection, Paris).

487 FABRICZY, C[ORNELIUS] de. "Adriano Fiorentino." Arte 4 (1901):415–17, no illus.
Publishes Medal of Degenhart Pfeffinger by Adriano and notes two letters about Adriano but does not transcribe them. Attributes to him bronze Bust of King Ferdinand of Naples (Museo nazionale, Naples), sometimes given to Guido Mazzoni.

488 KNAPP, FRITZ. "Adriano Fiorentino." In Thieme-Becker Künstler-Lexikon. Leipzig: Wilhelm Engelmann, 1907, 1:91–92.
Condensed survey of life and work. Valuable bibliography.

489 MESCHINI, ANNA. "Giano Làskeris e un busto del Pontanto." Italia medioevale e umanistica 20 (1977):411–12, 1 fig.
Identifies bust (Galleria di Palazzo Bianco, Genoa), recently attributed to Adriano Fiorentino, as portrait of Pontano described by Greek humanist, Lascaris.

AGOSTINO DI DUCCIO

Books

490 BACCI, MINA. Agostino di Duccio. I maestri della scultura, no. 45. Milan: Fratelli Fabbri, 1966, 6 pp., 3 figs., 17 color pls.
Valuable for excellent, large color plates.

491 BURMEISTER, ERNST. Der bildnerische Schmuck des Tempio
 malatestiano zu Rimini. Breslau: S. Schottlaender, 1891, 31
 pp., no illus.
 Discusses imagery of marble reliefs attributed to Agostino
 di Duccio decorating chapels in San Francesco, or Tempio Malates-
 tiano, Rimini. Includes commission history.

492 POINTNER, ANDY. Die Werke des Florentinischen Bildhauers
 Agostino d'Antonio di Duccio. Strasbourg: J.H. Ed. Heitz
 (Heitz & Mündel), 1909, 216 pp., 39 figs.
 Monograph covering all sculpture of Agostino di Duccio. No
 catalogue raisonné or footnotes. Extensive bibliography.

492a Schubring, Paul. Review of Die Werke des florentinischen
 Bildhauers Agostino d'Antonio di Duccio, by Andy Pointner.
 Repertorium für Kunstwissenschaft 33 (1910):163–66.
 Favorable review, but author objects to minimalization of
 role of Matteo de' Pasti at Tempio Malatestiano, Rimini.

 Unpublished Theses

*493 KUHLENTHAL, MICHAEL. "Studien zum Stil und zur Stilentwicklung
 Agostino di Duccios." Ph.D. dissertation, University of
 Vienna, 1969, 111 pp.
 See entry 520.

*494 POINTNER, ANDY. Agostino d'Antonio di Duccios Tätigkeit in
 Perugia von 1457–1462. Strasbourg: Heitz, 1909, 56 pp. [Ph.D.
 dissertation, Munich.]

 Monographs on a Single Commission

Tempio Malatestiano

495 BRANDI, CESARE. Il Tempio Malatestiano. Turin: Edizioni
 Radio Italiana, [1956], 204 pp., 75 figs., 3 color pls.
 Deals with architecture and sculptural decoration.
 Although it lacks footnotes and documents, the text presents evidence
 for chronology and authorship of sculpted reliefs by Agostino di
 Duccio. Well illustrated.

496 RICCI, CORRADO. Il Tempio Malatestiano. Milan and Rome:
 Bestetti & Tumminelli, 1925, 612 pp., 663 figs.
 Major study of Tempio Malatestiano and its sculptures, with
 extensive corpus of documents and photographs (including those of
 other Agostino sculptures).

Unpublished Theses

497 SHAPIRO, MAURICE L. "Studies in the Iconology of the Sculp-
 tures in the Tempio Malatestiano." 2 vols. Ph.D. disserta-
 tion, New York University, 1959, 233 pp., 107 figs. [Résumé in
 Marsyas 8 (1957–59):89.]

Reconstructs iconological program for eight chapels of
Tempio, arguing that, contrary to general belief, program is eschato-
logical, spiritual, and ethical rather than pagan or self-glorifying.
New identification for several reliefs, interpretations of which are
based on Neoplatonic theory with sources in St. Augustine's City of
God and Porphyry's Cave of the Nymphs.

Other Commissions

498 POPE-HENNESSY, JOHN. The Virgin and Child by Agostino di
 Duccio. Victoria and Albert Museum Monographs, no. 6. London:
 His Majesty's Stationery Office, 1952, 16 pp., 23 figs.
 Monograph on Madonna and Child relief (Victoria and Albert
Museum, London), considered here early work by Agostino from Rimini,
ca. 1454-55. Discusses stylistic influence of Piero della Francesca
and thematic influence of humanist court of Sigismondo Malatesta.
Reprinted in entry 59.

Articles

499 BALOGH, JOLÁN. "Eine unbekannte Madonna Agostino di Duccios."
 In Hommage à Alexis Petrovics. Budapest: Musée Hongrois des
 Beaux-Arts, 1934, pp. 71-75 (Hungarian text), pp. 198-203
 (German text), 7 figs.
 Attributes a Madonna and Child relief (Camerini collection,
Piazzola) to Agostino in his late period.

500 BERTAUX, E[MILE]. "L'Agostino di Duccio della collezione
 Aynard." Arte 10 (1907):144-46, no illus.
 Reasserts attribution to Agostino in face of Brunelli's
claim (entries 503-4) that relief in Aynard collection is nineteenth-
century forgery.

501 BODE, WILHELM von. "Marble Relief by Agostino di Duccio
 Recently Acquired by the Metropolitan Museum." Art in America
 2 (1914):336-42, 1 fig.
 Acquisition of Aynard relief (the Return of Christ from the
Temple), described as characteristic work by Agostino, ca. 1461.

502 BRUGNOLI, M.V. "Agostino di Duccio (attr.): Putto
 reggifestone." Bollettino d'arte 47 (1962):361-62, no illus.
 Attributes Putto with Garland to Agostino's late period and
associates it with Agostino's documented decoration of putti with
garlands for San Lorenzo, Perugia (1473-74). Pope-Hennessy doubts
attribution, see entry 61.

503 BRUNELLI, ENRICO. "Ancora del Bassorilievo attribuito ad
 Agostino di Duccio nella collezione Aynard." Arte 9
 (1906):454-55, no illus.; 10 (1907):146-48, no illus.
 Reiterates assertion (in entry 504) that relief attributed
to Agostino in Aynard collection is nineteenth-century forgery.

504 BRUNELLI, ENRICO. "Il preteso Agostino di Duccio nella
 collezione Aynard." Arte 9 (1906):379-81, 1 fig.
 Contests attribution to Agostino of relief in Aynard
collection, Lyons, on basis of weak execution and illogical iconog-
raphy. Assigns it to nineteenth century.

505 BRUNETTI, GIULIA. "Il soggiorno veneziano di Agostino di
 Duccio." Commentari 1 (1950):82-88, 8 figs.
 Attributes to Agostino statue of seated St. Louis of Tou-
louse over portal of Sant'Alvise, Venice. Dates statue between 1442
and 1446, hypothesizing that this until now unaccounted-for period in
Agostino's career was spent in Venice. Sojourn would account for
changes in style between early work in Modena and his post-1446
sculpture.

506 BRUNETTI, GIULIA. "Sul periodo 'amerino' di Agostino di
 Duccio." Commentari 16 (1965):47-55, 8 figs.
 Tombs of the Geraldini, San Francesco, Amelia, and Ruggiero
Mandosi, Duomo, Amelia, are redated to post-1484-85. Hypothesizes
they were Agostino's last works, unfinished at his death, and repre-
sent a late style which was dry and linear. Thus extends Agostino's
career by twenty-five years. (Otherwise last known documented work
by Agostino is a 1461 commission in Perugia.)

507 BRUNETTI, GIULIA. "Una Questione di Agostino di Duccio: La
 'Madonna d'Auvillers.'" Rivista d'arte 28 (1953):121-31, 5
 figs.
 Argues that marble relief called "Madonna d'Auvillers" is
workshop copy of original by Agostino in Schloss Rohoncz, Lugano.
The original is dated to Agostino's first sojourn in Perugia. Calls
painted stucco version of this composition in the Bargello, Florence,
autograph.

508 COURAJOD, LOUIS. "La Madone [sic] d'Auvillers." Gazette des
 beaux-arts, 4th per. 8 (1892):129-37, 2 figs.
 Attributes to Agostino marble Madonna d'Auvillers relief
(Parish Church, Auvillers).

509 De NICOLA, GIACOMO. "Due opere sconosciute di Agostino di
 Duccio." Arte 11 (1908):387, no illus.
 Publishes two little-known commissions by Agostino di
Duccio in Amelia, the Tomb of Bishop Giovanni Geraldini (Duomo), and
Tomb of Matteo and Elisabetta Geraldini (San Francesco), both ca.
1477.

510 FIOCCO, GIUSEPPE. "Agostino di Duccio a Venezia." Rivista
 mensile di Venezia 8 (June 1930):1-16, 14 figs. [Expanded
 version in Rivista d'arte 12 (1930):457-84, 16 figs.]
 Argues that Agostino di Duccio assisted Bartolomeo Buon in
execution of Coronation of the Virgin relief for Santa Maria della
Carità, Venice, now transferred to Santa Maria della Salute.

511 G., P. "Una Madonna di Agostino di Duccio a Pontremoli."
 Rivista d'arte 6 (1909):52-54, 1 fig.
 Publishes for first time marble relief of Madonna Adoring
 Child (San Francesco, Pontremoli), attributed here to Agostino di
 Duccio. Argues that it dates ca. 1463, when Agostino worked in
 nearby Bologna.

512 GABORIT, JEAN-RENE. "Hypothèse sur l'origine du bas-relief
 d'Agostino di Duccio dit la 'Madone d'Auvillers.'" Bulletin de
 la Société nationale des antiquaires de France, 1971:142-43, no
 illus. [Résumé.]
 Heraldic emblems in three terracotta copies, obliterated in
 marble original of the Madonna d'Auvillers (Louvre, Paris), permit
 identification of relief as work by Agostino for Piero de' Medici in
 Florence, ca. 1463-70.

513 GOSEBRUCH, MARTIN. "Florentinische Kapitelle von Brunelleschi
 bis zum Tempio Malatestiano und der Eigenstil der Früh-
 renaissance." Römisches Jahrbuch für Kunstgeschichte 8 (1958):
 63-193, 150 figs.
 Special consideration of chronology and meaning of reliefs
 in Tempio Malatestiano, Rimini.

514 GRIGIONI, CARLO. "I costruttori del Tempio Malatestiano in
 Rimini." Rassegna bibliografica dell'arte italiana 11
 (1908):117-28, 155-63, 196-203.
 Still useful for documentation of Agostino's role at Tempio
 Malatestiano.

515 JANSON, HORST W. "An Unpublished Florentine Early Renaissance
 Madonna." Jahrbuch der Hamburger Kunstsammlungen 11 (1966):
 28-46, 11 figs., 1 color pl.
 Attribution of Madonna and Child tondo recently acquired by
 Museum für Kunst und Gewerbe, Hamburg, to Agostino, ca. 1465-70.
 Sculpture characterized as lunette for funerary monument rather than
 domestic devotional image. Pope-Hennessy disputes this attribution,
 see entry 61.

516 JANSON, H[ORST] W. "The Beginnings of Agostino di Duccio."
 College Art Journal 1, no. 3 (March 1942):72-73, no illus.
 Summary of talk presented at College Art Association meet-
 ings. Attributes to Agostino di Duccio, rather than Pagno di Lapo,
 marble relief of Madonna and Child (Museo dell'Opera del Duomo,
 Florence). Style suggests Agostino was trained by Luca della Robbia
 rather than by Donatello, as is generally argued. Discussion of
 Agostino's Madonna and Child compositions.

517 JANSON, HORST W. "Madonna mit Kind." Stiftung zur Forderung
 der Hamburgischen Kunstsammlungen Erwerbungen, 1965:34-38, 1
 fig., 1 color pl.
 Brief essay tentatively attributing newly acquired poly-
 chromed marble tondo of Madonna and Child to Agostino di Duccio.

518 JANSON, HORST W. "Die stilistische Entwicklung des Agostino di
 Duccio mit besonderer Berücksichtigung des Hamburger Tondo."
 Jahrbuch der Hamburger Kunstsammlungen 14-15 (1970):105-28, 37
 figs.
 Establishes chronology for Agostino, relating his stylistic
 shifts to influence of contemporaries like Filarete, Donatello, Luca
 della Robbia, and in the Tempio Malatestiano, to different expressive
 goals. Attributes Madonna and Child tondo in Hamburg to Agostino,
 ca. 1460, when he was under influence of Rossellino brothers.

519 JANSON, H[ORST] W. "Two Problems in Florentine Renaissance
 Sculpture." Art Bulletin 24 (1942):326-34, 8 figs.
 Reattribution of Madonna and Child (Museo dell'Opera del
 Duomo, Florence) from Pagno di Lapo to Agostino through stylistic
 comparison with Agostino's early Madonna reliefs. Discussion of
 Agostino's relationship to Luca della Robbia prior to his assimila-
 tion of Michelozzo's influence. Opera Madonna considered as earliest
 commission in revised chronology of Agostino's Madonna reliefs.

520 KUHLENTHAL, MICHAEL. "Studien zum Stil und zur Stilentwicklung
 Agostino di Duccios." Wiener Jahrbuch für Kunstgeschichte 24
 (1971):59-100, 73 figs. [Derived from Ph.D. dissertation,
 University of Vienna, 1969 (entry 493).
 Examines stylistic development of Agostino's middle period
 and concludes that Matteo de' Pasti was designer of sculptural
 program of Tempio Malatestiano, Rimini, but attributes execution to
 Agostino on basis of penchant for linearity, low relief, eccentric
 poses, and specific use of color.

521 MICHEL, ANDRÉ. "La Madone dite d'Auvillers." Monuments et
 mémoires publiés par l'Académie des inscriptions et belles-
 lettres 10 (1903):95-103, 4 figs.
 History of marble Madonna d'Auvillers relief acquired by
 Louvre in 1892, including publication of two related works, apparent-
 ly contemporary variants: marble relief (Museo dell'Opera del Duomo,
 Florence) and stucco relief (Villa Petraia, Castello).

522 MIDDELDORF, ULRICH. "On the Dilettante Sculptor." Apollo 107
 (1978):310-22, 13 figs.
 History of dilettantism in sculpture that focuses on con-
 tribution of noted amateur, Matteo de' Pasti (died before 1467), in
 design of Tempio Malatestiano, Rimini. Ascribes conception of inter-
 ior reliefs to Matteo and relegates Agostino di Duccio to role of
 "master sculptor." Discusses Bertoldo, a close friend and perhaps
 relative of Lorenzo de' Medici, as dilettante sculptor. Reprinted in
 entry 54.

523 MITCHELL, CHARLES. "An Early Christian Model for the Tempio
 Malatestiano." In Intuition und Kunstwissenschaft:
 Festschrift für Hanns Swarzenski zum 70. Geburtstag am 30.
 August 1973. Edited by Peter Bloch, Tilmann Buddensieg, Alfred
 Hentzen, and Theodor Müller. Berlin: Gebr. Mann Verlag, 1973,
 pp. 427-38, 8 figs.

Model for interior of Tempio Malatestiano, designed by Matteo de' Pasti (ca. 1449), was Baptistry of Ravenna, thus providing example of a direct Renaissance quotation from Early Christian/ classical architecture. Clarifies chronology of Tempio interior construction.

524 MITCHELL, CHARLES. "The Imagery of the Tempio Malatestiano."
 Studi romagnoli 2 (1951):77-90, no illus. [Derived from Ph.D. dissertation, Warburg Institute, 1952.]
 Tempio imagery based on complex Neoplatonic iconography that simultaneously celebrates descent of Sigismondo Malatesta to earth as Sol/Apollo (based on Macrobius' Saturnalia) and charts progress of Sigismondo's immortal soul through heavens after death (based on Macrobius's Commentary on the Somnium Sciponius). Iconographic plan attributed to Alberti and Matteo de' Pasti.

525 PAOLETTI, JOHN T. "The Bargello David and Public Sculpture in Fifteenth-Century Florence." In Collaboration in Italian Renaissance Art (Charles Seymour, Jr. Festschrift). Edited by Wendy S. Sheard and John T. Paoletti. New Haven and London: Yale University Press, 1978, pp. 99-111, 3 figs.
 Extends Seymour's suggestion (entries 1043-44) that Donatello conceived colossal marble David for buttress of tribune of Florence Duomo in 1463, with Agostino as his assistant. Claims that bronze David (Bargello, Florence) universally attributed to Donatello, is cast from 1463 modello for buttress figure and was probably made after Donatello's death.

526 POINTNER, ANDY. "Un'opera finora sconosciuta di Agostino di Duccio." Rassegna d'arte 7 (November 1907):175-76, 1 fig.
 Attributes to Agostino half-length relief figure of Praying Virgin (Canonica di San Lorenzo, Perugia).

527 PORTOGHESI, PAOLO. "Il Tempio Malatestiano." In La vicenda figurativa del Quattrocento. Edited by Luciano Berti, et al. Florence: Sadea; Sansoni, 1966, pp. 25-31, 30 color pls.
 Valuable for large-scale color illustrations of sculptural decoration of Tempio Malatestiano, Rimini.

528 RAGGHIANTI, CARLO L. "Problemi di Agostino di Duccio." Critica d'arte 7 (1955):2-21, 13 figs.
 Analyzes documents and style of reliefs in the Tempio Malatestiano to establish their chronology and the role of assistants.

529 RAVAIOLI, CARLA. "Agostino di Duccio a Rimini." Studi romagnoli 2 (1951):113-20, no illus.
 Brief summary of Agostino's work in Rimini and problems connected with it.

530 ROSENAUER, ARTUR. "Bemerkungen zu einem frühen Werk Agostino di Duccios." Münchner Jahrbuch der bildenden Kunst 28 (1977):133-52, 19 figs.

111

Unusual, freestanding Madonna and Child in portal lunette of sacristy, Santa Maria del Carmine, Florence, ca. 1441, is discussed as early work by Agostino. Type derives from Nanni di Bartolo, but sculpture already shows tension between surface drawing and solidity of stone block characteristic of Agostino. Abstraction of figure indicates influence of Michelozzo and Jacopo della Quercia.

531 ROSSI, ADAMO. "Prospetto cronologico della vita e delle opere di Agostino d'Antonio, scultore fiorentino, con la storia e i documenti di quelle da lui fatte in Perugia." Giornale d'erudizione artistica 4, no. 1 (January 1875):3-25, no illus.; no. 2 (February 1875):33-50, no illus.; no. 3 (March 1875): 76-83, no illus.; no. 4 (April 1875):117-22, no illus.; no. 5 (May 1875):141-52, no illus.; no. 6 (June 1875):179-84, no illus.; no. 7 (July 1875):202-11, no illus.
 Publication of documents regarding Agostino's Perugian period: his work on façade of San Bernardino, the altar of San Lorenzo in San Domenico, the altar of the Pietà in San Lorenzo, city gates in the section of San Pietro, and Chapel of San Bernardino in the Duomo.

532 RUGGERI AUGUSTI, ADRIANA. "Un rilievo di Agostino di Duccio." Critica d'arte, n.s. 39, no. 133 (1974):41-48, 7 figs.; no. 134 (1974):53-61, 8 figs.
 First publication of frieze with bust of a girl flanked by frolicking putti from private collection in Capannoli (Pisa). Its similarities to Prato Pulpit are used to hypothesize that Agostino collaborated on the pulpit and to substantiate theory that he was trained in Donatello/Michelozzo shop. Analysis of speculation regarding Agostino's artistic formation, his Venetian sojourn, and Bartolomeo Buon's influence.

533 SANTI, F. "L'altare di Agostino di Duccio in S. Domenico di Perugia." Bollettino d'arte 46 (1961):162-73, 25 figs.
 Publishes newly restored altar of San Lorenzo in San Domenico, Perugia, commissioned from Agostino in 1459. Notes removal of post-fifteenth-century repaint and modifications.

534 SCHUBRING, PAUL. "Matteo de' Pasti." In Kunstwissenschaftliche Beiträge August Schmarsow gewidmet. Leipzig: Verlag von Karl W. Hiersemann, 1907, pp. 103-14, 7 figs.
 Summary of Matteo de' Pasti's career as medallist, painter, and amateur architect. Focuses on his designs for relief cycle of the Tempio Malatestiano, showing how his humanist training underlies iconography of Chapel of Planets. His stylistic influence established through comparing reliefs with his paintings.

535 URBINI, G. "Agostino Ducci." In Thieme-Becker Künstler-Lexikon. Leipzig: Wilhelm Engelmann, 1907, 1: 127-28.
 Condensed survey of life and work. Valuable bibliography.

536 V[ALENTINER], W.R. "Renaissance Sculptures." Bulletin of the
 Metropolitan Museum of Art 9, no. 6 (June 1914):142-45, 2 figs.
 Records acquisition of terracotta Pietà by Benedetto da
Maiano and marble relief (known as the Aynard relief) attributed to
Agostino di Duccio.

537 VENTURI, ADOLFO. "Pietro Lombardi e alcuni bassirilievi
 veneziani del '400." Arte 33, no. 2, n.s. 1 (March 1930):
 191-205, 15 figs.
 Harsh critique of Planiscig's article on Venetian sculpture
("Pietro Lombardi e alcuni bassirilievi veneziani del '400," Dedalo
10 [January 1930]:461-81, 24 figs.), specifically his attribution to
Agostino of relief of St. Paul on His Way to Damascus (San Marco,
Venice), and his attribution of Madonna di Solarola relief to Pietro
Lombardo rather than Francesco di Simone Fiesolano [Ferrucci] (Ven-
turi's attribution).

538 ZANOLI, ANNA. "Un messaggio di buon augurio dal Tempio
 Malatestiano." Paragone 20, no. 229 (1969):49-52, 1 fig.
 Disputes iconographic interpretations by Charles Mitchell,
Corrado Ricci, and Cesare Brandi (entries 495-96 and 524), of relief
in the Chapel of the Planets, which she reidentifies as "The Ship-
wreck of Sigismondo Malatesta on the Isola Fortunata."

539 ZANOLI, ANNA. "Il tabernacolo di Forno di Agostino di Duccio."
 Arte antica e moderna 13-17 (1961):148-50, 2 figs.
 Attributes tabernacle representing Trinity to Agostino di
Duccio, ca. 1454-57 (Abbey, Forno, near Forlì). Pope-Hennessy
rejects attribution, see entry 61.

ALBERTI

 Books

540 GADOL, JOAN. Leon Battista Alberti: Universal Man of the
 Early Renaissance. London and Chicago: University of Chicago
 Press, 1969, 281 pp., 64 figs.
 Intellectual biography of Alberti that explores all aspects
of his thought and its relationship to aesthetic, cosmological,
ethical, and scientific trends in Early Renaissance culture. Impor-
tant discussions of theories of perspective and proportion.

540a Galantic, Ivan. Review of Leon Battista Alberti: Universal
 Man of the Early Renaissance, by Joan Gadol. Art Quarterly 34,
 no. 4 (1971):482-85, no illus.
 Disputes author's dependence on mathematics as key to
Alberti's intellectual activity. Review summarizes unsystematic
pattern of Alberti's thought.

540b Westfall, Carroll W. Review of Leon Battista Alberti:
 Universal Man of the Early Renaissance, by Joan Gadol. Art
 Bulletin 53 (1971):526-28, no illus.

541 MANCINI, GIROLAMO. <u>Vita di Leon Battista Alberti</u>. 2d ed.
 Rome: Bardi, 1967, 527 pp., 51 figs. [Reprint of 1911 ed.,
 Florence: G. Carnesecchi & Sons, 527 pp.]
 Major scholarly study of Alberti's life and writings that
 sets his achievements within context of fifteenth-century Italy.

542 MICHEL, PAUL-HENRI. <u>Un idéal humain au XV^e siècle: La</u>
 <u>pensée de L.B. Alberti, 1404-1472</u>. Paris: Société d'Éditions
 "Les Belles Lettres," 1930. Reprint. Geneva: Slatkine
 Reprints, 1971, 643 pp., illus., diags. [Ph.D. dissertation,
 University of Paris, 1930.]
 "Thorough, though not always clear, presentation of
 Alberti's philosophy" (Krautheimer, entry 1179). Considers all
 aspects of Alberti's life: his architecture, theory, art, science,
 and social role. Summarizes Alberti's biography and contains a
 bibliography of writings.

 Articles

543 BADT, KURT. "Drei plastische Arbeiten von Leone Battista
 Alberti." <u>Mitteilungen des Kunsthistorischen Institutes in</u>
 <u>Florenz</u> 8 (1958):78-87, 4 figs.
 Attributes to Alberti two bronze plaquettes with self-
 portraits (National Gallery of Art, Washington, D.C., and Louvre,
 Paris), and a <u>Bust of Ludovico III Gonzaga</u> (Staatliche Museen,
 Berlin-Dahlem), which exhibit his dilettantism in their formal
 indecisiveness and technical deficiencies.

544 KIEFER, FREDERICK. "The Conflation of Fortuna and Occasio in
 Renaissance Thought." <u>Journal of Medieval and Renaissance</u>
 <u>Studies</u> 9, no. 1 (1979):1-27, 10 figs.
 Traces change in Renaissance iconography of Fortuna as
 compared to medieval representations and explores important role of
 Ruccellai <u>impresa</u> designed by Alberti for courtyard of Palazzo
 Ruccellai, Florence, in effecting that modification.

545 "Leone Battisti Alberti." Special issue of <u>Kunstchronik</u> 13
 (1960):337-73.
 Résumés of papers presented to the Zentralinstitut für
 Kunstgeschichte, Munich, March 7-9, 1960. Includes: E. Battisti,
 "Schauspiel und Theater im Werke Leon Battista Albertis"; H. Marder-
 steig, "L.B. Alberti und die Wiederbelebung der klassischen römischen
 Lapidarschrift im 15. Jahrhundert"; O. Lehmann-Brockhaus, "Albertis
 'Descriptio Urbis Romae'"; G. Soergel, "Die Proportionslehre Albertis
 und ihre Anwendung an der Fassade von S. Francesco in Rimini"; L.H.
 Heydenreich, "Die Cappella Ruccellai und die Badia Fiesolana:
 Untersuchung über architektonische Stilformen Albertis"; E. Hubala,
 "Sant'Andrea in Mantua: Beobachtungen zur ersten Bauphase"; C.
 Grayson, "Die Entstehung von Albertis Decem Libri 'De Re
 Aedificatoria'"; R. Krautheimer, "Albertis Templum Hetruscum"; A.
 Chastel, "Die künstlerische Erfahrung bei Alberti."

Individual Sculptors

546 SUIDA, W[ILLIAM]. "Alberti, Leone Battista." In Thieme-Becker
 Künstler-Lexikon. Leipzig: Wilhelm Engelmann, 1907,
 1:196-211.
 Condensed survey of life and work. Valuable bibliography.

ALBIZZO DI PIERO (ALBIZO DI PIERO)

547 ANON. "Albizo di Piero." In Thieme-Becker Künstler-
 Lexikon. Leipzig: Wilhelm Engelmann, 1907, 1:229.
 Condensed survey of life and work. Valuable bibliography.

548 KREYTENBERG, GERT. "Perfetto di Giovanni e Albizzo di Piero:
 Sulla scultura tardo-gotica all'inizio del Quattrocento a
 Firenze." Prospettiva 18 (July 1979):48-53, 20 figs.
 Discusses tabernacles by Perfetto di Giovanni at San Simone
 and Orsanmichele and architectural ornament by Albizzo di Piero at
 Orsanmichele as examples of the survival of Gothic style in early
 fifteenth-century sculpture.

549 WUNDRAM, MANFRED. "Albizzo di Pietro: Studien zur Bauplastik
 von Orsanmichele in Florenz." In Das Werk des Künstlers,
 Studien Ikonographie und Formgeschichte: Hubert Schrade zum
 60. Geburtstag dargebrächt von Kollegen und Schülern. Edited
 by Hans Feger. Stuttgart: W. Kohlhammer Verlag, 1960, pp.
 161-76, 6 figs.
 Previously unpublished documents clarify participation of
 various sculptors at Orsanmichele. In particular, Albizzo di Piero
 is identified as master of West Portal (1412-18), left unfinished by
 Niccolò Lamberti. Documents and identification of Albizzo's style
 permit attribution to him of St. Mark tabernacle (1411-15) and St.
 John tabernacle (1415). These precise datings influence chronology
 of Donatello's St. Mark and St. George.

ANDREA DA FIESOLE (ANDREA DI GUIDO DA FIESOLE)

550 BACCI, PELEO. "Documenti su Benedetto da Maiano e Andrea da
 Fiesole relativi al 'Fonte battesimale' del Duomo di Pistoia."
 Rivista d'arte 2 (1904):271-84, no illus.
 Publishes series of documents dating from 1497 to 1499 that
 discuss Andrea da Fiesole's and Benedetto's work on Cappella del
 Battesimo, Duomo, Pistoia.

551 BETTINI, SERGIO. "Un'opera sconosciuta di Andrea da Fiesole."
 Arte 34 (1931):506-12, 4 figs.
 Attributes to Andrea da Fiesole relief of St. Mark Blessing
 in San Pietro, Padua, and dates it 1424. Uses this sculpture to
 attribute to Andrea architectural decoration at San Petronio,
 Bologna.

552 BOTTARI, STEFANO. "Per Andrea di Guido da Firenze." Arte
 antica e moderna 1 (1958):285-95, 12 figs.
 Argues that references in Bolognese documents to "Andrea
Guidonis de Florentia," and "Andrea di Fiexoli" or "de Fesuli" refer
to two different artists, Andrea da Firenze and Andrea da Fiesole,
who have been conflated by most art historians. Andrea Guidonis da
Florentia is documented as working at San Petronio, Bologna, from
1392 to 1397, and Andrea da Fiesole is documented as working at San
Petronio, San Domenico, and the Palazzo dei Notai, Bologna, from 1412
to 1428. Attribtues many sculptures in Bologna to Andrea da Firenze.

553 GNUDI, CESARE. "Intorno ad Andrea da Fiesole." Critica d'arte
 3, no. 13 (1938):23-29, 21 figs.
 Analyzes early fifteenth-century Bolognese sculpture, in
particular the work of Andrea da Fiesole, to whom he attributes
several sculptures (relief of St. Peter between SS. Paul and Bene-
dict, San Pietro, Padua and Tomb Slab of B. Zambeccari, Museo civico,
Bologna) on basis of their similarities to Saliceto Monument.

554 MALAGUZZI-VALERI, F[RANCESCO]. "Andrea di Guido da Fiesole."
 In Thieme-Becker Künstler-Lexikon. Leipzig: Wilhelm
 Engelmann, 1907, 1:456.
 Condensed survey of life and work. Valuble bibliography.

555 SUPINO, I[GINO] B. "Andrea da Fiesole in Bologna." Rivista
 d'arte 6 (1909):228-32, 1 fig.
 Analyzes Andrea da Fiesole's activity in Bologna. Includes
documents. See Supino's later book (entry 200).

 ANDREA DA FIRENZE (ANDREA NOFRI)

556 ANON. "Andrea da Firenze." In Thieme-Becker Künstler-Lexikon.
 Leipzig: Wilhelm Engelmann, 1907, 1:453.
 Condensed survey of life and work. Valuable bibliography.

557 FILANGIERI di CANDIDA, RICCARDO. "La scultura in Napoli nei
 primi albori del Rinascimento." Napoli nobilissima, 2d ser. 1
 (1920):89-94, 4 figs.
 Challenges assignment to Andrea da Firenze of Tomb of King
Ladislao (San Giovanni a Carbonara, Naples). Concludes that tomb was
worked on by little-known Florentine sculptors but is part of Neapol-
itan Gothic tradition, not first Renaissance monument in Naples, as
had been claimed.

 ANDREA DELL'AQUILA

558 ANON. "Aquila, Andrea dell'." In Thieme-Becker Künstler-
 Lexikon. Leipzig: Wilhelm Engelmann, 1908, 2:49.
 Condensed survey of life and work. Valuable bibliography.

559 BONGIORNO, LAURINE M. "The Date of the Alar of the Madonna in
 S. Maria del Soccorso, Aquila." Art Bulletin 26 (September
 1944):188-92, 9 figs.
 Eclectic, derivative style of Altar of the Madonna reveals
 influences of Verrocchio and Antonio Rossellino. These influences,
 plus documents confirming consecration of church in 1469, suggest
 dating of ca. 1482-85 (rather than ca. 1445, as supposed by
 Valentiner, see following entry). Altar therefore not by Andrea
 dell'Aquila, but contemporary of Silvestro dell'Aquila.

560 VALENTINER, W.R. "Andrea and Silvestro dell'Aquila." Art in
 America 13, no. 4 (June 1925):166-77, 6 figs.
 Clarification of their work showing influence of Donatello
 on Andrea in large tabernacle (Madonna del Soccorso, Aquila) and
 Madonna and Child relief (Metropolitan Museum of Art, New York),
 generally given to Antonio Rossellino. Silvestro (also called
 L'Ariscola) was influenced by Rossellino in Rome and Naples, as shown
 by Tomb of Maria Camponeschi (San Bernardino, Aquila, ca. 1500-1505)
 and smaller wooden Madonnas (Detroit Institute of Arts; and another
 formerly in Kaiser Friedrich Museum, Berlin).

561 VALENTINER, W.R. "Andrea dell'Aquila in Urbino." Art
 Quarterly 1 (1938):275-88, 12 figs.
 Attributes to Andrea dell'Aquila limestone Bust of Princess
 of Urbino, probably Elizabetta da Montefeltro (Staatliche Museen-Bode
 Museum, East Berlin). Bust has been attributed to Desiderio and
 Francesco di Giorgio.

562 VALENTINER, W.R. "Andrea dell'Aquila: Painter and Sculptor."
 Art Bulletin 19 (1937):503-36, 43 figs.
 Analysis of work of Andrea dell'Aquila. Clarifies various
 sculptors' contributions to Triumphal Arch of Alphonso I of Aragon,
 Naples, 1452-68, and Andrea's sculpture in Aquila and Rome. As
 painter Andrea dell'Aquila is identified as so-called "Master of
 Castello Nativity."

 ANTONIO DA FIRENZE

563 FIOCCO, GIUSEPPE. "Antonio da Firenze." Rivista d'arte 22, 2d
 ser. 12, nos. 1-2 (1940):51-67, 7 figs.
 Attributes to Antonio da Firenze Tomb of Spinetta Malaspina
 (Victoria and Albert Museum, London) and situates this monument
 within his oeuvre. Monument shows collaboration of Pietro Lamberti.

564 MALAGUZZI-VALERI, FRANCESCO. "Antonio da Firenze." In Thieme-
 Becker Künstler-Lexikon. Leipzig: Wilhelm Engelmann, 1907,
 1:590.
 Condensed survey of life and work. Valuable bibliography.

ANTONIO DI BANCO

565 KNAPP, FRITZ. "Banco, Antonio di." In Thieme-Becker Künstler-Lexikon. Leipzig: Wilhelm Engelmann, 1908, 2:435.
 Condensed survey of life and work. Valuable bibliography.

566 WUNDRAM, MANFRED. "Antonio di Banco." Mitteilungen des Kunsthistorischen Institutes in Florenz 10, no. 1 (May 1961): 23-32, no illus. [Résumé in Italian.]
 Analyzes documents outlining life and artistic activities of Antonio di Banco (ca. 1345/48-1415), father of Nanni di Banco and briefly capomaestro of the Florentine Duomo (elected 1414). Discusses his influence on Nanni di Banco and sculpture of Porta della Mandorla.

ANTONIO DI CHELLINO

567 FABRICZY, CORNELIUS de. "Antonio di Chellino da Pisa." Arte 9 (1906):442-45, 2 figs.
 Attributes an unpainted terracotta relief (Bargello, Florence) to this Paduan assistant of Donatello and discusses his career briefly.

568 SEMRAU, MAX. "Antonio di Chellino (Michellino) da Pisa." In Thieme-Becker Künstler-Lexikon. Leipzig: Wilhelm Engelmann, 1907, 1:583.
 Condensed survey of life and work. Valuable bibliography.

569 ZIPPEL, GIUSEPPE. "Artisti alla corte degli Estensi nel Quattrocento." Arte 5 (1902):405-7, no illus.
 Transcribes part of oration by Lodovico Carbone, ca. 1460, that mentions artist, Antonio da Pisa, as working at Este court. Identifies him wtih Antonio di Chellino da Pisa (which is questioned by Hersey, entry 208).

NICCOLÒ DI GIOVANNI BARONCELLI (NICCOLÒ DAL CAVALLO)

570 AGNELLI, GIUSEPPE. "I monumenti di Niccolò III e Borso d'Este in Ferrara." Atti e memorie della Deputazione ferrarese di storia patria 23 (1919):3-34, 23 figs.; 26 (1926): ii-xviii, no illus.
 Thorough, solid discussion of available evidence concerning commission and original appearance of Baroncelli's Equestrian Monument of Niccolò III (1451) and Seated Statue of Borso d'Este (1454), destroyed in 1796. Based on documents, sources, sketches and prints after the sculptures.

571 CITTADELLA, LUIGI N. Notizie amministrative, storiche, artistiche relative a Ferrara, recavate dai documenti. 2 vols. Ferrara: Taddei, 1868, 1161 pp., no illus.

Compilation of information on all aspects of Ferrara, with sections on major monuments and commissions. Significant summary of available information about Baroncelli's equestrian monument for Niccolò d'Este, publishing documents about commission. For Baroncelli, see esp. pp. 46-49, 415-22.

572 De NICOLA, GIACOMO. "Baroncelli, Niccolò." In Thieme-Becker Künstler-Lexikon. Leipzig: Wilhelm Engelmann, 1908, 2:517.
 Condensed survey of life and work. Valuable bibliography.

573 FIOCCO, GIUSEPPE. "Sulle relazioni tra la Toscana e il Veneto nei secoli XV e XVI." Rivista d'arte 11, 2d ser. 1 (1929): 439-48, 7 figs.
 Discusses significance of Rigoni's publication of documents proving Baroncelli's presence in Padua in 1434, thus updating infusion of Tuscan influence in sculpture there.

574 LORENZONI, GIOVANNI. "L'attività padovana di Nicolò Baroncelli." Rivista d'arte 36, 3d ser. 11 (1961-62):27-52, 10 figs.
 Analysis of Baroncelli's sculptures from his Paduan sojourn (1434-43), which shows influence of Brunelleschi and Donatello. Documented commissions include relief of Miracle of St. Eligius, Museo civico, a fragment of retable for San Clemente (1440); and portal of the Eremitani (1441-42). Several new attributions.

575 RIGONI, ERICE. "Il soggiorno in Padova di Nicolò Baroncelli." Atti e memorie dell'accademia di scienze, lettere, ed arti in Padova, n.s. 43 (1926-27):215-38. Reprinted in Erice Rigoni, L'arte rinascimentale in Padova: Studi e documenti (Padua: Editrice Antenore, 1970), pp. 75-96, 1 fig.
 Publication of documents that prove for first time Baroncelli's sojourn in Padua (1434-42) and his commissions there, notably decoration around side door of Eremitani.

576 RIGONI, ERICE. "Una terracotta di Nicolò Baroncelli a Padova." Archivio veneto tridentino 10 (1926):180-85. Reprinted in Erice Rigoni, L'arte rinascimentale in Padova: Studi e documenti (Padua: Editrice Antenore, 1970), pp. 97-102, no illus.
 Publication of documents concerning Baroncelli's polychromed terracotta Miracle of St. Eligius from San Clemente, Padua, part of stone and terracotta altarpiece commissioned in 1440 and now lost.

BENEDETTO DA MAIANO

Books

577 CENDALI, LORENZO. Giuliano e Benedetto da Majano. Florence: Società Editrice Toscana, [1926], 192 pp., 60 figs.
 Superficial discussion of biography, sculpture,

119

architecture, <u>tarsia</u>, and drawings of both. Appendix of a few docu-
ments. Bibliography. Fuzzy illustrations. No footnotes. [Pope-
Hennessy (entry 61): "Should be read in conjunction with Schott-
müller (entry 603).]

578 DUSSLER, L[UITPOLD]. <u>Benedetto da Majano: Ein Florentiner
 Bildhauer des späten Quattrocento.</u> Munich: Hugo Schmidt,
 1924, 84 pp., 37 figs.
 Brief, superficial text with chapters on reliefs, portrait
sculpture, and statues. Notes and bibliography. No index. [Pope-
Hennessy (entry 61): "Should be read in conjunction with Schott-
müller" (entry 603).]

 Articles
579 BABELON, JEAN. "Un médaillon de cire du Cabinet des médailles:
 Filippo Strozzi et Benedetto da Majano." <u>Gazette des beaux-
 arts</u>, 5th per. 4 (October 1921):203-10, 4 figs.
 Red wax medallion of Filippo Strozzi (Cabinet des
médailles, Bibliothèque nationale, Paris) is original model for known
medal, here attributed to Benedetto da Maiano. Discussion of
Strozzi's patronage and Benedetto's bust of him (Louvre, Paris).

580 BODE, W[ILHELM] von. "Jugendwerke des Benedetto da Majano."
 <u>Repertorium für Kunstwissenschaft</u> 7 (1884):149-62, no illus.
 Examines early work of Benedetto da Maiano, especially work
in Marches: Tomb of Barbara Manfredi, San Biagio, Forlì (ca. 1468);
Shrine of San Savino, Duomo, Faenza (1471-72); Tomb of Sigismondo
Malatesta, San Francesco, Rimini. Discussion of busts and smaller
works and his relationship with Antonio Rossellino and Desiderio.

581 BORSOOK, EVE. "Documents for Filippo Strozzi's Chapel in Santa
 Maria Novella and Other Related Papers." <u>Burlington Magazine</u>
 112, no. 812 (November 1970):737-45, 800-804, 10 figs. CORTI,
 GINO. "Notes on the Financial Accounts of the Strozzi Chapel."
 <u>Burlington Magazine</u> 112, no. 812 (November 1970):746-47, 1 fig.
 Newly discovered documents (Archivo di stato, Florence)
pertaining to Strozzi Chapel, Santa Maria Novella, Florence, provide
specific dating of Filippino Lippi's frescoes (1487-1501) and history
of Benedetto da Maiano's relations with Strozzi, ca. 1491-95.

582 CARL, DORIS. "Der Fina-Altar von Benedetto da Mainao in der
 Collegiata zu San Gimignano zu seiner Datierung und Rekonstruc-
 tion." <u>Mitteilungen des Kunsthistorischen Institutes in
 Florenz</u> 22, no. 3 (1978):265-86, 16 figs.
 Reconstruction of Benedetto da Maiano's Santa Fina Altar
(Collegiata, San Gimignano) based on newly discovered documents.
Format combined fourteenth-century type of saints' tombs, perhaps
specifically that of earlier tomb of Sta. Fina, with a wall taber-
nacle. Documents prove the chapel was built from 1468 to 1472,
altarpiece from 1472 to 1477, and main altar ciborium in 1487.

583 CASPARY, HANS. "Ein Relieffragment des Benedetto da Maiano im Museo civico von San Gimignano." In Festschrift Ulrich Middeldorf. Edited by Antje Kosegarten and Peter Tigler. Berlin: Walter de Gruyter & Co., 1968, pp. 165-74, 9 figs.
 Putti relief fragments preserved in Museo civico, San Gimignano, are from frieze of high altar of Collegiata, San Gimignano (now restored), by Benedetto da Maiano.

584 DUSSLER, LUITPOLD. "A Clay Model by Benedetto da Majano for the Altar in Monte Oliveto, Naples." Burlington Magazine 45, no. 256 (July 1924):21-23, 2 figs.
 Discusses three studies (Oscar Bondy collection, Vienna) for marble altar of Annunciation in Mastrogiudice Chapel, Sant'Anna dei Lombardi [Monteoliveto], Naples (late 1480s). Clay study for St. John the Evangelist of same altar is also known (Lanz collection, Amsterdam).

585 DUSSLER, LUITPOLD. "Unpublished Terracottas of the Late Quattrocento." Burlington Magazine 43 (September 1923):128-31, 4 figs.
 Publishes little-known terracotta busts: two attributed to Benedetto da Maiano and an Ecclesiastic, attributed to Giovanni della Robbia (Michel van Gelder collection, Chateau Zeebrugge, near Brussels).

586 FABRICZY, CORNELIUS von. "Toscanische und oberitalienische Künstler in Diensten der Aragonescen zu Neapel." Repertorium für Kunstwissenschaft 20 (1897):85-120, no illus.
 Account books, preserved in Archivo di stato, Naples, record patronage of Alphonso I of Naples (ruled 1437-58). All documents pertaining to Italian artists are transcribed, including those for Giuliano and Benedetto da Maiano and Francesco di Giorgio.

587 FRIEDMAN, DAVID. "The Burial Chapel of Filippo Strozzi in Santa Maria Novella in Florence." Arte, n.s. 9 (1970):109-31, 12 figs. [Résumés in Italian, German, and French.]
 Funerary chapel of Filippo Strozzi (died 1491) was planned by him in 1487 but not completed until 1502. Its unique visual combination of tomb and altar commemorates life of deceased and celebrates salvation of his soul. These themes, plus influence of Savonarola, are relected in decorations by Filippino Lippi and Benedetto da Maiano.

588 GENNARI, GUALBERTO. "La Madonna della Scaletta: Terracotta inedita di Benedetto da Maiano a Lugo di Romagna." Arte 57 (1958):285-94, 5 figs.
 Publishes Madonna della Scaletta, which author considers an early Benedetto contemporary with Shrine of San Savino, Duomo, Faenza. Sculpture had great influence on terracotta and majolica works in Romagna.

589 GIANUIZZI, PIETRO. "Benedetto da Maiano, scultore in Loreto."
 Archivio storico dell'arte 1 (1888):176-81, 2 figs.
 Disputes some of Bode's attributions (entry 580) of Loreto
 sculptures to Benedetto da Maiano.

590 GONSE, LOUIS. "Le Buste de Philippe Strozzi au Louvre."
 Gazette des beaux-arts, 2d per. 19 (January 1879):43-57, 1
 fig.
 Marble Bust of Filippo Strozzi (Louvre, Paris) is attri-
 buted to Benedetto da Maiano, ca. 1490, during period in which
 Strozzi was his principal patron.

591 GRUYER, GUSTAVE. "Les monuments de l'art à San Gimignano."
 Gazette des beaux-arts, 2d per. 4 (1870):26-37, 162-79, no
 illus., esp. pp. 170-74.
 Guidelike article useful for description and discussion of
 tomb chapel of Santa Fina with tabernacle by Benedetto da Maiano,
 (1490-93) in Collegiata, San Gimignano.

592 HERSEY, GEORGE L. "Alfonso II, Benedetto e Giuliano da
 Majano, e la Porte Reale." Napoli nobilissima 4 (1964):77-95,
 19 figs.
 Inventory of sculpture in Benedetto's studio compiled at
 his death mentions two pieces identifiable with The Coronation of
 Alphonso II of Aragon (now in Bargello, Florence), and connected with
 Vasari's mention that Benedetto worked for Alphonso on an unrealized
 Neapolitan triumphal arch.

593 LISNER, MARGRIT. "Zu Benedetto da Maiano und Michelangelo."
 Zeitschrift für Kunstwissenschaft 12 (1968):141-56, 15 figs.
 Hypothesizes that youthful Michelangelo participated with
 Benedetto da Maiano in work on Altar of the Annunciation, ca. 1489
 (Sant'Anna dei Lombardi [Monteoliveto], Naples). Right putto and
 Virgin's head reflect Michelangelo's early style.

594 MARQUAND, ALLAN. "A Lunette by Benedetto da Majano." Burling-
 ton Magazine 40, no. 228 (March 1922):128-31, 1 fig.
 Newly discovered document of 1496 allows attribution to
 Benedetto da Maiano of glazed terracotta lunette of San Lorenzo with
 Two Angels (Refectory, Certosa Monastery, near Florence), generally
 given to Della Robbia shop. Notes Benedetto's work in terracotta.

595 MIDDELDORF, ULRICH. "A Forgotten Florentine Tomb of the
 Quattrocento." Antichità viva 14 (1976):11-13, 4 figs.
 Little-known Tomb of Antonio di Bellincioni (d. 1477) in
 Santa Maria dell'Impruneta, near Florence, and related Madonna and
 Child tondo are possibly by follower of Benedetto da Maiano.
 Reprinted in entry 54.

596 MORSELLI, PIERO. "Il pulpito del Quattrocento già in San
 Pancrazio di Firenze." Antichità viva 18, nos. 5-6 (1979):
 30-31, 2 figs.

Newly discovered documents prove that Bartolomeo di Salvatore Lorenzi carved marble pulpit from San Pancrazio, Florence, today in San Michele in Pianezzoli, Empoli. Pulpit was previously attributed to Benedetto da Maiano.

597 NUTI, RUGGERO. "La Cappella dei Talducci in S. Trinità di Prato." Rivista d'arte 16, 2d ser. 6 (July-September 1934): 297-303, no illus.
Publishes documents concerning this destroyed chapel for which Benedetto made a terracotta Pietà with SS. John and Mary Magdalen, similar to his Pietà for Santa Maria Nipotecosa in Florence.

598 PAOLUCCI, ANTONIO. "I 'Musici' di Benedetto da Maiano e il monumento di Ferdinando d'Aragona." Paragone 26, no. 303 (May 1975):3-11, 10 figs.
Publishes four related sculptures of musicians recently acquired by Bargello, Florence. Argues that they were carved by Benedetto, together with Coronation of Ferdinand of Aragon [Alphonso II?] (Bargello), and were intended to decorate Porta Capuana. Left unfinished at Ferdinando's death in 1494. See Hersey (entry 592) for different identification.

599 POGGI, GIOVANNI. "Un tondo di Benedetto da Majano." Bollettino d'arte 2 (1908):1-5, 7 figs.
First publication of Benedetto's undated Madonna and Child tondo from Scarperia, which author dates later than Madonna and Child tondo on the Filippo Strozzi Monument. Reproduces several glazed terracotta and stucco reliefs that reflect Benedetto's Scarperia tondo.

600 POZZO, TOMASO dal. "Il sepolcro di San Savino nel Duomo di Faenza." Rassegna d'arte 2, no. 1 (1902):129-31, 4 figs.
Hypothesizes about modifications to Benedetto's Shrine of San Savino (Duomo, Faenza), dismantled in the seventeenth century.

601 SALMI, MARIO. "Ricerche intorno alla Badia di SS. Fiora e Lucilla ad Arezzo." Arte 15 (1912):281-92, 6 figs.
History of church, particularly its fifteenth-century renovations. Clarifies attribution of fifteenth-century tabernacle: it is by Benedetto da Maiano according to manuscript source. [Fabriczy had attributed it to Bernardo Rossellino (entry 1864).]

602 SCHMARSOW, A[UGUST]. "La statuetta della Giustizia nel Cambio a Perugia." Archivio storico dell'arte 2 (1889):387-88, no illus.
Attributes seated figure of Justice on tribunal, Sala del cambio, Perugia, to Benedetto da Maiano.

603 SCHOTTMULLER, F[RIDA]. "Benedetto da Maiano." In Thieme-Becker Künstler-Lexikon. Leipzig: E.A. Seemann, 1909, 3:309-13.
Condensed survey of life and work. Valuable bibliography.

604 SECONDO TESSARI, ANTONIO. "Benedetto da Maiano tra il 1490 e
 il 1497, I." Critica d'arte, n.s. 40, no. 143 (1975):39-52, 7
 figs.
 Analyzes Benedetto's late period (1490-97), in particular,
Monument of Filippo Strozzi, Santa Maria Novella, Florence, docu-
mented as largely done in 1490-91 and worked on sporadically until
1495. Discusses wood Crucifix for Duomo; statue of seated Madonna
and Child in the Oratoria della Misericordia; and Altar of San Bar-
tolo, Sant Agostino, San Gimignano; and stresses how Benedetto's
style anticipates High Renaissance.

605 SECONDO TESSARI, ANTONIO. "Benedetto da Maiano tra il 1490 e
 il 1497, II." Critica d'arte, n.s. 41, no. 145 (1976):20-30,
 14 figs.
 Attributes to Benedetto, ca. 1495-97, wooden Mary Magdalen
(Santa Trinità, Florence) often assigned to Desiderio.

606 SERRA, LUIGI. "Due scultori fiorentini del '400 a Napoli."
 Napoli nobilissima 14 (1906):181-85, 4 figs.
 Brief discussion of several sculptures in Sant' Anna dei
Lombardi [Monteoliveto], Naples: Antonio Rossellino's Adoration of
the Shepherds altarpiece and his Tomb of Mary of Aragon, both in the
Piccolomini Chapel, and Benedetto's Annunciation altarpiece, in the
Mastrogiudice Chapel.

607 TSCHUDI, HUGO von. "Eine Madonnenstatue von Benedetto da
 Majano." Jahrbuch der königlich preussischen Kunstsammlungen 9
 (1888):128-32, 1 fig.
 Publishes Madonna dell'Ulivo (Duomo, Prato), an unusual
terracotta sculpture signed and dated by Benedetto da Maiano (1480).

608 V[ALENTINER], W.R. "An Unknown Work by Benedetto da Maiano."
 Bulletin of the Detroit Institute of Arts 9, no. 4 (January
 1928):41-42, 2 figs.
 Marble relief of two putti with garland and arms of Miner-
betti family is attributed to Benedetto da Maiano.

609 V[ALENTINER], W.R. "St. John the Baptist by Benedetto da
 Maiano." Bulletin of The Detroit Institute of Arts 8 (1926):
 22-24, 2 figs.
 Portraitlike bust in polychromed terracotta, previously
ascribed to the Verrocchio school, is attributed to Benedetto da
Maiano. Suggests it is possibly his lost St. John the Baptist for
Abbey of San Frediano, Pisa.

610 VALENTINER, W.R. "The Early Development of Domenico Gagini."
 Burlington Magazine 76, no. 444 (March 1940):76-87, 11 figs.
 Attributes to Gagini Nativity (Kress collection, New York)
generally given to Benedetto.

BERTOLDO

Books

611 BODE, WILHELM von. Bertoldo und Lorenzo dei Medici: Die Kunstpolitik des Lorenzo il Magnifico im Speigel der Werke seines Lieblingskünstlers Bertoldo di Giovanni. Freiburg im Breisgau: Pontos-Verlag, 1925, 132 pp., 72 figs.
Speculatiave essay without footnotes that discusses Bertoldo's life and sculpture. Separate chapters on medals, plaquettes, reliefs, bronze statuettes, and his relationship to Lorenzo de' Medici. Controversial attributions.

611a MacLagan, Eric. Review of Bertoldo und Lorenzo dei Medici, by Wilhelm von Bode. Burlington Magazine 48, no. 274 (January 1926):45-46, no illus.
Criticizes Bode's lack of information on Bertoldo's early life, relationship to Donatello, and extent of collaboration on Donatello's San Lorenzo pulpits. Questions attribution to Bertoldo of "Foulc group" (Philadelphia Museum of Art).

612 ROHWALDT, KARL. Bertoldo: Ein Beitrag zur Jugendentwicklung Michelangelos. Inaugural-Dissertation der Friedrich-Wilhelms Universität. Berlin: Preuss, 1896, 87 pp., no illus.
Publication of dissertation on Bertoldo, dealing especially with his stylistic development and his relationship to Michelangelo.

Articles

613 BODE, WILHELM von. "Un Calvario di Bertoldo di Giovanni nel museo di Berlino." Bollettino d'arte del Ministerio della pubblica istruzione, 2d ser. 1 (1922):347-55, 6 figs.
Attributes to Bertoldo stucco reliefs of Road to Calvary and Crucifixion (formerly Kaiser Friedrich Museum, Berlin, now Staatliche Museen, Berlin-Dahlem).

614 CIARDI DUPRÈ, MARIA GRAZIA. "Brevi note sui 'Bronzetti italiani del Rinascimento,' esposti a Londra-Amsterdam-Firenze." Paragone, no. 151 (1962):59-68, 9 figs.
Discusses Bertoldo's role in production of small bronzes in Florence.

615 FABRICZY, CORNELIUS de. "Bertoldo di Giovanni e il suo lavoro per 'Santo di Padova.'" Rassegna d'arte 8 (1908):26, no illus.
Publishes documents indicating that supervisors of Santo, Padua, intended to offer Bertoldo commission for twelve Old Testament bronze reliefs for choir, later executed by Bellano and Riccio.

616 FORATTI, ALDO. "I tondi nel cortile del Palazzo Riccardi a Firenze." Arte 20 (1917):19-30, 17 figs.
Sculptured tondi in courtyard, Palazzo Medici[-Riccardi], Florence, were carved by Bertoldo and Maso di Bartolomeo after ancient gems and medals.

617 FRIMMEL, THEODOR. "Die Bellerophongruppe des Bertoldo."
 Jahrbuch der Kunsthistorischen Sammlungen in Wien 5 (1887):
 90-96, 1 fig.
 Discussion of Bertoldo's life and work, focusing on
Bellerophon group (Kunsthistorisches Museum, Vienna, cast ca. 1486),
identifying that work with original seen by Vasari.

618 GENGARO, MARIA LUISA. "Maestro e scolaro: Bertoldo di
 Giovanni e Michelangelo." Commentari 12 (1961):52-56, 5 figs.
 Analyzes what Michelangelo learned from Bertoldo. Dis-
cusses relationship of Michelangelo's Battle relief (Casa Buonarroti,
Florence) and David (Accademia, Florence) to sculptures by Bertoldo.

619 GRONAU, GEORG. "Notizie inedite su due bronzi del Museo
 nazionale di Firenze." Rivista d'arte 5 (1907):118-21, no
 illus.
 Emblem of Piero di Cosimo Medici on bronze relief of Tri-
umph of Bacchus indicates it was commissioned either by him (and
therefore pre-1469, the year of his death), or to honor him. Relief
can also be traced in sixteenth- and seventeenth-century inventories
of Medici collections. Also publishes sixteenth-century letter that
describes how Ghiberti's Cassa of SS. Proto, Giacinto and Nemesio,
now in the Bargello, was displayed in Santa Maria degli Angeli
[Agnoli], Florence.

620 JACOBS, EMIL. "Die Mehemmed-Medaille des Bertoldo." Jahrbuch
 der preussischen Kunstsammlungen 48 (1927):1-17, 4 figs.
 Portrait medal of Mohammed II (ca. 1480-81), signed by
Bertoldo, was probably a gift from Lorenzo de' Medici to commemorate
Mohammed's role in extradition of murderers of Giuliano de' Medici in
1478. Medal probably made in Florence using profile portrait copies
from Bellini painting.

621 JESTAZ, BERTRAND. "Des nouveaux bronzes italiens. Reliefs et
 médailles." Revue du Louvre et des muséees de France 24, no.
 2 (1974):91-100, 8 figs., esp. pp. 96-98.
 Discusses iconography and significance of recently acquired
medal of Mohammed II (1480) by Bertoldo and Bertoldo's relationship
to Lorenzo de' Medici.

622 LISNER, MARGRIT. "Form und Sinngehalt von Michelangelos
 Kentaurenschlacht: Mit Notizen zu Bertoldo di Giovanni."
 Mitteilungen des Kunsthistorischen Institutes in Florenz 24,
 no. 3 (1980):299-344, 30 figs.
 In context of iconographical clarification of Michel-
angelo's Battle of Centaurs (Casa Buonarroti, Florence), identifies
Hercules on horseback as central figure in Bertoldo's Battle relief
(Bargello, Florence). Relates Hercules imagery to Medici family's
desired association with Florentine republic. Notes that Bertoldo
made a Centaur statuette (now lost) for room of the young Piero de'
Medici in the Palazzo Medici [-Riccardi]. Traces popularity of
Centaur themes in late fifteenth-century Florence.

623 PARRONCHI, ALESSANDRO. "The Language of Humanism and of
 Sculpture: Bertoldo as the Illustrator of the Apologia of
 Bartolomeo Scala." Translated by Alison M. Brown. Journal of
 the Warburg and Courtauld Institutes 27 (1964):108-36, 43 figs.
 Explication of complex iconography of Bertoldo's Palazzo
Scala-Gherardesca reliefs based on Bartolomeo Scala's Apologia (Latin
and English texts published). Comments on Bertoldo's famous letter
to Lorenzo de' Medici, which certifies the date, attribution, and
Bertoldo's opinion of commission. Relation of reliefs to sources
(Medici gems, etc.).

624 RICHARDSON, E.P. "Bertoldo and Verrocchio: Two Fifteenth
 Century Florentine Bronzes." Art Quarterly 12 (1959):204-15,
 10 figs.
 Attributes to Bertoldo bronze statuette, here identified as
Jason Resting after Slaying the Dragon Guarding the Golden Fleece
(probably ca. 1458-62), and to Verrocchio a Judith, an early work
perhaps for the Medici (both in Detroit Institute of Arts).

625 SCHOTTMULLER, F[RIDA]. "Bertoldo di Giovanni." In Thieme-
 Becker Künstler-Lexikon. Leipzig: E.A. Seemann, 1909, 3:505-7.
 Condensed survey of life and work. Valuable bibliography.

626 STITES, RAYMOND S. "The Bronzes of Leonardo da Vinci." Art
 Bulletin 12, no. 3 (September 1930):254-69, 28 figs.
 Attribution of Foulc Lion and Horseman bronze (Philadelphia
Museum of Art) to Leonardo, rather than Bertoldo (as is traditional),
based on greater sophistication of modelling and musculature.

627 VENTURI, A[DOLFO]. "Le sculture dei sarcofagi di Francesco e
 di Nera Sassetti in Santa Trinità a Firenze." Arte 13 (1910):
 385-88, 11 figs.
 Challenges traditional attribution of these sarcophagi to
Giuliano da San Gallo and proposes Bertoldo instead.

*628 WICKHOFF, FRANZ. "Die Antike im Bildungsgange Michelangelos."
 Mitteilungen des Instituts für oesterreichische Geschichts-
 forschung (Vienna) 3 (1882):408-35.

BRUNELLESCHI

Books

629 BALDINUCCI, FILIPPO. Vita di Filippo di Ser Brunellesco,
 architetto fiorentino. . . . Edited by Domenico Moreni.
 Florence: Niccolò Carli, 1812, xvi, 208 pp., no illus.
 Baldinucci's biography of Brunelleschi, derived largely
from Manetti, is here published together with Moreni's edition of
Manetti.

630 BATTISTI, EUGENIO. Filippo Brunelleschi. Milan: Electa
 Editrice, 1976, 411 pp., 357 figs. German ed. 1979.
 Profusely illustrated monograph that covers Brunelleschi's
 life, the biographies written about him, his perspective studies, his
 sculpture, and his architecture. Good detail photographs of sculp-
 ture and architecture.

*631 BEANI, GAETANO. L'Altare di S. Jacopo Apostolo nella
 Cattedrale di Pistoja. Pistoia, 1899, 44 pp.
 Early history of Silver Altar of Pistoia that discusses
 Brunelleschi's participation.

631a Fabriczy, Cornel[ius] von. Review of L'Altare di S. Jacopo
 Apostolo nella Cattedrale di Pistoja, by Gaetano Beani,
 Repertorium für Kunstwissenschaft 23 (1900):422-24, no illus.
 Summarizes new archival information discovered by Beani,
 providing details on history and chronology of Silver Altar of San
 Jacopo, especially Brunelleschi's possible participation.

632 BENIGNI, PAOLA. Filippo Brunelleschi, l'uomo e l'artista:
 Mostra documentaria. Ministero per i beni culturali e
 ambientali, Pubblicazioni degli archivi di stato, vol. 94.
 Florence: Biemme, 1977, 119 pp., 8 figs.
 Catalogue of exhibition of documents, codices, drawings,
 and prints relevant to life and career of Brunelleschi.

633 BOZZONI, CORRADO, and CARBONARA, GIOVANNI. Filippo
 Brunelleschi: Saggio di bibliografia. Vol. 1, Schede,
 1436-1976. Vol. 2, Schede e indici. Rome: Istituto di
 Fondamenti dell'Architettura dell'Università degli Studi di
 Roma, 1977, 562 pp., no illus.
 Comprehensive annotated bibliography of books and articles
 on Brunelleschi from 1436 to 1976, including citations relevant to
 his fellow artists.

634 FABRICZY, CORNEL[IUS] von. Filippo Brunelleschi: Sein Leben
 und seine Werke. 2 vols. Stuttgart: J.G. Cotta'schen, 1892,
 636 pp., no illus.
 The fundamental book on Brunelleschi. Unsurpassed compila-
 tion of biographical material, both personal and professional. Draws
 on all available archival material, most of which is accurately
 transcribed in copious appendices. Supplemented by entry 654.

635 Filippo Brunelleschi: La sua opera e il suo tempo (Convegno
 internazionale di studi tenutosi a Firenze, 1977). 2 vols.
 Florence: Centro Di, 1980, 1006 pp., 274 figs.
 Publication of talks given at conference, with footnotes.
 Most deal with architecture.

636 Filippo Brunelleschi nella Firenze del '3-'400. Edited by
 Massimiliano Rosito. Florence: Edizioni Città di Vita, 1977,
 159 pp., 140 figs.

Publication of lectures, mainly dealing ith architecture, aimed at general audience and interspersed with excerpts from sources.

637 FLORENCE, BARGELLO. Brunelleschi scultore: Mostra celebrativa nel sesto centenario della nascità. Catalogue by Emma Michel- etti and Antonio Paolucci. Florence: Soprintendenza ai Beni Artistici e Storici, 1977, 45 pp., 12 figs.
Catalogue of exhibition (28 May–31 October 1977) of Brunelleschi's sculptures, all of which were assembled for exhibi- tion. Ghiberti's Sacrifice of Isaac panel was also shown and, for the first time, Donatello's wood Crucifix was placed side by side with Brunelleschi's. Each entry includes bibliography.

638 [MANETTI, ANTONIO]. Le vite di Filippo Brunelleschi, scultore e architetto fiorentino scritta da Giorgio Vasari e da anonimo autore con aggiunte, documenti, e note. Edited by Carl Frey. Sammlung ausgewaehlter Biographien Vasaris, Zum Gebrauche bei Vorlesungen, vol. 4. Berlin, 1887.
Most precise transcription of the Magliabechiano version of Manetti's biography. Analyzes this in comparison to Vasari's life of Brunelleschi.

639 [MANETTI, ANTONIO]. Filippo Brunelleschi di Antonio di Tuccio Manetti. Mit Ergaenzungen aus Vasari und Anderen heraus- gegeben. . . . Edited by H. Holzinger. Stuttgart, 1887.
Republication of Moreni's edition of Manetti, with notes collating Manetti's biography and Moreni's edition of it.

640 [MANETTI, ANTONIO]. The Life of Brunelleschi. Introduction, notes, and critical edition by Howard Saalman. Translated by Catherine Enggass. University Park, Pa., and London: Penn- sylvania State University Press, 1970, 176 pp., 8 figs.
First modern edition of Manetti with full scholarly apparatus. Derived from the "Magliabechiano" manuscript and two fragments, the "Pistoiese" and the "Corsiniana," never before collated with the "Magliabechiano."

641 [MANETTI, ANTONIO]. Operette istoriche edite ed inedite di Antonio Manetti . . . raccolte per la prima volta e al suo vero autore restituite. . . . Edited by Gaetano Milanesi. Flor- ence, 1887.
Most authoritative version of Manetti's text, with sub- stantial and scholarly notations. Orthography is modernized and some nuances of meaning are consequently distorted.
New edition of Milanesi: published with Chiappelli's text of Pistoia codex by Elena Toesca (Florence: Rinascimento del Libro, 1927), 93 pp., no illus.

642 MARIANI, VALERIO. Artisti del primo rinascimento: Brunelleschi e Donatello. Edited by Antonio Videtta. Appunti

della lezione del corso ufficiale di storia dell'arte. Naples: Libreria Scientifica Editrice, [n.d.], 157 pp., 5 drawings.

Analyzes major architect and sculptor of the early fifteenth century in order to understand origins of Renaissance. Chapters on architecture, medieval tradition, perspective, Brunelleschi as sculptor and architect, and sculpture of Donatello.

643 SANPAOLESI, PIERO. Il Brunelleschi. Milan: Edizioni per il Club del Libro, [1962], 340 pp., 101 figs., 8 drawings, 24 color pls.

Monograph on sculpture and architecture of Brunelleschi that includes section on various contemporaries' remarks and biographies about Brunelleschi. Specific, brief comments about illustrations. No footnotes. Selective bibliography.

644 SANPAOLESI, PIERO. Brunellesco e Donatello nella Sacristia Vecchia di San Lorenzo. Pisa: Nistri -Lischi, [1948], 56 pp., 75 figs.

Analyzes collaboration of Brunelleschi and Donatello on architecture and decoration of Old Sacristy, including its bronze doors and stucco roundels of Evangelists and Life of St. John. Includes notes and documents.

Articles

645 BOTTO, CARLO. "L'edificazione della chiesa di Santo Spirito in Firenze." Rivista d'arte 13, 2d ser. 3 (1931):477-511, 9 figs.

First publication of documents establishing 1420 as date when Brunelleschi's lost figure of Mary Magdalen was carved for Santo Spirito, Florence.

646 BRUNETTI, GIULIA. "Un'aggiunta all'iconografia brunelleschiana: Ipotesi sul 'profeta imperbe' di Donatello." In Filippo Brunelleschi: La sua opera e il suo tempo (Convegno internazionale di studi tenutosi a Firenze, 1977). Florence: Centro Di, 1980, 1:273-77, 9 figs.

Suggests that Donatello's Unbearded Prophet for Campanile (Museo dell'Opera del Duomo, Florence) is portrait of Brunelleschi.

647 CASAZZA, ORNELLA, and BODDI, ROBERTO. "Il Crocifisso ligneo di Filippo Brunelleschi." Critica d'arte 43 (1978):209-12, 8 figs., diags.

Proportions of Brunelleschi's wood Crucifix (Santa Maria Novella, Florence) are compared with those in Giotto's painted Crucifix (now in the Museo dell'Opera di Santa Croce, Florence).

648 CASTELFRANCO, GIORGIO. "Sui rapporti tra Brunelleschi e Donatello." Arte antica e moderna, nos. 34-36 (1966):109-22, 22 figs.

Traces Donatello's and Brunelleschi's close association and influence of Brunelleschi's figures for Silver Altar in Pistoia on Donatello's St. John the Evangelist for façade of Duomo, Florence,

and <u>St. Mark</u> for Orsanmichele, Florence. Discusses the <u>St. Peter</u> for Orsanmichele, which early sources attribute to Brunelleschi and Donatello in collaboration.

649 CHIAPPELLI, ALESSANDRO. "Due sculture ignote di Filippo Brunelleschi." <u>Rivista d'Italia</u> 2 (May-August 1899):454-70, 2 figs.
 First identification of Brunelleschi's contributions to Silver Altar of San Jacopo, Pistoia, as two bust-length prophet figures in quatrefoils. Vasari's vague account of Brunelleschi's participation on Silver Altar had generally been discounted. Discusses Brunelleschi's career as sculptor.

650 CHIAPPELLI, ALESSANDRO. "Filippo Brunelleschi, scultore." In <u>Leggendo e meditando</u>. Rome: Società Editrice Dante Alighieri, 1900, pp. 225-44, no illus. Also published in <u>Pagine d'antica arte fiorentina</u> (Florence: F. Lumachi, 1905) [First published in <u>Rivista d'Italia</u>, 15 June 1899.]
 Essay on Brunelleschi's sculptural career that includes first art historical evaluaton of Brunelleschi's work on Silver Altar in Pistoia.

651 CHIAPPELLI, ALESSANDRO. "Della vita di Filippo Brunelleschi attribuita ad Antonio Manetti con un nuovo frammento di essa tratto da un codice pistoiese del sec. XVI." <u>Archivio storico italiano</u>, 5th ser. 17 (1896):241-78, no illus.
 Publishes newly found fragment from Pistoia of life of Brunelleschi attributed to Manetti.

652 DEGENHART, BERNHARD, and SCHMITT, ANNEGRIT. "Gentile da Fabriano in Rom und die Anfänge des Antikenstudiums." <u>Münchner Jahrbuch der bildenden Kunst</u> 3 folge, 11 (1960):59-151, 106 figs.
 Reproduces Pisanellˊs drawings after works by Donatello (<u>Madonna</u> and Prato putti) and Luca della Robbia (<u>Madonna</u> tondo with angels) (pp. 82-85). Discusses antique sources in Early Renaissance including alternative source for Brunelleschi's <u>Sacrifice of Isaac</u> in a Marsyas sarcophagus reproduced in Codex Pighianus, Berlin, F.297 (p. 97).

653 ERCOLI, GIULIANO. "Tecniche e concezione spaziale nelle formelle del Brunelleschi e del Ghiberti per la seconda porta del Battistero." In <u>Filippo Brunelleschi: La sua opera e il suo tempo</u> (Convegno internazionale di studi tenutosi a Firenze, 1977). Florence: Centro di, 1980, 1:265-72, 10 figs.
 Argues that Brunelleschi, an expert goldsmith, deliberately chose to cast figures separately for Competition panel of <u>Sacrifice of Isaac</u> (Bargello, Florence) because of his interest in spatial illusionism.

654 FABRICZY, CORNELIUS von. "Brunelleschiana." <u>Jahrbuch der königlich preussischen Kunstsammlungen</u> 28 (1907):1-84, no illus.

Important collection of documents pertaining to Filippo Brunelleschi (1377-1446) transcribed and analyzed. Supplements Fabriczy's monograph on Brunelleschi (entry 634).

655 FEHL, PHILIPP P. "The Naked Christ in Santa Maria Novella in Florence: Reflections on an Exhibition and the Consequences." Storia dell'arte 45 (1982):161-64, 12 figs.
 Argues that Brunelleschi's Crucifix, recently restored to leave Christ naked, was intended to be seen with loincloth, and should not be considered first nude Christ.

656 GUIDOTTI, ALESSANDRO. "La 'matricola' di Ser Brunellesco orafo." Prospettiva 9 (1977):60-61, no illus.
 Publishes corrected version of Brunelleschi's record of matriculation as a goldsmith in 1398.

657 HEYDENREICH, LUDWIG H. "Spätwerke Brunelleschis." Jahrbuch der preussischen Kunstsammlungen 52 (1931):1-28, 24 figs.
 Important article that thoroughly analyzes stylistic innovations of Brunelleschi's late style, with particular attention to Santa Maria degli Angeli [Angoli], Pazzi Chapel, San Lorenzo, and Santo Spirito. Excellent discussion of architectural and sculptural program for lantern of Duomo.

658 JANSON, H[ORST] W. "The Pazzi Evangelists." In Intuition und Kunstwissenschaft: Festschrift Hanns Swarzenski. Berlin: Gebr. Mann Verlag, 1973, pp. 439-48, 16 figs.
 New research suggests that Pazzi Chapel was largely constructed after Brunelleschi's death, thus putting in question traditional ascription of Evangelist tondi to him. Janson argues that tondi should be dated in 1460s or later and considered products of Della Robbia shop. Cites these tondi as models for similar examples in Martini Chapel, San Giobbe, Venice, ca. 1470-75.

659 KRISTELLER, PAUL. "Un ricordo della gara per le porte del Battistero di Firenze in una incisione antica." Bollettino d'arte 4 (1910):277-81, 3 figs.
 Publishes engraving of ca. 1450-1500 that seems to record lost panel submitted by unidentified sculptor for Baptistry competition.

660 LANG, SUSANNE. "Brunelleschi's Panels." In La prospettiva rinascimentale, codificazioni e trasgressioni: Atti del convegno (1977), Milan. Florence: Centro Di, 1980, 1:63-72, 4 figs.
 Argues that Brunelleschi's panels of Baptistry, Florence, and of Piazza della Signoria, now lost, were planned as prototypes for stage design. Considers spatial construction in Donatello's Feast of Herod, Baptismal Font, Baptistry, Siena, continuation of Brunelleschi's experiments with stage design.

661 LASCHI, GIULIANO; ROSELLI, PIERO; and ROSSI, PAOLO A.
 "Indagini sulla Cappella dei Pazzi." Commentari 13, no. 1
 (1962):24-41, 12 figs., 4 line reconstructions.
 Preliminary publication of analysis of architectural struc-
ture of Pazzi Chapel which argues that construction was protracted,
and therefore decoration must date later than conventionally assumed.

662 LIMBURGER, WALTHER. "Brunelleschi, Filippo." In Thieme-Becker
 Künstler-Lexikon. Leipzig: E.A. Seemann, 1911 5:125-32.
 Condensed survey of life and work. Valuable bibliography.

663 LONGHI, ROBERTO. Fatti di Masolino e di Masaccio e altri studi
 sul Quattrocento, 1910-1967. Florence: Sansoni, 1975, pp.
 23-24, figs. 18 and 19b.
 Attribution to Brunelleschi of silver plaquette depicting
Healing of a Woman Possessed by Demons (Louvre, Paris).

664 MARCHINI, GIUSEPPE. "L'Altare argenteo di San Jacopo e l'ore-
 ficeria gotica a Pistoia." In Il Gotico a Pistoia nei suoi
 rapporti con l'arte Gotica italiana (Atti del 2° convegno
 internazionale di studi, Pistoia, 22-30 April, 1966). Rome:
 Tip. Centenari, [1972], pp. 135-47, 24 figs.
 Analysis of Silver Altar of San Jacopo (Duomo, Pistoia)
within context of other fourteenth-century liturgical objects in
metal from Pistoia, such as chalices and processional crosses.

665 MARQUAND, ALLAN. "Note sul Sacrificio d'Isaaco di
 Brunelleschi." Arte 17 (1914):385-86, 1 fig.
 Interprets relief on altar in Brunelleschi's Sacrifice of
Isaac panel as Abraham's claim to Virgin that Isaac is ancestor of
Christ.

666 PAOLUCCI, ANTONIO. "Il Crocifisso di Brunelleschi dopo il
 restauro." Paragone 28, no. 329 (July 1977):3-6, 4 figs., 1
 color pl.
 Analysis of coloration of Brunelleschi's Crucifix as
revealed by recent restoration.

667 PARRONCHI, ALESSANDRO. "Brunelleschi: 'Un nuovo San Paulo.'"
 Paragone 12, no. 143 (1961):47-58, 4 figs.
 Makes analogy between Brunelleschi and St. Paul on basis of
Aquinas's commentaries on Letter of Paul; uses analogy to explain
Brunelleschi's use of mirror in experiments on vanishing point in
linear perspective. Also discusses Vitruvian proportions of
Brunelleschi's wood Crucifix (Santa Maria Novella, Florence).

668 PARRONCHI, ALESSANDRO. "Le due tavole prospettiche del
 Brunelleschi." Paragone 9, no. 107 (1958):3-32; no. 109
 (1959):3-31, 12 figs.
 Brunelleschi's system of linear perspective in his painting
of Baptistry and in silver plaquette of Healing of a Woman Possessed

by Demons (Louvre, Paris) attributed to him, shows acquaintance with theories of Pelacani, Bacon, Vitellione, and Toscanelli.

669 PARRONCHI, ALESSANDRO. "Un tabernacolo brunelleschiano." In Filippo Brunelleschi: La sua opera e il suo tempo (Convegno internazionale di studi tenutosi a Firenze, 1977). Florence: Centro Di, 1980, 1:239-55, 20 figs.
 Publishes additional documents which indicate that lost tabernacle designed by Brunelleschi and carved by Giusto di Francesco da Settignano for pilaster of San Jacopo in Campo Corbolini is dated 1426-27, making it earliest Renaissance wall tabernacle. Brunelleschi's tabernacle thus influenced development of the perspectivized wall tabernacle. Hypothesizes that Giusto di Francesco da Settignano may have worked on central part of tabernacle in San Lorenzo, usually attributed to Desiderio, on basis that it directly reflects Brunelleschi's ideas.

670 PARRONCHI, ALESSANDRO. "Tabernacolo brunelleschiano." Prospettiva 11 (1977):55-56, no illus.
 Publication of documents proving Brunelleschi designed a tabernacle for San Jacopo in Campo Corbolini, Florence (now lost).

671 POGGI, GIOVANNI. "Andrea di Lazzaro Cavalcanti e il pulpito di S. Maria Novella." Rivista d'arte 3 (1905):77-85, 2 figs.
 Sources and documents indicate that pulpit (Santa Maria Novella, Florence), was executed by his followers from model by Brunelleschi. Andrea di Lazzaro Cavalcanti [Buggiano] carved its reliefs between 1443 and 1448.

672 POGGI, GIOVANNI. "La 'maschera' di Filippo Brunelleschi nel Museo dell'Opera del Duomo." Rivista d'arte 12, 2d ser. 2 (1930):533--40, 4 figs.
 Brunelleschi's death mask (Museo dell'Opera del Duomo, Florence) is first one known according to Vasari, who recorded that Andrea di Lazzaro Cavalcanti [Buggiano] did marble sculpture after it. Poggi publishes documents for the sculpture, which is also reflected in plaster casts.

673 RAGGHIANTI, CARLO L. "Aenigmata pistoriensia, I." Critica d'arte, n.s. 1, no. 5 (September 1954):423-38, 12 figs.
 Observations occasioned by exhibition, "Mostra d'arte antica," Pistoia, 1950. Attributes angel on the Reliquary of San Jacopo (Duomo, Pistoia) to Ghiberti. Cleaning and good lighting of Silver Altar of San Jacopo make possible attribution to Brunelleschi of specific parts: busts of Isaiah and Jeremiah, as noted by Chiappelli, and figures of St. Augustine, St. Luke and St. Gregory the Great.

674 RAGGHIANTI, CARLO L. "Prospettiva 1401." In Scritti in onore di Roberto Pane. Naples: Istituto di Storia dell'Architettura dell'Università di Napoli, 1969-71, pp. 187-96, no illus.

Argues that formal characteristics of Brunelleschi's Sacrifice of Isaac panel demonstrate that by time of Baptistry competition he was already sophisticated in perspective and ancient art, interests which are sometimes dated much later in his career.

675 SAALMAN, HOWARD. "Filippo Brunelleschi: Capital Studies. Art Bulletin 40 (1958):113-37, 56 figs., 6 plans.
 Sculptural form of Brunelleschi's capitals and architectural details is reflected in work of sculptors in 1420s: Donatello, Michelozzo, and Ghiberti (especially the architectural forms on certain reliefs from the Gates of Paradise). Forms of capitals clarify dating of certain monuments and reveal extent of Brunelleschi's influence. Capitals indicate sources of Brunelleschi's style.

676 SANPAOLESI, PIERO. "Aggiunte al Brunelleschi." Bollettino d'arte, 4th ser. 38 (1953):225-32, 17 figs.
 Publishes documents concerning Silver Altar in Pistoia and contends that careful reading indicates that Brunelleschi modelled two statuettes: St. Ambrose and St. Augustine. Also attributes to Brunelleschi Evangelist roundels in Pazzi Chapel.

677 SANPAOLESI, PIERO; GARIN, EUGENIO; and PORTOGHESI, PAOLO. "Brunelleschi." In Encyclopedia of World Art. London: McGraw-Hill, 1960, 2: cols. 651-70, figs. 363-74.
 Condensed survey of Brunelleschi's career by leading authorities. Extensive bibliography.

678 SCHLEE, ERNST L. "Die Bekrönungszone der Silberaltars in Pistoia--zur Florentiner Skulptur um 1400." Kunstgeschichtliche Gesellschaft zu Berlin: Sitzungsberichte, no. 25 (1976-77):8-12, no illus.
 Silver Altar in San Jacopo, Pistoia (commissioned 1394), by local and Florentine artists reflects stylistic movement away from Gothic around 1400. This work may have directly affected sculpture in Florence, espeically artists working on Porta della Mandorla.

679 STEINGRÄBER, ERICH. "The Pistoia Silver Altar; A Re-examination." Connoisseur 138, no. 557 (November 1956):148-54, 13 figs.
 Concise study that traces history of the Pistoia Silver Altar project, allowing for attribution of various parts and understanding of aesthetic milieu, ca. 1400. Suggests Ghiberti's stepfather, Bartolo di Michele (Bartoluccio), as 1399 assessor, with "suo compagno" young Ghiberti. Clarifies Brunelleschi's role: two half-length prophets not by Brunelleschi (as Vasari says) but made after his designs by Lunardo di Mazzeo Ducci and Piero di Giovannino.

680 ZERVAS, DIANA FINIELLO. "Filippo Brunelleschi's Political Career." Burlington Magazine 121, no. 919 (October 1979): 630-39, 10 figs.

135

Reveals close ties between Brunelleschi's architectural career and political activities through examination of recently discovered documents pertaining to his participation on municipal councils in Florence from 1400 to 1432, and his activities in Pistoia in 1400.

BUGGIANO (ANDREA DI LAZZARO CAVALCANTI)

Books

681 Convegno su Andrea Cavalcanti, detto "Il Buggiano" (Atti del Convegno su Andrea Cavalcanti a cura del Comune di Buggiano, dell'Associazione civile pro Buggiano Castello, della Sezione della Val di Nievole, dell'Istituto storico lucchese, Buggiano Castello, June 23, 1979). Bologna: Rastignano, 1980, 94 pp., 22 figs.
 Publication of papers from recent conference on Buggiano. The only extensive treatment of this artist. See entries 683-85 for individual articles.

Articles

682 BIEHL, W.R. "Cavalcanti, Andrea di Lazzaro." In Thieme-Becker Künstler-Lexikon. Leipzig: E.A. Seemann, 1912, 6:213-15.
 Condensed survey of life and work. Valuable bibliography.

683 CIARDI DUPRÈ dal POGGETTO, MARIA G. "Il 'Buggiano' scultore." In Convegno su Andrea Cavalcanti, detto "Il Buggiano" (Atti del Convegno su Andrea Cavalcanti a cura del Comune di Buggiano, dell'Associazione civile pro Buggiano Castello, della Sezione della Val di Nievole, dell' Istituto storico lucchese, Buggiano Castello, June 23, 1979). Bologna: Rastignano, 1980, pp. 37-46, 11 figs.
 Discusses the few known sculptures by Buggiano together in first attempt to characterize his style and relationship to his adoptive father, Brunelleschi.

684 GURRIERI, FRANCESCO. "Andrea di Lazzaro Cavalcanti: Testi-monianze artistiche." In Convegno su Andrea Cavalcanti, detto "il Buggiano" (Atti del Convegno su Andrea Cavalcanti a cura del Comune di Buggiano, dell'Associazione civile pro Buggiano Castello, della Sezione della Val di Nievole, dell' Istituto storico lucchese, Buggiano Castello, June 23, 1979). Bologna: Rastignano, 1980, pp. 19-28, 16 figs.
 Overview of Buggiano's career, followed by chronology of his life. Somewhat rhetorical.

685 PROCACCI, UGO. "Nuovi documenti sul 'Buggiano.'" In Convegno su Andrea Cavalcanti, detto "il Buggiano" (Atti del Convegno su Andrea Cavalcanti a cura del Comune di Buggiano, dell'Associazione civile pro Buggiano Castello, della Sezione della Val

di Nievole, dell' Istituto storico lucchese, Buggiano Castello, June 23, 1979). Bologna: Rastignano, 1980, pp. 11-18, no illus.

Publishes many new documents, especially catasto accounts pertaining to Buggiano.

686 SCHLEGEL, URSULA. "Ein Sakramentstabernakel der Früh-renaissance in S. Ambrogio in Florenz." Zeitschrift für Kunstgeschichte 23 (1960):167-73, 7 figs.
 Tabernacle (Sant Ambrogio, Florence) is attributed to Buggiano (ca. 1430-35). Architecture of tabernacle relates to Brunelleschi (perhaps to tabernacle commissioned from Brunelleschi for San Jacopo, Campo Corbolini), while figurative socle shows influence of Donatello.

687 SCHLEGEL, URSULA. "Vier Madonnenreliefs des Andrea di Lazzaro Cavalcanti gennant Buggiano." With KRATZ, ARTUR. "Restaurier-ungsbericht über drei Madonnenreliefs des Buggiano." Jahrbuch der Berliner Museen 12 (1962):4-12, 15 figs.
 Four recently restored terracotta Madonna and Child reliefs (Staatliche Museen, Berlin-Dahlem) attributed to Buggiano (ca. 1450) under strong influence of Luca della Robbia.

BENEDETTO BUGLIONI

Books

688 MARQUAND, ALLAN. Benedetto and Santi Buglioni. Princeton Monographs in Art and Archaeology, vol. 9. Princeton: Princeton University Press, 1921, 223 pp., 148 figs.
 Major monograph on these glazed terracotta specialists closely associated with the Della Robbia. Catalogue raisonné. Large corpus of transcribed documents. Full scholarly apparatus.

Articles

689 BACCI, PELEO. "Una 'Resurrezione' di Benedetto Buglioni." Rivista d'arte 2 (1904):49-63, 7 figs.
 Publishes documents pertaining to Buglioni's commission for glazed terracotta Resurrection relief for Duomo, Pistoia (now in Museo civico, Pistoia). Relief, derived from works by Luca and Andrea della Robbia, indicates high quality of this little-known student of theirs.

690 BOMBE, WALTER. "Buglioni, Benedetto." In Thieme-Becker Künstler-Lexikon. Leipzig: E.A. Seemann, 1911, 5: 208-9.
 Condensed survey of life and work. Valuable bibliography.

691 GAI, LUCIA. "Arredi della cappella di S. Jacopo a Pistoia: La 'Resurrezione' di Benedetto Buglioni e le sue vicende nel secolo 17." Bullettino storico pistoiese 13, nos. 1-2 (1978): 77-89, 1 fig.

Traces history of modifications to Silver Altar and chapel which houses it, focusing on Buglioni's commission to do glazed terracotta altarpiece of Resurrection to go above Silver Altar. Buglioni's altarpiece was sold in seventeenth century and is now in Museo civico, Pistoia. Appendix of transcribed documents.

692 MARQUAND, ALLAN. "An Altarpiece by Benedetto Buglioni at Montefiascone." Art Studies 1 (1923):2-6, 1 fig.
 Terracotta relief of Madonna with SS. Benedetto and Flavia (or another female martyr) (Duomo, Montefiascone), formerly attributed to Andrea della Robbia, is here attributed to Benedetto Buglioni, ca. 1519.

BERNARDO CIUFFAGNI

693 BECK, JAMES H. "Brunelleschi, Ciuffagni, and il Saggio." In Essays Presented to Myron P. Gilmore. Edited by Sergio Bertelli and Gloria Ramakus. Villa I Tatti, The Harvard University Center for Italian Renaissance Studies. Florence: La Nuova Italia Editrice, 1978, 2:3-9, 2 figs.
 Unpublished documents of November 1427 record that Mercanzia of Firenze called on Brunelleschi to determine placement of coat of arms commissioned from Ciuffagni for Saggio, reflecting on relative status of both artists.

694 KREYTENBERG, GERT. "Das Statuettenpaar über Ghibertis Matthäustabernakel." In Art, the Ape of Nature: Studies in Honor of H.W. Janson. Edited by Moshe Barasch and Lucy F. Sandler. New York: Harry N. Abrams; Englewood Cliffs, N.J.: Prentice Hall, 1981, pp. 97-104, 9 figs.
 Identifies two statuettes atop Ghiberti's tabernacle for St. Matthew, Orsanmichele, as prophets and attributes them to Ciuffagni, ca. 1427-30. Reviews what little is known about Ciuffagni's career.

695 SCHOTTMULLER, F[RIDA]. "Ciuffagni, Bernardo di Piero di Bartol." In Thieme-Becker Künstler-Lexikon. Leipzig: E.A. Seemann, 1912, 7: 17-19.
 Condensed survey of life and work. Valuable bibliography.

696 WUNDRAM, MANFRED. "Donatello und Ciuffagni." Zeitschrift für Kunstgeschichte 22 (1959):85-101, 10 figs.
 Attribution to Ciuffagni of head of so-called "Poggio" (Duomo, Florence) is supported by documents (1424). With discussion of Ciuffagni's St. Matthew of 1410-15 (Museo dell'Opera del Duomo, Florence), Isaiah of 1427-34 (Duomo, Florence), and David of 1430-35 (Duomo, Florence) and comparison to works of Donatello.

MATTEO CIVITALI

Books

697 MELI, FILIPPO. L'arte di Matteo Civitali. Lucca: Libreria Editrice Baroni, 1934, 45 pp., 16 figs.

General discussion derived from lecture on Civitali's career as architect, sculptor of religious monuments, and portraitist. Chronology and bibliography added.

698 PETRUCCI, FRANCESCA. Matteo Civitali e Roma. Florence:
 S.P.E.S., 1980, 55 pp., 9 figs.
 Traces important role of Roman art, particularly decorative motives, in Civitali's sculptures.

699 RIDOLFI, E. L'arte in Lucca studiata nella sua cattedrale.
 Lucca: B. Canovetti, 1882, 400 pp., 8 line drawings.
 Elaborate appendix (pp. 291-334) traces Civitali's career. Publishes twenty-one documents (pp. 335-60).

700 YRIARTE, CHARLES. Matteo Civitali: Sa vie et son oeuvre.
 Paris: J. Rothschild, 1886, 140 pp., 9 figs., 100 line engrs.
 Early, uncritical monograph surveying Civitali's career, based on available information. Introductory chapters on his formation (under Antonio Rossellino) and place in fifteenth-century sculpture, followed by brief discussion of major commissions arranged chronologically. No bibliography. Index. Now out-of-date but the only book-length study on Civitali in existence. [Pope-Hennessy terms it "deplorable" in entry 61.]

 Articles

701 ARÙ, CARLO. "Scultori della Versilia." Arte 12 (1909):269-87,
 9 figs.
 Distinguishes sculpture of Lorenzo Stagi, father of better-known Stagio Stagi, from that of Matteo Civitali (with whom he worked).

702 LOWKOMSKI, G. "Matteo Civitali: Les caractéristiques de son
 talent et de sa matière." Art et les artistes, n.s. 24, no.
 129 (January 1932):325-33, 7 figs.
 General monographic introduction to life and sculptural style of Matteo Civitali.

703 MARANGONI, MATTEO. "Un'opera sconsciuta di Matteo Civitali
 nel Camposanto di Pisa." Bollettino d'arte 28, no. 10 (April
 1935):437-39, 3 figs.
 Attributes Crucified Christ relief in storerooms of Camposanto, Pisa, to Civitali.

704 MIDDELDORF, ULRICH. "A New Medal by Pisanello." Burlington
 Magazine 123, no. 934 (January 1981):19-20, 2 figs.
 Discovery of new Pisanello medal of Giovanni Pietro d'Avenza (d. 1457) proves that marble relief of d'Avenza on exterior of San Martino, Lucca, is not by Matteo Civitali.

705 MUSSI, LUIGI. "Un'ancona di Matteo Civitali." Arte cristiana
 40, no. 6 (June 1952):116-17, 1 fig.

Publishes marble Adoration of the Child relief carved by
Matteo Civitali in 1442 for private chapel in palace of Marchese of
Massa di Lunigiana.

706 NEGRI ARNOLDI, FRANCESCO. "Matteo Civitali: Scultore
 lucchese." In Egemonia fiorentina ed autonomie locali nella
 Toscana nordoccidentale del primo Rinascimento (7° convegno
 internazionale, Centro italiano di studi e storia d'arte di
 Pistoia). Pistoia: Centro di Studi, 1978, pp. 255-75, 14
 figs., catalogue raisonné.
 Important monographic essay on Civitali's sculpture and his
relationship with the Rossellinos and Quercia; he is documented as
having worked on Quercia's Tomb of Ilaria del Carretto in 1484.

707 NEGRI ARNOLDI, FRANCESCO. "Rilievi quattrocenteschi italiani
 nei musei di Francia." Commentari 13 (1962):219-25, 9 figs.
 Attributes relief bust of unidentified young woman to
school of Desiderio (Musée, Aix-en-Provence) and relief bust
inscribed St. Helena (Musée Calvet, Avignon) to Matteo Civitali,
rather than Mino da Fiesole, its usual attribution.

708 PROCACCI, UGO. "Il Tempietto sepolcrale dei SS. Pellegrino e
 Bianco di Matteo Civitali." Rivista d'arte 13, 2d ser. 3
 (1931):406-19, 5 figs.
 Publishes documented but little-known commission by
Civitali, the Shrine of SS. Pellegrino and Bianco (1474-84), for
sanctuary of San Pellegrino dell'Alpi.

709 RIDOLFI, ENRICO, ed. Scritti d'arte e d'antichità di Michele
 Ridolfi, pittore, a cura di Enrico, suo figlio. Florence:
 Successori le Monnier, 1879, 441 pp., no illus., index.
 Essays on painting and sculpture in Lucca, relevant here
for notes on work by Civitali. See esp. pp. 127-36, 171-74, and
207-11.

710 SCHOTTMULLER, F[RIDA]. "Civitali, Matteo di Giovanni." In
 Thieme-Becker Künstler-Lexikon. Leipzig: E.A. Seemann, 1912,
 7:23-28.
 Condensed survey of life and work. Valuable bibliography.

711 VALENTINER, WILHELM R. "Matteo Civitale." Art in America 2
 (1914):186-200, 6 figs.
 Reassessment of Matteo Civitali, focusing primarily on
works in terracotta in U.S.: Angel (Metropolitan Museum of Art, New
York), Madonna Adoring Christ (Gardner collection, Boston [now
Isabella Stewart Gardner Museum, Boston]), and Nativity (Ryan collec-
tion, New York).

712 VALENTINER, WILHELM R. "The Annunciation Group of Matteo
 Civitale." Art in America 9 (1921):202-5, 1 fig.
 Life-size Angel (Metropolitan Museum of Art, New York) by
Matteo Civitali is linked to stylistically similar Virgin (private

collection, Amsterdam), here attributed to Civitali, to form <u>Annun-ciation</u> group.

713 VARNI, SANTO. "Delle opere di Matteo Civitali: Scultore ed
 architetto lucchese." <u>Atti della Società ligure di storia
 patria</u> 4 (1866):1-31, no illus.
 Discusses formation of Civitali and outlines his entire
career but focuses on his reliefs and statues for Cappella di San
Giovanni Battista, Duomo, Genoa.

GIACOMO COZZARELLI

714 BACCI, PELEO. "Commentarii dell'arte senese, I: Il pittore,
 scultore, e architetto Iacopo Cozzarelli e la sua permanenza
 in Urbino con Francesco di Giorgio Martini del 1478 al 1488;
 II, I due 'angioletti' di bronzo (1489-90) per l'altare del
 Duomo di Siena." <u>Bullettino senese di storia patria</u> 39, n.s. 3
 (1932):97-112, 4 figs.
 Analyzes Cozzarelli's collaboration with Francesco di
Giorgio in Urbino (1478-88) in projects involving painting, architec-
ture, and architectural decoration. Pair executed two bronze <u>Candle-
bearing Angels</u> for the high altar of the Duomo, Siena (1489-90).

715 BERSANO, LAURA. "L'arte di Giacomo Cozzarelli." <u>Bullettino
 senese di storia patria</u> 64, 3d ser. 16 (1957):109-42, 2 figs.
 Monographic article surveying career of Cozzarelli in both
architecture and sculpture and examining problem of his relationship
with Vecchietta and Francesco di Giorgio.

716 CASTELFRANCO, GIORGIO. "La mostra del tesoro di Firenze sacra:
 Sculture toscane." <u>Bollettino d'arte</u>, 3d ser. 27 (December
 1933):264-83, 25 figs., 1 color pl.
 Comments on recent exhibition of Tuscan wood and terracotta
sculpture from Romanesque period through fifteenth century. Most of
fifteenth-century sculpture is anonymous, although polychromed <u>Bust
of St. Miniato</u> is here attributed to Cozzarelli.

717 De NICOLA, G[IACOMO]. "Cozzarelli, Giacomo di Bartolomeo di
 Marco." In <u>Thieme-Becker Künstler-Lexikon</u>. Leipzig: E.A.
 Seemann, 1913, 8:37-38.
 Condensed survey of life and work. Valuable bibliography.

718 De NICOLA, GIACOMO. "La Pietà del Cozzarelli all'Osservanza."
 <u>Rassegna d'arte senese</u> 6, no. 1 (1910):6-14, 3 figs., 1 recon-
 struction drawing.
 Physical examination of <u>Pietà</u> group (Osservanza Convent,
Siena) reveals figures are missing. Newly discovered document
indicates that figures missing are Mary Magdalen and St. John.
Author argues that figure of <u>St. John</u> (Museo dell'Opera del Duomo,
Siena) by Cozzarelli is missing St. John. Further confirmation of
this theory is provided by the <u>bozzetto</u>, see entry 722.

719 De NICOLA, GIACOMO. "La Pietà di Quercegrossa." Rassegna
 d'arte senese 6 (1910):60-64, no illus.
 Publishes terracotta Pietà group (Church of Quercegrossa,
 near Siena) by Cozzarelli student in early sixteenth century,
 modelled on Cozzarelli bozzetto (Museo artistico industriale, Rome).

720 LUSINI, V. "D'un gruppo della Pietà di Giacomo Cozzarelli e di
 un S. Giovanni che non ci ha che fare." Rassegna d'arte senese
 1 (1905):79-86, no illus.
 Disputes theory that figure of St. John (Museo artistico
 industriale, Rome) was originally part of Cozzarelli's Pietà group
 for Tomb of Pandolfo Petrucci (Osservanza Convent, Siena). Argues it
 was part of another Pietà group by Cozzarelli from same convent.

721 LUSINI, V. "Per chi studia il Cozzarelli: Un'altra nota
 critica." Rassegna d'arte senese 6 (1910):43-59, 4 figs.
 Disputes Misciattelli's and De Nicola's argument (entries
 718 and 722) that figure of St. John (Museo dell'Opera del Duomo,
 Siena) was originally part of Cozzarelli's Pietà group for Tomb of
 Pandolfo Petrucci (Osservanza Convent, Siena). Considers figure work
 of different artist.

722 MISCIATTELLI, PIERO. "Il bozzetto di una 'Lamentazione'
 sconosciuta di Giacomo Cozzarelli." Rassegna d'arte senese 6,
 no. 1 (1910):3-5, 3 figs.
 Publishes a terracotta bozzetto (Museo artistico indus-
 triale, Rome), identified here as Cozzarelli's bozzetto for Pietà
 (Osservanza Convent, Siena).

723 PORTER, A. KINGSLEY. "Giacomo Cozzarelli and the Winthrop
 Statuette." Art in America 9, no. 3 (April 1921):94-101, 6
 figs.
 Discusses Cozzarelli's style, which is distinguished from
 that of his master, Francesco di Giorgio. Attribution to Cozzarelli
 of Bacchus statuette (G.L. Winthrop collection, New York) previously
 given to Pollaiuolo but shown to derive from Apollo Belvedere, which
 he argues was known only after ca. 1505.

 CRISTOFORO DA FIRENZE

724 ANON. "Cristoforo da Firenze." In Thieme-Becker Künstler-
 Lexikon. Leipzig: E.A. Seemann, 1913, 8:120.
 Condensed survey of life and work. Valuable bibliography.

 DELLO DELLI

725 CONDORELLI, ADELE. "Precisazioni su Dello Delli e su Nicola
 Fiorentino." Commentari 19 (1968):197-211, 5 figs.
 Rereading of documents clarifies careers of Dello Delli and
 Nicola Fiorentino. Establishes that many paintings executed in Spain
 and traditionally attributed to Dello Delli are by Nicola Fiorentino.

726 FIOCCO, GIUSEPPE. "Dello Delli scultore." Rivista d'arte 11
 2d ser. 1 (1929):25-42, 4 figs.
 Monographic study of Dello Delli's career that includes
documents. Supports Vasari's claim that Delli was sculptor by
attributing to him relief lunette of Coronation of the Virgin
(Sant'Egidio, Florence), previously attributed to Master of Pelle-
grini Chapel (Michele da Firenze).

727 FIOCCO, GIUSEPPE. "Il mito di Dello Delli." In Arte in
 Europa: Scritti di storia dell'arte in onore di Edoardo
 Arslan. Milan: Artipo, 1966, pp. 341-49, figs. 248-54.
 Résumé of information about Dello Delli, derived primarily
from Vasari. Preliminary distinction of Dello from his son, who also
worked in Spain.

728 MAYER, AUGUST L. "Studien zur Quattrocentomalerei in Nordwest-
 kastilien." Repertorium für Kunstwissenschft 32 (1909):508-28,
 no illus., esp. pp. 509-12 and 521.
 Biographical details of Dello Delli's life in Spain, in
particular, his studio in Avila and fresco cycle in Salamanca (1445).

729 MIDDELDORF, ULRICH. "Dello Delli and The Man of Sorrows in
 the Victoria and Albert Museum.' Burlington Magazine 78
 (1941):70-78, 7 figs.
 Figure of Christ as Man of Sorrows (Victoria and Albert
Museum, London) is attributed to Dello Delli, who Vasari mentions was
a sculptor before he fled Florence in 1424 and turned to painting.
The London sculpture, the first sculpture identified as Delli's, is
represented in Bicci di Lorenzo's fresco of 1440-42 over a portal at
Sant'Egidio, Florence, allowing a further attribution to Dello Delli
of the Sant'Egidio Coronation. Reprinted in entry 54.

730 PARRONCHI, ALESSANDRO. "Probabili aggiunte a Dello Delli
 scultore." Cronache di archeologia e di storia dell'arte 8
 (1969):103-10, 17 figs.
 Attributes to Dello terracotta Apostle figure (head broken
off), Pazzi Chapel, Florence; and wood Crucifix (Old Sacristy, San
Lorenzo, Florence), which bears the arms of Nicholas V and which
author dates 1447-48.

731 W[EISBACH], W. "Dello di Niccolò Delli." In Thieme-Becker
 Künstler-Lexikon. Leipzig: E.A. Seemann, 1913, 9:27-28.
 Condensed survey of life and work. Valuable bibliography.

DESIDERIO

Books

732 CARDELLINI, IDA. Desiderio da Settignano. Studi e documenti
 di storia dell'arte, vol. 3. Milan: Edizioni di Comunità,
 1962, 312 pp., 141 figs.

Only modern monograph on Desiderio. Chapters on major commissions such as Marsuppini Tomb. Catalogue raisonné of docmented sculptures, attributions, lost works, and sculpture derived from Desiderio. Profusely illustrated. Lengthy, unselective bibliography. Pope-Hennessy, entry 61: "meticulous and unreliable."

732a Markham, Anne. Review of Desiderio da Settignano, by Ida Cardellini. Art Bulletin 46, no. 2 (June 1964):239-47.
Thorough review of all aspects of Desiderio's career, evaluating problems of attribution and biographical facts.

732b Negri Arnoldi, Francesco. Review of Desiderio da Settignano, by Ida Cardellini. Paragone, no. 171 (1964):64-70.

733 PLANISCIG, LEO. Desiderio da Settignano. Vienna: Anton Schroll & Co., 1942, 50 pp., 87 figs.
Brief, scholarly monograph, employing critical approach to establish a catalogue of Desiderio's work. Profusely illustrated, with notes on plates. Not superseded by Cardellini.

Unpublished Theses

*734 VINES, G. COCHRANE. "Desiderio da Settignano." Ph.D. dissertation, University of Virginia, 1981, 330 pp.

Monographs on One Sculpture or Group of Sculptures

735 KENNEDY, CLARENCE. The Magdalen and Sculptures in Relief by Desiderio da Settignano and His Associates. Studies in the History and Criticism of Sculpture, vol. 6. Northampton, Mass.: Smith College, 1929 (57 copies).
Portfolio of forty-six photographic prints (works of art themselves), without text, of sculptures by Desiderio, including full-length Mary Magdalen (Santa Trinità, Florence) and various reliefs. Many close-ups show details and texture of marble.

736 KENNEDY, CLARENCE. The Tabernacle of the Sacrament by Desiderio da Settignano and Assistants. Studies in the History and Criticism of Sculpture, vol. 5. Northampton, Mass.: Smith College, 1929 (57 copies)
Portfolio of sixty-six photographic prints (works of art themselves), without text, of Desiderio's tabernacle (San Lorenzo, Florence). Many details show precise handling of the marble.

737 KENNEDY, CLARENCE. The Tomb of Carlo Marsuppini by Desiderio da Settignano and Assistants. Studies in the History and Criticism of Art, vol. 2. Northampton, Mass.: Smith College, 1928 (25 copies).
Fifty-eight excellent photographs, including details, of the tomb. No text.

Articles

738 AVERY, CHARLES. "The Beauregard Madonna: A Forgotten Master-
 piece by Desiderio da Settignano." Connoisseur 193, no. 777
 (November 1976):186-95, 18 figs. Reprinted in Charles Avery,
 Studies in European Sculpture (London: Christie's, 1981), pp.
 25-34, 18 figs.
 Attributes Beauregard Madonna relief, now in Norton Simon
 Foundation, to Desiderio, ca. 1455. Previously attributed to Antonio
 Rossellino or Domenico Rosselli.

739 BECHERUCCI, LUISA. "Un angelo di Desiderio da Settignano."
 Arte 35, n.s. 3, no. 2 (March 1932):153-60, 5 figs.
 Attributes angel on right of Tomb of Beata Villana (Santa
 Maria Novella, Florence) to Desiderio while in shop of Bernardo
 Rossellino, to whom monument is documented. Attribution supported by
 early sources (Billi, l'Anonimo Magliabechiano, Vasari, Bocchi) who
 attribute whole tomb to Desiderio. Earliest hypothesis that Desider-
 io worked in Bernardo's shop.

740 BODE, WILHELM von. "Desiderio da Settignano und Francesco
 Laurana: Die wahre Büste der Marietta Strozzi." Jahrbuch der
 königlich preussischen Kunstsammlungen 10 (1889):28-33, 1 line
 drawing.
 Discusses Desiderio's Bust of "Marietta Strozzi"(National
 Gallery of Art, Washington, D.C.) in relationship to version in
 Berlin-Dahlem museum.

741 BODE, WILHELM von. "Neuaugefundene Repliken von Marmorbüsten
 Francesco Lauranas und Desiderio da Settignanos." Amtliche
 Berichte der Berliner Museen 36, no. 3 (December 1914): cols.
 51-55, 3 figs.
 Publishes two recently discovered variants of known
 Quattrocento marble busts: the so-called Beatrix of Aragon by
 Francesco Laurana (Duveen Bros., New York), and "Marietta Strozzi" by
 Desiderio da Settignano (Duveen Bros., New York).

742 BODE, WILHELM von. "Desiderio da Settignano und Francesco
 Laurana: Zwei italienische Frauenbüsten des Quattrocento im
 Berliner Museum." Jahrbuch der königlich preussischen Kunst-
 sammlungen 9 (1888):209-27, 7 line engrs.
 Discussion of Desiderio's Bust of "Marietta Strozzi" now in
 the Berlin-Dahlem Museum.

743 BUNT, CYRIL G.E. "A Quattrocento Bust: Desiderio or Francesco
 di Giorgio?" Connoisseur 113, no. 491 (March 1944):26, 60, 1
 fig.
 Marble relief of female in profile with nude bust (Victoria
 and Albert Museum, London) is considered original of several terra-
 cotta copies (in Berlin) and is attributed to Desiderio.

744 CARDELLINI, IDA. "Desiderio e i documenti." Critica d'arte 9,
 nos. 53-54 (1962):110-12, no illus.
 Disputes Corti's and Hartt's interpretation of documents
pertaining to Desiderio (entry 72).

745 CARDELLINI, IDA. "Desiderio e il tabernacolo di San Lorenzo."
 Critica d'arte 3, nos. 13-14 (1956):68-75, 12 figs.
 Discusses problems concerning original form of Desiderio's
tabernacle (San Lorenzo, Florence), modified by later additions and
several moves. Argues that 1948 reconstruction is inaccurate.

746 CARDELLINI, IDA. "Un problema desideriesco." In Studi in
 onore di Matteo Marangoni. Pisa and Florence: Vallecchi
 Editore Officine Grafiche, 1957, pp. 182-89, 8 figs. [First
 published in Critica d'arte 18 (1956):558-63.]
 Argues that Madonna and Child relief by Desiderio (Victoria
and Albert Museum, London), is based on Donatello composition and
other versions of Desiderio relief are shop works or
fifteenth-century copies.

747 COURAJOD, LOUIS. "Conjecture à propos d'un buste en marbre de
 Beatrix d'Este au Musée du Louvre." Gazette des beaux-arts, 2d
 per. 16 (1877):330-44, 5 figs.
 Marble Bust of "Beatrice d'Este" (1475-97), previously
attributed to Desiderio da Settignano (d. 1463), is here attributed
tentatively to Leonardo or Northern Italian sculptor close to Sforza
court, ca. 1487-90.

748 COURAJOD, LOUIS. "Observations sur deux bustes du Musée de
 sculpture de la Renaissance au Louvre." Gazette des
 beaux-arts, 2d per. 28 (1883):24-42, 10 figs.
 Discusses the provenance, authenticity, and significance of
two marble busts: a man (with a chain around his neck), late
fifteenth to early sixteenth century, artist unknown; and Bust of
"Beatrice d'Este," the so-called Diva Beatrix, is called a portrait
of a relative of Ferdinand I of Naples.

749 De NICOLA, GIACOMO. "La Giuditta di Donatello e la Madonna
 Panciatichi di Desiderio." Rassegna d'arte antica e moderna
 17, nos. 9-10 (1917):153-60, 6 figs.
 Argues that base of Judith statue is by Donatello and was
intended to hold this group. Attributes to Desiderio what he con-
siders preliminary drawing for Panciatichi Madonna relief.

750 GAMBA, CARLO. "La Madonna di Solarolo." Bollettino d'arte, 3d
 ser. 25, no. 2 (August 1931):49-53, 7 figs.
 Publishes late fifteenth-century marble (Bargello, Flor-
ence), done after Madonna di Solarolo; only other version is stucco
copy (Victoria and Albert Museum, London). Author attributes Madonna
di Solarolo (Palazzo Comunale, Solarolo) to Desiderio, not Donatello,
Antonio Rossellino, or Francesco di Simone Ferrucci.

751 GAMBA, CARLO. "La Madonna di Solarolo." Rivista d'arte 27, 3d
 ser. 2 (1951-52):165-75, 7 figs.
 Argues against current Francesco di Simone [Ferrucci]
 attribution for Madonna and Child relief (Palazzo Comunale, Solarolo)
 and attributes it to Desiderio before 1461.

752 KENNEDY, CLARENCE. "Documenti inediti su Desiderio da
 Settignano e la sua famiglia." Rivista d'arte 12, 2d ser. 2
 (1930):243-91, 5 figs.
 Publishes many documents regarding Desiderio, particularly
 catasti and family records. Few directly concern sculptures.

753 LISNER, MARGRIT. "Die Büste des Heiligen Laurentius in der
 Alten Sakristei von S. Lorenzo: Ein Beitrag zu Desiderio da
 Settignano." Zeitschrift für Kunstwissenschaft 12 (1958):
 51-70, 16 figs.
 Terracotta Bust of "St. Lawrence" (San Lorenzo, Florence),
 often attributed to Donatello, is here ascribed to Desiderio, influ-
 enced by Donatello (ca. 1450).

754 MIDDELDORF, ULRICH. "Die zwölf Caesaren von Desiderio da
 Settignano." Mitteilungen des Kunsthistorischen Institutes in
 Florenz 23, no. 3 (1979):297-312, 20 figs. [Résumé in Italian.]
 According to document of 1455, Desiderio was commissioned
 to make series of twelve heads based on antique coins. Argues that
 the number suggests they represented Suetonius's twelve Caesars and
 the low payment, that they were probably in low relief. Collects
 group of reliefs of Caesars in marble and pietra serena that reflect
 Desiderio's reliefs, which are apparently lost. Reprinted in entry
 54.

755 NEGRI ARNOLDI, FRANCESCO. "Un Desiderio da Settignano vero (e
 uno falso)." Paragone 15, no. 175 (July 1964):69-73, 3 figs.,
 1 color pl.
 Attributes profile bust relief of nude woman (Museo del
 Castello Sforzesco, Milan) to Desiderio, not to student of Donatello.
 Argues that it is not copy of similar relief in Victoria and Albert
 Museum, London, as others have claimed, but that latter is fake.

756 NYE, PHILA C. "A Terracotta Bambino by Desiderio." Art in
 America 3, no. 1 (December 1914):32-36, 3 figs.
 Terracotta Christ Child from a Nativity (formerly Allan
 Marquand collection, Princeton, N.J., [now The Art Museum, Princeton
 University]) is attributed to Desiderio, ca. 1460-64.

757 PAATZ, WALTER. "Vergessene Nachrichten über einige Hauptwerke
 der Florentiner Quattrocento-Skulptur." Mitteilungen des
 Kunsthistorischen Institutes in Florenz 4, nos. 2-3 (1932-34):
 140-41, no illus.
 Research based on Cianfogni-Moreni (entry 128, 1:15) pro-
 vides commission date of 1 August 1461 for Desiderio's tabernacle in
 San Lorenzo. Also supplies terminus post quem of 1457 for terracotta

Bust of St. Leonard [St. Lawrence] (now in Old Sacristy) attributed
to Donatello. It was intended for Neroni Chapel, built after 1457
(entry 128, 2:276). Evaluates Desiderio's role in the Rossellino
workshop's Tomb of Beata Villana, Santa Maria Novella, Florence.

758 PARRONCHI, ALESSANDRO. "Sulla collocazione originaria del
 tabernacolo di Desiderio da Settignano." Cronache di
 archeologia e di storia dell'arte 4(1965):130-40, 21 figs.
 Reconstructs original format of Desiderio's tabernacle and
its relationship to intended site, altar of chapel in Old Sacristy,
San Lorenzo, Florence. Argues it was executed prior to 1453, thus
predating the Marsuppini Tomb. Claims that Christ Child crowning
tabernacle was carved by Baccio da Montelupo and that original by
Desiderio is in Cleveland Museum of Art.

759 PASSAVANT, GUNTER. "Beobachtungen am Lavabo von San Lorenzo in
 Florenz." Pantheon 39 (1981):33-50, 33 figs.
 Vasari says Desiderio did marble pedestal with harpies for
Donatello's bronze David (now Bargello, Florence). Author argues
that pedestal was reworked into fountain for unspecified Medici
residence, and then into lavabo now in San Lorenzo.

760 PHILLIPS, JOHN G. "The Virgin with the Laughing Child." In
 Studies in the History of Art Dedicated to William E. Suida on
 His Eightieth Birthday. London: Phaidon Press for the Samuel
 H. Kress Foundation, 1959, pp. 146-53, 10 figs.
 Terracotta Virgin with the Laughing Child (Victoria and
Albert Museum, London), previously attributed to Antonio Rossellino
or Desiderio, is here ascribed to Leonardo. See entry 1832.

761 PLANISCIG, LEONE. "Santa Maria Maddalena di Desiderio da
 Settignano." Arte mediterranea 3 (March-April 1949):5-11, 8
 figs.
 Argues that Donatello's influence indicates Mary Magdalen
(Santa Trinità, Florence) was worked on by Desiderio in his early
career.

762 RICHARDSON, E.P. "A Profile Portrait of a Young Woman by
 Desiderio." Bulletin of the Detroit Institute of Arts 28, no.
 1 (1948):2-4, 1 fig. (cover). Reprinted in Art Quarterly 11,
 no. 3 (Summer 1948):280-85, 1 fig.
 Pietra serena relief (originally polychromed) acquired from
Edsel Ford collection is attributed to Desiderio.

763 SCHOTTMULLER, F[RIDA]. "Desiderio da Settignano." In Thieme-
 Becker Künstler-Lexikon. Leipzig: E.A. Seemann, 1913,
 9:132-33.
 Condensed survey of life and work. Valuable bibliography.

764 SPENCER, JOHN R. "Francesco Sforza and Desiderio da
 Settignano: Two New Documents." Arte lombarda 13, no. 1
 (1968):131-33, no illus.

Sforza's unsuccessful negotiations (1462) for two stuccos and a marble by Desiderio provide information on prices and availability of works of art, production of stuccos, and dating of Desiderio's San Lorenzo tabernacle (ca. 1461-64 for project). Translation of documents.

765 STROM, DEBORAH. "A New Look at the Mellon Christ Child in the National Gallery of Art." Antichità viva 22, no. 3 (1983): 9-12, 8 figs.
Argues that Bust of a Boy (Christ Child?) in National Gallery of Art, Washington, D.C., universally attributed to Desiderio, is nineteenth-century.

766 STROM, DEBORAH. "Desiderio and the Madonna Relief in Quattrocento Florence." Pantheon 40, no. 2 (April-June 1982):130-35, 10 figs.
Analyzes gesso squeezes from molds of Madonna and Child marble reliefs attributed to Desiderio technically and as objects of popular devotion. Argues that where two or more gesso or terracotta versions of motif survive, there was no original marble. Therefore, considers Panciatichi Madonna (Bargello, Florence) and tondo of Tomb of Carlo Marsuppini (Santa Croce, Florence), the only extant original marble reliefs by Desiderio. Considers Foulc Madonna and Child (Philadelphia Museum of Art) and Turin Madonna (Galleria Sabauda, Turin) nineteenth-century forgeries. Calls the Pazzi Madonna in Berlin a sixteenth-century version of a Donatello composition.

767 SUIDA, WILLIAM E. "Again the Simonetta Bust." Art Quarterly 12, no. 2 (Spring 1949):176-79, 4 figs.
Reasserts attribution to Leonardo of marble Bust of "Simonetta Vespucci" (National Gallery of Art, Washington, D.C.) but alters date, suggesting it was done ca. 1476-78, after her death in 1476. Generally attributed to Desiderio or Verrocchio.

768 SUIDA, WILLIAM E. "La Bella Simonetta." Art Quarterly 11, no. 1 (Winter 1948):2-8, 4 figs.
Marble Bust of a Lady (National Gallery of Art, Washington, D.C.) traditionally identified as Isotta, wife of Sigismondo Malatesta, is here identified as Simonetta Vespucci on basis of fresco by Domenico Ghirlandaio. Bust is attributed to Leonardo, ca. early 1470s, rather than to Desiderio or Verrocchio, as had usually been case.

769 VALENTINER, W.R. "Leonardo and Desiderio." Burlington Magazine 61, no. 353 (August 1932):52-61, 13 figs.
Francesco di Simone's sketchbook offers clues to working method in Verrocchio's workshop, indicating especially that work was copied from model books rather than nature. In this way Desiderio's work influenced young Leonardo, as in Study for Benois Madonna after a Madonna relief (Dreyfus collection) by Desiderio. Attribution to Leonardo of terracotta statuette of seated Virgin with Laughing Child (Victoria and Albert Museum, London), given by Bode to Antonio

Rossellino and later to Desiderio. For attribution of the latter, see Pope-Hennessy, entry 1832.

770 VERDIER, PHILIPPE. "Il putto ignoto: A Marble Statuette of Christ in Quest of a Father." Bulletin of the Cleveland Museum of Art 70, no. 7 (September 1983):303-11, 11 figs.
 Argues that sculpture of Christ Child crowning Desiderio's tabernacle, San Lorenzo, Florence, was carved for it by Baccio da Montelupo. Christ Child figure (Cleveland Museum of Art) usually identified as Baccio's sculpture is here reattributed to anonymous late fifteenth-century sculptor. Summarizes later history of Desiderio's tabernacle, clarifying several confusions.

771 WITTKOWER, RUDOLF. "Desiderio da Settignano's St. Jerome in the Desert." Studies in the History of Art, 1971-72:6-37, 25 figs. Reprinted in Rudolf Wittkower, Idea and Image: Studies in the Italian Renaissance (London: Thames and Hudson, 1978), pp. 137-51, 25 figs.
 Desiderio's marble relief of St. Jerome in the Desert (National Gallery of Art, Washington, D.C.) exhibits unusual iconography traced to influence of Castagno, Fra Filippo Lippi, Ghiberti, and Gozzoli. Dated ca. 1461-64 on basis of this iconography. Nearly identical version (Michael Hall collection, New York) is compared and considered a contemporary copy.

772 WOLFFLIN, HEINRICH. "Florentinische Madonnenreliefs." Zeitschrift für bildende Kunst, n.s. 4 (1893):107-11, 3 figs.
 Regards marble Madonna relief ("Madonna of the Steps" type) attributed to Desiderio (Dreyfus collection) as modern forgery; publishes cast of original, which he considers the work of an early sixteenth-century artist influenced by Michelangelo.

DOMENICO DI NICCOLO DE' CORI (DOMENICO DI NICCOLO SPINELLI)

773 BERNATH, M.H. "Cori, Domenico di Niccolò de'." In Thieme-Becker Künstler-Lexikon. Leipzig: E.A. Seemann, 1912, 7:412-13.
 Condensed survey of life and work. Valuable bibliography.

774 CARLI, ENZO. "Sculture inedite senesi del Tre e Quattrocento." In Jacopo della Quercia fra Gotico e Rinascimento (Atti del Convegno di studi, Siena, 1975). Edited by Giulietta C. Dini. Florence: Centro Di, 1977, pp. 15-20, 19 figs.
 Attributes to Domenico di Niccolò de' Cori eight heads on exterior of Baptistry, Siena, and a Crucifix called "Il Crocifisso di S. Bernardino," in the Oratory of the Compagnia dei disciplinati sotto le volte, Hospital of Santa Maria della Scala, Siena.

775 GUIDUCCI, ANNA MARIA. "Il Maestro di Lucignano e Domenico di Niccolò dei Cori." In Jacopo della Quercia fra Gotico e Rinascimento (Atti del Convegno di studi, Siena, 1975). Edited

by Giulietta C. Dini. Florence: Centro Di, 1977, pp. 38-42,
18 figs.
Group of stylistically similar wood sculptures are attrib-
uted to anonymous Sienese "Master of the Madonna of Lucignano," named
after standing Madonna and Child in Collegiata, Lucignano. Attrib-
utes to this master who is very close to Domenico di Niccolò de'
Cori, an Annunciation (Santa Chiara, Castelfiorentino) previously
attributed to Domenico di Niccolò de'Cori.

DONATELLO

Books

776 BALCARRES, LORD [David A.E.L. Crawford]. Donatello. London:
 Duckworth & Co., 1903, 211 pp., 58 figs.
 First monograph in English. Of historical interest only.

776 bis BENNETT, BONNIE A., and WILKINS, DAVID G. Donatello.
 Oxford: Phaidon, 1984; New York: Moyer-Bell, 1985, 248 pp., 4
 col. pls., 141 figs.
 Recent study that treats selected problems in Donatello's
career. Valuable assessment of recent scholarship in footnotes and
extensive bibliography.

777 BERTAUX, EMILE. Donatello. Paris: Plon-Nourrit & Cie, 1910,
 254 pp., 24 figs., tables.
 Early monograph useful for its thoroughness, though now
largely superseded. With bibliography.

778 CASTELFRANCO, GIORGIO. Donatello. Milan: Aldo Martelli,
 1963, 106 pp., 209 figs., 40 color pls.; English ed. Translated
 by R.H. Boothroyd. London: Heinemann, 1965. 2d Italian ed.
 Florence: Giunti Martello, 1981, 106 pp., 209 figs., 40 color
 pls.
 Overview of Donatello's sculpture that aims to introduce
and explain his work to a nonspecialized audience. Many color
photographs of details of sculptures.

778a Romanini, Angiola Maria. Review of Donatello, by Giorgio
 Castelfranco. Art Bulletin 53, no. 3 (September 1971):401-2.
 Analyzes Castelfranco's method ("which turns the reading of
a work of art into a way of getting at the human dimension of
Donatello").

779 CRUTTWELL, MAUD. Donatello. London: Methuen & Co., 1911, 162
 pp., 81 figs., Reprint. Freeport, N.Y.: Books for Libraries,
 1971.
 Serious early monograph that presents biography, then
attributed works. In some respects dated but still useful. Of
historical interest for establishing many prevailing interpretations
of Donatello's work (expressionism, inventiveness, first Renaissance
portraits, etc.).

780 Donatello e il suo tempo (Atti dell'VIII convegno internazio-
 nale di studi sul Rinascimento, Florence-Padua, 1966). Flor-
 ence: Istituto Nazionale di Studi sul Rinascimento, 1968, 407
 pp., 92 figs.
 Publication of conference on Donatello and his influence.
Limited notes and illustrations.

781 FECHHEIMER, S[AMUEL S]. Donatello und die Reliefkunst: Eine
 kunstwissenschaftliche Studie. Zur Kunstgeschichte des Aus-
 landes, vol. 17. Strasbourg: J.H. Ed. Heitz, 1904, 96 pp., 16
 figs.
 Analyzes evolution of Donatello's sculpture, especially in
relation to painting and freestanding sculpture, as well as to
Quercia's and Ghiberti's work and antique sources.

782 GOLDSCHEIDER, LUDWIG. Donatello. London and New York: Oxford
 University Press, 1941, 48 pp., 316 figs.
 Brief text, but useful for its large number of illustra-
tions of Donatello workshop copies and works related to Donatello's
oeuvre.

783 GRASSI, LUIGI. Tutta la scultura di Donatello. Biblioteca
 d'arte Rizzoli, vols. 30-31. Milan: Rizzoli, 1958, 117 pp.,
 216 figs. English ed. Translated by Paul Colacicchi. New
 York: Hawthorn, 1964, 147 pp., 220 figs., 4 color pls.
 Handy, popular monograph on Donatello with catalogue
raisonné and numerous good plates.

784 GREENHALGH, MICHAEL. Donatello and His Sources. London:
 Duckworth, 1982, 226 pp., 146 figs.
 Thorough study that considers range of antique and medieval
artifacts available in relation to Donatello's major sculptures,
tending to include all possible sources and iconographic readings.
Introductory chapter on antiquities and collecting in Renaissance
provides much new information on their availability, acquisition, and
study.

785 HARTT, FREDERICK. Donatello: Prophet of Modern Vision. New
 York: Abrams, 1973, 482 pp., 237 figs., 193 color pls.
 Large-scale, dramatic photographs of Donatello's sculpture
by David Finn, accompanied by rhetorical text by Frederick Hartt.

785a Pope-Hennessy, John. Review of Donatello: Prophet of Modern
 Vision, by Frederick Hartt. New York Review of Books 20, nos.
 21-22 (24 January 1974):7-9.
 Important review in which Pope-Hennessy summarizes his own
views on Donatello and disagrees with several attributions accepted
by Hartt. Stresses Donatello's empirical method, coherent evolution,
and important connection between painting and sculpture. Criticizes
photography, which distorts appearance of sculptures.

786 JANSON, H[ORST] W. The Sculpture of Donatello. 2 vols.
 Princeton: Princeton University Press, 1957, 277 pp., 512
 figs. 1 oversize drawing of reconstructions.
 Authoritative catalogue raisonné of Donatello's sculpture,
including major rejected attributions. Based on Lányi's notes and
corpus of photographs, most extensive available on any Italian
Renaissance sculptor. Entries thoroughly analyze documents and
earlier literature and suggest ideas for further research.
Subsequent editions contain complete text of original edition, with
reduced number of plates and/or illustrations.

786a Gilbert, Creighton. Review of The Sculpture of Donatello, by
 H.W. Janson. College Art Journal 18, no. 1 (Fall 1958):90-92
 Disputes Janson's rejection of St. John the Baptist (Cam-
panile, Florence) and Janson's acceptance of bronze Bust of a Youth
(Bargello, Florence).

786b Nicholson, Alfred. Review of The Sculpture of Donatello, by
 H.W. Janson. Art Bulletin 41, no. 2 (June 1959):203-13.
 Evaluates thoroughly each of Janson's attributions and
conclusions. Proposes later date for Martelli David (National
Gallery of Art, Washington, D.C.).

787 JANSON, H[ORST] W. The Sculpture of Donatello. 2d ed.
 Princeton: Princeton University Press, 1963, 260 pp., 316
 figs. Paperback ed. Princeton: Princeton University Press,
 1979, 260 pp., 316 figs.
 Contains complete text of first edition of 1957 but reduced
number of plates.

788 KAUFFMANN, HANS. Donatello: Eine Einführung in sein Bilden
 und Denken. Berlin: G. Grote'sche, 1935, 262 pp.,,104 figs.
 Major early monograph that approaches Donatello's sculpture
according to type of commission. Stresses Donatello's relationship
to medieval precedents. Extensive notes contain much new informa-
tion, plus new sources in bibliography. According to Pope-Hennessy
(entry 61), book contains "much information and many fresh observa-
tions. Since the picture of Donatello's personality presented in it
is in certain essential respects misconceived, and since its attitude
to attribution is uncritical, it will prove useful only to the
specialist."

788a Longhurst, M[argaret] H. Review of Donatello: Eine Einführung
 in sein Bilden und Denken, by Hans Kauffmann. Burlington
 Magazine 68 (1936):301.

788b Middeldorf, Ulrich. Review of Donatello: Eine Einführung in
 sein Bilden und Denken, by Hans Kauffmann. Art Bulletin 18
 (1936):570-85, 10 figs.
 Major statement of Middeldorf's view regarding various
aspects of Donatello's life and work: Donatello's architecture and
Brunelleschi, Gothic echoes in Donatello's work, Padua Altar, terra-

cotta bust called Niccolò da Uzzano (Bargello, Florence), and
development of rilievo schiacciato. Reprinted in entry 54.

LIGHTBROWN, R[ONALD] W. Donatello & Michelozzo: An Artistic
Partnership and Its Patrons in the Early Renasissance. 2 vols.
London: Harvey Miller, 1980, 151 pp., 145 figs.
See entry 1404.

789 MORISANI, OTTAVIO. Studi su Donatello. Collana di varia
critica, vol. 8. Venice: Neri Pozza, 1952, 239 pp., 71 figs.
Essays on Donatello's formation, his relationship with
ancient art, his "realism," and specific commissions: the Abraham
and Isaac, Cavalcanti Annunciation, two reliefs of Feast of Herod,
and Judith.

789a Marabottini, A. Review of Studi su Donatello, by Ottavio
Morisani. Commentari 5 (1954):256-60, no illus.

790 MUNTZ, EUGENE. Donatello. Paris: J. Rouam, 1885, 120 pp.,
line engrs.
Early monograph, now of historical interest only. Many
disputable attributions.

791 PARRONCHI, ALESSANDRO. Donatello e il potere. Bologna:
Cappelli; Florence: Il Portolano, 1980, 277 pp., 130 figs.,
diags., index.
Various approaches to Donatello's sculpture. Evaluates
Donatello's early naturalism. Reidentifies the bronze David (Bar-
gello, Florence) as Mercury. Reconstructs High Altar in Santo,
Padua, and altar, San Lorenzo, Florence, for which he argues the San
Lorenzo pulpits' reliefs were intended.. Analyzes Cosimo's patronage
of Donatello and makes new attributions.

792 PLANISCIG, LEO. Donatello. Vienna: Anton Schroll, 1939, 42
pp., 129 figs.
Popular monograph with brief introductory essay and com-
ments on plates. No catalogue raisonné or other scholarly apparatus.

793 POESCHKE, JOACHIM. Donatello: Figur und Quadro. Munich:
Wilhelm Fink, 1980, 138 p., 174 figs.
Analyzes Donatello's statues and reliefs from point of view
of their real and illusionistic spatial relationships. Uses Rosen-
auer's approach, entry 794, but covers all of Donatello's career.

794 ROSENAUER, ARTUR. Studien zum frühen Donatello: Skulptur im
projektiven Raum der Neuzeit. Wiener kunstgeschichtliche
Forschungen, vol. 3. Vienna; Verlag Adolf Holzhausens, 1975,
134 pp., 117 figs. [Derived from Ph.D. dissertation, Univer-
sity of Vienna, 1973.]
Study of Donatello's statues and reliefs ca. 1415-35, from
viewpoint of types of commissions, e.g., niche figure, tombs, and
relief sculpture, all of which are set within earlier traditions for

these categories of monument. Argues that Donatello's concern with
pictorial space explains novel features of these types. Suggests
that Cavalcanti Annunciation (Santa Croce, Florence) many have been
part of tomb.

794a Janson, H[orst] W. Review of Studien zum frühen Donatello:
 Skulptur in projektiven Raum der Neuzeit, by Artur Rosenauer.
 Art Bulletin 59, no. 1 (1977):136-39, no figs.
 Praises originality of approach and discusses many provoca-
 tive observations but faults author's interpretation of perception
 theory. Contends that Donatello's freestanding statuary is misinter-
 preted because of author's theories about pictorial relief.

794b Poeschke, Joachim. Review of Studien zum frühen Donatello:
 Skulptur im projektiven Raum der Neuzeit, by Artur Rosenauer.
 Kunstchronik 30, no. 8 (1977):340-45.

795 SCHUBRING, PAUL. Donatello: Des Meisters Werke. Klassiker
 der Kunst in Gesamtausgaben, vol. 11. Stuttgart and Leipzig:
 Deutsche Verlags-Anstalt, 1907, 53 pp., 164 figs.
 General introductory text; out-of-date but valuable corpus
 of Donatellesque sculptures.

796 SEMPER, HANS. Donatellos Leben und Werke: Eine Festschrift
 zum funfhundert jahrigen Jubiläum seiner Geburt in Florenz.
 Innsbruch: Wagner'schen Universitaets-Buchhandlung, 1887, 133
 pp., 8 figs.
 Abbreviated version of earlier monograph, here substan-
 tially revised, however, to correct previous errors.

797 SEMPER, HANS. Donatello: Seine Zeit und Schüle. Quellen-
 schriften für Kunstgeschichte und Kunsttechnik des Mittelalters
 und der Renaissance, 9. Vienna: C. Graeser, 1875; 338 pp.,
 no illus. Reprint. Osnabruck: Zeller, 1970.
 Most important early monograph with fine, systematic dis-
 cussion of monuments. Catalogue of Donatello's oeuvre and extensive
 transcriptions of sources and documents. Contains translation of
 Vasari's life of Donatello (1550) and Francesco Bocchi's Eccellenza
 della statua di San Giorgio di Donatello (1584), with notes.

797a Jansen, Albert. Review of Donatello: Seine Zeit und Schüle,
 by Hans Semper. Zeitschrit für bildende Kunst 11 (1876):
 316-19.

798 WUNDRAM, MANFRED. Donatello und Nanni di Banco. Beiträge zur
 Kunstgeschichte, vol. 3. Berlin: Walter de Gruyter & Co.,
 1969, 180 pp., 132 figs.
 Important recent contribution to study of early Donatello
 and his relationship to Nanni di Banco and the major monograph on
 Nanni di Banco. Revises chronological sequence of tabernacles at
 Orsanmichele. Some controversial attributions, particularly his
 attribution of Isaiah (Museo dell'Opera del Duomo, Florence) to
 Donatello, rather than Nanni.

798a Gaborit, Jean-René. Review of Donatello und Nanni di Banco, by
 Manfred Wundram. Bulletin monumental 128, no. 1 (1970):88–89.
 Cites visual and archival evidence that disputes Wundram's
attribution of Isaiah to Donatello. Raises questions about other
points concerning relationships of Donatello and Nanni di Banco to
Duomo sculpture.

798b Herzner, Volker. Review of Donatello und Nanni di Banco, by
 Manfred Wundram. Pantheon 30 (1972):82–84, no illus.

798c Jahn, Johannes. Review of Donatello und Nanni di Banco, by
 Manfred Wundram. Deutsche Literaturzeitung 92 (1971): cols.
 66–68, no illus.
 Discusses Nanni di Banco's role in Porta della Mandorla
archivolts and stresses importance of antique to first generation of
Quattrocento sculptors.

798d Janson, H.W. Review of Donatello und Nanni di Banco, by
 Manfred Wundram. Art Bulletin 54, no. 4 (December 1972):
 546–50, no illus.
 Thoroughly reevaluates relationship of Donatello and Nanni
di Banco ca. 1408–17. Contests Wundram's consideration of so-called
Isaiah as Donatello's David of 1408-9 (rather than Bargello marble
David).

798e Poeschke, Joachim. Review of Donatello und Nanni di Banco, by
 Manfred Wundram. Kunstchronik 24 (1971):10–23, no illus.
 Thorough review that critically examines not only Wundram's
hypotheses, but general literature regarding early work of Donatello
and Nanni di Banco. Discusses chronology, attributions, dating, and
style. Especially good for problem of statues for tribune but-
tresses, Duomo, Florence.

798f Rosenauer, Artur. Review of Donatello und Nanni di Banco, by
 Manfred Wundram. Mitteilungen der Gesellschaft für vergleich-
 ende Kunstforschung in Wien 26 (1974):28–30.

 Unpublished Theses

799 DUNKELMAN, MARTHA L. "Donatello's Influence on Italian
 Renaissance Painting." Ph.D. dissertation, New York Univer-
 sity, 1976, 350 pp., 304 figs., 5 color pls. [Dissertation
 Abstracts International 37, no. 9 (1976-77):5410A.]
 Argues that Donatello's freestanding sculpture was most
influential on contemporary painting by Masaccio and Castagno, while
his Madonna reliefs were widely imitated by lesser painters.

 Monographs on a Sculpture or Group of Sculptures

St. George, Orsanmichele

800 BOCCHI, FRANCESCO. Eccellenza della statua di San Giorgio di
 Donatello. Florence, 1571. First printed ed. 1584.

Reprinted in: Hans Semper, Donatello: Seine Zeit und Schüle, Quellenschriften für Kunstgeschichte und Kunsttechnik, 9 (Vienna: C. Graeser, 1875), pp.176-228, translated and annotated; and in Paola Barocchi, Trattati d'arte del Cinquecento (Bari: G. Laterza, 1962), 3: 125-94, no illus.
 Laudatory description of Donatello's statue of St. George, largely based on Vasari. First essay on single monument from earlier period, thus revealing high regard in which St. George was held in sixteenth century.

801 WUNDRAM, MANFRED. Donatello: Der Heilige Georg. Werkmono-
 graphien zur bildenden Kunst in Reclams Universal-Bibliothek, no. 120. Stuttgart: Reclam, 1967, 32 pp., 16 figs.
 Brief, handy monograph on Donatello's St. George for Orsan-
michele, written by an authority but intended for sophisticated visitor to monument.

Cantoria, Duomo, Florence

802 CORWEGH, ROBERT. Donatellos Sangerkanzel im Dom zu Florenz.
 Berlin: Bruno Cassirer, 1909, 58 pp., 24 figs.
 Monographic study of Donatello's Cantoria containing many conclusions now open to dispute regarding reconstruction (reproduces and argues against Del Moro's first reconstruction), attribution to Donatello of bronze putti with candelabra (Musée Jacquemart-André, Paris), meaning (in relation to Psalm 149), attribution to Donatello of "antique" heads below pulpit, and participation of Buggiano and Michelozzo.

802a Hadeln, Detlev von. Review of Donatellos Sangerkanzel im Dom
 zu Florenz, by Robert Corwegh. Repertorium für Kunstwissen-
 schaft 32 (1909):382-85, no illus.
 Rejects Corwegh's proposal that two bronze male heads (Bargello, Florence) are from Donatello's Cantoria, noting that they are not by Donatello nor do they fit tondi where Corwegh places them.

803 MARRAI, BERNARDO. Le cantorie di Luca della Robbia e di
 Donatello. Florence: Minori Corrigendi, 1900, 32 pp., 1 fig.
 Publishes documents about commissions for cantorie by Luca and Donatello (Museo dell'Opera del Duomo, Florence), line drawing of reconstruction of Luca's Cantoria, and scholars' favorable reactions to it.

Sienese Period

804 CARLI, ENZO. Donatello a Siena. Rome: Editalia, 1967, 141
 pp., 49 figs.
 Brief essays on Donatello's two phases of activity in Siena: 1423-29, when he primarily worked on Baptismal Font, and 1457-61, when he executed St. John the Baptist. Large plates showing numerous details.

805 LOTZ, WOLFGANG. Der Taufbrunnen des Baptisteriums zu Siena.
 Der Kunstbrief, vol. 50. Berlin: Gebr. Mann, 1948, 31 pp., 16
 figs., plan.
 Small pamphlet composed primarily of plates with brief text
 that outlines history of monument. Describes works and participation
 of Donatello, Ghiberti, Jacopo della Quercia, and Vecchietta. Argues
 that Ghiberti was responsible for overall design and architecture of
 font. Translates into German various commentaries by Vasari and
 Cellini. See entires 148 and 149.

Prato Pulpit

806 GUASTI, CESARE. Il pergamo di Donatello pel Duomo di Prato.
 Florence: Ricci, 1887, 30 pp., no illus.
 Essay on Prato Pulpit that includes transcribed documents.

807 GURRIERI, FRANCESCO. Donatello e Michelozzo nel pulpito di
 Prato. Florence: Edam, 1970, 112 pp., 88 figs.
 Extensive photographic corpus with numerous details,
 prefaced by brief essays on Donatello and Michelozzo and transcrip-
 tions of principal documents.

808 MARCHINI, GIUSEPPE. Il pulpito donatelliano del Duomo di
 Prato. Prato: Aziendo del Turismo, 1966, 43 pp., 22 figs.
 Convenient guide aimed at popular audience. No notes or
 bibliography.

809 MARCHINI, GIUSEPPE. Il Tesoro del Duomo di Prato. Milan:
 Electa, 1963, 217 pp., 87 figs., 22 color pls.
 Major publication of all liturgical objects now in
 Treasury, Duomo, Prato, including Maso di Bartolommeo's Reliquary
 Chest for the Holy Girdle. Appendix of many unpublished documents
 concerning Donatello's and Michelozzo's pulpit.

Paduan Period

810 BODE, WILHELM von. Donatello à Padoue: Gattamelata et les
 sculptures du Santo. Translated and revised by Charles
 Yriarte. Paris: Rothschild, 1883, 21 pp., 23 figs.
 Early survey of Donatello's sculptures in Padua. Of his-
 torical interest.

811 CESSI, FRANCESCO. Donatello a Padova. Padua: Lions Club,
 1967, 29 pp., 67 figs.
 Succinct and readable discussion of Paduan art before
 Donatello and Donatello's commissions in Padua. Many annotated
 illustrations.

812 GLORIA, A[NDREA]. Donatello, fiorentino, e le sue opere
 mirabili nel tempio di S. Antonio di Padova: Documenti rac-
 colti da A. Gloria per la occasione del settimo centenario
 dalla nascità di S. Antonio. Padua: Tip. e Lib. Antoniana,
 1895, 40 pp., no illus.

History of Donatello's commissions in Padua: <u>Equestrian Statue of Gattamelata</u> and High Altar, Santo, Padua. Argues that Donatello came to Padua as consultant for architectural projects at Santo. Some information on Giovanni Nani's work at Santo. Important appendix of transcribed documents.

Gattamelata

813 EROLI, GIOVANNI. <u>Erasmo Gattamelata da Narni: Suoi monumenti e sua famiglia.</u> Rome: Salviucci, 1879, 420 pp., 10 line drawings.
 Biography of Gattamelata with appendix of documents.

814 GOSEBRUCH, MARTIN. <u>Donatello: Das Reiterdenkmal des Gattamelata.</u> Werkmonographien zur bildenden Kunst in Reclams Universal-Bibliothek, vol. 29. Stuttgart: Reclam, 1958, 32 pp., 16 figs.
 Brief, handy monograph on monument, written by scholar and intended for sophisticated visitor.

High Altar, Santo, Padua

815 BOITO, CAMILLO. <u>L'altare di Donatello e le altre opere nella Basilica Antoniana di Padova.</u> Milan: Ulrico Hoepli, 1897, 71 pp., 48 figs.
 Publication of Boito's reconstruction of Donatello's High Altar, including documents transcribed from Gloria regarding altar (entry 812).

816 GLORIA, A[NDREA]. <u>L'altare di Donatello al "Santo": Ricostruzione dell'architetto F. Cordenons basata sui documenti amministrativi della Basilica.</u> Padua: Stab. Prosperini, 1895, 4 pp., 3 line engrs.
 Brief summation of allusions to original arrangement of Donatello's High Altar, Santo, Padua, with citations of documents justifying Cordenon's reconstruction of 1895.

817 GONZATI, BERNARDO. <u>La Basilica di S. Antonio di Padova descritta ed illustrata. . . .</u> 2 vols. Padua: Antonio Bianchi, 1852–53, 1:301 pp., clxx pp. of transcribed documents, 30 line engrs.; 2:513 pp., xxii pp. of transcribed documents, 11 line engrs.
 Authoritative history of construction and decoration of Santo, Padua. Based on extensive archival research. Lengthy section of transcribed documents and inscriptions. Fundamental for understanding Donatello's High Altar.

818 MANDACH, C[HARLES] de. <u>Saint Antoine de Padoue et l'art italien.</u> Paris: Librarie Renouard, 1899, 368 pp., 101 figs.
 Major iconographic study of St. Anthony of Padua and his representation in Italian art. Traces literary sources and collects all images of the saint and his miracles. Specifically analyzes iconography of Donatello's High Altar, Santo, Padua.

Pulpits, San Lorenzo

819 BECHERUCCI, LUISA. Donatello: I pergami di S. Lorenzo.
 Florence: La Nuova Italia Editrice, 1979, 25 pp., 60 figs.
 Brief essay summarizing literature on San Lorenzo pulpits
 followed by corpus of photographs, including many details. Proposes
 that some reliefs intended for projected Tomb of Cosmo de' Medici.

820 SEMRAU, MAX. Donatellos Kanzeln in S. Lorenzo: Ein Beitrag
 zur Geschichte der italienische Plastik im XV. Jahrhundert.
 Italienische Forschungen zur Kunstgeschichte, vol. 2. Breslau:
 S. Schottlaender, 1891, 232 pp., 24 figs.
 Extensive technical and stylistic examination of San Lor-
 enzo bronze pulpits. Proposes significant participation by assis-
 tants in design and execution of reliefs and even attributes some
 entire panels to Bertoldo and Bellano. Believes pulpits are largely
 complete; argues for early dating, ca. 1442; shows little interest in
 iconography.

Unpublished Theses

*821 HERZNER, VOLKER. "Die Kanzeln Donatellos in San Lorenzo."
 Ph.D. dissertation, University of Vienna, 1969, 179 pp., 19
 figs.

Bust of San Rossore, Museo Nazionale di San Matteo, Pisa

822 FONTANA, GIOVANNI. Un'opera di Donatello esistente nella
 Chiesa dei Cavalieri di S. Stefano di Pisa. Pisa: T. Nistri,
 1895, 16 pp., no illus.
 Publishes series of overlooked documents that establish
 reliquary Bust of San Rossore (now in Museo nazionale di San Matteo,
 Pisa) as by Donatello and elucidate its later history.

 Articles

823 AMES-LEWIS, FRANCIS. "Art History or Stilkritik? Donatello's
 Bronze David reconsidered." Art History 2, no. 2 (June 1979):
 139-55, 12 figs.
 Interprets and dates Donatello's bronze David (Bargello,
 Florence) using nonstylistic criteria. Argues it was commissioned by
 Piero di Cosimo de' Medici. Relates figure to Epicurean and
 Neoplatonic ideas current in 1460's and to decoration of Palazzo
 Medici[-Riccardi] courtyard, finished ca. 1460, all of which point to
 date ca. 1460.

824 BAND, ROLF. "Donatellos Altar im Santo zu Padua." Mitteil-
 ungen des Kunsthistorischen Institutes in Florenz 5 (1940):
 315-41, 11 figs., appendix.
 Publishes documents for Donatello's High Altar, Padua
 (1446-49), and establishes new chronology divided into two phases:
 First culminating in erection of provisional altar June 13, 1448;
 second extending until June 13, 1450, when altar was consecrated.

825 BANGE, E.F. "Piero de' Medici." Jahrbuch der preussischen
 Kunstsammlungen 59 (1938):83-88, 7 figs.
 Bust attributed to Donatello and traditionally identified
 as Ludovico III Gonzaga is here identified as Piero de' Medici.

826 BARASCH, MOSHE. "Character and Physiognomy; Bocchi on
 Donatello's St. George: A Renaissance Text on Expression in
 Art." Journal of the History of Ideas 36, no. 3 (1975):413-30,
 no illus.
 Analyzes this representative sixteenth-century view of
 Donatello's importance. Bocchi's 1571 treatise on St. George (pub-
 lished in Florence in 1584) stresses that expression, or representa-
 tion of character, is Donatello's principal aim.

827 BARELLI, EMMA. "Donatello's Judith and Holofernes: An Extreme
 Moral Instance." Gazette des beaux-arts, 6th per. 92, no. 1317
 (1978):147-48, no illus.
 Analyzes Judith's moral role in Judith and Holofernes group
 as parallel to that of Holofernes, not antithetical, because of
 unusual isolation of both figures on single base and base reliefs
 which refer to their joint ecstasy.

828 BEARZI, BRUNO. "Considerazioni di tecnica sul S. Ludovico e la
 Giuditta di Donatello." Bollettino d'arte, 4th ser. 36 (1951):
 119-23, 7 figs.
 Technical analysis of devices Donatello used in his models
 for these bronzes and their casting.

829 BEARZI, BRUNO. "La tecnica fusoria di Donatello." In Dona-
 tello e il suo tempo (Atti dell'VIII convegno internazionale
 di studi sul Rinascimento, Florence-Padua, 1966). Florence:
 Istituto Nazionale di Studi sul Rinascimento, 1968, pp. 97-105,
 6 figs.
 Technical analysis of modelling and casting of several
 Donatello bronzes. Points out that Donatello is only major
 Renaissance artist who did not personally cast all his own works.

830 BECHERUCCI, LUISA. "Donatello." In Encyclopedia of World Art.
 Edited by Istituto per la Collaborazione Culturale, Rome. New
 York: McGraw-Hill, 1961, 4: cols. 427-42, figs. 240-51.
 Concise, readable account of Donatello's career by an
 authority. Biographical summary clarifies collaboration with
 Michelozzo and cites Donatello's opposition to Brunelleschian math-
 ematical canons. Summarizes critical response to Donatello's work
 from Renaissance to present. With extensive bibliography.

831 BECHERUCCI, LUISA. "Donatello e la pittura." In Donatello e
 il suo tempo (Atti dell'VIII convegno internazionale di studi
 sul Rinascimento, Florence-Padua, 1966). Florence: Istituto
 Nazionale di Studi sul Rinascimento, 1968, pp. 41-58, no illus.
 Evaluation of Donatello's relationship with contemporary
 painters like Masaccio, Uccello, Lippi, and Castagno.

832 BECK, JAMES H. "Donatello's Black Madonna." Mitteilungen des
 Kunsthistorischen Institutes in Florenz 14 (1969-70):456-60, 3
 figs. [Résumé in Italian.]
 Argues that Donatello's Madonna for High Altar, Padua (ca.
 1450) is deliberately retardataire and probably reproduces style of
 preexisting Byzantine-Romanesque "Black Madonna." Located earlier in
 Chapel of Madonna Mora, this image was possibly brought to Padua by
 St. Anthony, ca. 1220.

833 BECK, JAMES H. "Ghiberti giovane e Donatello giovanissimo."
 In Lorenzo Ghiberti nel suo tempo (Atti del Convegno inter-
 nazionale di studi, Florence, 18-21 October 1978). 2 vols.
 Florence: Leo S. Olschki, 1980, 1:111-34, 16 figs.
 Argues that Donatello's earliest training was with
 Brunelleschi in 1400-1401, when he worked as silversmith on Silver
 Altar, Duomo, Pistoia, where two prophet quatrefoils, David and
 Daniel, can be attributed to him. Traces Brunelleschi's influence on
 Donatello's early sculptures. Attributes St. Peter statue (Orsan-
 michele, Florence) to their collaboration in ca. 1409. Redates
 Donatello's St. George (Orsanmichele) to 1410, rather than widely
 accepted 1417. Ghiberti's role in Donatello's formation is conse-
 quently diminished.

834 BERTAUX, ÉMILE. "Autour de Donatello." Gazette des beaux-
 arts, 3d per. 22 (1899):241-55, 397-413, 10 figs.
 Places Donatello in artistic and historical context through
 consideration of relations to other artists (especially Nanni di
 Banco at Orsanmichele and partnership with Michelozzo), influence of
 Northern sculpture, and importance of antique for his development.
 Thorough, monographic. Of historical interest.

835 BERTAUX, ÉMILE. "Le 'Saint Jean' des Martelli." Revue de
 l'art
 ancien et moderne 34 (1913):187-95, 7 figs.
 Analyzes marble St. John the Baptist by Donatello [?],
 formerly belonging to the Martelli family (now Bargello, Florence),
 as Byzantine type. Compares it iconographically and stylistically to
 other versions by Donatello.

836 BERTI, LUCIANO. "Donatello e Masaccio." Antichità viva 5, no.
 3 (1966):3-12, 14 figs., 1 color pl.
 Traces Donatello's influence on early paintings of
 Masaccio, especially attributed San Giovenale Triptych (1422), and
 Masaccio's reciprocal impact on Donatello.

837 BERTI TOESCA, ELENA. "Il cosiddetto Omero degli Uffizi."
 Bollettino d'arte 4th ser. 38 (1953):307-9, 5 figs.
 Hypothesizes that so-called bust of Homer in the Uffizi
 (and related busts in Capitoline Museum, Rome; Galleria estense,
 Modena; and Musée Jacquemart-André, Paris) are versions of ancient
 busts by Donatello and his circle.

838 BERTONI, GIULIO, and VICINI, EMILIO P. "Donatello a Modena."
Rassegna d'arte 5 (1905):69-72, no illus.
Publishes documents from 1450 to 1453 concerning Dona-
tello's proposed sculpture of Duke Borso d'Este of Modena.

839 BODE, WILHELM von. "Ein Blick in Donatellos Werkstatt."
Monatshefte für Kunstwissenschaft 1 (1908):3-10, 5 figs.
Distinguishes Donatello's style in various Madonna reliefs
from that of students and followers. Discussion of Martelli David.

840 BODE, WILHELM von. "Donatello als Architekt und Dekorator."
Jahrbuch der königlich preussischen Kunstsammlungen 22
(1901):3-28, 3 figs.
Traces stylistic development of architectural elements in
Donatello's work (tombs, pulpits, plus illusionistic architecture in
reliefs), demonstrating his innovatory role in Early Renaissance
architecture. As Michelozzo never worked independently as architect
before projects with Donatello, the latter is proposed as author of
their collaborations (Prato Pulpit and Tomb of Pope John XXIII
[Coscia]). Discusses stylistic changes after Roman trip in 1433.

841 BODE, W[ILHELM von]. "Die italienischen Skulpturen der
Renaissance in den Königlichen Museen zu Berlin, III:
Bildwerke des Donatello und seiner Schüle." Jahrbuch der
koñiglich preussischen Kunstsammlungen 5 (1884):27-42, 10 figs.
First extended discussion of Donatello's Madonna and Child
reliefs centering on examples in Berlin Museum. Also discusses
bronze statuette of St. John the Baptist (now presumed destroyed, see
entry 787, p. 246), perhaps that commissioned for the font of Orvieto
Cathedral in 1423 but never delivered.

842 BODE, WILHELM von. "Die Marmorstatuette einer Maria mit dem
Kinde im Kaiser-Friedrich-Museum, ein Jugendwerk Donatellos?"
Jahrbuch der königlich preussischen Kunstsammlungen 33 (1912):
225-28, 4 figs.
Attributes marble Madonna and Child statuette to Donatello,
ca. 1405-10, through stylistic analogy with prophet statues on the
Porta della Mandorla attributed to him.

843 BODE, WILHELM von. "A Newly Discovered Bas-Relief by
Donatello." Burlington Magazine 46 (1925):106, 108-14, 4 figs.
Attributes small marble Christ in Glory relief to Dona-
tello, ca. 1427. The lunette-shaped piece is unusual for iconography
(Redeemer in Glory) and inclusion of donors.

844 BODE, WILHELM von. "Newly Discovered Works by Donatello."
Burlington Magazine 49 (July 1926):4-9, 4 figs.
Attributes to Donatello marble Pietà relief (art market,
Florence) dated ca. 1438-40 and executed "with assistance," and
Minerbetti coat of arms (art market), dated ca. 1440 and similar to
Martelli coat of arms.

845 BODE, WILHELM von. "Eine Porträtplakette des Dogen Franceso
 Foscari von Donatello." Jahrbuch der preussischen Kunst-
 sammlungen 44 (1923):53-56, 2 figs.
 Attributes to Donatello plaquette here identified as por-
trait of Doge Francesco Foscari (d. 1457).

846 BOITO, CAMILLO. "La ricomposizione dell'altare di Donatello."
 Archivio storico dell'arte, 2d ser. 1 (1895):141-62, 3 figs.
 Early hypothesis about original arrangement of Donatello's
High Altar in Santo, Padua.

847 BRAGHIROLLI, WILLELMO. "Donatello a Mantova con documenti
 inediti." Giornale di erudizione artistica 2 (1873):4-10, no
 illus.
 First publication of letters from Mantuan archives proving
that Donatello was commissioned by Ludovico Gonzaga to sculpt Shrine
of Sant'Anselmo in 1450. Donatello evidently made modello of it, but
work was then interrupted by his trip to Venice.

848 BRUNETTI, GIULIA. "Su alcune sculture di Orsanmichele." In
 Studien zur toskanischen Kunst: Festschrift für Ludwig
 Heinrich Heydenreich zum 23. März 1963. Munich: Prestel-
 Verlag, 1963, pp. 29-36, 7 figs.
 Reattributes to early fifteenth-century sculptor, perhaps
Donatello before 1406, three Prophet statuettes from Orsanmichele now
in Bargello. Previous attribution was to Simone Talenti, ca.
1367-80.

849 BRUNETTI, GIULIA. "Le statuette sul Tabernacolo del Cambio a
 Orsanmichele." Mitteilungen des Kunsthistorischen Institutes
 in Florenz 24, no. 3 (1980):283-98, 18 figs.
 Two statuettes above tabernacle of Ghiberti's St. Matthew,
Orsanmichele, Florence, are reidentified as Sibyls, rather than
Annunciate Angel and Virgin. One on right, attributed here to Dona-
tello, 1406-9, must have been planned for another location as its
base and plinth do not match that of the other.

850 BRUNETTI, GIULIA. "Una testa di Donatello." Arte, n.s. 5
 (1969):81-93, 10 figs. [Summary in English, French, and
 German.]
 Head on Jacopo di Piero Guidi's late fourteenth-century
figure of Faith (Loggi dei Lanzi, Florence) has been replaced.
Author argues that replacement head is work of Donatello, ca.
1429-31, and was taken from his figure of Dovizia which fell down in
1721 but was not totally destroyed, as is generally thought.

851 BURGER, FRITZ. "Donatello und die Antike." Repertorium für
 Kunstwissenschaft 30 (1907):2-13, 1 fig.
 Analyzes influence of "types" of antique sculpture, rather
than specific exmaples, on Donatello's work after second Roman trip
(ca. 1432). These are apparent in its greater intensity and higher
relief.

852 BUSIGNANI, ALBERTO. "Donatello: L'altare del Santo." In
Umanesimo e rinascimento, by Umberto Baldini et al. Il mondo
delle forme, vol. 6. Florence: Sadea; Sansoni, 1966, pp.
33-40, 2 figs., 1 reconstruction, 30 color pls.
Corpus of color plates of High Altar in Santo, Padua, with
brief introduction and bibliography.

853 CANESTRINI, G. "Testamento del Cardinale Baldassare Coscia,
già papa col nome di Giovanni XXIII." Archivio storico
italiano 4 (1843):292-96, no illus.
Publication of Coscia's will without annotation.

854 CARLI, ENZO. "Urbano da Cortona e Donatello a Siena." In
Donatello e il suo tempo (Atti dell'VIII convegno inter-
nazionale di studi sul Rinascimento, Florence-Padua, 1966).
Florence: Istituto Nazionale di Studi sul Rinascimento, 1968,
pp. 155-61, 1 fig.
Contends that Donatello planned to settle permanently in
Siena in late 1450s and that he worked with Urbano da Cortona on
Chapel of Madonna delle Grazie, Duomo. Argues that "Madonna del
Perdono" was Donatello's contribution.

855 CASTELFRANCO, GIORGIO. "Sui rapporti tra Brunelleschi e
Donatello." Arte antica e moderna, nos. 34-36 (1966):109-22,
23 figs.
Stresses importance of Donatello's and Brunelleschi's rela-
tionship and their joint trip to Rome for Donatello's sculpture.
Argues that Brunelleschi's Sacrifice of Isaac and figures for Silver
Altar of San Jacopo, Duomo, Pistoia, influenced Donatello's St. Mark
and that his experiments with linear perspective were crucial for
Donatello's reliefs.

856 CHASTEL, ANDRE. "La traité de Gauricus et la critique
donatellienne." In Donatello e il suo tempo (Atti dell'VIII
convegno internazionale di studi sul Rinascimento, Florence-
Padua, 1966). Florence: Istituto Nazionale di Studi sul
Rinascimento, 1968, pp. 291-305, 5 figs.
Analysis of Gauricus's remarks about Donatello in De
Sculptura (1504).

857 CHASTEL, ANDRE. "Le jeune homme au camée platonicien du
Bargello." Proporzioni 3 (1950):73-74, no illus.
Argues that classical eloquence and deliberate artifici-
ality of bronze Bust of a Youth (Bargello, Florence) suggest date ca.
1460-80 and attribution to Desiderio or Mino da Fiesole, influenced
by Ficino's Neoplatonism. Bust has been frequently attributed to
Donatello.

858 CIACCIO, LISETTA. "Copie di un'opera perduta di Donatello in
Roma." Arte 8 (1905):375-81, 4 figs.
Publishes three nearly identical wall tabernacles (Santa
Francesca Romana, Rome; Cloister, Sant'Agostino, Rome; Duomo Vecchio,

Capranica) that are very similar to niche at Orsanmichele now housing
Verrocchio's Doubting Thomas and argues they reflect lost Donatello
tabernacle once in Rome.

859 CIARDI DUPRÈ dal POGGETTO, MARIA GRAZIA. "Una nuova proposta
 per il 'Niccolò da Uzzano.'" In Donatello e il suo tempo (Atti
 dell'VIII convegno internazionale di studi sul Rinascimento,
 Florence-Padua, 1966). Florence: Istituto Nazionale di Studi
 sul Rinascimento, 1968, pp. 283-89, 7 figs.
 So-called Niccolò da Uzzano bust (Bargello, Florence) is
 taken from Donatello's oeuvre and considered late fifteenth-century
 portrait by Torrigiano.

860 COLASANTI, ARDUINO. "Donatelliana." Rivista d'arte 16, 2d
ser.
 6 (1934):45-63, 11 figs.
 Analyzes Donatello's creative transformation of ancient
 Roman friezes of putti in Cantoria (Museo dell'Opera del Duomo,
 Florence) and Prato Pulpit.

861 COLASANTI, ARDUINO. "L'Eros di bronzo della Collezione
 estense." Bollettino d'arte, 2d ser. 2 (April 1923):433-57, 19
 figs.
 Study of iconography and ancient sources of bronze putto
 (Este collection) and variant (Museo archeologico nazionale, Naples)
 leads to reattribution to Antico, not Donatello or school, as
 generally believed.

862 COOLIDGE, JOHN. "Observations on Donatello's Madonna of the
 Clouds." In Festschrift Klaus Lankheit zum 20. Mai 1973.
 Cologne: Verlag M. DuMont Schauberg, 1973, pp. 130-31, 2 figs.
 Argues that Donatello's Madonna of the Clouds (Museum of
 Fine Arts, Boston), ca. 1425-35, is fragment possibly from altar, Old
 Sacristy, San Lorenzo, Florence, thus explaining funerary theme and
 viewpoint from above.

863 CORWEGH, ROBERT. "Berichte über Sitzungen des Instituts."
 Mitteilungen des Kunsthistorischen Institutes in Florenz 1
 (1908):39-41, 2 figs.
 First publication of pair of bronze heads (Museo
 archeologico nazionale, Naples) attributed to Donatello and said to
 be missing heads from his Cantoria (Museo dell'Opera del Duomo,
 Florence).

864 CORWEGH, ROBERT. "Farbige Wandgräber der Renaissance."
 Mitteilungen des Kunsthistorischen Institutes in Florenz 1
 (1908-11):168-72, 1 fig.
 Sketch of Tomb of Pope John XXIII (Coscia) (Baptistry,
 Florence) in Codex Ghiberti provides indication of original poly-
 chromy. [Janson, entry 787, p. 61: "not to be regarded as wholly
 reliable."]

865 CORWEGH, ROBERT. "Ein Grabmal von Donatello in S. Maria del
 Popolo." Zeitschrift für bildende Kunst 19 (1908):186-88, 3
 figs.

Attributes to Donatello worn Tomb Slab of Canon Johannes Scade (Santa Maria del Popolo, Rome), because of its similarity to his Tomb Slab of Giovanni Crivelli (Aracoeli, Rome), dated 1432.

866 CORWEGH, ROBERT. "Das Rätsel der Niccolò da Uzzano-Büste von Donatello." Kunstwanderer 10 (1928):67-71, 2 figs.
Publishes exact duplicate of Niccolò da Uzzano bust attributed to Donatello (Frau Claire v. Abegg Estate, Strüb Berchtesgaden, Austria).

867 CZOGALLA, ALBERT. "David und Ganymedes: Beobachtungen und Fragen zu Donatellos Bronzeplastik 'David und Goliath.'" In Festschrift für Georg Scheja zum 70. Gebutstag. Edited by Albert Lenteritz, Barbara Lipps-Kant, Ingrid Nedo, and Klaus Schwager. Sigmaringen: Jan Thorbecke, 1975, pp. 119-27, 2 figs.
Donatello's bronze David (Bargello, Florence), here dated ca. 1450, is reinterpreted as Ganymede, thus explaining sexual allusions and David's uncharacteristic hat with prominent wings as alluding to Zeus's eagle.

868 DAVIES, GERALD S. "A Sidelight on Donatello's Annunciation." Burlington Magazine 13 (1908):222-27, 4 figs.
Dates Donatello's Annuciation (Santa Croce, Florence) after 1433 because Bernardo Rossellino's Annunciation at Empoli reflects Donatello's work, but his earlier Annunciation (dated 1433) in Duomo in Arezzo does not.

869 Dell'ACQUA, GIAN ALBERTO. "Die Ausstellung alter italienischer Goldschmiedewerke." Pantheon 18 (1936): 392-97, 7 figs.
Review of Sixth Triennial Exhibition in Milan of religious and secular goldsmithery, seventh century B.C. to eighteenth century. Attributes reliquary Bust of San Rossore (Museo nazionale di San Matteo, Pisa) to Donatello's assistant, Giovanni di Jacopo.

870 DELLWING, HERBERT. "Un tabernacolo degno di nota a Fiesole." Antichità viva 8, no. 2 (1969):52-64, 21 figs.
Unattributed marble tabernacle (Santa Maria Primerana, Fiesole) reflects influence of young Donatello and is datable ca. 1420-25.

871 Del VIVO MASINI, M. CECILIA. "Intorno a una Madonna inedita della cerchia donatelliana." Antichità viva 15, no. 5 (1976):22-26, 5 figs. [Summary in English.]
Publishes Madonna and Child relief (Biagini collection) that author argues is early sixteenth-century work done after lost Donatello from his Paduan period.

872 De NICOLA, GIACOMO. "Il S. Giovannino Martelli di Donatello." Bollettino d'arte 7 (1913):277-80, 7 figs.
Discusses early sources that record sculpture and attribute it to Donatello. Discusses Martelli David.

873 De NICOLA, GIACOMO. "Notes on the Museo Nazionale of
 Florence--III." Burlington Magazine 30 (1917):87-95, 3 figs.
 Argues that three chalk bas-reliefs, Crowning with Thorns,
Christ before Pilate, and Way to Calvary, all in Bargello, Florence,
may be sketch models for Donatello's Old Sacristy doors, ca. 1437-46.

874 Di STEFANO, ROBERTO. "La chiesa di S. Angelo a Nilo e il
 Seggio di Nido." Napoli nobilissima 4, nos. 1-2 (1964):12-21,
 5 line drawings, 5 figs.
 Clarifies construction history of Sant'Angelo a Nilo.
Begun in fifteenth century, the church's modifications in sixteenth
century led to relocation of Donatello's and Michelozzo's Tomb of
Cardinal Rainaldo Brancacci.

875 DIXON, JOHN W., Jr. "The Drama of Donatello's David:
 Re-Examination of an Enigma." Gazette des beaux-arts, 6th per.
 93 (January 1979):6-12, no illus.
 Argues that Donatello's bronze David (Bargello, Florence),
ca. 1430, is literal, dramatic interpretation of biblical character,
representing energetic and erotic transformation from boyhood to
maturity. Refutation of Schneider's thesis (entry 1033) pertaining
to homosexual iconography. Reply by Laurie Schneider, "More on
Donatello's Bronze 'David.'" Gazette des beaux-arts, 6th per. 94
(1979):48.

876 DOEBLER, JOHN. "Donatello's Enigmatic 'David.'" Journal of
 European Studies 1 (1971):337-40, 4 figs.
 Donatello's bronze David is typical of Renaissance
iconography in its eclectic combination of themes: nude athlete of
virtue, a "type" of Christ, Christian warrior, Arcadian natural
man--all symbolizing virtue triumphant over evil.

877 DUNKELMAN, MARTHA L. "Donatello's Influence on Mantegna's
 Early Narrative Scenes." Art Bulletin 62, no. 2 (June
 1980):226-35, 16 figs.
 Demonstrates Mantegna's borrowing of compositional devices
and details from Donatello's Paduan reliefs and Old Sacristy tondi to
augment expressiveness of his own Ovetari Chapel frescoes.

878 EISLER, COLIN. "The Athlete of Virtue: The Iconography of
 Asceticism." In De Artibus Opuscula, XL: Essays in Honor of
 Erwin Panofsky. Edited by Millard Meiss. New York: New York
 University Press, 1961, pp. 82-97, 10 figs.
 Analyzes iconography of naked athlete, symbol of discipline
required of Christian virtue that resulted from revival of orthodox
monasticism in early fifteenth century. The metaphor is employed in
Donatello's High Altar, Santo, Padua, and in the David (Bargello,
Florence).

879 EISLER, COLIN. "The Madonna of the Steps: Problems of Date
 and Style." In Stil und Überlieferung in der Kunst des Abend-
 landes (Akten des 21. internationalen Kongresses für Kunst-

geschichte, Bonn, 1964). Berlin: Gebr. Mann, 1967, 2:115-21, 4 figs.
Michelangelo's Madonna of the Steps (Casa Buonarrotti, Florence) reflects popularity of Donatellesque pastiches in late fifteenth century.

880 ERFFA, HANS MARTIN von. "Judith--Virtus Virtutum--Maria." Mitteilungen des Kunsthistorischen Institutes in Florenz 14 (1969-70):460-65, no illus.
Argues that Donatello's Judith (Piazza della Signoria, Florence) rpresents paragon of Christian virtue, an iconography stemming from Old Testament and medieval "Speculum," where Judith is regarded as "type" for Mary, who defeats the devil.

881 ESCHERICH, MELA. "Donatellos Beziehungen zur altchristlichen Kunst." Repertorium für Kunstwissenschaft 31 (1908):522-27, 3 figs.
Proposes specific late Roman and Early Christian sarcophagi that Donatello may have seen in Catacombs during his 1432-33 trip to Rome as probable sources for architectural frames of Cantoria, Museo dell'Opera del Duomo, Florence, and Prato Pulpit.

882 FABRICZY, CORNELIUS von. "Donatellos Hl. Ludwig und sein Tabernakel an Or San Michele." Jahrbuch der königlich preussischen Kunstsammlungen 21 (1900):242-61, 5 figs.
Publishes documents (1406-87) clarifying history of St. Louis tabernacle, Orsanmichele. Discusses removal of Donatello's St. Louis of Toulouse (before 1460), sale of niche, and its improvement (Luca della Robbia medallion and Verrocchio group).

883 FABRICZY, CORNELIUS de. "Recherches nouvelles sur Donatello, Masaccio, et Vellano." Gazette des beaux-arts, 3d per. 8 (1892):327-31, no illus.
Discusses three unpublished letters of 1450-52 from Gonzaga archives, Mantua, on Donatello's activities there and documents from Municipal archives, Pisa, that relate to Masaccio and Donatello's work in Pisa, ca. 1426.

884 FABRICZY, CORNELIUS von. "Ueber die Statue des Hl. Ludwig von Donatello." Repertorium für Kunstwissenschaft 17 (1894):78-79, no illus.
Evaluates contribution of Franceschini's book on Orsanmichele (entry 114), specifically his support for argument that Donatello's St. Louis of Toulouse (Bargello, Florence) stood originally in niche now occupied by Verrocchio's Doubting Thomas group.

885 FALKE, OTTO von. "Eine Büste des Cosimo Medici von Donatello." Pantheon 9 (1932):117-21, 7 figs.
Attributes unpublished terracotta bust (Dr. Rudolf Ergas collection) to Donatello and identifies it as portrait of Cosimo de' Medici, ca. 1460.

886 FIOCCO, GIUSEPPE. "Ancora dell'altare di Donatello al Santo."
Il Santo 3, no. 3 (1963):345-46, no illus.
 Discusses recent contribution by Band (entry 824) and
Parronchi (entry 993) to reconstruction of Donatello's High Altar in
the Santo, Padua.

887 FIOCCO, GIUSEPPE. "Fragments of a Donatello Altar."
Burlington Magazine 60 (1932):198-204, 6 figs.
 Proposes that two limestone volutes (now Library,
Sant'Antonio, Padua) and two fragmentary relief panels of SS.
Prosdocimus and Massimo (Fondazione Salvatore Romano, Florence) are
fragments of Donatello's dismantled Padua High Altar.

888 FIOCCO, GIUSEPPE. "La statua equestre del Gattamelata." Il
Santo 1, no. 3 (1961):300-317, 11 figs.
 Fiocco's translation into Italian of Janson's catalogue
entry on Gattamelata, with minor objections.

889 FIOCCO, GIUSEPPE. "Tracce di Donatello a Padova." In
Donatello e il suo tempo (Atti dell'VIII convegno inter-
nazionale di studi sul Rinascimento, Florence-Padua, 1966).
Florence: Istituto Nazionale di Studi sul Rinascimento, 1968,
pp. 399-404, no illus.
 Sketches various findings of Sartori's documentary research
about Donatello's bronze casters in Padua.

890 FIOCCO, GIUSEPPE. "Tracce di Donatello a Padova." Il Santo
10, nos. 1-2 (1970):161-65, no illus.
 Newly discovered documents reveal that Pizzolo painted and
gilded Donatello's bronze Crucifix for Santo and that Donatello did
Crucifix (now lost) for Sant' Agostino. Notes regarding bronze
casters used by Donatello.

891 FIOCCO, GIUSEPPE. "L'altare grande di Donatello al Santo." Il
Santo 1, no. 1 (January-April 1961):21-36, 30 figs., 11 recon-
struction drawings. (Figs. shared with article by Sartori,
entry 1027).
 Reviews earlier proposals for reconstruction of Donatello's
High Altar in the Santo as preface for new reconstruction proposed
here.

892 FOSTER, PHILIP. "Documentation: Donatello Notices in Medici
Letters." Art Bulletin 62, no. 1 (March 1980):148-50, no
illus.
 Publishes two new letters from Medici archive that refer to
at least two otherwise undocumented sculptures, marble work for the
Giovanni de' Medici's Scrittoio and a Madonna, also for him. These
provide only evidence of Donatello's connection with Medici in
1454-55.

893 FRANCHI, ROBERTO; GALLI, GUGLIELMO; and MANGAGNELLI Del FÀ,
CARLO. "Researches on the Deterioration of Stonework, VI: The

Donatello Pulpit." Studies in Conservation 23, no. 1 (February 1978):23-37, 13 figs., 2 tables [Summaries in English, French, and German.]
Technical study of effects of pollution on Donatello's outdoor Prato Pulpit.

894 FRANCOVICH, GEZA de. "Appunti su Donatello e Jacopo della Quercia." Bollettino d'arte, 2d ser. 9 (October 1929):145-71, 25 figs.
Argues that many borrowings from Roman sources in Donatello's early sculptures, especially the Abraham and Isaac (Museo dell'Opera del Duomo, Florence) which author sees as dependent on the Pasquino group, Rome, substantiate Vasari's and Manetti's claim that he visited Rome (1402-3). Demonstrates Donatello's influence on Jacopo della Quercia's relief, Baptismal Font, Siena.

895 GAI, LUCIA. "Per la cronologia di Donatello: Un documento inedito del 1401." Mitteilungen des Kunsthistorischen Institutes in Florenz 18, no. 3 (1974):355-57, no illus. [Summary in German.]
Publication of earliest references to Donatello that prove his presence in Pistoia in 1400-1401 and suggest he was still a minor. This evidence supports generally accepted birth date of 1386, rather than earlier dates proposed.

896 GASPAROTTO, CESIRA. "Iconografia antoniana: I 'Miracoli' dell'altare di Donatello." Il Santo 8 (1968):79-91, 8 figs.
Analyzes iconography of Donatello's bronze reliefs of St. Anthony's miracles on High Altar, Santo, Padua, in relation to thirteenth- to fifteenth-century biographies of St. Anthony.

897 GASPAROTTO, CESIRA. "Sant'Antonio nell'altare maggiore di Donatello al Santo di Padova." Il Santo 15, 2d ser. no. 3 (1975):339-44, 6 figs.
Analyzes iconography of Donatello's High Altar themes of Original Sin and Salvation. Stresses radical innovation of altar decorated on both sides.

898 GASPAROTTO, CESIRA. "Tito Livio in Donatello." Atti e memorie dell'Accademia patavina di scienze, lettere, ed arti, Padova, n.s. 80, no. 3 (1967-68):125-38, 2 figs.
Analyzes iconography of Donatello's reliefs of miracles of St. Antony on High Altar, Santo, Padua, in light of early legends regarding saint. Identifies presence of Livy in relief of Miracle of Reattached Leg. Claims this was spurred by fifteenth-century rediscovery of Livy's burial site in his native Padua.

899 GAVOTY, FRANÇOISE. "Gli angeli reggicandelabro del Museo Jacquemart-André." In Donatello e il suo tempo (Atti dell'VIII convegno internazionale di studi sul Rinascimento, Florence-Padua, 1966). Florence: Istituto Nazionale di Studi sul Rinascimento, 1968, pp. 353-59, 15 figs.

Attributes two gilded bronze Angels (Musée Jacquemart-André, Paris) to Donatello and his shop. Argues they relate to notation in archives of Duomo and were planned to have been placed above Donatello's Cantoria. Previously, Angels considered part of Donatello's Santo High Altar or part of Luca della Robbia's Cantoria, Duomo, Florence.

900 GNOLI, DOMENICO. "Le opere di Donatello in Roma." Archivio
 storico dell'arte 1 (1888):24-31, 2 figs.
 Analyzes sculptures Donatello executed in Rome. First publication of signed Donatello Tomb Slab of Giovanni Crivelli (Aracoeli, Rome). Attributes to Donatello wood statue of St. John the Baptist, Baptistry, San Giovanni in Laterano, Rome.

901 GOLDBERG, VICTORIA L. "The School of Athens and Donatello."
 Art Quarterly 34 (1971):229-37, 5 figs.
 Argues that Donatello's San Lorenzo roundels (ca. 1434-38) influenced Raphael's School of Athens (1509-11), especially in architectural setting. Discusses influence of Ghiberti's reliefs.

902 GOLDNER, GEORGE. "The Tomb of Tommaso Mocenigo and the Date of
 Donatello's 'Zuccone' and the Coscia Tomb." Gazette des
 beaux-arts, 6th per. 83 (1974):187-92, 6 figs.
 Argues that figure of Providence on Tomb of Tommaso Mocenigo by Piero Lamberti and Giovanni Martino da Fiesole (SS. Giovanni e Paolo, Venice, dated 1423) derives from Donatello's Zuccone (Museo dell'Opera del Duomo, Florence), which must thus predate it. Virtues of that tomb are modelled after those on Donatello's Tomb of Pope John XXIII (Coscia) (Baptistry, Florence), generally dated later but here dated 1423, thus precluding Michelozzo's collaboration on it.

903 GOSEBRUCH, MARTIN. "Osserazioni sui pulpiti di San Lorenzo."
 In Donatello e il suo tempo (Atti dell'VIII convegno internazionale di studi sul Rinascimento, Florence-Padua, 1966).
 Florence: Istituto Nationale di Studi sul Rinascimento, 1968,
 pp. 369-86, 2 figs.
 Discusses problems of attribution and chronology raised by stylistic diversity of pulpit reliefs. Criticizes attempts to interpret reliefs in terms of consciously chosen borrowings from medieval art.

904 GRABSKI, JÓZEF. "L'Amor-Pantheos di Donatello." Antologia di
 belle arti 3, nos. 9-12 (December 1979):23-26, 2 figs.
 Interpretation of Donatello's Atys-Amorino (Bargello, Florence) as Amor-Panteos, Renaissance combination of various ancient gods and themes.

905 GRASSI, LUIGI. "Donatello nella critica di Giorgio Vasari."
 In Donatello e il suo tempo (Atti dell'VIII convegno internazionale di studi sul Rinascimento, Florence-Padua, 1966).
 Florence: Istituto Nazionale di Studi sul Rinascimento, 1968,
 pp. 59-68, no illus.

Analyzes Vasari's remarks about Donatello in his biography of Donatello and in biographies of Brunelleschi and other contemporaries.

906 GRUNWALD, ALOIS. "Zur Arbeitsweise einiger hervorragender Meister der Renaissance." Münchner Jahrbuch der bildenden Kunst 7 (1912):165-77, 19 figs.
Examines Donatello's possible sources for putti reliefs on base of Judith (Piazza della Signoria, Florence). Contends that bronze head of Eros (Bargello, Florence), school of Donatello, is modelled after ancient Child with a Goose (Glyptothek, Munich).

907 GUIDALDI, P. LUIGI. "Ricerche sull'altare di Donatello." Il Santo 4, no. 4 (1932):239-89, 43 figs., appendix of 10 documents.
Quite systematic attempt to reconstruct Donatello's High Altar. Publishes numerous entries from account books of Santo regarding Donatello's High Altar. Important supplement to documents in Gonzati (entry 817) and Gloria (entry 812).

908 HADELN, DETLEV F. von. "Ein Rekonstruktionversuch des Hochaltars Donatellos im Santo zu Padua." Jahrbuch der königlich preussischen Kunstsammlungen 30 (1909):35-55, 10 figs.
Argues that later copies of general design of Donatello's Padua High Altar, including Mantegna' San Zeno Altarpiece, Verona (ca. 1456-59), provide model for reconstruction, while new reading of documents and discovery of lost pilasters suggest massive architectural scale of the altar. (Important early reconstruction, though now discounted on scale.)

909 HAHR, AUGUST. "Donatellos Bronze-David und das praxitelische Erosmotiv." Monatshefte für Kunstwissenschaft 5 (1912):303-10, 7 figs.
Proposes specific antique eroti as models for Donatello's bronze David (Bargello, Florence), including Eros de Centrocelle (Vatican, Rome), Eros (Museo archeologico nazionale, Naples), and Eros of Nicopolis.

910 HARTT, FREDERICK. "New Light on the Rossellino Family." Burlington Magazine 103 (September 1961):385-92, 12 figs., 1 diag.
Attributes to Bernardo Rossellino Bust of a Woman (Staatliche Museen, Berlin-Dahlem), previously given to Desiderio, and Martelli David (National Gallery of Art, Washington, D.C.), traditionally atributed to Donatello but assigned to Antonio by Pope-Hennessy (entry 1004). Attribution to Bernardo based on similarities to angel on left, Tomb of the Cardinal of Portugal (San Miniato, Florence), where newly discovered documents prove participation of Bernardo.

911 HATFIELD, RAB CONAN. "Sherlock Holmes and the Riddle of the
 'Niccolò da Uzzano.'" In Essays Presented to Myron P. Gilmore.
 Edited by Sergio Bertelli and Gloria Ramakus. Villa I Tatti,
 The Harvard University Center for Italian Renaissance Studies.
 Florence: La Nuova Italia Editrice, 1978, 2:219-38, 5 figs.
 Proposes identification of terracotta bust, traditionally
 called Niccolò da Uzzano (Bargello, Florence) and attributed to
 Donatello, as portrait (from life mask) of Gino di Neri Capponi.
 Questions attribution to Donatello.

912 HERSEY, G[EORGE] L. "The Arch of Alfonso in Naples and Its
 Pisanellesque 'Design.'" Master Drawings 7 (1969):16-24, 8
 figs.
 Argues that drawing by Pisanello follower (Museum
 Boysmans-Van Beuningen, Rotterdam), believed to be design for
 Alphonso's triumphal arch, is probably a Neapolitan stage design (ca.
 1466). Documents suggest equestrian figure of Alphonso as Eumelos in
 drawing recalls an earlier, unrealized equestrian project of Dona-
 tello for Alphonso.

913 HERZNER, VOLKER. "David Florentinus, I: Zum Marmordavid
 Donatellos im Bargello." Jahrbuch der Berliner Museen 20
 (1978):43-115, 29 figs,; "David Florentinus, II: Der Bronze
 David Donatellos im Bargello." Jahrbuch der Berliner Museen 24
 (1982):63-142, 32 figs.
 Argues that Donatello's marble David (Bargello, Florence)
 was executed for Palazzo Vecchio in 1412-16 and must be different
 from David statue commissioned in 1408-9 as part of prophet series
 for Duomo tribune. (It is generally thought that marble David was
 commissioned in 1408-9 and recut for 1412-16 project.) Studies David
 as Florentine political symbol, eclipsing position held earlier by
 Hercules.
 Pt. 2 provides thorough analysis of arguments concerning
 dating and iconography of Donatello's bronze David (Bargello);
 Herzner dates it in the late 1430s. Also discusses Verrocchio's
 David (Bargello) and the Martelli David (National Gallery of Art,
 Washington, D.C.), which he attributes to Desiderio.

914 HERZNER, VOLKER. "Donatello in Siena." Mitteilungen des
 Kunsthistorischen Institutes in Florenz 15 (1971):161-86, 6
 figs.
 Transcribes documents relating to Donatello's later period
 in Siena, 1457-59, especially project for bronze Doors of Duomo,
 unfinished St. John the Baptist, and various projects for Cappella di
 San Callisto.

915 HERZNER, VOLKER. "Donatello und die Sakristei-Türen des
 Florentiner Domes." Wiener Jahrbuch für Kunstgeschichte 29
 (1976):53-63, 8 figs.
 Argues that design of iconography and architectural frame-
 work of bronze doors, New Sacristy, Duomo, Florence, should be
 assigned to Donatello. His model for project was used when project

was transferred to Michelozzo, Luca della Robbia, and Maso di
Bartolommeo in 1446.

916 HERZNER, VOLKER. "Donatello und Nanni di Banco: Die
 Prophetenfiguren für die Strebepfeiler des Florentiner Domes."
 Mitteilungen des Kunsthistorischen Institutes in Florenz 17,
 no. 1 (1973):1-28, 19 figs. [Summary in Italian.]
 Offers extensive support for arguments first proposed by
Wundram (see especially entries 798 and 1088), but largely rejected,
that so-called Isaiah statue is in fact the "Daniel" figure commis-
sioned from Donatello for tribune buttress of Duomo, Florence, in
1408. Argues that Donatello's marble David (Bargello, Florence) has
been wrongly associated with this commission. Accepts as second
statue commissioned in 1408 for tribune buttress figure of uniden-
tified prophet, attributed to Giuliano da Poggibonsi (Museo
dell'Opera del Duomo, Florence) but here identified as Nanni di
Banco's statue.

917 HERZNER, VOLKER. "Donatellos Madonna vom Paduaner Hochaltar--
 eine 'Schwarze Madonna'?" Mitteilungen des Kunsthistorischen
 Institutes in Florenz 16 (1972):143-52, 7 figs. [Summary in
 Italian.]
 Disputes Beck's contention (entry 832) that Donatello's
Madonna (High Altar, Padua) is "Black Madonna." Explains its
appearance stylistically instead.

918 HERZNER, VOLKER. "Donatellos 'pala over ancona' für den
 Hochaltar des Santo in Padua: Ein Rekonstructionversuch."
 Zeitschrift für Kunstgeschichte 33 (1970):89-126, 14 figs.
 (including diags.).
 Building on the work of White (entry 1082), Janson (entry
786), and others, proposes new reconstruction of architectural form
and sculptural layout of Padua Altar, gauging its influence on
Mantegna's San Zeno Altarpiece, Luca della Robbia's tabernacle in
Santa Maria dell' Impruneta, and an altar design by Francesco di
Giorgio. Provides detailed history of the Padua High Altar, 1450 to
present.

919 HERZNER, VOLKER. "Die 'Judith' der Medici." Zeitschift für
 Kunstgeschichte 43, no. 2 (1980):139-80, 22 figs.
 Analyzes Donatello's Judith stylistically and iconograph-
ically. Traces her association with David and her role as allegory
of humility and justice. Argues statue was commissioned as symbol of
political power of Medici, to be displayed along with Donatello's
David in their palace.

920 HERZNER, VOLKER. "Die Kanzeln Donatellos in San Lorenzo."
 Münchner Jahrbuch der bildenden Kunst 23 (1972):101-64, 32
 figs.
 Thoroughly studies physical and iconographic structure of
San Lorenzo pulpits, especially iconography of Resurrection and
Martyrdom of St. Lawrence. Resurrection panel probably designed for
a tomb (ca. 1456-57). Clarification of assistance of Bertoldo and
Bellano.

921 HERZNER, VOLKER. "Regesti donatelliani." Rivista
dell'Istituto nazionale d'archeologia e storia dell'arte 2
(1979):169-228, no illus.
 Collects all documents regarding Donatello and arranges
them chronologically (397 documents transcribed) in first attempt
since Semper's 1875 monograph to analyze archival information on
Donatello. Indexed by name and location of Donatello's sculptures
and by proper names.

922 HERZNER, VOLKER. "Zwei Frühwerke Donatellos: Die
Prophetenstatuetten von der Porta del Campanile in Florenz."
Pantheon 37, no. 1 (January-March 1979):27-36, 16 figs.
[Summary in English, French, and Italian.]
 Two statues (Museo dell'Opera dell Duomo, Florence),
previously attributed to Nanni di Banco or Nanni di Bartolo, are here
assigned to Donatello, ca. 1404-7, under Ghiberti's influence.
Proposes they are original Prophets commissioned (1406-8) for Porta
della Mandorla (despite slight discrepancy in size).

923 HESS, REINHARD. "Beobachtungen an der Judith-Holofernes Gruppe
des Donatello." In Argo: Festschrift für Kurt Badt zu seinem
80. Geburtstag am 3. März 1970. Edited by Martin Gosebruch and
Lorenz Dittman. Cologne: M. DuMont Schauberg, 1970, pp.
176-205, 2 figs.
 Thoroughly analyzes Judith (Piazza della Signoria,
Florence) in terms of style and placement and as classical istoria
according to Alberti.

924 HORSTER, MARITA. "'Mantuae Sanguis Preciosus.'" Wallraf-
Richartz-Jahrbuch 25 (1963):151-80, 24 figs.
 Reattribution to student of Donatello, rather than
Mantegna, of Man of Sorrows relief (Sant'Andrea, Mantua). Detailed
iconographic study of motif of Christ's wounds bleeding into chalice
and Mantuan cult of blood of Christ.

925 HUSE, NORBERT. "Beiträge zum Spätwerk Donatellos." Jahrbuch
der Berliner Museen 10 (1968):125-50, 14 figs.
 Considers Donatello's two versions of St. John the Baptist
(Duomo, Siena, and Santa Maria Gloriosa dei Frari, Venice) and
alterations of their right arms. Establishes chronology for San
Lorenzo pulpit reliefs (1457-66), all conceived by Donatello but some
executed by Bertoldo.

926 JANSON, H[ORST] W. "Donatello (s.v. Bardi, Donato)." In
Dizionario biografico degli Italiani. Rome: 1964, 6:287-96,
no illus.
 Useful, brief biographical and bibliographical sketch on
Donatello by leading authority.

927 JANSON, H[ORST] W. "Donatello and the Antique." In Donatello
e il suo tempo (Atti dell'VIII convegno internazionale di studi
sul Rinascimento, Florence-Padua 1966). Florence: Istituto

Nazionale di Studi sul Rinascimento, 1968, pp. 77-96, 57 figs.
Analyzes Donatello's extensive debt to antique art, principally Roman portraiture, architectural ornaments, and reliefs, but occasionally to Etruscan, Early Christian, and Byzantine models, which he also considered "antique." Although Donatello referred mainly to anonymous types, certain works allude to specific antique sources known in Renaissance.

928 JANSON, H[ORST] W. "The Equestrian Monument from Cangrande della Scala to Peter the Great." In Aspects of the Renaissance: A Symposium. Edited by Archibald R. Lewis. Austin and London: University of Texas Press, 1967. Reprinted in H.W. Janson, 16 Essays (New York: Harry N. Abrams, 1973), pp. 157-88, 30 figs.
Brief history of equestrian monument from ancient Greece through nineteenth century focusing on its distinguishing characteristics in Renaissance, as well as other themes. Discusses Baroncelli's and Antonio di Cristoforo's statue of Niccolò d'Este in Ferrara (destroyed in 1796), Donatello's Gattamelata Monument in Padua, and Verrocchio's Colleoni Monument in Venice.

929 JANSON, H[ORST] W. "Giovanni Chellini's Libro and Donatello." In Studien zur toskanischen Kunst: Festschrift für Ludwig Heinrich Heydenreich zum 23. März 1963. Edited by Wolfgang Lotz and Lise Lotte Möller. Munich: Prestel-Verlag, 1964, pp. 131-38, no illus.
Analyzes how Chellini's Libro (1456) provides contemporary view of Donatello's achievements plus important information on Chellini Madonna and Child, Judith, and lost terracotta Joshua for Duomo, Florence, and its companion David.

930 JANSON, H[ORST] W. "The Image of Man in Renaissance Art: From Donatello to Michelangelo." In The Renaissance Image of Man and the World. Edited by Bernard O'Kelly. Columbus: University of Ohio Press, 1966, pp. 77-103. Reprinted in H.W. Janson, 16 Essays (New York: Harry N. Abrams, 1973), pp. 116-48, 25 figs.
Analyzes creation of "new image of man" in fifteenth-century Italian sculpture, specifically in works by Donatello and Nanni di Banco. Discusses historical and social circumstances favoring this new interpretation, particularly revival of interest in Greco-Roman civilization.

931 JANSON, HORST W. "La signification politique du David en bronze de Donatello." Revue de l'art, no. 39 (1978):33-38, 9 figs.
Interprets Donatello's bronze David (Bargello, Florence) as specific political allegory of Florence's triumph over Filippo Maria Visconti, probably commissioned by Signoria of Florence ca. 1423-28 for public exhibition and later acquired by the Medici (ca. 1444). Discusses its influence on political iconography of Donatello's Judith.

932 KAUFFMANN, GEORG. "Zu Donatellos Sängerkanzel." Mitteilungen
 des Kunsthistorischen Institutes in Florenz 9, no. 1 (1959):
 55-59, 7 figs. [Résumé in Italian.]
 Publishes newly discovered fragment of top cornice of
Donatello's Cantoria (Museo dell'Opera del Duomo, Florence) that
allows more accurate restoration.

*933 KAUFFMANN, HANS. Donatellos Junglingsstatuen David und
 Johannes." Sitzungsberichte der Kunstgeschichtliche Gesell-
 schaft zu Berlin, 1931-32:1-4.
 Proposes date of ca. 1457 for bronze David (Bargello,
Florence) and argues it was commissioned as part of Palazzo
Medici[-Riccardi] decoration (begun 1453). Notes that base was by
Desiderio da Settignano, according to Vasari. Allies David
thematically with Donatello's late nude figures (Crucifix; Padua High
Altar), symbolizing Christian humility. Influenced Florentine
painters and sculptors--Castagno, Bertoldo, Bellano, Pollaiuolo,
Verrocchio--only after 1450.

934 KELLER, HARALD. "Ursprünge des Gedächtnismals in der
 Renaissance." Kunstchronik 7 (1954):134-37, no illus.
 Examines Roman and Early Christian precedents for Tempio
Malatestiano, Rimini, and Donatello's Gattamelata Monument in Padua.
With discussion by Paatz, Kauffmann, and Heydenreich.

935 KEIL, HANNA. "Donatellos Holzkruzifix aus S. Croce nach der
 Restaurierung, Florenz, Museo del Bargello." Pantheon 32
 (1974):20, 1 fig.
 Brief report of restoration of Donatello's polychromed wood
Crucifix from Santa Croce, 1412-13.

936 KIEL, HANNA. "Toskanische Bildwerke in der Ausstellung
 'Firenze Restaurata.'" Pantheon 30 (1972):314-17, 5 figs.
 Discussion of restoration of Crucifix attributed to
Donatello (Convento di San Francesco, Bosco ai Frati); St. Jerome
attributed to Donatello (Museo civico, Faenza); Donatello's Mary
Magdalen (Baptistry, Florence); and Standing Madonna and Child
attributed to Nanni di Bartolo (Ognissanti, Florence).

937 LÁNYI, JENO. "Donatello's Angels for the Siena Font: A
 Reconstructon." Burlington Magazine 75 (October 1939):142-47,
 151, 9 figs.
 One of the three putti made by Donatello for Siena Bap-
tistry Font is identified as in Berlin (formerly Kaiser Friedrich
Museum, now Staatliche Museen, Berlin-Dahlem). (The other two are in
place.) Similar putto (Bargello, Florence) is attributed to later
Sienese follower.

938 LÁNYI, JENO. "Problemi della critica donatelliana." Critica
 d'arte 19, no. 2 (1939):9-23, 21 figs.
 Discusses history of Donatello scholarship as prelude to
remarks regarding Kauffmann's monograph, which he criticizes for

making Donatello into medieval scholar. Questions many of Kauff-
mann's attributions. Spells out his own more rigorous method of
determining attributions to Donatello (on the basis of how sculpture
was made) by comparing documented Reliquary Bust of San Rossore
(Museo nazionale di San Matteo, Pisa) with Bust of a Youth (Bargello,
Florence), which is often ascribed to Donatello but rejected here.
Appended is list of certain Donatello sculptures most helpful in
establishing attributions. Many sharp photographs of both busts from
several points of view underscore Lányi's emphasis on need to study
sculpture three-dimensionally.

939 LÁNYI, JENO. "Tre rilievi inediti di Donatello." Arte 38,
 n.s. 6 (1935):284-97, 5 figs.
 First stylistic analysis and publication of photographs of
Donatello's relief of half-length God the Father in tympanum of the
St. George tabernacle, Orsanmichele, and two heads of prophets from
the Porta della Mandorla, Duomo.

940 LÁNYI, JENO. "Zur Pragmatik der Florentiner Quattrocento-
 plastik (Donatello)." Kritische Berichte 5 (1932-33):126-31,
 no illus.
 Schematic attempt to clarify Donatello's oeuvre primarily
through reattributions of works previously given to Donatello:
assigns to Nanni di Banco wooden Crucifix (Santa Croce, Florence); to
Nanni di Bartolo (Il Rosso), St. John the Baptist on east side of
Campanile (erroneously inscribed "Donatello"); to Bernardo Ciuffagni,
St. Peter (Orsanmichele, Florence), and left Prophet (Porta della
Mandorla); to Michelozzo, entire left side of Cantoria; to Luca della
Robbia, bronze Angels with Candelabra (Musée Jacquemart-André,
Paris); to Desiderio, the St. John the Baptist from Casa Martelli
(now Bargello, Florence).

941 LAVIN, IRVING. "An Observation on 'Medievalism' in Early
 Sixteenth Century Style." Gazette des beaux-arts, 6th per. 50
 (September 1957):113-18, 2 figs.
 Discusses Gothicism in High Renaissance style, especially
Donatello's influence on Pontormo. Analysis of Donatello's unique
dichotomy of figures and spatial perspective, especially in Christ
before Pilate, South Pulpit, San Lorenzo, Florence.

942 LAVIN, IRVING. "The Sources of Donatello's Pulpits in San
 Lorenzo. Revival and Freedom of Choice in the Early
 Renaissance." Art Bulletin 41 (1959):19-38, 37 figs.
 Analyzes typology of San Lorenzo pulpits by Donatello as
revival of earlier medieval twin pulpit tradition; examines contin-
uation of Tuscan Romanesque tradition of pulpits with narrative
cycles, and their references to antique and contemporary sarcophagi.
Claims iconography of narrative shows complex and eclectic
revivalism.

943 LAWSON, JAMES G. "New Documents on Donatello." Mitteilungen
 des Kunsthistorischen Institutes in Florenz 18 (1974):357-62,
 no illus.

Publishes new documents from 1458 that shed light on Dona-
tello's unrealized plans to return to Mantua that year and demon-
strate Ludovico Gonzaga's efforts to make Donatello complete Shrine
of St. Anselm, which he began in 1450.

944 LAZZARINI, V. "Nuovi documenti intorno a Donatello e all'opera
 del Santo." Nuova archivio veneto, n.s. 12 (1906):161-67, no
 illus.
 Publishes two additional contracts for Donatello's High
Altar in the Santo overlooked by Gonzati (entry 817), and Gloria
(entry 812). These clarify chronology of its execution and verify
identities of Donatello's assistants.

945 LIGHTBOWN, RONALD W. "Giovanni Chellini, Donatello, and
 Antonio Rossellino." Burlington Magazine 104 (1962):102-4,
 2 figs.
 Analyzes sixteenth-century biography of Giovanni Chellini
(ca. 1372-1462) that provides previously unknown descriptions of Bust
of Giovanni Chellini by Antonio Rossellino (Victoria and Albert
Museum, London) and bronze tondo of Madonna and Child made by Dona-
tello for Chellini in 1456, probably similar to tondo by Bertoldo
(National Gallery of Art, Washington, D.C.)

946 LISNER, MARGRIT. "Appunti sui rilievi della Deposizione nel
 sepolcro e del Compianto su Cristo morto di Donatellos." In
 Scritti di storia dell'arte in onore di Ugo Procacci. Edited
 by Maria Grazia Ciardi Dupré dal Poggetto and Paolo dal
 Poggetto. Milan: Electa, 1977, pp. 247-53, 7 figs.
 Identifies Virgin Mary in Donatello's Lamentation relief,
High Altar, Santo, Padua, countering earlier writers who claimed she
was not depicted. Discusses vertical reading of iconography of altar
back, with Adam and Eve on Madonna's throne, Madonna and Child, and
Mary Magdalen, thus presenting sin, repentance, and redemption.
Analysis of Donatello's changed ideas for Lamentation relief, San
Lorenzo pulpits.

947 LISNER, MARGRIT. "Gedanken vor frühen standbildern des
 Donatello." In Kunstgeschichtliche Studien für Kurt Bauch zum
 70. Geburtstag von seinen Schülern. Edited by Margrit Lisner
 and Rudiger Becksmann. Munich and Berlin: Deutscher Verlag
 Kunstverlag, 1967, pp. 77-92, no illus.
 Identifies marble David (Bargello, Florence) with statue
commissioned from Donatello in 1408-9 for the North Tribune of the
Duomo, Florence, making it earliest of his lifesize sculptures. Some
discussion of Isaiah statue (Museo dell'Opera del Duomo, Florence)
and iconography of David.

948 LISNER, MARGRIT. "Intorno al Crocifisso di Donatello in Santa
 Croce." In Donatello e il suo tempo (Atti dell'VIII convegno
 internazionale di studi sul Rinascimento, Florence-Padua,
 1966). Florence: Istituto Nazionale di Studi sul
 Rinascimento, 1968, pp. 115-29, 11 figs.

Reaffirms attribution of wood Crucifix, (Santa Croce, to Donatello, rather than Nanni di Banco (as argued by Lányi, [entry 940] and Parronchi [entry 989]). Demonstrates its innovations. Attributes to Donatello, rather than Nanni di Banco, Christ as Man of Sorrows, Porta della Mandorla, and uses this to corroborate attribution of Crucifix.

949 LISNER, MARGRIT. "Zur frühen Bildhauerarchitektur Donatellos."
 Münchner Jahrbuch der bildenden Kunst, 3d ser. 9-10 (1958-59):
 72-127, 17 figs.
 Analyzes Donatello's important role in transformation of Quattrocento architecture as seen in architectural elements enframing his sculpture: tabernacle of Parte Guelfa, Orsanmichele; Tomb of Pope John XXIII (Coscia), Baptistry; and decoration of Old Sacristy. Publishes documents for Tomb of Pope John XXIII, Prato Pulpit (1428-38), and the Tomb of Onofrio Strozzi, Sacristy of Santa Trinità, Florence.

950 LLOYD, CHRISTOPHER. "A Bronze Cupid in Oxford and Donatello's
 'Atys-Amorino.'" Storia dell'arte 28 (1976):215-16, 4 figs.
 Argues that second-century Roman bronze Cupid (Ashmolean, Oxford), excavated in 1733, is type on which Donatello based his Atys-Amorino. Discusses iconography and function.

951 LOTZ, WOLFGANG. Summary of lecture on Donatello [untitled].
 Jahresberichte: Kunsthistorisches Institut in Florenz,
 1939-40: unpaginated, no illus.
 Suggests dependence of Donatello's High Altar on altar commissioned in 1437 from Aegidius of Wiener Neustadt for Convent of San Prosdocimus in Padua.

952 LUSINI, V. "La Madonna sotto il titolo 'Mater Misericordiae'
 nella Chiesa della Contrada della Selva in Siena." Rassegna
 d'arte senese 10, nos. 1-2 (1914):15-25, 1 fig.
 Attributes to Donatello well-documented half-length Madonna and Child relief (San Sebastiano, Contrada della Selva, Siena), commissionned by Bartolomeo Pecci (1420s).

953 MACCHIONI, SILVANA. "Il San Giorgio di Donatello: Storia di
 un processo di musealizzazione." Storia dell'arte 36-37 (May-
 December 1979):135-56, 28 figs.
 Traces history of Donatello's St. George statue after its carving (ca. 1415-17) and placement on exterior of Orsanmichele. Its high reputation is demonstrated by fifteenth- and sixteenth-century sources and versions by Piero di Niccolò Lamberti and other artists.

954 MANDACH, CHARLES de. "La Cathédrale de Lyon et Donatello."
 Revue de l'art ancien et moderne 22 (1907):433-42, 7 figs.
 Suggests relationship between early fourteenth-century bas-reliefs on doors of Lyons Cathedral and Donatello's bronze doors, San Lorenzo, Florence (1461-66).

955 MARCHINI, GIUSEPPE. "Calchi donatelliani." In Festschrift
 Klaus Lankheit zum 20. Mai 1973. Edited by Wolfgang Hartmann.
 Cologne: M. DuMont Schauberg, 1973, pp. 132-34, 6 figs.
 Publishes gesso casts after Donatello reliefs, especially
 Prato Pulpit, and analyzes them technically.

956 MARCHINI, GIUSEPPE. "Nella bottega di Donatello." Prato:
 Storia e arte 14, no. 38 (1973):5-16, 7 figs.
 Argues that technique of casts in various collections
 (Museo Horne, Florence; Wallace Collection, London; and Rijksmuseum,
 Amsterdam) provs they were done from reliefs on Donatello's Prato
 Pulpit by his own workshop.

957 MARLE, RAIMOND van. "An Unknown Marble Relief by Donatello."
 Apollo 16, no. 92 (August 1932):50-52, 2 figs.
 Attributes to Donatello ca. 1435 rough [unfinished?] marble
 relief of standing Madonna and Child Surrounded by Angels (reportedly
 ex-Martelli collection and then Otto Lanz collection, Amsterdam).
 Small bronze plaquette by Bertoldo (Louvre, Paris) is derived from
 it.

958 MARQUAND, ALLAN. "Some Works by Donatello in America." Art in
 America 1 (1913):210-25, 7 figs.
 Attributes to Donatello two cherub heads (Walters Art
 Gallery, Baltimore, ca. 1433-38), two bronze Cupids (Morgan collec-
 tion, New York, ca. 1430s), and a Cupid bust (Widener collection [now
 National Gallery of Art, Washington, D.C.] ca. 1430).

959 MARQUAND, ALLAN. "The Martelli David and the Youthful St. John
 Baptist." Art in America 4 (1916):358-66, 2 figs.
 Attributes Martelli David to Donatello, ca. 1440-43, and
 Martelli St. John the Baptist to Desiderio, ca. 1464, rather than to
 Antonio Rossellino.

960 MARRAI, B[ERNARDO]. Donatello nelle opere di decorazione
 architettonica. Florence: G. Ramella, 1903, 50 pp., no illus.
 Analyzes Donatello's architectural designs throughout his
 career, focusing on niche at Orsanmichele.

961 MARTINELLI, VALENTINO. "Donatello e Michelozzo a Roma."
 Commentari 8, no. 3 (1957):167-94, 13 figs.
 First thorough publication of Donatello's Tabernacle, St.
 Peter's, Rome. Discussion of extent of Michelozzo's collaboration
 and reconstruction of its original format. Argues that Ascension of
 Christ relief (now Victoria and Albert Museum, London) was below it
 and that the Dead Christ with Two Angels relief (attributed here to
 Michelozzo) in the same museum was an altar antependium.

962 MARTINELLI, VALENTINO. "Donatello e Michelozzo a Roma (II)."
 Commentari 9 (1958):3-24, 15 figs.
 Continuation of analysis of Donatello's sojourn in Rome in
 1432-33, its effect on his art, and influence on other artists.

Argues that, as Vasari indicated, Donatello must have finished face of Martin V on tomb slab by Simone Ghini (San Giovanni in Laterano, Rome). Discusses tomb slab in relation to others by Donatello, like those of Bishop Giovanni Pecci (Duomo, Siena), and Giovanni Crivelli (Aracoeli, Rome).

963 MARTINELLI, VALENTINO. "La'compagnia' di Donatello e Michelozzo e la 'sepoltura' del Brancacci a Napoli, I." Commentari 14, no. 4 (1963):211-26, 12 figs.
 Stylistic analysis of Tomb of Cardinal Rainaldo Brancacci in terms of collaboration between Michelozzo and Donatello. Analysis of Simone Ghini's role in Tomb Slab of Pope Martin V.

964 MARTINELLI, VALENTINO. "Il non-finito di Donatello." In Donatello e il suo tempo (Atti dell'VIII convegno internazionale di studi sul Rinascimento, Florence-Padua, 1966). Florence: Istituto Nazionale di Studi sul Rinascimento, 1968, pp. 179-94, 24 figs.
 Analysis of Donatello's deliberate choice of unfinished surfaces for some bronze reliefs and marble sculptures in which, as Vasari first noted, Donatello imitated ancient sculptors' technique for sculptures viewed from a distance. Asserts Donatello also used technique to increase vitality and mobility of figures.

965 MASCIOTTA, MICHELANGELO. "Opere d'arte restaurate in una mostra a Firenze." Emporium 105 (1947):210-14, 6 figs.
 Review of exhibition of restored works, including pre- and post-restoration photographs of wood statue of St. Jerome (Museo civico, Faenza) attributed to Donatello.

966 MATHER, RUFUS G. "Donatello: Debitore oltre la tomba." Rivista d'arte 19, 2d ser. 9 (1937):181-92, no illus.
 Publishes Donatello's catasto records, which reveal his financial indebtedness.

967 MELLER, PETER. "La Cappella Brancacci: Problemi ritrattistici ed iconografici." Acropoli 1 (1960-61):186-227, 273-312, 75 figs., 24 color pls.
 Deals primarily with identifying portraits among figures in fresco cycle but suggests that Donatello's relief of Ascension of Christ and Giving of Keys (Victoria and Albert Museum, London) was not predella (Pope-Hennessy's idea, entry 1001) but was intended to be frieze of altar tabernacle. Discusses its iconographic relationship with fresco cycle.

968 MIDDELDORF, ULRICH. "An Erroneous Donatello Attribution." Burlington Magazine 54 (1929):184-88, 4 figs.
 Rejects attribution of three stucco passion scene reliefs (Bargello, Florence) to Donatello. Reprinted in entry 54.

969 MILANESI, CARLO. "Della statua equestre di Erasmo da Narni detto il Gattamelata . . . documento inedito del MCCCCLIII."

Archivio storico italiano, n.s. 2, la (1855):45-62, no illus.
Publishes document of 1453 that indicates that Gattame-
lata's son, rather than Venetian Senate, commissioned the equestrian
statue from Donatello, and that it was almost finished by 1453.

970 MOELLER, INGRID. "Zwei Madonnen von Ghiberti und Donatello."
 Bildende Kunst, no. 12 (1960):806-8, 2 figs.
 Attributes two Madonna and Child reliefs (formerly Kaiser
Friedrich Museum, Berlin?) one to Ghiberti and one to Donatello.

971 MORISANI, OTTAVIO. "Letture donatelliane: L'Abramo ed
 Isaaco." Bollettino di storia dell'arte (Salerno) 1, no. 1
 (March 1951):7-19, 4 figs.
 Compares statue of Abraham and Isaac (Museo dell'Opera del
Duomo, Florence), which author attributes to Donatello without any
collaboration of Nanni di Bartolo, to Brunelleschi's and Ghiberti's
Sacrifice of Isaac panels.

972 MORISANI, OTTAVIO. "Il monumento Branccacci nell'ambiente
 napoletano del Quattrocento." In Donatello e il suo tempo
 (Atti dell'VIII convegno internazionale di studi sul
 Rinascimento, Florence-Padua, 1966). Florence: Istituto
 Nazionale di Studi sul Rinascimento, 1968, pp. 207-13, 2
 reconstruction drawings.
 Hypothesis about original arrangement of Tomb of Cardinal
Rainaldo Brancacci (Sant'Angelo a Nilo, Naples) based on Neapolitan
tradition of tombs by Tino da Camaino and his imitators.

973 MORISANI, OTTAVIO. "Per una rilettura del monumento Bran-
 cacci." Napoli nobilissima 4, nos. 1-2 (1964):3-11, 6 figs.
 Attribution of various parts of Tomb of Cardinal Rainaldo
Brancacci (Sant'Angelo a Nilo, Naples) to Michelozzo's design:
architecture (which was also influenced by the patron's desire to
follow Neapolitan tradition) and all sculpture, except for Assumption
of the Virgin relief, an autograph Donatello.

974 MORMONE, RAFFAELE. "Donatello, Michelozzo, e il monumento
 Brancacci." Cronache di archeologia e di storia dell'arte 5
 (1966):121-33, 2 line drawings, 4 figs.
 Analyzes influence of style and technique of Assumption of
the Virgin relief on Tomb of Cardinal Rainaldo Brancacci (Sant'Angelo
a Nilo, Naples). Argues that tomb as a whole relates closely to
Tuscan, not just Neapolitan, precedents; and that top of tomb was
carved by Michelozzo on basis of its similarities with his portal
architecture at Sant'Agostino, Montepulciano.

975 MOSKOWITZ, ANITA. "Donatello's Reliquary Bust of Saint
 Rossore." Art Bulletin 63, no. 1 (March 1981):41-48, 11 figs.
 Argues that unusual features of Donatello's reliquary Bust
of San Rossore (Museo nazionale di San Matteo, Pisa)--use of gilt
bronze and portraitlike characterization--relate to its representa-
tion of moment of conversion as recorded in fifteenth-century Vita,
marking sharp break with medieval reliquary tradition.

976 MURARO, MICHELANGELO. "Donatello e Squarcione." In Donatello
 e il suo tempo (Atti dell'VIII convegno internazionale di studi
 sul Rinascimento, Florence–Padua, 1966). Florence: Istituto
 Naztionale di Studi sul Rinascimento, 1968, pp. 387–97, 19
figs.
 Discusses generally Donatello's influence on fifteenth-
century Paduan art, as seen especially in Squarcione and circle.

977 NEGRI ARNOLDI, FRANCESCO. "Sul Maestro della Madonna
 Piccolomini." Commentari 14, no. 1 (January–March 1963):8–16,
 11 figs.
 Tentative attribution to Donatello of well-known Piccolo-
mini Madonna (Palazzo Saraceni–Chigi, Siena), frequently imitated by
fifteenth-century artists. Previously attributed to Vecchietta,
Buggiano, Giovanni di Stefano, and "Master of the Piccolomini
Madonna."

978 NEUMANN, CARL. "Die Wahl des Platzes für Michelangelos David
 in Florenz im Jahr 1504." Repertorium für Kunstwissenschaft 38
 (1915):1–27, 2 figs.
 Discusses thoroughly political and iconographic signif-
icance of Michelangelo's David ; analyzes David as late Gothic and
early Renaissance symbol of leadership, as seen in Donatello's sculp-
tures. Evaluates David's relationship to Donatello's Judith.

979 NEW YORK, WILDENSTEIN GALLERY. Donatello: San Ludovico.
 Catalogue by Giovanni Poggi, Leo Planiscig, and Bruno Bearzi.
 Translated by E. Vaquer and S.M. Abernathy. New York:
 Wildenstein Galleries, 1949, 30 pp., 9 figs., 4 color pls.
 Catalogue of exhibition at Wildenstein's, January 26–
March 5, 1949. Previously unpublished document recording payments to
Donatello, May 14–19, 1423, confirms dating of St. Louis of Toulouse
as 1422–25, with tabernacle completed by 1422. Technical report
includes verification that St. Louis originally occupied niche now
holding Verrocchio's Doubting Thomas on Orsanmichele.

980 NICCO FASOLA, GIUSTA. "Bassorilievi donatelleschi nel Museo
 Calvet." In Studi in onore di Matteo Marangoni. Pisa and
 Florence: Vallecchi Editore Officine Grafiche, 1957, pp.
 176–81, 4 figs. [Originally published in Critica d'arte 18
 (1956):558–63.]
 Attributes half-length Madonna and Child relief (Musée
Calvet, Avignon) to Paduan student of Donatello. Discusses Madonna
and Child in the Clouds relief, which author calls shop work.

981 NICCOLI, RAFFAELLO. "Di due disegni che riguardano progetti
 del tardo Cinquecento per un nuovo altar maggiore nella
 basilica del Santo a Padova." Rivista d'arte 14, 2d ser. 4
 (1932):114–19, 2 figs.
 Publishes two drawings (Uffizi, Florence) that indicate
Girolamo Campagnola's and Cesare Franco's plans to redo Donatello's
High Altar, Santo, Padua.

982 NICHOLSON, ALFRED. "Donatello: Six Portrait Statues." Art in
 America 30 (1942):77-104, 38 figs.
 Six figures from Florence Campanilera identified as those
 sculpted by Donatello (1416-26). Relates their portraitlike features
 to Roman portrait busts.

983 NYE, PHILA C. "The Cherub Frieze of the Pazzi Chapel in
 Florence." Art and Archeology 1 (1914):72-80, 7 figs.
 Attributes frieze of cherub tondi on Pazzi Chapel façade to
 Donatello (ca. 1435), rather than Desiderio.

984 P., CH. [Picard, Charles?]. "Donatello et l'antique." Revue
 archéologique, 6th ser. 28 (July-September 1947):77-78, no
 illus.
 Relates Donatello's Atys-Amorino (Bargello, Florence),
 Cavalcanti Annunciation Virgin (Santa Croce, Florence), and Paduan
 High Altar Madonna to specific antique prototypes.

985 PAATZ, WALTER. "Ein frühes donatellianisches Lünettengrabmal
 vom Jahre 1417." Mitteilungen des Kunsthistorischen Institutes
 in Florenz 3 (1919-32):539-40, no illus.
 Publishes two Donatellesque double-sided lunette tombs:
 the now dispersed Tomb of Maso degli Albizzi (originally in San Pier
 Maggiore, Florence), dated 1417 and formerly attributed to Donatello;
 and the Tomb of Onofrio Strozzi (Sacristy of Santa Trinità, Florence)
 by Piero di Niccolò Lamberti.

986 PACCIANI, RICCARDO. "Ipotesi di omologie fra impianto fruitivo
 e struttura spaziale di alcune opere del primo Rinascimento
 fiorentino: Il rilievo della base del 'S. Giorgio' di Dona-
 tello, la 'Trinità' di Masaccio, 'l'Annunciazione' del Convento
 di S. Marco del Beato Angelico." In La prospettiva rinascimen-
 tale: Codificazioni e trasgressioni (Atti del convegno, Milan,
 1977). Florence: Centro Di, 1980, 1:73-93, 15 figs.
 Analyzes Donatello's spatial illusionism in St. George
 Killing the Dragon relief for Orsanmichele, especially in relation to
 relief's placement and viewer's vantage point. Traces revival of
 interest in St. George as result of fourteenth-century accounts of
 trips to Jerusalem.

987 PANE, ROBERTO. "Il tabernacolo donatelliano di S. Maria del
 Carmine." Napoli nobilissima 10 (1971):77-87, 9 figs.
 Attributes wall tabernacle (Santa Maria del Carmine,
 Naples) to Donatello and shop, ca. 1461.

988 PAOLETTI, JOHN. "Donatello and Brunelleschi: An Early
 Renaissance Portrait." Commentari 21, nos. 1-2 (June-July
 1970):55-60, 3 figs.
 Suggests that figure in Donatello's Feast of Herod (Bap-
 tismal font, Baptistry, Siena) is portrait of Brunelleschi.

989 PARRONCHI, ALESSANDRO. "L'autore del 'Crocifisso' di Santa
 Croce: Nanni di Banco." Prospettiva, no. 6 (July 1976):50-55,
 19 figs.
 Argues that wood Crucifix (Santa Croce, Florence), gener-
ally attributed to Donatello, is by Nanni di Banco and that Crucifix
(Convento di San Francesco, Bosco ai Frati), attributed here to
Donatello, is his only wood crucifix.

990 PARRONCHI, ALESSANDRO. "Il Crocifisso del Bosco." In Scritti
 di storia dell'arte in onore di Mario Salmi. Rome: De Luca,
 1962, 2:233-62, 17 figs.
 Attributes to Donatello newly discovered wood Crucifix
(Convento di San Francesco, Bosco ai Frati). Argues that this is
Crucifix to which Vasari referred in anecdote about competition
between Brunelleschi's wood Crucifix (now Santa Maria Novella,
Florence) and one by Donatello. Questions whether wood Crucifix in
Santa Croce is by Donatello.

991 PARRONCHI, ALESSANDRO. "Il soggiorno senese di Donatello del
 1457-61." In Donatello e il suo tempo (Atti dell'VIII convegno
 internazionale di studi sul Rinascimento, Florence-Padua,
 1966). Florence: Istituto Nazionale di Studi sul
 Rinascimento, 1968, pp. 166-77, 12 figs.
 Contends that Donatello went to Siena in 1457 in quasi-
official role for Cosimo de' Medici. Attributes to Donatello while
there bronze head of bearded old man (Bargello, Florence), which he
identifies with documented figure called Guliatte, and Madonna del
Perdono roundel, Duomo, Siena. Argues that Donatello's modelli (now
lost) for bronze doors of Duomo (never executed) influenced Francesco
di Giorgio and Matteo di Giovanni.

992 PARRONCHI, ALESSANDRO. "Storia di una 'Gatta malata.'"
 Paragone 14, no. 157 (January 1963):60-68, no illus.
 Publishes documents for silver equestrian votive sculpture
of Gattamelata, done before 1441 probably by Donatello, for altar of
Orsanmichele. Uses this to support his theory that Donatello's first
commission in Padua was Gattamelata's bronze equestrian statue.

993 PARRONCHI, ALESSANDRO. "Per la ricostruzione dell' altare del
 Santo." Arte antica e moderna 22 (1963):109-23, 21 figs.
 Reviews and analyzes documents published by Sartori (entry
1027). Argues that Crucifix finished in 1445 is one still on High
Altar (not an earlier Crucifix, as claimed by Sartori) and that it
was intended to go above the altar. Argues against Sartori's inter-
pretation that authorities decided to completely redo altar only in
1448. Contends that altar had short extensions that projected at
right angles to its central section and that St. Giustina was placed
on one and St. Daniel on the other.

994 PERKINS, CHARLES. "Donatello." Gazette des beaux-arts, 1st
 per. 25 (1868):299-320, 2 figs.
 Early monographic study of Donatello that assembles
available information on life and oeuvre.

995 PFEIFFENBERGER, SELMA. "Notes on the Iconology of Donatello's 'Judgment of Pilate' at San Lorenzo." Renaissance Quarterly 20 (1967):437-54, 6 figs.

Opposing Janson and Lavin (entries 786 and 942), author argues that San Lorenzo pulpits portray Pilate in favorable role as servant of God.

996 PLANISCIG, LEO. "Di alcune opere falsamente attribuite a Donatello." Phoebus 2, no. 2 (1948-49):55-59, 6 figs.

Publishes four rejected attributions omitted from his catalogue of Donatello's work: so-called Niccolò da Uzzano bust (Bargello, Florence); Martelli David (now National Gallery of Art, Washington, D.C.); and two statues of St. John the Baptist (Bargello), one attributed by Planiscig to Desiderio, the other to Francesco da Sangallo.

997 PLANISCIG, LEO. "Desiderio da Firenze. Dokumente und Hypothesen." Zeitschrift für bildende Kunst 64 (1930-31): 71-78, 11 figs.

Monographic study of sixteenth-century bronze sculptor, active in Padua and Venice (ca. 1532-45), whose works are occasionally attributed to Donatello.

998 PLANISCIG, LEO. "I profeti sulla Porta della Mandorla del Duomo fiorentino." Rivista d'arte 24, 2d ser., 4 (July-December 1942):125-42, 8 figs.

Argues that young Prophet on right of Porta della Mandorla is by Nanni di Banco, while that on left is by Donatello.

999 POPE-HENNESSY, JOHN. "A Terracotta 'Madonna' by Donatello." Burlington Magazine 125, no. 959 (February 1983):83-84, 1 color pl., 4 figs.

Attributes to Donatello pigmented terracotta relief of Madonna and Child with Seraphim (Cryam collection, Boca Raton, Florida), making it one of few autograph reliefs. Argues that it was done while Donatello was in Padua. Calls marble version of it in SS. Annunziata, Florence, nineteenth-century forgery, countering usual attributions to Michelozzo or Luca Della Robbia.

1000 POPE-HENNESSY, JOHN. "Donatello and the Bronze Statuette." Apollo 105 (1977):30-33, 6 figs.

Attributes to Donatello, ca. 1440, bronze statuette of Pugilist (Bargello, Florence). Vasari mentions Donatello's renown as sculptor of small bronzes, but none were previously known.

1001 POPE-HENNESSY, JOHN. Donatello's Relief of the Ascension with Christ Giving the Keys to St. Peter. Victoria and Albert Museum Monograph, no. 1. London: His Majesty's Stationery Office, 1949, 12 pp., 18 figs.

Small Ascension of Christ relief (Victoria and Albert Musuem, London) by Donatello, carved in Florence ca. 1427-32, represents rare iconography of Christ giving the keys to St. Peter, a

theme recorded in near-contemporary play staged in Santa Maria del
Carmine in 1439. Stylistic and thematic links to Masaccio's St.
Peter frescoes in the Carmine (1425-28) suggest relief may have been
for Brancacci Chapel tabernacle. Reprinted in entry 59.

1002 POPE-HENNESSY, JOHN. "The Fifth Centenary of Donatello." In
 Essays on Italian Sculpture. New York and London: Phaidon,
 1969, pp. 22-36, 4 figs.
 Text of a lecture at the Victoria and Albert Museum,
London, December 13, 1966. Valuable general assessment of
Donatello's relationship to principal intellectual and aesthetic
ideas of Renaissance. Deals with Donatello historiography, his
creative procedures, and his Madonna and Child reliefs.

1003 POPE-HENNESSY, JOHN. "The Madonna Reliefs of Donatello."
 Apollo 103 (1976):172-91, 35 figs.
 Connoisseurship of various Madonna and Child reliefs
attributed to Donatello, including (Shaw) Madonna of the Clouds
(Museum of Fine Arts, Boston); Pazzi Madonna (Staatliche Museen,
Berlin-Dahlem); and Chellini Madonna and Child (Victoria and Albert
Museum, London, on loan), newly attributed to Donatello and iden-
tified with work recorded in Chellini's Libro in 1456, previously
believed lost.

1004 POPE-HENNESSY, JOHN. "The Martelli David." Burlington
 Magazine 101 (1959):134-39, 9 figs.
 Attributes to Antonio Rossellino (ca. 1470-75) the Martelli
David (National Gallery of Art, Washington, D.C.) often considered an
early Donatello. Reprinted in entry 59.

1005 POPE-HENNESSY, JOHN. "Some Donatello Problems." In Studies in
 the History of Art: Dedicated to William E. Suida on His
 Eightieth Birthday. London: Phaidon Press, 1959, pp. 47-65,
 20 figs.
 Proposes new attributions: Baptism of Christ, Baptismal
Font, Duomo, Arezzo, by Donatello, ca. 1410-15; marble Lamentation
(Victoria and Albert Museum, London) by Donatello with assistance,
ca. 1435-40; Torrita lunette by Donatello workshop, ca. 1433; bronze
Lamentation (Victoria and Albert Museum, London) by Donatello, ca.
1440-43; three stucco reliefs (Museo dell'Opera del Duomo, Florence)
attributed to Urbano da Cortona. Reprinted in entry 59.

1006 POPE-HENNESSY, JOHN. "The Medici Crucifixion of Donatello."
 Apollo 101, no. 156 (1975):82-87, 7 figs.
 Bronze Crucifixion relief (Bargello, Florence), attributed
to Donatello and dated ca. 1453-56 is identified as work seen by
Vasari and Borghini in Medici guardaroba.

1007 PREVITALI, GIOVANNI. "Una data per il problema dei pulpiti di
 San Lorenzo." Paragone 12, no. 133 (January 1961):48-56, 8
 figs.

Discovery of inscription of 15 June 1465 on Martyrdom of
St. Lawrence relief dates it before Donatello's death. Previtali
argues it was finished by Donatello. Defines role of Donatello in
pulpit reliefs. Designed by Donatello, cast, and chased under his
supervision: Pentecost, Ascension, Entombment, Deposition (chasing
finished by Bertoldo), Descent in to Limbo, and Resurrection.
Reliefs where Donatello was responsible for composition only: Christ
in the Garden of Gethsemane, Christ before Pilate and Caiphus, Holy
Women at Sepulchre (where faulty casting may have led to student
redoing it). Argues Bertoldo did wax model for Crucifixion.

1008 PROCACCI, UGO. "Le catasto florentin de 1427." Revue de
 l'art, no. 54 (1981):7-22, 15 figs.
 Analyzes tax declarations of Brunelleschi, Ghiberti,
Michelozzo, and Donatello. Because of partnership between Michelozzo
and Donatello, joint tax declaration of 1427 proves that Bust of San
Rossore and Feast of Herod bronze relief were finished by 1425, while
Tombs of Pope John XXIII (Coscia) and Cardinal Rainaldo Brancacci and
the Habbukah were begun after mid-1425.

1009 PUPPI, LIONELLO. "Osservazioni sui riflessi dell'arte di
 Donatello tra Padova e Ferrara." In Donatello e il suo tempo
 (Atti dell'VIII convegno internazionale di studi sul
 Rinascimento, Florence-Padua, 1966). Florence: Istituto
 Nazionale di Studi sul Rinascimento, 1968, pp. 307-29, 10 figs.
 Discusses influence of Donatello and circle, especially on
Paduan and Ferrarese schools of painting.

1010 RADCLIFFE, ANTHONY, and AVERY, CHARLES. "The 'Chellini
 Madonna' by Donatello." Burlington Magazine 118, no. 879
 (1976):377-87, 12 figs.
 Analyzes iconography and function of Donatello's Chellini
Madonna and Child (Victoria and Albert Museum, London), ca. 1448-53,
which may be birth salver even though plaster and gesso casts were
taken from the reverse.

1011 RASMO, NICOLO. "Il crocefisso ligneo di S. Giorgio Maggiore a
 Venezia." Festschrift Karl M. Swoboda zur 28. Januar 1959.
 Vienna and Wiesbaden: Rudolf M. Rohrer, 1959, pp. 237-43, 4
 figs.
 Attributes Crucifix in San Giorgio Maggiore to Giovanni da
Judenberg, an Austrian active in North Italy in the 1420s, rather
than Donatello, as sometimes claimed. Argues that Giovanni da Juden-
burg influenced Donatello's wood sculpture, particularly St. John the
Baptist (Santa Maria Gloriosa dei Frari, Venice).

1012 REYMOND, MARCEL. "La Tomba di Onofrio Strozzi nella Chiesa
 della Trinità in Firenze." Arte 6 (1903):7-14, 6 figs.
 Argues that Tomb of Onofrio Strozzi (Sacristy of Santa
Trinità, Florence) must date largely ater 1429, date of Giovanni de'
Medici Tomb attributed to Donatello, from which it derives.
Discounts 1418 as completion date, as is sometimes argued, since
amount of payment then for Strozzi tomb was insignificant.

1013 RINALDIS, ALDO de. "Di un'antica testa di cavailo in bronzo
 attribuita a Donatello." Bollettino d'arte 5 (1911):241-60, 8
 figs.
 Rejects attribution to Donatello of colossal Horse head
(Museo archeologica nazionale, Naples).

1014 RINALDIS, ALDO de. "Per una testa di cavallo in bronzo nella
 Pinacoteca di Napoli." Rassegna d'arte 9, no. 1 (1909):13-16,
 1 fig.
 Colossal bronze Horse head (Museo archeologica nazionale,
Naples), attributed to Donatello by Billi and other early sources but
called an ancient work by Vasari, is here attributed to Donatello.
Newly discovered letter of 1471 to Lorenzo de' Medici mentions bronze
horse by Donatello.

1015 ROCHE-PÉZARD, FANETTE. "Travaux récents sur Donatello." Revue
 des études italiennes 16 (1970):71-91, no illus.
 Summaries of papers on various aspects of Donatello's life
and work presented to the VIII convegno internazionale di studi sul
Rinascimento (Florence-Pauda, September 25-October 1, 1966).

1016 ROMANINI, ANGIOLA MARIA. "Donatello e il Rinascimento in Alta
 Italia." In Donatello e il suo tempo (Atti dell'VIII convegno
 internazionale di studi sul Rinascimento, Florence-Padua,
 1966). Florence: Istituto Nazionale di Studi sul
 Rinascimento, 1968, pp. 215-34, no illus.
 Traces Donatello's major role in disseminating Renaissance
style in Veneto.

1017 ROMANINI, ANGIOLA M. "Donatello e la 'prospettiva.'"
 Commentari 17, no. 4 (1966):290-323, 15 figs.
 Analyzes Dontello's sculpture in relationship to linear
perspective, especially how Donatello's dynamic use of perspective,
beginning with roundels in Old Sacristy, San Lorenzo, breaks with
Brunelleschi's "ideal" perspective.

1018 RORIMER, JAMES J. "A Reliquary Bust Made for Poggio
 Bracciolini." Metropolitan Museum of Art Bulletin 14
 (1955-56):246-51, 9 figs.
 Gilt silver reliquary bust (Metropolitan Museum of Art, New
York), commissioned by Poggio Bracciolini in 1438-39 for Santa Maria
in Terranuova, may have been made by the goldsmith Ludovico da
Foligno of Ferrara or by Poggio's close friend, Donatello.

1019 ROSE, PATRICIA. "Bears, Baldness, and the Double Spirit; The
 Identity of Donatello's Zuccone." Art Bulletin 63, no. 1
 (March 1981):31-41, 11 figs.
 Identifies prophet relief by Ghiberti flanking East Doors
(Baptistry, Florence) and Donatello's Zuccone (Museo dell'Opera del
Duomo, Florence), here dated ca. 1423-26, as Elisha.

1020 ROSENAUER, ARTUR. "Zum Geremia vom Florentiner Campanile."
 Münchner Jahrbuch der bildenden Kunst 33 (1982):67-76, 11 figs.
 Attributes Jeremiah prophet, formerly Campanile, now Museo
dell'Opera del Duomo, Florence, to Donatello in collaboration with
Michelozzo through comparisons with figures from Tomb of Bartolommeo
Aragazzi, Duomo, Montepulciano.

1021 ROSENBERG, CHARLES M. "Some New Documents Concerning
 Donatello's Unexecuted Monument to Borso d'Este in Modena."
 Mitteilungen des Kunsthistorischen Institutes in Florenz 17,
 no. 1 (1973):149-52, no. illus.
 Reexamines documents related to Borso d'Este Equestrian
Monument (commissioned March 10, 1454) that shed light on Donatello's
techniques and aesthetic attitudes. New documents show project
earlier assigned to Niccolò da Fiorenza, probably Niccolò di Giovanni
Baroncelli.

1022 RUBIÓ, JORDI. "Alfons el Magnànim, rei de Nàpols, i Daniel
 Florentino, Leonardo da Bisuccio i Donatello.' In Miscellània
 Puig i Cadafalchi: Recull d'estudis d'arqueologia, d'historia
 de l'art, i d'historia oferts a Josep Puig i Cadafalch per la
 Societat catalana d'estudis històrics. Barcelona; Institut
 d'Estudis Catalans, 1947-51, 1:25-35, no illus.
 Publishes two letters from Alphonso to Francesco Foscari,
Doge of Venice, and to Spanish ambassador to Venice, requesting that
Donatello cast for Alphonso equestrian bronze statue like
Gattamelata.

1023 SALMI, MARIO. "Antico e nuovo in Donatello." In Donatello e
 il suo tempo (Atti dell'VIII convegno internazionale di studi
 sul Rinascimento, Florence-Padua, 1966). Florence: Istituto
 Nazionale di Studi sul Rinascimento, 1968, pp. 1-10, no illus.
 Outlines critical evaluations of Donatello's sculpture from
Cristoforo Landino in 1481 to Marcel Reymond in 1898, especially
their assessments of Donatello's relationship to ancient art.

1024 SALMI, MARIO. "Riflessioni sulla civiltà figurativa di
 Ferrara nei suoi rapporti con Padova durante il primo
 Rinascimento." Rivista d'arte 34 (1959):19-48, 28 figs.
 Traces indirect influence of Donatello's decorative motifs
on fifteenth-century Ferrarese miniatures and painting.

1025 SALMI, MARIO. "Rinascimento, classicismo e anticlassicismo."
 Rinascimento, 2d ser. 6 (1966):3-26, no illus.
 Discusses nature of classicism in Renaissance and various
interpretations of both these terms. Defines Donatello's role as
important synthesizer of Northern realism, Christian spirituality,
and anticlassical elements of ancient art.

1026 SANPAOLESI, PIERO. "Il pergamo di Prato." Prato: Storia e
 arte, no. 29 (1970):5-56, 44 figs.
 Detailed restoration report on Donatello's Prato Pulpit.

1027 SARTORI, ANTONIO. "Documenti riguardanti Donatello e il suo altare." Il Santo 1, no. 1 (January-April 1961):37-99 (figures shared with Fiocco article, entry 891).
Publishes and analyzes lengthy series of newly discovered documents about High Altar of the Santo; integrates them into discussion of known documents and early sources.

1028 SARTORI, ANTONIO. "Il donatelliano monumento equestre a Erasmo Gattamelata." Il Santo 1, no. 3 (1961):318-44, no illus.
Publishes many additional documents and integrates findings of Soranzo (entry 1051), which were published after Janson.

1029 SARTORI, ANTONIO. "Di nuovo sulle opere donatelliane al Santo." Il Santo 3, no. 3 (1963):347-58, 9 figs.
Publishes additional documents concerning Donatello's altar and its later transformations. Argues that altar had steps in front and back and back of altar may have been more visible than front. Corroborates Parronchi's theory (entry 993) that altar had short extensions projecting at right angles from its main part and that St. Giustina and St. Daniel stood on these extensions. Argues that altar held tabernacle.

1030 SCHLEGEL, URSULA. "Problemi intorno al David Martelli." In Donatello e il suo tempo (Atti dell'VIII convegno internazionale di studi sul Rinascimento, Florence-Padua, 1966). Florence: Istituto Nazionale di Studi sul Rinascimento, 1968, pp. 245-58, 16 figs.
Argues that bronze statuette (Staaliche Museen, Berlin-Dahlem) was cast after wax model by Donatello and that wax model was inspiration for Martelli David, which author attributes to Bernardo Rossellino.

1031 SCHLEGEL, URSULA. "Zu Donatello und Desiderio da Settignano: Beobachtungen zur physiognomischen Gestaltung in Quattrocento." Jahrbuch der Berliner Museen 9 (1967):135-55, 27 figs. [Summary in English.]
Carefully compares stylistic similarities between Donatello and Desiderio da Settignano, noting that close formal proximity belies great difference of expression. Attributes to Desiderio bust of Niccolò da Uzzano (Bargello, Florence).

1032 SCHNEIDER, LAURIE. "Donatello and Caravaggio: The Iconography of Decapitation." American Imago 33 (1976):76-91, 5 figs.
Analyzes Donatello's bronze David (Bargello, Florence) in regard to Freud's decapitation/castration theory. Considers its oedipal meaning in regard to Donatello's personality, biblical account of David, and Neoplatonism.

1033 SCHNEIDER, LAURIE. "Donatello's Bronze David." Art Bulletin 55, no. 2 (1973):213-16, 4 figs.

Donatello's bronze <u>David</u> (Bargello, Florence, ca. 1430-40) symbolizes contemporary political situation, interest in humanism and Neoplatonism, and Donatello's homosexuality, especially Plato's intellectual justification for homosexuality.

1034 SCHNEIDER, LAURIE. "More on Dontallo's Bronze <u>David</u>." <u>Gazette des beaux-arts</u>, 6th per. 94 (July-August 1979):48.
Counters Dixon's interpretation (entry 875), and reasserts her argument that <u>David</u>'s nudity relates to Donatello's alleged homosexuality.

1035 SCHNEIDER, LAURIE. "Some Neo-platonic Elements in Donatello's Gattamelata and Judith and Holofernes." <u>Gazette des beaux-arts</u>, 6th per. 87 (1976):41-48, 9 figs. [Summary in French.]
Donatello's interest in Neoplatonism is reflected in putti and Gorgon heads on Gattamelata's armor and in bacchic reliefs on <u>Judith</u> socle.

1036 SCHOTTMULLER, FRIDA. "Ein Jugendwerk Donatellos im Kaiser-Friedrich Museum." <u>Zeitschift für Kunstgeschichte</u> 1 (1933):336-40, 2 figs.
Attributes terracotta <u>Madonna and Child</u> (formerly Kaiser Friedrich Museum, Berlin) to Donatello, ca. 1415. Dates marble <u>David</u> (Bargello, Florence) ca. 1415-16, rather than ca. 1408-9.

1037 SCHOTTMULLER, FRIDA. "Zur Donatello-Forschung." <u>Monatshefte für Kunstwissenschaft</u> 2 (1909):38-45, 4 figs.
Cites earliest source (1745) attributing bust of <u>Niccolò da Uzzano</u> (Bargello, Florence) to Donatello; attributes to Donatello <u>Baptism of Christ</u> relief (Baptismal Font, Duomo, Arezzo), which was attributed by Vasari to Simone, Donatello's brother; and discusses Vasari's remarks about Donatello's brother.

1038 SCHROETELER, H. "Zur Rekonstruktion des Donatello-Altars im Santo zu Padua." <u>Il Santo</u> 16, no. 1 (1976):3-45, 16 figs.
Proposes reconstruction of Donatello's High Altar as part of choir screen complex built in 1450 in the Santo. Reconstruction based on drawings of church interior and references in documents. Appendix of transcribed documents.

1039 SCHUBRING, PAUL. "Zu Donatello." <u>Cicerone</u> 19(1927):399-405, 6 figs.
Attributes to Donatello caryatid on Tomb of Cardinal Rainaldo Brancacci (Sant'Angelo a Nilo, Naples, ca. 1427), while assigning other two to Michelozzo; attributes to Donatello bronze relief of <u>Martyrdom of St. Sebastian</u> (Musée Jacquemart-André, Paris, ca. 1450); and to student of Donatello stucco <u>Madonna and Child</u> relief (Böhler collection, Lucerne). <u>Christ Crowned with Thorns</u> (Galleria San Giorgio, Rome) is by Fiamberti, and small sculpture of <u>Meeting of Mary Magdalen</u> (Böhler collection, Lucerne) is assigned to Benedetto da Maiano.

1040 SEMRAU, MAX. "Donatello." In Thieme-Becker Künstler-Lexikon.
 Leipzig: E.A. Seemann, 1913, 9:420-25.
 Condensed survey of life and work. Valuable bibliography.

1041 SEMRAU, MAX. "Donatello und der sogennante Forzori-Altar." In
 Kunstwissenschaftliche Beiträge: August Schmarsow, gewidmet
 zum funfzigsten Semester seiner akademisschen Lehrtätigkeit.
 Leipzig: Karl W. Hiersemann, 1907, pp. 95-102, 2 figs.
 So-called "Forzori Altar" (Victoria and Albert Museum,
 London) was not commissioned by Forzori family as arms are later
 addition. Rather, scenes represent two-thirds of Donatello's
 original sketch for North Pulpit of San Lorenzo and were probably
 executed ca. 1455.

1042 SERAFINI, ALBERT. Donatello and Michelozzo in an Unpublished
 Work of Collaboration: A Critical Study of Some Donatellian
 Madonnas. Rome: Privately Printed, 1918, 32 pp., 14 figs.
 Attributes marble Madonna and Child in Clouds relief
 (formerly private collection, Rome) to Donatello and Michelozzo, ca.
 1427-32.

1043 SEYMOUR, CHARLES, Jr. "Homo Magnus et Albus: The Quattrocento
 Background for Michelangelo's David of 1501-04." Stil und
 Überlieferung in der Kunst des Abendlandes (Akten des 21.
 internationalen Kongresses für Kunstgeschichte, Bonn, 1964).
 Berlin: Gebr. Mann, 1967, 2:96-105, 11 figs.
 Argues that Donatello was supervisor of program of prophet
 figures for tribunes of Florentine Duomo. Discusses classical
 prototype of colossal statuary. Describes each figure in Duomo
 series, concluding that Agostino di Duccio only executed Donatello's
 designs.

1044 SEYMOUR, CHARLES, Jr. Michelangelo's David: A Search for
 Identity. Pittsburgh: University of Pittsburgh Press, 1967,
 194 pp., 36 figs.
 Traces background of Michelangelo's David, especially
 earlier colossal statues planned for Duomo, like Donatello's lost
 terracotta Joshua, Agostino di Duccio's lost terracotta Hercules, and
 Agostino di Duccio's never completed marble David. Seymour argues
 that Donatello designed both the Hercules and David for Agostino.

1045 SEYMOUR, CHARLES, Jr. "Some Aspects of Donatello's Methods of
 Figure and Space Construction: Relationships with Alberti's De
 Statua and Della pittura." In Donatello e il suo tempo (Atti
 dell'VIII convegno internazionale di studi sul Rinascimento,
 Florence-Padua, 1966). Florence: Istituto Nazionale di Studi
 sul Rinascimento, 1968, pp. 195-206, 7 figs.
 Analyzes Donatello's use of Albertian theories in statues
 and reliefs after their joint Roman trip of 1431-32.

1046 SHAPIRO, MAURICE L. "Donatello's 'Genietto.'" Art Bulletin 45
 (1963):135-42, 6 figs.







Individual Sculptors

Identifies Donatello's Atys-Amorino (Bargello, Florence) as "genius," or Roman guardian spirit, perhaps functioning as incense burner.

1047 SIEBENHÜNER, HERBERT. "Der Hl. Georg des Donatello." Kunstchronik 7 (1954):266-68, no illus.
Summary of lecture at the Deutscher Kunsthistorikertag, Hannover, July 28, 1954. Proposes that Orsanmichele St. George was originally carved (ca. 1409-13) for Duomo as portrayal of victorious David, that unpublished document records the armorers' guild's purchase of work from Duomo in October 1415, and that statue was reworked by Donatello ca. 1415-17. [For discussion and rebuttal see Janson, entry 787, pp. 27-8.]

1048 SIMON, ERIKA. "Der sogenannte Atys-Amorino des Donatello." In Donatello e il suo tempo (Atti dell'VIII convegno internazionale di studi sul Rinascimento, Florence-Padua, 1966). Florence: Istituto Nazionale di Studi sul Rinascimento, 1968, pp. 331-51, 15 figs.
Identifies Donatello's Atys-Amorino (Bargello, Florence) as image of superbia that reflects important influence of Christian thinking rather than antique precedents, as generally adduced.

1049 SIRÉN, OSVALD. "The Importance of the Antique to Donatello." American Journal of Archaeology 18 (1914):438-61, 20 figs.
Proposes that Atys-Amorino (Bargello, Florence) is after an Amor-Hercules type, Cantoria replicates Roman sarcophagus in Florence, and bronze David (dated after Rome, ca. 1432-34) imitates Praxitelean nude.

1050 SIRÉN, OSVALD. "Two Florentine Sculptures Sold to America." Burlington Magazine 29 (1916):197-99, 4 figs.
Records sale to Joseph Widener of Philadelphia of Martelli David, attributed to Donatello and compared to so-called original bronze sketch, and Martelli Bust of Young St. John the Baptist [both now in the National Gallery of Art, Washington, D.C.]. Latter attributed to Desiderio (rather than Antonio Rossellino).

1051 SORANZO, GIOVANNI. "Due note intorno alla donatelliana statua equestre del Gattamelata." Bollettino del Museo civico di Padova 46-47 (1957-58):21-50, no illus.
Reviews all known documents and sources concerning Donatello's Gattamelata Monument, concluding there is no evidence that Venetian Senate commissioned it. Sifts records of payment to Donatello by Gattamelata's family who, he believes, commissioned the statue, revealing that their refusal to pay Donatello resulted in six-year delay in erection of already finished statue (1447-53).

1052 SPINA BARELLI, EMMA. "Note iconografiche in margine al Davide in bronzo di Donatello." Italian Studies 29 (1974):28-44, 2 figs.

Interprets Donatello's bronze David (Bargello, Florence) according to Lorenzo Valla's De Voluptate (1431).

1053 SPINA BARELLI, EMMA. "Note iconografiche in margine alla Cantoria di Donatello." Storia dell'arte 15-16 (1972):283-91, no illus. [Summary in English.]
 Interprets Donatello's imagery o Cantoria (Museo dell'Opera del Duomo, Florence) in light of Lorenzo Valla's De Voluptate and its images of Paradise.

1054 STANG, RAGHNA, and STANG, NIC. "Donatello e il Giosuè per il Campanile di S. Maria del Fiore alla luce dei documenti." Institutum Romanum Norvegiae: Acta ad Archaeologiam et Artium Historiam Pertinentia 1 (1962):113-29, 22 figs.
 Careful reading of documents shows that statue called St. John the Baptist is figure referred to as Joshua, carved between 1415-17 by Ciuffagni, and finished by Donatello and Nanni di Bartolo in 1421 for Campanile. Secondly, argues that statue called Poggio Bracciolini should be connected with documented commission in 1419-20 to Donatello and Nanni di Barlolo for old prophet for Duomo façade. They contend that Donatello carved head and Nanni di Bartolo body of figure.

1055 STITES, RAYMOND S. "Un cavallo di bronzo di Leonardo da Vinci." Critica d'arte, n.s. 17, fasc. 110 (March-April 1970):13-34, 45 figs.
 Analyzes Donatello's and Verrocchio's sculptures of horses in context of attributing bronze Horse (Trott collection, National Gallery of Art, Washington, D.C.) to Leonardo.

1056 STROM, DEBORAH. "A New Chronology for Donatello's Wooden Sculpture." Pantheon 38 (1980):239-48, 21 figs.
 Argues that newly discovered date of 1438 painted on Donatello's wood St. John the Baptist (Santa Maria Gloriosa dei Frari, Venice) is corroborated by documents. Analyzes Donatello's technique of wood carving, which makes radical break with Tuscan tradition. Redates Mary Magdalen to 1440s by stylistic analogy with redated Baptist. Supports attribution to Donatello of wood Crucifix (Convento di San Francesco, Bosco ai Frati).

1057 STUDNICZKA, FRANZ. "Niccolò da Uzzano?" In Festschrift Heinrich Wölfflin: Beiträge zur Kunst- and Geistesgeschichte zum 21. Juni 1924. Munich: Hugo Schmidt, 1924, pp. 135-53, 12 figs.
 Argues that so-called Niccolò da Uzzano bust (Bargello, Florence), often attributed to Donatello, reflects features of Cicero portraits.

1058 SWARZENSKI, GEORG. "Donatello's 'Madonna in the Clouds' and Fra Bartolommeo." Bulletin of the Museum of Fine Arts (Boston) 40 (1942):64-77, 13 figs.

197

Identifies Donatello's Madonna of the Clouds relief, ca. 1430-34, a small tabernacle relief commissioned by Piero del Pugliese and later seen by Vasari in Medici guardaroba.

1059 TAUBE, OTTO F. "Zur Ikonographie St. Georgs in der italienischen Kunst." Münchner Jahrbuch der bildenden Kunst 6 (1911):186-203, 25 figs.
 Traces style and iconography of St. George from Roman coins through Italian Trecento art as background for Donatello's representation of him.

1060 TOLNAY, CHARLES de. "Donatello e Michelangelo." In Donatello e il suo tempo (Atti dell'VIII convegno internazionale di studi sul Rinascimento, Florence-Padua, 1966). Florence: Istituto Nazionale di Studi sul Rinascimento, 1968, pp. 259-75, 49 figs.
 Traces important influence of Donatello throughout most of Michelangelo's career.

1061 TRACHTENBERG, MARVIN. "An Antique Model for Donatello's Marble David." Art Bulletin 50 (1968):268-69, 9 figs.
 Identifies bronze Etruscan goddess or smaller bronze Etruscan statuette (both Museo archeologico, Florence) as sources for Donatello's marble David, 1408 (as opposed to strictly International Gothic influences).

1062 TRACHTENBERG, MARVIN. "Donatello's First Work." In Donatello e il suo tempo (Atti dell'VIII convegno internazionale di studi sul Rinascimento, Florence-Padua, 1966). Florence: Istituto Nazionale di Studi sul Rinascimento, 1968, pp. 361-67, 2 figs.
 Attributes Prophet statue on North Tribune of Duomo to Donatello, linking it to payment to him of sixteen florins in 1408 and citing it as Donatello's first work. With discussion of Donatello's early life and trip to Rome in 1403-4.

1063 TSCHUDI, HUGO von. "Donatello e la critica moderna." Rivista storica italiana 4, no. 2 (1887):193-228, no illus.
 Essay on aspects of Donatello's sculpture and its historiography. No notes, illustrations, or bibliography.

1064 VALENTINER, W[ILHELM] R. "Donatello and Ghiberti." Art Quarterly 3 (1940):182-215, 29 figs.
 Attributes to Donatello Prophet statue (Musée Jacquemart-André, Paris) made for Porta della Mandorla. Rejects sculpture now in place on left spire. Stylistic comparison of Donatello's early work with Ghiberti's to attribute terracotta Madonnas. Reprinted in entry 68.

1065 VALENTINER, W[ILHELM] R. "Donatello and the Medieval Front Plane Relief." In Studies of Italian Renaissance Sculpture. New York and London: Phaidon, 1950, pp. 1-22, 21 figs. [Reprinted and revised publication of "The Front Plane Relief in Medieval Art," Art Quarterly 2 (1939):155-72.]

Wide-ranging discussion of spatial construction, including Donatello's use of medieval system for expressive purposes in Paduan reliefs and San Lorenzo pulpits.

1066 VALENTINER, WILHELM R. "Donatello or Nanni di Banco." Critica d'arte 27, no. 1 (May 1949):25-31, 8 figs.
 Attributes right Prophet on Porta della Mandorla to Donatello, and left Prophet to Nanni di Banco, claiming that original left Prophet by Donatello is now in Musée Jacquemart-André, Paris.

1067 VALENTINER, WILHELM R. "Notes on the Early Works of Donatello." Art Quarterly 14 (1951):307-25, 4 figs., appendix.
 Prophets now on Porta della Mandorla are attributed to Jacopo di Piero Guidi (left Prophet, 1388-89) and Donatello (right Prophet, ca. 1408). Attribution to Nanni di Banco eliminated on basis of stylistic comparison.

1068 VALENTINER, W[ILHELM] R. "Late Gothic Sculpture in the North and in Italy." In Studies of Italian Renaissance Sculpture. New York: Phaidon, 1950, pp. 22-43, 24 figs. [Reprinted from "Late Gothic Sculpture in Detroit." Art Quarterly 6(1943): 276-304.]
 Discusses parallel phases in fifteenth-century Burgundian and German Gothic style and fifteenth-century Florentine sculpture by Donatello, Agostino di Duccio, Mino da Fiesole, and Antonio Pollaiuolo.

1069 VALENTINER, WILHELM R. "Toward a Chronology of Donatello's Early Work." In Festschrift Friedrich Winkler. Edited by Hans Möhle. Berlin: Verlag Gebr. Mann, 1959, pp. 71-82, 8 figs.
 Proposes marble Prophet (Musée Jacquemart-André, Paris) as first prophet commissioned from Donatello in 1406 for Porta della Mandorla and right Prophet (now in place) as the second.

1070 VENTURI, ADOLFO. "L'Altare di Donatello nella chiesa del Santo a Padova." Arte 17 (1914):307-14, 8 figs.
 Early reconstruction of Donatello's High Altar that points out its discrepancies with Mantegna's San Zeno Altarpiece, which seems to reflect it.

1071 VENTURI, ADOLFO. "Collaboratori di Donatello nell'Altare del Santo." Arte 10 (1907):436-45, 6 figs.
 Distinguishes styles of sculptors who worked on High Altar and attributes Donatellesque Madonna and Child reliefs in Veneto to various of them.

1072 VENTURI, ADOLFO. "Donatello e Padova." Arte 10 (1907):276-85, 11 figs.
 Discusses Donatello's role in decoration of Santo choir (1444), which had been entrusted to Giovanni called Nani, another Florentine

who preceded Donatello to Padua. Publishes pilasters that he argues Donatello designed for High Altar but were later incorporated into choir decoration. [Identification of Giovanni Nani is questioned by Lorenzoni, entry 574.]

1073 VENTURI, ADOLFO. "Due statuette donatelliane nel Museo del Santo a Padova." Arte 19 (1916):51-54, 8 figs.
 Identifies two small terracotta figures of St. Anthony and St. Louis of Toulouse (Santo, Padua) as bozzetti for Donatello's High Altar bronze statues.

1074 VOGE, WILHELM. "Dontello greift ein reimsisches Motiv auf." In Festschrift für Hans Jantzen. Berlin: Gebr. Mann, 1951, pp. 117-27, 7 figs.
 Suggests Donatello's St. Mark (Orsanmichele, Florence, ca. 1411-13) was influenced by figures on Reims Cathedral (ca. 1250) but rejects often proposed influence of Burgundian school of Claus Sluter.

1075 VOGE, WILHELM. Raffael und Donatello: Ein Beitrag zur Entwicklungsgeschichte der italienischen Kunst. Strasbourg: J.H. Ed. Heitz, 1896, 37 pp., 27 figs.
 Brief essay establishes specific influences of Donatello on Raphael, including several Raphael drawings after Donatello's reliefs.

1076 W., R. [Wittkower, Rudolf?]. "A Symbol of Platonic Love in a Portrait Bust by Donatello." Journal of the Warburg and Courtauld Insitutes 1 (1938):260-61, 2 figs.
 Suggests that Donatello's bronze Bust of a Youth called Antonio di Narni (Bargello, Florence, ca. 1440), which includes cameo deriving from Plato's Phaedrus, was commissioned by Cosimo de' Medici. Cosimo encouraged Neoplatonic studies and owned similar cameo.

1077 WEISE, GEORG. "Donatello e la corrente tardo-gotica degli ultimi decenni del Quattrocento." In Donatello e il suo tempo (Atti dell'VIII convegno internazionale di studi sul Rinascimento, Florence-Padua, 1966). Florence: Istituto Nazionale di Studi sul Rinascimento, 1968, pp. 107-13, no illus.
 Argues that Donatello's post-Paduan sculptures are anticlassical and intensely religious and their influence promoted "Gothic" trend in late fifteenth century.

1078 WEISE, GEORG. "Donatello und das Problem der Spätgotik." Zeitschrift für Kunstgeschichte 17 (1954):79-88, no illus.
 Donatello's influence on linear, abstract style in Italy (1450-1500) corresponds to late Gothic/International style in Northern Europe.

1079 WELLIVER, WARMAN. "Narrative Method and Narrative Form in Masaccio's Tribute Money." Art Quarterly 1 (1977):40-58, 16 figs.

Analyzes simultaneous narrative method in Masaccio's
Tribute Money (Brancacci Chapel, Santa Maria del Carmine, Florence,
1425), Donatello's Feast of Herod reliefs (Baptismal Font, Baptistry,
Siena; Musée Wicar, Lille, and Ghiberti's Baptistry doors.

1080 WESTER, URSULA, and SIMON, ERIKA. "Die Reliefmedaillons im
 Hofe des Palazzo Medici zu Florenz." Jahrbuch der Berliner
 Museen 7 (1965):15-91, 36 figs. [Summary in English.]
 Attributes relief medallions, Palazzo Medici[-Riccardi]
courtyard, ca. 1460, to follower of Donatello, who derived them from
gems and sarcophagus reliefs. Analyzes iconographic program as
combining Lucretius's history of man and Neoplatonic theory.

1081 WHITE, JOHN. "Developments in Renaissance Perspective--II."
 Journal of the Warburg and Courtauld Institutes 14 (1951):
 42-69, 20 figs., diag.
 Analyzes Donatello's relief sculptures, noting that
Donatello used linear and aerial perspective to organize pictorial
compositions, create illusionistic space, and harmonize new realism
and surface.

1082 WHITE, JOHN. "Donatello's High Altar in the Santo at Padua,
 Part One: The Documents and Their Implications." Art Bulletin
 51, no. 1 (March 1969):1-14; "Donatello's High Altar in the
 Santo at Padua, Part Two: The Reconstruction," no. 2 (June
 1969):119-41, 26 figs.
 Studies for first time all available documents and second-
ary sources on Padua High Altar. Disputes earlier reconstructions
and proposes new reconstruction conforming to all documents,
Michiel's description (ca. 1520), and iconographic logic. Analyzes
what documents reveal about Donatello's work and his personality.

1083 WILKINS, DAVID G. "Donatello's Lost Dovizia for the Mercato
 Vecchio: Wealth and Charity as Florentine Civic Virtues." Art
 Bulletin 65, no. 3 (September 1983):401-23, 22 figs.
 Reconstructs Donatello's lost Dovizia, ca. 1430, an
overlife-sized allegorical figure that was made to stand atop column
in Mercato Vecchio. Analyzes its iconography and its relationship to
contemporary Florentine economic history and humanist ideas about
wealth and charity. Of importance as only thorough analysis of this
lost commission, which was the first fully classicizing statue in
Donatello's career and greatly influential in the fifteenth century.

1084 WIND, EDGAR. "Donatello's Judith: A Symbol of Sanctimonia."
 Journal of the Warburg and Courtauld Institutes 1 (1937):62-63,
 no illus.
 Relates Donatello's Judith to Durandus's Rationale Divin-
orum Officiorum, which interprets tale of Judith and Holofernes as
victory of superbia over luxuria.

1085 WOLTERS, WOLFGANG. "Eine Antikenergänzung aus dem Kreis des
 Donatello in Venedig." Pantheon 32, no. 2 (1974):130-33, 4
 figs. [Summary in English and French.]

Notes that figure on exterior of San Paolo, Venice, is antique (2d half of fourth century B.C.), but was restored as St. Paul, ca. 1435-45, by a Florentine close to Donatello.

1086 WOLTERS, WOLFGANG. "Due capolavori della cerchia di Donatello a Trogir e a Sibenik." Antichità viva 7, no. 1 (1968):11-24, 19 figs.

Attributes to sculptor in Donatello's circle Lamentation of Christ (San Giovanni, Trogir) and Entombment (Santa Maria Valverde, Sibenic), both of which derive from sculptures by Donatello.

1087 WOLTERS, WOLFGANG. "Freilegung der Signatur an Donatellos Johannesstatue in S. Maria dei Frari." Kunstchronik 27 (1974):83, 1 fig.

Restoration of St. John the Baptist (Santa Maria Gloriosa dei Frari, Venice) revealed original polychromy, signature ("Opus Donati de Florentia"), and date of 1438. More thoroughly published by Francesco Valcanover, "Il San Giovanni Battista di Donatello ai Frari," Quaderni della Soprintendenza di beni artistici e storici di Venezia 8 (1979):23-32, 41 figs.

1088 WUNDRAM, MANFRED. "Donatello e Nanni di Banco negli anni 1408-1409." In Donatello e il suo tempo (Atti dell'VIII convegno internazionale di studi sul Rinascimento, Florence-Padua, 1966). Florence: Istituto Nazionale di Studi sul Rinascimento, 1968, pp. 69-75, no illus.

Identifies Prophet statue (Museo dell'Opera del Duomo) as one of two figures commissioned for Duomo buttress in 1408-9, the other being the so-called Isaiah. Wundram attributes prophet figure to Nanni di Banco, Isaiah to Donatello, and asserts that marble David (Bargello, Florence) by Donatello, usually connected with 1408-9 commission, is later.

1089 YBL, ERVIN. "La Madone du Musée Calvet d'Avignon: Donatello or Desiderio?" Gazette des beaux-arts, 6th per. 6 (1931): 298-306, 2 figs.

Considers marble relief of celestial Madonna and Child (Musée Calvet, Avignon) a copy of collaboration between Donatello and Desiderio da Settignano (with Donatello executing the Madonna).

1090 ZUCKER, PAUL. "Raumdarstellung and Architektur wiedergabe bei Donatello." Monatshefte für Kunstwissenschaft 6 (1913):360-73, 4 figs.

Donatello's innovative use of perspective for depicting architectural interiors is shown in Feast of Herod relief (Musée Wicar, Lille, ca. 1433-350 and traced to his first relief, St. George Killing the Dragon (Orsanmichele, Florence, ca. 1416).

ANTONIO FEDERIGHI DEI TOLOMEI

1091 De NICOLA, GIACOMO. "Antonio Federighi." In Thieme-Becker
Künstler-Lexikon. Leipzig: Wilhelm Englemann, 1907, 1:587-88.
Condensed survey of life and work. Valuable bibliography.

1092 LUSINI, V. "Di alcune sculture in Duomo." Rassegna d'arte
senese 7 (October-December 1911):83-93, no illus.
Argues that two holy water basins near portals of Duomo,
attributed to Federighi and sometimes described as comprised of
ancient sculpture, were carved in part by Quercia.

1093 MANTURA, BRUNO. "Contributo ad Antonio Federighi." Commentari
19, nos. 1-2 (1968):98-110, 13 figs.
Attributes marble statuette of Bishop, part of wood altar-
piece from Monastero dell'Angelo outside Lucca (now in Pinacoteca,
Lucca), to Antonio Federighi. Argues that statuette was not commis-
sioned for altarpiece, but was added later.

1094 NATALI, ANTONIO. "Un inedito per un attribuzione controversa."
Paragone 25, no. 287 (January 1974):61-67, 3 figs.
Publishes half-length terracotta Madonna and Child relief
(private collection) that is replica of stucco Madonna and Child
(National Gallery of Art, Washington, D.C.) attributed to Quercia,
Ghiberti, or Nanni di Bartolo. Attributes both to Antonio Federighi
because terracotta reveals more obvious Sienese features.

1095 PAOLETTI, JOHN T. "Antonio Federighi: A Documentary
Re-Evaluation and a New Attribution." Jahrbuch der Berliner
Museen 17 (1975):87-143, 6 figs., transcription of 149
documents.
Reconstruction of Federighi's oeuvre, focusing on his only
documented freestanding sculpture of St. Peter for Loggia di San
Paolo, Siena, ca. 1454-49. (Identified as St. Peter now on the
Cappella del Campo, Siena). Discussion of Loggia project that
involved Donatello, Jacopo della Quercia, and Vecchietta.

1096 PAOLETTI, JOHN T. "Quercia and Federighi." Art Bulletin 50
(1968):281-84, no illus.
Publishes new documents that closely approximate
Federighi's birth date (ca. 1423) and prove he was apprenticed to
Jacopo della Quercia, not Pietro del Minella, in Duomo workstop of
Siena.

ANDREA DI PIERO FERRUCCI

1097 BRUNORI, DIONISIO. "L'altare marmoreo di Andrea Ferrucci nella
cattedrale di Fiesole." Arte e storia, October 1913:301-3, 1
fig.
Publishes marble altar (Duomo, Fiesole) carved by Andrea
Ferrucci between 1484 and 1493 and discusses history of commission.

1098 FABRICZY, C. de. "Due opere di Andrea Ferrucci esistenti in
Ungheria." Arte 12 (1909):302-7, 3 figs.
Corroborates Vasari's remarks that among sculptures by
Andrea Ferrucci sent to Hungary was tomb for Cardinal of Strigonia by
publishing monument (actually an altar) of Cardinal Tommaso Bakocz in
Strigonia. Attributes to Ferrucci Tabernacle of Holy Sacrament
(Funfkirchen, Pécs).

1099 SCHOTTMULLER, FRIDA. "Ferrucci, Andrea di Piero." In Thieme-
Becker Künstler-Lexikon. Leipzig: E.A. Seemann, 1915,
11:489-91.
Condensed survey of life and work. Valuable bibliography.

FRANCESCO DI SIMONE FERRUCCI

1100 BEDESCHI, GIOVANNI. "Tre sculture di Francesco di Simone
Fiesolano." Arte 3 (1900):154-55, 1 fig.
Attributes marble Madonna di Solarolo relief to Francesco
di Simone who is seen to imitate Desiderio rather than Antonio
Rossellino. Assigns to him "ciborietto" (Museo civico, Bologna) and
relief in Malerbi collection, Lugo.

1101 CALZINI, E. "Francesco di Simone Ferrucci a Forlì."
Miscellanea d'arte 1 (1903):25-32, 3 figs.
Reattributes Bust of Pino III Ordelaffi (Museo civico,
Forlì) once assigned to Donatello, to Francesco di Simone Ferrucci.
Also attributes to Francesco poral lunette of Pinacoteca and marble
capitals and decorative sculpture of portico, Palazzo Comunale.

1102 COVI, DARIO A. "A Florentine Relief." North Carolina Museum
of Art Bulletin (Raleigh) 7, no. 4 (1968):12-23, 9 figs.
Madonna and Child tondo (North Carolina Museum of Art) is
attributed to Francesco di Simone Ferrucci (after 1477), influenced
by Verrocchio. It probably derives from tomb monument, though not
from so-called Tomb of Francesca Tornabuoni, as proposed by
Valentiner.

1103 FABRICZY, C[ORNELIUS] de. "Tre sculture di Francesco di Simone
fiesolano." Arte 4 (1901):58-59, no illus.
Response to Bedeschi's article (entry 1100), reaffirming
his original attribution of the Madonna di Solarolo to Antonio
Rossellino, rather than Francesco di Simone Ferrucci.

1104 FATTORI, ONOFRIO. "Ancora della 'Cappella Oliva' di Monte-
fiorentino." Rassegna d'arte 2 (1902):6-8, 4 figs.
Attributes to Francesco di Simone Tomb of Gianfrancesco
Oliva in Montefiorentino.

1105 Madonna: Bas-Relief in White Marble by Francesco di Simone
Ferrucci from the Palazzo del Pozzo, at Imola. Paris: Trotti
& Co. [after 1901], 7 pp., 1 fig.

Brief text is comprised of excerpts concerning relief from major books and articles.

1106 LIPHART, E. de. "Le sculpteur Francesco Ferrucci et Léonard de Vinci." Gazette des beaux-arts, 5th per. 9 (1924):7-11, 8 figs.
 Attributes numerous lesser marble Madonna and Child reliefs to Francesco di Simone Ferrucci (many previously assigned to Desiderio da Settignano or Leonardo). In particular, Dreyfus collection relief of Madonna of the Steps type is given to Ferrucci (rather than Desiderio), with the design based on a sketch by Leonardo.

1107 SCHOTTMULLER, FRIDA. "Ferrucci, Francesco di Simone da Fiesole." In Thieme-Becker Künstler-Lexikon. Leipzig: E.A. Seemann, 1915, 11:492-93.
 Condensed survey of life and work. Valuable bibliography.

1108 VENTURI, ADOLFO. "Francesco di Simone, fiesolano." Archivio storico dell'arte 5, no. 6 (1892):371-86, 22 figs.
 Monographic essay that reviews Vasari, Lami, and published documents. Traces stylistic development, especially relationship to Desiderio and Verrocchio, and attributes to him various sculptures in Romagna.

1109 ZUCCHINI, GUIDO. "Il rinvenimento di un'opera d'arte a Bologna." Rivista d'arte 14, 2d ser. 4, no. 3 (July-September 1932):330-41, 5 figs.
 Provenance of four Istrian stone figures of putti, now in Dukes of Bevilacqua collection, Castello Rossi, Pontecchio, is traced to Rossi family commission for their chapel (San Petronio, Bologna). Attributes them to Francesco di Simone.

SIMONE DI NANNI FERRUCCI

1110 FABRICZY, CORNELIUS von. "Die Bildhauerfamilie Ferrucci aus Fiesole." Jahrbuch der königlich preussischen Kunstsammlungen (supp.) 29 (1908):1-28, no illus.
 Provides detailed chronologies, assembled from all available documentation, of lives of Simone di Nanni Ferrucci (1402-69), Francesco di Simone Ferrucci (1436-93), and Andrea di Piero Ferrucci (1465-1526). Transcribes all related portate and other pertinent documents in appendices. Notes discuss attributions and relations to other sculptors, including Donatello, Verrocchio, and Desiderio.

1111 SCHOTTMULLER, [FRIDA]. "Ferrucci, Simone di Nanni." In Thieme-Becker Künstler-Lexikon. Leipzig: E.A. Seemann, 1915, 11:495.
 Condensed survey of life and work. Valuable bibliography.

FILARTETE (AVERLINO, ANTONIO DI PIETRO)

1112 LAZZARONI, MICHELE, AND MUÑOZ, ANTONIO. Filarete: Scultore e architetto del secolo XV. Rome: W. Modes, 1908, 291 pp., 89 figs.

Monograph on Filarete's career with three chapters devoted to his sculpture, his beginnings in Florence, the doors of St. Peter's, and his minor sculpture in Rome. Profusely illustrated.

1112a Schubring, Paul. Review of Filarete: Scultore e architetto del secolo XV, by Michele Lazzaroni and Antonio Muñoz. Monatshefte für Kunstwissenschaft 1, no. 2 (1908):684-85, no illus.

1112b Venturi, Adolfo. Review of Filarete: Scultore e architetto del secolo XV, by Michele Lazzaroni and Antonio Muñoz. Arte 11 (1908):393-400, 5 figs.

Points out suppositions authors assume as fact, like theory that Filarete went to Council of Florence.

1113 OETTINGEN, WOLFGANG von. Ueber des Leben und die Werke des Antonio Averlino genannt Filarete. Beiträge zur Kunstgeschichte, n.s. 6. Leipzig: E.A. Seemann, 1888, 68 pp., no illus.

Excellent and still useful short study that analyzes sources for Filarete's biography and provides extensive notes.

Articles

1114 CERULLI, E. "L'Etiopia del secolo XV in nuovi documenti storici." Africa italiana 5 (1933):57-112, 12 figs.

Pt. 1, pp. 57-80, concerns Filarete's bronze doors for St. Peter's, Rome, and their depiction of Ethiopian delegation at Council of Florence, 1441. Uses letter of Eugenius IV, translated here, to clarify problematic aspects of Filarete's reliefs.

1115 EBERSOLT, JEAN. "Sur le buste de Jean VIII Paléologue au Vaticane." Revue de l'art ancien et moderne 53, no. 293 (February 1928):130-33, 1 fig.

Bronze Bust of Byzantine Emperor John Paleologus VIII (Vatican Museums, Rome) is attributed to Filarete, ca. 1438-45. Scene of emperor arriving in 1438 is included on Filarete's bronze doors of St. Peters'. [Bust elsewhere attributed to Donatello, see entry 294.]

1116 GEROLA, GIUSEPPE. "Una croce processionale del Filarete a Bassano." Arte 9 (1906):292-96, 3 figs.

Publishes silver processional cross commissioned from Filarete by Cathedral, Bassano, in 1449.

1117 GRIGIONI, CARLO. "Chi è uno degli autori del reliquario di Montalto?" Arte e storia 29 (April 1910):97-99, no illus.
 Attributes to Filarete, ca. 1450, reliquary in Montalto commissioned by Pietro Barbo.

1118 HYMAN, ISABELLE. "Examining a Fifteenth-Century 'Tribute' to Florence." In Art, the Ape of Nature: Studies in Honor of H.W. Janson. Edited by Mosche Barasch and Lucy F. Sandler. New York: Harry N. Abrams; Englewood Cliffs, N.J.: Prentice Hall, 1981, pp. 105-26, 21 figs.
 Attributes silver and enamel plaquette of Healing of a Woman Possessed by Demons (Louvre, Paris; bronze aftercast, National Gallery of Art, Washington, D.C.) to Filarete in the 1450s. Analyzes its architectural setting as Florentine. Proposes that it was gift from Medici to Pietro da Milano and that it helped transmit Florentine style to Milan and elsewhere.

1119 KEUTNER, HERBERT. "Hektor zu Pferde: Eine Bronzestatuette von Antonio Averlino Filarete." In Studien zu toskanischen Kunst: Festschrift für Ludwig Heinrich Heydenreich zum 23. März 1963. Edited by Wolfgang Lotz and Lise Lotte Möller. Munich: Prestel-Verlag, 1964, pp. 139-54, 14 figs.
 Equestrian statuette of Hector Defeating Hercules is attributed to Filarete (Museo arqueologico, Madrid, ca. 1458-60), and related to popular French/Venetian poem.

1120 LAZZARONI, M., and MUÑOZ, A. "Opere ignote di Antonio Filarete." Rivista d'arte 5 (1907):103-11, 3 figs.
 Attributes to Filarete bronze Bust of Byzantine Emperor John Paleologus VIII (Propaganda Fide, Rome [now Vatican Museums, Rome]). Dates it early 1439, during Council of Florence, making it earliest dated Renaissance portrait bust. Ascribes to him bronze plaquette of Triumph of Julius Caesar (Louvre, Paris). For attribution of Paleologus bust to Donatello, see entry 294.

1121 LORD, CARLA. "Solar Imagery in Filarete's Doors to St. Peter's." Gazette des beaux-arts, 6th per. 87 (April 1976):143-50, 4 figs.
 Reliefs on bronze doors, St. Peter's, Rome, combine pagan and erotic scenes with Christian iconography to emulate classical ekphrases, specifically Ovid's description of Sun's palace in the Metamorphoses.

1122 MARINESCO, CONSTANTIN. "Deux empereurs byzantins, Manuel II et Jean VIII Paléologue, vus par des artistes parisiens et italiens." Bulletin des Société nationale des antiquaires de France, 1958:38-40, no illus.
 Précis of paper discussing works of art inspired by visit of Emperor John Paleologus VIII to Italy in 1445, including medal by Pisanello, bronze bust in the Vatican (Filarete?), bronze doors of St. Peter's by Filarete, and Piero della Francesca's Arezzo frescoes.

1123 MIDDELDORF, ULRICH. "Filarete?" Mitteilungen des Kunst-
historischen Institutes in Florenz 17, no. 1 (1973):75-86, 14
figs.
 Attributes to Filarete marble Rediscovery of the Image of
the Virgin relief, below Luca della Robbia's tabernacle (Santa Maria
dell'Impruneta, near Florence). Analyzes Filarete's style,
especially in relation to doors of St. Peter's and attributes to him
other small bronzes. Reprinted in entry 54.

1124 RAKINT, V. "Une plaquette du Filarete au musée de l'Ermitage."
Gazette des beaux-arts, 5th per. 10 (September-October 1924):
157-66, 2 figs.
 Bronze plaquette representing bull, lion, and tree bears
inscription by Antonio Averlino, called Filarete. Conjunction of
these heraldic emblems of popes, ca. 1466-71, provides confirmation
of Filarete's later activity in Rome.

1125 ROEDER, HELEN. "The Borders of Filarete's Bronze Doors to St.
Peter's." Journal of the Warburg and Courtauld Institutes 10
(1947):150-53, 12 figs.
 Provides sources and identification of scenes from
classical antiquity found in acanthus patterns of Filarete's bronze
doors. Recounts literature on subject from Grimaldi and Sauer (entry
1126), who traced sources in Aesop and Ovid, to Lazzaroni and Munoz
(entry 1112) and Schubring (entry 1127). Sauer adds Livy, Virgil,
and Valerius to Grimaldi's identification of sources. Publication of
list of interpretations by Sauer, Muñoz, and Schubring.

1126 SAUER, BRUNO. "Die Randreliefe an Filaretes Bronzethur von St.
Peter." Repertorium für Kunstwissenschaft 20 (1897):1-22, no
illus.
 Fundamental study of iconography of Filarete's bronze
doors, St. Peter's, Rome. Proposes Ovid and Aesop as principal
sources, plus Virgil, Livy, and Valerius.

1127 SCHUBRING, PAUL. "Filarete, Antonio di Pietro Averlino." In
Thieme-Becker Künstler-Lexikon. Leipzig; E.A. Seemann, 1915,
11: 552-56.
 Condensed survey of life and work. Valuable bibliography.

1128 SEYMOUR, CHARLES, Jr. "Some Reflections on Filarete's Use of
Antique Visual Sources." Arte lombarda 18, nos. 38-39
(1973):36-47, 16 figs.
 Distinguishes Filarete's "rediscovery of non-classical
antiquity," that is, late Imperial to early Christian sculpture, from
Ghiberti's classical sources through comparison of St. Peter's doors
to East Doors, Baptistry, by Ghiberti.

1129 SPENCER, JOHN R. "Filarete's Bronze Doors at St. Peter's." In
Collaboration in Italian Renaissance Art (Charles Seymour, Jr.
Festschrift). Edited by Wendy Stedman Sheard and John T.
Paoletti. New Haven and London: Yale University Press, 1978,
pp. 33-58, 15 figs.

Cleaning of Filarete's bronze doors, St. Peter's, and new
photographic campaign permit first thorough analysis. Conclusions:
casting faults required artificial patina to conceal them and unify
doors visually. Although Filarete received commmission in 1433, work
went slowly as he was often out of Rome between 1433 and 1443. Pope
Eugenius IV altered doors' program between 1439 and 1443, requiring
already cast sections of frame to be broken out and replaced with
reliefs commemorating pope. Work done between 1443 and 1445 was
executed very quickly and chasing is more rough.

1130 SPENCER, JOHN R. "Filarete: The Medallist of the Roman
 Emperors." Art Bulletin 61 (1979):550-61, 27 figs.
 Thorough discussion of Filarete's career as medallist in
relationship to his sculpture. Attributes to Filarete various medals
of Roman emperors ca. 1445-49.

1131 SPENCER, JOHN. "Il progetto per il cavallo di bronzo per
 Francesco Sforza." Arte lombarda 18, nos. 38-39 (1973):23-35,
 12 figs.
 Analyzes rearing horse motif and its Lombard origins (ca.
1450-1500). Earliest example is gold ducat of Francesco I Sforza.
It was first mentioned in letter of 1454 concerning Filarete as
sculptor of equestrian monument to Francesco in Cremona. Discussion
of Pollaiuolo's drawing (Robert Lehman collection, Metropolitan
Museum of Art, New York), a later study for this equestrian monument.

1132 SPENCER, JOHN R. "Two Bronzes by Filarete." Burlington
 Magazine 100, no. 668 (November 1958):392-95, 397, 10 figs.
 Processional cross in Bassano, signed by Filarete and
dated 1449, sheds light on his later sculpture and allows attributon
to him of bronze statuettes of the Virgin and St. John (Ashmolean
Museum, Oxford, ca. 1449-51).

1133 TSCHUDI, HUGO von. "Filaretes Mitarbeiter an den Bronzethüren
 von St. Peter." Repertorium für Kunstwissenschaft 7 (1884):
 291-94, no illus.
 Evaluates Vasari's claim that Simone, Donatello's brother,
worked on St. Peter's doors. Identifies Filarete's six assistants
(none of them Simone) whose names are inscribed on St. Peter's doors.
These include Beltrami di Angelo Belferdeli (VARRUS FLORENTINAE) and
Pasquino di Mattheo da Montepulciano (PASSQUINUS). Traces what is
known regarding these figures.

FRANCESCO DI GIORGIO MARTINI

Books

1134 BRINTON, SELWYN. Francesco di Giorgio Martini of Siena:
 Painter, Sculptor, Civil and Military Architect, 1439-1502.
 2 vols. London: Besant & Co., 1934-35, 1:119 pp. 27 figs.;
 2:111 pp., 26 figs.
 Biographical survey considering Francesco di Giorgio as

painter, sculptor, and architect. Casually written and (according to
Pope-Hennessy, entry 61) often inaccurate.

1134a Weller, Allen. Review of Francesco di Giorgio Martini of
 Siena: Painter, Sculpture, Civil and Military Architect,
 1439-1502, by Selwyn Brinton. Art Bulletin 18, no. 1 (March
 1936):120-22.
 Corrects numerous attributions Brinton deduced from other
 scholars and advises caution in use. Offers some additions to list
 of sculptural attributions.

1135 MALTESE, CORRADO. Francesco di Giorgio. I maestri della
 scultura, vol. 51. Milan: Fratelli Fabbri, 1966, 7 pp., 17
 color pls.
 Excellent color plates of Francesco di Giorgio's sculp-
 tures, including several details, preceded by brief biography.

1136 PANTANELLI, ANTONIO. Di Francesco di Giorgio Martini:
 Pittore, scultore, e architetto senese del secolo XV e
 dell'arte de' suoi tempi in Siena. Siena: Ignazio Gati,
 1870, 143 pp., no illus.
 Early monograph that focuses on biographical details and
 architecture.

1137 PAPINI, ROBERTO. Francesco di Giorgio architetto. 2 vols.
 Florence: Electa, [1946], 1:623 pp. 38 figs.; 2:307 figs.,
 index.
 Elaborate monograph on Francesco's architecture, with
 introductory chapters on his life and artistic formation. Discussion
 of architecture in his reliefs and of architectural sculpture at
 Urbino.

1138 SALMI, MARIO. Disegni di Francesco di Giorgio nella collezione
 Chigi Saracini. Quaderni dell'Accademia chigiana, vol. 11.
 Siena: Ticci Editore, 1947, 48 pp., 32 figs.
 Publication of drawings, principally for battle machines,
 but includes a few sketches for figurative sculpture.

1139 WELLER, ALLEN STUART. Francesco di Giorgio Martini, 1439-1502.
 Chicago: University of Chicago Press, 1943, 430 pp.,
 118 figs.
 Major monograph on Francesco di Giorgio; thorough, well-
 documented coverage of all aspects of career. Catalogue raisonné of
 authentic, attributed, and rejected works. Appendix of documents
 culled from diverse published sources (not checked against
 originals). Full scholarly apparatus.

1139a Douglas, [R.] Langton. Review of Francesco di Giorgio Martini,
 1439-1502, By Allen Stuart Weller. Art in America 32 (1944):
 102-3, no illus.

1139b Kennedy, Ruth W. Review of Francesco di Giorgio Martini, 1439-1502, by Allen Stuart Weller. Art Bulletin 26, no. 2 (June 1944):130-31, no illus.

Articles

1140 BRANDI, CESARE. "Disegni inediti di Francesco di Giorgio." Arte 37, n.s. 5 (January 1934):45-57, 3 figs.
 Publishes drawing of Magdalen (Uffizi, Florence), which author attributes to Francesco di Giorgio. Since figure is study for Magdalen in Deposition relief (Santa Maria del Carmelo, Venice), it substantiates attribution of relief to Francesco di Giorgio.

1141 BULLETTI, P. ENRICO. "Dov'è sepolto Francesco di Giorgio?" Rassegna d'arte senese 16, nos. 3-4 (1923):64-68, no illus.
 Publishes record from Convento dell'Osservanza that indicates Francesco di Giorgio was buried there.

1142 CARLI, ENZO. "A Recovered Francesco di Giorgio." Burlington Magazine 91, no. 551 (February 1949):32-39, 5 figs.
 Recently restored wood statue of St. John the Baptist (San Giovanni Battista, Fogliano, near Siena [now Pinacoteca, Siena]), previously attributed to Vecchietta, is identified as work commissioned from Francesco di Giorgio in 1464 by Compagnia di S. Giovanni Battista della Morte. It is thus earliest known sculpture by Francesco di Giorgio.

1143 CECI, GIUSEPPE. "Nuovi documenti per la storia dell'arte a Napoli durante il Rinascimento." Napoli nobilissima 9, no. 6 (1900):81-84, no illus.
 Publishes group of overlooked documents from Cedole della Tesoreria, Naples, which includes notice of Francesco di Giorgio's return to Siena in 1497.

1144 EIMER, GERHARD. "Francesco di Giorgios Fassadenfries am Herzogspalast zu Urbino." In Festschrift Ulrich Middeldorf. Edited by Antje Kosegarten and Peter Tigler. Berlin: Walter de Gruyter, 1968, pp. 187-98, 3 figs.
 Frieze of military accoutrements is linked to designs by Francesco di Giorgio, ca. 1480.

1145 FABRICZY, C[ORNELIUS] d[e]. "Una statua senese al Louvre." Arte 10 (1907):222-25, 1 fig.
 Attributes to Francesco di Giorgio polychromed, gilded wood sculpture of St. Christopher (Louvre, Paris), probably from Bichi family chapel, Sant'Agostino, Siena. Statue has been attributed to Quercia and Vecchietta.

1146 FUMI, FRANCESCO, "Nuovi documenti per gli angeli dell'altare maggiore del Duomo di Siena." Prospettiva 26 (July 1981):9-25, 20 figs.

Publishes new documents that permit more secure dating and attribution to Francesco di Giorgio, Giovanni di Stefano, Vecchietta, and Cozzarelli of bronze Angels on High Altar, Duomo, Siena.

1147 HARTLAUB, G.F. "Francesco di Giorgio und seine 'Allegorie der Seele' in Kaiser-Friedrich-Museum." Jahrbuch der preussischen Kunstsammlungen 60 (1939):197-211, 7 figs.
Terracotta relief of Bacchic Scene (formerly Kaiser Friedrich Museum) identified as "Allegory of the Soul" and attributed to Francesco di Giorgio. Panel is related to group of works (including Discord, Victoria and Albert Museum, London), previously attributed by Bode to Leonardo.

1148 HILL, G.F. "Notes on Italian Medals-IX: Francesco di Giorgio and Federigo of Urbino." Burlington Magazine 17, no. 87 (June 1910):142-46, 6 figs.
Unfinished medal, with bust of Federigo (obverse) and horseman and lion (reverse) (Max Rosenheim collection, [London]), is attributed to Francesco di Giorgio and connected with a medal mentioned by Vasari.

1149 McCOMB, ARTHUR. "The Life and Works of Francesco di Giorgio." Art Studies 2 (1924):2-32, 37 figs.
Analyzes Francesco di Giorgio's entire artistic output, biographical information about him, and historiography of Francesco di Giorgio studies. Only authenticated sculpture by artist: two bronze Angels on High Altar, Duomo, Siena, 1489-97. With catalogue and bibliography.

1150 MALTESE, CORRADO. "Il ciborio del Duomo di Siena." Belle arti, nos. 5-6 (1948):298-310, 9 figs.
Attributes to Francesco di Giorgio two small putti on ciborium by Vecchietta (Duomo, Siena).

1151 MALTESE, CORRADO. "Opere e soggiorni urbinati di Francesco di Giorgio." Studi artistici urbinati 1 (1949):59-83, 24 figs.
Discussion of Francesco di Giorgio's sojourns in Urbino and sculpture executed there: seventy-two reliefs of battle machines on Palazzo Ducale façade designed by him; reliefs of Deposition (Santa Maria del Carmelo, Venice), which includes Guidobaldo Montefeltro, Flagellation (Pincoteca nazionale, Perugia), and Discord (Victoria and Albert Museum, London), among others.

1152 MALTESE, CORRADO. "Il protomanierismo di Francesco di Giorgio Martini." Storia dell'arte 4 (1969):440-46, 26 figs.
Characterizes Francesco di Giorgio's style (1475-1501) as moving away from earlier dramatic and naturalistic interpretation toward elegant stylization, as seen in serpentinata poses of Candle-bearing Angels (Duomo, Siena), and in drawings and paintings. Points out links with later Mannerism and his influence on Beccafumi.

1153 MARCHINI, G. "Il Palazzo Ducale di Urbino." Rinascimento 9, no. 1 (June 1958):77-78 (appendix), figs. 24-26.
In appendix, attributes to Francesco di Giorgio bronze Paschal candlestick (Duomo, Urbino) on basis of its correspondence to candlestick drawings in his Trattato dell'architettura.

1154 MILLIKEN, WILLIAM M. "A Renaissance Bronze from Siena." Bulletin of the Cleveland Museum of Art 35, no. 8 (November 1948):207-9, 1 fig. (cover).
Attributes Sienese statuette of nude male (Cleveland Museum of Art) to Francesco di Giorgio, ca. 1490s. Statuette is related to Aesculapius (Albertinum, Dresden), often attributed to Francesco di Giorgio but here given to Cozzarelli.

1155 PLANISCIG, LEO. "Toskanische Plastiken des Quattrocento (Unbekannte Werke Francesco di Giorgios und Andrea del Verrocchios)." Jahrbuch der Kunsthistorischen Sammlungen in Wien, n.s. 3 (1929):73-89, 24 figs.
Discusses primarily Francesco di Giorgio, including attribution to him of terrcotta Bust of St. John the Baptist (formerly Kaiser Friedrich Museum, Berlin). Attributes to Verrocchio bronze Putto (Straus collection, New York).

1156 RAGGHIANTI, CARLO R. "Note ai disegni di Francesco di Giorgio." Critica d'arte, n.s. 14, no. 89 (1967):38-53, 18 figs.
Attributes to Francesco di Giorgio drawing of male figure (shepherd?) in Kupferstichkabinett, Dresden. Discussion of his style in painting and sculpture and his relationship to Pollaiuolo.

1157 SALMI, MARIO. "Il Palazzo Ducale di Urbino e Francesco di Giorgio." Studi artistici urbinati 1 (1949):11-55, 31 figs.
Discusses briefly three sculptures in palace but focuses on architecture.

1158 SCHUBRING, PAUL. "Eine Maddalena von Francesco di Giorgio." Cicerone 22, nos. 21-22 (November 1930):549-52, 4 figs.
Attributes to Francesco di Giorgio Bust of Mary Magdalen (Victoria and Albert Museum, London) that relates stylistically to Bust of St. John the Baptist (formerly Kaiser Friedrich Museum, Berlin) attributed by Planiscig (entry 1155) to Francesco di Giorgio. Dated ca. 1490-1500.

1159 SCHUBRING, PAUL. "Francesco di Giorgio Martini." In Thieme-Becker Künstler-Lexikon. Leipzig: E.A. Seemann, 1916, 12:303-6.
Condensed survey of life and work. Valuable bibliography.

1160 SCHUBRING, PAUL. "Francesco di Giorgio." Monatshefte für Kunstwissenschaft 9 (March 1916):81-91, 16 figs.
Brief, insightful biographical overview covering Francesco di Giorgio's varied activities as painter, sculptor, architect, and theorist. Stylistic discussion focuses on sculpture.

1161 VALENTINER, W[ILHELM] R. "A Bronze David by Francesco di
 Giorgio in the Frick Collection." Art in America 29, no. 4
 (October 1941):200-208, 7 figs.
 Claims that large statuette of David, here attributed to
 Francesco di Giorgio (ca. 1470-73), is his earliest bronze and shows
 his affinities with Florentine workshop of Verrocchio.

1162 VENTURI, ADOLFO. "Francesco di Giorgio Martini scultore."
 Arte 26 (1923):197-228, 24 figs.
 Monograph analyzing stylistically Francesco di Giorgio's
 entire career as sculptor. Includes many attributions.

1163 VENTURI, ADOLFO. "Per Francesco di Giorgio Martini." Arte 28
 (1925):51-58, 6 figs.
 Attributes to Francesco di Giorgio wood Bust of an Uniden-
 tified Woman (Louvre, Paris) and various paintings and drawings.

1164 YBL, ERVIN. "Francesco di Giorgio ismeretlen bronz-
 szobrocskája" [Statuette en bronze inconnue de Francesco di
 Giorgio]. Szépmüveszeti muzeum evkönyvei 6 (1931):109-17, 1
 fig.
 In Hungarian, with French summary. Bronze statuette of
 Neptune (Wittman collection, Budapest) attributed to Francesco di
 Giorgio.

 FRANCESCO DI VALDAMBRINO

 Books

1165 BACCI, PELEO. Francesco di Valdambrino: Emulo del Ghiberti e
 collaboratore di Jacopo della Quercia. Siena: Istituto
 Comunale d'Art e di Storia, 1936, 452 pp., 50 figs.
 Thorough monograph on Francesco di Valdambrino as indepen-
 dent sculptor and as Quercia's collaborator, based on extensive
 archival work. Analyzes 103 documents.

1165a Ragghianti, Carlo L. "Su Francesco di Valdambrino." Review of
 Francesco di Valdambrino: Emulo del Ghiberti e collaboratore
 di Jacopo della Quercia, by Pèleo Bacci. Critica d'arte 3
 (1938):136-43, 27 figs.
 Thorough review that discusses Bacci's attributions of
 major sculptures.

1165b Venturi, Adolfo. Review of Francesco di Valdambrino: Emulo
 del Ghiberti e collaboratore di Jacopo della Quercia, by Pèleo
 Bacci. Arte 40, n.s. 8, no. 1 (January 1937):70.

 Articles

1166 ANON. "Valdambrino, Francesco di." In Thieme-Becker Künstler-
 Lexikon. Leipzig: E.A. Seemann, 1940, 34:55.
 Condensed survey of life and work. Valuable bibliography.

1167 Del BRAVO, CARLO. "Schede sulla scultura senese del Quattro-
 cento." Antichità viva 8, no. 1 (1969):15-21, 9 figs.
 Publishes four little known fifteenth-century Sienese
sculptures: wood Crucifix (Sant'Egidio, Montalcino), attributed here
to Francesco di Valdambrino; wood figure of St. Leonard (San
Leonardo, Monticchiello); wood figure of St. Sebastian (Monticello
Amiata); and terracotta standing Virgin and Child (Sant'Agostino,
Santa Fiora), the last three by unknown artists.

1168 FREYTAG, CLAUDIA. "Beiträge zum Werk des Francesco di
 Valdambrino." Pantheon 29, no. 5 (September-October
 1971):363-78, 18 figs., 1 color pl. (cover).
 Reconstructon of Valdambrino's oeuvre, especially in rela-
tion to early Jacopo della Quercia. Valdambrino's part in the Fonte
Gaia termed "organizational." Only direct collaboration is secular
equestrian monument (San Cassiano, Controne, Lucca, ca. 1422-25),
which is related to drawing by Jacopo della Quercia (Merton collec-
tion, Maidenhead).

1169 NERI LUSANNA, ENRICA. "Un episodio di collaborazione tra
 scultori e pittori nella Siena del primo Quattrocento: La
 'Madonna del Magnificat' di Sant'Agostino." Mitteilungen des
 Kunsthistorischen Institutes in Florenz 25, no. 3 (1981):
 324-40, 17 figs., 1 reconstruction.
 Proves through documents that Madonna del Magnificat sculp-
ture was center part of painted polyptych signed by Taddeo di Bartolo
and Gregorio di Cecco, dated 1420. Reconstructs polyptych and
attributes sculpture to Francesco di Valdambrino.

1170 RICHARDSON, E.P. "A Virgin Annunciate by Francesco di Valdam-
 brino." Bulletin of the Detroit Institute of Arts 37, no. 1
 (1957-58):1-3, 2 figs.
 Attributes to Francesco di Valdambrino, ca. 1420-30, a
polychromed wood Virgin (Detroit Institute of Arts) through stylistic
comparison with his Annunciation group from San Francesco, Pienza
(now Rijksmuseum, Amsterdam).

1171 TORRITI, P. "A proposito di un' Annunciazione a S. Quirico
 d'Orcia." Bollettino d'arte, 4th ser. 33 (1948):260-61, 5 '
 figs.
 Tentative attribution to Francesco di Valdambrino, ca.
1409, of polychromed wood Annunciation group (Santa Maria di
Vitaleta, San Querico d'Orcia).

LORENZO GHIBERTI

 Books

1172 CHIARELLI, RENZO. Lorenzo Ghiberti. I maestri della scultura,
 vol. 8. Milan: Fratelli Fabbri, [1966], 6 pp., 4 figs., 17
 color pls.

Large, clear color plates of both sets of bronze doors for
Baptistry, as well as details of Shrine of St. Zenobius (Duomo,
Florence) and Shrine of SS. Proto, Giacinto, and Nemesio (Bargello,
Florence).

1173 CLARK, KENNETH. The Florence Baptistry Doors. Photographs by
 David Finn. Commentaries by George Robinson. New York:
 Viking Press, 1980, 328 pp., 268 figs., 43 color pls.
 Detailed photographic survey of the three sets of bronze
doors (Baptistry, Florence) by Andrea Pisano and Lorenzo Ghiberti,
with brief introduction and commentaries.

1174 I disegni antichi degli Uffizi: I tempi del Ghiberti. Desegni
 e stampe degli Uffizi, no. 50. Introduction by Luciano
Bellosi.
 Catalogue by Fiora Bellini and Giulia Brunetti. Florence: Leo
 S. Olschki, 1978, 105 pp., 142 figs.
 Scholarly catalogue of 102 late fourteenth- and fifteenth-
century drawings in International Gothic style by artists associated
with Lorenzo Ghiberti, including one (Female Saint in Aedicule, cat.
31) attributed to Ghiberti. Each entry with full description, pro-
venance, and bibliography.

*1175 EULER KUNSEMULLER, S. Bildgestalt und Erzählung: Zum frühen
 Reliefwerk Lorenzo Ghibertis. Frankfurt am Main, Berlin, and
 Cirencester: Lang, 1980, 228 pp., 64 figs.
 Argues that differences in style visible on North Doors,
Baptistry, Florence, are due to participation of students rather than
to Ghiberti's own stylistic development, as argued by Krautheimer.

1176 Ghiberti e la sua arte nella Firenze del '3-'400. Florence:
 Edizioni Città di Vita, 1979, 171 pp., 41 figs.
 Publication of lectures intended for general audience by
authorities on Ghiberti like Parronchi, Krautheimer, Sanpaolesi, and
Marchini. These texts are interspersed with excerpts from sources
like Bruni and Savonarola.

1177 GOLDSCHEIDER, LUDWIG. Ghiberti. London: Phaidon Publishers,
 1950, 154 pp., 185 figs.
 Short essay plus translations of Vasari's biography and
Ghiberti's autobiography excerpted from his Commentaries (ca. 1445).
Catalogue with plates and notes; some new attributions, especially of
Madonna reliefs.

1178 GOLLOB, HEDWIG. Lorenzo Ghibertis künstlerischer Werdegang.
 Zur Kunstgeschichte des Auslandes, vol. 126. Strasbourg; J.H.
 Ed. Heitz, 1929, 64 pp., 20 figs.
 Considers interaction of painting and sculpture in Early
Renaissance in relation to Ghiberti's sculpture, especially reliefs.

1179 KRAUTHEIMER, RICHARD (in collaboration with Trude Krautheimer-
 Hess). Lorenzo Ghiberti. Princeton: Princeton University
 Press, 1956, 457 pp., 284 figs.; 2d ed. with corrections, new

preface, and additional bibliography, 2 vols, 1970; 3d ed., paperback, [1982].
 Major monograph on Ghiberti that approaches his work chronologically in terms of style and conceptually in relation to Renaissance artistic theory. Considers linear perspective, Ghiberti's architecture, Ghiberti and antiquity, humanism, Ghiberti's writings, and Ghiberti's relationship to Alberti. Comprehensive translation of documents and excellent plates.

1179a Cannon-Brookes, Peter. Review of Lorenzo Ghiberti (2d ed.) and Ghiberti's Bronze Doors, by Richard Krautheimer. Apollo 97, no. 132 (February 1973):202, no illus.
 Criticizes Krautheimer's inflexible view of Ghiberti as founder of Renaissance style and his failure to admit late Gothic influences in Ghiberti's work.

1179b Clark, Kenneth. Review of Lorenzo Ghiberti, by Richard Krautheimer. Burlington Magazine 100 (1958):174-78, 1 fig.
 Suggests influence of painters, especially Sienese Ambrogio Lorenzetti, as well as the Pisani and Lorenzo Maitani, on Ghiberti. Proposes that rather than Ghiberi's having influenced Alberti (whose Della pittura was written ca. 1435), perhaps Alberti's ideas influenced Ghiberti's style as early as ca. 1428-33 in Rome.

1179c Gombrich, Ernst. Review of Lorenzo Ghiberti, by Richard Krautheimer. Apollo 45, no. 389 (July 1957):306-7, 3 figs.

1179d Janson, H[orst] W. Review of Lorenzo Ghiberti, by Richard Krautheimer. Renaissance News 10, no. 2 (Summer 1957):103-5, no illus.

1179e Kurz, Otto. Review of Lorenzo Ghiberti, by Richard Krautheimer. Gazette des beaux-arts, 6th per. 51 (May-June 1958): 364-65, no illus.
 Adds information about Ghiberti's art historical reputation in eighteenth century; disputes influence of French jewelry; denies attribution of Flagellation drawing.

1179f Lowry, Bates. Review of Lorenzo Ghiberti, by Richard Krautheimer. College Art Journal 18, no. 2 (Winter 1959):184-87, no illus.
 Verifies 1434-37 as principal period of design and casting of East Doors and sees certification of this date as central to chronology of Early Renaissance. Good evaluation and précis of Krautheimer's themes.

1179g Steingräber, Erich. Review of Lorenzo Ghiberti, by Richard Krautheimer. Zeitschrift für Kunstgeschichte 21 (1958):271-74, no illus.
 Excellent commentary on Krautheimer's work, especially influence of Northern goldsmith work.

1179h Verdier, Philippe. Review of Lorenzo Ghiberti, by Richard
Krautheimer. Vie des arts 66 (1972):64-65, no illus.
Useful review (prompted by reprinting of Krautheimer's
book) argues for Ghiberti's seminal role as humanist theorist, as
opposed to Krautheimer's view of Ghiberti as more traditional late
Gothic goldsmith.

1180 KRAUTHEIMER, RICHARD. Ghiberti's Bronze Doors. Princeton:
Princeton University Press, 1971, 135 pp., 155 figs., 4 color
pls., 2 diags.
Brief introductory essay accompanies fine photographic
details of Ghiberti's North and East Doors for Baptistry, Florence.

1181 Lorenzo Ghiberti: "Materia e ragionamenti." Catalogue of
Exhibition held in Museo dell'Accademia and Museo di San Marco,
Florence, October 1978-January 1979. Florence: Centro Di,
1978, 764 pp., 817 figs.
Major catalogue, compiled under supervision of committee of
scholars, accompanying exhibition of Ghiberti material. Numerous
brief essays covering biography, artistic formation, 1401
competition, North Doors, Orsanmichele, Ghiberti's role in rebirth of
terracotta, his relationship with Siena, stained glass, workshop,
East Doors, architecture, relationship to humanism, and techniques.
Incorporates latest findings. Profusely illustrated, although most
phographs are too small for study purposes. Exhaustive,
undiscriminating bibliography at end of volume.

1182 Lorenzo Ghiberti nel suo tempo (Atti del Convegno inter-
nazionale di studi, Florence, 18-21 October 1978). 2 vols.
Florence: Leo S. Olschki, 1980, 679 pp. 204 figs.
Publication of thirty-seven papers on all aspects of
Ghiberti's career, presented at conference held in Florence in 1978.
Contributions summarized in introductory essay by Richard
Krautheimer. Notes and illustrations added to papers.

1183 MARCHINI, GIUSEPPE. Ghiberti architetto. Florence: La Nuova
Italia Editrice, 1978, 32 pp., 87 figs.
Analyzes evolution of Ghiberti's ideas about architecture,
as traced in architectural projects attributed to him, niches for his
statues, and background settings of his reliefs. Many large-scale
illustrations.

1183a Beck, James. Review of Ghiberti architetto, by Giuseppe
Marchini. Burlington Magazine 122 (1980):266-69, no illus.

1184 MARCHINI, G[USEPPE]. Italian Stained Glass Windows. New York:
Harry N. Abrams, 1956, 264 pp. 36 figs., 94 color pls., 18
diags.
Fundamental history of stained glass windows in Italy from
earliest examples at San Francesco, Assisi (ca. 1250-1300) through
the sixteenth century. Introductory survey, followed by detailed
notes on examples of stained glass. Profusely illustrated. Impor-
tant for windows designed by Ghiberti and Donatello.

1185 PATCH, THOMAS. The Gates of the Baptistery of St. John in
Florence by Lorenzo Ghiberti. Engraved by Ferdinand Gregori
and Thomas Patch. Florence: 1774, 34 figs. [Translation of
Italian text, 1773.]
 Major early publication on Ghiberti's doors with fine
engraved illustrations that stimulated interest in his sculpture in
Italy and England.

1186 PERKINS, CHARLES. Ghiberti et son école. Paris: Jules Rouam,
1886, 150 pp., 36 figs.
 Early monograph in limited edition of 500, now of histor-
ical interest only.

1187 PLANISCIG, LEO. Lorenzo Ghiberti. Vienna: Verlag Anton
Schroll & Co., 1940, 33 pp., 110 figs.
 Good, general introductory essay accompanied by fine photo-
graphs of Baptistry doors after cleaning.

1187a Lotz, Wolfgang. Review of Lorenzo Ghiberti, by Leo Planiscig.
Rinascità 4, no. 18 (March 1941):289-91, no illus.

1188 POGGI, GIOVANNI. La Porta del Paradiso di Lorenzo Ghiberti.
Florence: Società Fotografie Artistiche, 1949, 5 pp. 61 figs.
 Brief essay introducing photographic survey of East Doors,
Baptistry, Florence. Many details.

1189 SCHLOSSER, JULIUS von. Leben und Meinungen des Florentinischen
Bildners Lorenzo Ghiberti. Basel: Holbein-Verlag, 1941, 236
pp., 96 figs.
 Important biography that considers Ghiberti as intellectual
whose response to antiquity and collecting was highly personal. In-
cludes valuable essays on antique works in Ghiberti's collection and
on Ghiberti as critic and historian. Excellent background on
intellectual climate of Early Renaissance.

1189a Keller, Harald, Review of Leben und Meinungen des Floren-
tinischen Bildners Lorenzo Ghiberti, by Julius von Schlosser.
Zeitschrift für Kunstgeschichte 11 (1943-44):64-67, no illus.
 Important review that amplifies Schlosser's text and adds
valuable bibliographic information on related research.

1190 WUNDRAM, MANFRED. Lorenzo Ghiberti: Paradiestür. Stuttgart:
Reclam, 1963, 32 pp., 8 figs.
 Handy monograph by leading authority aimed at knowledgeable
visitor to monument.

 Unpublished Theses

*1191 ALBRECHT, BRIGITTE. "Die erste Tür Lorenzo Ghibertis am
Florentiner Baptisterium: Ein Beitrag zum Verständnis der
frühen Schaffensperiode des Künstlers." Ph.D. dissertation,
Heidelberg University, 1950, 165 pp.

1192 OESTERREICH, GEZA von. "Die Rundfenster des Lorenzo Ghiberti."
 2 vols. Ph.D. dissertation, Freiburg, 1965, 319 pp., 91 figs.
 Thorough treatment of Ghiberti's career as designer of
stained glass that covers windows for Duomo and Santa Croce.
Analyzes stylistic development, chronology, and iconography.
Discusses Ghiberti's career as painter before Baptistry competition
and influences on his style.

1193 SCAGLIA, GIUSTINA. "Studies in the 'Zibaldone' of Buonaccorso
 Ghiberti." Ph.D. dissertation, New York University, 1960.
 [Summary in Marsyas 10 (1960-61):71.]
 Buonaccorso Ghiberti's manuscript 'Zibaldone' (Biblioteca
nazionale, Florence, MS.BR 228) contains unpublished drawings for
sculpture, plus texts for Lorenzo Ghiberti's treatise on
architecture. Study traces sources of drawings and texts (in
Vitruvius).

*1194 WUNDRAM, MANFRED. Die künstlerische Entwicklung im Reliefstil
 Lorenzo Ghibertis. Munich, 1957. [Ph.D. dissertation,
 Göttingen, 1952.]

1195 ZERVAS, DIANE R.F. "Systems of Design and Proportion Used by
 Ghiberti, Donatello, and Michelozzo in Their Large-Scale
 Sculpture-Architectural Ensembles between 1412-1434." Ph.D.
 dissertation, Johns Hopkins University, 1973, 309 pp., 56
 diags.
 Studies proportions in major figure sculptures to show
stylistic transformation of medieval sculpture into more classical
forms of Early Renaissance. Ghiberti favored classical proportions,
while Donatello maintained earlier systems.

 Articles

1196 ACIDINI LUCHINAT, CRISTINA. "Momenti della fortuna critica di
 Lorenzo Ghiberti." In Lorenzo Ghiberti nel suo tempo (Atti del
 Convegno internazionale di studi, Florence, 18-21 October
 1978). 2 vols. Florence: Leo S. Olschki, 1980, 2:523-40, 4
 figs.
 Traces history of opinion about Ghiberti as architect and
sculptor from Vasari to end of nineteenth century.

1197 ALESSANDRINI, GIOVANNI; DASSÙ, GRAZIA; PEDEFERRI, PIETRO; and
 RE, GIORGIO. "On the Conservation of the Baptistery Doors in
 Florence." Studies in Conservation 24, no. 3 (August 1979):
 108-24, 18 figs., 2 tables. [Résumé in French and German.]
 Technical analysis of deterioration of Baptistry doors,
Florence, and possible conservation methods.

1198 ANDROSOV, S. "Rel'ef masterskoj Giberti" [Relief from the
 workshop of Ghiberti]. Soobščenija gosudarstvennogo ordena
 Lenina Ermitaža Leningrad 38 (1974):4-6, 1 figs. [Résumé in
 English.]
 In Russian. Reattributes to Ghiberti's shop, ca. 1430-40,

polychromed stucco relief of Madonna and Child (Hermitage, Leningrad) usually attributed to Quercia.

1199 ANGIOLA, ELOISE M. "'Gates of Paradise' and the Florentine Baptistery." Art Bulletin 60, no. 2 (June 1978):242-48, 9 figs.
 Recognition of Florentine Baptistry as medieval "porta paradiso," or portal to Heavenly City, allows reinterpretation of Ghiberti's East Doors. Old Testament scenes chronicle route from loss to return to Paradise through redemptive faith.

1200 ANON. "Triple-Headed Sceptre: Workshop of Lorenzo Ghiberti." Burlington Magazine 115 (1973):844, 1 color pl. (pl. X).
 Gilt bronze pommel composed of three heads (Prudentia?), recently acquired by Bayerisches Nationalmuseum, Munich, is attributed to Ghiberti's shop and related to heads in clipei on North Doors, Baptistry, Florence. Two similar pommels, one on art market, other in Fitzwilliam Museum, Cambridge, are related to Munich example.

1201 ARUCH, ALDO. "Il ricorso di Lorenzo Ghiberti contro la prima sentenza della Signoria fiorentina (17 April 1444)." Rivista d'arte 10 (1917-18):117-23, no illus.
 Publishes two anonymous denunciations of Ghiberti's East Doors, Baptistry, Florence, made in 1444. Attached to second, heretofore unpublished, is Ghiberti's response; issue was Ghiberti's illegitimacy.

1202 BEARZI, BRUNO. "La tecnica usata dal Ghiberti per le porte del Battistero." In Lorenzo Ghiberti nel suo tempo (Atti del Convegno internazionale di studi, Florence, 18-21 October 1978). 2 vols. Florence: Leo S. Olschki, 1980, 1:219-22, no illus.
 Stresses importance of Ghiberti's Commentaries as source of information about technical procedures of casting. Analyzes briefly casting and gilding of North and East Doors, noting that panels were cast and gilded prior to attachment to framework.

1203 BECK, JAMES. "Uccello's Apprenticeship with Ghiberti.' Burlington Magazine 122 (December 1980):837, no illus.
 Clarifies dates during which Uccello worked as assistant to Ghiberti as 1412-16, rather than ca. 1410, as was generally believed.

1204 BELLOSI, LUCIANO. "A proposito del disegno dell'Albertina (dal Ghiberti a Masolino)." In Lorenzo Ghiberti nel suo tempo (Atti del Convegno internazionale di studi, Florence, 18-21 October 1978). 2 vols. Florence: Leo S. Olschki, 1980, 1:135-46, 12 figs.
 Reattributes drawing of Studies of "Flagellation" (Albertina, Vienna), generally accepted as Ghiberti's preparatory sketches for Flagellation relief on North Doors, Baptistry, Florence, to Masolino.

1205 BLOOM, KATHRYN. "Lorenzo Ghiberti's Space in Relief: Method and Theory." Art Bulletin 51 (1969):164-69, 7 figs.
 Analyzes construction of space in three vertical zones based on height of figures in landscape panels of East Doors and sources for that technique.

1206 BODE, WILHELM [von]. "Ghiberti's Versuche: Seine Tonbildwerke zu glasieren." Jahrbuch der preussischen Kunstsammlungen 42 (1921):51-54, 4 figs.
 Attributes to Ghiberti ceramic reliefs (cassone front, Victoria and Albert Museum, London; Madonna and Child statuette, Victoria and Albert Museum; Birth of Eve, Museo dell'Opera del Duomo, Florence) and cites Ghiberti's technical expertise as probable source of Luca della Robbia's development of glazed terracotta sculpture.

1207 BODE, WILHELM von. "Lorenzo Ghiberti als führender Meister unter den Florentiner Tonbildern: Der ersten Hälfte des Quattrocento." Jahrbuch der königlich preussischen Kunstsammlungen 35 (1914):71-89, 20 figs.
 Traces Ghiberti's influence on mass-produced Madonna and Child terracottas of Early Renaissance. Attributes most important examples to Ghiberti, others to his shop, but sees almost all as reflecting Ghiberti's model. (Attributions disputed by Pope-Hennessy, entry 60, p. 206.)

1208 BROCKHAUS, ENRICO [HEINRICH von]. Ricerche sopra alcuni capolavori d'arte fiorentina. Edited by Francsco Malaguzzi Valeri. Milan: Ulrico Hoepli, 1902, 132 pp., 43 figs. German ed. Leipzig: F.A. Brockhaus, 1902, 139 pp., 43 figs.
 Includes essays on Ghiberti's East Doors (with documents), pp.3-48, and chapel in Palazzo Medici that houses Andrea della Robbia's glazed terracotta Madonna Adoring the Child relief (now in Bargello, Florence), pp. 51-60.

1209 BRUNETTI, GIULIA. "Ghiberti orafo." In Lorenzo Ghiberti nel suo tempo (Atti del Convegno internazionale di studi, Florence, 18-21 October 1978). 2 vols. Florence: Leo S. Olschki, 1980, 1:223-44, 15 figs.
 Attributes to Ghiberti ca. 1412 drawing of figure within niche (Gabinetto dei disegni e stampe, Uffizi, Florence, no. 17E) and identifies it as modello for goldsmith work. Argues that Reliquary of St. Andrew (formerly San Francesco; now Pinacoteca comunale, Città di Castello) was designed by Ghiberti. Previously two statuettes of saints on reliquary had been atttributed to Ghiberti's shop (and also to Michelozzo) but reliquary itself had not usually been associated with Ghiberti.

1210 BURCKHARDT, JACOB. "Randglossen zur Skulptur der Renaissance." Edited by Heinrich Wöfflin. In Jacob Burckhardt-Gesamtausgabe. Berlin and Leipzig: Deutsche Verlags, 1934, 13:167-366, esp. p. 238.

Suggests influence on Ghiberti of Genesis reliefs on façade of Duomo, Orvieto.

1211 CAROCCI, G[UIDO]. "Le porte del Battistero di Firenze e l'ornamento imitato della natura." Arte italiana decorativa ed industriale 5 (1896):69-72, 20 figs.
 Extensive series of photographs of fruit and vegetable friezes for South and East Doors, Baptistry, Florence, designed by Lorenzo Ghiberti and executed by Vittorio Ghiberti.

1212 CIARDI-DUPRÉ dal POGGETTO, MARIA G. "Sulla collaborazione di Benozzo Gozzoli alla Porta del Paradiso." Antichità viva 6, no. 6 (1967):60-73, 16 figs., 1 color pl.
 Discusses Gozzoli's work on East Doors, Baptistry, Florence (contract of 1445-48) and Ghiberti's influence on Gozzoli.

1213 CONTI, ALESSANDRO. "Un libro di disegni della bottega del Ghiberti." In Lorenzo Ghiberti nel suo tempo (Atti del Convegno internazionale di studi, Florence, 18-21 October 1978). 2 vols. Florence: Leo S. Olschki, 1980, 1:147-64, 9 figs.
 Attributes to Ghiberti's shop sketchbook (Biblioteca mediceo-laurenziana, Florence, MS. Plut. 90 inf. 50.) in which there are several sketches after ancient sculptures. Supports attribution to Masolino of sheet of Studies of "Flagellation" (Albertina, Vienna).

1214 CORWEGH, ROBERT. "Der Verfasser des kleinen Kodex Ghiberti." Mitteilungen des Kunsthistorischen Institutes in Florenz 1 (1910):156-67, 2 figs.
 Through textual references and by tracing Ghiberti family genealogy, certifies as author of Codex Ghiberti Buonaccorso Ghiberti, grandson of Lorenzo, ca. 1472-83.

1215 DANILOVA, IRINA. "Sull'interpretazione dell'architettura nei bassorilievi del Ghiberti e di Donatello." In Lorenzo Ghiberti nel suo tempo (Atti del Convegno internazionale di studi, Florence, 18-21 October 1978). 2 vols. Florence: Leo S. Olschki, 1980, 2:503-6, no illus.
 Notes that Manetti's account of Brunelleschi-Ghiberti rivalry has obscured their relationship. Points out Ghiberti's dependence on Brunelleschian architecture in settings on bronze panels, East Doors, Baptistry, Florence. Distinguishes Ghiberti's architecture in his reliefs from those types found in Donatello's reliefs.

1216 DAVISSON, DARRELL D. "The Iconology of the S. Trinità Sacristy, 1418-1435: A Study of the Private and Public Functions of Religious Art in the Early Quattrocento." Art Bulletin 57 (September 1975):315-34, 16 figs., 1 plan.
 Reconstruction of Sacristy, Santa Trinità (1418-35), including tomb monuments by Ghiberti workshop (ca. 1420-22). Relates iconography to Strozzi family and to funerary character of chapel.

1217 Degli'INNOCENTI, GIOVANNI. "Problematica per l'applicazione
 della metodologia di restituzione prospettica a tre formelle
 della Porta del paradiso di Lorenzo Ghiberti: Proposte e
 verifiche." In Lorenzo Ghiberti nel suo tempo (Atti del
 Convegno internazionale di studi, Florence, 18-21 October
 1978). 2 vols. Florence: Leo S. Olschki, 1980, 2:561-87, 9
 diags.
 Analyzes perspective system of Isaac, Joseph, and Solomon
 and Sheba panels, East Doors, Baptistry, Florence.

1218 DOREN, ALFRED. "Das Aktenbuch für Ghibertis Matthäusstatue an
 Or San Michele zu Florenz." In Kunsthistorisches Institut in
 Florenz: Italienische Forschungen. Berlin: Bruno Cassirer,
 1906, 1:1-58, 2 figs.
 Exemplary publication of account book (Libro del pilastro)
 of Arte del cambio [bankers' guild] regarding commission of
 Ghiberti's St. Matthew for Orsanmichele, 1419-22. Introduction plus
 full transcription of text.

1219 EISLER, JÁNOS. "Vierge à l"Enfant: Style et date d'exécution
 d'une terre cuite provenant de l'atelier de Lorenzo Ghiberti."
 Bulletin du Musée hongrois des beaux-arts 55 (1981):35-45, 6
 figs.; 56-57 (1981):55-64, 7 figs.
 Attributes to follower of Ghiberti ca. 1425-30 terracotta
 statue of seated Madonna and Child (Museum of Fine Arts, Budapest).

1220 ETTLINGER, HELEN. "A Textual Source for Ghiberti's 'Creation
 of Eve.'" Journal of the Warburg and Courtauld Institutes 44
 (1981):176, no illus.
 Argues that unique iconography of Eve being lifted from
 Adam's body by angels derives from Petrus Comestor's Historica
 Scholastica.

1221 FALLANI, GIOVANNI. "Ghiberti: Un libro aperto sulla religione
 e la vita." In Ghiberti e la sua arte nella Firenze del
 '3-'400. Edited by Massimiliano G. Rosito. Florence:
 L'Artigraf, 1979, pp. 27-33, 1 fig.
 Argues for importance of metalwork on Ghiberti's stylistic
 development. Explains iconography of Baptistry doors in terms of
 contemporary theology and Florentine history.

1222 FIOCCO, G[IUSEPPE]. "Le porte d'oro del Ghiberti." Rinasci-
 mento 7, no. 1 (June 1956):3-11, no illus.
 Argues for reevaluation of Ghiberti's historically under-
 estimated East Doors, Baptistry, Florence.

1223 FRANCIA, ENNIO. "Ghiberti: Biografo di sè e della sua arte."
 In Ghiberti e la sua arte nella Firenze del '3-'400. Edited by
 Massimiano G. Rosito. Florence: L'Artigraf, 1979, pp. 45-58,
 1 fig.
 Analyzes Ghiberti's comments on his art and that of others,
 his definition of realism and creativity, and criteria for being
 perfect artist. Primarily drawn from Third Commentary.

Individual Sculptors

1224 FREYTAG, CLAUDIA. "Italienische Skulptur um 1400: Untersuchungen zu den Einflussbereichen." Metropolitan Museum of Art Journal 7 (1973):5-36, 38 figs.
Traces Northern European influences on emergence of Early Renaissance style in pre-1400 sculptural programs (including Altar of San Francesco, Bologna [ca. 1388]) by itinerant sculptors, in particular, Jacopo della Quercia. Also considers Florentine Duomo and Baptistry, where influence of classical art and French goldsmithery were synthesized by Ghiberti and others.

1225 GABORIT, JEAN RENE. "Ghiberti et Luca della Robbia: A propos de deux reliefs conservés au Louvre." In Lorenzo Ghiberti nel suo tempo (Atti del Convegno internazionale di studi, Florence, 18-21 October 1978). 2 vols. Florence: Leo S. Olschki, 1980, 1:187-93, 2 figs.
Attributes to Luca della Robbia terracotta relief of Madonna and Child with Six Angels and plaster relief of Madonna and Child with Four Saints (Louvre, Paris), which are rejected by other authorities. Dates them before Cantoria (Duomo, Florence) and asserts that their Ghibertesque features demonstrate Luca was trained by Ghiberti.

1226 GENGARO, MARIA LUISA. "Precisazioni su Ghiberti architetto." Arte, n.s. 9, no. 3 (1938):280-96, 8 figs.
Traces stylistic evolution of Ghiberti's architecture as represented in relief sculpture.

1227 GINORI-CONTI, PIERO. "Un libro di ricordi e di spese di Lorenzo e Vittorio Ghiberti." Rivista d'arte 20, 2d ser. 10, no. 3 (July-September 1938):290-303, no illus.
Publishes records from recently recovered account book of Lorenzo and Vittorio Ghiberti.

1228 HARTT, FREDERICK. "Lucerna Ardens et Lucens: Il significato della Porta del Paradiso." In Lorenzo Ghiberti nel suo tempo (Atti del Convegno internazionale di studi, Florence, 18-21 October 1978). 2 vols. Florence: Leo S. Olschki, 1980, 1:27-57, 12 figs.
Argues that Summa Theologica of St. Antoninus is source for program of East Doors and their iconographic coordination with North and South Doors: John the Baptist, whose life is represented on South Doors by Andrea Pisano is, according to Antoninus, "lantern" who reveals in Old Testament (East Doors) essence of New Testament (North Doors). Reidentifies several episodes represented.

1229 JONES, ROGER. "Documenti e precisazioni per Lorenzo Ghiberti, Palla Strozzi, e la Sagrestia di Santa Trinità." In Lorenzo Ghiberti nel suo tempo (Atti del Convegno internazionale di studi, Florence, 18-21 October 1978). 2 vols. Florence: Leo S. Olschki, 1980, 2:507-21, 12 figs.
Publishes for first time little-noticed document of 1418 (Archivio di stato, Florence) that suggests Ghiberti designed

225

heraldic emblem for Palla Strozzi, here identified as relief roundel
on exterior of Sacristy of Santa Trinità, Florence. Argues that
Ghiberti was responsible for architectural sculpture of sacristy but
not structure.

1230 KAUFFMANN, HANS. "Eine Ghibertizeichnung im Louvre." Jahrbuch
der preussischen Kunstsammlungen 50 (1929):1-10, 5 figs.
Drawing of St. Stephen (Louvre, Paris) is attributed to
Ghiberti ca. 1425 and posited as study for St. Stephen statue and
niche (Orsanmichele).

1231 KOSEGARTEN, ANTJE MIDDELDORF. "The Origins of Artistic
Competitions in Italy." In Lorenzo Ghiberti nel suo tempo
(Atti del Convegno internazionale di studi, Florence, 18-21
October 1978). 2 vols. Florence: Leo S. Olschki, 1980,
1:167-86, no illus.
Establishes that while 1401 competition for Baptistry doors
had precedents in medieval Italian city-republics' procedures for
awarding artistic commissions, new awareness of Greco-Roman prece-
dents for artistic competitions distinguished Baptistry competition
from medieval models.

1232 KRAUTHEIMER, RICHARD. "Ghiberti." In Encyclopedia of World
Art. Edited by Istituto per la collaborazione culturale, Rome.
London: McGraw-Hill Publishing Co., 1962, 6: cols. 312-20,
figs. 169-77.
Concise summary of Ghiberti's life, writings, and artistic
production by the leading authority. With bibliography.

1233 KRAUTHEIMER, RICHARD. "Ghiberti and the Antique." Renaissance
News 6, no. 2 (Summer 1953):24-26, no illus.
Evaluates classical influences on Ghiberti as deriving from
Roman sarcophagus reliefs, many of which can be identified. That
influence apparent only after ca. 1430, suggesting trip to Rome then.
Traces shift, inspired by Alberti, from early borrowing of classical
motifs to more generally antique style in the East Doors.

1234 KRAUTHEIMER, RICHARD. "Ghiberti and Master Gusmin." Art
Bulletin 29 (1947):25-35, 15 figs.
In his Commentaries, Ghiberti praises Northern sculptor
named Gusmin, identified here as "Master Gusmin" (ca. 1340-1420?),
court goldsmith to Louis I, duke of Anjou. Analysis of French
goldsmithery as factor in formation of Ghiberti's early style.

1235 KRAUTHEIMER, RICHARD. "Ghibertiana." Burlington Magazine 71
(August 1937):68-80, 20 figs.
Establishes chronology for panels of Ghiberti's first
Baptistry doors (1403-24); attributes to Ghiberti or his shop silver
Crucifix (ca. 1415-20) in the Santa Maria dell'Impruneta, near
Florence; examines late diary of Ghiberti (1441) concerning personal
matters.

1236 KRAUTHEIMER, RICHARD. "Ghiberti-Architetto." Allen Memorial
 Art Museum Bulletin, Oberlin College 12 (1955):48-67, 6 figs.
 Analyzes Ghiberti's architectural concepts, embodied in
East Door reliefs (ca. 1436-37) and in Shrine of St. Zenobius, as
surpassing classicizing aspects even of Brunelleschi's architecture.
Relates Ghiberti's sculpted architecture to Alberti's theories,
though it is uncertain whether theories originate with Alberti or
Ghiberti.

1237 KRAUTHEIMER, RICHARD. "A Postscript to Start With." In
 Lorenzo Ghiberti nel suo tempo (Atti del Convegno inter-
 nazionale di studi, Florence, 18-21 October 1978). 2 vols.
 Florence: Leo S. Olschki, 1980, 1:v-xii, no illus.
 Reviews contributions to understanding of Ghiberti made by
papers presented at conference (some of them unpublished in that
volume) and recent books and articles on Ghiberti. Notes recent
focus on Ghiberti as architect, historian, and theoretician of art.
Observes distinction between Ghiberti as architect and architecture
of his sculptures, which derives from traditions of architectural
backdrops in painting.

1238 KRAUTHEIMER, RICHARD. "Terracotta Madonnas." Parnassus 8
 (1936):4-8. Reprinted, with postscript and updated bib-
 liography, in Richard Krautheimer Studies in Early Christian,
 Medieval, and Renaissance Art (New York: New York University
 Press; London: University of London Press, 1969), pp. 315-22,
 5 figs.
 Marble wellhead in Ca' d'Oro courtyard, Venice, documented
sculpture by Bartolommeo Buon of 1427, establishes terminus ante quem
for lost Madonna and Child sculpture by Ghiberti that is reflected in
many terracottas and stuccos from Ghiberti's circle, ca. 1430-50.
Second group of Madonna and Child terracottas, in which Madonna
presses child to her cheek, is traced back to Quercia.

1239 KRAUTHEIMER, RICHARD. "Ritratto dell'uomo." In Ghiberti e la
 sua arte nella Firenze del '3-'400. Edited by Massimiliano G.
 Rosito. Florence: L'Artigraf, 1979, p. 85, 2 figs.
 Analyzes two self-portraits of Ghiberti on Baptistry doors:
first, that on North Doors, shows Ghiberti at about forty; that on
East Doors at about seventy.

1240 KRAUTHEIMER-HESS, TRUDE. "More Ghibertiana." Art Bulletin 46
 (1964):307-21, no illus.
 Ghiberti's collections of books and drawings are referred
to in legal transactions of descendants and in shopbook, "Zibaldone"
(ca. 1515), of grandson Buonaccorso.

1241 KREYTENBERG, GERT. 'La prima opera del Ghiberti e la scultura
 fiorentina del Trecento." In Lorenzo Ghiberti nel suo tempo
 (Atti del Convegno internazionale di studi, Florence, 18-21
 October 1978). 2 vols. Florence: Leo S. Olschki, 1980,
 1:59-78, 12 figs.

Analyzes Ghiberti's Sacrifice of Isaac panel in terms of
its sources in fourteenth-century Italian relief sculpture, counter-
ing Krautheimer's suggestions of more far-flung sources. Reasserts
Giovanni d'Ambrogio's major role in Porta della Mandorla, denying
participation of young Jacopo della Quercia there. Attributes to
Giovanni d'Ambrogio left door embrasure, including reliefs of Her-
cules and Apollo, and figure of Annunciate Angel, often attributed to
Nanni di Banco. Argues for progressiveness of Giovanni d'Ambrogio,
points to advanced character of statues of Church Fathers by Niccolò
di Piero Lamberti (1395-1401), and indicates young Ghiberti's inter-
est in these sculptors.

1242 LANE, ARTHUR. "Florentine Painted Glass and the Practice of
 Design." Burlington Magazine 91, no. 551 (1949):42-48, 10
 figs.
 Traces history of stained glass production in Italy, focus-
ing on late fourteenth- and fifteenth-century Florence. Notes that
by end of fourteenth century, stained glass artists were reduced to
executing designs provided by others like Ghiberti, who designed
twenty-six windows for Duomo, Florence.

1243 MANTOVANI, GIUSEPPE. "Brunelleschi e Ghiberti in margine
 all'iconografia del Sacrificio." Critica d'arte, n.s. 39, no.
 138 (1974):22-32, 3 figs.
 Analyzes Ghiberti's and Brunelleschi's adaptations of
biblical narrative in their panels of Sacrifice of Isaac (Bargello,
Florence). Identifies figures on altar in Brunelleschi's relief as
conflation of Christ-Isaac, Mary-Church, and God the Father-Abraham,
reinforcing theme of panel as obedience to God.

1244 MANTOVANI, GIUSEPPE. "Brunelleschi e Ghiberti: Osservazioni
 sulle formelle." Critica d'arte, n.s. 38, no. 130 (July-August
 1973):19-30, 9 figs.
 Analysis of conceptual differences in compositions of
Brunelleschi's and Ghiberti's Sacrifice of Isaac panels.

1245 MARCHINI, GIUSEPPE. "Ancora primizie sul Ghiberti." In
 Lorenzo Ghiberti nel suo tempo (Atti del Convegno inter-
 nazionale di studi, Florence, 18-21 October 1978). 2 vols.
 Florence: Leo S. Olschki, 1980, 1:89-97, 9 figs.
 Makes new attributions to Ghiberti's early activity as
painter in Marches: triptych of Madonna and Child (Musei civici,
Pesaro), polyptych of Madonna of Humility and scenes of St.
Bartholomew (formerly Church of San Bartolommeo; now Galleria
nazionale delle Marche, Urbino), and Gonfalon with the Madonna of
Humility (Galleria nazionale delle Marche, Urbino).

1246 MARCHINI, GIUSEPPE. "Ghiberti ante litteram." Bollettino
 d'arte, 5th ser. 50 (1965):181-92, 10 figs., 1 color pl.
 Attributes to Ghiberti while in Marches before Baptistry
competition bronze Assumption of the Virgin relief (Santa Maria dei
Servi in Sant'Angelo in Vado), wood sculpture of Annunciate Virgin

(San Filippo in Sant'Angelo in Vado), and terracotta Virgin and Child relief (Galleria nazionale delle Marche, Urbino).

1247 MARCHINI, GIUSEPPE. "Le vetrate." In Primo Rinascimento in Santa Croce. Florence: Edizioni Città di Vita, 1968, pp. 55-78, 16 figs.

Discusses all twenty-four stained glass windows in Santa Croce, attributing one with Saints to Antonio Pollaiuolo and one with Prophets to Ghiberti.

1248 MARQUAND, ALLAN. "A Terracotta Sketch by Lorenzo Ghiberti." American Journal of Archaeology 9, no. 2 (April-June 1894): 207-11, 2 figs.

Identifies as modello by Ghiberti newly discovered terracotta relief (formerly Allan Marquand collection, Princeton, N.J., now The Art Museum, Princeton University) corresponding to Moses panel, East Doors, Baptistry, Florence.

1249 MARQUAND, ALLAN. "Two Windows in the Cathedral of Florence." American Journal of Archaeology, n.s. 44 (1900):192-203, 2 figs.

First photography and discussion of stained glass windows, Duomo, Florence, designed by Donatello in 1434 (Coronation of the Virgin) and by Ghiberti (Agony in the Garden, executed in 1443; Ascension, executed in 1444; and Presentation in the Temple, designed in 1443 and executed in 1445). With documents.

1250 MENDES ATANASIO, M.C. "Documenti inediti riguardanti la 'Porta del Paradiso' e Tommaso di Lorenzo Ghiberti." Commentari 14, nos. 2-3 (April-September 1963):92-103, 4 figs.

Publication of documents from archives, Ospedale degli Innocenti, concerning East Doors of Baptistry; Silver Altar, Duomo, Florence; and role played by Ghiberti and his son, Tommaso, in their execution.

1251 MIDDELDORF, ULRICH. "Additions to Lorenzo Ghiberti's Work." Burlington Magazine 113, no. 815 (February 1971):72-79, 11 figs.

Attributes to Ghiberti bronze relief of bull's head (coat of arms) on Tomb Slab of Pietro Lenzi (Ognissanti, Florence). Argues that Ghiberti provided design for Tomb Slab of Leonardo Dati (Santa Maria Novella, Florence), and for Tomb Slab of John Ketterick, Bishop of Exeter (Santa Croce, Florence). Also assigns to Ghiberti's design sarcophagus of Tomb of Onofrio Strozzi (Sacristy, Santa Trinità, Florence) and Tomb of Maso degli Albizzi (formerly San Pier Maggiore, now San Paolino, Florence). These last two have been associated with Donatello. Emphasizes his association with Fra Angelico and Uccello, suggesting that Ghiberti may have drawn sinopie under Uccello's Genesis fresco, Chiostro Verde, Santa Maria Novella, Florence. Reprinted in entry 54.

1252 MIDDELDORF, ULRICH. "L'Angelico e la scultura." Rinascimento
 6 (1955):179-94, 19 figs.
 Argues that close relationship between Fra Angelico and
 Ghiberti extended to Ghiberti's designing framework of Linaioli
 Altarpiece (San Marco, Florence). Notes numerous instances of their
 stylistic closeness, some of which may derive from Ghiberti's having
 provided models to Angelico. Reprinted in entry 54.

1253 MIELKE, URSULA. "Zum Programm der Paradiesestür." Zeitschrift
 für Kunstgeschichte 34 (1971):115-34, 16 figs.
 Iconographical analysis of Ghiberti's East Doors, Baptis-
 try, Florence, that interprets Old Testament scenes as antitypes of
 Christ, the Virgin, and the Church according to Bible moralisée.

1254 MORSELLI, PIERO. "The Proportions of Ghiberti's Saint Stephen:
 Vitruvius's De Architectura and Alberti's De Statua." Art
 Bulletin 60, no. 2 (June 1978):235-41, 3 figs.
 Asserts that Ghiberti's St. Stephen (Orsanmichele, Flor-
 ence, 1425-28) is first monumental fifteenth-century sculpture to
 reflect classical proportions, according to Vitruvian canon as inter-
 preted by Alberti. Break with Cennini's medieval proportions used in
 St. Stephen presentation drawing of 1425 (Louvre, Paris) suggests
 Alberti was in Florence by 1427-28.

1255 PACCIANI, RICCARDO. "Lorenzo Ghiberti o il Rinascimento senza
 avanguardie." In Lorenzo Ghiberti nel suo tempo (Atti del
 Convegno internazionale di studi, Florence, 18-21 October
 1978). 2 vols. Florence: Leo S. Olschki, 1980, 2:621-42, 6
 diags.
 Points out that critical appreciation of Ghiberti is dis-
 torted because of comparison with Donatello and Brunelleschi, who
 have been deemed "avant-garde."

1256 PAOLETTI, JOHN. "Nella mia giovanile età mi partì . . . da
 Firenze." In Lorenzo Ghiberti nel suo tempo (Atti del
 Convegno internazionale di studi, Florence, 18-21 October
 1978). 2 vols. Florence: Leo S. Olschki, 1980, 1:99-110, 3
 figs.
 Reviews biographies of fifteenth-century sculptors like
 Brunelleschi, Ghiberti, Donatello, Bernardo Rossellino, and Filarete
 to suggest pattern that Florentine sculptors sought their commissions
 outside city to gain experience prior to facing high Florentine
 standards. Notes impact of this practice on dissemination of
 Florentine models. As example, attributes Crucifixion relief in
 portal lunette of San Martino, Pietrasanta, to Nanni di Banco through
 stylistic analogy with disputed Isaiah statue (Duomo, Florence).

1257 PAOLUCCI, ANTONIO. "Ghiberti orafo: Al servizio della
 liturgia." In Ghiberti e la sua arte nella Firenze del
 '3-'400. Edited by Massimiliano G. Rosito. Florence:
 L'Artigraf, 1979, pp. 115-32, 5 figs.
 Evaluates iconography of East and North Doors, Baptistry,

Florence, suggesting St. Antoninus's influence on East Doors. Also discusses iconography of fifteenth-century gold crosses.

1258 PARRONCHI, ALESSANDRO. "Le 'misure dell'occhio' secondo il Ghiberti." Paragone 12, no. 133 (1961):18-48, 16 figs.
 Claims Ghiberti believed in mobile viewpoint of observer, as opposed to Brunelleschi's idea of fixed vantage point. System is revealed in Commentaries and in perspective system of East Doors and derives from Peckham's theories.

1259 PERKINS, CHARLES. "Lorenzo Ghiberti." Gazette des beaux-arts, 1st per. 25 (1868):457-69, no illus.
 Early heroicizing biography based largely on Vasari. Summarizes known facts; of historical value only.

1260 POGGI, GIOVANNI. "La ripulitura delle porte del Battistero fiorentino." Bollettino d'arte, 4th ser. 33 (1948):244-57 12 figs., 2 color pls.
 Analysis of technical aspects, particularly gilding, of Ghiberti's North and East Doors, Baptistry, Florence.

1261 POLZER, JOSEPH. "A Note on a Motif Derived from a Roman Meleager-Sarcophagus in a Fresco at Mistra." Marsyas 7 (1957):72-74, 2 figs.
 Claims rare Roman sarcophagus motif of bearers of dead Meleager is borrowed in Ghiberti's Joshua panel, East Doors, Baptistry, Florence.

1262 POPE-HENNESSY, JOHN. "The Sixth Centenary of Ghiberti." In The Study and Criticism of Italian Sculpture. New York: Metropolitan Museum of Art, 1980, pp. 39-70, 26 figs.
 Stresses Ghiberti's important role in fifteenth-century painting through his stained glass, reliefs, and the designs he gave other sculptors and painters. Argues that Ghiberti used several perspective systems. Contends that panels on base of East Doors were earliest and that Ghiberti worked up from them. Attributes to Ghiberti invention of reproductive relief.

1263 RAGGHIANTI, CARLO L. "Incontri fatidici." Critica d'arte, n.s., no. 145 (January-February 1976):70-73, no illus.
 According to Ghiberti's autobiography, he stayed with an unidentified painter in Pesaro in 1400. Argues that it must have been Gentile da Fabriano, whose International Style may have influenced Ghiberti.

1264 RAY, STEFANO. ". . . L'arte naturale e la gentilezza con essa, non uscendo dalle misure: Costruzione e concezione dello spazio in Ghiberti." In Lorenzo Ghiberti nel suo tempo (Atti del Convegno internazionale di studi, Florence, 18-21 October 1978). 2 vols. Florence: Leo S. Olschki, 1980, 2:483-502, 11 figs.
 Discusses architecture in Ghiberti's reliefs, its use in

spatial construction, and its relationship to narrative, and some of its sources in painting of the Lorenzetti.

1265 REYMOND, MARCEL. "Lorenzo Ghiberti." Gazette des beaux-arts, 3d. per. 16 (1896):125-36, 3 figs.
Stylistic discussion of differences between Ghiberti's two sets of Doors for Baptistry, Florence. Of historical interest.

1266 ROSITO, MASSIMILIANO. "Lorenzo Ghiberti, 1378-1978." In Ghiberti e la sua arte nella Firenze del '3-'400. Edited by Massimiliano G. Rosito. Florence: L'Artigraf, 1979, pp. 9-14, no illus.
Analyzes early fifteenth-century Florentine belief, revealed in writings of Bruni and Ghiberti, that Florence was "New Jerusalem."

1267 ROSSI, FILIPPO. "The Baptistery Doors in Florence." Burlington Magazine 89 (1947):334-41, 3 figs.
Documents and recent cleanings reveal original gilding patterns of Ghiberti's Baptistry doors.

1268 SALE, J. RUSSELL. "Palla Strozzi and Lorenzo Ghiberti: New Documents." Mitteilungen des Kunsthistorischen Institutes in Florenz 22 (1978):355-58, no illus.
Two new documents that reveal Strozzi's business and personal favoritism toward Ghiberti (ca. 1420-23) may explain extent of Ghiberti's involvement in Sacristy of San Trinità decoration.

1269 SALMI, MARIO. "Lorenzo Ghiberti e Mariotto di Nardo." Rivista d'arte 30 (1955):147-52, no figs.
Identifies Mariotto as the "egregio pittore" whom Ghiberti in his autobiography mentions as a close associate in his early career.

1270 SALMI, MARIO. "Lorenzo Ghiberti e la pittura." In Scritti di storia dell'arte in onore di Lionello Venturi. Rome: De Luca, 1956, pp. 223-37, 15 figs.
Traces stylistic evolution of Ghiberti's designs for stained glass windows, Duomo, Florence, 1405-45.

1271 SANPAOLESI, PIERO. "Architetture ghibertiane: Le radici religiose." In Ghiberti e la sua arte nella Firenze del '3-'400. Edited by Massimiliano G. Rosito. Florence: L'Artigraf, 1979, pp. 95-106, no illus.
Analyzes architecture of Santa Trinità Sacristy, Baptistry doors, and Shrine of St. Zenobius (Duomo, Florence), especially its religious meaning.

1272 SCAGLIA, GIUSTINA. "A Miscellany of Bronze Works and Texts in the 'Zibaldone' of Buonaccorso Ghiberti." Proceedings of the American Philosophical Society 120, no. 6 (1976):485-513, 30 figs.

Reconstructs activities of Ghiberti's shop and foundry after his death through study of drawings and text in "Zibaldone" of his grandson, Buonaccorso. Shop produced bells and cannons, although some sketches for equestrian funeral monuments suggest that Buonaccorso may have planned to do one for Orsini family.

1273 SCHLOSSER, JULIUS von. "Künstlerprobleme der Frührenaissance, III. Heft (V. Stuck): Lorenzo Ghiberti." Akademie der Wissenschaften in Wien, Philosophisch-historische Klasse, Sitzungsberichte 215, no. 4 (1934):3-80, no. illus.
 Studies development of Ghiberti's reputation among nineteenth-century critics but also contains important critique (pp. 27ff.) of Schmarsow's interpretation of North Doors, Baptistry, Florence.

1274 SCHLOSSER, JULIUS von. "Uber einige Antiken Ghibertis." Jahrbuch der Kunsthistorischen Sammlungen des allerhöchsten Kaiserhauses (Vienna) 24 (1903):125-59, 14 figs.
 "Schlosser traces with meticulous care the history of a small number of Roman sculptures . . . known to Ghiberti. He establishes Ghiberti's approach to antiquity and his mania for collecting within a large historical framework. . . ." (Krautheimer, entry 1179, p. 28).

1275 SCHMARSOW, AUGUST. "Ghibertis Kompositionsgesetze an der Nordtür des Florentiner Baptisteriums." Abhandlungen der philologisch-historischen Klasse der königlich sächsischen Gesellschaft der Wissenschaften (Leipzig) 18, no. 4 (1899):1-47.
 Proposes that Ghiberti planned overall rhythmical composition of first Baptistry doors, but that plan was upset by misplacements in casting ("corrected" here through photomontage). Also provides thorough discussion of doors' iconography and chronology. [Krautheimer terms this article "somewhat pedantic." For thorough critique, see Schlosser, entry 1273.]

1276 SCHOTTMULLER, F[RIDA]. "Ghiberti, Lorenzo." In Thieme-Becker Künstler-Lexikon. Leipzig: E.A. Seemann, 1920, 13:541-46.
 Condensed survey of life and work. Valuable bibliography.

1277 SEMRAU, MAX. "Notiz zu Ghiberti." Repertorium für Kunstwissenschaft 50 (1929):151-54, no illus.
 Discusses significance of small scene at far left of Ghiberti's Solomon and the Queen of Sheba panel of East Doors of Baptistry which depicts two women pointing to a young man with a large bird. This scene, though absent from biblical description of encounter, occurs in Aramaic source, the Targum II to the Book of Esther, and in the Koran. Representations of scene on other Early Renaissance works suggest familiarity with Eastern legends.

1278 SHAPLEY, FERN R. "Brunelleschi in Competition with Ghiberti."
 Art Bulletin 5 (December 1922):31-34, 8 figs. [Photographs by
 Clarence Kennedy.]
 Stylistic comparison of bronze competition panels of Sac-
 rifice of Isaac for Baptistry doors, Florence (now Bargello,
 Florence). Study facilitated by photographs of details by Clarence
 Kennedy.

1279 SIRÉN, OSVALD. "Due Madonne della bottega del Ghiberti."
 Rivista d'arte 5 (1907):49-54, 2 figs.
 Attributes to Ghiberti terracotta Madonna and Child with
 Angels relief (Victoria and Albert Museum, London) and to his shop
 terracotta Enthroned Madonna and Child relief (formerly Santa Maria
 Nuova, now Bargello, florence).

1280 STIX, ALFRED. "Eine Zeichnung von Lorenzo Ghiberti."
 Kunstchronik und Kunstmarkt, n.s. 35 (1925-26):139-41, 2 figs.
 Publishes drawing of Studies of "Flagellation" (Albertina,
 Vienna), which he identifies as Ghiberti's preliminary sketches for
 Flagellation relief, North Doors, Baptistry, Florence.

1281 SWARZENSKI, GEORG. "A Bronze Statuette of St. Christopher."
 Bulletin of the Museum of Fine Arts (Boston) 49 (1951):84-95,
 17 figs.
 Bronze statuette of St. Christopher (Museum of Fine Arts,
 Boston) is Florentine, not Northern, as formerly believed. Date on
 work was misread as 1497; it is 1407. New dating establishes it as
 earliest bronze statuette and relates it to Ghiberti's circle or
 perhaps that of Nanni di Banco.

1282 Van WAADENOIJEN, JEANNE. "Ghiberti and the Origin of His
 International Style." In Lorenzo Ghiberti nel suo tempo (Atti
 del Convegno internazionale di studi, Florence, 18-21 October
 1978). 2 vols. Florence: Leo S. Olschki, 1980, 1:81-87, no
 illus.
 Argues that Ghiberti's absorption of International Style
 was due to its importation into Florence from Spain by Starnina
 between 1402 and 1404. In this regard questions importance of Master
 Gusmin, whose role is stressed by Krautheimer. Identifies so-called
 "Master of Bambino Vispo" with Starnina.

1283 VAYER, L[AJOS]. "L''imago pietatis' di Lorenzo Ghiberti."
 Acta Historiae Artium 8 (1962):45-53, 4 figs.
 Discusses Ghiberti's commission in 1419 to do mitre (now
 lost) for Pope Martin V. Argues that it is reflected in broach of
 Imago Pietatis on St. Martin's cope in Masolino's SS. John the
 Evangelist and Martin (Johnson collection, Philadelphia Museum of
 Art) and in Donatello's bronze Imago Pietatis for High Altar, Padua.

1284 VENTURI, LIONELLO. "Lorenzo Ghiberti, certezza di notizie e
 discordia di giudizii--Goticismo e Classicismo--il rilievo

pittorico: La superiorità della prima sulla seconda porta e l'arte del Ghiberti." Arte 26 (1923):233-52, 15 figs.
Discussion of Ghiberti's "fortuna critica." Analysis of Donatello's and Ghiberti's relief techniques.

1285 WULFF, OSKAR. "Ghibertis Entwicklung im Madonnenrelief."
Berliner Museen: Berichte aus den preussischen Kunstsammlungen 43, nos. 9-10 (September-October 1922):91-103, 13 figs.
Attempts to establish chronology and stylistic development in group of terracotta Madonna reliefs attributed to Ghiberti. Based largely on work of Bode and on sculptures in Kaiser Friedrich Museum, Berlin.

1286 WUNDRAM, MANFRED. "Lorenzo Ghiberti: Zur 600. Wiederkehr seines Geburtstages." Neue Zürcher Zeitung 239 (14-15 October 1978):65-66, 1 fig.
Sees evolution of spatial illusionism in Ghiberti's reliefs as gradual development and traces it back to last panels executed for North Doors, Baptistry, Florence.

1287 ZERVAS, DIANE F. "Ghiberti's St. Matthew Ensemble at Orsanmichele: Symbolism in Proportion." Art Bulletin 58, no. 1 (March 1976):36-44, 7 figs.
Ghiberti's sophisticated use of proportions in Orsanmichele St. Matthew (1419-20) and its tabernacle (1422) surpasses traditions of medieval stone masonry. Specifically Pythagoreo-Platonic musical ratios create balanced, well-proportioned ensemble and symbolize Matthew's harmonizing of Old and New Law.

TOMMASO GHIBERTI

1288 SCHOTTMÜLLER, F[RIDA]. "Ghiberti, Tommaso." In Thieme-Becker Künstler-Lexikon. Leipzig: E.A. Seemann, 1920, 13:546.
Condensed survey of life and work. Valuable bibliography.

VITTORIO GHIBERTI

1289 CIARDI DUPRÉ dal POGGETTO, MARIA G. "Proposte per Vittorio Ghiberti." In Lorenzo Ghiberti nel suo tempo (Atti del Convegno internazionale di studi, Florence, 18-21 October 1978). 2 vols. Florence: Leo S. Olschki, 1980, 1:245-65, 16 figs.
Attempts to distinguish participation of Lorenzo Ghiberti's son, Vittorio, in father's shop by attributing to him portions of decorative borders of East and South Doors, Baptistry, Florence. Further reconstructs his oeuvre by assigning to him Pastoral of San Lorenzo (Treasury, San Lorenzo, Florence), and reliquary chest (Museo dell'Opera del Duomo, Florence).

1290 SCHOTTMÜLLER, F[RIDA]. "Ghiberti, Vittorio." In Thieme-Becker Künstler-Lexikon. Leipzig: E.A. Seemann, 1920, 13:546.
Condensed survey of life and work. Valuable bibliography.

GIAN CRISTOFORO ROMANO

Unpublished Theses

1291 NORRIS, ANDREA S. "The Tomb of Gian Galeazzo Visconti at the
Certosa di Pavia." Ph.D. dissertation, New York University,
1977, 413 pp., 186 figs. [Dissertation Abstracts, order no.
7808548.]
 Monograph on Tomb of Gian Galeazzo Visconti (Certosa,
Pavia) by Gian Cristoforo Romano, 1491-97. Discusses iconography,
attribution, and influence.

Articles

1292 BROWN, CLIFFORD M., and LORENZONI, ANNA MARIA. "Gleanings from
the Gonzaga Documents in Mantua: Gian Cristoforo Romano and
Andrea Mantegna." Mitteilungen des Kunsthistorischen Insti-
tutes in Florenz 17 (1973):153-59, 6 figs.
 Newly discovered documents from Gonzaga archives allow more
precise dating of Gian Cristoforo's portrait medal of Isabella d'Este
to 1495-99. Publishes two sketches by Gian Cristoforo Romano for
Marchese Francesco II Gonzaga's heraldic emblem; these differ from
sculpted emblem on terracotta Bust of Francesco II (Palazzo Ducale,
Mantua).

1293 F[ABRICZY], C[ORNELIUS] v[on]. "Ein neues Skulpturwerk von
Gian Cristoforo Romano." Repertorium für Kunstwissenschaft 27
(1904):379-80, no illus.
 Attributes Tomb of Hieronymus Stanga, dated 1498, in Santa
Maria delle Grazie, outside Mantua, to Gian Cristoforo Romano and
Tomb of Bernardo Corradi in same church to his shop.

1294 FILANGIERI di CANDIDA, RICCARDO. "Romano, Giovanni Cristo-
foro." In Thieme-Becker Künstler-Lexikon. Leipzig: E.A.
Seemann, 1934, 28:552-53.
 Condensed survey of life and work. Valuable bibliography.

1295 FILIPPINI, FRANCESCO. "La tomba di Lodovico il Moro e Beatrice
d'Este." Archivio storico lombardo, n.s. 2 (1937):198-201, no
illus.
 Associates sonnet by Girolamo da Casio, which names Gian
Cristoforo Romano as sculptor of tomb for "Madonna Giustizia," with
Tomb of Ludovico il Moro and Beatrice d'Este.

1296 GEREVICH, LADISLAS. "Le maître des reliefs en marbre du roi
Mathias et de sa femme Béatrice." Bulletin du Musée hongrois
des beaux-arts 27 (1965):15-32, 17 figs.
 Attributes to Gian Cristoforo Romano pair of confronted
profile bust reliefs of king and queen of Hungary, Matthias Corvinus
and Beatrice of Aragon (Museum of Fine Arts, Budapest), which have
been attributed to Verrocchio and Benedetto da Maiano.

1297 GIORDANI, PAOLO. "Studii sulla scultura del Rinascimento: Gian
Cristoforo Romano a Roma." Arte 10 (1907):197-208, 12 figs.
Clarifies identity of Paolo di Mariano and Paolo "de Urbe,"
or Paolo Romano. Collects Roman sculpture by Gian Cristoforo Romano,
student of Paolo Romano: Tomb of Marco di Antonio Albertoni, Tomb
of Bernardino Lonate, and Tomb of Cardinal Podocataro, all in Santa
Maria del Popolo. In addition, three medals cast by Gian Cristoforo
in Rome are published: two of Julius II and one of Sannazzaro.
Transcription of documents.

1298 MELLER, SIMON. "Diva Beatrix." Zeitschrift für Kunstwissen-
schaft 9 (1955):73-80, 5 figs.
Marble portrait reliefs of Beatrice of Aragon and Matthias
Corvinus, rulers of Hungary (Museum of Fine Arts, Budapest) can be
attributed to Gian Cristoforo Romano, rather than Francesco Laurana.

1299 VALTON, P. "Gian Cristoforo Romano médailleur." Revue
numismatique, 13th ser. 3 (1885):316-24, 6 figs.
Attributes to Gian Cristoforo Romano medals of Isabella
d'Este, Isabella d'Aragon, and Julius II, all in Cabinet des
Médailles, Bibliothèque nationale, Paris.

1300 VENTURI, A[DOLFO]. "Gian Cristoforo Romano." Archivio storico
dell'arte 1, no. 3 (March 1888):49-59, 107-18, 148-59, 17 figs.
Fundamental monograph on entire career, including documents
and contemporary sources.

GIOVANNI D'AMBROGIO

1301 BRUNETTI, GIULIA. "Giovanni d'Ambrogio." Rivista d'arte 14,
2d ser. 4 (1932):1-22, 10 figs.
Monograph on career of Giovanni d'Ambrogio, with citation
of important documents.

1302 KELLER, HARALD. "Ein Engel von der Florentiner Domfassade im
Frankfurter Liebighaus." In Festschrift für Herbert von Einem
zum 16. Februar 1965. Edited by Gert van der Osten and Georg
Kauffmann. Berlin: Gebr. Mann, 1965, pp. 117-22, 6 figs.
Attributes marble Angel (Liebighaus, Frankfurt, ca. 1390)
to Giovanni d'Ambrogio, on basis of its derivation from pair of
angels flanking saints on Florentine Duomo façade. It reflects
transitional style between Gothic and Early Renaissance.

1303 K[REPLIN], B.C. "Giovanni d'Ambrogio da Firenze." In Thieme-
Becker Künstler-Lexikon. Leipzig: E.A. Seemann, 1921, 14:103.
Condensed survey of life and work. Valuable bibliography.

1304 KREYTENBERG, GERT. "Giovanni d'Ambrogio." Jahrbuch der
Berliner Museen 14 (1972):5-32, 28 figs.
Traces stylistic evolution of Giovanni d'Ambrogio
(1345-1418), which typifies Early Renaissance move away from Gothic

styles. Reconstructs work on Duomo and Orsanmichele, and examines his relationship to early Donatello and Nanni di Banco.

1305 WUNDRAM, MANFRED. "Der Meister der Verkündigung in der Domopera zu Florenz." In Beiträge zur Kunstgeschichte: Eine Festgabe für Heinz Rudolf Rosemann zum 9. Oktober 1960. Edited by Ernst Guldan. Munich: Deutscher Kunstverlag, 1960, pp. 109-25, 14 figs.
 Attribution of fragmentary Apostle statue (Museo dell'Opera del Duomo, Florence) to "Master of the Annunciation," here identified through documents and stylistic analysis as Giovanni d'Ambrogio. Considers Giovanni d'Ambrogio's oeuvre in relation to emergent Early Renaissance style. Identifies his apostle for Porta della Mandorla (1396) as St. Barnabas.

GIOVANNI DA FIRENZE

1306 ANON. "Nani (Nanni), Giovanni da Firenze." In Thieme-Becker Künstler-Lexikon. Leipzig: E.A. Seemann, 1931, 24:337-38.
 Condensed survey of life and work. Valuable bibliography.

1307 MONTOBBIO, LUIGI. "Lo scultore Giovanni da Firenze, detto Nani, e una sua opera nel Battistero del Duomo di Padova." Atti e memorie dell'Accademia patavina di scienze, lettere, ed arti, n.s. 82, no. 3 (1969-70):231-47, 5 figs.
 Publishes new documents that clarify career and importance of Giovanni da Firenze, called Nani, who worked in Padua from 1429 to 1480 and collaborated with Donatello at Santo. Documents concern his commission in 1440s for Baptismal Font for Baptistry of Duomo, Padua. Reviews all known information regarding artist.

GIOVANNI DI MARTINO DA FIESOLE

1308 K[REPLIN], B.C. "Giovanni di Martino da Fiesole." In Thieme-Becker Künstler-Lexikon. Leipzig: E.A. Seemann, 1921, 14:127.
 Condensed survey of life and work. Valuable bibliography.

GIOVANNI DA PISA (GIOVANNI DI FRANCESO)

1309 K[REPLIN], B.C. "Giovanni da Pisa." In Thieme-Becker Künstler-Lexikon. Leipzig: E.A. Seemann, 1921, 14:142.
 Condensed survey of life and work. Valuable bibliography.

1310 SCHUBRING, PAUL. "Zwei Madonnenreliefs von Giovanni di Pisa und Domenico Paris." Cicerone 18 (1926):565-70, 4 figs.
 Attributes marble Madonna relief (A.S. Drey collection, Munich) to Giovanni da Pisa, one of four sculptors who assisted

Individual Sculptors

Donatello in Padua in 1450. Attributes another marble Madonna relief
to Domenico Paris, a student of Niccolò Baroncelli (Museo Civico,
Padua).

GIOVANNI DI STEFANO

1311 K[REPLIN], B.C. "Giovanni di Stefano da Siena." In Thieme-
 Becker Künstler-Lexikon. Leipzig: E.A. Seemann, 1921,
 14:144-45.
 Condensed survey of life and work. Valuable bibliography.

1312 KUHLENTHAL, MICHAEL. "Das Grabmal Pietro Foscaris in S. Maria
 del Popolo in Rom: Ein Werk des Giovanni di Stefano."
 Mitteilungen des Kunsthistorischen Institutes in Florenz 26,
 no. 1 (1982):47-62, 13 figs.
 Reattributes tomb to Giovanni di Stefano, rather than
Antonio Pollaiuolo or Vecchietta, on basis of newly discovered
anonymous sixteenth-century Spanish manuscript. It records inscrip-
tion once on sarcophagus citing Giovanni di Stefano as the artist
responsible for its creation. Attempts to reconstruct oeuvre of
Giovanni di Stefano (only two other documented commissions survive).

GIULIANO DA MAIANO

1313 BORGO, LUDOVICO. "Giuliano da Maiano's Santa Maria del Sasso."
 Burlington Magazine 114 (July 1972):448-52, 5 figs.
 Publishes new records that prove Giuliano designed (ca.
1486) church of Santa Maria del Sasso in Bibbiena and tabernacle
framing its High Altar for Lorenzo de' Medici.

1314 CECI, GIUSEPPE. "Nuovi documenti su Giuliano da Maiano ed
 altri artisti." Archivio storico per le provincie napoletane
 29 (1904):784-92, no illus.
 Publishes Giuliano's will and documents concerning his
career as architect to Alphonso, duke of Calabria.

1315 FABRICZY, CORNELIUS von. "Giuliano da Majano." Jahrbuch der
 königlich preussischen Kunstsammlungen (supp.) 24 (1903):
 137-76, no illus.
 Documented chronology of life of Giuliano da Maiano.
Extensive notes provide important information on Verrocchio,
Desiderio da Settignano, and Benedetto da Maiano (Sala dei gigli
doorway, Palazzo Vecchio, Florence). Transcribes all portate and
other documents pertinent to Giuliano.

1316 GIGLIOLI, ODOARDO H. "Le pitture di Andrea da Castagno e di
 Alessio Baldovinetti per la chiesa di Sant'Egidio ed il pergamo
 di Giuliano da Maiano." Rivista d'arte 3 (1905):206-8, no
 illus.
 Publishes document commissioning Giuliano da Maiano to do
pulpit at Sant'Egidio.

1317 MORSELLI, PIERO. "Documents of the Second Half of the
Fifteenth Century on Santa Croce, Florence." Mitteilungen des
Kunsthistorischen Institutes in Florenz 22 (1978):359-60, no
illus.
Publishes new documents of 1462 referring to embellishment
of Santa Croce interior with furniture by Giuliano da Maiano. Docu-
mented commission strengthens assumption that Giuliano da Maiano
worked in adjacent Pazzi Chapel (1461-62).

1318 PATRIZI, IRNERIO. Le grandi orme dell'arte del Quattrocento in
Recanati. Recanati: Simboli, 1928, viii, 70 pp., 55 figs.
Essay on architecture and architectural sculpture in Recan-
ati attributed to Giuliano da Maiano, particularly portals of
churches of Sant'Agostino and San Domenico, the designs of which are
attributed to Giuliano.

1319 SCHOTTMÜLLER, FRIDA. "Sammlung der Bildwerke der christlichen
Epoche: Arbeiten von Giuliano da Maiano." Amtliche Berichte
aus den königlichen Kunstsammlungen 39, no. 4 (January 1918):
cols. 79-90, 5 figs.
Suggests intarsia doors with Annunciation (formerly Kaiser
Friedrich Museum) are Giuliano da Maiano's doors for Badia,
commissioned by the Medici. Discusses work of Giuliano's shop ca.
1451-62.

1320 SEMRAU, MAX. "Giuliano da Maiano." In Thieme-Becker Künstler-
Lexikon. Leipzig: E.A. Seemann, 1921, 14:211-13.
Condensed survey of life and work. Valuable bibliography.

GIULIANO DA POGGIBONSI ("IL FACCHINO")

1321 ANON. "Giuliano di Giovanni da Poggibonsi." In Thieme-Becker
Künstler-Lexikon. Leipzig: E.A. Seemann, 1921, 14:210.
Condensed survey of life and work. Valuable bibliography.

1322 SARTORI, ANTONIO. "I reliquiari della lingua di S. Antonio."
Il Santo, n.s. 3, no. 1 (1963):31-60, 18 figs.
Publication and analysis of many newly discovered documents
elucidating commission of Giuliano's Reliquary of the Tongue of St.
Anthony, its function, and later history. Discusses other Venetian
commissions by Giuliano, including new attributions like his collab-
oration on the Monument of the Beato Pacifico (Santa Maria Gloriosa
dei Frari, Venice) with Piero Lamberti rather than the Piero
Lamberti/Nanni di Bartolo collaboration usually proposed. Appendix
of transcribed documents.

1323 SARTORI, ANTONIO. "Il Reliquiario della lingua di S. Antonio
di Giuliano da Firenze.' Rivista d'arte 34 (1959):123-49, 1
fig.
Identifies Giuliano da Poggibonsi as sculptor of Reliquary
of the Tongue of St. Anthony (Santo, Padua) in 1433-36. Transcribes
extensive corpus of documents for commission.

Individual Sculptors

ANDREA GUARDI

1324 BACCI, PELEO. "Opere sconosciute di A. Guardi a Piombino sotta
la signoria di Jacopo III d'Appiano." Rassegna d'arte antica e
moderna 6, no. 1 (January–February 1919):1–8, 15 figs.
 Discusses sculptures by Andrea Guardi for Jacopo III
d'Appiano in Piombino (1468–70).

1325 CARLI, ENZO. "Un'opera sconosciuta di Andrea Guardi a Pisa."
Bollettino storico pisano 3 (1933):32–37, 2 figs.
 Attributes to Guardi a dated (1470) marble altarpiece of
the Madonna and Child with SS. Peter and John the Evangelist in San
Giovanni al Gaetano, Pisa.

1326 MARANGONI, MATTEO. "Opere sconosciute di Andrea Guardi." In
Miscellanea di storia dell'arte in onore di Igino Benvenuto
Supino. Florence: Leo S. Olschki, 1933, pp. 429–34, 3 figs.
 Attributes half-length Madonna and Child relief (San
Martino, Pisa) and lunette fragment with angel (private collection,
Pisa) to Andrea Guardi.

1327 MIDDELDORF, ULRICH. "Quelques sculptures de la Renaissance en
Toscane occidentale." Revue de l'art 36 (1977):7–26, 34 figs.
 Important study of activity of Andrea di Francesco Guardi
and his shop in western Tuscany. Attribution of three marble sculp-
tures (private collection) to the young Matteo Civitali just after he
left Guardi shop. Stresses connections with Lombardy, Liguria, and
Rome. Reprinted in entry 54.

1328 MORIONDO, MARGHERITA. "Ricostruzione di due opere di Andrea
Guardi.' Belle arti 1, nos. 5–6 (August–September 1948):
325–37, 12 figs.
 Reconstructs Tomb of Bishop Ricci (Camposanto, Pisa).
Observes that Madonna and Child with Two Angels lunette (now over
Porta di Bonanno, Duomo, Pisa) was originally its lunette. Recon-
structs Guardi's signed marble polyptych for High Altar (Duomo,
Carrara), now dispersed in several museums.

1329 SCHUBRING, P[AUL]. "Andrea Guardi." In Thieme-Becker
Künstler-Lexikon. Leipzig: Wilhelm Engelmann, 1907, 1:456.
 Condensed survey of life and work. Valuable bibliography.

1330 SCIOLLA, GIANNI. "Due inediti di scultura toscana del Quattro-
cento a Roma." Antichità viva 10, no 5 (1971);35–38, 4 figs.
[Résumé in English.]
 Attributes to Guardi tabernacle (Baptistry, San Giovanni in
Laterano, Rome) and to Jacopo della Quercia and assistants marble
figure of St. Francis (Castel Sant'Angelo, Rome).

1331 VIRGILI, E. "Un documento inedito su Andrea Guardi fioren-
tino.' Bollettino storico pisano 46 (1977):189–94, no illus.
 Publishes 1444 contract in which Andrea Guardi was

commissioned to do marble funerary monument in Pisa for Speciale family. Monument was never executed since commission was later transferred to the Gagini.

See also entry 1897, appendix: "Andrea Guardi: Ein Florentiner Plastiker des Quattrocento in Pisa."

ISAIA DA PISA

Unpublished Theses

*1332 DAVISON, M. "Isaia da Pisa." Master's thesis, Yale University, 1959.

1333 BATTAGLINI, ANGELO. "Memoria sopra uno sconsciuto egregio scultore del secolo XV e sopra alcune sue opere." Dissertazioni [Atti] dell'Accademia Romana di Archaeologia 1 (1821): 115-32, no illus.
 Publishes Porcellio's ode to Isaia da Pisa, "Ad Immortalitatem Isaie Pisani Marmorum Celatoris," from manuscript in Vatican Library, Rome, "De Felicitate Temporum Divi Pii II Pont. Max." Discusses the five works attributed to Isaia by Porcellio: Tomb of Pope Eugenius IV (San Salvatore in Lauro, Rome); Effigy of St. Monica (Sant'Agostino, Rome); collaboration on Alphonso's Triumphal Arch, Naples; statues of Nero and Poppaea riding on animals for Porcellio; and a Virgin Enthroned with SS. Peter and Paul, Pope Eugenius IV, and Cardinal Latino Orsini in the Vatican Grottoes, Rome.

1334 BURGER, FRITZ. "Isaia da Pisas plastische Werke in Rom." Jahrbuch der königlich preussischen Kunstsammlungen 27 (1906): 228-44, 14 figs.
 Reconstructs Isaia da Pisa's work in Rome (ca. 1439-63), previously known only through Porcellio's contemporary poem (see preceding entry). Proposes attribution of relief of Virgin and Child Enthroned with SS. Peter and Paul, Pope Eugenius IV, and Cardinal Latino Orsini (now Vatican Grottoes) as earliest surviving work, ca. 1439. Also discusses work on Chiavez tomb (San Giovanni in Laterano, Rome); Effigy of St. Monica (Sant'Agostino, Rome); Tomb of Pope Eugenius IV (San Salvatore in Lauro, Rome); Tomb of Fra Angelico (Santa Maria sopra Minerva, Rome); and in collaboration with Paolo Romano (ca. 1463), Tabernacle of St. Andrew (now Vatican Grottoes.).

1335 Da MORRONA, ALESSANDRO. Pisa illustrata nelle arti del disegno. 2d ed. 3 vols. Livorno: Giovanni Marenighi, 1812, 2:453-64, no illus.
 Early account of career of Isaia da Pisa in context of Pisan history, her artistic traditions, and major monuments. Includes Porcellio's encomium.

1336 KACZMARZYK, DARIUSZ. "Isaia da Pisa: Auteur présumé du bas-relief d'Apollon au Musée national de Varsovie." Bulletin

du Musée national de Varsovie (Warsaw) 15 (1974):1-2, 28-32, 4 figs.
Marble relief of Apollo with Lyre (National Museum, Warsaw) is attributed to Isaia da Pisa (ca. 1430) through stylistic comparison with Temperance and Prudence reliefs on Tomb of Cardinal Martinez de Chiavez, San Giovanni in Laterano, Rome (1447-48).

1337 KUHLENTHAL, MICHAEL. "Zwei Grabmälen des frühen Quattrocento in Rom: Kardinal Martinez de Chiavez und Papst Eugen IV." Römisches Jahrbuch für Kunstgeschichte 16 (1976):17-56, 45 figs., plans, elevations, drawings.
Reconstructs chronology and original appearance of two tombs. Demonstrates that wall Tomb of Cardinal Martinez da Chiavez (San Giovanni in Laterano, Rome), designed by Filarete (1447) and executed by Isaia da Pisa and studio (1449), provided prototype for Isaia's Tomb of Pope Eugenius IV (1447-53), originally in Old St. Peter's (now San Salvatore in Lauro, Rome).

1338 MIDDELDORF, ULRICH A. "The Tabernacle of Sta. Maria Maggiore." Bulletin of the Art Institute of Chicago 38, no. 1 (January 1944):6-10, 4 figs.
Argues that fragmentary relief of angels (Art Institute, Chicago) and reused marble lavabo (Santa Maria Maggiore, Rome) are part of very large marble tabernacle, now dispersed, but probably made for main choir of Santa Maria Maggiore, ca. 1447-63. Classicizing tabernacle, often attributed to Isaia da Pisa, is more likely by Filarete student. Unique style provides clue to Agostino di Duccio's orgins.

1339 SEMRAU, MAX. "Isaia (di Pippo Ghanti) da Pisa." In Thieme-Becker Kuñstler-Lexikon. Leipzig: E.A. Seemann, 1926, 19:240-42.
Condensed survey of life and work. Valuable bibliography.

JACOPO DI PIERO GUIDI

1340 RATHE, KURT. "Jacopo di Piero Guidi." In Thieme-Becker Künstler-Lexikon. Leipzig: E.A. Seeman, 1925, 18:283.
Condensed survey of life and work. Valuable bibliography.

1341 WUNDRAM, MANFRED. "Jacopo di Piero Guidi." Mitteilungen des Kunsthistorischen Institutes in Florenz 13, nos. 3-4 (October 1968):195-222, 21 figs. [Résumé in Italian.]
Monograph defining Jacopo di Piero Guidi's style; clarifying work on Duomo façade (1382-88), Loggia dei Lanzi (1380-90), and Porta della Mandorla; and examining his influence on formation of Early Renaissance style.

NICCOLO LAMBERTI (NICCOLO D'AREZZO; "IL PELA")

Books

1342 GOLDNER, GEORGE R. Niccolò and Piero Lamberti. 2 vols.
Outstanding Dissertations in the Fine Arts. New York:
Garland, 1978, 286 pp., 160 figs. [Ph.D. dissertation,
Princeton University, 1972.]
Establishes the Lamberti's oeuvre through connoisseurship,
including complete stylistic discussion of sculptural program for San
Marco. Clarifies relative importance of Piero and Niccolò and icon-
ography of Tomb of Tommaso Mocenigo, SS. Giovanni e Paolo, Venice,
and ducal palace capitals.

1343 VASARI, GIORGIO. La vita di Niccolò di Piero, scultore e
architetto aretino, letta da Mario Salmi. Arezzo: Presso gli
Amici dei Monumenti, 1910, 80 pp., 3 figs.
Scholarly annotation of Vasari's life of Niccolò di Piero
Lamberti. Extensive bibliography and notes.

Articles

1344 BECHERUCCI, LUISA. "Una statuetta del Bargello." Antichità
viva 14, no. 2 (1976):9-13, 7 figs.
Attributes to Niccolò Lamberti, ca. 1385-96, statuette of
standing Madonna and Child (Bargello, Florence) through comparison
with Madonna and Child on Porta dei Canonici, Duomo, Florence.

1345 BRUNETTI, GIULIA. "Osservazioni sulla Porta dei Canonici."
Mitteilungen des Kunsthistorischen Institutes in Florenz 8
(October 1957):1-12, 18 figs.
First scholarly analysis of sculptural decoration of Porta
dei Canonici, Duomo, Florence. Sculptured figures of standing Virgin
and Child and Two Adoring Angels attributed here to Niccolò Lamberti.
One of angels documented to him, 1396-1402; payments of 1396 for a
Madonna and Child may refer to this group.

1346 FABRICZY, C[ORNELIUS] von. "Neues zum Leben und Werke des
Niccolò d'Arezzo." Repertorium für Kunstwissenschaft 23
(1900):85-91, no illus.
Reviews career of Niccolò Lamberti, especially work in
Venice, with documents. New documents place removal of Donatello's
St. George from Orsanmichele niche after 1628. Additional documents
clarify Niccolò Lamberti's commission of 1404-6 for St. Luke statue
for Orsanmichele.

1347 FABRICZY, C[ORNELIUS] von. "Neues zum Leben und Werke des
Niccolò d'Arezzo." Repertorium für Kunstwissenschaft 25
(1902):157-69, no illus.
Publishes 1392 marriage certificate and payment record for
Tomb Slab of Francesco di Marco Datini (San Francesco, Prato),
1411-12. Appended are detailed chronologies of lives of Niccolò and
Piero Lamberti based on documents.

Individual Sculptors

1348 FABRICZY, CORNELIO de. "Niccolò di Piero Lamberti d'Arezzo: Nuovi appunti sulla vita e sulle opere del maestro.' Archivio storico italiano, 5th ser. 29 (1902):308-27, no illus.
Publishes new documents and detailed chronology of Niccolò di Piero Lamberti's entire career, with appropriate references to relevant documents and secondary sources.

1349 FABRICZY, C[ORNELIUS von]. "Opere dimenticate di Niccolò d'Arezzo." Archivio storico dell'arte 3, nos. 3-4 (1890):161, no illus.
Discusses two documented, but overlooked, commissions of Niccolò Lamberti: Tomb Slab of Francesco di Marco Datini in San Francesco, Prato, inscribed 1410; and design of Duomo façade, Prato.

1350 FIOCCO, GIUSEPPE. "I Lamberti a Venezia, I: Niccolò di Pietro." Dedalo 8 (October 1927):287-314, 22 figs.
Analyzes introduction of Tuscan Renaissance art into Venice with Niccolò Lamberti's arrival in 1415. Discusses Niccolò's early career in Florence, especially work on Porta della Mandorla, figures of St. Luke (Bargello, Florence) and St. Mark (Duomo, Florence), and his many statues along roofline of San Marco façade in Venice.

1351 GOLDNER, GEORGE. "Niccolò Lamberti and the Gothic Sculpture of San Marco in Venice." Gazette des beaux-arts, 6th per. 89 (February 1977):41-50, 24 figs.
Analyzes extent of Niccolò Lamberti's contribution to decoration of upper façade of San Marco, Venice, 1416-19. Attributes to Niccolò figure of St. Mark on central arch of west side, and to Niccolò and assistants Angel, St. Matthew, St. John, and Virgin and Angel Annunciate, all on west side. Attributes to Piero Lamberti two gable reliefs on west side.

1352 GOLDNER, GEORGE. "Two Statuettes from the Doorway of the Campanile of Florence." Mitteilungen des Kunsthistorischen Institutes in Florenz 18 (1974):219-26, 8 figs.
Attributes to Niccolò Lamberti two Prophet statues placed on Campanile doorway in 1431 (Now Museo dell'Opera del Duomo, Florence), previously attributed to Nanni di Bartolo. Dates them ca. 1415-16, just before he left for Venice, or 1419-20, when he visited Florence.

1353 GOMBOSI, GEORG. "Eine Kleinbronze Niccolò Lambertis aus dem Jahre 1407." In Adolph Goldschmidt zu seinem siebenzigsten Geburtstag am 14. Januar 1933. Berlin: Wurfel Verlag, 1935, pp. 119-20, 4 figs.
Attributes small bronze St. Christopher, dated 1407 (Emil Delmar collection, Budapest; now Museum of Fine Arts, Boston), to Niccolò Lamberti.

1354 GOMEZ MORENO, CARMEN. "Wandering Angels." Bulletin of the Metropolitan Museum 20, no. 4 (December 1961):127-34, 6 figs.
Recently acquired marble relief of Angel, which probably

245

derives from Venetian tomb, is attributed to artist close to Niccolò
Lamberti, ca. 1425, probably so-called Master of the Mascoli Altar.

1355 KREYTENBERG, GERT. "Zwei Marienstatuen über der Porta dei
 Cornacchini des Florentiner Doms." Pantheon 34, no. 3 (1976):
 183-89, 16 figs.
 Attributes to Niccolò Lamberti figure of Annunciate Angel
mounted on left of pediment of Porta dei Cornacchini, Duomo,
Florence. Associates it with documented commission of 1402. Argues
that 1402 document has been mistakenly linked to Niccolò's Madonna on
Porta dei Canonici, Duomo, Florence, which should be redated, along
with one angel in Porta dei Canonici tympanum, to 1396 on the basis
of another document. A third document indicates that Niccolò carved
second Angel in Porta dei Canonici tympanum in 1402.

1356 PIATTOLI, RENATO. "Un mercante del Trecento e gli artisti del
 tempo suo.' Rivista d'arte 11 (1929):221-53, 396-437, 537-79;
 12 (1930):97-150, 4 figs.
 Publication of all records about commissions of Francesco
di Marco Datini, including his tomb slab by Niccolò Lamberti in San
Francesco, Prato.

1357 P[LANISCIG], L[EO]. Nicolò di Piero Lamberti, gen. 'Il Pela.'"
 In Thieme-Becker Künstler-Lexikon. Leipzig: E.A. Seemann,
 1931, 25:436-38.
 Condensed survey of life and work. Valuable bibliography.

1358 PROCACCI, UGO. "Niccolò di Piero Lamberti, detto il Pela, di
 Firenze e Niccolò di Luca Spinelli d'Arezzo." Vasari 1
 (1927-28):300-316, no illus.
 Argues that Niccolò d'Arezzo and Niccolò Lamberti are
separate artists, as distinguished by Ghiberti in record of entrants
in Baptistry competition. Contends that Vasari conflated them, and
most later historians have also done so. Publishes documents
relevant to each.

1359 REYMOND, MARCEL. "La porte de la Chapelle Strozzi." Mis-
 cellanea d'arte [Rivista d'arte] 1 (1903):4-11, 4 figs.
 Studies architectural and sculptural composition of two
Quattrocento doorways: door to Strozzi Chapel, Santa Trinità,
Florence, in transitional (proto-Renaissance) style, ca. 1421; and
door of Parte Guelph in Palazzo Vecchio, Florence, ca. 1410, related
in style to works by Niccolò Lamberti and Ghiberti.

1360 RUBBIANI, ALFONSO. "La Tomba di Alessandro V. in Bologna:
 Opera di M. Sperandio da Mantova." Atti e memorie della Regia
 deputazione di storia patria per le provincie di Romagna, 3d
 ser. 11 (1892-93):57-68, no illus.
 Disproves Vasari's attribution to Niccolò di Piero Lamberti
of this tomb, reattributing it to Sperandio of Mantua.

1361 SALMI, MARIO. "Una terracotta dei primi del Quattrocento."
Rivista d'arte 11 (1929):100-104, 1 fig.
Questions Vasari's attribution to Niccolò Lamberti of
terracotta figure of St. Anthony from San Giuseppe, Arezzo.

1362 SCHMARSOW, AUGUST. "Bemerkungen über Niccolò d'Arezzo."
Jahrbuch der königlich preussischen Kunstsammlungen 8 (1887):
227-30, no illus.
Reconstructs Niccolò Lamberti's career at Duomo and
Orsanmichele, Florence, on basis of stylistic evaluation, changing
many attributions (without documentary evidence). Reaffirms his
attribution to Niccolò Lamberti of Annunciation group, Porta della
Mandorla, Duomo, Florence.

1363 SCHMARSOW, AUGUST. "Vier Statuetten in der Domopera zu Flo-
renz." Jahrbuch der königlich preussischen Kunstsammlungen 8
(1887):137-53, 2 line engrs.
Early attempt to clarify style of Niccolò Lamberti.
Attributes figures of St. Reparata and Christ, Museo dell'Opera del
Duomo, Florence, to school of Andrea Pisano, rather than Lamberti.
Maintains attribution to Lamberti of Annunciation group, Porta della
Mandorla, and discusses his role in that project. Of historical
interest.

1364 WUNDRAM, MANFRED. "Der Heilige Jacobus an Or San Michele in
Florenz." In Festschrift Karl Oettinger. Edited by Hans
Sedlmayr and Wilhelm Messerer. Erlangen and Nuremberg: Uni-
verstätsbund, 1967, pp. 193-207, 8 figs.
Attributes statue of St. James Major (Orsanmichele, Flor-
ence) to Niccolò di Piero Lamberti, ca 1420-22, using documentary and
stylistic evidence. Discusses Niccolò's style and Ghiberti's influ-
ence on him.

1365 WUNDRAM, MANFRED. "Niccolò di Piero Lamberti und die Floren-
tiner Plastik um 1400." Jahrbuch der Berliner Museen, n.s. 4
(1962):78-115, 26 figs.
Monographic study of Niccolò di Piero Lamberti providing
new biographical information and thorough stylistic analysis. Draws
upon unusual number of new documents. Clarifies division of work on
Porta della Mandorla among Niccolò, Nanni di Banco, and Antonio di
Banco. Thorough certification of various attributions Niccolò--Tomb
Slab of Francesco di Marco Datini, San Francesco, Prato; seated St.
Mark the Evangelist, Duomo, Florence; Madonna over Porta dei Canonici
(with Giovanni d'Ambrogio)--demonstrates Niccolò's conservatism and
artistic limitations. Explores how this influenced his commissions.

PIERO LAMBERTI

1366 FIOCCO, GIUSEPPE. "Erice Rigoni: Notizie dei scultori toscani
a Padova nella prima metà del Quattrocento." Rivista d'arte
12, 2d ser. 2 (1930):151-60, 7 figs.

Analyzes significance of Rigoni's archival researches on
Tuscan sculptors in Padua; reasserts his own controversial attribu-
tion to Piero Lamberti of Porta della Carta and portal lunette,
Scuola di San Marco, Venice.

1367 FIOCCO, GIUSEPPE. "Gino Fogolari: L'urna del Beato Pacifico
 ai Frari." Rivista d'arte 13, 2d ser. 3 (January–June 1931):
 282–84, 2 figs.
 Reviews Fogolari's articles, arguing that Tomb of Beato
Pacifico (Santa Maria Gloriosa dei Frari, Venice) by Piero Lamberti
was finished by 1436.

1368 FIOCCO, GIUSEPPE. "I Lamberti a Venezia, II: Pietro di
 Niccolò Lamberti." Dedalo 8 (November 1927):343–76, 37 figs.
 Traces Piero Lamberti's career in Venice, attributing to
him sculptures on upper façade of San Marco, lunette of Corner Chapel
(Santa Maria Gloriosa dei Frari), Judgment of Solomon relief (Palazzo
Ducale), various figures on Porta della Carta, Palazzo Ducale, portal
lunette (Scuola di San Marco), and Tomb of Beato Pacifico (Santa
Maria Gloriosa dei Frari).

1369 FIOCCO, GIUSEPPE. "I Lamberti a Venezia, III: Imitatori e
 sequaci." Dedalo 8 (December 1927):432–58, 24 figs.
 Analyzes the Lamberti influence in Venice, especially on
Bartolomeo Buon and Antonio and Paolo Bregno.

1370 FOGOLARI, GINO. "Gli scultori toscani a Venezia nel Quattro-
 cento e Bartolomeo Bon veneziano." Arte 33, n.s. 1
 (September–October 1930):427–64, 21 figs.
 Argues against tendency to overestimate importance of Piero
and Niccolò Lamberti in Venice, which led to attribution to them of
sculptures by native Venetians like Buon. Criticism, supported by
newly discovered date of Piero Lamberti's death in 1435, earlier than
previously thought, is directed against Fiocco's articles in Dedalo,
1927–28 (entries 1368–69 and 1350). Discussion of what Fogolari
considers sculptures securely attributed to the Lamberti.

1371 GOLDNER, GEORGE. "The Decoration of the Main Façade Window of
 San Marco in Venice." Metteilungen des Kunsthistorischen
 Institutes in Florenz 21 no. 1 (1977):13–34, 44 figs.
 Attributes to Piero Lamberti, Niccolò Lamberti, and Gio-
vanni di Martino da Fiesole, ca. 1430–35, nine Genesis reliefs, eight
seated figures, and eight Old Testament and Evangelist statuettes
around main façade window of San Marco, Venice.

1372 LAZZARINI, VITTORIO. "Il mausoleo di Raffaele Fulgosio nella
 Basilica del Santo." Archivio veneto-tridentino, 4th ser. 4
 (1923):147–56, no illus.
 Analyzes history of Tomb of Raffaele Fulgosio (Santo,
Padua). New documents prove that Nanni di Bartolo assisted Piero di
Niccolò Lamberti in execution, disproving theory that Giovanni di
Martino da Fiesole was collaborator.

1373 P[LANISCIG], L[EO]. "Piero d Nicolò Lamberti.' In Thieme-
 Becker Künstler-Lexikon. Leipzig: E.A. Seeman, 1933,
 27:24-25.
 Condensed survey of life and work. Valuble bibliography.

LEONARDO DEL TASSO

1374 MIDDELDORF, ULRICH. "Tasso, Leonardo di Chimenti." In Thieme-
 Becker Künstler-Lexikon. Leipzig: E.A. Seemann, 1938, 22:
 460-61.
 Condensed survey of life and work. Valuable bibliography.

1375 PLATHER, LEIF E., and PLATHER, UNN. "The St. Sebastian Taber-
 nacle by Leonardo del Tasso in the Church of St. Ambrogio in
 Florence: Technique and Restoration." Acta ad Archaeologiam
 et Artium Historiam Pertinentia 6 (1975):151-62, 14 figs.
 Polychromed wood tomb monument of del Tasso family is
 attributed to Leonardo del Tasso by Vasari, with paintings by Filip-
 pino Lippi. Description of its restoration after 1966 floods.

LORENZO DI GIOVANNI D'AMBROGIO

1376 K[REPLIN], B.C. "Lorenzo di Giovanni d'Ambrogio." In Thieme-
 Becker Künstler-Lexikon. Leipzig: E.A. Seemann, 1929, 23:
 390-91.
 Condensed survey of life and work. Valuable bibliography.

MICHELE MARINI

1377 ANON. "Marini, Michele di Luca." In Thieme-Becker
 Künstler-Lexikon. Leipzig: E.A. Seemann, 1930, 24:106.
 Condensed survey of life and work. Valuable bibliography.

1378 COLASANTI, ARDUINO. "Un bassorilievo di Michele Marini." Arte
 8 (1905):201-5, 4 figs.
 Marble reliefs of Martyrdom of St. Sebastian, Flagellation,
 and Pietà (Palazzo della Minerva, Rome) are attributed to Michele
 Marini. Proposes they were part of decoration of Chapel of St.
 Sebastian (Santa Maria sopra Minerva, Rome), where statue of St.
 Sebastian attributed by Vasari to Michele, still stands.

1379 STEINMANN, ERNST. "Michele Marini: Ein Beitrag zur Geschichte
 der Renaissanceskulptur in Rom." Zeitschrift für bildende
 Kunst, n.s. 14 (1903):147-57, 10 figs.
 Reconstructs works in Rome by Michele Marini, attributing
 to him Ponzetti Chapel in Santa Maria della Pace, Chapel of St.
 Sebastian (Maffei Chapel) in Santa Maria sopra Minerva, Tomb of the
 Cibo in San Cosimato, and Tomb of Filippo della Valle in the
 Aracoeli.

MASACCIO

1380 BECK, JAMES H. "Masaccio's Early Career as a Sculptor." Art
Bulletin 53 (1971):177-95, 27 figs.
Attributes to Masaccio, rather than Dello Delli, Coronation
of the Virgin lunette (Sant'Egidio, Florence), which would be
Masaccio's only sculpture.

MASO DI BARTOLOMMEO

Books

1381 YRIARTE, CHARLES. Journal d'un sculpteur florentin au XVe
siècle: Le livre de souvenirs de Maso di Bartolommeo, dit
Masaccio. Paris, 1894, 96 pp., 47 figs. [Reprinted from
Gazette des beaux-arts, 2d per. 23 (1880):427-34; 24 (1881):
142-55, 6 figs.]
Reprints record book of Maso di Bartolommeo, architect,
entrepreneur, and ornamentalist (1447-55). Records payments in 1452
or decoration of Palazzo Medici[-Riccardi] courtyard, including
medallions attributed to Michelozzo and Donatello. Also assisted
Luca della Robbia on Sacristy doors, Duomo, Florence.

Monographs on a Single Commission

Cappella del Sacro Cingolo, Duomo, Prato

1382 MARCHINI, GIUSEPPE. La Cappella del Sacro Cingolo nel Duomo di
Prato. Prato: Azienda Autonoma di Turismo, [n.d.], 43 pp., 65
figs., 8 color pls.
Monograph covering all aspects of decoration, bronze grill-
work, fresco cycle, and reliquary casket by Maso di Bartolommeo
(1446). Comments on each illustration. Notes including bibliog-
raphy. Good detail photos of grillwork.

Articles

1383 BUSIGNANI, ALBERTO. "Maso di Bartolommeo, Pasquino da Monte-
pulciano, e gli inizi di Andrea Verrocchio." Antichità viva 1,
no. 1 (January 1962):35-39, 11 figs.
Argues Verrocchio was probably trained by Maso di Bartolom-
meo and Pasquino da Montepulciano on basis of stylistic comparison
between Verrocchio's lavabo and Tomb of Giovanni and Piero de' Medici
(both in San Lorenzo, Florence) and grillwork (Cappella del Sacro
Cingolo, Duomo, Prato) by Maso and Pasquino.

1384 K[REPLIN], B.C. "Maso di Bartolommeo, gen. 'Masaccio.'" In
Thieme-Becker Künstler-Lexikon. Leipzig: E.A. Seemann, 1930,
24:210.
Condensed survey of life and work. Valuable bibliography.

1385 MARCHINI, GIUSEPPE. "Maso di Bartolommeo." In Donatello e il
 suo tempo (Atti dell'VIII convegno internazionale di studi sul
 Rinascimento, Florence-Padua, 1966). Florence: Istituto
 Nazionale di Studi sul Rinascimento, 1968, pp. 235-43, 22 figs.
 [A version of his "Maso di Bartolommeo: Aiuto di Donatello."
 Prato: Storia e arte 7, no. 17 (1966):17-29, 22 figs.].
 Monographic article on Maso, who collaborated with
 Donatello and Michelozzo on Prato Pulpit, and is best known for
 grillwork of Cappella del Sacro Cingolo (Duomo, Prato). Discusses
 his metalwork and architectural sculpture. Attributes to him left
 center relief on Prato Pulpit and architecture of Palazzo Quaratesi,
 Florence.

1386 MARCHINI, GIUSEPPE. "Di Maso di Bartolommeo e d'altri."
 Commentari 3 (1952):108-27, 23 figs.
 Newly discovered documents for grillwork of Cappella del
 Sacro Cingolo, Duomo, Prato, reveal phases of its construction
 (1438-67) and dominant role of Maso di Bartolommeo in design and
 execution. Grillwork was completed by Pasquino da Montepulciano.
 Analysis of style and chronology. Bibliography for Maso di
 Bartolommeo.

 MASTER OF THE MARBLE MADONNAS

1387 ANON. "Meister der Marmormadonnen." In Thieme-Becker
 Künstler-Lexikon. Leipzig: E.A. Seemann, 1950, 37:222.
 Condensed survey of life and work. Valuable bibliography.

1388 MIDDELDORF, ULRICH. "An Ecce Homo by the Master of the Marble
 Madonnas." In Album Amoricum: J.G. van Gelder. Edited by J.
 Bruyn, J.A. Emmens, E.de Jongh, and D.P. Snoep. The Hague:
 Martinus, 1973, pp. 234-36, 7 figs. Reprinted in Italian with
 better plates in Arte illustrata 7, no. 57 (March 1974):2-9, 11
 figs.
 Marble bust of Ecce Homo (private collection, Switzerland
 [1490]), attributed to Master of the Marble Madonnas. Dismisses
 identification of Master of Marble Madonnas as Matteo Civitali,
 Tommaso Fiamberti, or Giovanni Ricci; terms Master a Florentine
 influenced by Lombard style. Also reprinted in entry 54.

1389 MIDDELDORF, ULRICH. "Gesù Pellegrino: A Quattrocento
 Sculpture
 Rediscovered." Apollo 108, no 202 (December 1978):382-83, 3
 figs.
 Pietra serena roundel of Christ as a Pilgrim (private
 collection, Florence) is identified as a sculpture recorded in
 meeting place of Confraternity of Gesù Pellegrino (Convent of Santa
 Maria Novella, Florence) in 1787. Attributed to anonymous sculptor
 of the 1470s, perhaps Master of the Marble Maddonas. Reprinted in
 entry 54.

MICHELE DA FIRENZE ("MASTER OF THE PELLEGRINI CHAPEL")

1390 ANON. "Meister der Pellegrini-Kapelle." In <u>Thieme-Becker</u>
 <u>Künstler-Lexikon</u>. Leipzig: E.A. Seemann, 1950, 37:267-68.
 Condensed survey of life and work. Valuable bibliography.

1391 CIPOLLA, CARLO. "Ricerche storiche intorno alla chiesa di
 Santa Anastasia in Verona." <u>Arte</u> 17 (1914):91-106, 181-97,
 396-414; 18 (1915):296-304, 459-67, 20 figs.
 Publishes documents naming Michele da Firenze as creditor
of Pellegrini family, corroborating hypothesis that Michele sculpted
their chapel in Santa Anastasia, Verona.

1392 FAINELLI, VITTORIO. "Per la storia dell'arte a Verona." <u>Arte</u>
 13 (1910):219-22, no illus.
 Publishes notice about Michele da Firenze and his son,
Marsilio, who were given two years to pay debts to Pellegrini famiy.
This has been related to Pellegrini Chapel, Santa Anastasia, Verona,
and used as proof that Michele sculpted it.

1393 FIOCCO, GIUSEPPE. "Michele da Firenze." <u>Dedalo</u> 12 (1932):
 542-63, 21 figs.
 Proposes that so-called "Master of the Pellegrini Chapel"
should be identified with Michele da Firenze, who is documented as
working in chapel, 1433-38. Argues that he worked on Ghiberti's
North Doors. Outlines his probable career in Arezzo, Verona, Modena,
and Ferrara and attributes to him Tomb of Francesco Rozzelli, San
Francesco, Arezzo, and altar, Duomo, Modena.

1394 FIOCCO, GIUSEPPE. "Un altare di Michele da Firenze." <u>Rivista</u>
 <u>d'arte</u> 27, 3d ser. 2 (1952):145-51, 3 figs.
 Publishes terracotta polyptych of Madonna and Child flanked
by four standing saints (Parish Church of Raccano di Polesella) as by
Michele da Firenze. <u>Dormition of the Virgin</u> relief (Church of the
Tomb, Adria), which Fiocco had attributed to Michele da Firenze, he
here reattributes tentatively to Niccolò Baroncelli. See Lorenzoni,
entry 574.

1395 MARCHINI, GIUSEPPE. "Su Michele da Firenze." In <u>Jacopo della</u>
 <u>Quercia fra Gotico e Rinascimento</u> (Atti del Convegno di studi,
 Siena, 1975). Edited by Giulietta C. Dini. Florence: Centro
 Di, 1977, pp. 201-2, 1 fig.
 Clarifies confusion between Michele di Niccolaio and
Michele called "Lo Scalcagna," who is known as Michele da Firenze.
Brief assessment of Michele da Firenze's career focusing on
Pellegrini Chapel, Santa Anastasia, Verona; and other terracotta
images for popular devotion.

1396 MARIACHER, GIOVANNI. "Contributo su Michele da Firenze."
 <u>Proporzione</u> 3 (1950):68-72, 11 figs.
 Attributes to Michele da Firenze fragmentary terracotta
sculptures (Museo civico, Verona; Museo Bocchi, Adria; Museo civico,

Treviso), and relief of <u>Madonna and Child Enthroned</u> (San Luca, Venice). Assigns Tomb of Beato Pacifico (Santa Maria Gloriosa dei Frari, Venice) to Michele in collaboration with Nanni di Bartolo.

1397 MIDDELDORF, ULRICH. "Due Madonne ferraresi in America."
<u>Bollettino annuale: Musei ferraresi</u> 4 (1974):130-33, 4 figs.
Publishes half-length terracotta <u>Madonna and Child</u> (Gallery of Fine Arts, Columbus, Ohio), identical to piece in Church of Basil the Great, Correggio, and similar to another terracotta (Museum of Fine Arts, Boston). Calls them early fifteenth-century Florentine, close to Michele da Firenze and to Cristoforo da Firenze, who modelled terracotta <u>Madonna and Child</u>, Duomo façade, Ferrara. Reprinted in entry 54.

1398 PETROBELLI, E. "Michele da Firenze ad Adria." <u>Rivista d'arte</u> 29 (1954):127-32, 1 fig.
Analysis of early sources on destroyed terracotta altar-pieces sculpted for Duomo, Adria, ca. 1440, by Michele da Firenze. Publishes standing <u>Madonna and Child</u> (Duomo, Adria), only piece extant from these altarpieces.

1399 STEINGRÄBER, ERICH. "A Madonna Relief by Michele da Firenze."
<u>Connoissseur</u> 140, no. 565 (December 1957):166-67, 2 figs.
Attributes newly discovered terracotta <u>Madonna</u> relief (Julius Böhler collection, Munich) to Michele da Firenze, ca. 1430-40, head of large workshop here identified with works attributed to "Master of the Pellegrini Chapel." His adherence to International Style suggests early connections to Ghiberti and Jacopo della Quercia.

1400 VENTURI, ADOLFO. "Per lo studio del problematico 'Maestro della Cappella Pellegrini.'" <u>Arte</u> 11 (1908):298-300, 1 fig.
First attempt to group sculptures by Master of Pellegrini Chapel and to define his style. Venturi included in his oeuvre: Altar, Pellegrini Chapel (Santa Anastasia, Verona); "Altare delle statuine" (Duomo, Modena); Tomb of Francesco Roselli [Rozzelli] (San Francesco, Arezzo); and Tomb of Beato Pacifico (Santa Maria Gloriosa dei Frari, Venice).

MICHELE DI GIOVANNI DI BARTOLO ("IL GRECO")

1401 DEGENHART, BERNHARD. "Michele di Giovanni di Bartolo: Disegni dall'antico e il camino 'della Iole.'" <u>Bollettino d'arte</u>, 4th ser. 35 (1950):208-15, 20 figs.
Drawings of Roman sarcophagus motifs, now in British Museum, London, are attributed to sculptor, Michele di Giovanni di Bartolo. These, in turn, establish attribution to him of frieze on "camino della Iole" (Palazzo Ducale, Urbino). Ghiberti also depended on this sarcophagus in decorative frieze around North Doors of Baptistry, Florence.

1402 KENNEDY, CLARENCE. "Il Greco aus Fiesole." Mitteilungen des
Kunsthistorischen Institutes in Florenz 4 (1932):25-40, 9 figs.
Traces entire life, particularly his career in Urbino,
where he went in 1454 with Maso di Bartolommeo and Pasquino da
Montepulciano. Assigns to him camini and doorframes in Palazzo
Ducale, Urbino. Decoration of "Sala di Iole" and Madonna and Child
relief in Palazzo Ducale museum are identified as his masterpieces.

MICHELOZZO DI BARTOLOMMEO

Books

1403 CAPLOW, HARRIET McNEAL. Michelozzo. 2 vols. Outstanding
Dissertations in the Fine Arts. New York and London: Garland,
1977, 718 pp., 286 figs., notes, bibliography, no index.
[Ph.D. dissertation, Columbia University, 1970.]
Careful, thorough monograph, whch is only recent discussion
of Michelozzo's sculpture and only detailed analysis of both his
architecture and sculpture.

1404 LIGHTBOWN, R[ONALD] W. Donatello & Michelozzo: An Artistic
Partnership and Its Patrons in the Early Renaissance. 2 vols.
London: Harvey Miller, 1980, 451 pp., 145 figs.
Important study of socioeconomic milieu of Early
Renaissance Florence and major patrons. Detailed historical and
stylistic analysis of four major collaborations between Donatello and
Michelozzo: Tomb of Pope John XXIII (Coscia), Baptistry, Florence;
Tomb of Cardinal Rainaldo, Sant'Angelo a Nilo, Naples; Tomb of Bar-
tolommeo Aragazzi, Duomo, Montepulciano; and Prato Pulpit. Full
scholarly apparatus.

1404a Herzner, Volker. Review of Donatello & Michelozzo: An
Artistic Partnership and Its Patrons in the Early Renaissance,
by Ronald W. Lightbown. Zeitschrit für Kunstgeschichte 44,
no. 3 (1981):300-313, no illus.
Thorough critique of Lightbown's assessment of Donatello
and Michelozzo's collaboration which, despite lavish format of book,
he finds lacking. Disputes his dating of Tomb of Pope John XXIII
(Coscia) (Baptistry, Florence) on basis of record of token payment,
the date of which cannot be precisely fixed. Argues against attrib-
uting all sculptures on Tomb Cardinal Rainaldo Brancacci (Sant'Angelo
a Nilo, Naples) to Donatello, although he agrees Donatello designed
tomb. Disagrees with dating beginning of Tomb of Bartolommeo
Aragazzi (Duomo, Montepulciano) in 1429. Many other objections.

1405 MORISANI, OTTAVIO. Michelozzo architetto. Turin: G. Einaudi,
[1951], 108 pp., 177 figs.
Monograph on Michelozzo's architecture that briefly
analyzes tombs and Prato Pulpit. Well illustrated. Bibliography is
incomplete and often inaccurate.

1406 NATALI, ANTONIO. L'umanesimo di Michelozzo. I dattiloscritti,
 vol. 2. Florence: SPES, [n.d.], 65 pp., 4 figs.
 Attempts to refine definition of Michelozzo's classicism;
relates his sculpture to writing of humanists in circle of Cosimo on
basis of Michelozzo's close association with Cosimo.

1407 STEGMANN, HANS. Michelozzo di Bartolommeo: Eine kunst-
 geschichtiche Studie. Munich: Wolf, 1888, 64 pp., no illus.
 Brief analysis of Michelozzo's activity as sculptor and
architect that deems him wholly dependent on Donatello and other
great contemporaries. Very limited documentation.

1407a Semrau, Max. Review of Michelozzo di Bartolommeo: Eine
 kunstgeschichtliche Studie, by Hans Stegmann. Repertorium für
 Kunstwissenschaft 13 (1890):193-96, no illus.
 Clarifies relationship of Michelozzo and Donatello and
division of sculptural projects.

1408 WOLFF, FRITZ. Michelozzo di Bartolommeo: Ein Beitrag zur
 Geschichte der Architektur und Plastik im Quattrocento.
 Strasbourg: Heitz & Mündel, 1900, 101 pp., no illus.
 Considers Michelozzo's sculpture and architecture as
largely dependent on more notable contemporaries. Limited documen-
tation; largely out of date and without photographs.

 Unpublished Theses

*1409 JANSON, HORST W. "The Sculptured Works of Michelozzo di
 Bartolommeo." Ph.D. dissertation, Harvard University, 1941,
 259 pp.
 Monograph on Michelozzo as sculptor with complete analysis
of earlier attributions and bibliography. No discussion of inter-
related problem of Michelozzo's architecture.

 Articles

1410 ANON. "Donazione di un bassorilievo di Michelozzo." Bollet-
 tino d'arte 10 (1931):478, 1 fig.
 Publishes recently donated marble Madonna and Child relief
by Michelozzo (Bargello, Florence).

*1411 BRUNI, LEONARDO. Leonardi Bruni Arretini Epistolarum Libri
 VIII. Florence, 1741, 2:45-46.
 Letter of Bruni to Poggio Bracciolini, ca. 1430-31, that
provides evidence for dating and sequence of execution of Tomb of
Bartolommeo Aragazzi (Duomo, Montepulciano).

1412 BURNS, HOWARD. "Quattrocento Architecture and the Antique:
 Some Problems." In Classical Influences on European Culture,
 A.D. 500-1500 (Proceedings of an International Conference Held
 at Kings College, Cambridge, April 1969). New York and Cam-
 bridge: Cambridge University Press, 1971, pp. 269-87, 8 figs.

Analyzes attitude toward and knowledge of antiquity--in
particular, Donatello's use of antique elements in architectural
decoration; Michelozzo's use of isolated motifs, rather than general
classicizing style; and Francesco di Giorgio's translations of
complex antique schemes.

1413 CAPLOW, HARRIET M. "Sculptors' Partnerships in Michelozzo's
 Florence." Studies in the Renaissance 21 (1974):145-75, no
 illus., appendices.
 Clarifies chronology and nature of Michelozzo's business
relationships with Donatello, Ghiberti, Luca della Robbia, and Maso
di Bartolommeo. Discusses Michelozzo's role, with Donatello, in the
Tomb of Pope John XXIII (Coscia) (Baptistry, Florence, ca. 1424-27)
and, with Ghiberti, in Baptistry doors and Strozzi Chapel and Sac-
risty (Santa Trinità, Florence). Analyzes Michelozzo's partnership
with Luca della Robbia and Maso di Bartolommeo for execution of
bronze doors, North Sacristy, Duomo, Florence, beginning in 1446.

1414 COOLIDGE, JOHN. "Further Observations on Masaccio's Tinity."
 Art Bulletin 48 (1966):382-86, 7 figs.
 Relates pylon supporting God the Father in Masaccio's
Trinity to Tomb of Pope John XXIII (Coscia) (Baptistry, Florence) by
Donatello and Michelozzo. Notes that tomb was apparently built
without relief and curtains and suggests these were added by
Michelozzo. (Shows reconstruction without curtains, fig. 4.)

1415 DARCEL, ALFRED. "Les autels de Pistoja et de Florence."
 Gazette des beaux-arts, 2d per. 27 (1883):19-34, 7 figs.
 Iconography, composition, authorship, and history of
prolonged Pistoia Silver Altar project (1287-1400) and of Silver
Altar of Baptistry, Florence (1366-1402 and 1452-78). Relevance of
each to emerging sculptural style of Renaissance. Includes silver
St. John the Baptist statue by Michelozzo for Baptistry altar, 1452.

1416 ESCH, ARNOLD, and ESCH, DORIS. "Die Grabplatte Martins V. and
 andere Importstücke in den römischen Zollregistern der Früh-
 renaissance." Römisches Jahrbuch für Kunstgeschichte 17
 (1978):209-17, no illus.
 Roman harbor customs records from 1445 indicate Pope Martin
V's bronze tomb slab (San Giovanni in Laterano, Rome) was imported to
Rome from Florence and not, as Vasari thought, cast in Rome ca. 1433.
This throws new light on sculptor, whether Michelozzo or Donatello.

1417 FABRICZY, CORNELIUS von. "Michelozzo di Bartolommeo." Jahrbuch
 der königlich preussischen Kunstsammlungen (supp.) 25 (1904):
 34-110, no illus.
 Collects all documents then known on Michelozzo and
establishes chronology, but with "little or no attempt to interpret
documents or to analyze individual works" (Caplow, entry 1403).

1418 GEYMÜLLER, HEINRICH von. "Die architektonische Entwicklung
 Michelozzos und sein Zusammenwirken mit Donatello." Jahrbuch

der königlich preussischen Kunstsammlungen 15 (1894):247-59, no illus.
 Thorough discussion of collaboration between Michelozzo and Donatello (ca. 1435-44), focusing on architectural projects. With valuable chronology of documents.

1419 GIGLIOLI, ODOARDO H. "La statua in legno del Battista nella chiesa di S. Romolo a Bivigliano." Rivista d'arte 6 (1909): 128-29, 1 fig.
 First publication of wood statue of St. John the Baptist, accepted by Caplow (entry 1403) as by Michelozzo.

1420 HEYDENREICH, LUDWIG H. "Gedanken über Michelozzo di Bartolomeo." In Festschrift Wilhelm Pinder zum sechszigsten Geburtstage. Leipzig: E.A. Seemann, 1938, pp. 264-90, 14 figs., plan.
 Provides important reevaluation of Michelozzo's architecture, especially as crucial link in transition between classicism of Gothic and that of Early Renaissance. Considers briefly Michelozzo's decorative sculpture (pp. 281-88), particularly his style in capitals. Also discusses Tombs of Cardinal Rainaldo Brancacci and Bartolommeo Aragazzi.

1421 LENSI, ALFREDO. "Una scultura sconosciuta di Michelozzo nell'Annunziata di Firenze." Dedalo 2, no. 6 (1921-22):358-62, 1 fig.
 Attributes to Michelozzo half-length Madonna and Child (Cloister, SS. Annunziata, Florence), identifying it with one described by Vasari.

1422 LIGHTBOWN, RONALD W. "The Sculptor and the Architect." Connaissance des arts 347 (January 1981):50-55, 9 color pls.
 Discusses Michelozzo's and Donatello's collaboration on Tomb of Cardinal Rainaldo Barancacci (Sant'Angelo a Nilo, Naples). Argues that Donatello did effigy and four angels, and Michelozzo did no sculpture by himself but focused on architecture. Good color photographs.

1423 LISNER, MARGRIT. "Ein unbekanntes Werk des Michelozzo di Bartolommeo." Pantheon 26 (1968):173-84, 16 figs.
 Large wood Crucifix (San Niccolò oltr'Arno, Florence) is attributed to Michelozzo, ca. 1438-45, perhaps directly influenced by Donatello's bronze Crucifix (Santo, Padua).

1424 LOESER, CHARLES. "An Unknown Terracotta Madonna by Michelozzo at Buda-Pest." Rivista d'arte 7 (1910):107-11, 3 figs.
 Stucco Madonna and Child relief (Museum of Fine Arts, Budapest) is attributed to Michelozzo and related to his terracotta tympanum at S. Agostino, Montepulciano (c. 1437).

1425 LONGHI, ROBERTO. "Un busto marmoreo di Michelozzo." Vita artistica 2, no. 1 (January 1927):16-18, 3 figs.

Attributes to Michelozzo marble Bust of an Unidentified
Woman (private collection, Rome).

1426 MARIANI, VALERIO. "Una scultura in legno del Museo di Palazzo
 Venezia." Dedalo 12 (June 1932):429-39, 6 figs., 1 color pl.
 Attributes tentatively to Michelozzo polychromed wood
Female Martyr figure from church of San Demetrio de' Vestini, now in
Museo di Palazzo Venezia, Rome.

1427 MATHER, RUFUS G. "New Documents on Michelozzo." Art Bulletin
 24 (1942):226-31, 2 figs.
 Transcription of all Michelozzo's "portata al catasto"
records (1427/1430/1433/1442/1446/1451/1457/1469). Of special
importance is 1442 document that notes Michelozzo working on
Ghiberti's bronze doors. Pope-Hennessy regards transcriptions as
unreliable, see entry 61.

1428 PARRONCHI, ALESSANDRO. "Un Crocifisso d'argento in San
 Lorenzo." In Festschrift Ulrich Middeldorf. Edited by Antje
 Kosegarten and Peter Tigler. 2 vols. Berlin: Walter Gruyter
 & Co., 1968, pp. 143-9, 7 figs.
 Attributes to Michelozzo ca. 1440s a silver Cricifix in San
Lorenzo, donated by Cosimo de' Medici to replace an earlier one that
was stolen.

1429 PARRONCHI, ALESSANDRO. "Michelozzo orafo per San Lorenzo."
 Michelangelo 6 (1977):24-35, 15 figs.
 Michelozzo's work ca. 1444-54 on eight silver figures for
cross is reconstructed through documents from San Lorenzo archive
(Biblioteca Medico-Laurenziana, Florence). Only the Crucifix is
extant in San Lorenzo, but figure for it (St. Stephen?) was later
added to a Pastoral (Museo delle Cappelle medicee) given in 1520 to
San Lorenzo by Leo X.

1430 POGGI, G[IOVANNI]. "Appunti d'archivio." Miscellanea d'arte 1
 (1903):15-16, no illus.
 Publishes documents about Michelozzo working as caster of
bells.

1431 POPE-HENNESSY, JOHN. "The Arezzo Exhibition." Burlington
 Magazine 93 (1951):26-27, 1 fig.
 Brief review of exhibition of antiquities from vicinity of
Arezzo. Includes notice of newly discovered stucco Virgin and Child
relief (San Michele a Raggiolo, Ortignano), probably based on lost
marble by Michelozzo.

1432 R[AGGHIANTI], C[ARLO] L. "Un busto di Michelozzo." Critica
 d'arte 1 (1936):139-40, 1 fig.
 Attributes to Michelozzo ca. 1426-29 silvered bronze Bust
of a Woman (Museo della Confraternità di Sant'Anna, Pisa).

1433 RUBENSTEIN, NICOLAI. "Michelozzo and Niccolò Michelozzi in
 Chios, 1466-67." In Cultural Aspects of the Italian
 Renaissance: Essays in Honour of Paul Oskar Kristeller.
 Edited by Cecil H. Clough. New York: Alfred F. Zambelli;
 Manchester: Manchester University Press, 1976, pp. 216-28, no
 illus., appendices.
 New documents (letters from his son) confirm Michelozzo's
 service to the Mahona in Chios, 1466-67, clarifying Michelozzo's
 later years, his impoverishment, and his travels to Greece, Constan-
 tinople, and Venice.

1434 SAALMAN, HOWARD. "The Palazzo Communale in Montepulciano: An
 Unknown Work by Michelozzo." Zeitschift für Kunstgeschichte 28
 (1965):1-46, 43 figs., appendices.
 New documents link Michelozzo to design of Palazzo
 Communale, Montepulciano, and detail its construction (ca. 1440-59)
 by Michelozzo's assistant, Checo di Meo da Settignano. Documents
 clarify legal disputes surrounding Tomb of Bartolommeo Aragazzi
 commission (ca. 1437).

1435 SCHMARSOW, A[UGUST]. "Nuovi studi intorno a Michelozzo."
 Archivio storico dell'arte 6 (1893):241-55, 4 figs.
 Analysis of Michelozzo's Tomb of Bartolommeo Aragazzi
 (Duomo, Montepulciano) and portal lunette sculpture of Madonna and
 Child with St. John the Baptist and St. Augustine (Sant'Agostino,
 Montepulciano). Lunette sculpture was attributed by local tradition
 to Pasquino da Montepulciano.

1436 WILLICH, H. "Michelozzo." In Thieme-Becker Künstler-Lexkon.
 Leipzig: E.A. Seemann, 1930, 24:530-31.
 Condensed survey of life and work. Valuable bibliography.

 MIN⁀⁀ DA FIESOLE

 Books

1437 ANGELI, DIEGO. Mino da Fiesole. Florence: Alinari, 1905, 156
 pp., 53 figs.
 Early monograph in French on Mino's career, with notes that
 include some bibliography. No documents or index. Small, unclear
 photographs.

1437a V[enturi], A[dolfo]. Review of Mino da Fiesole, by Diego
 Angeli. Arte 8 (905):69, no illus.

1438 CIONINI VISANI, MARIA. Mino da Fiesole. I maestri della
 scultura, vol. 62. Milan: Fratelli Fabbri, 1966, 7 pp., 3
 figs., 16 color pls.
 Valuable corpus of large color plates.

1439 LANGE, HILDEGARD. Mino da Fiesole: Ein Beitrag zur Geschichte
 der florentinischen und römischen Plastik des Quattrocento.
 Greifswald: Abel, 1928, 129 pp., no illus. [Ph.D.
 dissertation, Munich, 1928.]
 Still useful monograph, though "questionable in many
 deductions" (Valentiner, entry 1486). Contains an almost complete
 list of works. With bibliography.

1440 SCIOLLA, GIANNI CARLO. La scultura di Mino da Fiesole.
 Università di Torino, Facoltà di lettere e filosofia,
 archeologia e storia dell'arte, vol. 3. Turin: G.
 Giappichelli, 1970, 151 pp., 88 figs.
 Major monograph on Mino (identifying Mino da Fiesole with
 Mino del Reame) with essay on his career followed by catalogue
 raisonné of certain, attributed, and lost works. Specific citations
 included in each catalogue entry; general bibliography appears at end
 of volume.

1440a Schulz, Anne M. Review of La scultura di Mino da Fiesole, by
 Gianni Carlo Sciolla. Art Bulletin 54 (1972):208-9, no illus.
 Disputes Mino's apprenticeship to Michelozzo; criticizes
 lack of attempt to isolate Mino from his workshop; regards catalogue
 as highly erroneous.

 Articles

1441 ALAZARD, JEAN. "Mino da Fiesole à Rome." Gazette des
 beaux-arts, 4th per. 14 (1918):75-86, 6 figs.
 Attributes to Mino da Fiesole center part of Last Judgment
 relief for Tomb of Pope Paul II (now dispersed), and figure of Faith
 for same (both parts in Vatican Grottoes). Attributes to Mino and
 Giovanni Dalmata tabernacle with reliefs of Melchisedek Blessing
 Abraham and Jacob and Isaac. Death date of Francesco Tornabuoni in
 1480 establishes that Mino was still in Rome then to work on his tomb
 (Santa Maria sopra Minerva). Disputes attribution to Mino of reliefs
 in apse and sacristy, Santa Maria Maggiore (from the ciborium
 commissioned by Cardinal d'Estouteville).

1442 BIASIOTTI, GIOVANNI. "Di alcune opere scultorie conservate in
 S. Maria Maggiore di Roma." Rassegna d'arte antica e moderna
 5, no. 1 (1918):42-57, 18 figs.
 Fifteenth-century sculptures discussed here include:
 effigy of Cardinal Lando, the Ciborium of Cardinal d'Estouteville
 (with summary of the Mino da Fiesole/Mino del Reame problem), and
 marble altar dossal of Madonna and SS. Jerome and Bernard attributed
 to follower of Andrea Bregno.

1443 BODE, WILHELM von. "Die Marmorbüste des Alesso di Luca Mini
 von Mino da Fiesole." Jahrbuch der königlich preussischen
 Kunstsammlungen 4 (1894):272-74, 2 figs.

Marble bust inscribed "Alexo di Luca Mini 1456" (formerly Kaiser Friedrich Museum, now Staatliche Museen, Berlin-Dahlem) is attributed to Mino da Fiesole and identified as portrait of Alexo di Luca Mini, Florentine apothecary (age twenty-five in 1456), as recorded in archival documents.

1444 BORSOOK, EVE. "Cults and Imagery at Sant'Ambrogio in Florence." Mitteilungen des Kunsthistorischen Institutes in Florenz 25, no. 2 (1981):147-202, 21 figs.
 Monograph on Sant'Ambrogio and its painted and sculpted decoration considered in light of precocious emergence there of cult of Virgin's Immaculate Conception. Mino da Fiesole's reliquary tabernacle is analyzed in terms of this iconography. Brief mention of tabernacle attributed to Buggiano.

1445 BURGER, FRITZ. "Neuaufgefundene Skulptur- und Architekturfragmente vom Grabmal Pauls II." Jahrbuch der königlich preussischen Kunstsammlungen 27 (1906):129-41, 9 figs.
 Reconstructs Tomb of Pope Paul II (Saint Peter's, Rome, 1472), by Mino da Fiesole and Giovanni Dalmata. Examines dispersed fragments (now mostly in Vatican Grottoes) and clarifies each sculptor's contribution.

1446 CALLISEN, S.A. "A Bust of a Prelate in the Metropolitan Museum of Art, New York." Art Bulletin 18 (1936):401-6, 7 figs.
 Bust, identified here as Cardinal Guillaume d'Estouteville (1403-83), is attributed to Mino del Reame, rather than to Mino da Fiesole, as generally believed. Work possibly intended for Cardinal's tomb (ca. 1483), although it shows him as middle-aged. Discusses d'Estouteville's patronage generally.

1447 CARRARA, LIDIA. "Nota sulla formazione di Mino da Fiesole." Critica d'arte 13-14 (January–March 1956):76-83, 7 figs.
 Argues that Michelozzo had primary role in formation of Mino da Fiesole.

1448 COURAJOD, LOUIS. "Un bas-relief de Mino da Fiesole." Musée archéologique (April 1876):1-19, 5 figs.
 Attributes marble Madonna and Child relief (Louvre, Paris) to Mino and distinguishes his style from that of Antonio Rossellino. Includes annotated list of all Mino's sculptures; of historical interest.

1449 COURAJOD, LOUIS. "Deux fragments des constructions de Pie II à Saint-Pierre de Rome, aujourd'hui au musée du Louvre." Gazette des beaux-arts, 2d per. 26 (September 1882):199-204, 3 line drawings.
 Identifies two marble reliefs of putti with garlands and lion's heads as by Mino da Fiesole. Proposed as fragments of Benediction Pulpit of Pius II for St. Peter's, Rome, ca. 1463 (unfinished, now dispersed).

1450 COURAJOD, LOUIS. "Le portrait de Sainte Catherine de Sienne de la collection Timbal au Louvre." Mémoires de la Société nationale des antiquaires de France 43, 5th ser. 3 (1882):1-16, 4 figs.

Stucco relief of so-called St. Catherine identified as contemporary copy of original marble Madonna relief (Palmieri collection, Siena). Though the marble is attributed to Jacopo della Quercia on seventeenth-century engraving, it is probably by school of Mino da Fiesole.

1451 DOUGLAS, R. LANGTON. "'Mino del Reame.'" Burlington Magazine 87 (1945):217-24, 6 figs.

Denies existence of so-called "Mino del Reame," seeing name as variant of Mino da Fiesole. Through documentary and stylistic analysis, reattributes all works of Mino del Reame to Mino da Fiesole, including Ciborium of Cardinal d'Estouteville, Santa Maria Maggiore, Rome; and Bust of Cardinal d'Estouteville (Metropolitan Museum of Art, New York).

1452 DOUGLAS, R. LANGTON. "'Mino del Reame.'" Burlington Magazine 88 (1946):23, no illus.

Clarifies versions of Mino da Fiesole's name and how confusion with so-called "Mino del Reame" resulted.

1453 FABRICZY, C[ORNELIO] de. "Alcuni documenti su Mino da Fiesole." Rivista d'arte 2 (1904):40-46, no illus.

Publishes documents concerning Mino, including his record of matriculation as sculptor and his will.

1454 FABRICZY, C[ORNELIUS] de. "Portate al catasto di Mino da Fiesole." Rivista d'arte 3 (1905):265-67, no illus.

Publication of Mino's tax documents from 1469 and 1480.

1455 FOVILLE, JEAN de. "Le Mino de Fiesole de la Bibliothèque nationale." Gazette des beaux-arts, 4th per. 5 (February 1911):149-56, 2 figs.

Small polychromed marble relief Bust of a Young Woman, signed OPUS MINI (Cabinet des médailles, Bibliothèque nationale, Paris) is attributed to Mino da Fiesole (not Mino del Reame).

1456 GIGLIOLI, ODOARDO H. "La pila battesimale di Mino da Fiesole nella chiesa di S. Maria a Peretola e le pitture di Giusto di Andrea di Giusto." Rivista d'arte 3 (1905):267-69, 1 fig.

A holy water font in Santa Maria, Peretola, was carved by Mino in 1466, as proved by document published here.

1457 GIGLIOLI, ODOARDO H. "Tre importanti sculture inedite: Due di Mino da Fiesole ed una di Antonio Rossellino." Bollettino d'arte 9 (1915):149-54, 7 figs.

Attributes to Mino two marble Candle-bearing Angels, and to Antonio Rossellino a marble Madonna and Child relief, all in San Clemente, Sociana.

1458 GNOLI, D. "Le opere di Mino da Fiesole in Roma." Archivio storico dell'arte 1 (1889):455-67, 9 figs.
Analyzes Mino's earliest sculptures in Rome: Bust of Nicola Strozzi of 1454 (Staatliche Museen, Berlin-Dahlem); Benediction Pulpit of Pius II for St. Peter's (1463); Ciborium of Pope Sixtus IV (Vatican Grottoes); and pediment sculpture at San Giacomo degli Spagnuoli.

1459 GNOLI, DOMENICO. "Le opere di Mino da Fiesole in Roma, II." Archivio storico dell'arte 3 (1890):89-106, 16 figs.
Detailed analysis of reliefs comprising dismembered Santa Maria Maggiore Ciborium of Cardinal d'Estouteville and reliefs of busts of Old Testament figures and saints in niches for dismembered St. Jerome Altar in destroyed chapel for that saint, Santa Maria Maggiore. Both complexes, commissioned by Cardinal d'Estouteville in 1463-64, show softening of linear style characteristic of Mino's middle period.

1460 GNOLI, DOMENICO. "Le opere di Mino da Fiesole in Roma, III." Archivio storico dell'arte 3 (1890):175-86, 10 figs.
Concentrates on Mino's sculptures between 1471 and 1473, especially Tomb of Pope Paul II (once in St. Peter's and now dispersed), which he carved with Giovanni Dalmata.

1461 GNOLI, DOMENICO. "Le opere di Mino da Fiesole in Roma, IV." Archivio storico dell'arte 4 (1890):258-71, 6 figs., 2 line drawings.
Concentrates on tabernacle (Sacristy, San Marco, Rome); Bust of Pope Paul II (Palazzo di San Marco, Rome); and Tomb of Cardinal Niccolò Forteguerri (Santa Cecilia in Trastevere, Rome).

1462 GNOLI, DOMENICO. "Le opere di Mino da Fiesole in Roma, V." Archivio storico dell'arte 5 (1890):424-40, 8 figs., 1 line engr.
Deals wtih Mino's sculptures of 1474-80: Tomb of Cardinal Pietro Riario (SS. Apostoli, Rome), Tomb of Cardinal Giacomo Amannati (Sant'Agostino, Rome), Tomb of Francesco Tornabuoni (Santa Maria sopra Minerva, Rome), and tabernacle, Santa Maria in Trastevere.

1463 GNOLI, DOMENICO. "Ricostruzione del monumento del Cardinale Forteguerri, di Mino da Fiesole." Archivio storico dell'arte 4 (1891):209, no illus.
Comments on recent reconstruction of Tomb of Cardinal Niccolò Forteguerri in Santa Cecilia in Trastevere, its original location.

1464 HIPKISS, EDWIN J.; YOUNG, W.J.; and EDGELL, G.H. "A Modified Tomb Monument of the Italian Renaissance." Bulletin of the Museum of Fine Arts (Boston) 35 (1937):83-90, 12 figs.
Through scientific analysis tomb (Museum of Fine Arts, Boston) attributed to Mino da Fiesole is determined to be original

fifteenth-century Roman tomb, though rebuilt, in part recut, and with many later alterations.

1465 MARQUAND, ALLAN. "Mino da Fiesole." Art and Archeology 9 (May 1920):223-30, 9 figs.
 General discussion of style and principal works, especially portrait busts and reliefs and fragments of Tomb of Pope Paul II (now dispersed, Vatican Grottoes, Rome).

1466 MARUCCHI, ELISA. "Dove nacque Mino da Fiesole." Rivista d'arte 21 (1939):324-26, no illus.
 Publishes document that proves Mino was born in 1429 in Papiano, not Fiesole, as Vasari claimed.

1467 MIDDELDORF, ULRICH. Review of Römische Porträtbüsten der Gegenreformation, by Dr. August Grisebach. Art Bulletin 20 (1938):111-17, 4 figs.
 Book review of catalogue of sixteenth-century Roman portrait busts. Author elaborates on fifteenth-century origins of portrait bust, regarding Mino da Fiesole's Bust of Cardinal d'Estouteville (Metropolitan Museum of Art, New York, ca. 1482) as earliest and noting move from its realism to classicism of sixteenth century.

1468 NEGRI ARNOLDI, FRANCESCO. "Il monumento sepolcrale del Card. Niccolò Forteguerri in Santa Cecilia a Roma e il suo cenotafo nella cattedrale di Pistoia." In Egemonia fiorentina ed autonomie locali nella Toscana nordoccidentale del primo Rinascimento (7° convegno internazionale, Centro italiano di studi e storia d'arte di Pistoia). Pistoia: Centro di Studi, 1978, pp. 211-26, 7 figs.
 Analyzes chronology and shop assistance in Mino da Fiesole's Tomb of Cardinal Niccolò Forteguerri (Santa Cecilia in Trastevere, Rome). Reconstructs Verrocchio's Cenotaph of Cardinal Niccolò Forteguerri (Duomo, Pistoia). Attributes various parts of monument and related sculptures. Assigns bozzetto (Victoria and Albert Museum, London) to Lorenzo di Credi.

1469 PEPE, MARIO. "Sul soggiorno napoletano di Mino da Fiesole." Napoli nobilissima 5 (1966):116-20, no illus.
 Reexamines and corroborates Valentiner's (entry 1487) identification of Mino da Fiesole with the Domenico da Montemigiano mentioned in Neapolitan documents of 1455 as working for Alphonso I. Briefly notes that Mino da Fiesole was also known as Mino del Reame.

1470 PHILLIPS, JOHN G. "The Case of the Seven Madonna." Bulletin of the Metropolitan Museum of Art, n.s. 4, no. 1 (Summer 1945): 18-28, 12 figs.
 Clarifies Mino da Fiesole's development through stylistic comparison and redating of seven Madonna and Child reliefs, firmly attributed to him: Bargello, Florence, ca. 1472-74; Metropolitan

Museum of Art, New York, ca. 1472-74; SS. Apostoli, Rome, ca.
1475-76; Santa Maria del Popolo, Rome, ca. 1479-80; hospital of Santo
Spirito, Rome, 1479-80; Badia, Florence, ca. 1480-81; formerly Kaiser
Friedrich Museum, Berlin, ca. 1480-81. Each relief derives from
Antonio Rossellino's Madonna del Latte (Santa Croce, Florence), here
redated from ca. 1478 to ca. 1470.

1471 POGGI, GIOVANNI. "Mino da Fiesole e la Badia fiorentina."
Miscellanea d'arte 1 (1903):98-103, 2 figs.
 Publishes corrected documents about Mino da Fiesole's
commissions at Badia, Florence. Incompletely published earlier by
Milanesi in his edition of Vasari and by Müntz (entry 164).

1472 POPE-HENNESSY, JOHN. "A Cartapesta Mirror Frame." Burlington
Magazine 92 (1950):288-91, 1 fig.
 A cartapesta mirror frame (Victoria and Albert Museum,
London), previously attributed to Mino da Fiesole or Giuliano da San
Gallo, is attributed to Neroccio's workshop (ca. late 1470s).

1473 POPE-HENNESSY, JOHN. "Three Marble Reliefs in the Gambier-Parry
Collection." Burlington Magazine 109 (1967):117-21, 7 figs.
 Publishes marble Madonna and Child relief signed by Mino da
Fiesole and probably related to reliefs for Antonio Rossellino's
pulpit (Duomo, Prato, ca 1472-73); Madonna and Child relief by Master
of the Marble Madonnas (probably done in Urbino, ca. 1490s); and
marble Madonna and Child relief after Verrocchio. Rejects identifi-
cation of Master of the Marble Madonnas as Tommaso Fiamberti.

1474 RICCI, CORRADO. "Il tabernacolo e gli angeli di Mino da
Fiesole in Volterra." Rivista d'arte 2 (1904):260-67, 2 figs.
 Publishes payment records for Mino's tabernacle, Duomo,
Volterra.

1475 RICCOBONI, ALBERTO. "Nuovi apporti all'arte di Mino del Regno
a Roma." Urbe, n.s. 29 (1966):16-23, 4 figs.
 Attributes to Mino del Reame (Regno) statue of St. Paul
(Vatican Grottoes); statue of St. John the Baptist (San Giovanni dei
Fiorentini); Ciborium of Cardinal d'Estouteville (Santa Maria
Maggiore); Tomb of General Rido (Santa Francesca Romana); and Tomb of
Pope Paul II (now dispersed, Vatican Grottoes).

1476 RORIMER, JAMES J. "Ultra-Violet Rays and a Mino da Fiesole
Problem." Technical Studies in the Field of the Fine Arts 2,
no. 2 (October 1933):71-80, 5 figs.
 Relief portrait Bust of the Diva Faustina (Metropolitan
Museum of Art, New York) is attributed to Mino da Fiesole based on
examination with ultraviolet rays (which reveal recuttings uncharac-
teristic of Mino). Includes first photographs ever taken of
ultraviolet-ray examination.

1477 SANTI, FRANCESO. "Pittura e scultura nella basilica di S. Pietro [Perugia]." Bollettino della Deputazione di Storia Patria per l'Umbria 64, no. 2 (1967):167-74, no illus.
 Discusses Mino's altarpiece-tabernacle in Chapel of Holy Sacrament, San Pietro, Perugia, inscribed 1473 and commissioned by the Baglioni Ribi, in context of rest of decoration in San Pietro.

1478 SCHOTTMULLER, FRIDA. "Mino da Fiesole." In Thieme-Becker Künstler-Lexikon. Leipzig: E.A. Seemann, 1930, 24:580-82.
 Condensed survey of life and work. Valuable bibliography.

1479 SCHOTTMULLER, FRIDA. "Mino (Dino) del Reame (Regno)." In Thieme-Becker Künstler-Lexikon. Leipzig: E.A. Seemann, 1930, 24:582.
 Condensed chronological survey with bibliography of artist often identified with Mino da Fiesole.

1480 SCHUBRING, PAUL. "Minos Büste des Rinaldo della Luna in Terra-cotta." Cicerone 14 (1922):202-5, 3 figs.
 Terracotta Bust of Rinaldo della Luna by Mino da Fiesole (Julius Böhler collection, Munich), larger and more subtle in style than marble version (signed by Mino) in Bargello, Florence, is probably modello for it, ca. 1460.

1481 SCIOLLA, GIANNI C. "L'ultima attività di Mino da Fiesole." Critica d'arte 15, no. 96 (June 1968):35-44, 10 figs.
 Discusses Mino's commissions in Florence after return from Rome in 1480: completion of Tomb of Count Hugo (Badia, Florence) and tabernacle, Sant'Ambrogio, Florence. Notes archaistic Sienese influence on Mino in this period.

1482 STEINMANN, E[RNST]. "Cancellata und Cantoria in der Sixtin-ischen Kapelle." Jahrbuch der königlich preussischen Kunst-sammlungen 18 (1897):24-45, 5 figs.
 Two little known architectural ornaments in Sistine Chapel, Rome, are collaborative works of Giovanni Dalmata and Mino da Fiesole, ca. 1477-80.

1483 TSCHUDI, HUGO V. "Das Konfessionstabernakel Sixtus' IV in St. Peter zu Rom." Jahrbuch der königlich preussischen Kunst-sammlungen 8 (1887):11-24, 2 figs.
 Early attempt to analyze sculptural fragments, mainly reliefs from martyrdoms of SS. Peter and Paul from Ciborium of Pope Sixtus IV, here attributed to unknown master influenced by Mino da Fiesole.

1484 VALENTI, FRANCESCO. "Il modello della Madonna nel monumento di Pietro Riario ai Santi Apostoli." Bollettino d'arte, 3d ser. 1 (1933):295-306, 11 figs.
 Argues that terracotta Madonna relief published here is modello for marble version in Tomb of Cardinal Pietro Riario, SS. Apostoli, Rome, attributed to Mino.

1485 V[ALENTINER], W.R. "A Bust of a Florentine Lady by Mino da Fiesole." Bulletin of the Detroit Institute of Arts 7, no. 2 (November 1925):15-17, 2 figs.
Publishes newly acquired portrait Bust of a Woman by Mino da Fiesole (ca. 1455-65) showing his characteristic style (and Desiderio's influence).

1486 VALENTINER, W[ILHELM] R. "Mino da Fiesole." Art Quarterly 7 (1944):150-80, 24 figs.
Thorough summary of Mino's oeuvre, focusing on portraits, Roman period, distinction from Mino del Reame, and late tomb sculptures. Good illustrations. Reprinted in entry 68.

1487 VALENTINER, W[ILHELM] R. "A Portrait Bust of King Alphonso I of Naples." Art Quarterly 1 (1938):61-89, 15 figs.
Discusses Alphonso's biography and iconography, including Mino da Fiesole's marble relief bust (Louvre, Paris). Equates Mino with mysterious "Domenico da Montemigiano," who was commissioned to do portrait of Alphonso, and proposes other attributions to Mino's "Naples period."

1488 WICKOFF, FRANZ. "Ein Pissmännchen von Mino da Fiesole." Zeitschrift für bildende Kunst 24 (1889):198-200, 1 fig.
Attributes marble statue of a boy to Mino da Fiesole (Palazzo della Trocetta, Florence).

NANNI DI BANCO

Books

1489 BELLOSI, LUCIANO. Nanni di Banco. I maestri della scultura, no. 64. Milan: Fratelli Fabbri, [1966], 6 pp., 4 figs., 17 color pls.
Useful color reproductions, including many details, that illustrate all his major works.

1490 PLANISCIG, LEO. Nanni di Banco. Florence: Arnaud Editore, 1946, 58 pp., 65 figs.
Essay tracing career of Nanni di Banco, followed by brief comments and document citations for each illustration. Brief bibliography and index. No footnotes. Valuable photographic corpus with many details.

1490a Brunetti, Giulia. Review of Nanni di Banco, by Leo Planiscig. Belle arti 1, nos. 3-4 (1947):217-19, no illus.
Criticizes format of book, which is incomplete monograph on Nanni: it lacks discussion of sources. Reviews his attributions and chronology.

1491 VACCARINO, PAOLO. Nanni. Introduction by Roberto Longhi. Florence: Sansoni, 1951, 52 pp., 147 pls.

Major monograph on Nanni di Banco. Brief chapters about each commission. Cites or transcribes all known documentation. Extensive photographic corpus with many details. Evaluation flawed by injudicious opinions of author.

1491a Carboneri, Nino. Review of Nanni, by Paolo Vaccarino. Rivista d'arte, 3d ser. 27 (1951-52):231-35, no illus.
Brief review of literature on Nanni di Banco that discusses recent periodical articles but focuses on Vaccarino's monograph.

WUNDRAM, MANFRED. Donatello und Nanni di Banco. Beiträge zur Kunstgeschichte, vol. 3. Berlin: Walter de Gruyter & Co., 1969, 180 pp., 132 figs.
See entry 798.

Unpublished Theses

*1492 PACHALY, GERHARD. "Nanni di Antonio di Banco." Ph.D. dissertation, Heidelberg, 1907.

Articles

1493 BOTTARI, STEFANO. "Una scultura di Nanni di Banco." Emporium 107 (1948):159-62, 4 figs.
Reattributes to Nanni di Banco badly damaged marble head of male figure (Museo dell'Opera del Duomo, Florence), which he had earlier attributed to Jacopo della Quercia.

1494 BRUNETTI, GIULIA. "Un'opera sconosciuta di Nanni di Banco e nuovi documenti relativi all'artista." Rivista d'arte, 2d ser. 12 (1930):229-37, 2 figs.
Attributes to Nanni half-length Prophet relief on exterior of Orsanmichele to right of Four Crowned Saints. Publishes series of documents, primarily referring to elected offices Nanni held.

1495 EINEM, HERBERT von. "Bemerkungen zur Bildhauerdarstellung des Nanni di Banco." In Festschrift für Hans Sedlmayr. Edited by Karl Oettinger and Mohammed Rassem. Munich: Verlag C.H. Beck, 1962, pp. 68-79, 2 figs.
Explains signficance of Nanni di Banco's Orsanmichele socle relief of sculptor, builder, architect, and stonemason in relation to artist's new role in Early Renaissance.

1496 HERZNER, VOLKER. "Bemerkungen zu Nanni di Banco und Donatello." Wiener Jahrbuch für Kunstgeschichte 26 (1973):74-95, 26 figs.
Through comparison of style and documentation, reverses traditional attributions of several works by Nanni di Banco and Donatello. Assigns to young Donatello Christ figure and young Prophet on Porta della Mandorla; attributes to Nanni di Banco tabernacles of St. George, St. Eligius (including the socle relief), and Four Crowned Saints.

1497 JANSON, HORST W. "Nanni di Banco's Assumption of the Virgin on
the Porta della Mandorla." In Studies in Western Art--Acts of
the Twentieth International Congress of the History of Art,
New York, 1961. Vol. 2; The Renaissance and Mannerism.
Princeton: Princeton University Press, 1963, pp. 98-107, 16
figs.
Analyzes Nanni di Banco's Assumption (1414-18) in terms of
style (more gothicizing and archaic than his earlier, classical
style) and iconography (use of tree-climbing bear denotes
wilderness). Source of flying angels may be Byzantine prototypes;
their form affected Florentine artists only after ca. 1450.

1498 KNAPP, FRITZ. "Banco, Nanni d'Antonio di." In Thieme-Becker
Künstler-Lexikon. Leipzig: Wilhelm Englemann, 1908, 2:435-36.
Condensed survey of life and work. Valuable bibliography.

1499 KURZ, OTTO. "Giorgio Vasari's Libro de' desegni." Old-Master
Drawings 12, no. 45 (June 1937):1-15, 33 figs.; no. 47
(December 1937):32-44, 33 figs., appendix with catalogue.
Reconstructs Vasari's famous collection of drawings, many
perhaps obtained from Ghiberti's collection. Reproduces two drawings
by Nanni di Banco (Chatsworth) and one by Desiderio (Victoria and
Albert Museum, London).

1500 LÀNYI, JENO. "Il profeta Isaia di Nanni di Banco." Rivista
d'arte 18, 2d ser. 8 (1936):137-78, 11 figs.
Major article that analyzes documents concerning buttress
statues of North Tribune of Duomo and defines Nanni's style. Con-
cludes that marble David (Bargello, Florence) is by Donatello, and
Isaiah, or "Daniel," is Nanni di Banco's first independent commission
(1408).

1501 LISNER, MARGRIT. "Josua und David: Nannis und Donatellos
Statuen für den Tribuna-Zyklus des Florentiner Doms." Pantheon
32 (1974):232-43, 15 figs.
Contends that documents indicate Nanni carved Isaiah figure
and Donatello David. Argues that figure in Museo dell'Opera del
Duomo is neither Isaiah nor David, but Joshua, and that misidentifi-
cation derives from similar spellings of two names. Considers figure
by Nanni di Banco. David by Donatello is now in Bargello, Florence.
Campanile Prophet, identified as Nanni di Banco commission by Wundram
and Herzner (entries 798, 1088, and 1496) should be associated with
documented commission by Nanni di Bartolo for figure of Elijah for
Campanile.

1502 MILLIKEN, WILLIAM M. "A Marble Bust by Nanni di Banco."
Bulletin of the Cleveland Museum of Art 36, no. 10 (December
1949):188-91, 1 fig. (cover).
Attributes recently discovered marble Bust of a Youth
(perhaps Christ or St. John the Baptist), acquired by Cleveland
Museum, to Nanni di Banco, ca. 1410-14.

1503 PHILLIPS, MICHAEL. "A New Interpretation of the Early Style of
 Nanni di Banco." Marsyas (1962-64):63-66, 12 figs., 1 plan.
 [Abstract of author's Master's thesis, New York University,
 1962, "The Development of the Style of Nanni di Banco."]
 Discounts attribution to Nanni of Annunciation group, Porta
della Mandorla. Provides stylistic division of archivolt reliefs
among Niccolò Lamberti, Antonio di Banco, and Nanni di Banco.
Attributes to Nanni four fragments from right archivolt, 1406 (now in
Museo dell'Opera del Duomo, Florence).

1504 WULFF, OSKAR. "Giovanni d'Antonio di Banco und die Anfänge der
 Renaissanceplastik in Florenz." Jahrbuch der königlich
 preussischen Kunstsammlungen 34 (1913):99-164, 31 figs.
 Attributes marble statue of David, the Psalm Singer
(formerly Kaiser Friedrich Museum, Berlin) to Antonio di Banco,
father of Nanni di Banco. Uses statue and thorough analysis of
documentary evidence to determine role of each in sculpture of Porta
della Mandorla. Discussion of influences on young Donatello.

 NANNI DI BARTOLO ("IL ROSSO")

1505 BELLINI, FIORA. "Da Federighi a Nanni di Bartolo? Riesame di
 un gruppo di terrcotte fiorentine." In Jacopo della Quercia
 fra Gotico e Rinascimento (Atti del Convengno di Studi, Siena,
 1975). Edited by Giulietta C. Dini. Florence: Centro Di,
 1977, pp. 180-83, 11 figs.
 Reattributes three sculptures previously attributed to
Antonio Federighi by Del Bravo: Bust of St. Miniato (San Miniato al
Monte, Florence) to Nanni di Bartolo; Madonna and Child relief
(National Gallery of Art, Washington, D.C.) to Donatello; and Madonna
and Child relief (formerly Kaiser Friedrich Museum, Berlin) to Nanni
di Bartolo.

1506 BIADEGO, GIUSEPPE. "Pisanus Pictor." Atti del Reale istituto
 veneto 72, pt. 2 (1912-13):1315-29, no. illus.
 Reevaluates inscriptions on San Nicola in Tolentino, con-
cluding that Nanni di Bartolo went there no earlier than 1435 and
that he was probably in the Veneto between 1424 and 1435. Questions
attribution of Tomb of Cortesia Serego (Sant'Anastasia, Verona) to
Nanni di Bartolo, suggesting Antonio da Firenze instead.

1507 BRUNETTI, GIULIA. "I Profeti sulla porta del Campanile di
 Santa Maria del Fiore." In Festschrift Ulrich Middeldorf.
 Edited by Antje Kosegarten and Peter Tigler. Berlin: Walter
 de Gruyter & Co., 1968, pp. 106-11, 12 figs.
 Argues against attribution of Christ as Man of Sorrows
relief, Porta della Mandorla, to either Donatello or Nanni di Banco.
Groups sculpture on stylistic grounds with Prophet statue, once in
second niche, east façade, Campanile, three busts of Angels and
frieze fragments; and two statuettes of Prophets, all from the door

decoration of Campanile. All above sculptures, now in Museo
dell'Opera del Duomo, are attributed here to young Nanni di Bartolo
before he came under Donatello's influence.

1508 BRUNETTI, GIULIA. "Riadattamenti e spostamenti di statue
 fiorentine del primo Quattrocento." In Donatello e il suo
 tempo (Atti dell'VIII convegno internazionale di studi sul
 Rinascimento, Florence-Padua, 1966). Florence: Istituto
 Nazionale di Studi sul Rinascimento, 1968, pp. 277-82, 12 figs.
 Contends that Prophet figure from second niche, east
 façade, Campanile, which author attributes to Nanni di Bartolo and
 tentatively entitles Elijah, was originally intended for one of Duomo
 buttresses, not façade, as has been widely believed. Argues that
 second figure from left in Nanni di Banco's Four Crowned Saints
 (Orsanmichele) was originally intended to go on buttress. Operai
 probably intended to decorate all four buttresses, not just two where
 Nanni di Banco's Isaiah and Donatello's David were to have gone.
 These changes in location of statues caution against use of statues'
 location as criterion for identification.

1509 BRUNETTI, GIULIA. "Ricerche su Nanni di Bartolo, 'Il Rosso.'"
 Bollettino d'arte, 3d ser. 28 (1934):258-72, 14 figs.
 Monographic article on Nanni di Bartolo's sculptures in
 Florence and the Veneto. Attributes to him Judgment of Solomon,
 Palazzo Ducale, Venice.

1510 BRUNETTI, GIULIA. "Sull'attività di Nanni di Bartolo
 nell'Italia Settentrionale." In Jacopo della Quercia fra
 Gotico e Rinascimento (Atti del Convegno di studi, Siena,
 1975). Edited by Giulietta C. Dini. Florence: Centro Di,
 1977, pp. 189-91, 12 figs.
 Analyzes recent restoration of Tomb of the Brenzoni by
 Nanni di Bartolo and Pisanello in San Fermo Maggiore, Verona.
 Attributes to Jacopo della Quercia large stone relief of St. George
 Killing the Dragon (Museo Storico dell'Antichità, Cesena), which
 bears Malatesta coat of arms.

1511 Del BRAVO, CARLO. "Proposte e appunti per Nanni di Bartolo."
 Paragone 12, no. 137 (May 1961):26-32, 16 figs.
 Analyzes Nanni di Bartolo's style during Venetian sojourn
 and later: Four Apostles, façade of Santa Maria dell'Orto, here
 dated ca. 1425; Madonna and Child in portal lunette of San Nicola,
 Tolentino, and four nearly nude male doccioni on north side of San
 Marco, dating ca. 1432-34. Attributes figure of Christ on Tomb of
 the Brenzoni, San Fermo Maggiore, Verona, to Nanni di Bartolo (1426).

1512 FABRICZY, CORNELIUS von. "Giovanni di Bartolo, il Rosso, und
 das Portal von S. Niccolò zu Tolentino in den Marken." Reper-
 torium für Kunstwissenschaft 28 (1905):96-98, no illus.
 First thorough analysis of Nanni di Bartolo's work on
 portal of San Nicola in Tolentino; its inscriptions, which date it to

1432-35, and its sculpted components; Madonna and two saints, relief of St. George, half-figure reliefs on pilasters and figure of God the Father. Points out that according to the inscription, Nanni di Bartolo only put the sculptures together, apparently working with some pieces already carved in Venice by others.

1513 GILBERT, CREIGHTON. "La presenza a Venezia di Nanni di Bartolo, il Rosso." In Studi di storia dell'arte in onore di Antonio Morassi. Edited by "Arte Veneta." Venice: Alfieri, 1971, pp. 35-39, no illus.
 Publishes first unequivocal evidence of Nanni di Bartolo's presence in Venice in 1424. Supports attribution to him of Judgment of Solomon relief (Palazzo Ducale). Questions document of 1451 that has been interpreted as meaning that Nanni was still alive at that time. Argues last recorded date for Nanni is work in San Nicola in Tolentino of 1435.

1514 P[LANISCIG], L[EO]. "Rosso, Giovanni (Nanni) di Bartolo, called 'Il Rosso.'" In Thieme-Becker Künstler-Lexikon. Leipzig: E.A. Seemann, 1935, 29:58-59.
 Condensed survey of life and work. Valuable bibliography.

1515 SCHLEGEL, URSULA. "Dalla cerchia del Ghiberti: Rappresentazioni della Madonna di Nanni di Bartolo." Antichità viva 18, no. 1 (1979):21-26, 10 figs.
 Attributes to Nanni di Bartolo five Madonna and Child sculptures in museums in Berlin and Krefeld, Germany. Sculptures previously attributed to Ghiberti's circle.

1516 SCHOTTMULLER, FRIDA. "Nanni di Bartolo, Il Rosso." In Miscellanea di storia dell'arte in onore di Igino Benvenuto Supino. Edited by Giuseppe Fiocco, et al. Florence: Leo S. Olschki, 1933, pp. 295-304, 3 figs.
 Clarifies what is known of Nanni di Bartolo, his life and artistic style. Attributes to Nanni di Bartolo two unpublished works, both seated Madonnas in terracotta (Kaiser Wilhelm Museum, Krefeld; Kaiser Friedrich Museum, Magdeburg); also a later Gothicizing king in wood, from an Epiphany (formerly Kaiser Friedrich Museum, Berlin).

NEROCCIO DEI LANDI

Books

1517 COOR, GERTRUDE. Neroccio de' Landi, 1447-1500. Princeton: Princeton University Press, 1961, 235 pp., 146 figs.
 Scholarly monograph that deals primarily with Neroccio as painter but discusses his limited sculptural production in relation to Verrocchio's and Francesco di Giorgio's influence. With catalogue of documents, including very detailed will.

1517a Stubblebine, James H. Review of Neroccio de' Landi, 1447-1500, by Gertrude Coor. Speculum 37 (1962):425-29, no illus.

1517b Vertova, Luisa. Review of Neroccio de' Landi, 1447-1500, by Gertrude Coor. Apollo 76, no. 4 (June 1962):320-22, 1 figs.
 Situates Neroccio (as both painter and sculptor) as minor talent responding to fashions of late fifteenth-century Siena.

 Articles

1518 CARLI, ENZO. "Two Stucco Reliefs by Neroccio di Bartolommeo." In Collaboration in Italian Renaissance Art (Charles Seymour, Jr. Festschrift). Edited by Wendy Stedman Sheard and John Paoletti. New Haven and London: Yale University Press, 1978, pp. 21-29, 6 figs.
 Two large stucco reliefs, interior portal of "Pellegrinaio," Hospital of Santa Maria della Scala, Siena, are attributed to Neroccio. One bears Capacci coat of arms suggesting pair were commissioned by Salibene di Cristofano Capacci, while rector of hospital between 1483 and 1497.

1519 DAMI, LUIGI. "Neroccio di Bartolomeo Landi." Rassegna d'arte 13 (October 1913):160-70, 12figs.
 Brief discussion of Neroccio's most important sculptures, Sta. Caterina of Fonte Branda (1465-74); Tomb of Bishop Piccolomini in Duomo, Siena (1464); and Sta. Caterina in Duomo, Siena.

1520 SCHUBRING, PAUL. "Landi, Neroccio di Bartolomeo di Benedetto de'." In Thieme-Becker Künstler-Lexikon. Leipzig: E.A. Seemann, 1928, 22:295-96.
 Condensed survey of life and work. Valuable bibliography.

NICCOLO DI GIOVANNI COCARI (NICCOLO FIORENTINO)

 Books

1521 SCHULZ, ANNE MARKHAM. Niccolò di Giovanni Fiorentino and Venetian Sculpture of the Renaissance. New York: New York University Press, 1978, 136 pp. 101 figs.
 Analysis of Venetian period of Niccolò di Giovanni Fiorentino, whom author does not identify with Niccolò di Giovanni Cocari. Attributes to him Tomb of Doge Francesco Foscari (Santa Maria Gloriosa dei Frari); sections of Arco Foscari, Ducal Palace; the Tomb of Orsato Giustiniani (Sant'Andrea della Certosa, now dispersed); and Tomb of Vittore Capello (Sant'Elena). Only comprehensive study of this sculptor. Appendix with lengthy digest of documents concerning him. Extensive corpus of photographs, many taken expressly for this book.

1521a Kruft, Hanno-Walter. Review of Niccolò di Giovanni Fiorentino and Venetian Sculpture of the Renaissance, by Anne Markham Schulz. Kunstchronik 33 (1980):108-110, no illus.

Articles

1522 FOLNESICS, HANS. "Studien zur Entwicklungsgeschichte der Architektur und Plastik des XV Jahrhunderts in Dalmatien." Jahrbuch des kunsthistorischen Institutes der k. k. Zentralkommission für Denkmalpflege, n.s. 8 (1914):27-196, 160 figs.
 Best single source on Florentine artists in Dalmatia. Includes important discussion of sculpture of Orsini Chapel, Trau, as well as thorough considerations of Niccolò di Giovanni Fiorentino, Giovanni Dalmata, and Andrea Alexi. Discusses Michelozzo's late work in Ragusa.

1523 FREY, DAGOBERT. "Der Dom von Sebenico und sein Baumeister Giorgio Orsini." Jahrbuch des kunsthistorischen Institutes der k. k. Zentralkommission für Denkmalpflege, n.s. 7 (1913):1-169, 82 figs., plans, maps, diags.
 Monographic study of Cathedral of St. James, Sibenik (Yugoslavia). Useful for thorough analysis of Orsini Chapel and late architecture of Niccolò di Giovanni Fiorentino, proto maestro of cathedral, 1477-1505. Includes appendix of documents compiled by Vojeslav Molè.

1524 STELE, FR. "Niccolò di Giovanni Cocari, gen. Niccolò Fiorentino." In Thieme-Becker Künstler-Lexikon. Leipzig: E.A. Seemann, 1931, 25:434.
 Condensed survey of life and work. Valuable bibliography.

PAGNO DI LAPO PORTIGIANI

1525 ANON. "Pagno di Lapo Portigiani." In Thieme-Becker Künstler-Lexikon. Leipzig: E.A. Seemann, 1932, 26:144.
 Condensed survey of life and work. Valuable bibliography.

1526 FABRICZY, CORNELIUS von. "Pagno di Lapo Portigiani." Jahrbuch der königlich preussischen Kunstsammlungen (supp.) 24 (1903): 119-36, no illus.
 Assembles and analyzes all documents relevant to Pagno di Lapo. Includes chronology of his life.

PAOLO DI MARIANO OR PAOLO ROMANO

1527 ANON. "Taccone, Paolo di Mariano, gen. Paolo Romano." In Thieme-Becker Künstler-Lexikon. Leipzig: E.A. Seemann, 1938, 32:392.
 Condensed survey of life and work. Valuable bibliography.

1528 BERTOLOTTI, A[NTONINO]. "Urkundliche Beiträge zur Biographie des Bildhauers Paolo di Mariano." Repertorium für Kunstwissenschaft 4 (1881):426-42, no illus.

Publishes series of archival notices and documents regarding Paolo di Mariano (Paolo Romano), including his will and its codicils. Includes references to his and Isaia da Pisa's work on Tabernacle of St. Andrew (Vatican Grottoes, Rome) and their work on Benediction Pulpit of Pius II (1463-64), now dispersed.

1529 BURGER, FRITZ. "Das Konfessionstabernakel Sixtus' IV. and sein Meister." Jahrbuch der königlich preussischen Kunstsammlungen 28 (1907):95-116, 20 figs.
 Reconstructs Ciborium of Pope Sixtus IV for St. Peter's, ca. 1480, with stylistic discussion of reliefs of Martyrdoms of SS. Peter and Paul (fragments now in Vatican Grottoes, Rome). Scenes derive in part from reliefs on Trajan's Arch and can be attributed to Paolo Romano, who was influenced by Mino da Fiesole.

1530 CHASTEL, ANDRE. "Two Roman Statues: Saints Peter and Paul." In Collaboration in Italian Renaissance Art (Charles Seymour, Jr. Festschrift). Edited by Wendy Stedman Sheard and John T. Paoletti. New Haven and London: Yale University Press, 1978, pp. 59-76, 9 figs.
 Traces later history of statue of St. Paul by Paolo Romano, a papal commission ca. 1460, which was placed on a pedestal on Ponte Sant'Angelo, together with a St. Peter by Lorenzetto, in ca. 1530.

1531 CORBO, ANNA MARIA. "L'attività di Paolo di Mariano a Roma." Commentari 17 (1966):195-226, no illus.
 Major article that assembles and transcribes all documents pertaining to Paolo Romano's Roman period.

1532 CORBO, ANNA MARIA. 'Un'opera sconosciuta e perduta di Paolo Romano: Il tabernacolo di San Lorenzo in Damaso." Commentari, n.s. 24, nos. 1-2 (1973):120-21, no illus.
 Publishes contract of 1465 recording Paolo Romano's commission to carve marble tabernacle for San Lorenzo in Damaso, Rome (now lost).

1533 HOOGEWERFF, G.J. "De beeldhouwkunst te Rome in den loop der XIVe eeuw: Het altaar en grafmonument van den Kardinaal d'Alençon." Mededeelingen van het Nederlandsch historisch instituut te Rome 4 (1924):123-52, 7 figs.
 Discusses sculpture by Paolo Romano, particuarly Tomb of Cardinal d'Alençon (Santa Maria in Trastevere, Rome), usually attributed to him, but here reassigned to Giovanni d'Ambrogio and his son, Lorenzo. Author claims these artists sculpted only extant fifteenth-century sections of monument, the effigy and ciborium.

1534 LEONARDI, VALENTINO. "Paolo di Mariano marmoraro." Arte 3 (1900):259-74, 4 figs.
 Clarifies Paolo di Mariano's (Paolo Romano) career in Rome, pointing out that he carved two statues of St. Paul for St. Peter's (1461 and 1463) and reviewing his other commissions in that city.

Attributes to young Paolo damaged statue of St. James of Compostella for San Giacomo.

1535 MUÑOZ, ANTONIO. "Maestro Paolo da Gualdo, detto 'Paolo Romano.'" Rassegna d'arte umbra 2, nos. 2-3 (1911):29-35, 3 figs.
 Distinguishes the Paolo Romano (or Paolo da Gualdo) who sculpted Tomb of Bartolommeo Caraffa (Santa Maria del Priorato, Rome), Tomb of Cardinal Stefaneschi (Santa Maria in Trastevere, Rome), and other works from Paolo di Mariano di Tuccio and other artists with similar names.

1536 NEW YORK, METROPOLITAN MUSEUM OF ART. The Vatican Collections: The Papacy and Art. Catalogue no. 10. New York: Metropolitan Museum of Art, 1982, pp. 40-41, 8 figs.
 Most recent scholarly discussion of eight reliefs of Trials of the Apostles Peter and Paul, from so-called Ciborium of Pope Sixtus IV, High Altar, St. Peter's, generally attributed to Paolo Romano and his shop, ca. 1460-64. Includes bibliography.

1537 VALENTINER, W[ILHELM] R. "Italian Renaissance Sculpture: The Tomb of Roberto Malatesta." Art in America 35, no. 4 (October 1947):300-312, 4 figs.
 Attributes to Antonio Pollaiuolo large equestrian relief of Roberto Maltesta (d. 1482) in Louvre (originally from St. Peter's, Rome), wrongly attributed by Vasari to Paolo Romano.

PASQUINO DI MATTEO DA MONTEPULCIANO

1538 NUTI, RUGGERO. "Pasquino di Matteo da Montepulciano e le sue sculture nel Duomo di Prato." Bullettino senese di storia patria 17, n.s. 10 (1939):338-41, no illus.
 Summary of published information about roles of Maso di Bartolommeo, Pasquino da Montepulciano, Mino da Fiesole, and Antonio Rossellino in decoration of Cappella della Cingola, Duomo, Prato.

1539 PLANISCIG, L. "Pasquino di Matteo da Montepulciano." In Thieme-Becker Künstler-Lexikon. Leipzig: E.A. Seemann, 1932, 26:275.
 Condensed survey of life and work. Valuable bibliography.

PERFETTO DI GIOVANNI

1540 ANON. "Perfetto di Giovanni." In Thieme-Becker Künstler-Lexikon. Leipzig: E.A. Seemann, 1932, 26:411.
 Condensed survey of life and work. Valuable bibliography.

PIETRO DEL MINELLA

1541 ANON. "Minella, Pietro di Tommaso del." In Thieme-Becker Künstler-Lexikon. Leipzig: E.A. Seemann, 1930, 24:575-76.
Condensed survey of life and work. Valuable bibliography.

ANTONIO POLLAIUOLO

Books

1542 BUSIGNANI, ALBERTO. Pollaiuolo. Florence: Edizioni d'Arte il Fiorino, 1970, 359 pp., 146 figs., 20 color pls.
Major monograph on Antonio and Piero Pollaiuolo with catalogue raisonné of certain, attributed, and lost works. Extensive bibliography. Specific comments on each illustration. Indexed.

1543 CHIARINI, MARCO. Antonio Pollaiuolo. I maestri della scultura, vol. 1. Milan: Fratelli Fabbri, [1966], 6 pp., 4 figs., 17 color pls.
Large, clear color plates illustrating most of documented and attributed sculpture of Pollaiuolo.

1544 COLACICCHI, GIOVANNI. Antonio del Pollaiuolo. Florence: Chessa, 1943, 34 pp., 98 figs.
Brief appreciation of Pollaiuolo followed by corpus of large, clear black-and-white illustrations.

1544a Pope-Hennessy, John. Review of Antonio del Pollaiuolo, by Giovanni Colacicchi. Burlington Magazine 88 (July 1946): 180-81, no illus.

1545 CRUTTWELL, MAUD. Antonio Pollaiuolo. London: Duckworth & Co.; New York: Charles Scribner's Sons, 1907, 286 pp., 51 figs., appendices.
Early, partly superseded monograph, still useful for its thorough compilation of stylistic and documentary information.

1546 ETTLINGER, LEOPOLD D. Antonio and Piero Pollaiuolo. Oxford and New York: Phaidon, 1978, 183 pp., 159 figs., 4 color pls.
Principal monograph, with introductory essay that establishes historical position of Pollaiuolo brothers, reasserts role and importance of Piero, and examines their work in all media. With detailed critical catalogues.

1546a Ames-Lewis, Francis. Review of Antonio and Piero Pollaiuolo, by Leopold D. Ettlinger. Burlington Magazine 122, no. 924 (March 1980):198-99, no illus.
Suggests art historical problems not raised by Ettlinger's brief text: relation of Pollaiuolo and Maso Finiguerra, Pollaiuolo's

response to antique, Pollaiuolo and birth of landscape painting in Italy, and relationship between Pollaiuolo as goldsmith/sculptor and as painter.

1547 ORTOLANI, SERGIO. Il Pollaiuolo. . . . Milan: Ulrico Hoepli, 1948, 249 pp., 202 figs.
 Essay on Antonio's stylistic development as traced in his major commissions. Biographical data with references to sources. Lists of works attributed to him and lost works. Comments on each illustration. No notes or bibliography.

1548 SABATINI, ATTILIO. Antonio e Piero del Pollaiuolo. Monografie e studi, Istituto di Storia dell'Arte dell'Università di Firenze, vol. 4. Florence: G.C. Sansoni, 1944, 141 pp., 64 figs.
 Essay on work of Antonio Pollaiuolo, analysis of his biography, and catalogue raisonné of secure works, attributions, lost works, and drawings by Antonio and his students. Brief remarks about his brother, Piero. Extensive bibliography. Inadequate illustrations.

1548a Pope-Hennessy, John. Review of Antonio e Piero del Pollaiuolo, by Attilio Sabatini. Burlington Magazine 88 (July 1946): 180-81, no illus.

1548b Pittaluga, Mary. Review of Antonio e Piero del Pollaiuolo, by Attilio Sabatini. Rivista d'arte 26, 3d. ser. 1 (1950):241-44, no illus.

Unpublished Theses

1549 FUSCO, LAURIE S. "The Nude as Protagonist: Pollaiuolo's Figural Style Explicated by Leonardo's Study of Static Anatomy, Movement, and Functional Anatomy." Ph.D. dissertation, New York University, 1978, 446 pp., 554 figs. [Dissertation Abstracts 39/06 (December 1978):3189A-90A.]
 Uses Leonardo's criteria for scientific study of anatomy to understand Antonio Pollaiuolo's attitude toward figure studies. Stresses importance of dissection to Renaissance artists. Examines in detail Pollaiuolo's technique.

Articles

1550 BELTRAMI, GIUSEPPE. "Il monumento sepolcrale di Sisto IV e sue vicende." In Atti del IIIe congresso nazionale di studi romani. Rome: Istituto di Studi Romani, 1935, 2:369-79, 4 figs.
 Analyzes documents and available information concerning original appearance, location, and later transfer of Pollaiuolo's Tomb of Pope Sixtus IV, now in Vatican Grottoes.

1551 BEMPORAD, DORA LISCIA. "Appunti sulla bottega orafa di Antonio del Pollaiuolo e di alcuni suoi allievi." Antichità viva 19, no. 3 (May-June 1980):47-53, 8 figs.

Documents from silk guild registers, where Antonio's name appears often, reveal that he headed one of most active late fifteenth-century silversmith shops and trained many important silversmiths.

1552 BORSOOK, EVE. "Two Letters Concerning Antonio Pollaiuolo." Burlington Magazine 115, no. 844 (July 1973):464-68, no illus., appendix.
 Correspondence of Jacopo and Giovanni Lanfredini (Biblioteca nazionale, Florence), sheds light on Pollaiuolo's relations with patrons, including Piero de' Medici. Clarifies dating (ca. 1461) of Pollaiuolo's painted Labors of Hercules (lost) for the Palazzo Medici[-Riccardi].

1553 BUNT, CYRIL G.E. "A Florentine Nielloed Cross." Burlington Magazine 65 (July 1934):26-30, 4 figs.
 Large nielloed cross (J.P. Morgan collection, New York), bearing short inscription and mongram "AP" is attributed to Antonio Pollaiuolo before 1484 and traced to Convent of Santa Chiara, Florence.

1554 CARL, DORIS. "Zur Goldschmiedefamilie Dei." Mitteilungen des Kunsthistorischen Institutes in Florenz 26, no. 2 (1982): 130-66, 5 figs.
 Publishes extensive documentation that clarifies history of Dei family. Significant for Antonio Pollaiuolo, who worked with them from 1457 to 1459 on silver cross, Baptistry, Florence (now Museo dell'Opera del Duomo). Concludes that Pollaiuolo did lower part of cross. Documents also describe composition of Pollaiuolo's studio from 1459 to 1487, prove Verrocchio's presence in Dei shop (1453-56), and discuss latter's relationship with Francesco di Luca Verrocchio, whose name he took.

1555 CHIAPPELLI, ALBERTO. "I beni di Antonio del Pollaiuolo intorno a Pistoia." Bullettino storico pistoiese 3 (1901):110, no illus.
 Summary of Pollaiuolo's business dealings in Pistoia, with references to corroborating documents.

1556 COVI, DARIO A. "Nuovi documenti per Antonio e Piero del Pollaiuolo e Antonio Rossellino." Prospettiva 12 (January 1978):61-72, 3 figs.
 Publication of forty-nine new documents from Archivio dell'Ospedale degli Innocenti, Florence, concerning Pollaiuolo's metalwork commissions. Includes those for Cardinal Francesco Gonzaga and Benedetto Salutati in 1468, on the latter of which Antonio Rossellino also worked.

1557 CRUTTWELL, MAUD. "Quattro portate del catasto e della decima fatte da Antonio Pollaiuolo, dal fratello Giovanni, e da Jacopo loro padre." Arte 8 (1905):381-85, no illus.

First complete transcription of tax declarations of Jacopo Pollaiuolo for 1457; of Giovanni and Antonio for 1480; and of Antonio for 1498.

1558 DAMI, LUIGI. "Due nuove opere pollaiolesche." Dedalo 4 (1924):695-710, 12 figs.
 Attributes to Antonio (with Piero's possible assistance) painting of Archangel Michael (Museo Bardini, Florence) and identifies stucco relief of Hercules and Cacus (Palazzo Guicciardini, Florence), as reflection of lost composition by Antonio. [Ettlinger, entry 1546, rejects first attribution (cat. no. 40) and omits second.]

1559 DAMI, LUIGI. "Il cosiddetto Machiavelli del Museo del Bargello." Dedalo 6 (February 1926):559-69, 9 figs.
 Attributes to Antonio a marble Bust of a Man (Bargello, Florence) dated 1495 but proves it does not represent Machiavelli. This bust, which would be Antonio's only marble sculpture, is rejected by Ettlinger and others. See Ettlinger, entry 1546, cat. no. 67.

1560 D'ANCONA, PAOLO. "Le rappresentazioni allegoriche delle arti liberali nel Medio Evo e nel Rinascimento." Arte 5 (1902): 137-55, 211-28, 270-89, 370-85, 64 figs.
 Analysis of iconography of Liberal Arts from pulpits of Nicola Pisano through the Stanze of Raphael; includes Campanile reliefs by Luca della Robbia, Tomb of Pope Sixtus IV by Antonio Pollaiuolo, and Tempio Malatestiano reliefs of Agostino di Duccio and Matteo de' Pasti.

1561 DEGENHART, BERNHARD. "Unbekannte Zeichnungen Francesco di Giorgios, II, Francesco di Giorgio und Pollaiuolo: Das früheste nachweisbare Modellmännchen." Zeitschrift für Kunstgeschichte 8 (1939):125-35, 10 figs.
 Incisive analysis of drawings by Pollaiuolo and his school and their relationship to drawings and reliefs by Francesco di Giorgio. Near-identical shop drawings of anatomical subjects suggest use of sculpted mannikins by Pollaiuolo.

1562 De NICOLA, GIACOMO. "Opere perdute del Pollaiuolo." Rassegna d'arte antica e moderna 18 (1918):210-14, 4 figs.
 Identifies drawing by Alfonso Ciacconio of Martyrdom of St. Sebastian as recording lost relief by Antonio Pollaiuolo.

1563 EITELBERGER, R. von. "Zwei Niellen von Antonio Pollaiuolo." Repertorium für Kunstwissenschaft 5 (1882):106, no illus.
 Two niellos in collection of Alexander Castellani (scenes from life of Mary and Three Kings with Angels in Glory) are attributed to Antonio Pollaiuolo.

1564 ETTLINGER, LEOPOLD D. "Hercules Florentinus." Mitteilungen
 des Kunsthistorischen Institutes in Florenz 16, no. 2 (1972):
 128-42, 20 figs. [Summary in Italian.]
 Traces iconography of Hercules as symbol of Florence,
including Trecento use on city seal, various representations on Porta
della Mandorla (ca. 1391-1405), and Pollaiuolo's painted and sculpted
versions for Lorenzo de' Medici.

1565 ETTLINGER, LEOPOLD. "Pollaiuolo." In Encyclopedia of World
 Art. London: McGraw-Hill Publishing Co., 1966, 11: cols.
 415-20, figs. 179-86.
 Concise survey of Pollaiuolo's life and work by leading
authority. With bibliography.

1566 ETTLINGER, LEOPOLD. "Pollaiuolo's Tomb of Pope Sixtus IV."
 Journal of the Warburg and Courtauld Institutes 16 (1953):
 239-74, 37 figs., 1 diag., appendices.
 Very detailed study of unusual Tomb of Pope Sixtus IV (St.
Peter's, Rome, ca. 1484-93) that investigates sources of design,
reasons for its location, and intricate, sophisticated iconography of
reliefs.

1567 FUSCO, LAURIE. "Antonio Pollaiuolo's Use of the Antique."
 Journal of the Warburg and Courtauld Institutes 42 (1979):
 257-63, 39 figs.
 Through examining Pollaiuolo's drawings and general antique
precedents, clarifies his pattern book method of combining and
reversing stock poses. Links Hercules and Antaeus sculpture
(Bargello, Florence) to Villa Gallina frescoes of dancers and to
unpublished drawing after Pollaiuolo (Oppé collection, England).

1568 HAINES, MARGARET. "Documenti intorno al reliquario per San
 Pancrazio di Antonio del Pollaiuolo e Piero Sali." In Scritti
 di storia dell'arte in onore di Ugo Procacci. 2 vols. Milan:
 Electa, 1977, 1:264-69, 2 figs.
 Publishes series of documents and drawing related to
Pollaiuolo's lost gold Reliquary of San Pancrazio for San Pancrazio,
Florence.

1569 HOFF, URSULA. "The Sources of 'Hercules and Antaeus' by
 Rubens." In In Honour of Daryl Lindsey: Essays and Studies.
 Edited by Franz Philipp and Jane Stewart. Melbourne: Oxford
 University Press, 1964, pp. 67-79, 19 figs., appendix.
 Traces iconography of Rubens's oil sketch of Hercules and
Antaeus (National Gallery of Victoria, Australia). Cites Philos-
tratus and Lucan as literary sources for posing of Pollaiuolo's
sculptural group, which represents synthesis of medieval and
classical style and iconography.

1570 HULSEN, CHRISTIAN, and EGGER, HERMANN. Die römischen Skizzen-
 bücher von Martin van Heemskerck. 2 vols. Berlin: J. Bard,
 1913-16.

Heemskerck's Roman sketchbooks of ca. 1532–36 show original states of Pollaiuolo's Tombs of Pope Sixtus IV (1:pl. 73) and Pope Innocent VIII (2:pl.27).

1571 JACOBSEN, MICHAEL A. "A Note on the Iconography of Hercules and Antaeus in Quattrocento Florence." Source: Notes in the History of Art 1, no. 1 (Fall 1981):16–20, 3 figs.
 Interprets representations of Hercules and Antaeus, including Pollaiuolo's bronze, in light of Salutati's De Laboribus Herculis and Landino's De Vera Nobilitate, which present Antaeus as representing vice.

1572 KRISTELLER, PAUL. "Die italienischen Niellodrucke und der Kupferstich des XV Jahrhunderts." Jahrbuch der königlich preussischen Kunstsammlungen 15 (1894):94–119, 11 figs.
 Thorough survey of rise of niello technique among mid-fifteenth-century Florentine and Bolognese goldsmiths. Focuses on Maso Finiguerra, originator of technique, and Antonio Pollaiuolo in Florence.

1573 LISNER, MARGRIT. "Ein Krucifixus des Antonio del Pollaiuolo in San Lorenzo in Florenz." Pantheon 25 (1967):319–28, 9 figs. [Summary in English.]
 Attributes to Pollaiuolo poorly preserved corkwood Crucifix (originally from church of San Basilio, now San Lorenzo, Florence, ca. 1470), ascribed by Vasari to mythical Simone, brother of Donatello.

1574 LÓPEZ-REY y ARROJO, JOSE. Antonio del Pollaiuolo y el fin del Quattrocento. Boletin de la Sociedad española de excursiones. Madrid: Hauser & Menet, 1935, 57 pp., 20 figs.
 Compressed catalogue raisonné. Comprehensive bibliography. Poor illustrations.

1575 MACKOWSKY, HANS. "Das Silberkreuz für den Johannisaltar im Museo di Santa Maria del Fiore zu Florenz." Jahrbuch der königlich preussischen Kunstsammlungen 23 (1902):235–46, 4 figs.
 Commission to transform altar cross into reliquary for piece of true cross given to Antonio Pollaiuolo, Miliano di Domenico Dei, and Betto di Francesco Betti in 1457, according to new documents.

1576 MARCHINI, GIUSEPPE. "Ricchezze sconosciute della provincia." In Festschrift Ulrich Middeldorf. Edited by Antje Kosegarten and Peter Tigler. Berlin: Walter De Gruyter & Co., 1968, pp. 161–64, 3 figs.
 Attributes to Antonio Pollaiuolo gold Reliquary of St. Christopher (Cathedral, Urbanio) inscribed 1472 and made for relic donated by Cardinal Bessarion. Rejected by Ettlinger, entry 1546, cat. no. 68.

1577 MAYOR, A. HYATT. "Artists as Anatomists." <u>Metropolitan Museum of Art Bulletin</u> 22 (February 1964):201-10, 11 figs.
Argues that Pollaiuolo, whom he accepts as first artist to use dissection commonly to study anatomy, probably recorded his studies in wax models rather than drawings. Traces influence of such anatomical sculptures on Pollaiuolo's and Mantegna's prints.

1578 MELLER, SIMON. "Antonio Pollaiuolo tervrajzai Francsco Sforza lovasszobráhorz." [Antonio Pollaiuolo's projects for the equestrian statue of Francesco Sforza]. In <u>Petrovics Elek Emlékönyv: Miscellanea in onore di Alesso Petrovic.</u> Budapest: Hungarian Museum of Fine Arts, 1934, pp. 76-79, 2 figs. [Summary in Italian, pp. 204-5.]
In Hungarian. Identifies newly discovered drawing in unnamed private collection, New York (now in Robert Lehman collection, Metropolitan Museum of Art, New York), as project by Antonio Pollaiuolo for Equestrain Monument of Francesco Sforza, ca. 1480-82. [See Ettlinger, entry 1546, cat. no. 34.]

1579 MIDDELDORF, ULRICH. "Two Little-Known Florentine Marbles in the Musée Jacquemart-André." <u>Art in America</u> 25, no. 4 (October 1937):154-63, 7 figs.
Marble relief of <u>Caesar</u> is ascribed to Pollaiuolo and marble <u>Bust of a Gentleman</u> attributed to Benedetto da Maiano, ca. 1475-80. Reprinted in entry 54.

1580 MUNTZ, E[UGENE]. "Nuovi documenti: L'architettura a Roma durante il pontificato d'Innocenzo VIII." <u>Archivio storico dell'arte</u> 4 (1891):363-70, 2 figs.
Comments on descriptions of Tomb of Pope Innocent VIII (St. Peter's, Rome) in fifteenth-century Magliabechiano Codex and in Grimaldi's remarks (written in the seventeenth century) about its relocation in new St. Peter's.

1581 PANE, ROBERTO. "Guido Mazzoni e la Pietà di Monteoliveto." <u>Napoli nobilissima</u> 11 nos. 4-6 (1972):49-69, 10 figs.
Reattributes to Mazzoni terracotta <u>Bust of Charles VIII</u> (Bargello, Florence), traditionally assigned to Antonio Pollaiuolo.

1582 PARRONCHI, ALESSANDRO. "Il modello michelangiolesco del 'David' bronzeo per Pietro di Roano." <u>Arte antica e moderna</u> 5, no. 18 (1962):170-80, 20 figs.
Argues that small bronze figure of <u>David</u> (Museo e gallerie di Capodimonte, Naples) is model by Michelangelo for marble <u>David</u> (Accademia, Florence). It was commissioned from him by Pierre de Rohan in 1501 and was to imitate Donatello's <u>David</u>. The statuette has been attributed to Antonio Pollaiuolo and Francesco di Giorgio.

1583 PARRONCHI, ALESSANDRO. "Prima traccia dell'attività del Pollaiolo per Urbino." <u>Studi urbinati di storia, filosofia e letteratura</u> 45, nos. 2-3 (1971):1176-94, 25 figs.

Letter from Duke of Urbino to Lorenzo de' Medici establishes Pollaiuolo's presence in Urbino in 1473. Likely he was working for Duke in late 1471. Attributes to Pollaiuolo Bust of Battista Sforza (Bargello, Florence) and various architectural and decorative projects in Palazzo Ducale.

1584 RAGGHIANTI, CARLO L. "Antonio Pollaiolo e l'arte fiorentina dell'400." Critica d'arte 1 (1935):10-17, 69-81, 115-26, 157-65, 54 figs.
 Outline of fifteenth-century Florentine painting, sculpture, and architecture that serves as background for Ragghianti's projected monograph on Pollaiuolo.

1585 REYMOND, MARCEL. "Le buste de Charles VIII par Pollaiuolo (Musée de Bargello) et le tombeau des enfants de Charles VIII (Cathédrale de Tours)." In Bulletin archéologique du Comité des travaux historiques et scientifiques. Paris: Imprimerie Nationale, 1895, pp. 245-52, no illus.
 Argues that Pollaiuolo's terracotta Bust of Charles VIII (Bargello, Florence) was probably sculpted during king's trip to Rome in January 1495. Charles's preference for Pollaiuolo also reflected in his children's tomb (Cathedral, Tours, ca. 1496-1500), decorated with scenes of Hercules and Samson after compositions by Pollaiuolo.

1586 SANPAOLESI, PIERO. "Due sculture quattrocentesche inedite." Belle arti, 1951:71-80, 6 figs.
 Attributes to Antonio Pollaiuolo silver Bust of St. Ottaviano (Duomo, Volterra), relating it to documents for such a commission dated 1466-70. Attributes to Verrocchio terracotta Bust of a Man (Museo nazionale di San Matteo, Pisa).

1587 SCHIAVO, ARMANDO. "La cappella vaticana del coro e vicende dei sepolcri di Sisto IV e Giulio II." Studi romani 6 (1958): 297-307, 5 figs.
 Reconstructs destroyed chapel of Sixtus IV on south side of Old St. Peter's, where Pollaiuolo's Tomb of Pope Sixtus IV was intended to stand.

1588 SCHOTTMULLER, FRIDA. "Pollaiuolo (Pollagiolo), Antonio di Jacopo d'Antonio (Benci) del." In Thieme-Becker Künstler-Lexikon. Leipzig: E.A. Seemann, 1933, 27:210-14.
 Condensed survey of life and work. Valuable bibliography.

1589 SHAPLEY, FERN R. "A Student of Ancient Ceramics: Antonio Pollajuolo." Art Bulletin 2, no. 2 (December 1919):78-86, 13 figs.
 Traces Pollaiuolo's characteristic style—sharp clear outlines, eccentric movement, and awkward grace—to study of Greek vase painting and ceramics in fifteenth-century Florence.

1590 STITES, RAYMOND S. "Leonardo da Vinci: Sculptor." Art Studies 4 (1926):103-10, 10 figs.

Attributes to Leonardo terracotta group (Camondo collec-
tion, Louvre, Paris), usually attributed to Pollaiuolo.

1591 ULMANN, HERMANN. "Bilder und Zeichnungen der Brüder
 Pollajuoli." Jahrbuch der königlich preussischen Kunst-
 sammlungen 15 (1894):230-47, 4 figs., catalogue.
 Early attempt to delineate oeuvre of the Pollaiuolo with
 stylistic analysis of key works and list of attributions.

1592 VENTURI, ADOLFO. "Frauenbildnisse von Antonio Pollaiolo."
 Pantheon 3 (1929):12-15, 4 figs.
 Attributes female profile portrait (Howard Young Galleries,
 New York) to Antonio Pollaiuolo.

1593 VENTURI, ADOLFO. "Una lettura di Antonio del Pollaiuolo."
 Archivio storico dell'arte 5 (1892):208-11, 1 fig.
 Publishes autograph letter by Antonio to Virginio Orsini in
 1494 that mentions his Tomb of Pope Sixtus IV (St. Peter's, Rome).

1594 VENTURI, ADOLFO. "Per Antonio Pollaiuolo." Arte 29 (1926):
 179-81, 2 figs.
 Attributes to Antonio terracotta figure of Sleeping Man,
 previously assigned to Verrocchio, formerly in Kaiser Friedrich
 museum, Berlin (now in Staatliche Museen, Berlin-Dahlem).

1595 VENTURI, ADOLFO. "Romolo e Remo di Antonio Pollaiuolo nella
 Lupa Capitolina." Arte 22 (1919):133-35, 1 fig.
 Attributes to Antonio Pollaiuolo figure of Romulus and
 Remus added to Etruscan bronze She-Wolf (Palazzo dei Conservatori,
 Rome) before 1510. [Rejected by Ettlinger, entry 1546, cat. no. 66.]

1596 VICKERS, MICHAEL "A Greek Source for Antonio Pollaiuolo's
 Battle of the Nudes and Hercules and the Twelve Giants." Art
 Bulletin 59, no. 2 (1977):182-87, 9 figs.
 Pollaiuolo's style reflects not just general understanding
 of Greek vase painting but specific emulation of one artist, the
 Niobid Painter. Pollaiuolo's print, Battle of the Nudes, may reflect
 lost work by Niobid Painter.

PIERO POLLAIUOLO

1597 SCHO[TTMULLER], F[RIDA]. "Pollaiuolo, Piero di Jacopo
 d'Antonio Benci del." In Thieme-Becker Künstler-Lexikon.
 Leipzig: E.A. Seemann, 1933, 27:215.
 Condensed survey of life and work. Valuable bibliography.

JACOPO DELLA QUERCIA

Books

1598 BACCI, PELEO. Jacopo della Quercia; Nuovi documenti e
 commenti. Siena: Libreria Editrice Senese, 1929, 357 pp.,
 46 figs.
 Analysis of three Quercia commissions—wood Annunciation
 group, Pieve di San Gimignano; Baptismal Font, Baptistry, Siena; and
 Casini Chapel, Duomo, Siena—based on extensive documentary evidence
 published here. Attributes to Domenico di Niccolò de' Cori two
 figures in San Pietro Ovile, Siena (pp. 52-59).

1599 BERTINI, ALDO. L'opera di Jacopo della Quercia. Edited by A.
 Quazza and A. Solaro. Turino. Università, Facoltà di lettere
 e filosofia, Corsi universitari. Turin: G. Giappichelli,
 1966, 108 pp., no illus.
 Brief summary of Quercia's career that notes other authors'
 major contributions and unresolved problems.

1600 BIAGI, LUIGI. Jacopo della Quercia. Florence: Arnaud, 1946,
 86 pp., 81 figs.
 Good short summary of Quercia's career followed by
 catalogue of his secure and attributed sculptures. Bibliography for
 each catalogue entry.

1601 BUSCAROLI, REZIO. La scultura senese del Trecento e Jacopo
 della Quercia (Corso 1950-1951). Edited by Vittorio Pelosio.
 Bologna, Accademia di belle arti, Corso 1950-51. Published
 typescript. Bologna: Riccardo Patron, 1951, 68 pp., no illus.
 Lectures on fourteenth-century Sienese sculptural tradition
 in relation to Quercia.

1602 CHIARELLI, RENZO. Jacopo della Quercia. I maestri della scul-
 tura, vol. 5. Milan: Fratelli Fabbri, 6 pp., 4 figs., 17
 color pls.
 Good, large color illustrations, including standing Madonna
 and Child (Duomo, Siena) and details of Annunciation group from the
 Porta della Mandorla (Museo dell'Opera del Duomo, Florence)
 attributed to early Quercia.

1603 CORNELIUS, CARL. Jacopo della Quercia; Eine kunsthistorische
 Studie. Halle a. S.: Wilhelm Knapp, 1896, 194 pp., 5 figs.
 First full-length monograph on Jacopo della Quercia; based
 on author's dissertation, University of Basel, 1896. Summarizes
 known biographical information, then discusses each monument
 chronologically.

1604 GIELLY, LOUIS. Jacopo della Quercia. Les maitres du Moyen Âge
 et de la Renaissance. Paris: A. Michel, 1930, 89 pp., 64
 figs.

Brief text summarizes known facts about Jacopo della Quercia's life and works. With chronology, bibliography, and list of works. [Seymour, entry 1607: "Unoriginal--a version of Supino's monograph."]

1605 MORISANI, OTTAVIO. Tutta la scultura di Jacopo della Quercia. Biblioteca d'arte Rizzoli, vols. 46-47. Milan: Rizzoli, 1962, 89 pp., 176 figs., 1 diag.
Brief essay on Quercia's career and chronological outline introduce handy corpus of small-scale but clear illustrations.

1605a Beck, James H. Review of Tutta la scultura di Jacopo della Quercia, by Ottavio Morisani. Arte antica e moderna 20 (1962):456-57, no illus.

1606 NICCO FASOLA, GIUSTA. Jacopo della Quercia. Florence: Bemporard, 1934, 127 pp., 47 figs.
Early monograph on Quercia, still useful for its insights. No notes or bibliography.

1607 SEYMOUR, CHARLES, Jr. Jacopo della Quercia; Sculptor. Yale Publications in the History of Art, vol. 23. New Haven and London: Yale University Press, 1973, 140 pp., 168 figs., 6 diags.
Summary of Jacopo della Quercia's life and sculptural oeuvre. Not a full-scale monograph; lacks documents and catalogue. [Seymour: "the intention of this book is to provide an interim publication."]

1607a Cannon-Brookes, Peter. Review of Jacopo della Quercia: Sculptor, by Charles Seymour, Jr. Apollo 49, no. 146 (April 1974):289-91, no illus.
Disputes Seymour's conclusions about Jacopo della Quercia's early life and training.

1607b Freytag, Claudia. Review of Jacopo della Quercia: Sculptor, by Charles Seymour, Jr. Art Bulletin 57, no. 3 (September 1975):441-43, no illus.
Rejects so-called Piccolomini Madonna and Child; posits Burgundian influences; attributes part of frieze of Tomb of Ilaria del Carretto (San Martino, Lucca) to Matteo Civitali shop, 1484 (not Valdambrino); redates Lucca Apostle to ca. 1420-22.

1607c Janson, H.W. "The Giotto of Sculpture." Yale Review, n.s. 63, no. 1 (October 1973):91-96, no illus.
Notes that Seymour's work is not a monograph, nor does it identify Quercia's role in development of Renaissance sculpture. Some new contributions, such as redating Quercia's Madonna and Child (San Petronio, Bologna) to 1425-28. Faults accuracy of transcribed documents.

1608 SIENA, PALAZZO PUBBLICO, and GROSSETTO, MUSEO ARCHEOLOGICO E
 D'ARTE DELLA MAREMMA. Jacopo della Quercia nell'arte del suo
 tempo. Catalogue by Giulietta C. Dini and Giovanni Previtali.
 Introduction by Cesare Brandi. Introduction to documents by
 James H. Beck. Siena: Palazzo Pubblico; Grosseto; Museo
 Archeologico e d'Arte della Maremma, 1975, 367 pp., 343 figs.
 Major educational exhibition that sets Quercia within his
 artistic milieu. Arranged as catalogue, profusely illustrated, with
 full bibliography following each catalogue entry.

1608a Del Bravo, Carlo. Review of Jacopo della Quercia nell'arte del
 suo tempo, by Giulietta C. Dini and Giovanni Previtali. Bur-
 lington Magazine 117, no. 870 (September 1975):624-28, 8 figs.
 Unfavorable review of exhibition of Jacopo della Quercia's
 sculpture in Siena. Notes discrepancies between catalogue and cap-
 tions, lack of critical analysis, and unconvincing character of new
 attributions.

1608b Chelazzi Dini, Giulietta, and Bagnoli, Alessandro. "Due
 lettere al direttore di 'The Burlington Magazine.'"
 Prospettiva
 5 (June 1976):68-69, 2 figs.
 Response to del Bravo's unfavorable review of Quercia
 exhibition, Palazzo Pubblico, Siena, May-October 1975, specifically
 his criticism of student participation in writing of catalogue and
 attribution to Quercia's shop of wooden statue of St. John the
 Baptist (Baptistry, Siena).

1609 SUPINO, I[GINO]B. Jacopo della Quercia. Bologna: Casa
 Editrice Apollo, 1926, 84 pp., 75 figs.
 Early monograph analyzing stylistic development of Quercia.
 Few notes; no bibliography, documents, or index.

 Unpublished Theses

1610 FREYTAG, CLAUDIA. "Jacopo della Quercia; Stilkritische
 Untersuchungen zu seinen Skulpturen unter besonderer Berück-
 sichtigung des Frühwerks." Inaugural-Dissertation, Ludwig-
 Maximilians-Universität, Munich, 1969, 155 pp., no illus.
 Focuses on early works: Silvestri Madonna and Child
 (Duomo, Ferrara), and Tomb of Ilaria del Carretto (San Martino,
 Lucca). Analyzes Quercia's sources in ancient sculpture, Inter-
 national Gothic style, and North Italian sculpture.

 Monographs on a Single Commission

 Tomb of Ilaria del Carretto

1611 LUNARDI, GIOVANNI GIUSEPPE. Ilaria del Carretto o Maria
 Antelminelli? Ricerche e documenti. Pescia: Benedetti &
 Niccolai, 1928, 27 pp., no illus.

Argues that Quercia's Tomb of Ilaria del Carretto in fact commemorates Maria Caterina degli Antelminelli, the first wife of Paolo Giunigi, rather than his second wife, Ilaria del Carretto, as is commonly believed.

Fonte Gaia, Siena

1612 BARGAGLI-PETRUCCI, FABIO. Le fonti di Siena e i loro aquedotti: Note storiche dalle origini fino al MDLV. 2 vols. Siena: 1906, 961 pp., 26 figs., 3 charts.
History of Sienese fountains that provides context for Quercia's Fonte Gaia, which is studied in detail here. Publishes corpus of documents for Fonte Gaia.

1613 HANSON, ANNE COFFIN. Jacopo della Quercia's Fonte Gaia. Oxford-Warburg Studies, vol. 2, Oxford: Clarendon Press, 1965, 123 pp., 96 figs.
Monograph on Fonte Gaia, Siena, and its context in Jacopo della Quercia's oeuvre, including major contributions regarding sources, chronology of sculptures, and stylistic differences between Quercia and Francesco di Valdambrino. Contains digests of all documents relating to Fonte Gaia and Trenta Chapel, San Frediano, Lucca.

1613a Balogh, Jolán. Review of Jacopo della Quercia's Fonte Gaia, by Anne Coffin Hanson. Acta Historiae Artium 14 (1968):110-11, no illus.

1613b Beck, James H. Review of Jacopo della Quercia's Fonte Gaia, by Anne Coffin Hanson. Art Bulletin 48, no 1 (March 1966):114-15, no illus.
Suggests North Italian sojourn after competition of 1401-2 influenced Quercia's style. Argues that drawing of Fonte Gaia requires further study.

1613c Carli, Enzo. Review of Jacopo della Quercia's Fonte Gaia, by Anne Coffin Hanson. Renaissance News 19, no. 1 (Spring 1966):20-22, no illus.

Porta Magna--Portal of San Petronio, Bologna

1614 BECK, JAMES H. Jacopo della Quercia e il portale di San Petronio a Bologna: Ricerche storiche, documentarie, e iconografiche. Bologna: Alfa, 1970, 155 pp., 62 figs. (Revision of Ph.D. dissertation, Columbia University, 1963, 263 pp.
Monograph on Quercia's decoration of Portal of San Petronio, Bologna, including reconstruction of original project (1425), chronology of second campaign, and final execution (1428-34). Analyzes iconography. Transcribes and reviews all documents, of which 100 were previously unpublished.

1614a Janson, H.W. Review of Jacopo della Quercia e il portale di
 San Petronio a Bologna, by James Beck. Speculum 48, no. 3
 (July 1973):550-52, no illus.
 Offers evidence for placement of figures of SS. Peter and
 Paul on tympanum flanking Christ Enthroned, rather than beside
 lunette figures; disputes Beck's reading of portal's iconography.

1614b Krautheimer, Richard. Review of Jacopo della Quercia e il
 portale di San Petronio a Bologna, by James Beck. Renaissance
 Quarterly 25, no. 3 (Autumn 1972):321-26, no illus.
 Denies relation of portal's iconography to election of
 Martin V, 1418; finds Beck's reconstruction of designs convincing,
 but argues for successive revisions.

1615 DAVIA, VIRGILIO. Le sculture delle porte della basilica di S.
 Petronio, scolpite da eccellenti maestri de' secoli XV e XVI,
 pubblicate per la prima volta dal professore Giuseppe
 Guizzardi, . . . illustrate con una memoria e documenti inediti
 dal marchese Virgilio Davia. Bologna: Volpe, 1834, 38 pp., no
 illus.
 Historically interesting as the first study of Quercia's
 program for Portal of San Petronio, Bologna.

1616 EMILIANI, ANDREA, et al. Jacopo della Quercia e la facciata di
 San Petronio a Bologna: Contributi allo studio della deco-
 razione e notizie sul restauro. Bologna: Alfa, 1981, 289 pp.,
 180 figs., 22 color pls.
 Essays reevaluate documents for Portal of San Petronio
 [Gnudi] and examine sculptures on side doors [Brugnoli] and lower
 façade decoration [Grandi]. These are followed by technical analyses
 of sculptures' restoration and preservation.

1617 GATTI, ANGELO. La Basilica petroniana. Bologna: Libreria
 Beltrami di L. Cappelli, 1913, 350 pp., 68 figs.
 Account of building history and decoration of San Petronio,
 with relevant documents. Important for discussion and documents
 about Quercia's sculpture for the portal.

1618 GATTI, ANGELO. La fabbrica di San Petronio: Indagini
 storiche. Bologna: Regia Tipografia, 1889, 141 pp., 18 figs.
 Building history of San Petronio presented with documents.
 Includes brief discussion and documents pertaining to Quercia's work
 on portal.

1619 MATTEUCCI, ANNA MARIA. La Porta Magna di S. Petronio in
 Bologna. L'arte in Emilia, vol. 4. Bologna: Riccardo Pàtron,
 1966, 125 pp., 74 figs.
 Monograph on Quercia's sculptures for Portal of San
 Petronio, Bologna. Discusses commission and original arrangement of
 sculpture and briefly examines other works by Quercia and his shop in
 Emilia.

1619a Beck, James H. Review of La Porta Magna di S. Petronio in
 Bologna, by Anna Maria Matteucci. Art Bulletin 50, no. 4
 (December 1968):384-85, no illus.
 Clarifies attribution of statue of Sant'Ambrogio, which
 Matteucci gives to Jacopo, but which documents show was assigned
 wholly to Domenico Aimo da Varignana, 1510-11.

1620 SUPINO, I[GINO] B. Le sculture delle porte di San Petronio in
 Bologna illustrate con documenti inediti. Florence: Istituto
 Micrografico Italiano, 1914, 124 pp., 83 figs.
 Most reliable, comprehensive publication of documents about
 this commission prior to Beck's (entry 1614). Good illustrations.

Tomb of Vari-Bentivoglio

1621 DAVIA, VIRGILIO. Cenni istorico-artistici intorno al monumento
 di Antonio Galeazzo Bentivogli esistente nella chiesa di S.
 Giacomo di Bologna. Bologna: Volpe al Sassi, 1835, 31 pp., no
 illus.
 Essay on Tomb of Vari-Bentivoglio, San Giacomo, Bologna,
 that first proposed attribution to Jacopo della Quercia.

1622 MATTEUCCI, ANNA MARIA. Il tempio di San Giacomo Maggiore in
 Bologna: Studi sulla storia e le opere d'arte, Regesto
 documentario. Bologna: Padri Agostiniani di San Giacomo
 Maggiore, 1967, 280 pp., 327 figs., 56 color pls., esp. pp.
 73-82, 32 figs.
 Publishes documentation and corpus of photographs of Tomb
 of Vari-Bentivoglio by Jacopo della Quercia.

1623 BACCI, PELEO. "L'altare della famiglia Trenta in San Frediano
 di Lucca." Bollettino storico lucchese 5 (1933):230-36, no
 illus.
 Basic publication on this commission. With documents.

1624 BACCI, PELEO. "Le statue dell'Annunciazione intagliate nel
 1421 da Jacopo della Quercia." Balzana: Rassegna d'arte
 senese e del costume, n.s. 1 (1927):149-75, 16 figs.
 Discussion of Quercia's wood Annunciation group (Pieve di
 San Gimignano) in context of his other sculptures; publication of
 documents.

1625 BAGNOLI, ALESSANDRO. "Su alcune statue lignee della bottega di
 Jacopo." In Jacopo della Quercia fra Gotico e Rinascimento
 (Atti del Convegno di Studi, Siena, 1975). Edited by Giulietta
 C. Dini. Florence: Centro Di, 1977, pp. 151-54, 16 figs.
 Attribution to Quercia's shop of eight wood statues: Angel
 and Annunciate Virgin (Pinacoteca nazionale, Siena); St. Anthony
 Abbot, Bishop Saint, and St. Ambrose (Museo civico, Siena); Madonna
 and Child (Santa Maria, Villa a Sesta); and St. John the Baptist
 (Pieve di San Giovanni, Siena).

1626 B[ANTI], A[NNA]. "Una Sibilla del Suomo di Orvieto." Paragone
 4, no. 39 (1953):39-40, 2 figs.
 Reattributes to Quercia Sibyl statue on exterior, Duomo,
 Orvieto, usually considered work of Federighi who was capomaestro
 there.

1627 BARGAGLI-PETRUCCI, F. "Una statua senese al Louvre."
 Rassegna d'arte senese 3, no. 1 (1907):85-90, 6 figs.
 Argues that St. Christopher statue, attributed to Francesco
 di Giorgio by Fabriczy (entry 1145), was begun by Quercia and
 finished by Pietro del Minella (with whom Quercia made a contract to
 finish his sculptures).

1628 BECHERUCCI, LUISA. "Convergenze stilistiche nella scultura
 fiorentina del Trecento." In Jacopo della Quercia fra Gotico e
 Rinascimento (Atti del Convegno di Studi, Siena, 1975). Edited
 by Giulietta C. Dini. Florence: Centro Di, 1977, pp. 30-37, 1
 fig.
 Argues that Quercia followed Luca di Giovanni from Siena to
 Florence, ca. 1386, where Quercia entered shop of Giovanni d'Ambrogio
 and worked on Porta della Mandorla. Attributes to Quercia Apollo
 figure on portal's side.

1629 BECK, JAMES H. "A Document Regarding Domenico da Varignana."
 Mitteilungen des Kunsthistorischen Institutes in Florenz 11,
 nos. 2-3 (November 1964):193-94, no illus.
 Document of January 21, 1571 proves relief bust of Moses on
 Portal of San Petronio, Bologna, is by Domenico da Varignana, rather
 than Amico Aspertini. Statue of S. Ambrogio documented to Domenico,
 not Jacopo della Quercia.

1630 BECK, JAMES H. "An Important New Document for Jacopo della
 Quercia in Bologna." Arte antica e moderna 18 (April-June
 1962):206-7, no illus.
 Publishes document that refers to Jacopo della Quercia as
 sculptor of San Petronio figure for Portal of San Petronio, Bologna,
 in 1434.

1631 BECK, JAMES H. "Jacopo a Todi." In Jacopo della Quercia fra
 Gotico e Rinascimento (Atti del Convegno di Studi, Siena,
 1975). Edited by Giulietta C. Dini. Florence: Centro Di,
 1977, pp. 104-6, 3 figs.
 Letter of 1418 documents Quercia's call to Todi on behalf
 of Opera of San Fortunato and suggests that Quercia had previous
 contact with Todi. Attributes to Quercia and his shop male Saints
 from niches of main portal, San Fortunato. Related to them is
 tabernacle relief of Annunciation (known only in plaster cast in
 Sant'Eugenia al Monastero, Siena) that author argues reflects
 Quercia's earliest sculpture.

1632 BECK, JAMES H. "Jacopo della Quercia's Design for the Porta
 Magna of San Petronio in Bologna." Journal of the Society of

Architectural Historians 24, no. 2 (May 1965):115-26, 5 figs., appendix.
Drawing of 1522 by Peruzzi (Museo dell'Opera di S. Petronio, Bologna) reproduces Jacopo della Quercia's original plan of 1425, showing that despite subsequent alterations, portal as it now exists reflects Jacopo's intentions.

1633 BECK, JAMES H., AND FANTI, MARIO. "Un probabile intervento di Michelangelo per la 'porta magna' di San Petronio." Arte antica e moderna 27 (1964):349-54, no illus.
Publication of 1510 documents clarifies that rearrangement of Quercia's sculptures for Portal of San Petronio undertaken then (for which Michelangelo may have been responsible) did not change their original order.

1634 BERLINER, RUDOLF. "A Relief of the Nativity and a Group from an Adoration of the Magi." Art Bulletin 35, no. 2 (June 1953):145-49, 4 figs.
Argues that unusual viewpoint of Jacopo della Quercia's Madonna of Humility (National Gallery of Art, Washington, D.C.) suggests that it was once part of Nativity ensemble.

1635 BERTINI, ALDO. "Calchi dalla Fonte Gaia." Critica d'arte, n.s. 15, no. 97 (September 1968):35-54, 20 figs.
Publishes mid-nineteenth-century casts after Fonte Gaia reliefs that indicate their appearance then. Proposes sequence of execution of reliefs based on these casts and uses this hypothesis to propose chronology for other Quercia sculptures.

1636 BISOGNI, FABIO. "Sull'iconografia della Fonte Gaia." In Jacopo della Quercia fra Gotico e Rinascimento (Atti del Convegno di Studi, Siena, 1975). Edited by Giulietta C. Dini. Florence: Centro Di, 1977, pp. 109-14, 4 figs.
Challenges accepted iconographical interpretation of Fonte Gaia by reevaluating identity of two female figures with babies, widely agreed to represent Rhea Silvia and Acca Larentia. Drawing for Fonte, fragments of which are in the Metropolitan Museum of Art and the Victoria and Albert Museum, shows monkey and dog beside these figures. Reidentifies Rhea Silvia as Charity (with her opposite, Envy, symbolized by dog), and Acca Larentia as Liberality (with her opposite, Avarice, symbolized by monkey).

1637 BRUNETTI, GIULIA. "Dubbi sulla datazione dell'Annunciazione di San Gimignano." In Jacopo della Quercia fra Gotico e Rinascimento (Atti del Convegno di Studi, Siena, 1975). Edited by Giulietta C. Dini. Florence: Centro Di, 1977, pp. 101-2, 2 figs.
Argues that San Gimignano Annunciation, documented to 1421 through eighteenth-century transcription of fifteenth-century book of financial records of Opera, is stylistically similar to Madonna of ca. 1406-7 in Ferrara. Hypothesizes that Quercia was asked by

commissioners to copy fourteenth-century sculpture or, more likely, that he copied one of his own early sculptures still in his shop.

1638 BRUNETTI, GIULIA. "Il San Giorgio di Cesena: Un capolavoro di Jacopo della Quercia?" Prospettiva 13 (April 1978):58-63, 12 figs.
 Fuller publication of her earlier attribution to Jacopo della Quercia of limestone St. George Killing the Dragon relief (Museo storico dall'antichità, Cesena), which bears the Malatesta coat of arms. Proposed dating of 1408/9-16 (see entry 1510).

1639 BRUNETTI, GIULIA. "Jacopo della Quercia a Firenze." Belle arti (1951):3-17, 14 figs.
 Following Vasari, attributes to young Jacopo della Quercia an Annunciation group for lunette, plus various reliefs (including Hercules and Apollo), framing the Porta della Mandorla. Discusses Jacopo della Quercia's Baptistry competition relief (now lost); his early Florentine style, and his relationship with his contemporaries.

1640 BRUNETTI, GIULIA. "Jacopo della Quercia and the Porta della Mandorla." Art Quarterly 15, no. 2 (Summer 1952):119-31, 9 figs.
 Restatement of her thesis that Quercia worked on Porta della Mandorla, focusing on analysis of Vasari's account and on style of portal sculptures.

1641 CAMPETTI, PLACIDO. "L'altare della famiglia Trenta in S. Frediano di Lucca." In Miscellanea di storia dell'arte in onore di Igino Benvenuto Supino. Florence: Leo S. Olschki, 1933, pp. 271-94, 15 figs.
 Discussion of Sienese goldsmith work and its connections with sculpture; points out that Quercia's drawing for Fonte Gaia (Metropolitan Museum of Art, New York; Victoria and Albert Museum, London) reveals his links with goldsmith traditions.

1642 CANTELLI, GIUSEPPE. "Sulla oreficeria senese fra Tre e Quattrocento." In Jacopo della Quercia fra Gotico e Rinascimento (Atti del convegno di studi, Siena, 1975). Edited by Giulietta C. Dini. Florence: Centro Di, 1977, pp. 67-80, 18 figs.
 Discussion of Sienese goldsmith work and its connections with sculpture; points out that Quercia's drawing for Fonte Gaia (Metropolitan Museum of Art, New York; Victoria and Albert Museum, London) reveals his links with goldsmith traditions.

1643 CARATTI, ERMANNO [pseud. of Roberto Longhi]. "Un osservazione circa il monumento d'Ilaria." Vita artistica 1 (1926):94-96. Reprinted in Saggi e ricerche, 1925-1928 (Florence: G.C. Sansoni, 1967), pp. 49-52, 10 figs.
 Suggests that Quercia may have intended much lower base for Tomb of Ilaria del Carretto (San Martino, Lucca) because most striking viewpoint is from above the effigy, but he later modified his plan.

1644 CARDILE, PAUL. "The Benabbio Annunciation and the Style of
 Jacopo della Quercia's Father, Piero d'Angelo." Antichità viva
 17, no. 2 (March–April 1978):25–32, 17 figs.
 Suggests that young Jacopo may have carved Virgin in wood
Annunciation group (San Benabbio) attributed to Piero d'Angelo.
Other works attributed to Piero d'Angelo: St. Catherine of
Alexandria (Monte de' Paschi, Siena), Angel of Annunciation (San
Paolino, Lucca), and six marble heads (Duomo, Lucca). Discusses
relation of Jacopo's early style to father's work.

1645 CARLI, ENZO. "Un inedito quercesco." In Jacopo della Quercia
 fra Gotico e Rinascimento (Atti del Convegno di Studi, Siena,
 1975). Edited by Giulietta C. Dini. Florence: Centro Di,
 1977, pp. 141–42, 8 figs.
 Attributes to Quercia and shop wood Madonna and Child
(private collection, Milan). Relates statue, stripped of the heavy
polychromy added later, to sculptures from San Petronio, Bologna, and
to wood Madonna and Child (Sangiorgi collection, Rome), published by
Ragghianti (entry 1688).

1646 CARLI, ENZO. "Una primizia di Jacopo della Quercia." Critica
 d'arte 8, no. 27 (May 1949):17–24, 4 figs.
 Attributes to Quercia ca. 1397 standing Madonna and Child
statue on Piccolomini altarpiece, Duomo, Siena.

1647 CHELAZZI DINI, GIULIETTA. "Jacopo della Quercia nell'arte del
 suo tempo, Siena, Palazzo Pubblico, Maggio–Ottobre 1975."
 Prospettiva 1 (April 1975):62–64, 3 figs.
 Discussion of issues raised by exhibition. Tentatively
attributes to Michele da Firenze Madonna of Humility (National
Gallery of Art, Washington, D.C.) that has been assigned to Quercia,
Giovanni di Turini, and Domenico di Niccolò de' Cori.

1648 CIARDI DUPRÉ dal POGGETTO, MARIA G. "Sul ruolo di Jacopo della
 Quercia nella scultura del Rinascimento." In Jacopo della
 Quercia fra Gotico e Rinascimento (Atti del Convegno di Studi,
 Siena, 1975). Edited by Giulietta C. Dini. Florence: Centro
 Di, 1977, pp. 235–40, 12 figs.
 Reevaluates Jacopo della Quercia's influence on Renaissance
sculpture, revising modern consensus that his Bolognese sojourn, with
its important impact on later Bolognese sculpture and on
Michelangelo, was only influential aspect of his work. Cites Vasari,
who called Quercia important innovator in second phase of Renaissance
art, and shows his impact on Sienese Renaissance sculpture and,
through Berruguete, on Spanish sculpture.

1649 FORATTI, ALDO. "I profeti di Iacopo della Quercia nella Porta
 Maggiore di S. Petronio." Comune di Bologna 9 (September
 1932):1–15, 16 figs.
 Reviews earlier opinions concerning whether Prophet reliefs
on main Portal of S. Petronio, Bologna, were carved by Jacopo or his
assistants. Argues they are autograph.

1650 FORATTI, ALDO. "Quercia, Jacopo della." In Thieme-Becker
 Künstler-Lexikon. Leipzig: E.A. Seemann, 1933, 27:513-16.
 Condensed survey of life and work. Valuable bibliography.

1651 FREYTAG, C[LAUDIA]. "Ilaria del Carretto. L'Apostolo di S.
 Martino." Provincia di Lucca 15, no. 4 (1975):75-78, 5 figs.
 Argues that effigy of Ilaria del Carretto was carved ca.
1408, whie her sarcophagus dates from after 1413; contends that its
rear side was carved by Civitali shop. Dates figure of Apostle, also
in San Martino, Lucca, ca. 1420-22.

1652 FREYTAG, CLAUDIA. "Jacopo della Quercia ed i fratelli Dalle
 Masegne." In Jacopo della Quercia fra Gotico e Rinascimento
 (Atti del Convegno di Studi, Siena, 1975). Edited by Giu-
 lietta C. Dini. Florence: Centro Di, 1977, pp. 81-87, 6 figs.
 Argues that Quercia worked in Dalle Masegne shop in Bologna
and that this influence can be seen in his Madonna of Humility
(National Gallery of Art, Washington, D.C.), and his Silvestri
Madonna and Child (Duomo, Ferrara). Attributes gilded bronze
standing Madonna and Child statuette (Victoria and Albert Museum,
London) to Quercia, under influence of Sluter.

1653 GIELLY, LOUIS. "Jacopo della Quercia." Revue de l'art ancien
 et moderne 39 (April 1921):243-52, 5 figs.; 40 (November 1921):
 262-76, 5 figs.; 40 (December 1921):301-15, 6 figs.
 Monograph on Jacopo della Quercia with general discussion
of major monuments and Jacopo's influence in Siena and Florence.
[Seymour (entry 1607): "Mostly art appreciation, but important for
its evidence of interest in Quercia's art in France."]

1654 GNUDI, CESARE. "Communicazioni su Jacopo della Quercia."
 Rassegna lucchese 5 (1951):9-10, 1 fig.
 Summary of Gnudi's lecture on Silvestri Madonna and Child,
Duomo, Ferrara, which he dates later than Tomb of Ilaria del Carretto
(San Martino, Lucca) on basis of newly discovered documents.

1655 GNUDI, CESARE. "La Madonna di Jacopo della Quercia in S.
 Petronio a Bologna." Atti e memorie della Deputazione di
 storia patria per le provincie di Romagna, 5th ser. 3-4
 (1951-53):325-34, 5 figs.
 Analyzes style of Quercia's San Petronio lunette sculpture
of the Madonna and Child, remarking on surface deterioration.

1656 GNUDI, CESARE. "Per una revisione critica della documentazione
 riguardante la 'Porta Magna' di San Petronio." Römisches
 Jahrbuch für Kunstgeschichte 20 (1983):155-80, 1 fig.
 Offers several interpretations of documents at variance
with Beck's (entry 1614) concerning chronology of Quercia's work on
Portal of San Petronio, Bologna: suggests Quercia began work before
date of contract (28 March 1425) and that he did work on portal
between 1425 and 1427.

1657 GOMBOSI, GEORG. "Vier Statuen an der San Marco-Basilika und ihre mögliche Zuschreibung an Jacopo della Quercia." In International Congress on the History of Art (14th. Basel, 1936): Résumés des communications presentées . . . Actes du Congrès. Laupen-Bern: Polygraphische Gesellschaft, 1936-38, 1:104-5, no illus.

Four statues on north façade, San Marco, Venice, are attributed to Jacopo della Quercia, ca. 1420-25.

1658 GORRINI, GIACOMO. "Documenti di Jacopo della Quercia che ritornano a Siena.' Bullettino senese di storia patria 40, n.s. 4 (1933):303-13, 1 fig.

Announces acquisition by Sienese archives of 1416 document asking Quercia's advice on work at San Fortunato, Todi, and of 1437 autograph letter.

1659 HANSON, ANNE COFFIN. "Jacopo della Quercia fra classico e Rinascimento: alcuni pensieri sui motivi di Ercole e Adamo." In Jacopo della Quercia fra Gotico e Rinascimento (Atti del Convegno di Studi, Siena, 1975). Edited by Giulietta C. Dini. Florence: Centro Di, 1977, pp. 119-30, 16 figs.

Analyzes two reliefs, Creation of Adam and Expulsion from Paradise (Palazzo Pubblico, Siena) intended for final project of Fonte Gaia and today in very damaged condition. Figure of Adam in Expulsion from Paradise based on classical Hercules nude found in similar striding pose on many Roman sarcophagi depicting labors of Hercules. Since Hercules was well-established analogue for Christ and Adam by fifteenth century, source contributed to Salvation and Good Government program of Fonte Gaia by stressing efficacy of one's work.

1660 KLOTZ, HEINRICH. "Jacopo della Quercias Zyklus der 'Vier Temperamente' am Dom zu Lucca." Jahrbuch der Berliner Museen 9 (1967):81-99, 16 figs.

Attributes to Quercia, ca. 1418-30, seven marble heads (and another to his shop) on exterior of clerestory walls (San Martino, Lucca). Four on south flank are called series of Four Ages and Humors and are cited as earliest example in sculpture of this iconography.

1661 KOSEGARTEN, ANTJE. "Das Grabrelief des San Aniello Abbate im Dom von Lucca: Studien zu den früheren Werken des Jacopo della Quercia." Mitteilungen des Kunsthistorischen Institutes in Florenz 13, nos. 3-4 (October 1968):223-72, 43 figs. [Résumé in Italian.]

Attributes to Quercia low-relief effigy from Shrine of San Agnello, documented to 1392 and once in north transept of San Martino, Lucca (now in sacristy), making it Quercia's earliest sculpture. Thorough analysis of Quercia's other early works, especially Tomb of Ilaria del Carretto (San Martino, Lucca) and work for Duomo, Florence. [Attribution is questioned by Seymour, entry 1607.]

1662 KRAUTHEIMER, RICHARD. "A Drawing by Jacopo della Quercia?"
Diana 3 (1928):276-79. Translated from the Italian by Marjorie
Licht and reprinted in Studies in Early Christian, Medieval,
and Renaissance Art (New York: New York University Press;
London: University of London Press, 1969) pp. 311-13, 2 figs.
Attributes to Quercia pen and ink drawing of standing male
saint (Museum Boymans-van Beuningen, Rotterdam), ca. 1411-13. Sug-
gests drawing represents lost sculpture.

1663 KRAUTHEIMER, RICHARD. "A Drawing for the Fonte Gaia in Siena."
Bulletin of the Metropolitan Museum of Art 20 (1952):265-74, 6
figs.
Identifies drawing fragment, recently acquired by
Metropolitan Museum of Art, as left half of second project (1409) for
Quercia's Fonte Gaia in Siena. Right half of drawing is in Victoria
and Albert Museum, London (Dyce collection, no. 181). Center portion
of project is lacking since center strip is lost.

1664 KRAUTHEIMER, RICHARD. "Quesiti sul sepolcro di Ilaria." In
Jacopo della Quercia fra Gotico e Rinascimento (Atti del
Convegno di Studi, Siena, 1975). Edited by Giulietta C. Dini.
Florence: Centro Di, 1977, pp. 91-97, 3 figs.
Reconstructs Tomb of Ilaria del Carretto (San Martino,
Lucca) by Quercia (disassembled in 1429) on basis of Vasari's
description of gisant, sarcophagus, and base with figures. Argues
that parts of reconstructed monument are similar to Tomb of Doge
Antonio Venier (died ca. 1400), SS. Giovanni e Paolo, Venice, by
Dalle Masegne shop, corroborating Quercia's connections with them and
refuting idea that Tomb of Ilaria del Carretto should be related to
Franco-Burgundian precedents. Contends monument should be dated
between early 1406 and 1412, when Quercia was working on several
other commissions.

1665 LABARTE, JULES. "L'église cathédrale de Sienne et son trésor
d'après un inventaire de 1467." Annales archéologiques 25
(1865):261-85, 1 engr.
Transcription of most complete early inventory of Cathedral
of Siena. Records many works of art now lost. Important for Quercia
and other artists who worked there.

1666 LÁNYI, JENO. "Der Entwurf zur Fonte Gaia in Siena." Zeit-
schrift für bildende Kunst 61 (1927-28):257-66, 3 figs.
Identifies early Sienese drawing as plan mentioned in
documents of 1409 for revised program of Fonte Gaia. Argues that
drawing (Victoria and Albert Museum, London), half of full composi-
tion, is probably not by Jacopo della Quercia, but by his son,
Priamo. See Krautheimer entries 1662-63.

1667 LÁNYI, JENO. "Quercia-Studien." Jahrbuch für Kunstwissen-
schaft, 1930:25-63, 16 figs.
Clarifies Jacopo della Quercia's authorship of Silvestri
Madonna and Child (Duomo, Ferrara), dated 1408, making it his

earliest work; proposes late dating of Tomb of Ilaria del Carretto (San Martino, Lucca) after 1420, rather than ca. 1405 as generally accepted; studies important role of drawings in Quercia's shop especially for Fonte Gaia reliefs; attributes drawing of Fonte Gaia (Victoria and Albert Museum, London) directly to Quercia. Many of these conclusions now disputed: Pope-Hennessy (entry 60), "Of interest more for method than for results."

1668 LAZZARRESCHI, EUGENIO. "La dimora a Lucca d' Jacopo della
 Guercia e di Giovanni da Imola." Bullettino senese di storia
 patria 32 (1925):63-97, 6 figs.
 History of Quercia's stay in Lucca, as well as that of
Quercia's family and followers, based on extensive research in
Lucchese archives. Very important analysis of documentation of
Trenta Chapel sculptures in San Frediano, Lucca.

1669 LISNER, MARGRIT. "Zu Jacopo della Quercia und Giovanni
 d'Ambrogio." Pantheon 34, no. 4 (1976):275-79, 9 figs.
 Takes up Brunetti's thesis (entry 1639) that young Quercia
worked on Porta della Mandorla, Duomo, Florence. Argues he was
student of Giovanni d'Ambrogio and traces Giovanni d'Ambrogio's
influence on Quercia's Silvestri Madonna and Child, Duomo, Ferrara,
of 1403-6/7. Questions Quercia's participation in Dalle Masegne
altarpiece, San Francesco, Bologna, finished in 1392.

1670 LUSINI, V. "Di alcune sculture in Duomo." Rassegna d'arte
 senese 7 (1911):83-93, no illus.' 9 (1913):3-14, 2 figs.
 Discusses holy water font with carved base (Duomo, Siena),
traditionally attributed to Quercia.

1671 MANCINI, AUGUSTO. "Ilaria del Carretto o Caterina degli
 Antelminelli?" Giornale di politica e di letteratura 4
 (May-August 1928):433-44, 1 fig.
 Argues that Tomb of Ilaria del Carretto (San Martino,
Lucca) by Quercia was originally in the Giunigi burial area behind
Chapel of Santa Lucia, San Francesco, Lucca. Reviews problem of
whether monument was commissioned for Ilaria or Giunigi's first wife,
Maria Caterina degli Antelminelli.

1672 MARANGONI, MATTEO. "Una scultura quercesca." Critica d'arte,
 n.s. 1 (January 1954):20-21, 3 figs.
 Attributes to Quercia marble Madonna and Child statuette
above doorway of Municipio, Pisa.

1673 MARLE, RAIMOND van. "L'Annonciation dan la sculpture
 monumentale de Pise et de Sienne." Revue de l'art ancien et
 moderne 67, no. 359 (February 1935):88-92, 5 figs.
 Publishes additional Annunciation groups from Pisa and
Siena that illuminate Jacopo della Quercia's artistic milieu.

1674 MARLE, RAIMOND van. "L'Annonciation dans la sculpture
monumentale de Pise et de Sienne, II." Revue de l'art ancien
et moderne 65, no. 353 (May 1934):165-82, 19 figs.
Survey of Annunciation groups includes several works by
Jacopo della Quercia: Annunciation (Pieve di San Gimignano), two
groups in polychromed wood (private collection, Pienza and San
Francesco, Chiusura), and Annunciation (Louvre, Paris) attributed to
the school of Jacopo.

1675 MEZZETTI, LAURA GRANDI. "Teste quattrocentesche del Duomo di
Lucca." Rivista d'arte 18 (1936):265-81, 11 figs.
Distinguishes influence of Quercia, Niccolò Lamberti,
Donatello, and ancient Roman portrait heads in series of heads on
exterior of San Martino, Lucca.

1676 MICHEL, ANDRÉ. "La Madone et l'Enfant: Statue en bois peint
et doré attribuée à Jacopo della Quercia." Monuments et
mémoires publiés par l'Académie des Inscriptions et
Belles-Lettres, Fondation Eugène Piot 3 (1896):261-69, 10 figs.
First scholarly article on wood Madonna and Child (Louvre,
Paris). Attributes it to Jacopo della Quercia through comparison
with standing wood Madonna and Child of 1421 (San Martino, Siena).

1677 MIDDELDORF, ULRICH. "Due problemi querceschi." In Jacopo
della Quercia fra Gotico e Rinascimento (Atti del Convegno di
Studi, Siena, 1975). Edited by Giulietta C. Dini. Florence:
Centro Di, 1977, pp. 147-50, 4 figs.
Identifies fifteenth-century polychromed wood relief of St.
Martin on Horseback Dividing His Cloak with a Beggar (private German
collection) as after lost relief by Quercia. Relates relief to St.
Ansano [Martin?] on Horseback (San Cassiano, Controne, Lucca), which
Middeldorf attributes to early Quercia, not Francesco di Valdambrino.
Reprinted in entry 54.

1678 MISCIATTELLI, PIERO. "Sculture inedite di Jacopo della
Guercia." Diana 2 (1927):188-92, 5 figs.
Attributes to Quercia wood Enthroned Madonna and Child and
wood Standing Male Saint (private collection, Rome). Attributes to
followers standing Madonna and Child in same collection and half-
length Madonna (Museo d'Arte Industriale, Bologna).

1679 MORISANI, OTTAVIO. "Struttura e plastica nell'opera di Jacopo
della Quercia." Studi in onore di Giusta Nicco Fasola. Arte
lombarda 10A (1965):75-90, 13 figs.
Essay on diversity of Quercia's solutions to problem of
relationship between sculpture and architecture as seen in his
oeuvre.

1680 NATALI, ANTONIO. "Un inedito per un'attribuzione controversa."
Paragone 25, no. 287 (1974):61-67, 3 figs.
Reattributes to Antonio Federighi, post-1460, half-length
stucco Madonna and Child (National Gallery of Art, Washington, D.C.),

previously attributed to Ghiberti, Quercia, and Nanni di Bartolo. Publishes damaged terracotta variant owned by anonymous collector.

1681 NICCO, GIUSTA. "Argomenti querceschi." Arte 32 (1929): 193-202, 8 figs.
Argues that Quercia was not responsible for architectural form of Baptismal Font, Baptistry, Siena, and that all relief sculptures decorating Portal of San Petronio, Bologna, are by his hand.

1682 NICCO FASOLA, GIUSTA. "Della Quercia, Jacopo." In Encyclopedia of World Art. London: McGraw-Hill Publishing Co., 1961, 4: cols. 286-95, figs. 147-54.
Succinct summary of life and career of Quercia. Extensive bibliography.

1683 NICCO, GIUSTA. "Jacopo della Quercia e il problema di classicismo." Arte 32 (1929):126-37, 193-202, 13 figs.
Argues that Greco-Roman models were important in Early Renaissance primarily as aid to sculptors reacting against Gothic art.

1684 NICOLOSI, C.A. "Un gruppo di Jacopo della Quercia a Bergamo." Rassegna d'arte senese 2 (1906):125, 1 fig.
Attributes to Quercia bust-length Madonna and Child (Galleria Morelli, Bergamo).

1685 PAOLETTI, JOHN T. "Il tabernacolo del Fonte Battesimale e l'iconografia medioevale." In Jacopo della Quercia fra Gotico e Rinascimento (Atti del Convegno di studi, Siena, 1975). Edited by Giulietta C. Dini. Florence: Centro Di, 1977, pp. 131-40, 5 figs.
Analysis of unusual typology of Siena Baptismal Font, Baptistry, Siena, first example of baptismal font holding tabernacle. Rarely imitated. Sources indicate that it likely held both Eucharist and baptismal oils, which explains relief sculptures, the subjects of which were directly linked to Eucharist in contemporary sermons by San Bernardino.

1686 PAOLI, MARCO. "Jacopo della Quercia e Lorenzo Trenta: Nuove osservazioni e ipotesi per la Cappella di San Frediano di Lucca." Antichità viva 19, no. 3 (May-June 1980):27-36, 13 figs.
Argues that dates on Quercia's sculptures in Trenta Chapel, San Frediano, Lucca, cannot be used to date his work in chapel. Inscription "1416" on two funeral slabs indicates when relics of Lucca's patron saint were translated into chapel and "1422" on polyptych relates to date of saint's death in 722. Connects iconography of polyptych to Council of Constance (1414-18). Argues that Trenta commissioned funeral slabs for his wife and himself for this chapel but on his deathbed decided not to use them and was buried instead in Santa Caterina.

1687 PIT, A. "Zwei Porträt-Büsten von Jacopo della Quercia."
Münchner Jahrbuch der bildenden Kunst 2 (1907):38-40, 2 figs.
Attributes to Jacopo della Quercia two stucco busts after
full-length figure of Wisdom from Fonte Gaia (formerly Lanz
collection, Amsterdam, now Rijksmuseum, Amsterdam), ca. 1419-25.

1688 RAGGHIANTI, CARLO L. "Novità per Jacopo della Quercia."
Critica d'arte 12, no. 75 (1965):35-47, 16 figs.
Publishes rediscovered polychromed wood Madonna and Child,
reproduced as untraceable by Bacci in his book on Quercia (entry
1598). Location not given. Base inscribed in lettering similar to
that of Annunciation, San Gimignano, corroborating date ca. 1419-21.

1689 RONDELLI, NELLO. "Jacopo della Quercia a Ferrara, 1403-1408."
Bullettino senese di storia patria 71, 3d ser. 23 (1964):
131-42, 5 figs.
Transcription of documents concerning Silvestri Madonna and
Child, Duomo, Ferrara, that prove it was commissioned in 1403, but
not begun before 1406. It was finished by late 1406. Documents also
indicate that Quercia did not begin Tomb of Ilaria del Carretto (San
Martino, Lucca) before mid-1408.

1690 SALMI, MARIO. "La giovinezza di Jacopo della Quercia."
Rivista d'arte 12 (1930):175-91, 11 figs.
Attributes to young Quercia marble predella in San Martino,
Lucca, in which he sees influence of followers of Nino Pisano.
Argues that Quercia's early years were spent in Lucca, where his
father was a sculptor, and that Quercia's style was formed by Nino's
followers.

1691 SANPAOLESI, PIERO. "Una figura lignea di Jacopo della
Quercia." Bollettino d'arte 43 (1958):112-16, 8 figs.
Attributes to Quercia wood statue of St. Leonard in Santa
Maria degli Ulivi, Massa. Dates it contemporaneously with Trenta
Chapel [Seymour doubts attribution, entry 1607].

1692 SEYMOUR, CHARLES, Jr. "'Fatto di sua mano': Another Look at
the Fonte Gaia Drawing Fragments in London and in New York."
In Festschrift Ulrich Middeldorf. Edited by Antje Kosegarten
and Peter Tigler. Berlin: Walter de Gruyter & Co., 1968, pp.
93-105, 7 figs.
Attributes drawing fragments of Fonte Gaia in Metropolitan
Museum of Art, New York, and Victoria and Albert Museum, London, to
Martino di Bartolommeo, painter who polychromed Quercia's San
Gimignano Annunciation. Corroborates Krautheimer's and Hanson's
argument that drawing fragments derive from Fonte Gaia project of
1409 (entries 1613 and 1663).

1693 SEYMOUR, CHARLES Jr. "Invention and Revival in Nicola Pisano's
'Heroic Style.'" In Romanesque and Gothic Art: Studies in
Western Art (Acts of the 20th International Congress in the

History of Art, New York, 1961). Princeton: Princeton Univer-
sity Press, 1961, 1:207-26, 20 figs.
 Analyzes Nicola Pisano's heroic style and his influence on
Quercia and Nanni di Banco.

1694 SEYMOUR, CHARLES, Jr., and SWARZENSKI, HANNS. "A Madonna of
 Humility and Quercia's Early Style." Gazette des beaux-arts,
 6th per. 30 (1946):129-52, 27 figs.
 Attributes to young Quercia Madonna of Humility now in
National Gallery of Art, Washington, D.C. Traces influence of Nino
Pisano and Sienese art in general and of Franco-Burgundian style
transmitted through small-scale decorative objects. Sculpture called
Quercia's earliest extant work and dated ca. 1400.

1695 STROM, DEBORAH. "A New Attribution to Jacopo della Quercia:
 The Wooden St. Martino in S. Cassiano in Controne." Antichità
 viva 19, no. 1 (January-February 1980):14-19, 11 figs.
 Attributes to Jacopo della Quercia solely, rather than
Francesco di Valdambrino either alone or in collaboration with
Quercia, wooden equestrian saint in San Cassiano, Controne, Lucca.
Identifies it as St. Martin and claims that figure of beggar must
have been lost. Argues that this and San Gimignano Annunciation
group are only autograph Quercia wooden sculptures.

1696 STROM, DEBORAH. "A New Look at Jacopo della Quercia's Madonna
 of Humility." Antichità viva 19, no. 6 (July 1981):17-23, 15
 figs.
 Reasserts attribution to young Quercia, ca. 1400, of
Madonna of Humility (now in National Gallery of Art, Washington, DC.)
on basis of style and choice of Sienese Trecento iconography.

1697 SUPINO, I[GINO] B. "Un'opera sconosciuta di Iacopo della
 Quercia." Dedalo 2, no. 1 (1921):149-53, 3 figs.
 Attributes to Quercia marble Madonna di Corsano relief
(Ojetti collection, Florence). [Seymour questions attribution, entry
1607.]

1698 TORRITI, PIERO. "Il nome di Jacopo della Quercia
 nell'Annunciazione di San Gimignano." In Jacopo della Quercia
 fra Gotico e Rinascimento (Atti del Convegno di Studi, Siena,
 1975). Edited by Giullietta C. Dini. Florence: Centro Di,
 1977, pp. 98-100, 3 figs.
 Announces that restoration of Annunciation revealed
inscription on base of angel, "Hoc opus fecit Magister Giacopus Pieri
de Senis," in same lettering as inscription already known from base
of Madonna, "Martinus Bartolomei de Senis pinxit MCCCCXXVI."

1699 VALENTINER, W[ILHELM] R. "The Equestrian Statue of Paolo
 Savelli in the Frari." Art Quarterly 16 (Winter 1953):280-93,
 10 figs.

Attributes to Quercia, ca. 1406-7, equestrian figure and sarcophagus reliefs of Tomb of Paolo Savelli (Santa Maria Gloriosa dei Frari, Venice). [Seymour considers attribution farfetched, entry 1607.]

1700 VALENTINER, W.R. "A Statuette in Wood by Jacopo della Quercia." Bulletin of the Detroit Institute of Arts 20 (1940):14-15, 1 fig. (cover).
Identifies small wooden statuette of Apostle, possibly St. John (Detroit Institute of Arts) as model for larger work by Jacopo della Quercia. [Unconvincing attribution according to Seymour, entry 1607.]

1701 VENTURI, ADOLFO. "San Martino di Lucca." Arte 25 (1922): 207-19, 17 figs.
First attribution to Quercia of series of heads on clerestory, San Martino, Lucca.

1702 VENTURI, ADOLFO, "Statua di Jacopo della Quercia nel Duomo di Lucca." Arte 23 (1920):160-61, 2 figs.
Stresses importance for his early career of Apostle sculpture by Quercia, once on an exterior buttress of San Martino, Lucca, and now inside that church.

1703 WUNDRAM, MANFRED. "Die Sienesische Annunziata in Berlin: Ein Frühwerk des Jacopo della Quercia." Jahrbuch der Berliner Museen 6 (1964):39-52, 8 figs.
Attributes to Quercia, ca. 1406-10, Virgin Annunciate (Staatliche Museen, Berlin-Dahlem). Considers it prototype for wood Annunciation groups attributed to Francesco di Valdambrino. Seymour says sculpture is very close to Quercia, while Pope-Hennessy disputes attribution (entries 1607 and 60).

1704 WUNDRAM, MANFRED. "Jacopo della Quercia und das Relief der Gürtelspende über der Porta della Mandorla." Zeitschrift für Kunstgeschichte 28 (1965):121-29, 6 figs.
Suggests spiral torsion of figures in Quercia's Fonte Gaia reliefs (especially the Temperance) influenced Nanni di Banco's figure of Virgin in his contemporaneous Assumption, Porta della Mandorla, Duomo, Florence.

1705 ZUCCHINI, GUIDO. "Un'opera inedita di Iacopo della Quercia." Arte mediterranea, 3d ser. (July-August 1949):14-15, 3 figs.
Attributes to Quercia Tomb Slab of Antonio da Budrio (Convent of San Michele in Bosco, Bologna) and dates it 1435 on basis of eighteenth-century transcription of documents from San Michele in Bosco (Bibiloteca Malvezzi-De Medici, Bologna).

AMBROGIO DELLA ROBBIA

1706 De NICOLA, GIACOMO. "Arte inedita in Siena e nel suo antico territorio." Vita d'arte 5 (March 1912):85-111, 22 figs.
Publishes many fifteenth-century Sienese sculptures not included in Fabriczy's catalogue (entry 259), including only documented work by Ambrogio della Robbia then known, a polychromed terracotta Adoration from Santo Spirito, Siena. On basis of this sculpture, author attributes other works to Ambrogio.

1707 SUPINO, I.B. "Robbia, Ambrogio dealla." In Thieme-Becker Künstler-Lexikon. Leipzig: E.A. Seemann, 1934, 28:413.
Condensed survey of life and work. Valuable bibliography.

ANDREA DELLA ROBBIA

Books

1708 MARQUAND, ALLAN. Andrea della Robbia and His Atelier. 2 vols. Princeton Monographs in Art and Archaeology, no. 11. Princeton: Princeton University Press, 1922, 446 pp., 434 figs. Reprint. New York: Hacker Art Books, 1973.
Catalogue of works attributed to Andrea della Robbia with transcription of all relevant documents.

Articles

1709 CORTI, GINO. "Addenda robbiana." Burlington Magazine 115, no. 844 (July 1973):468-69, no illus.
Supplemental notes to entry 1710. Further examination of Strozzi and Company accounts establishes that another terracotta by Andrea della Robbia was sent to London in June 1504.

1710 CORTI, GINO. "New Andrea della Robbia Documents." Burlington Magazine 112 (1970):749-52, 2 figs.
Unpublished commercial documents dating from 1487 to 1502 record shipment of three works by Andrea della Robbia: bas-relief Nativity, ca. 1487 (now Santa Maria della Stella, Militello, Sicily); Mary Magdalen; and eight-figure Pietà (both now lost), shipped to London in 1501.

1711 F[ABRICZY] C[ORNELIUS] v[on]. "Urkundliches über Andreas della Robbia Arbeiten für S. Maria del Fiore." Repertorium für Kunstwissenschaft 29 (1906):284-85, no illus.
Unpublished documents contain five references to works commissioned from Andrea della Robbia for Florence Duomo, including a date (1489) for Madonna and Child with Two Angels (Museo dell'Opera del Duomo, Florence).

1712 GIGLIOLI, O[DOARDO] H. "Un dossale d'altare della bottega di Andrea della Robbia nella chiesa di S. Romolo a Bivigliano."

Rivista d'arte 6 (1909):45–48, 1 fig. [Documents on p. 48–52 appended by "g.p."]
Attributes altar dossal in San Romolo, Bivigliano, to Andrea della Robbia ca. 1489. Date corroborated by documents published here.

1713 La GRASSA-PATTI, FRANCESCO. "Opere dei della Robbia in Sicilia." Arte 6 (1903):37–47, 5 figs.
Publishes four terracottas by Andrea della Robbia and shop: Madonna degli Angeli, Santa Maria di Gesù, Trapani; Madonna and Child tondo, Santa Maria della Scala, Messina; Madonna Adoring the Child, San Niccolò lo Gurgo, Palermo; and Madonna del Cuscino, Museo Nazionale, Palermo.

1714 LUSZCZKIEWICZ, WLADYSLAW. "Plaskorzezba Andrzeja della Robbia w kosciele w Lasku" [La bas-relief d'Andrea della Robbia à l'église de Lask]. Sprawozdania komisji do badania historji sztuki w Polsce 9 (1914):317–30, 2 figs. [Résumé in French.]
In Polish. Discusses marble Madonna and Child relief (Lask) by Andrea della Robbia in terms of style and provenance. Documented gift of Pope Clement VII to archbishop of Gniezno, Jan Laski.

1715 MATHER, RUFUS G. Unpublished Documents Relating to the Will of Andrea della Robbia." American Journal of Archaeology 24 (1920):136–45, 1 fig.
Reproduction and transcription of Andrea della Robbia's will (14 September 1522) and related documents. Provides biographical information on Della Robbia family.

1716 MESNIL, JACQUES. "La Madonne des constructeurs d'Andrea della Robbia." Miscellanea d'arte 1, no. 12 (December 1903):208–10, 1 fig.
Newly discovered document in records of Maestri di pietre e di legnami (Archivo di stato di Firenze) notes Andrea della Robbia's commission in 1474 for Madonna and Child tabernacle with emblems (identified with one in Bargello, Florence). This is Andrea della Robbia's earliest documented work.

1717 PAPINI, ROBERTO. "Un rilievo ignorato di Andrea della Robbia." Arte 15 (1912):36–40, 2 figs.
Unpublished documents establish Andrea as artist of lunette relief of SS. Stephen and Lawrence (Duomo, Prato) of 1489–90. Justifies attribution to Andrea della Robbia of relief of Tobias and the Angel (Biblioteca Roncioni, Prato) at about same date.

1718 PAS, J. de. "Le mausolée de Guillaume Fillastre, d'après les relations au XVIIIe siècle." Société des Antiquaires de la Morinie, Saint-Omer: Bulletin Historique 14 (1926):486–88, no illus.
Publishes previously unrecorded description (from journal of Abbé Delaporte, ca. 1760) of Tomb of Guilaume Fillastre (now

surviving in fragments) by Andrea della Robbia in Saint-Bertin, France.

1719 PODESTA, FERDINANDO. Monumento robbiano nella cattedrale di
 Sarzana. Sarzana: Tipografia Lunense, 1903, 56 pp., 1 fig.
 Monograph on glazed terracotta altarpiece of Penitent St.
Jerome by Andrea in Cathedral, Sarzana, covering commission,
iconography, and later history of altarpiece.

1720 POPE-HENNESSY, JOHN. "Thoughts on Andrea della Robbia."
 Apollo 109 (March 1979):176-97, 24 figs., 3 color pls.
 Major publication on Andrea della Robbia and his shop that
establishes his artistic independence from his uncle, Luca della
Robbia. Examines Andrea's altarpieces for La Verna between 1476 and
1502 in terms of documents, Observant Franciscan iconography, and
style. Their popularity led to many other commissions from
Franciscan churches. Sketches Andrea's relationship with Benedetto
da Maiano, Rustici, Sansovino, Verrocchio, and other artists.

1721 RAGGIO, OLGA. "Andrea della Robbia's Saint Michael Lunette."
 Metropolitan Museum of Art Bulletin 20 (December 1961):135-44,
 12 figs.
 Saint Michael lunette (recently acquired by Metropolitan
Museum of Art, New York), which originally crowned portal of San
Michele Arcangelo, Faenza, is attributed to Andrea della Robbia (ca.
1475).

1722 RICHARDSON, E.P. "The Virgin and Child by Andrea della
 Robbia." Bulletin of the Detroit Institute of Arts 25
 (1946):50-51, 1 fig. (cover).
 Glazed terracotta Madonna and Child (Detroit Institute of
Arts) is attributed to Andrea della Robbia, ca. 1490-1500, while he
was under influence of Savonarola.

1723 RUGGIERI AUGUSTI, ADRIANA. "Due busti robbiani." Bollettino
 annuale, Musei ferraresi 1 (1971):61-64, 4 figs.
 Publishes Bust of St. Nicholas of Tolentino and Bust of St.
Bernardino (Museo Civico di Schifanoia, Ferrara), which author
attributes to Andrea della Robbia shop.

1724 SALE, J. RUSSELL. "New Documents for Andrea della Robbia's
 Militello Altarpiece." Burlington Magazine 122, no. 932
 (November 1980):764-66, no illus.
 Publishes additional documents clarifying Andrea della
Robbia's 1487 commission from count of Militello for terracotta
altarpiece of Nativity (Santa Maria della Stella, Militello, Sicily).

1725 SALMI, MARIO. "Fortuna di Andrea della Robbia." Commentari
 20, no. 4 (October-December 1969):270-80, 11 figs.
 Traces history of convent at La Verna, which was trans-
ferred to Observant Franciscans in 1433. In 1434 its administration

and upkeep were entrusted to Florentine Arte della lana, ensuring
Florentine influence on convent. Many commissions for altarpieces
went to Andrea della Robbia and shop, which consequently received
many other commissions from Franciscans in area.

1726 SUPINO, I[GINO]. "Robbia, Andrea della." In Thieme-Becker
 Künstler-Lexikon. Leipzig: E.A. Seemann, 1934, 28:414.
 Condensed survey of life and work. Valuable bibliography.

1727 VACCAJ, GIULIO. "La Madonna di Andrea della Robbia e la chiesa
 di San Domenico a Pesaro.' Rassegna marchigiani 1 (February
 1923):178-81, no illus.
 Clarifies later history of glazed terrcotta tondo of
Madonna Adoring the Child (San Domenico, Pesaro) and reasserts its
attribution to Andrea della Robbia, not Luca.

1728 VALENTINER, W[ILHELM] R. "'The Annunciation' by Andrea della
 Robbia." Art Quarterly 11 (1948):167-72, 1 fig. Published
 with additional illustrations in the Bulletin of the Art Divi-
 sion of the Los Angeles Country Museum 1 (1947-48):3-7, 5 figs.
 Lifesize Annunciation group (acquired by Los Angeles County
Museum) is by Andrea della Robbia, ca. 1475. Work comes from San
Nicolò, Florence, and may have been commissioned for Palazzo di Bardi
by Tempi family.

1729 VALENTINER, W[ILHELM] R. "Unglazed Terra Cotta Groups by
 Andrea della Robbia." Art in America 14 (1926):120-30, 5 figs.
 Attributes Nativity group (Metropolitan Museum of Art, New
York) to Andrea della Robbia based on its similarity to two groups
ascribed to Andrea della Robbia's youth, Nativity and Adoration of
the Magi (both Duomo, Volterra).

GIOVANNI DELLA ROBBIA

1730 MARQUAND, ALLAN. Giovanni della Robbia. Princeton Monographs
 on Art and Archaeology, vol. 8. Princeton: Princeton
 University Press, 1920, 233 pp., 161 figs.
 Major monograph on Giovanni della Robbia with biography,
transcribed documents, catalogue raisonné, bibliography, and index.
Only ten sculptures predate 1500.

1731 SUPINO, I.B. "Robbia, Giovanni della." In Thieme-Becker
 Künstler-Lexikon. Leipzig: E.A. Seemann, 1934, 28:414-15.
 Condensed survey of life and work. Valuable bibliography.

LUCA DELLA ROBBIA

Books

1732 BODE, WILHELM von, ed. Die Werke der Familie della Robbia.
Berlin: Julius Bard, 1914, 10 pp., 48 figs.
Short pamphlet with very brief text accompanying numerous
small plates.

1733 BURLAMACCHI, Marchesa LUCIA. Luca della Robbia. London:
George Bell & Sons, 1900, xiv, 126 pp., 41 figs.
General study of Luca della Robbia supplemented by exten-
sive descriptions and list of works then attributed to him.

1734 CAVALLUCCI, JACOPO, and MOLINIER, EMILE. Les Della Robbia:
Leur vie et leur oeuvre. Paris: J. Rouam, 1884, 289 pp.,
illus., appendices.
Sketchy early monograph that provides catalogue of Della
Robbia workshops, with some effort to differentiate individual
styles.

1735 CRUTTWELL, MAUD. Luca and Andrea della Robbia and Their
Successors. London: J.M. Dent & Co.; New York: E.P. Dutton &
Co., 1902, 363 pp., 92 figs., appendices. Reprint. New York:
AMS Press, 1972.
Readable, pre-Marquand account of activity of Della Robbia
family hampered by many misattributions.

1736 DARCEL, ALFRED. Recueil de faïences italienes des XVe, XVIe
et XVIIe siècles. Edited by Henri Delange. Paris: E.
Martinet, 1869, 44 pp., 100 color pls. [Edition of 300.]
Primarily portfolio of 100 color plates of Italian
Renaissance ceramics. Also contains valuable and informative
introduction that includes histories of various manufactures,
catalogue of marks and monograms, and classified catalogue of
illustrated works.

1737 DOERING-DACHAW, OSCAR. Die Künstlerfamilie della Robbia. Die
Kunst dem Volke, no. 14. Munich: Allgemeine Vereingigung für
christliche Kunst, 1913, 40 pp., 60 figs.
Brief early monograph that judiciously divides Della Robbia
works. Includes excellent photographs, though study is now
superseded.

1738 GAETA BERTELA, G[IOVANNA]. Donatello, Della Robbia. Flor-
ence: Scala, 1970, 96 pp., 16 figs., 8 color pls.
Brief text that serves as introduction to lavish, large
illustrations, mainly in color.

1739 MARQUAND, ALLAN. Della Robbias in America. Princeton Mono-
graphs in Art and Archaeology, vol. 1. Princeton: Princeton

University Press, 1912, 184 pp., 72 figs. Reprint. New York: Hacker Art Books, 1973.

Catalogue of seventy-three works, then in American collections, ascribed to Luca, Andrea, and Giovanni della Robbia and their workshops.

1739a Cust, Lionel. Review of Della Robbias in America, by Allan Marquand. Burlington Magazine 24 (January 1914):234-35, no illus.

1740 MARQUAND, ALLAN. Luca della Robbia. Princeton Monographs in Art and Archaeology, vol. 3. Princeton: Princeton University Press, 1914, 286 pp., 186 figs.

Important early monograph that clarifies attributions of works by Luca della Robbia. Arranged as catalogue raisonné with thorough transcription of documents and biographical information.

1740a Bode, W[ilhelm] v[on]. Review of Luca della Robbia, by Allan Marquand. Mitteilungen des Kunsthistorischen Institutes in Florenz 2 (1912-17):71-80, no illus.

1740b Horne, Herbert. "Notes on Luca della Robbia." Review of Luca della Robbia, by Allan Marquand. Burlington Magazine 28, no. 151 (October 1915):3-7, no illus.

Rejects early dating of Pistoia Visitation, citing documents that prove that Monastery of San Giovanni Laterno was founded in 1470, thus providing terminus post quem for Luca's lunette (Marquand dated it ca. 1440). Refers to documents that place his change-over to medium of terracotta at ca. 1440 and redate Tomb of Bishop Federighi 1454-57 (not 1455-57). Identifies subjects of Campanile reliefs.

1741 PLANISCIG, LEO. Luca della Robbia. Vienna: Anton Schroll & Co., 1940, 38 pp., 112 figs.

Brief, informative essay accompanies good corpus of photographs of Luca della Robbia's oeuvre.

1742 PLANISCIG, LEO. Luca della Robbia. Florence: Del Turco, [1948], 79 pp., 134 figs., 2 color pls.

Expansion of German edition (entry 1741). Brief essay and comments on plates but no footnotes or bibliography. [Pope-Hennessy (entry 61): "Adds little to Marquand's conclusions in factual sense, but is more adequately illustrated."]

1743 POPE-HENNESSY, Sir JOHN W. Luca della Robbia. Ithaca, N.Y.: Cornell University Press, 1980, 288 pp., 194 figs., 32 color pls.

Major monograph on Luca della Robbia, focusing on stylistic discussion of groups of works. Documents transcribed in appendix; attributions greatly clarified in catalogue raisonné.

1743a Ames-Lewis, Francis. "A New Perspective on Early Renaissance in Florentine Art?" Art History 4, no. 3 (1981):339-44, no illus.
 Review of Luca della Robbia by John Pope-Hennessy and Donatello and Michelozzo by Ronald Lightbown (entry 1404), as well as Helmut Wohl's Domenico Veneziano and Marita Horster's Andrea del Castagno.

1743b Ettlinger, L[eopold] D. Review of Luca della Robbia, by John Pope-Hennessy. Art Bulletin 63, no. 3 (September 1981):510-12, no illus.

1743c Janson, H.W. Review of Luca della Robbia, by John Pope-Hennessy. New York Review of Books 27, no. 2 (17 April 1980):39-40, 1 fig.
 Criticizes Pope-Hennessy for lack of careful attention to problem of Luca's training and formation. Unlike Pope-Hennessy, Janson feels that Luca played no role in Porta della Mandorla Assumption of the Virgin by Nanni di Banco (although Nanni may have been his master). He also believes that Michelozzo was a major influence on young Luca.

1743d Middeldorf, Ulrich. Review of Luca della Robbia, by John Pope-Hennessy. Apollo 112, no. 223 (1980):210-12, no illus.
 Some criticisms of attributions and suggestions for early sculptures by Luca in context of laudatory review.

1744 REYMOND, MARCEL. Les Della Robbia. Florence: Alinari Frères, 1897, 278 pp., 170 figs.
 Generally uncritical monograph covering Luca, Andrea, and Giovanni della Robbia, with descriptive catalogue of works, lists, and profuse illustrations.

1745 SALVINI, ROBERTO. Luca della Robbia. Novara: Documentario Athaeneum Fotografico, 1943, 4 pp., 40 figs. French ed., Paris: Alpina, 1944.
 Short introduction accompanies large plates of Luca della Robbia's work.

1746 SCHUBRING, PAUL. Luca della Robbia und seine Familie. Bielfeld and Leipzig: Verlag von Velhagen & Klasing, 1921, 154 pp., 157 figs., 13 color pls.
 Brief monograph that offers new attributions and some stylistic discussion of Della Robbias.

Monographs on One or More Monuments

1747 BACCI, PELEO. Il gruppo pistojese della Visitazione, già attribuito a Luca della Robbia: Note d'archivio. Florence: Tipografica Domenicana, 1906, 20 pp., 2 figs.
 Publishes documents concerning endowment of 1445 that mentions figure of Virgin of Visitation. Argues that they refer to a

wholly different sculpture and that Visitation group in San Giovanni
Fuorcivitas, Pistoia, is not by Luca della Robbia but dates from
early sixteenth century when altar and tabernacle were reconstructed.
Argument is rejected by later scholars. [See Pope-Hennessy, entry
1743, cat. no. 10].

1747a GRONAU, GEORG. Review of Il gruppo pistojese della
 Visitazione, già attribuito a Luca della Robbia: Note
 d'archivio, by Pèleo Bacci. Monatshefte der kunstwissen-
 schaftlichen Literatur 3 (1907):2-3, no illus.

1748 LISNER, MARGRIT. Luca della Robbia: Die Sängerkanzel.
 Werkmonographien zur bildenden Kunst, no. 59. Stuttgart:
 Reclam, [1960], 32 pp., 15 figs.
 Handy monograph in small format aimed at educated visitor
 to monument. Derives from Ph.D. dissertation, Albert-Ludwigs-
 Universität, Breisgau, 1955.

1749 MARQUAND, ALLAN. Robbia Heraldry. Princeton Monographs in Art
 and Archaeology. Princeton: Princeton University Press, 1919,
 310 pp., 277 figs.
 Catalogue of heraldic medallions, tablets, and stemma
 produced by various Della Robbia workshops, with introductory notes
 on heraldic devices and shields.

1750 MARRAI, BERNARDO. Le Cantorie di Luca della Robbia e di
 Donatello. Florence: Minori Corrigendi, 1900, 32 pp., 1 fig.
 Publishes new documents about dating of Luca's and Dona-
 tello's Cantorie (Duomo, Florence) and proposed reconstruction of
 Luca's Cantoria.

1751 MARRAI, BERNARDO. La Primavera di Botticelli, le Cantorie di
 Luca della Robbia e di Donatello, la Sepoltura di Lemmo
 Balducci: Opere d'arte dell'Arcispedale di Santa Maria Nuova.
 Florence: Tipografia Domenicana, 1907, 80 pp., 5 figs.
 Expansion of earlier essay on Cantorie, Duomo, Florence.
 Includes essay on Francesco di Simone Fiesolano's [Ferrucci] Tomb of
 Lemmo Balducci (Sant'Egidio, Florence).

1752 AVERY, CHARLES. "Three Marble Reliefs by Luca della Robbia."
 Museum Studies (Art Institute of Chicago) 8 (1976):6-37, 31
 figs., 1 color pl. (cover). Reprinted in Charles Avery,
 Studies in European Sculpture (London: Christie's, 1981), pp.
 1-24, 31 figs.
 Attributes to Luca della Robbia marble relief of God the
 Father with Cherubim (Art Institute, Chicago); marble relief of
 half-length Madonna of the Snow, SS. Annunziata, Florence, which is
 Luca's only marble Madonna and Child; and coat of arms of Amico della
 Torre, dated 1431, on courtyard wall of Bargello, Florence. The coat
 of arms is Luca's earliest dated sculpture. Traces iconography of
 God the Father theme in fifteenth-century Florentine sculpture.

1753 BACCI, PELEO. "Il gruppo della Visitazione in S. Giovanni
 Fuorcivitas di Pistoia." Illustratore fiorentino
 (1907):174-85,
 no illus.
 Publishes archival research concerning Compagnia di S.
Elisabetta, patron of Visitation (San Giovanni Fuorcivitas, Pistoia).
Includes 1446 document which can be interpreted as referring to it
and providing a terminus ante quem.

1754 BALDINI, UMBERTO. "La bottega dei della Robbia." In Umanesimo
 e Rinascimento. Edited by Alberto Busignani, et al. Il mondo
 delle forme, vol. 6. Florence: Sadea; Sansoni, 1966, pp.
 57-96, 8 figs., 33 color pls.
 Corpus of color plates of sculpture by the Della Robbia,
principally Luca. Introduced by brief essay and bibliography.

1755 BALLARDINE, GAETANO. "An Unknown Della Robbia Tilework Floor
 at Bologna." Burlington Magazine 55, no. 318 (September 1929):
 121-28, 7 figs.
 Attributes majolica tile floor of Bentivoglio family
private chapel to Andrea della Robbia through comparison with similar
pavements in Empoli and San Gimignano. The design, however, may be
by Luca della Robbia.

1756 BALLARDINE, GAETANO. "Sulla tomba robbiana del vescovo
 Federighi (1455-1459)." Faenza 17 (1929):9-13, 3 figs.
 Argues that gilded areas of glazed terracotta border of
Tomb of Bishop Federighi (Santa Trinità, Florence), dated 1455-59,
were executed in gold leaf by specialist, rather than by Luca della
Robbia working in glazed terracotta.

1757 BELLOSI, LUCIANO. "Per Luca della Robbia." Prospettiva 27
 (October 1981):62-71, 20 figs.
 Attributes marble Madonna and Child Enthroned with SS.
Stephen, Lucy, and a Donor relief (Count Franco collection, Vicenza)
to young Luca. Also attributes to Luca Little Prophet on right
pinnacle of Porta della Mandorla, an attribution first proposed by
Seymour (entry 1811).

1758 BIEHL, W[ALTHER]. "Eine Marmorbüste des Luca della Robbia."
 Monatshefte für Kunstwissenschaft 8 (1915):147-49, 11 figs.
 Marble Bust of a Young Woman (Bargello, Florence)--an ideal
image, not a portrait--is attributed to Luca della Robbia, ca.
1440-50.

1759 BODE, [WILHELM von]. "Bildwerke der christlichen Epoche."
 Amtliche Berichte aus den königlichen Kunstsammlungen, no. 4
 (1 October): xliii, no illus. Jahrbuch der königlich
 preussischen Kunstsammlungen 15 (1894).
 Brief note recording acquisition of large relief of Madonna
and Child, an early work of Luca della Robbia; also, bust-length

Individual Sculptors

relief portrait of a young man by Andrea della Robbia, close in style
to Verrocchio.

1760 BODE, W[ILHELM von]. "Die Gruppe der Begegnung Maria mit der
 Hl. Elisabeth in S. Giovanni Fuorcivitas zu Pistoja." Kunst-
 chronik 18 (1907):512-13, no illus.
 New documents concerning glazed terrcotta Visitation (San
Giovanni Fuorcivitas, Pistoia) confirm attribution to Luca della
Robbia, its commission in 1445, and its subsequent history.

1761 BODE, W[ILHELM von]. "Luca della Robbia." Jahrbuch der
 königlich preussischen Kunstsammlungen 6 (1885):170-85, 6 figs.
 Stylistic analysis of Luca della Robbia's glazed terra-
cottas with special attention to Madonna and Child reliefs. Attribu-
tions of works in London (Victoria and Albert Museum), Paris
(Louvre), and Berlin museum. Some discussion of bronze reliefs.

1762 BODE, WILHELM [von]. "Luca della Robbia." Jahrbuch der
 königlich preussischen Kunstsammlungen 21 (1900):1-33, 6 figs.
 Traces stylistic development of Luca della Robbia's oeuvre
with particular emphasis on Madonna and Child reliefs and portraits.
Discusses development of glazing technique and related style of
Andrea della Robbia.

1763 BODE, WILHELM [von]. "Luca della Robbia e i suoi precursori in
 Firenze." Archivio storico dell'arte 2 (1889):1-9, 127-33, 14
 figs.
 Hypothesizes that Luca began by making painted terracotta
Madonna and Child sculptures such as were widely done in early
fifteenth-century Florence.

1764 BODE, W[ILHELM von]. "La Madonna di Luca della Robbia del
 1428." Rivista d'arte 3 (1905):1-3, 1 fig.
 Publishes stucco cast (Von Bülow collection, Berlin) after
Luca della Robbia stucco Madonna and Child (Ashmolean Museum,
Oxford). Stucco cast here dated mid-fifteenth century, thus
supporting controversial 1428 date of the Luca della Robbia stucco.

1765 BODE, WILHELM [von]. "Neuendeckte Bildwerke in glasiertem Ton
 von Luca della Robbia." Zeitschrift für bildende Kunst, n.s.
 21 (1910):305-7, 3 figs.
 Attributes to Luca della Robbia Madonna and Child (J.P.
Morgan collection, New York), Madonna, and Nativity (private
collections).

1766 BODE, WILHELM [von]. "Originalwiederholungen glasierter
 Madnnenreliefs von Luca della Robbia." Münchner Jahrbuch der
 bildenden Kunst 1 (1906):28-32, 4 figs.
 Demonstrates that four terracotta reliefs of Madonna and
Child in niche (Genoese Madonna type) are variations of single mold
from Luca della Robbia's shop (Bargello, Florence; formerly

Kaiser Friedrich Museum, Berlin; Gustav Benda collection, Vienna [now Kunsthistorisches Museum, Vienna]; E. Simon collection, Berlin [now Detroit Institute of Arts]).

1767 BROCKHAUS, HEINRICH. "Die Sängerkanzeln des Florentiner Doms in ihrer kirchlichen Bedeutung." Zeitschrift für bildende Kunst 19 (1908):160-61, 2 figs.
 Proposes that inscription of Psalms 148 and 149 once decorated Donatello's Cantoria and that Donatello's and Luca della Robbia's paired Cantorie illustrate first and last parts (Psalms 148-50) of Sunday morning Catholic mass.

1768 BRUNETTI, GIULIA. "Della Robbia." In Encyclopedia of World Art. Edited by Istituto per la collaborazione culturale, Rome. London: McGraw-Hill Publishing Co., 1961, 4:cols. 295-302, figs. 155-62.
 Succinct summary of Luca's life and oeuvre by a leading authority. Extensive bibliography.

1769 BRUNETTI, GIULIA. "Note su Luca della Robbia." In Scritti in onore di Mario Salmi. Rome: De Luca, 1962, 2:263-72, 8 figs.
 Attributes to Luca marble half-length Madonna and Child (in little cloister of SS. Annunziata, Florence) usually assigned to Michelozzo. Suggests that Luca worked closely with Donatello and Brunelleschi in 1430s and attributes to Luca parts of painted terracotta frieze decoration in Old Sacristy, San Lorenzo, and Pazzi Chapel, Santa Croce. Attributes tentatively to Donatello parts of stucco putti frieze on tabernacle of Santa Maria dell'Impruneta.

1770 CAROCCI, G[UIDO]. "Il monumento del vescovo Benozzo Federighi e l'ornamentazione floriale robbiana." Arte italiana decorativa ed industriale 8 (1904):85-88, 7 figs., 4 color pls.
 Survey of floral patterns used by the Della Robbia, focusing on Tomb of Bishop Federighi (Santa Trinità, Florence).

1771 CAROCCI, G[UIDO]. "I tondi robbiani in Toscana." Arte italiana decorativa ed industriale 5 (1896):29-31, 14 figs.
 Collects different types of decorative tondi by Luca and Andrea della Robbia to show their range of invention in this format.

1772 CASALINI, EUGENIO. "Culto ed arte all'Annunziata nel '400." In La SS. Annunziata di Firenze: Studi e documenti sulla chiesa e il convento. 2 vols. Florence: Convento della SS. Annunziata, 1978, 1:9-60, 30 figs.
 Attributes to Luca two terracotta figures of St. John the Evangelist and Virgin Mary, which he argues were part of Pietà group, and are now part of Crocifisso dei Bianchi on altar in Villani Chapel, SS. Annunziata. Dates figures in 1430s.

1773 CONTRUCCI, P[IETRO]. Monumento robbiano nella loggia dello spedale di Pistoja. Prato: Fratelli Giachetti, 1835, 374 pp., no illus.

315

Monograph on this structure with an appended critique by Giuseppe Pellegrini.

1774 De MELY, F. "La dorure sur céramique et l'émail de Jehan
 Fouquet au Louvre." Gazette des beaux-arts, 3d per.
 34 (1905):281-87, 3 figs.
 Notes that border of 1456 Tomb of Bishop Federighi by Luca
della Robbia (Santa Trinità, Florence) is decorated with background
of metallic gold, one of the early known uses of it on ceramic.

1775 De NICOLA, GIACOMO. "A Recently Discovered Madonna by Luca
 della Robbia." Burlington Magazine 35 (1919):48-55, 3 figs.
 Attributes glazed Madonna and Child (San Michele, Lucca) to
Luca della Robbia (ca. 1440). Notes Annunciation by Andrea della
Robbia in San Nicolò, Florence (then unpublished).

1776 Del BRAVO, CARLO. "L'umanesimo di Luca della Robbia."
 Paragone, no. 285 (1973):3-34, 26 figs., 1 color pl.
 Major study on Luca's marble and glazed terracotta
sculpture: its stylistic evolution; sources in ancient gems, coins,
and sarcophagi; Luca's relationship with humanist, Niccolò Niccoli;
his influence on Lippi; and his interaction with Ghiberti and Piero
della Francesca.

1777 DENIS, VALENTIN. "La représentation des instruments de musique
 dans les arts figurés du XV siècle en Flandre et en Italie."
 Bulletin de l'Institut Historique Belge de Rome 21 (1940-41):
 327-45, 19 figs.
 Understanding of types and uses of musical instruments in
Quattrocento is derived largely from painting and, less commonly,
sculpture. Identifies, describes, and illustrates instruments with
references to sculptures of Agostino di Duccio and Luca della Robbia.

1778 FABRICZY, CORNELIUS von. "Die Heimsuchungsgruppe in S.Gio-
 vanni Fuorcivitas zu Pistoja." Repertorium für Kunstwissen-
 schaft 30 (1907):285-86, no illus.
 Agrees with Bacci (entry 1747) and denies attribution of
Visitation group (San Giovanni Fuorcivitas, Pistoia) to Luca della
Robbia. Considers it work of Buglioni and part of later production
of Della Robbia shop.

1779 FORATTI, ALDO. "Note robbiane." Rassegna d'arte antica e
 moderna 19 (1919):22-32, 11 figs.
 Distinguishes technical and stylistic traits of Luca,
Andrea, and their shops.

1780 GLASSER, HANNELORE. "The Litigation concerning Luca della
 Robbia's Federighi Tomb." CORTI, GINO. "New Documents."
 Mitteilungen des Kunsthistorischen Institutes in Florenz 14
 (1969-70):1-32, 8 figs., appendix.
 Reexamines documents concerning Luca della Robbia's Tomb of
Bishop Federighi (Santa Trinità, Florence), clarifying date (1454-59)

and original appearance of monument. Reveals protracted dealings involved in execution, construction, and finishing of monument.

1781 HATFIELD, RAB. "Some Unkown Descriptions of the Medici Palace in 1459." Art Bulletin 52 (1970):232-49, 7 figs., appendix.
 Two letters and a poem (previously unpublished) stemming from Galeazzo Maria Sforza's visit to Florence in April 1459 offer new evidence regarding early appearance and impact of the Palazzo Medici[-Riccardi] interior. Omission of Gozzoli's frescoes and Luca della Robbia's studiolo reliefs suggests datings after 1459.

1782 LETHABY, W.R. "Majolica Roundels of the Months of the Year at the Victoria and Albert Museum." Burlington Magazine 9, no. 42 (September 1906):404-7, 2 figs.
 Suggests that since majolica roundels (Victoria and Albert Museum, London) are curved, they may be those made for barrel-vaulted vestibule of Palazzo Medici[-Riccardi] by Luca della Robbia (ca. 1430?), as mentioned by Vasari.

1783 MARQUAND, ALLAN. "An Altarpiece by Luca della Robbia." American Journal of Archaeology 13 (1909):328-33, 1 fig.
 Attributes glazed terracotta altarpiece of Madonna and Child with SS. Jacopo and Biagio (Cappella del Vescovado, Duomo, Pescia) to Luca della Robbia and suggests it is his earliest work of this type. Hypothesizes regarding the work's donor and origin. [Pope-Hennessy, entry 1743, pp. 261-62, dates it ca. 1465-70.]

1784 MARQUAND, ALLAN. "Coat of Arms of the Ginori Family." Art in America 2, no. 1 (April 1914):242-46, 1 fig.
 Attributes to Luca della Robbia's shop glazed terracotta coat of arms for Ginori family.

1785 MARQUAND, ALLAN. "Luca della Robbia." Art and Progress 5, no. 3 (January 1914):79-85, 6 figs.
 Brief general study listing attributions to Luca. Cites date (1445) by which Visitation was in Pistoia and rejects recent attempts to attribute the work to Buglioni.

1786 MARQUAND, ALLAN. "Luca della Robbia and His Use of Glazed Terra-cotta." Brickbuilder 4, no. 12 (December 1895):249-51, 4 figs.
 Discusses Luca della Robbia's various technical applications of terracotta, beginning ca. 1443. Reasserts attribution of Pistoia Visitation.

1787 MARQUAND, ALLAN. "The Madonnas of Luca della Robbia." American Journal of Archaeology 9 (1894):1-25, 19 figs.
 Stylistic classification of Luca della Robbia's glazed terracotta Madonna and Child reliefs into five chronological periods, with critical catalogue of forty works.

1788 MARQUAND, ALLAN. "On Some Recently Discovered Works by Luca
 della Robbia." American Journal of Archaeology 16 (1912):
 163-74, 4 figs.
 Identifies four new works by Luca della Robbia: Wellington
Madonna (Nynehead Parish Church, Somerset); Wellington Adoration
(Nynehead Parish Church, Somerset) [attributed by Pope-Hennessy,
entry 1743, cat. no. 64, to Andrea della Robbia]; and two medallions,
Prudence and Faith (both Paris art market).

1789 MARQUAND, ALLAN. "Robbia Pavements." Brickbuilder 11, no. 3
 (March 1902):55-57; no. 5 (May 1902):98-101, no illus.
 Studies of tile pavements; none by Luca della Robbia
survive; an important pavement by Andrea della Robbia at Empoli; Luca
di Andrea della Robbia made tile floor for Raphael's Loggie, Vatican,
1518, which can be reconstructed through drawings by Francesco la
Vega (1742).

1790 MARQUAND, ALLAN. "A Search for Della Robbia Monuments in
 Italy." Scribner's Magazine 14, no. 6 (December 1893):681-98,
 14 figs.
 Preliminary record of Marquand's researches on Della
Robbia. Presented as travelogue but contains interesting observa-
tions and attributions.

1791 MARQUAND, ALLAN. "Some Unpublished Monuments by Luca della
 Robbia." American Journal of Archaeology 8 (1893):153-70,
 8 figs.
 New document confirms attribution of Orsanmichele medallion
of Council of Merchants to Luca della Robbia and provides date of
1463, making it latest dated terracotta in Luca's oeuvre. Attributes
to Luca della Robbia four other medallions on Orsanmichele and, at
Santa Maria dell'Impruneta, Altar (ca. 1477), and ceiling of Cappella
della Croce, Altar of Madonna, and Crucifixion (ca. 1441-46).

1792 MARQUAND, ALLAN. "The Visitation by Luca della Robbia at
 Pistoia." American Journal of Archaeology 11 (1907):36-41,
 2 figs.
 New documents record Visitation installed at Pistoia in
1475 and still in the church. This work is the same Visitation
attributed to Luca della Robbia (ca. 1430-45).

1793 MARRAI, B[ERNARDO]. "La ricomposizioni della Cantoria di Luca
 della Robbia e gli altari del Quattrocento scoperti nel Duomo
 di Firenze." Arte italiana decorativa ed industriale 9
 (1900):82-84, 4 figs.
 Analysis of reconstruction and reinstallation of Cantoria
in Museo dell'Opera del Duomo, Florence. Discussion of fifteenth-
century altar recovered in Tribuna della Santa Croce, Duomo, Flor-
ence, perhaps one for which Luca was to do reliefs of St. Peter and
Michelozzo a bronze grillwork.

1794 MATHER, RUFUS G. "Documents Relating to the Will of Luca di
 Simone della Robbia." American Journal of Archaeology 24
 (1920):342-51, 1 fig.
 Corrected transcriptions of documents, plus two new docu-
 ments relating to Luca della Robbia's will. These provide additional
 biographical details pertaining to Della Robbia family.

1795 MATHER, RUFUS G. "Nuovi documenti robbiani." Arte 21 (1918):
 190-209, no illus.
 Publishes without annotation lengthy series of documents
 concerning Della Robbia, Buglioni, and Michelozzo's role in Luca's
 bronze doors (Duomo, Florence).

1796 MATTHIAE, GUGLIELMO. "Un Luca della Robbia nella cattedrale di
 Atri." Bollettino d'arte, 4th ser. 44 (1959):321-23, 2 figs.
 Argues that glazed terracotta Madonna and Child relief
 (Duomo, Atri) is by Luca and contemporary with bronze doors for
 Duomo, Florence.

1797 MIDDELDORF, ULRICH. "A Florentine Madonna Relief." Register
 of the Museum of Art of the University of Kansas 5 (February
 1955):4-8, 1 fig.
 Painted stucco Virgin and Child relief, University Museum,
 Lawrence (first half of fifteenth century) falls within category of
 popular sculpture for street tabernacles, etc. Compares style and
 technique to Luca della Robbia's; argues work is student's montage of
 master's style.

1798 MIDDELDORF, ULRICH. "Two Florentine Sculptures at Toledo."
 Art in America 28 (1940):13-30, 6 figs.
 Attributes terracotta Madonna relief to Luca della Robbia
 (ca. 1445-50) and marble profile head of St. Cecilia (both in Toledo
 Museum of Art) to Desiderio da Settignano. [Luca della Robbia relief
 is now known as Demidoff Madonna and is attributed by Pope-Hennessy
 (entry 1743) to Andrea della Robbia, ca. 1465-70.] Reprinted in
 entry 54.

1799 MOLINIER, EMILE. "Une oeuvre inédite de Luca della Robbia: Le
 tabernacle en marbre de l'église de Peretola, près de
 Florence."
 Gazette archéologique 9 (1884):364-70, 2 figs.
 Small tabernacle with Pietà in marble and enamelled terra-
 cotta in church of Peretola near Florence is attributed to Luca della
 Robbia. Relates it to tabernacle for Santa Maria Nuova, Florence,
 commissioned in 1441-43, according to new documents transcribed here.

1800 MOROZZI, GUIDO. "Ricerche sull'aspetto originale dello
 Spedale degli innocenti di Firenze." Commentari 15, nos.
 3-4 (1964):186-201, 18 figs.
 Analysis of building history and original appearance of
 Ospedale degli innocenti, Florence, by Brunelleschi, deduced from

documents in the Libro di muraglie. Useful for background to Luca's glazed terracotta roundels which, according to this author, were put on façade in 1487.

1801 PARRONCHI, ALESSANDRO. "L'aspetto primitivo del Sepolcro Federighi." Paragone 15, no. 179 (November 1964):49-51, 3 figs.
 Publishes drawing from "'Sepoltuario' Baldovinetti" (Biblioteca riccardiana, Florence) that shows original format of Luca della Robbia's now-transformed Tomb of Bishop Federighi. Similarity between lower part of original monument and elevation of upper façade, Pazzi Chapel, leads to speculation that Luca had role in that work as well.

1802 PARRONCHI, ALESSANDRO. "La croce d'argento dell'altare di San Giovanni." In Lorenzo Ghiberti nel suo tempo (Atti del Convegno internazionale di studi, Florence, 18-21 October 1978). 2 vols. Florence: Leo S. Olschki, 1980, 1:195-217, 20 figs.
 Argues that figures of Crucified Christ, Virgin Mary, and St. John the Evangelist, now attached to the altered Silver Crucifix of the Altar of St. John the Baptist (Museo dell'Opera del Duomo, Florence) were part of lost Crucifix by Luca della Robbia done before the Cantoria and reused here. This supports theory that Luca was trained as bronze sculptor by Ghiberti.

1803 POGGI, GIOVANNI. "Documenti sulla tomba Federighi di Luca della Robbia." Rivista d'arte 4 (1906):156-57, no illus.
 Publishes complete document concerning Tomb of Bishop Federighi (Santa Trinità, Florence) by Luca, incorrectly published in Gaye (entry 1).

1804 POGGI, GIOVANNI. "Per la storia della tomba di S. Giovanni Gualberto." Rivista d'arte 4 (1906):158-59, no illus.
 Publishes sixteenth-century document that clarifies later history of unfinished Tomb of San Giovanni Gualberto (now dispersed among Bargello, Museo dell'Opera del Duomo, and Palazzo Pitti, Florence).

1805 POPE-HENNESSY, JOHN. "The Evangelist Roundels in the Pazzi Chapel." Apollo 106, no. 188 (1977):262-69, 11 figs.
 Four Evangelist roundels in Pazzi Chapel, Florence, were modelled by Donatello, and glazed by Della Robbia workshop (possibly Andrea) in late 1450s, and installed soon after completion of cupola, ca. 1460-61.

1806 RABIZZANI, GIOVANNI. "Il gruppo pistoiese della Visitazione in S. Giovanni Fuorcivitas." Bolletino storico pistoiese 10 (1908):43-45, no illus.
 Argues that 1446 document discovered by Bacci (entry 1753) can only be interpreted as referring to Visitation group, which thus predates 1446 and must be by Luca della Robbia.

1807 RENÉ I of ANJOU. Extraits des comptes et mémoriaux du roi René pour servir à l'histoire des arts au XV^e siècle. Edited by Albert Lecoy de la Marche. Paris: Alphonse Picard, 1873, 365 pp., no illus.
 Contains documents demonstrating close relationship between Jacopo de' Pazzi and King René of Anjou that resulted in commission of Stemma of King René of Anjou (Victoria and Albert Museum, London) from Luca della Robbia, ca. 1466-75.

1808 REYMOND, MARCEL. "La Madone Corsini de Luca della Robbia." Rivista d'arte 2 (1904):93-100, 5 figs.
 Describes previously unknown glazed terracotta tondo of Madonna and Child by Luca della Robbia, ca. 1470 (Palazzo Corsini, Florence). Compares it to various types of Madonnas in Luca's oeuvre.

1809 RICHARDSON, E.P. "The Virgin and Child with Six Angels by Luca della Robbia." Bulletin of the Detroit Institute of Arts 29, no. 4 (1949-50):78-80, 1 fig.
 Argues that this tondo (Detroit Institute of Arts) is early work by Luca della Robbia, one of several copies in stucco and terracotta that dates from 1428 to 1438.

1810 SCHOTTMULLER, FRIDA. "Zwei neuerworbene Reliefs des Luca della Robbia im Kaiser-Friedrich-Museum." Jahrbuch der königlich preussischen Kunstsammlungen 27 (1906):224-27, 2 figs.
 Records acquistion of so-called Mugello Lunette (now Staatliche Museen-Bode Museum, East Berlin), a relief in enamelled terracotta of Madonna with Two Angels. Discusses an early Madonna relief with faulty, perhaps experimental, enamelling (now destroyed). [Pope-Hennessy, entry 1743, cat. nos. 31 and 26.]

1811 SEYMOUR, CHARLES, Jr. "The Young Luca della Robbia." Allen Memorial Art Museum Bulletin (Oberlin) 20 (1963):92-119, 18 figs.
 Argues that Luca della Robbia apprenticed to Nanni di Banco before Nanni's death in 1421. See Nanni's influence reflected in Luca's interest in antiquity and in real, rather than apparent, mass in Little Prophet on right (ca. 1416) and left Angel (ca. 1422) of Porta della Mandorla and in Sant'Egidio Coronation of the Virgin (ca. 1424), possibly Luca's earliest glazed terracotta.

1812 SUPINO, I[GINO] B. "Robbia, Luca della." In Thieme-Becker Künstler-Lexikon. Leipzig: E.A. Seemann, 1934, 28:413-14.
 Condensed survey of life and work. Valuable bibliography.

1813 SUTTON, DENYS. "Robert Langton Douglas: The Architectonic Quality of Luca della Robbia." Apollo 109, no. 207 (May 1979):342-45 [78-81], 10 figs.
 Abstract of R.L. Douglas's views on Luca della Robbia (whom he considered greatest Renaissance artist), especially regarding

importance of setting for proper appreciation of work of art. Some
evaluation of Douglas's attributions to Luca and others of the Della
Robbia famiy. (Based on Douglas's Cantor Lectures.)

1814 TOESCA, PIETRO. "Sculture fiorentine del Quattrocento."
 Bollettino d'arte 1 (1921):149-58, 8 figs.
 Publishes group of fifteenth-century Florentine sculptures:
camino frieze of putti and stucco Madonna and Child relief by
Rosselli, both in Palazzo Ducale, Urbino; Enthroned Madonna and Child
relief, San Domenico, Ferrara,by Antonio Rossellino; full-length
Madonna and Child relief from tabernacle in Sant'Angelo, Ancarano,
and Bust of St. John the Baptist in Palazzo Ducale, Urbino, both by
Francesco di Simone Ferrucci; and glazed terracotta Bust of a Youth
by Luca della Robbia shop in Bargello, Florence.

1815 WALTHER, JOSEPHINE. "The Genoese Madonna by Luca della
 Robbia." Bulletin of the Detroit Institute of Arts 11, no. 3
 (December 1929):34-35, 1 fig. (cover).
 Publishes newly acquired glazed terracotta relief of
Madonna and Child (Genoese Madonna) by Luca della Robbia, ca.
1455-60.

1816 WULFF, OSKAR. "Ein verkanntes Frühwerk von Luca della Robbia
 und des Künstlers Werdegang." Jahrbuch der königlich
 preussischen Kunstsammlungen 38 (1917):213-52, 20 figs.
 Traces Luca della Robbia's early development in relation to
Madonna and Child formerly in Kaiser Friedrich Museum, Berlin.
Emphasizes Luca's Madonna reliefs and influence of antique.

DELLA ROBBIA SHOP

 Books

1817 BARGELLINI, PIERO. I Della Robbia. Milan: Arti Grafiche
 Ricordi, 1965, 268 pp., 23 figs., 32 color pls.
 Survey of careers of Luca, Andrea, and Giovanni della
Robbia and Santi Buglioni. Useful for its many large-scale, clear
black-and-white illustrations and color plates, which allow compar-
isons of works by members of dynasty. Each plate with commentary.
No notes or bibliography.

1818 MARQUAND, ALLAN. The Brothers of Giovanni della Robbia: Fra
 Mattia, Luca, Girolamo, Fra Ambrogio. . . . Edited and
 expanded by Frank Jewett Mather, Jr., and Charles Rufus Morey.
 Princeton Monographs in Art and Archaeology, vol. 13. Prince-
 ton: Princeton University Press, 1928, 221 pp., 60 figs.
 Clarification of work and personalities of the late Della
Robbia sculptors (primarily sixteenth century). Only serious attempt
to sort out attributions to them. Published posthumously and not
thoroughly checked by author. Biography, transcribed documents,

catalogue raisonné, biblography for each. Includes appendix of "Additions and Corrections for All the Della Robbia Catalogues."

Articles

1819 BORSOOK, EVE. "A Florentine 'Scrittoio' for Diomede Carafa."
 In Art, the Ape of Nature: Studies in Honor of H.W. Janson.
 Edited by Mosche Barasch and Lucy F. Sandler. New York: Harry
 N. Abrams; Englewood Cliffs, N.J.: Prentice Hall, 1981, pp.
 91-96, no illus.
 Traces important role of Strozzi family and its bank in
 Naples in introduction of Florentine Renaissance style to that city.
 Discusses specifically Diomede Carafa's commission to imitate
 scrittoio of Piero de' Medici, Palazzo Medici[-Riccardi], Florence,
 decorated with Della Robbia glazed tiles.

1820 GENNARI, GUALBERTO. "Il pavimento robbiano della cappella
 Bentivoglio a S. Giacomo di Bologna." Faenza 43 (1957):127-30,
 8 figs.
 Analysis of tile pavement of Della Robbia shop for
 Bentivoglio Chapel, San Giacomo, Bologna, 1486-94. Attributes to
 same shop two tiles from Rossi Chapel in San Giacomo (now Museo
 Civico, Bologna).

1821 GERSPACH, EDOUARD. "Notes sur quelques ouvrages genre Robbia
 inconnus ou peu connus." Rassegna d'arte 6 (April 1906):14-15,
 no illus.
 Description of various Della Robbia school sculptures,
 particularly those from Giovanni's atelier, located in Pistoia
 region.

1822 TERVARENT, GUY de. "Sur deux frises d'inspiration antique."
 Gazette des beaux-arts, 6th per. 55 (1960):307-16, 11 figs.
 Discusses terracott_ frieze by Della Robbia shop (after
 1480) at Medici Villa, Poggio a Caiano, near Florence, that relates
 history of soul according to antique authors.

DOMENICO ROSSELLI

1823 FABRICZY, C[ORNELIUS] de. "Sculture di Domenico Rosselli."
 Arte 10 (1907):218-22, 5 figs.
 Publishes newly discovered sculptures by Rosselli:
 Altarpiece of the Madonna and Child and Standing Saints (Duomo,
 Fossombrone), and four half-length Madonna and Child reliefs (South
 Kensington Museum [Victoria and Albert Museum], London; Museum,
 Krefeld; Kauffmann collection, Berlin; and Liechtenstein collection,
 Vienna.

1824 MIDDELDORF, ULRICH. "Rosselli, Domenico di Giovanni." In
Thieme-Becker Künstler-Lexikon. Leipzig: E.A. Seemann, 1935,
29:36-37.
Condensed survey of life and work. Valuable bibliography.

1825 MIDDLEDORF, ULRICH. "Some New Works by Domenico Rosselli."
Burlington Magazine 62, no. 361 (April 1933):165-72, 7 figs.,
catalogue.
Clarifies career of Rosselli (ca. 1439-97) who, trained by
Antonio Rossellino, transmitted Florentine style to Marches. New
attributions: wood Madonna (Berenson collection, Villa I Tatti, near
Florence); Nativity tondo (Palazzo Brindini-Gattai, Florence, ca.
1470); Baptismal Font (Santa Maria in Monte, near Empoli, 1468); and
reliefs of local saints, Aldebrand and Hieronymus, from Fossombrone
(Musée Jacquemart-André, Paris). Attribution to Antonio Rossellino,
rather than Benedetto da Maiano, of Shrine of San Savino (Duomo,
Faenza, ca. 1470-75). Reprinted in entry 54.

1826 VENTURI, LIONELLO. "Opere di scultura nelle Marche." Arte 19
(1916):25-50, 21 figs.
Publishes Madonna and Child relief (San Giuseppe, Urbino)
as by Domenico Rosselli.

ANTONIO ROSSELLINO

Books

1827 GOTTSCHALK, HEINZ. Antonio Rossellino. Liegnitz: J.H.
Burmeister, 1930, 101 pp., no illus. [Ph.D. dissertation,
Christian-Albrechts-Universität, Kiel, 1930.]
Systematic survey of problems arising from Antonio's work.

1828 PETRIOLI, ANNA MARIA. Antonio Rossellino. I maestri della
scultura, vol. 50. Milan: Fratelli Fabbri, [1966], 7 pp., 3
figs., 17 color pls.
Valuable for its large-scale color illustrations.

1829 PETRUCCI, FRANCESCA. Introduzione alla Mostra fotografica di
Antonio Rossellino, Settignano, 1980. Florence: Eurografica
S.p.A., 1980, 61 pp., 32 figs.
Essay to acompany photographic exhibition (Settignano,
1980), celebrating fifth centenary of Antonio Rossellino's death.

1830 PLANISCIG, LEO. Bernardo and Antonio Rossellino. Vienna: A.
Schroll, [1942], 60 pp., 94 figs.
Useful, small monograph that contains sensible catalogue of
works attributed to both brothers. Well illustrated.

Individual Sculptors

Monographs on a Single Commission

1831 HARTT, FREDERICK; CORTI, GINO; and KENNEDY, CLARENCE. The
Chapel of the Cardinal of Portugal, 1434-1459, at San Miniato
in Florence. Philadelphia: University of Pennsylvania Press,
1964, 192 pp., 152 figs., 4 color pls.
 Major monograph on chapel covering chronology, architecture
(attributed to Manetti's design), sculpture documented to Luca della
Robbia and the Rossellinos with their shops, and painting documented
to the Pollaiuolos and Baldovinetti. Analysis of iconography and
inscriptions. Transcriptions of all known documents. Extensive
corpus of photographs, many of them new.

1831a Seymour, Charles. Review of The Chapel of the Cardinal of
Portugal, 1434-1459, at San Miniato in Florence, by Frederick
Hart, Gino Corti, and Clarence Kennedy. Art Bulletin 52, no. 2
(June 1970):212-15, no illus.

1832 POPE-HENNESSY, JOHN. The Virgin with the Laughing Child.
Victoria and Albert Museum Monographs, no. 2. London: Her
Majesty's Stationery Office, 1957, 10 pp., frontispiece, 22
figs.
 Attributes sculpture to Antonio, rather than Leonardo,
clarifying its clear stylistic relationship to Antonio's Madonna
reliefs (Berlin), and especially to his angel for Chapel of the
Cardinal of Portugal (1465). Reprinted in entry 59.

Articles

1833 ANDROSOV, S.O. "Zametki o poddelkah ital'janoskoj renesansnoj
skulptury" [Comments on the forgery of Italian Renaissance
sculpture]. Muzej 2 (1981):21-30, 8 figs. [Résumé in
English.]
 In Russian. Discusses various forgeries by Bastianini of
Italian Renaissance sculptures in Hermitage collection. Reasserts
attribution of Madonna and Child relief to Antonio Rossellino in
response to Pope-Hennessy's questioning of it.

1834 BECK, JAMES. "An Effigy Tomb Slab by Antonio Rossellino."
Gazette des beaux-arts, 6th per. 95 (1980):213-17, 3 figs.
 Publishes new document (Merchant's Court, Florence, 1474),
recording Rossellino's suit against heir of Leonardo and Elizabetta
Tedaldi for payment for their tomb. Tomb slab by Rossellino, still
extant but quite worn (Santa Croce, Florence), is unusual for its
double effigy and use of perspectival foreshortening.

1835 BODE, WILHELM von. "Eine Büste des Christusknaben von Antonio
Rossellino in den königlich Museen zu Berlin." Jahrbuch der
königlich preussischen Kunstsammlungen 21 (1900):215-24,
11 figs.
 Discusses popularity of representations of Christ as child,
c. 1450-1500, as evinced by many busts of Christ child attributed to

Desiderio da Settignano and relief tondo of Christ Child with St. John (Marchesa Niccolini collection, Florence). Bust of the Christ Child (formerly Kaiser Friedrich Museum, Berlin) is attributed to Antonio Rossellino.

1836 BODE, WILHELM von. "Neue Erwerbungen an Bildwerken der italienischen Renaissance." Amtliche Berichte aus den königlichen Kunstsammlungen 37 (1916):254-58, 5 figs.
 Attributes young St. John the Baptist (formerly Kaiser Friedrich Museum, Berlin, now Staatliche Museen, Berlin-Dahlem) to Antonio Rossellino, relief of Baptism of Christ to Florentine school ca. 1450, and minor decorative relief to school of Donatello.

1837 CARL, DORIS. "A Document for the Death of Antonio Rossellino." Burington Magazine 125, no. 967 (October 1983):612-14, no figs.
 Publishes document (Archivio di Stato, Florence) that describes circumstances of Rossellino's death, from which it is inferred that he died in 1479.

1838 CASPARY, HANS. "Tabernacoli quattrocenteschi meno noti." Antichità viva 2, no. 7 (September 1963):39-47, 10 figs.
 Attributes to Antonio Rossellino wall tabernacle (Duveen collection, New York) and to followers of Antonio tabernacle in Badia, Settimo, and another from Santa Maria Maddalena dei Pazzi, Florence, now in Bargello. Two tabernacles attributed to Domenico Rosselli (Prepositura di Scarperia, Mugello; present whereabouts of the second unknown).

1839 FABRICZY, C[ORNELIUS] de. "Documenti su due opere di Antonio Rossellino." Rivista d'arte 5 (1907):162-66, no illus.
 Publishes documents that prove that Tomb of Mary of Aragon (Sant'Anna dei Lombardi [Monteoliveto], Naples) was begun by Antonio Rossellino and finished by Benedetto da Maiano and that Tomb of Bishop Roverella (San Giorgio, Ferrara) was commissioned from Antonio Rossellino.

1840 FABRICZY, CORNELIUS de. "Scultura donatellesca a Solarola." Archivio storico dell'arte 1 (1888):331-32, no illus.
 Attributes marble tabernacle of Madonna and Child (Castello, Solarola), which F. Argagni published as Donatello, to shop of Antonio Rossellino.

1841 FRIZZONI, GUSTAVO. "Un'opera inedita di Antonio Rossellino." Rassegna d'arte antica e moderna 3, no. 1 (1916):54-58, 6 figs.
 Attributes to Antonio seated Madonna and Child relief (Hermitage, Leningrad).

1842 GIGLIOLI, ODOARDO H. "Tre capolavori di scultura fiorentina in una chiesa di Napoli." Rivista d'Italia 5 (July-December 1902):1030-44, 8 figs.
 Discusses documents and style of Antonio Rossellino's and Benedetto da Maiano's work in Sant'Anna dei Lombardi [Monteoliveto],

Naples: Rossellino's Tomb of Mary of Aragon and Adoration of the Shepherds altarpiece, Piccolomini Chapel, and Benedetto's Annunciation altar, Mastrogiudice Chapel.

1843 GRAVES, DOROTHY B. "Early Works of Antonio Rossellino." Parnassus 1, no. 2 (15 February 1929):18, 2 figs.
 Attributes Tomb of Giovanni Chellini (San Domenico, San Miniato al Tedesco) to Antonio Rossellino (ca. 1462), rather than Bernardo Rossellino. Argues that Tomb of "Catherina de Sabella" (Museum of Fine Arts, Boston), attributed to Mino da Fiesole, is modern forgery by Dossena based on Bernardo Rossellino's Tomb of Beata Villana (Santa Maria Novella, Florence).

1844 GUTMAN, WALTER. "Rossellino's Sculptures in America." International Studio 92, no. 382 (March 1929):32-36, 9 figs.
 Biographical sketch, including brief analysis of Bernardo's influence and discussion of Chapel of the Cardinal of Portugal, San Miniato al Monte. Describes several sculptures in American collections: St. Joseph, Virgin (Metropolitan Museum of Art, New York); Young St. John the Baptist (Blumenthal collection, New York); Young Christ (Morgan collection, New York).

1845 JENKINS, A.D. FRASER. "A Florentine Marble Tabernacle with a Door by Francesco Granacci." Burlington Magazine 117, no. 862 (1975):44-47, 7 figs.
 Attributes to anonymous Florentine follower of Desiderio or Antonio marble tabernacle (National Museum of Wales, Cardiff) commissioned by 1461 for church of Santa Maria alle Campora, near Florence, by Agnolo Vettori.

1846 KACZMARZYK, DARIUSZ. "La 'Madonna dei candelabri' d'Antonio Rossellino." Bulletin du Musée national de Varsovie 12, nos. 1-2 (1971):54-58, 4 figs.
 Publishes painted stucco relief of Madonna and Child from Museum Narodwe, Warsaw. It is one of four stucco versions of marble relief of Madonna and Child with Candelabra (Altman Madonna) by Antonio Rossellino (Metropolitan Museum of Art, New York).

1847 MARQUAND, ALLAN. "Antonio Rossellino's Madonna of the Candelabra." Art in America 7, no. 5 (August 1919):198-206, 4 figs.
 Marble relief by Rossellino (Altman Madonna, Metropolitan Museum of Art, New York) is proposed as source for several similar stucco Madonna reliefs (Prince Giovanni del Drago collection, New York; Victoria and Albert Museum, London; formerly Kaiser Friedrich Museum, Berlin; formerly Gavet collection, Paris).

1848 MARQUAND, ALLAN. "The Barney Madonna with Adoring Angels by Antonio Rossellino." Art Studies 2 (1924):34-37, 1 fig.
 Madonna and Child relief (Charles T. Barney collection, New York) is attributed to Rossellino, ca. 1461, because of its Donatellesque aspects.

1849 MATZOULEVITCH, J.A. "Quelques sculptures inédites d'Antonio Rossellino, Giovanni della Robbia, et Tommaso Fiamberti au Musée de l'Ermitage." Annuaire du Musée de l'Ermitage 1 (1936):55–72, 11 figs. [In Russian with French summary, pp. 71–72.]
 Marble relief of Madonna and Child, first published here, is considered Antonio Rossellino's masterpiece and source of many copies (four in Hermitage). Also publishes St. Sebastian by Giovanni della Robbia and three Madonna reliefs by Fiamberti.

1850 NEGRIARNOLDI, FRANCESCO. "Un marmo autentico di Desiderio all'origine di un falso Antonio Rossellino." Paragone 18, no. 109 (July 1967):23–26, 4 figs.
 Attributes marble Bust of a Boy (English private collection) to Desiderio and argues that bronze bust of boy (formerly Kaiser Friedrich Museum, Berlin) first published as Antonio Rossellino by Bode (entry 1835) is crude bronze cast done from marble sculpture.

1851 OZZOLA, LEANDRO. "Lavori dei Rossellino e di altri in San Lorenzo a Firenze." Bollettino d'arte 7 (1927):232–34, 2 figs.
 Attributes friezes above capitals of nave colonnade in San Lorenzo, Florence, to Antonio Rossellino on basis of Cosimo de' Medici's account book. Pagno di Lapo is also noted as carving column capitals there.

1852 PERKINS, F. MASON. "Un S. Giovannino di Antonio Rossellino." Arte 16 (1913):165–66, 2 figs.
 Attributes to Antonio marble bust of Young St. John the Baptist (Blumenthal collection, New York).

1853 POPE-HENNESSY, JOHN. "The Altman Madonna by Antonio Rossellino." Metropolitan Museum Journal 3 (1970):133–48, 17 figs.
 Argues that marble relief of Altman Madonna and Child with Candelabra (Metropolitan Museum of Art, New York) reflects Rossellino's early contacts with Desiderio's and Donatello's circle, ca. 1457–61. Compares it with many related and derivative Madonna reliefs, all reflecting influence of Fra Filippo Lippi's paintings.

1854 SCHMARSOW, AUGUST. "Un capolavoro di scultura fiorentina del Quattrocento a Venezia." Archivio storico dell'arte 4 (1891): 225–35, 1 fig.
 Attributes to Antonio Rossellino St. John the Baptist figure in sculptured altarpiece, Chapel of St. John the Baptist, San Giobbe, Venice, and suggests the rest was executed in Rossellino's style by associate, perhaps Bellano.

1855 SCHOTTMULLER, F[RIDA]. "Rossellino, Antonio." In Thieme-Becker Künstler-Lexikon. Leipzig: E.A. Seemann, 1935, 29:40–42.
 Condensed survey of life and work. Valuable bibliography.

1856 SERRA, LUIGI. "Due scultori fiorentini del '400 a Napoli." Napoli nobilissima 14 (November 1905):181-85, 4 figs.; 15 (January 1906):4-8, 3 figs.
 Traces Antonio Rossellino's commissions in Naples: marble altarpiece, Piccolomini Chapel, Sant'Anna dei Lombardi [Monteoliveto], and Tomb of Mary of Aragon in same church. Benedetto da Maiano finished upper part of tomb and carved Annunciation altar in the Mastrogiudice Chapel in the same church. Discusses their influence.

1857 VALENTINER, WILHELM R. "A Group of the Nativity, by Antonio Rossellino." Bulletin of the Metropolitan museum of Art 6, no. 11 (November 1911):207-10, 3 figs.
 Polychromed terracotta Nativity (Metropolitan Museum of Art, New York) is attributed to Antonio Rossellino.

1858 WEINBERGER, MARTIN, and MIDDELDORF, ULRICH. "Unbeachtete Werke der Brüder Rossellino." Münchner Jahrbuch für bildende Kunst 5 (1928):85-100, 11 figs.
 Attributes to Antonio Rossellino and shop Tomb of Giovanni Chellini at San Domenico, San Miniato al Tedesco. Compares it with Michelozzo's Tomb of Bartolommeo Aragazzi (Duomo, Montepulciano) and Bust of Giovanni Chellini by Antonio Rossellino (Victoria and Albert Museum, London). In the Badia, also identifies a marble eagle that formed console of lost tabernacle commissioned from Bernardo Rossellino, 1436-37. Finally, attributes to Antonio Rossellino three drawings of putti and Madonnas, now in Uffizi, Florence. Reprinted in entry 54.

BERNARDO ROSSELLINO

Books

1859 SCHULZ, ANNE MARKHAM. The Sculpture of Bernardo Rossellino and His Workshop. Princeton: Princeton University Press, 1977, xxiii, 176 pp., 225 figs.
 Catalogue raisonné of sculpture of Bernardo Rossellino and workshop. Evaluates participation of Antonio Rossellino, Desiderio da Settignano, Buggiano, and other shop members. Analysis of documentation and iconography, as well as style. Important role of Bernardo Rossellino in development of the Florentine wall tomb and wall tabernacle is discussed.

1859a Passavant, Günter. Review of The Sculpture of Bernardo Rossellino and His Workshop, by Anne Markham Schulz. Kunstchronik 32, no. 7 (1979):251-58, no illus.
 Criticizes Schulz's limited examination of Bernardo Rossellino, which excluded his architecture and Antonio's sculpture. Argues that Planiscig's monograph (entry 1830) which dealt with these issues, was better conceived. Points out need to investigate members of Donatello's shop who remained in Florence when he went to Padua.

1859b Pincus, Debra. Review of The Sculpture of Bernardo Rossellino
 and His Workshop, by Anne Markham Schulz. R.A.C.A.R. (Revue
 d'art canadienne/Canadian Art Review) 5, no. 1 (1978):76-79,
 2 figs.
 Clarifies certain attributions and the author's focus,
which stresses the economic and social importance rather than indiv-
idual artistic contribution of Bernardo Rossellino.

1860 TYSZKIEWICZOWA, MARYLA. Bernardo Rossellino. Florence:
 Privately Printed, 1928, 141 pp., 33 figs. [In Polish. Type-
 script of 1966 English translation by Rosa Rosmaryn, edited by
 Anne Markham Schulz, is available at Frick Art Reference
 Library, New York, and Kunsthistorisches Institut, Florence.]
 Important monograph on Bernardo's architecture and
sculpture that is extremely useful for its collection of relevant
documents. Focuses on Bernardo rather than his shop or his
relationship with Antonio and Desiderio.

1860a Kennedy, C[larence]. Review of Bernardo Rossellino, by Maryla
 Tyszkiewiczowa. Rivista d'arte 15 (1933):115-27, 6 figs.
 Disputes some of author's conclusions about relative
participation of Antonio and Bernardo Rossellino in sculptures
commissioned from Bernardo's workshop and corrects misreading of
document regarding Cappella dell'Annunziata, Church of the Servi,
Florence.

 Unpublished Theses

*1861 GRAVES, DOROTHY B. "Bernardo and Antonio Rossellino."
 Master's thesis, Smith College, Northampton, Mass., 1929.

*1862 KREMERS, MARGARET. "The Sculptured Friezes in the Nave of San
 Lorenzo." Master's thesis, Smith College, Northampton, Mass.,
 1933.

 Articles

1863 CASPARY, HANS. "Ancora sui tabernacoli eucaristici del
 Quattrocento.' Antichità viva 3 (July 1964):27-36, 9 figs.
 Identifies wall tabernacle in Pieve di San Giovanni
Battista, Remole, as tabernacle documented in 1433 and 1435,
commissioned from Bernardo for Badia, Arezzo, and until Caspary's
research thought to be lost. Early date makes this prototype for
fifteenth-century wall tabernacles. Attributes another tabernacle to
Antonio Rossellino (Victoria and Albert Museum, London).

1864 FABRICZY, CORNELIUS von. "Ein Jugendwerk Bernardo Rossellinos
 und spätere unbeachtete Schöpfungen seines Meissels." Jahrbuch
 der königlich preussischen Kunstsammlungen 21 (1900):33-54,
 99-113, 4 figs.
 Fundamental, early monographic article that includes
detailed chronology of life and works as well as documents for façade

of Misericordia, Arezzo; for work at Badia, Florence; for Tomb of
Beata Villana; and for others. Some attributions now out-of-date.

1865 FERRALI, SABATINO. "Un monumento contrastato." In Scritti di
 storia dell'arte in onore di Ugo Procacci. Edited by Maria
 Grazia Ciardi Dupré dal Poggetto and Paolo dal Poggetto.
 Milan: Electa, 1977, pp. 262-63, no illus.
 Publishes document for Tomb of Filippo Lazzari (San
Domenico, Pistoia) commissioned from Bernardo Rossellino and finished
after his death by Antonio.

1866 HEYDENREICH, L[UDWIG], and SCHOTTMULLER, F[RIDA]. "Rossellino,
 Bernardo." In Thieme-Becker Künstler-Lexikon. Leipzig: E.A.
 Seemann, 1935, 29:42-45.
 Condensed survey of life and work. Valuable bibliography.

1867 MARKHAM, ANNE. "Desiderio da Settignano and the Workshop of
 Bernardo Rossellino." Art Bulletin 45, no. 1 (march
 1963):35-45, 15 figs.
 Demonstrates Becherucci's hypothesis (entry 739) that
Desiderio trained in Bernardo Rossellino's shop. Attributes to
Desiderio effigy of Beata Villana (Santa Maria Novella, Florence) and
Madonna's face from lunette of Tomb of Leonardo Bruni (Santa Croce,
Florence).

1868 MIDDELDORF, ULRICH. "Un rame inciso nel Quattrocento." In
 Scritti di storia dell'arte in onore di Mario Salmi. Rome:
 De Luca, 1962, 2:273-89, 15 figs.
 Argues that gilded copper door on late sixteenth-century
tabernacle, Cappella di San Mauro, Badia, Florence, was executed in
first half of fifteenth century as part of chapel's original
tabernacle by Bernardo Rossellino, although gilded copper door is
probably not by Rossellino. Traces influence of its decoration, the
standing Christ holding cross and bleeding from chest wound.
Reprinted in entry 54.

1869 POGGI, GIOVANNI. "Il ciborio di Bernardo Rossellino nella
 chiesa di S. Egidio (1449-1450)." Miscellanea d'arte 1
 (1903):105-7, 1 fig.
 Publishes documents from archive of hospital of Santa Maria
Nuova that prove that tabernacle in Sant'Egidio was carved by
Bernardo Rossellino and its bronze door done by Ghiberti, 1449-50.
Tabernacle previously dated earlier and attributed to Mino da Fiesole
and Buggiano.

1870 SALMI, MARIO. "Bernardo Rossellino ad Arezzo." In Scritti di
 storia dell'arte in onore di Ugo Procacci. Edited by Maria
 Grazia Ciardi Dupré dal Poggetto and Paolo dal Poggetto.
 Milan: Electa, 1977, pp. 254-61, 10 figs.
 Analyzes early work by Bernardo Rossellino: Madonna della
Misericordia relief and flanking sculptures on façade of Palazzo
della Fraternità dei Laici, Arezzo.

331

1871 SCHULZ, ANNE MARKHAM. "The Tomb of Giovanni Chellini at San Miniato al Tedesco." Art Bulletin 51, no. 4 (December 1969):317-32, 22 figs.
　　　Argues that Tomb of Giovanni Chellini, as originally executed ca. 1460-62, consisted of an effigy atop sarcophagus (now lost) on two consoles, with an epitaph between them. Above this a semicircular lunette with frescoed or carved Madonna and Child and fresco (Resurrection of Christ?) were planned for back wall of niche. This type of fourteenth-century tomb was deemed old-fashioned in late fifteenth century and reworked; it was transformed further in eighteenth century. Attribution uncertain.

GIULIANO DA SAN GALLO

Books

1872 BORSOOK, EVE, and OFFERHAUS, JOHANNES. Francesco Sassetti and Ghirlandaio at Santa Trinità, Florence: History and Legend in a Renaissance Chapel. Doornspijk: Davaco, 1981, 93 pp., 96 figs., 1 color pl.
　　　First thorough monograph on chapel; focuses on program. Publishes all known documents. Important discussion of iconography of Tombs of Francesco and Nera Sassetti. Reidentifies so-called Niccolò da Uzzano bust (Bargello, Florence), attributed to Donatello, as Neri di Gino Capponi.

1873 CLAUSSE, GUSTAVE. Les San Gallo: Architectes, peintres, sculpteurs, médailleurs; XVe et XVIe siècles. 3 vols. Paris: Ernest Leroux, 1900-1902, 1:1-288, 26 figs. relevant to Giuliano.
　　　Detailed monograph on successive generations of family. Vol. 1 covers Giuliano and Antonio (the elder) da San Gallo, focusing primarily on architecture but also considering architectural sculpture and decorations. Contains useful study of Palazzo Gondi. With bibliography.

1874 FALB, RODOLFO, ed. Il taccuino senese di Giuliano da San Gallo: 50 facsimili di disegni d'architettura, scultura, ed arte applicata. Siena: Olschki, 1902, 53 pp., 51 figs.
　　　Facsimile publication of so-called Taccuino of Giuliano da San Gallo (Biblioteca del Comune, Siena), prefaced by introductory essay on sketchbook and comments about each drawing.

1875 HUELSEN, CRISTIANO. Il libro di Giuliano da San Gallo: Codice Vaticano Barberiniano latino 4424. 2 vols. Leipzig: Ottone Harrassowitz, 1910, 162 pp., 193 figs.
　　　Large-scale, high-quality facsimile edition of Sangallo's sketchbook in the Vatican. Vol. 1 contains Huelsen's discussion of codex, chronology of sheets, analysis of ancient sources, and discussion of each drawing in codex.

Articles

1876 HEYDENREICH, L[UDWIG]. "San Gallo, Giuliano da." In Thieme-
Becker Künstler-Lexikon. Leipzig: E.A. Seemann, 1935,
24:406-8.
Condensed survey of life and work. Valuable bibliography.

1877 LISNER, MARGRIT. "Zum bildhauerischen Werk der Sangallo."
Pantheon 27 (1969):99-119, 190-208, 42 figs. [Summary in
English.]
Discusses carved wood sculptures by San Gallo family.
Documents record Crucifix carved by Giuliano da San Gallo in 1481-82
for SS. Annunziata and St. John the Baptist in S. Romolo, Bivigliano,
derived from Donatello's Old Sacristy doors.

1878 MARCHINI, GIUSEPPE. "Aggiunte a Giuliano da Sangollo."
Commentari 1 (1950):34-38, 8 figs., 2 ground plans.
Proposes that Giuliano da San Gallo made glazed terracotta
St. Matthew sculpture in Santa Maria delle Carceri, Prato, although
Andrea della Robbia is documented overseer of church's sculpted
decoration.

1879 MARCHINI, GIUSEPPE. "San Gallo, Giuliano da." In Encyclopedia
of World Art. Edited by Istituto per la Collaborazione Cul-
turale, Rome. London: McGraw-Hill Publishing Co., 1966, 12:
cols. 682-86.
Succinct summary of San Gallo's life and career. With
extensive bibliography.

1880 MIDDELDORF, ULRICH. "Giuliano da Sangallo and Andrea San-
sovino." Art Bulletin 16, no. 2 (June 1934):106-15, 9 figs.,
1 drawing.
Argues that San Gallo, to whom many sculptures are
attributed (such as Tombs of Francesco and Nera Sassetti, Santa
Trinità; capitals in Santo Spirito, etc.) was sculptor of limited
skill and conservative taste. Claims that generally sculptural
aspects of his architectural projects were assigned to master
stonecutters, such as Giovanni di Betto and Simone del Caprino, whose
work is documented at Santo Spirito. Attributes mythological frieze
at Poggio a Caiano to young Andrea Sansovino under San Gallo's
direction, ca. 1485.

1881 STECHOW, WOLFGANG. "Zum plastischen Werk des Giuliano da San
Gallo." In Italienischen Studien: Paul Schubring, zum 60.
Geburtstag gewidmet. Leipzig: Karl W. Hiersemann, 1929, pp.
138-43, 7 figs.
Identifies Giuliano da San Gallo as master of series of
capitals in Sacristy of Santo Spirito, Florence, ca. 1493-94,
previously attributed to Andrea Sansovino. Also attributes to
Giuliano da San Gallo glazed terrcotta frieze at Poggio a Caiano,
near Florence, and capitals for Palazzo Gondi in Florence.

1882 WARBURG, ABY. "Francesco Sassetti's letztwillige Verfügung."
 In Gesammelte Schriften. Vol. 1; Die Erneuerung der heid-
 nischen Antike. Leipzig: B.G. Teubner, 1932, pp. 127-58,
 9 figs.
 Traces history of Sassetti burial chapel in Santa Trinità,
 Florence, focusing on its classical motives, especially Fortuna
 symbolism, and their meaning in this context.

 SILVESTRO DELL'AQUILA

1883 ANON. "Silivestro dell'Aquila." In Thieme-Becker Künstler-
 Lexikon. Leipzig: E.A. Seemann, 1937, 31:40-41.
 Condensed survey of life and work. Valuable bibliography.

1884 BONGIORNO, LAURINE M. "Notes on the Art of Silvestro
 dell'Aquila." Art Bulletin 24 (September 1942):232-43, 19
 figs.
 Major survey of work of Silvestro dell'Aquila (d. 1504),
 whose sculpture reflects influences from Florence and Rome.
 Attributes to Silvestro terracotta Bust of the Virgin (Farnsworth
 Museum, Wellesley College, Wellesley, Mass.).

1885 CHINI, MARIO. Silvestro Aquilano e l'arte in Aquila nella II
 metà del sec. XV. Aquila: La Bodoniana, 1954, 471 pp., 12
 figs.
 Monograph concerning Silvestro d'Aquila's oeuvre in
 painting, sculpture, and architecture, as well as his followers'
 production. Introductory chapters deal with history of region of
 Aquila and goldsmith workshops there. Bibliography in notes.

1886 ROTONDI, PASQUALE. "Contributo a Silvestro dell'Aquila."
 Emporium 115 (1952):105-10, 9 figs.
 Attributes to Silvestro marble Bust of San Giovannino
 (Galleria Nazionale, Urbino) and two wood Madonnas (Museum Nazionale,
 Aquila, and Santa Maria delle Grazie, Teramo). Proposes that
 Silvestro learned various features of Verrocchio's art indirectly
 through Francesco di Simone Ferrucci, rather than through trip to
 Florence proposed by Bongiorno (entry 1884), and that Silvestro was
 trained by Francesco di Simone.

 NICCOLO SPINELLI

1887 CIARDI-DUPRÉ dal POGGETTO, MARIA G. "Un'ipotesi su Niccolò
 Spinelli Fiorentino." Antichità viva 6, no. 1 (1967):22-34,
 20 figs.
 Attributes to the medallist Niccolò Spinelli painted wood
 Crucifix (private collection, Florence) which would be his only
 sculpture. Notes influence of Verrocchio and Bertoldo in Crucifix.

1888 TEA, EVA. "Le fonti delle Grazie di Raffaello." <u>Arte</u> 17
 (1914):41-48, 5 figs.
 Discusses obverse of Niccolò Spinelli's <u>Medal of Giovanni</u>
 <u>Albizzi Tornabuoni</u>, which represents Three Graces, as example of
 fifteenth-century revival of ancient type.

 GIOVANNI TURINI

1889 ANON. "Turini, Giovanni." In <u>Thieme-Becker Künstler-Lexikon</u>.
 Leipzig: E.A. Seemann, 1939, 33:488-89.
 Condensed survey of life and work. Valuable bibliography.

1890 BACCI, PELEO. "La 'Colonna' del Campo proveniente da avanzi
 romani presso Orbetello e la 'Lupa' di Giovanni e Lorenzo
 Turini, orafi senesi (1428-1430)." <u>Balzana: Rassegna d'arte</u>
 <u>senese e del costume</u>, n.s. 1 (1927):227-31, 2 figs.
 Publishes documents that prove gilded bronze <u>She-Wolf</u> was
 put on column near Palazzo Pubblico, Siena, in 1430 and was executed
 by the Turini, not Urbano da Cortona.

1891 CARLI, ENZO. "Due Madonne senesi (tra il Ghiberti e Jacopo
 della Quercia)." <u>Antichità viva</u> 1, no. 3 (1962):9-17, 8 figs.,
 1 color pl.
 Wood <u>Virgin Annunciate</u> (private collection, Switzerland) is
 attributed to Giovanni Turini under Quercia's influence. Standing
 <u>Madonna and Child</u> (Palazzo Civico, Sarteano) is attributed to
 anonymous early fifteenth-century Sienese sculptor.

1892 CECCHINI, GIOVANNI. "Vicende di tre opere d'arte, fra
 l'ordinazione e il loro compimento." <u>Bulletino senese di</u>
 <u>storia patria</u>, 3d ser. 14-15 (1955-56):1-21, no illus.
 Newly found documents clarify history of now destoryed
 grillwork and silver statuettes for chapel in Palazzo Pubblico,
 Siena, and for Silver Reliquary of San Bernardino in Osservanza
 Convent, Siena. Documents permit corrections in Milanesi's account
 of Giovanni Turini, who made silver statuettes along with Lorenzo
 Turini.

1893 COURAJOD, LOUIS. "La porte du tabernacle de la cuve bap-
 tismale du Baptistère de Sienne." <u>Gazette archéologique</u> 11
 (1886):3-6, 1 fig.
 Attributes to Giovanni Turini enamel and bronze tabernacle
 door (D'Ambras collection, Vienna), associated here with tabernacle
 for Baptistry, Siena, commissioned from Turini in 1434. (The docu-
 ments were published by Milanesi (entry 143) along with documents
 that show that Donatello did a tabernacle door for Baptistry in 1428,
 but it was rejected and apparently lost.)

1894 De NICOLA, GIACOMO. "Studi sull'arte senese, II: Di alcune
 sculture nel Duomo di Siena." <u>Rassegna d'arte</u> 18 (1918):
 144-54, 12 figs.

Discusses Giovanni Turini's work for Baptismal Font, Siena, and his collaboration wtih his father, Turino di Sano, on low reliefs for pulpit, Duomo, Siena. Also attributes to Antonio Federighi two putti sculptures (Museo dell'Opera del Duomo, Siena).

1895 MILANESI, GAETANO. Sulla storia dell'arte toscana: scritti vari. Rev. ed. Soest: Davaco, 1973, 376 pp., 1 fig.
Includes brief essays on Giovanni Turini, Giuliano da Maiano and Dello Delli, which are expansions of his annotation of Vasari's accounts of these artists.

1896 RICHARDSON, E.P. "A Note on the Attribution of a Relief of the Nativity." Art Quarterly 15 (1952):67-72, 5 figs.
Attributes to Giovanni Turini terracotta Nativity relief (Mrs. Edsel B. Ford collection, Detroit) previously attributed to Donatello and Ghiberti.

URBANO DA CORTONA

Books

1897 SCHUBRING, PAUL. Urbano da Cortona: Ein Beitrag zur Kenntnis der Schule Donatellos und der Seneser Plastik im Quattrocento. Strasbourg: J.H. Ed. Heitz, 1903, 91 pp., 30 figs.
Speculative monograph reconstructing biographies and styles of assistants to Donatello on Padua High Altar. Reproduces and supports Cordenon's reconstruction of altar and proposes major role for Urbano da Cortona in reliefs. Transcribes relevant documents. Includes supplement on Andrea Guardi.

Articles

1898 ANON. "Urbano da Cortona." In Thieme-Becker Künstler-Lexikon. Leipzig: E.A. Seemann, 1939, 33:591.
Condensed survey of life and work. Valuable bibliography.

1899 BACCI, PELEO. "La figura di terracotta di 'San Bernardino' eseguita e donata ai frati dell'Osservanza dallo scultore Urbano di Pietro da Cortona (1453-1457)." Balzana: Rassegna d'arte senese e del costume, n.s. 1 (1927):231-36, 2 figs.
Publishes documents that prove Urbano da Cortona made terracotta figure of St. Bernardino in 1453 and donated it to Osservanza Convent, Siena.

VARRONE

1900 ANON. "Varro[ne]." In Thieme-Becker Künstler-Lexikon. Leipzig: E.A. Seemann, 1940, 34:118.
Condensed survey of life and work. Valuable bibliography.

1901 VALENTINER, WILHELM R. "The Florentine Master of the Tomb of
 Pope Pius II." Art Quarterly 21, no. 2 (Summer 1958):116-50,
 27 figs.
 Establishes oeuvre of so-called Master of the Piccolomini
Tomb, active in Rome ca. 1450-75. Probably identifiable with
Varrone, a Florentine student of Filarete and Paolo Romano.

 VECCHIETTA

 Books

1902 VIGNI, GIORGIO. Lorenzo di Pietro, detto il Vecchietta.
 Florence: G.C. Sansoni, 1937, 95 pp., 30 figs.
 Brief monograph on Vecchietta's sculptures and paintings
that incorporates into his oeuvre the work of "Master of the
Piccolomini Madonna." Discussion of Vecchietta's work in each medium
and list of his secure, attributed, and lost works. Bibliography.
Small black-and-white plates.

1902a Pope-Hennessy, John. Review of Lorenzo di Pietro, detto il
 Vecchietta, by Giorgio Vigni. Burlington Magazine 73 (November
 1938):228, no illus.

 Articles

1903 BACCI, PELEO. "Una scultura inedita e sconosciuta di Lorenzo
 di Pietro, detto il Vecchietta." Arte 41 (April-June 1938):
 97-109, 6 figs.
 Attributes to Vecchietta life-size painted terrcotta figure
of sleeping St. Catherine of Siena (Oratorio della Compagnia di Santa
Caterina della Notte, Santa Maria della Scala, Siena).

1904 CARLI, ENZO. "Il Vecchietta e Neroccio a Siena e 'in quel di
 Lucca.'" Critica d'arte, n.s. 1, no. 4 (July 1954):336-54, 18
 figs.
 Publishes Dormition and Assumption of the Virgin relief
(Museo Civico, Lucca) by Vecchietta and Neroccio, previously
attributed to Matteo Civitali, with a transcription of documents
which support new attribution. Discusses several other sculptures
attributed to Vecchietta and Neroccio in collaboration.

1905 CELLINI, PICO. "Due opere minori del Vecchietta." Diana 7
 (1932):176-78, 3 figs.
 Attributes to Vecchietta marble relief of heads of SS.
Monica and Paul the Hermit (Santa Maria del Popolo, Rome) and two
bronze sculptures of feet (private collection, Rome).

1906 CELLINI, PICO. "La reintegrazione di un'opera sconosciuta di
 Lorenzo di Pietro, detto il Vecchietta." Diana 5 (1930):
 239-43, 5 figs.

 337

Reconstructs, reidentifies, and reattributes bronze <u>gisant</u> on sarcophagus in Santa Maria del Popolo, Rome, as Vecchietta's Tomb of Bishop Gerolamo [Pietro?] Foscari.

1907 CLAPP, FREDERICK MORTIMER. "Vecchietta." <u>Art Studies:</u>
 <u>Medieval, Renaissance, and Modern</u> 4 (1926):41-55, 30 figs.
 Comprehensive treatment of Vecchietta's paintings and
 sculptures. Small, unclear illustrations. Brief notes include
 references to documents and some bibliography.

1908 Del BRAVO, CARLO. "Una scultura del Vecchietta." <u>Antichità</u>
 <u>viva</u> 11, no. 2 (1972):35-38, 5 figs.
 Attributes to Vecchietta wood Angel from <u>Annunciation</u> group
 attributed to another unidentified sculptor.

1909 LAVIN, IRVING. "The Sculptor's 'Last Will and Testament.'"
 <u>Allen Memorial Art Museum Bulletin</u> (Oberlin) 35, no. 1/2
 (1977-78):4-39, 32 figs.
 Establishes that Vecchietta's funerary chapel in Santa
 Maria della Scala, for which Vecchietta did bronze <u>Risen Christ</u> (now
 on high altar of the hospital church), was first Renaissance funerary
 monument in which a sculptor commemorated himself. Analyzes its
 iconography in conjunction with programs of sixteenth-century
 artists' funerary monuments.

1910 OS, HENDRIK W. van. "Vecchietta and the Persona of the
 Renaissance Artist." In <u>Studies in Late Medieval and</u>
 <u>Renaissance Painting in Honor of Millard Meiss</u>. Edited by
 Irving Lavin and John Plummer. New York: New York University
 Press, 1977, 1:445-54, 2: 18 figs.
 Analyzes how Vecchietta's personality is reflected in great
 expressivity of his works, in particular, the tomb that he designed
 for himself for which he made <u>Risen Christ</u> sculpture.

1911 PERKINS, F. "Vecchietta." In <u>Thieme-Becker Künstler-Lexikon</u>.
 Leipzig: E.A. Seemann, 1940, 34:152-56.
 Condensed survey of life and work. Valuable bibliography.

1912 PREVITALI, GIOVANNI. "Domenico 'dei cori' e Lorenzo
 Vecchietta: Necessità di una revisione." <u>Storia dell'arte</u>
 38-40 (1980):141-44, 21 figs.
 Argues that Domenico di Niccolò's birth date is 1375,
 rather than generally accepted 1363. Reattributes to him <u>Madonna and</u>
 <u>Child</u> in the Salvatore, Istia D'Ombrone. Since it had been attrib-
 uted to Vecchietta, author assigns to Domenico di Niccolò fifteen
 other sculptures originally associated with Vecchietta and related to
 Salvatore <u>Madonna and Child</u>.

1913 RAGGHIANTI, CARLO. "Vecchietta scultore." <u>Critica d'arte</u>,
 n.s. 1, no. 4 (July 1954):330-35.
 Survey of state of knowledge of Vecchietta's sculpture. At
 time of article no sculptures were attributed to Vecchietta prior to

1460, although he was recorded as painter in 1428 and even his paint-ings reflect a sculptor's conception. Article serves as preface to Carli (entry 1904), who introduces new attributions to Vecchietta, the sculptor.

1914 VALENTINER, W[ILHELM] R. "Marble Reliefs by Lorenzo Vecchietta." Art in America 12, no. 2 (February 1924):55-63, 4 figs.
 Attributes to Lorenzo Vecchietta two marble reliefs of Annunciate Angel and Virgin, a Madonna and Child (formerly Kaiser Friedrich Museum, Berlin), and a Madonna and Child (Louvre, Paris) with Piccolomini arms, probably made for Pope Pius II (Piccolomini) of Pienza when Vecchietta was there in 1461.

1915 VIGNI, GIORGIO. "Per il 'Maestro dei Piccolomini.'" Rivista d'arte 18 (October-December 1936):367-74, 3 figs.
 Reattributes three versions of marble half-length Madonna and Child relief (Chigi Saraceni collection, Siena; Louvre, Paris; Museo Oliveriano, Pesaro) respectively to Vecchietta, Vecchietta's shop, and Florentine follower of Vecchietta. These had been assigned to Master of the Piccolomini Madonna. [Pope-Hennessy (entry 61) views this as misguided.]

VERROCCHIO

Books

1916 BERTINI, ALDO. Verrocchio e la scultura fiorentina del '400. Edited by C. Segre Montel and A. Quazza. Turin: G. Giap-pichelli, 1964, 202 pp., no illus.
 Publication of author's lectures at University of Turin in 1963-64. Introduction to fifteenth-century Florentine sculpture that focuses on Verrocchio.

1917 BUSIGNANI, ALBERTO. Verrocchio. I diamanti dell'arte, no. 8. Florence: Sadea; Sansoni, [1966], 39 pp., 4 figs., 83 color pls.
 Short text on Verrocchio's paintings and sculptures with many color illustrations; in handy pocket-size format.

1918 CHIARINI, MARCO. Andrea del Verrocchio. I maestri della scultura, no. 24. Milan: Fratelli Fabbri, [1966], 6 pp., 4 figs., 17 color pl.
 Most of Verrocchio's documented and attributed sculpture is illustrated in large, good color plates.

1919 CRUTTWELL, MAUD. Verrocchio. London: Duckworth & Co., 1904, 264 pp., 45 figs.
 Concentrates on Verrocchio's sculpture, including many works later rejected by Passavant. Contains some discussion of pupils. Reproduces many documents and letters.

1919a Holmes, Sir Charles. Review of Verrocchio, by Maud Cruttwell. Burlington Magazine 6 (January 1905):413-14, no illus.

1920 PASSAVANT, GUNTER. Andrea del Verrocchio als Maler. Bonner Beiträge zur Kunstwissenschaft, vol. 6. Düsseldorf: L. Schwann, 1959, 248 pp., 150 figs.
 Detailed discussion of six paintings attributed here to Verrocchio. Includes valuable compilation of documents and bibliography and one brief chapter on Verrocchio's career as sculptor.

1921 PASSAVANT, GUNTER. Andrea del Verrocchio: Skulpturen, Gemälde, und Zeichnungen, Gesamtausgabe. Cologne: Phaidon-Verl, 1969, 239 pp., 216 figs., 4 color pls. English ed. Verrocchio: Sculptures, Paintings, and Drawings, Complete Edition. Translated by Katherine Watson. London: Phaidon, 1969, 223 pp., 216 figs., 4 color pls. Italian ed. Verrocchi: Sculture, pitture, e disegni. Venice: Alfieri, 1969, 231 pp., 71 figs.
 Deals with problems in Verrocchio's work in all three media. Discards many attributions accepted by earlier authors. Extremely useful corpus of photographs of authentic and erroneously attributed works, as well as works given to shop members. Catalogue raisonné. [Pope-Hennessy (entry 61) advises caution in its use because of mistaken attributions.]

1921a Covi, Dario A. Review of Verrocchio: Sculptures, Paintings, and Drawings, Complete Edition, by Günter Passavant. Art Bulletin 54 (1972):90-94, no illus.
 Disagrees with Passavant's rejection of Careggi Resurrection, lavabo in Old Sacristy, San Lorenzo, and Louvre angels for Cenotaph of Cardinal Niccolò Forteguerri. Discusses omissions in Passavant study.

1921b Gilbert, Creighton. Review of Verrocchio: Sculptures, Paintings, and Drawings, Complete Edition, by Günter Passavant. Art Quarterly 33 (1970):441-43, no illus.
 Argues that Death of Francesca Tornabuoni relief (Bargello, Florence) should be eliminated from Verrocchio's oeuvre.

1922 PLANISCIG, LEO. Andrea del Verrocchio. Vienna: A. Schroll, 1941, 53 pp., 81 figs.
 Essay on Verrocchio's work, treated chronologically. Illustrations are preceded by notes on works represented. Attributes to Verrocchio Bust of Giuliano de' Medici in National Gallery of Art, Washington, D.C., and San Lorenzo lavabo.

1923 REYMOND, MARCEL. Verrocchio. Paris: J. Rouam, 1906, 168 pp., 24 figs.
 Presentation of Verrocchio's career in both sculpture and painting. Includes general discussions of Verrocchio's importance

for fifteenth-century art, his pupils, catalogue of Verrocchio's work arranged by collection, and bibliography.

1923a Frizzoni, Gustavo. Review of Verrocchio, by Marcel Reymond. Arte 9 (1906):390-93, 1 fig.

1924 SEYMOUR, CHARLES, Jr. The Sculpture of Verrocchio. Greenwich, Conn.: New York Graphic Society, 1971, 192 pp., 181 figs.
 Discussion of Verrocchio's work, which is divided into documented and attributed groups. Includes catalogue of principal works, selected group of documents, and essay by Wendy Stedman Sheard, "Notes on Proportions of the Base of the Colleoni Monument."

1924a Passavant, Günter. Review of The Sculpture of Verrocchio, by Charles Seymour, Jr. Burlington Magazine 117, no. 862 (January 1975):55-56, no illus.
 Cites as problematical Seymour's discussion of Verrocchio's early work and criticizes his failure to integrate Verrocchio's sculpture and painting. Contests Seymour's dismissal of famous Lady with Primroses (Bargello, Florence) as not by Verrocchio.

1925 THIIS, JENS. Leonardo da Vinci: The Florentine Years of Leonardo and Verrocchio. London: Herbert Jenkins, 1913, 280 pp., 277 figs.
 Very thorough, though idiosyncratic, study of Leonardo's artistic development through about 1483. Focuses primarily on painting with detailed analysis of individual works. Some discussion of Verrocchio's workshop and Leonardo's early training in sculpture.

Monographs on a Single Commission

Silver Dossal, Baptistry, Florence

1926 FRANCESCHINI, PIETRO. Il dossale d'argento del tempio di San Giovanni in Firenze. Florence: A. Ciardi, 1894, 31 pp., no illus.
 Argues that Verrocchio's silver dossal for Baptistry, Florence (now Museo dell'Opera del Duomo) is complete and unharmed, challenging earlier opinion.

Cenotaph to Cardinal Niccolò Forteguerri

1927 KENNEDY, CLARENCE; BACCI, PELEO; and WILDER, ELIZABETH. The Unfinished Monument by Andrea del Verrocchio to the Cardinal Niccolò Forteguerri at Pistoia. Studies in the History and Criticism of Sculpture, vol. 7. Northampton, Mass.: Smith College, 1932, 95 pp., 9 figs., 32 pls. [100 copies, plus limited edition of 10 with 58 pls.]
 Invaluable analysis of this disputed monument, detailing protracted negotiations (ca. 1481-83), functioning of Verrocchio's bottega, and various artists involved (Verrocchio, Lorenzo di Credi,

Francesco di Simone Ferrucci, Lorenzo Lotto, and Rustici). Full
compilation of documents and extraordinary photographic prints that
show views of details. Discussion of Piero Pollaiuolo's terracotta
modello for monument (Victoria and Albert Museum, London).

1927a Degenhart, Bernhard. Review of The Unfinished Monument by
 Andrea del Verrocchio to the Cardinal Niccolò Forteguerri at
 Pistoia, by Clarence Kennedy, Pèleo Bacci, and Elizabeth
 Wilder. Pantheon 11 (1933):179-84, 6 figs.
 Reproduces Kennedy's photographs along with short summary
and review. Some discussion of attributions of parts of monument to
various members of Verrocchio's studio.

1927b Middeldorf, Ulrich. Review of The Unfinished Monument by
 Andrea del Verrocchio to the Cardinal Niccolò Forteguerri at
 Pistoia, by Clarence Kennedy, Pèleo Bacci, and Elizabeth
 Wilder. Zeitschrift für Kunstgeschichte 3 (1934):54-58, 1 fig.
 Emphasizes importance of Verrocchio's drawing for Tomb of
Doge Andrea Vendramin (Victoria and Albert Museum, London) for under-
standing his intended plan for the cenotaph. Stresses importance of
Verrocchio's response to Venetian taste. Reprinted in entry 54.

Colleoni Monument

1928 DALMA, JUAN. La estatua ecuestre del Colleoni y su enigma.
 Tucuman, Argentina: Universidad Nacional, 1961, 28 pp., 82
 figs.
 Considers Colleoni Monument, and especially relationship
between Verrocchio and Leonardo, in regard to equestrian sculpture,
proportion, and physiognomy. Evaluates portrait of Colleoni by
comparing it to other known portraits.

1929 GRAEVENITZ, GEORG von. Gattamelata (Erasmo da Narni) und
 Colleoni und ihre Beziehungen zur Kunst. Beiträge zur
 Kunstgeschichte, vol. 34. Leipzig: E.A. Seemann, 1906, 148
 pp., 16 figs.
 Cross-cultural study (Padua, Bergamo, Venice) of
Renaissance military images focusing on representations of
condottieri in works of art (chapels, tombs, frescoes, medals, and
equestrian statues). In particular, Donatello's Gattamelata
Equestrian Monument in Padua and Verrocchio's Colleoni Monument in
Venice.

1930 ISERMEYER, CHRISTIAN ADOLF. Verrocchio und Leopardi: Das
 Reiterdenkmal des Colleoni. Werkmonographien zur bildenden
 Kunst in Reclams Universal-Bibliothek, vol. 93. Stuttgart:
 Philipp Reclam Jun., [1963], 32 pp., 16 figs.
 Small, monographic guidebook to Colleoni Monument that
analyzes commission; gives brief biography of Colleoni, Leopardi, and
Verrocchio; and situates the monument within Verrocchio's career.

Doubting Thomas Group, Orsanmichele

1931 SACHS, CURT. Das Tabernakel mit Andreas del Verrocchio
Thomasgruppe an Or San Michele zu Florenz: Ein Beitrag zur
Florentiner Kunstgeschichte. Zur Kunstgeschichte des
Auslandes, vol. 23. Strasbourg: J.H. Ed. Heitz, 1904, 44 pp.,
4 figs.
 Provides complete history and documentation for tabernacle,
Verrocchio's Doubting Thomas group, and Donatello's St. Louis of
Toulouse. Supports late dating for tabernacle; attributes architec-
ture to Michelozzo and figure to Donatello. Claims Donatello made
two sculptures of St. Louis; the sculpture then in Santa Croce is not
the same as the one made for Orsanmichele, which was lost or never
completed.

1931a Steinmann, Ernst. Review of Das Tabernakel mit Andreas del
Verrocchio Thomasgruppe an Or San Michele zu Florenz: Ein
Beitrag zur Florentiner Kunstgeschichte, by Curt Sachs.
Deutsche Literatur-Zeitung 26 (1905):111, no illus.

 Articles

1932 AGGHÁZY, MARIA G. "'Locus amoenus' et 'vinculum delictorum'
dans l'art de la Renaissance." Bulletin du Musée Hongrois des
Beaux-Arts (Budapest) 51 (1978):55-62, 3 figs.
 In French and Hungarian. Argues against standard inter-
pretation of Verrocchio's Tomb of Giovanni and Piero de' Medici (San
Lorenzo, Florence) as having no religious content. Claims that the
knots of its bronze screen represent bonds of sin preventing deceased
from approaching Desiderio's Sacrament tabernacle, originally located
in adjacent chapel. Parallel symbolism is found in Leonardo's Sala
delle Asse, Castello Sforzesco, Milan.

1933 AGGHÁZY, MARIA G. "Problemi nuovi relativi a un monumento
sepolcrale del Verrocchio." Acta Historiae Artium Academicae
Scientiarum Hungaricae 24, nos. 1-4 (1978):159-66, 5 figs.
 History of commission and execution of Verrocchio's Tomb of
Francesca Tornabuoni, with attention to group of terracotta figures
representing "Imago pietatis" (now dispersed, Museum of Fine Arts,
Budapest; Toledo Museum of Art) which would have been placed on tomb.
Rejects Balogh's hypothesis (entry 1934) that group was for lunette.

1934 BALOGH, JOLÁN. "Un capolavoro sconosciuto di Verrocchio:
Studi nella collezione di sculture del Museo di Belle Arti,
IV." Acta Historiae Artium Academicae Scientiarum Hungaricae
8, nos. 1-2 (1962):55-98, 53 figs.
 Places terracotta figures of Christ (Museum of Fine Arts,
Budapest) and two kneeling Angels (Toledo Museum of Art) in
Verrocchio's oeuvre and shows how they belonged to same composition.
[Pope-Hennessy (entry 61): "doubtful attribution."]

1935 BERTINI, ALDO. "L'arte del Verrocchio." Arte 38 (November 1935):433-73, 7 figs.
Argues against overemphasizing Leonardo's role in Verrocchio's shop and his influence on Verroccho.

1936 BERTINI, ALDO. "Verrocchio." In Encyclopedia of World Art. Edited by Istituto per la Collaborazione Culturale, Rome. London: McGraw-Hill Publishing Co., 1967, 14:757-66, figs. 351-60.
Concise survey of Verrocchio's life and career by an authority. With extensive bibliography.

1937 BODE, W[ILHELM von]. "Die italienischen Skulpturen der Renaissance in den königlichen Museen, II: Bildwerke des Andrea del Verrocchio.' Jahrbuch der königlich preussischen Kunstsammlungen 3 (1882):91-105, 235-67, 3 figs., 8 drawings.
Monographic study of Verrocchio's artistic development based primarily on Vasari's biography and works formerly in Kaiser Friedrich Museum, Berlin. Focuses specifically on Verrocchio and Leonardo, Madonna and Child reliefs, classicizing reliefs (such as Scipio relief, Rattier collection, Paris), Verrocchio's workshop, and relationship of Verrocchio's sculpture to his painting.

1938 BODE, WILHELM [von]. "Una tavola in bronzo di Andrea del Verrocchio rappresentante la Deposizione nella chiesa del Carmine in Venezia." Archivio storico dell'arte 6 (1893): 77-84, 3 figs.
Attributes to Verrocchio bronze Deposition relief (Santa Maria del Carmelo, Venice), bronze relief of Discord (Victoria and Albert Museum, London) and bronze relief of Judgment of Paris (Dreyfus collection, Paris [now National Gallery of Art, Washington, D.C.]), generally ascribed to Francesco di Giorgio.

1939 BODE, WILHELM [von]. "Verrocchio und das Altarbild der Sakramentskapelle im Dom zu Pistoja," Repertorium für Kunstwissenschaft 22 (1899):390-94, no illus.
Applicable to Verrocchio's activity as sculptor only in short discussion of Cenotaph of Cardinal Niccolò Forteguerri, where author disagrees with Marcel Reymond's assertion (entry 1923) that Victoria and Albert Museum, London, (then South Kensington Museum) sketch is modern forgery. Otherwise deals only with painting.

1940 BONGIORNO, LAURINE MACK. "A Fifteenth-Century Stucco and the Style of Verrocchio." Allen Memorial Art Museum Bulletin (Oberlin) 19 (1961-62):115-38, 8 figs.
Analyzes stucco Madonna and Child relief (Allen Memorial Art Museum, Oberlin) in terms of various Madonna and Child reliefs by Verrocchio and/or his shop and followers. Attributes relief to unknown follower of Verrocchio.

1941 BRUGNOLI, MARIA VITTORIA. "Documenti, notizie, e ipotesi sulla scultura di Leonardo." In Leonardo, Saggi e ricerche. Rome:

Istituto Poligrafico dello Stato, 1954, pp. 359-90, 21 figs.
Analysis of Leonardo's projected equestrian statues with excursus on scholarly debate about Leonardo's participation in sculptures commissioned from Verrocchio while Leonardo was in his shop. Discusses relationship between Verrocchio and Leonardo.

1942 CANNON-BROOKES, PETER. "Verrocchio Problems." Apollo 99, no. 143 (January 1974):8-19, 15 figs.
Argues that Verrocchio trained as bronze sculptor, not as marble sculptor as others have maintained. Claims that paucity of surely attributed marbles means Verrocchio employed specialists in marble carving. Discusses links between Donatello's shop and Verrocchio's bronzes. Examines Tomb of Cosimo de' Medici (San Lorenzo, Florence), generally attributed to Verrocchio, to determine how much of original fifteenth-century work survives.

1943 CHASTEL, ANDRÉ. "Les capitaines antiques affrontés dans l'art florentin du XVe siècle." Mémoires de la Société nationale des antiquaires de France 3 (1954):279-89, 4 figs.
Groups marble, bronze, and terracotta sets of ancient captains arranged in pairs of profile busts. Attributes them to circle of Verrocchio and discusses their vogue in late fifteenth-century Florence.

1944 CHIAPPELLI, ALESSANDRO. "Il Verrocchio e Lorenzo di Credi a Pistoia." Bollettino d'arte, 2d ser. 5 (August 1925):49-68, 10 figs.
Deals with sculpture (Cenotaph of Cardinal Niccolò Forteguerri; relief Bust of Donato de' Medici; marble tabernacle, Duomo) and painting by Verrocchio in Pistoia. Considers terracotta sketch of cenotaph (Victoria and Albert Museum, London) modern imitation and defines Lorenzo di Credi's role in creation of monument. Rejects attribution to Antonio Rossellino of Donato de' Medici bust and gives it to Verrocchio.

1945 CHIAPPELLI, ALESSANDRO, and CHITI, ALFREDO. "Andrea del Verrocchio in Pistoia." Bollettino storico pistoiese 1 (1899):41-49, no illus.
Publishes documents concerning Verrocchio's role in Cenotaph of Cardinal Niccolò Forteguerri (Duomo, Pistoia), as well as miscellaneous documents about other works by him in Pistoia.

1946 CHIARONI, VINCENZO P., O.P. "Il Vasari e il monumento sepolcrale del Verrocchio per Francesca Tornabuoni." In Studi vasariani (Atti del Convegno internationale per il IV centenario della prima edizione delle 'Vite' del Vasari, September 1950). Florence: G.C. Sansoni, 1952, pp. 144-45, no illus.
Newly discovered documents correct various mistakes in Vasari's life of Verrocchio concerning commission and site of Tomb of Francesca Tornabuoni (of which a relief is now in Bargello, Florence).

1947 CLARK, KENNETH. A Catalogue of the Drawings of Leonardo da
 Vinci in the Collection of Her Majesty the Queen at Windsor
 Castle. 2d ed. 3 vols. London: Phaidon Press, 1968,
 1:104-5.
 Detailed analysis of relationship between early drawing by
 Leonardo (no. 12558) of a woman's hands, marble Lady with Primroses
 by Verrocchio, and painting of Ginevra de' Benci (National Gallery of
 Art, Washington, D.C.).

1948 CLEARFIELD, JANIS. "The Tomb of Cosimo de' Medici in San
 Lorenzo." Rutgers Art Review 2 (January 1981):13-30, 4 figs.
 Analyzes history and significance of 1467 Tomb of Cosimo
 de' Medici (San Lorenzo, Florence), which consists of floor slab in
 colored marble geometric patterns and subterranean burial vault.
 Supports its traditional attribution to Verrocchio and notes that
 crediting Verrocchio with architectural design of vault suggests his
 possible training with marble sculptor. Discusses Cosimo's patronage
 at San Lorenzo.

1949 COVI, DARIO A. "The Date of the Commission of Verrocchio's
 Christ and St. Thomas." Burlington Magazine 110 (January
 1968):37, 1 fig.
 Publishes document from Archivio di stato, Florence, which
 establishes that commission to fill tabernacle on Orsanmichele had
 not been given by 14 May 1466.

1950 COVI, DARIO A. "Four New Documents concerning Andrea del
 Verrocchio." Art Bulletin 48, no. 1 (March 1966):97-103, no
 illus.
 Publishes documents of 1488-90 from Archivio di stato,
 Florence (all but one previously known), concerning Verrocchio's
 death date, work in Venice, association with Lorenzo di Credi,
 studios in both Florence and Venice, and Cenotaph of Cardinal Niccolò
 Forteguerri.

1951 COVI, DARIO A. "An Unnoticed Verrocchio?" Burlington Magazine
 110 (January 1968):4-9, 10 figs.
 Attributes to Verrocchio, ca. 1465-66, Tomb Slab of Fra
 Giuliano del Verrocchio, Santa Croce, Florence. Discusses chronology
 of Verrocchio's sculpture of 1460s, concluding that Careggi Resur-
 rection (Bargello, Florence) dates from early to mid-1460s.

1952 COVI, DARIO A. "Verrocchio and the Palla of the Duomo." In
 Art, the Ape of Nature: Studies in Honor of H.W. Janson.
 Edited by Mosche Barasch and Lucy F. Sandler. New York: Harry
 N. Abrams; Englewood Cliffs, N.J.: Prentice Hall, 1981, pp.
 151-69, 1 fig.
 Publishes new documents regarding Verrocchio's gilt copper
 ball, or palla, for Duomo, Florence. These clarify this project and
 document previously unknown trip by Verrocchio to Venice and Treviso
 in 1469. Suggests, but does not analyze, important Venetian

influence on his style as result of trip. With many transcribed documents.

1953 COVI, DARIO A. "Verrocchio and Venice, 1469." Art Bulletin 65, no. 2 (June 1983):253-73, 13 figs.
Explores impact on Verrocchio of his documented, but unremarked, visit to Venice and Treviso in 1469. Suggests influence of San Marco mosaic of Incredulity of St. Thomas on Verrocchio bronze figures for Orsanmichele and influence of Equestrian Monument to Paolo Savelli (Santa Maria Gloriosa dei Frari, Venice) on Colleoni Monument. Also proposes that putti details in Castagno's frescoes (San Zaccaria, Venice) inspired pose of Verrocchio's Putto with a Dolphin (Palazzo Vecchio, Florence) and that Venetian colorism led Verrocchio to more pictorial style in 1470s.

1954 DUSSLER, L. "Verrocchio, Andrea del." In Thieme-Becker Künstler-Lexikon. Leipzig: E.A. Seemann, 1940, 34:292-98.
Condensed survey of life and work. Valuable bibliography.

*1955 EGGER, HERMANN. "Francesca Tornabuoni und ihre Grabstatte in S. Maria sopra Minerva." Römische Forschungen des Kunsthistorischen Institutes (Graz), 1934.
Argues that Tomb of Francesca Tornabuoni (Santa Maria sopra Minerva, Rome) was executed by Mino and that Verrocchio's relief of Death of Francesca Tornabuoni (Bargello, Florence) and his figures of Virtues (Musée Jacquemart-André, Paris) were part of rejected project for tomb.

1956 FABRI, FELIX. The Books of the Wanderings of Brother Felix Fabri, 1483. 2 vols. London: Library of the Palestine Pilgrims' Text Society, 1893-97, 1:95-96, no illus. Reprint. New York: AMS Press, 1971.
Describes competition for commission for Colleoni Manument.

1957 FABRICZY, CORNELIO de. "Andrea del Verrocchio ai servizi dei Medici." Archivio storico dell'arte, 2d ser. 1 (1895):163-76, no illus.
Publishes, with annotations and comments, 1496 inventory of works executed for Medici family by Andrea; record compiled by his brother, Tommaso.

1958 GAMBA, CARLO. "La Resurrezione di Andrea Verrocchio al Bargello." Bollettino d'arte (November 1931):193-98, 6 figs.
Argues that sleeping soldier in Resurrection relief for Medici Villa at Careggi (now Bargello, Florence), is portrait of Lorenzo de' Medici, who in his dream sees an apparition of resurrected Christ.

1959 GAMBA, CARLO. "Una terracotta del Verrocchio a Careggi." Arte 7 (1904):59-61, 2 figs.

First publication of painted terracotta <u>Resurrection</u> relief (formerly Villa Careggi, near Florence, now Bargello, Florence) by Verrocchio.

1960 HEIL, WALTER. "A Marble Putto by Verrocchio." <u>Pantheon</u> 27 (1969):271-82, 13 figs. [Summary in German.]
Suggests that marble <u>Reclining Putto</u> (De Young Memorial Museum, San Francisco) was part of fountain decoration commissioned by Matthias Corvinus of Hungary while Verrocchio was in Venice, on basis of document of 1488. [Pope-Hennessy (entry 61): "doubtful attribution."]

1961 HOLMAN, BETH. "Verrocchio's <u>Marsyas</u> and Renaissance Anatomy." <u>Marsyas</u> 19 (1977-78):1-9, 18 figs.
Verrocchio's <u>Marsyas</u>, mentioned by Vasari, used as point of departure for discussion of association between representations of <u>Marsyas</u> and écorché studies.

1962 KENNEDY, CLARENCE. "A Clue to a Lost Work by Verrocchio." In <u>Festschrift Ulrich Middeldorf</u>. Edited by Antje Kosegarten and Peter Tigler. 2 vols. Berlin: Walter de Gruyter & Co., 1968, 1:158-60, 1 fig.
Argues that several drawings of old man in sketchbook from Verrocchio's shop are copied from one prototype, Verrocchio's lost terracotta of <u>St. Jerome</u>, mentioned by Vasari. Suggests that drawings record common teaching practice in Verrocchio's shop, that of pupils copying master's sculptures.

1963 KLAPSIA, HEINRICH. "Eine Christusbüste von Andrea del Verrocchio." <u>Jahrbuch der Kunsthistorischen Sammlungen in Wien</u> 13 (1944):377-86, 8 figs.
Attributes to Verrocchio, ca. 1473-75, terracotta <u>Bust of Christ</u> (Kunsthistorisches Museum, Vienna) characterized as new Christ type created by Verrocchio. Argues bust was model for lost statue of Christ by Verrocchio.

1964 LENKEY, SUSAN V. <u>An Unknown Leonardo Self-Portrait: Revision of the Authorship of the Alexander the Great Relief in the National Gallery of Art, Washington, D.C.</u> Stanford, Calif.: Privately Printed, 1963, 23 pp., 21 figs.
Reattributes marble <u>Alexander the Great</u> relief, usually given to Verrocchio, to Leonardo's design on basis of what author considers Leonardo self-portrait, hence a signature, on Alexander's armor. Relief may have been sent to Matthias Corvinus by Lodovico il Moro, Leonardo's partron.

1965 LIPINSKY, ANGELO. "Das Antependium des Baptisteriums zu Florenz." <u>Münster</u> 9, nos. 5-6 (May-June 1956):133-45, 14 figs.
Thorough study of Silver Altar of Baptistry, Florence that includes iconographic exegesis. Useful for archival sources regarding chronology (1366-1480) and collaborators (including

Michelozzo, Pollaiuolo, Verroccho, Antonio di Salvi Salvucci, and Francesco di Giovanni). Excellent large reproductions.

1966 MACKOWSKY, HANS. "Die Lavabo in San Lorenzo zu Florenz." Jahrbuch der königlich preussischen Kunstsammlungen 17 (1896): 239-44, 3 figs.
 Attributes marble lavabo in Old Sacristy, San Lorenzo, Florence, to Verrocchio and Antonio Rossellino, ca. 1466-69, calling it earliest marble carving by Verrocchio.

1967 MACLAGAN, ERIC. "A Stucco after Verrocchio." Burlington Magazine 39 (September 1921):131-38, 4 figs.
 Identifies stucco reliefs (Victoria and Albert Museum, London, and formerly Kaiser Friedrich Museum, Berlin) as copies after Verrocchio's lost bronze reliefs of Alexander the Great and Darius which, according to Vasari, were sent to King Matthias Corvinus of Hungary.

1968 MELLER, PETER. "Physiognomical Theory in Renaissance Heroic Portraits." In The Renaissance and Mannerism: Studies in Western Art (Acts of the Twentieth International Congress of the History of Art). Princeton: Princeton University Press, 1963, 2:53-69, 25 figs.
 Analysis of relationship between ancient and medieval physiognomic treatises and Renaissance heroic portraiture, as exemplified by Donatello's portrait of Gattamelata, Verrocchio's of Colleoni, and Leonardo's of Trivulzio (as preserved in drawings).

1969 MICHEL, ANDRÉ. "Two Italian Bas-Reliefs in the Louvre." Burlington Magazine 2, no. 4 (June 1903):84-89, 2 figs.
 Attributes marble relief of Scipio to Verrocchio or Leonardo school and Madonna d'Auvillers to Agostino di Duccio.

1970 MIDDELDORF, ULRICH. "Frühwerke des Andrea Verrocchio." Mitteilungen des Kunsthistorischen Institutes in Florenz 5 (1939):209-10, no illus.
 Summary of lecture at Kunsthistorisches Institut, May 1935. Corrects Vasari's misinterpretation of the Codex Magliabechiano and Antonio Billi: Verrocchio did not work on Bernardo Rossellino's Tomb of Leonardo Bruni but on Desiderio's Tomb of Carlo Marsuppini. Middeldorf traces Desiderio's influence on Verrocchio, especially in early works like lavabo, San Lorenzo. Argues that Desiderio's influence lasted longer in Verrocchio's decorative carvings and, through Verrocchio, influenced Leonardo.

1971 MOLLER, EMIL. "Beiträge zu Leonardo da Vinci als Plastiker und sein Verhältnis zu Verrocchio." Mitteilungen des Kunsthistorischen Institutes in Florenz 4 (1932-34):138-39, no illus.
 Summary of lecture delivered March 12, 1933. Discusses authorship and meaning of series of hero reliefs (Alexander, Darius, Scipio, etc.), variously attributed to Leonardo and Verrocchio. Topic discussed more fully in Möller's article, following entry.

1972 MÜLLER, EMIL. "Leonardo e il Verrocchio: Quattro relievi di capitani antichi lavorati per Re Mattia Corvino." Raccolta vinciana 14 (1930-34):3-38, 12 figs.
 Reviews literature on reliefs associated with Matthias Corvinus of Hungary. Gives Louvre Scipio to Leonardo and claims it as model for other three reliefs by Verrocchio and his shop: Alexander the Great (formerly Straus collection, New York, now National Gallery of Art, Washington, D.C.), and Darius and Hannibal, preserved in copies from shop of Giovanni della Robbia (formerly Kaiser Friedrich Museum, Berlin; Museu de arte antiga, Lisbon).

1973 MÜLLER, EMIL. "Verrocchio's Last Drawing." Burlington Magazine 66, no. 385 (April 1935):192-95, 2 figs.
 Drawing (Victoria and Albert Museum, London) attributed to Leonardo is here given to Verrocchio and related to near-identical example in Louvre. Vasari mentions Verrocchio sketch for tomb of Doge in Venice and, since angels bear Vendramin arms, drawing must be for tomb of Doge Andrea Vendramin (d. 1478). It was probably done just before Verrocchio's death (1488).

1974 MUNTZ, EUGENE. "Andrea Verrocchio et le tombeau de Francesca Tornabuoni." Gazette des beaux-arts, 3d per. 6 (1891):277-87, 5 figs.
 Vasari's account of Verrocchio's Tomb of Francesca Tornabuoni in Santa Maria sopra Minerva, Rome, is reaffirmed (after recent discrediting by art historians) and various fragments of now dispersed monument are examined. Relief of Death of Francesca Tornabuoni (Bargello, Florence), and four marble Virtues (formerly M. Edouard André collection, Paris, now Musée Jacquemart-André, Paris) are all attributed to Verrocchio.

1975 OZZOLA, LEANDRO. "Due bronzi verrocchieschi in Campidoglio." Bollettino d'arte, 2d ser. 5 (December 1925):254-59, 4 figs.
 Attributes to Verrocchio's shop two bronze statuettes of Shield-bearing Warriors (Palazzo dei Conservatori, Rome).

1976 PASSAVANT, GUNTER. "Beobachtungen am Silberaltar des Florentiner Baptisteriums." Pantheon 24 (1966):10-23, 21 figs. [Summary in English.]
 Discusses history of altar, concentrating on Verrocchio's Decollation of St. John the Baptist relief and other figures attributed here to Verroccho and his shop. Suggests late 1470s as period of Verrocchio's participation.

1977 PHILIPS, CLAUDE. "Verrocchio or Leonardo da Vinci?" Art Journal, n.s. 61 (January 1899):33-39, 7 figs.
 Terracotta Madonna and Child (Victoria and Albert Museum, London), formerly ascribed to Antonio Rossellino, is attributed to school of Verrocchio, perhaps Leonardo.

1978 PHILLIPS, JOHN GOLDSMITH. "The Lady with the Primroses."
 Metropolitan Museum of Art Bulletin 27 (April 1969):385–95,
 15 figs.
 Discusses two versions of Lady with Primroses. Attributes
marble in Bargello, Florence, to Leonardo and painted plaster and
stucco version (Metropolitan Museum of Art, New York) to Leonardo and
shop of Verrocchio.

1979 PLANISCIG, LEO. "Andrea del Verrocchios Alexander-Relief."
 Jahrbuch der Kunsthistorischen Sammlungen in Wien 7 (1933):
 89–96, 9 figs.
 Alexander the Great relief (formerly Straus collection, New
York, now National Gallery of Art, Washington, D.C.) is identified as
by Verrocchio, while portrait of Darius (formerly Kaiser Friedrich
Museum, Berlin) is copy of the pendant. Discusses Louvre relief of
Scipio, here identified as "after Verrocchio" and elsewhere attrib-
uted to Leonardo.

1980 POPE-HENNESSY, JOHN. "Quatre sculptures de la Renaissance au
 Victoria and Albert Museum." Information d'histoire de l'art
 11 (1966):66–78, 4 figs.
 Translation from Pope-Hennessy's Catalogue of Italian
Renaissance Sculpture in the Victoria and Albert Museum includes
entry regarding Verrocchio's Cenotaph of Cardinal Niccolò
Forteguerri.

1981 POPE-HENNESSY, JOHN. "Some Newly Acquired Italian Sculptures:
 A Relief of the Rape of Europa." Victoria and Albert Museum
 Yearbook [Victoria and Albert Museum Bulletin] 4 (1974):11–19,
 9 figs.
 Attributes to Verrocchio (possibly after him) enamelled
terracotta relief of Rape of Europa (formerly Lanckoronski collec-
tion, Vienna, now Victoria and Albert Museum, London). Earlier
attributed to Agostino di Duccio. Glazed by Giovanni della Robbia,
proving that Della Robbia glazed work of other sculptors.

1982 REUMONT, ALFRED. "Il monumento Tornabuoni del Verrocchio."
 Giornale di erudizione artistica 2 (1873):167–68, no illus.
 Clarifies Vasari's misidentification of Tornabuoni family
member for whom Verrocchio was commissioned to do tomb and his
misidentification of tomb's intended location as Santa Maria sopra
Minerva, Rome. Argues tomb was planned for Florence.

1983 RICCI, SEYMOUR de. "Une sculpture inconnue de Verrocchio."
 Gazette des beaux-arts, 6 per. 11 (1934):244–45, 1 fig.
 Marble relief of Alexander the Great (formerly Straus
collection, New York, now National Gallery of Art, Washington, D.C.)
may be work by Verrocchio mentioned by Vasari; companion piece
representing Darius is known through drawing by Leonardo.

1984 SCAGLIA, GUSTINA. "Leonardo's Non-Inverted Writing and Verrocchio's Measured Drawing of a Horse." Art Bulletin 64, no. 1 (March 1982):32-44, 12 figs.

Discusses drawings by Verrocchio, Leonardo, and an unidentified member of shop. Attributes to Verrocchio measured drawing of a Horse (Metropolitan Museum of Art, New York), and elucidates shop practice of using this sort of measured drawing as pattern to produce animal's correct proportions in small models and large sculpture.

1985 SCHULZ, ANNE MARKHAM. "A New Venetian Project by Verrocchio: The Altar of the Virgin in SS. Giovanni e Paolo." In Festschrift für Otto von Simson zum 65. Geburtstag. Edited by Lucius Grisebach and Konrad Renger. [Berlin]: Propyläen, [1977], pp. 197-208, 10 figs.

Sculpted Altar of the Virgin in apsidal chapel to right of Cappella Maggiore, SS. Giovanni e Paolo, Venice, was commissioned from Lombardo shop ca. 1480 and finished in 1486. Commissioner asked Verrocchio to supply modelli for the enlarged altarpiece, which accounts for strong Verrocchio influence on its reliefs of God the Father with Cherubim and Adoring Angels.

1986 SHEARD, WENDY STEDMAN. "'Asa Adorna': The Prehistory of the Vendramin Tomb." Jahrbuch der Berliner Museen 20 (1978): 117-56, 11 figs.

Tomb of Doge Andrea Vendramin, now in SS. Giovanni e Paolo, Venice, is by Tullio Lombardo; however, Verrocchio was first commissioned to do tomb, as drawing (Victoria and Albert Museum, London, no. 2314) dated to the 1480s demonstrates. Analysis of tomb type represented in drawing and its adaptation of Florentine sources to Venetian decorative taste. Second drawing (Louvre, Paris, no. 1788) by Verrocchio follower shows second phase of tomb project and shop's modifications to Verrocchio's scheme after his death.

1987 SIREN, OSVALD. "Some Sculptures from Verrocchio's Workshop." Art in America 3 (February 1915):56-65, 8 figs.

Discusses terracottas attributed to Verrocchio or to his shop. Concludes that Madonna and Child statuette (Victoria and Albert Museum, London) is by young Leonardo working in Verrocchio's shop.

1988 STITES, RAYMOND S. "Leonardo scultore e il busto di Giuliano de' Medici del Verrocchio." Critica d'arte 10, nos. 57-58 (May-August 1963):1-32, 41 figs.; nos. 59-60 (September-December 1963):25-38, 8 figs.

Attributes to Leonardo terracotta Battle Scene (Louvre, Paris), Scipio relief (Louvre), and Madonna statuette (formerly Kaiser Friedrich Museum, Berlin). Also discusses what he considers to be extensive collaboration of Leonardo with Verrocchio on works such as Bust of Giuliano de' Medici (National Gallery of Art, Washington, D.C.), and Bargello David.

1989 TOESCA, ELENA BERTI. "Una campagna della bottega del Verrocchio." Bollettino d'arte, 4th ser. 41 (April–June 1956):144–46, 6 figs.
 Attributes the bell called "La Piagnona" (Convent of San Marco, Florence) to Verrocchio's shop on basis of style of decorations.

1990 ULLMANN, HERMANN. "Il modello del Verrocchio per il rilievo del dossale d'argento." Archivio storico dell'arte 7 (1894):50–51, 1 fig.
 Publishes for first time Verrocchio's terracotta modello (Eperjesy collection, Rome) for Decollation of St. John the Baptist relief from Silver Altar, now in Museo dell'Opera del Duomo, Florence.

1991 VALENTINER, W[ILHELM] R. "An Early Work by Verrocchio." Art in America 28 (1940):150–56, 8 figs.
 Reattributes marble relief of Neptune (Louvre, Paris) to early Verrocchio, rather than Federighi.

1992 VALENTINER, WILHELM R. "Leonardo as Verrocchio's Co-Worker." Art Bulletin 12 (1930):43–89, 40 figs.
 Reviews literature on Leonardo's training with Verrocchio, ca. 1468–78. Discusses projects with which he believes Leonardo was involved, including Careggi Resurrection (Bargello, Florence).

1993 VALENTINER, W[ILHELM] R. "On Leonardo's Relation to Verrocchio." In Studies of Italian Renaissance Sculpture. New York: Phaidon, 1950, pp. 113–78, figs. 129–91. [Revised from Art Quarterly 4 (1941) and entry 1992.]
 Reinvestigates Leonardo's relationship to Verrocchio on premise that in Verrocchio's shop parts of paintings and sculptures were likely done by different artists. Sees collaboration of Leonardo as especially important in Careggi Resurrection relief (Bargello, Florence). Traces connections between Verrocchio's shop and Francesco di Giorgio and Andrea della Robbia.

1994 VALENTINER, W[ILHELM] R. "Rediscovered Works by Andrea del Verrocchio." In Studies of Italian Renaissance Sculpture. London: Phaidon, 1950, pp. 97–112, 16 figs. [Combines three previously published articles from Burlington Magazine 62 (1933), Pantehon 20 (1937), and Art in America 28 (1940).
 Three new attributions to Verrocchio: (1) large candlestick commissioned for Palazzo Vecchio, 1468 (formerly Schloss Museum, Berlin, now Rijksmuseum, Amsterdam; (2) red marble Marsyas, restoration of ancient work for Lorenzo de' Medici recorded by Vasari, now identified with work in Uffizi; and (3) small marble relief of nude Neptune (Louvre, Paris), possibly water spout mentioned in Tommaso Verrocchio's 1495 list of works.

1995 VALENTINER, WILHELM R. "Der 'Rote Marsyas' des Verrocchio."
 Pantheon 20 (1937):329-34, 11 figs.
 Identifies red marble Marsyas (Uffizi, Florence) as antique
 Marsyas that Verocchio restored for Lorenzo de' Medici.

1996 VALENTINER, W[ILHELM] R. "Two Terracotta Reliefs by Leonardo."
 Art Quarterly 7, no. 1 (Winter 1944):2-22, 13 figs.
 Investigates Leonardo's role in Verrocchio's shop,
 especially in relation to Cenotaph of Cardinal Niccolò Forteguerri
 (Duomo, Pistoia, 1473-83). Although most of monument and terracotta
 sketch for it (Victoria and Albert Museum, London) are by Verrocchio,
 two terracotta models for angels (Louvre, Paris) are attributed here
 to Leonardo.

1997 VALENTINER, W[ILHELM] R. "Verrocchio's Lost Candlestick."
 Burlington Magazine 62, no. 362 (May 1933):228-32, 4 figs.
 Large bronze candlestick (formerly Schloss Museum, Berlin,
 now Rijksmuseum, Amsterdam) dated 1468 is identified with work
 commissioned from Verrocchio for Palazzo Vecchio and recorded in
 documents of 1468, 1469, and 1480. Candlestick is Verrocchio's
 earliest bronze work and one of his first recorded works. Drawing of
 Horse with measurement (Metropolitan Museum of Art, New York),
 previously attributed to Leonardo, is related to Vasari's statement
 regarding similar work by Verrocchio.

1998 VAYER, LAJOS. "Il Vasari e l'arte del Rinascimento in
 Ungheria." In Il Vasari: Storiografo e artista (Atti del
 Congresso internazionale nel IV centenario della morte,
 Arezzo-Florence, 1974). Florence: Istituto Nazionale di Studi
 sul Rinascimento, 1976, pp. 501-24, no illus.
 Analyzes Vasari's and modern accounts of Italian artists at
 court of Matthias Corvinus, king of Hungary, and Verrocchio's
 commissions from that ruler.

1999 VAYER, LAJOS. "Vasari nyomain" [In the wake of Vasari].
 Müvészet 15, no. 11 (1974):41-42, 6 figs. [Summaries in
 English, French, German, and Russian.]
 In Hungarian. Analysis of Vasari's remarks about reliefs
 of Alexander the Great and Darius by Verrocchio, sent by Lorenzo the
 Magnificent to Matthias Corvinus, king of Hungary.

2000 VOLPI, ELIA. Lorenzo de' Medici: Busto in terracotta, opera
 di Andrea del Verrocchio. Città di Castello: Tipografia
 Grifani-Donati, 1935, unpaginated, 3 figs.
 Correspondence (in facsimile and type) among Wilhelm Bode,
 Volpi, Leo Planiscig, and Adolfo Venturi concerning terracotta Bust
 of Lorenzo de' Medici (National Gallery of Art, Washington, D.C.)
 attributed to Verrocchio.

Author Index

Author Index

Martinelli, Valentino, 961-64
Marucchi, Elisa, 1466
Masciotta, Michelangelo, 965
Masi, Gino, 248
Mather, Rufus G., 75, 966, 1427,
 1715, 1794-95
Matteucci, Anna Maria, 1619, 1622
Matthiae, Guglielmo, 1796
Matzoulevitch, J.A., 1849
Mayer, August L., 449, 728
Mayor, A. Hyatt, 1577
McComb, Arthur, 1149
Meiss, Millard, 363
Meli, Filippo, 697
Meller, Peter, 967, 1968
Meller, Simon, 1298, 1578
Mendes Atanasio, M.C., 1250
Meschini, Anna, 489
Mesnil, Jacques, 1716
Metz, Peter, 398 bis
Mezzetti, Laura Grandi, 1675
Michel, André, 391, 521, 1676,
 1969
Michel, Paul-Henri, 542
Middeldorf, Ulrich, 54, 223 bis,
 241, 246, 340, 379a, 400a,
 435, 437, 473, 522, 595, 704,
 729, 754, 788b, 968, 1123,
 1251-52, 1327, 1338, 1374,
 1388-89, 1397, 1467, 1579,
 1677, 1743d, 1797-98,
 1824-25, 1858, 1868, 1880,
 1927b, 1970
Mielke, Ursula, 1253
Migliore, Ferdinando L. del, 85
Milanesi, Carlo, 969
Milanesi, Gaetano, 2 (ed.), 11
 (ed.), 143, 641 (ed.), 1895
Milliken, William M., 1154, 1502
Minto, Antonio, 341
Misciattelli, Piero, 722, 1678
Mitchell, Charles, 523-24
Möller, Emil, 1971-73
Moeller, Ingrid, 970
Moisè, Filippo, 123, 126
Molinier, Emile, 286, 1734, 1799
Monod, François, 432
Montini, Renzo U., 178
Montobbio, Luigi, 1307
Moreni, Domenico, 96, 128 (ed.)
Moriondo, Margherita, 1328

Morisani, Ottavio, 7, 27 (ed.),
 789, 971-73, 1405, 1605, 1679
Mormone, Raffaele, 974
Morozzi, Guido, 1800
Morselli, Piero, 271, 596, 1254,
 1317
Moskowitz, Anita, 975
Müntz, Eugène, 55, 91, 162-65,
 327, 790, 1580, 1974
Munman, Robert, 106
Muñoz, Antonio, 1112, 1120, 1535
Muraro, Michelangelo, 976
Murray, Peter, 32, 77 (ed.), 84,
 166 (ed.)
Mussi, Luigi, 705

Natali, Antonio, 1094, 1406, 1680
Negri Arnoldi, Francesco, 483,
 706-7, 732b, 755, 977, 1468,
 1850
Neri di Bicci, 86
Neri Lusanna, Enrica, 1169
Neumann, Carl, 978
Nicco [Fasola], Giusta, 980,
 1606, 1681-83
Niccoli, Raffaello, 981
Nicholson, Alfred, 786b, 982
Nicodemi, Giorgio, 224
Nicolosi, C.A., 1684
Norris, Andrea S., 1291
Nuti, Ruggero, 597, 1538
Nye, Phila C., 756, 983

Oesterreich, Géza von, 1192
Oettingen, Wolfgang von, 24, 1113
Offerhaus, Johannes, 1872
Olcott, Lucy M., 147
Onians, John, 14a
Orlandi, Pellegrino, 8
Ortolani, Sergio, 1547
Os, Hendrik W. Van, 1910
Ozzòla, Leandro, 1851, 1975

Paatz, Elizabeth, 97
Paatz, Walter, 97, 757, 985
Pacciani, Riccardo, 986, 1255
Pachaly, Gerhard, 1492
Pane, Roberto, 987, 1581
Panofsky, Erwin, 306, 328
Pantanelli, Antonio, 1136
Paoletti, John T., 149, 153b,
 525, 988, 1095-96, 1256, 1685

Subject Index